Nationalism and Cosmopolitanism in the Avant-Garde and Modernism

The Impact of the First World War

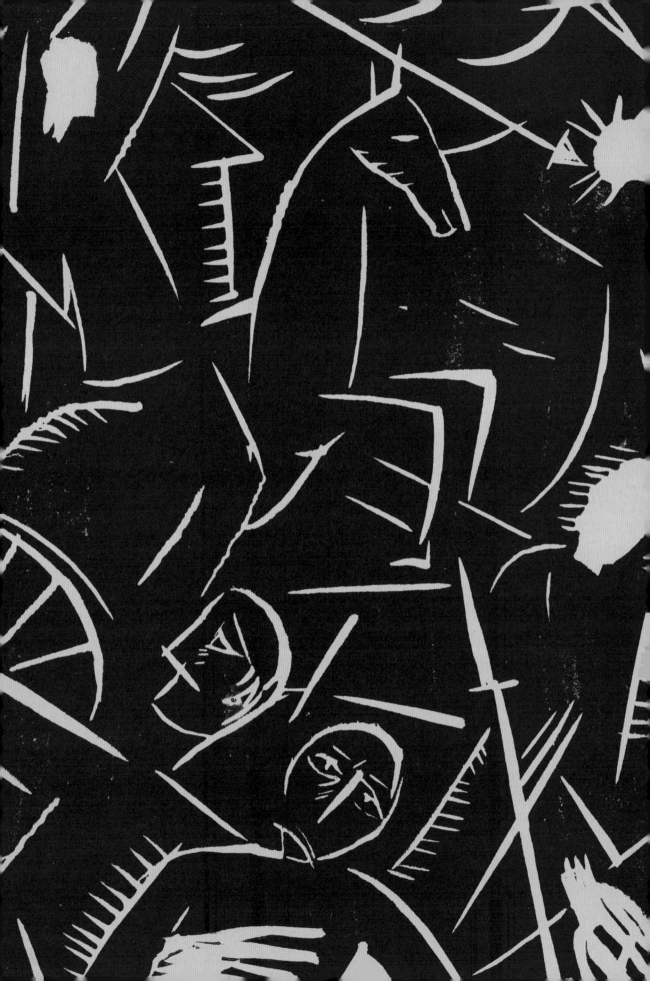

Nationalism and Cosmopolitanism in the Avant-Garde and Modernism

The Impact of the First World War

Lidia Głuchowska — Vojtěch Lahoda (eds.)

 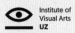

This book was published with support from the Czech Academy of Sciences.

Reviewed by: Assoc. Prof. Marie Rakušanová, Ph.D. and Assoc. Prof. Nicholas Sawicki, Ph.D.

Cover and frontispiece: Romans Suta, *Uzbrukumā* [Attack], 1919, detail. Private collection. See pp. 322, 568
Page 5: Stanisław Kubicki, *Wohin?* [Where to Go?], 1919. Private collection. See p. 562

Published by Artefactum Publishing House, Institute of Art History of the Czech Academy of Sciences, with the cooperation of Karolinum Publishing House, Charles University, and Institute of Visual Arts, University of Zielona Góra

Prague 2022

ISBN 978-80-88283-69-0 (Artefactum)
ISBN 978-80-246-5121-7 (Karolinum)

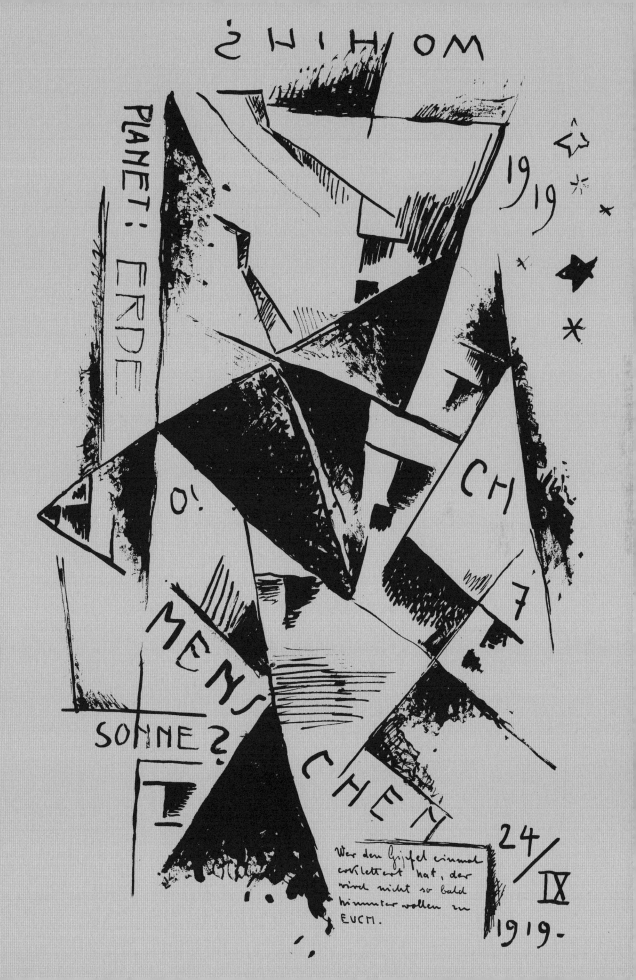

Preface

**Lidia Głuchowska, Vojtěch Lahoda†,
and Tomáš Winter**

The volume *Nationalism and Cosmopolitanism in the Avant-Garde and Modernism. The Impact of the First World War* (WWI) presents wide-ranging scientific research within the framework of the centenary of the Great War (WWI), the military conflict which was from both internal and external perspectives perceived as partly global, and partly as a "Great War of White Men" or "European Civil War". The reflection of its artistic and sociopolitical impact on world history and historiography includes on one side references to the reception of the war in the Old Continent from diverse perspectives — invaders, defenders, neutrals and independence fighters — with the prospect of establishing a "new world" to replace the *avant guerre* old order. On the other side it offers close insights into the details of particular discourses, e.g. within "the peripheries of the peripheries" — in Iceland, Finland or Georgia — considering the hitherto overlooked views of intellectuals and cultural activists from the African, Asian and other colonized territories. The publication thus establishes that around the time of WWI the claim for universality of cultural, civilizational and artistic progress was still mostly limited to Europeanism or (partly) Euroamericanism. The awareness of the faltering of the colonial *status quo*, despite its muscling for expansion still apparent in interwar Europe, is a clear subcontext of the presented contributions.

The studies collected in this book, due to the primary selection of accumulated knowledge and the presentation of new insights into previously unknown archival materials, whilst not intended to be comparative, still nevertheless address the question of "close others" and "quite others". As such they make evident that the process of national awakening initiated in the 18th and 19th centuries, claimed to be peaceful and democratic around WWI, resulted in many local, protracted conflicts with ramifications to this day. The discourse of those colonized and dominated was accompanied by concurrent concerns of economic prospects and political machinations, regarding the possession of bordering territories inhabited by diverse ethnic groups and religious communities. These included multicultural identities active too in cultural life. The review of the local, pro-state

rhetoric expressed in a spirit of a *future antérieur* of the expected post-1918 political reality makes clear that the modernism and avant-garde intertext of nationhood was far stronger than had been previously espoused in the international compendia, without a wider focus on WWI and arts.

Concerning aesthetic output around the time of WWI, one can state a paradoxical fact. The polyphony of modern styles (at the epoch mostly labelled as new art) and international Constructivism, intended as universal, became in many cases synonymous with the representation of local identities and their particular political aspirations. Universal new art, abbreviated with ethnically oriented motifs and stylizations, was largely nationalized and in this way cosmopolitanism created a basis for the official art of the new states. New building, design, experimental film and photography, functional typography, performative means of expression oriented towards direct interaction with the audience and, above all, poetry — understood in an extended sense — all formed the approach of the intermedial *Gesamtkunstwerk*. This blurring of the boundaries between "high" and "low", this overcoming of linguistic barriers, introduced in various transnational, anational or even antinational approaches from an aesthetic and even political sense, forged the common identity of popular culture of the 20th century, still manifested today as emblems of both cosmopolitanism and national ambitions. By contrast, the concepts of the "end of art", with traditional academic genres of visual expression, or the "postnational constellation", from any true perspective, seem questionable.

The presented book contributes to the understanding of the complex dissemination and translation of modern artistic and political concepts emerging around WWI through the analysis of networks, including "non human agents" (such as art magazines, manifestos and exhibitions). So too the reframing of the cultural geography and questioning of terms used in the reflection on art, such as designations of certain regions within Central and Eastern Europe are all rigorously discussed, having as they do so many possible meanings. The collected essays make evident that cultural historiography, being a collection of national narratives, is an evolving construct created *post*

factum and dependent on current perspectives. In this sense the discourse on the relation between cosmopolitan and national factors in modernism and the avant-garde in general differs from focusing solely on WWI. A century on, being a period of many local conflicts with a global impact, such as the ongoing Ukraine war, and socioeconomic crises influenced by recent migration on an unexpected scale and the unprecedented COVID pandemic creates a new perspective for the perception of cultural life in the first decades of the 20th century. Artists and intellectuals of modernism and the avant-garde perceived themselves as organizers of life and constructors of the world who were not only interested in the dissemination of progressive aesthetic concepts, but also in changing the condition of humanity. But how comprehensible or influential were their efforts in realizing a universal community? How much impact did they really have in creating this global society, emerging from the 19th century to extend beyond mere European confines? This is surely one of the key questions discussed in the contributions collected in this book, the intention of which is to stimulate further research and the rethinking of methodological tools of contemporary historiography and socialpolitical discourse.

The volume *Nationalism and Cosmopolitanism in the Avant-Garde and Modernism. The Impact of the First World War* is the result of the collaborative work of researchers and their earlier discussions during the conference of the same name organized by the Institute of Art History of the Czech Academy of Sciences in Prague at the centenary of the beginning of WWI (November 25–27, 2014). The scientific exchange which took place there was initiated a year earlier at the international symposium *The European Artistic Avant-Garde c. 1910–1930: Formations, Networks and Transnational Strategies* in Stockholm (Södertörn University, September 11–13, 2013), and continued at the conference *Avant-Garde Migrations* in Lisbon (Instituto de História da Arte, Universidade Nova de Lisboa/Calouste Gulbenkian Foundation, November 19–21, 2015). Its further important convocations summarized in this book were the symposia at the Institute of Art History at the Faculty of Arts of Charles University in Prague — *Cosmopolitan*

Kubišta: The Necessity of Art in the Modern Era (December 10–11, 2018), and at the occasion of the opening of the exhibition *The Great War* in the Museum of Art in Łódź (November 22, 2018) at the end of the centenary of WWI.

The *spiritus movens* of this research project has been Vojtěch Lahoda, one of the most esteemed experts in Central and Eastern European modern art. His death in 2019 was an extraordinary loss not only for the project's participants, but also the entire art historical community. After the *interregnum* — following Vojtěch's succumbing to long-term illness — the Institute of Art History of the Academy of Sciences of the Czech Republic in Prague, whose director he had been for many years, under successor Tomáš Winter, in cooperation with the editing house Artefactum headed by Helena Dáňová, undertook the necessary efforts to acquire the necessary financial support for the final edition and publication of the completed work. As a result of this collaboration Lidia Głuchowska has been able to finalize all the combined texts which ultimately led to the presented book.

We would like to express our acknowledgements to all those, without whom the final volume would never have been possible. First of all, our thanks go to the mentor and patron of the project Steven Mansbach, who has supported us tirelessly during the complex process of its production. Due to Steven's commitment we were able to gain a valuable collaborator, Eleanor Stoltzfus, who over a considerable period encouraged the optimization of linguistic expression achieved in the collected texts. Due to her efforts and to the final proof-reading by Rupert Brow, we are able to present the results of our research in the modern *lingua franca* — English — which is an indispensable condition of international research, and to mutually acknowledge the local expertise of "quite others" and "close others" in a spirit of collaborative harmony — the main aim of our book. Our thanks go also to Jiří Odvárka, editorial assistant at Artefactum, who assumed responsibility for the contacts with the contributors, clearing copyrights for the reproduction of artworks and acquiring their legal copies. By this token we are grateful to all the institutions who granted us their publication in this volume.

Our special acknowledgements go to the Academy of Sciences for financial support of the book.

This volume would have never received its graphical form without the excellent design created by Jana Vahalíková, who following the patterns of the international, and especially Czechoslovak, typography of the interwar period, achieved a result both visually clear and aesthetically appealing. Last but not least we would like to express our gratitude towards our contributors, whose work is an echo of the non-profit activities of the modernist and avant-garde network with its efforts in transborder exchange and an understanding and appreciation of each other's identity and diversity.

"The War to End all Wars"…

(A)Nationalism and Cosmopolitanism in the Avant-Garde and Modernist Studies in Visual Culture and Literature

Introduction

Lidia Głuchowska
University of Zielona Góra, Institute of Visual Arts. Poland

"The Austrian Archduke, whose name Frenchmen don't even know, was murdered in Sarajevo by some fanatics. As a result six weeks later Germany attacks Belgium to invade France. A paradoxical brawl..."
Ernest Denis, 1915[1]

"[...] this great war is a European civil war, a war against the internal invisible enemy of the European spirit."
Franz Marc, 1914[2]

"The twentieth century was not able to come into being. Fourteen years after its baptism it remained an embryo in the tail of its predecessor. It was a shadow of its body, an echo of its voice; it possessed only its number: twenty [...]. The war alone diverted humanity from the path at which it should embrace the soul of the previous century and evolve it."
Tadeusz Peiper, 1922[3]

"The War to End all Wars"...

The First World War (WWI) was initially called "the War of the Nations", by the Germans, "the War for Justice" or "War for Civilization", by the French and Belgians, and over time, with reference to its scale, it became known in Anglo-American historiography as the Great War (WWI). This term soon spread to other countries of the Entente, with the connotation that, for them, the outcome would be victorious.[4] Interestingly the conflict, which soon after its outbreak in 1914 proved to have global consequences, had first been called "world war",[5] but some of its

1 Denis (1915: 111), transl. by: L.G. Due to his long illness and subsequent passing, the co-editor of this book Vojtěch Lahoda was not able to consult this introduction. I would like to express my cordial thanks for the final remarks to this text to Marie Rakušanová, Steven Mansbach, and Marcin Wawrzyńczak.
2 Marc (1978: 165), transl. by: L.G.
3 Peiper (1922: 6), transl. by: L.G.
4 Kurc-Maj/Polit/Saciuk-Gąsowska (2018: 12); Chwalba (2017: 5).
5 The term was coined by Ernst Haeckel, the German biologist and philosopher. See: Sondhaus (2011: 3). Due to Andrzej Chwalba: "[...] in the defeated countries, such as Germany, Austria, Hungary, and Turkey, the term 'World War I' is favoured." Chwalba (2017: 5). Quot. after: Kurc-Maj/Polit/Saciuk-Gąsowska (2018: 12).

"The War to End all Wars"...
(A)Nationalism and Cosmopolitanism in the Avant-Garde and Modernist Studies in Visual Culture and Literature. Introduction

eyewitnesses — what an illusion — perceived it as "the war to end all wars". The latter term originated from the 1914 book *The War That Will End War* by Herbert George (H.G.) Wells,[6] and would shortly prove ironic, as WWI's aftermath directly contributed to the outbreak of the even-more-devastating Second World War (WWII), following a mere twenty or so years later, and in the consciousness of many nations overshadowed the first.

The optimistic title of Wells' publication allies with the belief of many of his contemporaries, among them artists and intellectuals, who enthusiastically volunteered for military service, perceiving the war as the "rites of spring", the inauguration of the collapse of imperialism, and beginning of the "epoch of the new spirituality", to quote the title of the famous book by Modris Eksteins,[7] and the message of Wassily Kandinsky's publication of 1911.[8] In fact they were previously mere civilians, children of the *belle époque*, having no perception of the trauma awaiting them. By contrast some politicians and historians suspected the conflagration of global conflict long before it started as there were numerous indications it could erupt,[9] but those attempting to warn of its possibility, such as Jan Bloch or Norman Angell, mostly concluded that such an apocalyptic vision was unlikely.[10]

The Armageddon, however, became reality. WWI led to the mobilization of more than 70 million military personnel, including 60 million Europeans, making it one

6 Wells (1914). The book included a justification of Anglo-American engagement in the war. "[...] Wells demonstrated the worldwide scale of the emerging conflict, which he perceived as an international fight for democracy aimed against German militarism." Quot. after: Kurc-Maj/Polit/Saciuk-Gąsowska (2018: 12).

7 Eksteins (1989). Eksteins' book's title refers to the *Rite of Spring*, performed by Sergey Diaghilev's *Ballets Russes* in 1913 anticipated ongoing cultural changes. "It was not due to Stravinsky's cutting edge music or Vaslav Nijinsky's choreography; it was due to the libretto in which the coming of spring depends upon the act of sacrifice: a selected girl must die during a ritual sacrificial dance in order to awaken the Earth. At the time, the sacrifices of war seemed necessary; it was only over time that the question arose about whether the price was too high." Quot. after: Kurc-Maj/Polit/Saciuk-Gąsowska (2018: 13).

8 Kandinsky (1911).

9 See: Renouvin (1925); Schmitt (1930); Albertini (1942/1943).

10 Szramm (2014: 11).

of the largest and bloodiest conflicts in history,[11] with an estimated 8.5 million combatant and 13 million civilian deaths as a direct result of the war.[12] It left three million widows and six million orphans.[13] These numbers may appear abstract, but there is something in common with humanity's experience over 100 years ago and our situation today. Genocides resulting from the war, such as the first — against the Armenians[14] — and the related 1918 Spanish flu pandemic, caused another 17–100 million deaths worldwide,[15] including an estimated 2.64 million Spanish flu deaths in Europe and as many as 675 thousands in the United States.[16] The latter could draw comparisons with the current COVID pandemic, and prompt us to question what exactly the global conflict of more than 100 years ago signifies in today's civilian experience.

"European Civil War"? "Europe's Fraternal War"? "Foreign" War vs. "Ours"

The outbreak of WWI is mostly associated with the decline of the Austro-Hungarian, German, Ottoman, and Russian Empires, and the reframing of the map of the Old Continent. But of course it had a fundamental impact on civilian populations outside Europe, playing a pivotal role in the shaping of the Canadian, New Zealand and Australian national identities, altering the relationships between the USA and Europe, and contributing to a rising anticolonial ferment.[17]

The global conflict however originated in Europe. In Arnold Zweig's renowned series of novels, the most comprehensive literary reflection by a German writer about WWI (1927–1954), it was already referred to "The Great War of White Men" ("Der große Krieg der weißen Männer").[18] In the period after WWII, from the postcolonial

11 Keegan (1998: 8); Bade (1998: 167–168); Willmott (2003: 307).
12 For *World War I: Killed, wounded, and missing* in *Encyclopædia Britannica*, see: https://www.britannica.com/event/World-War-I/Killed-wounded-and-missing (accessed: 29.10.2021).
13 Chwalba (2017: 626–627).
14 Duménil (2013: 121–125); see: Werfel (1933).
15 Spreeuwenberg (2019: 2561–2567); Williams (2014: 4–10).
16 Ansart/Pelat/Boelle (2009: 99–106).
17 Bloch (1899); Angell (1910); Szramm (2014: 7).
18 The series of Arnold Zweig's novels, "Der große Krieg der weißen Männer" (primarily intended as "Trilogie des Übergangs" includes

"The War to End all Wars"…
(A)Nationalism and Cosmopolitanism in the Avant-Garde and Modernist Studies in Visual Culture and Literature. Introduction

perspective, it has often been described, to quote the Hindu Historian Kavalam Madhava Panikkar, as the "European Civil War".[19] Somehow echoing this, albeit from an internal perspective in one of the newest anthologies on the topic, it has been called "Europe's Fraternal War".[20] Whilst both terms seem to be synonyms, they in fact have opposite connotations. While the first, formulated from the postcolonial point of view, Europe of 1914–1918 is perceived as united and as such a center of power and oppression against non-European ethnicities, the second can be perceived as a generalizing metaphor.

Bearing in mind that during the described period several European small nations were dominated by the Austro-Hungarian, Russian, German, and Ottoman powers (with shifting borders of influence) and sought opportunities to achieve their independence, a crucial fact should be stressed: There were no common European aims during the war. Concerning the usage of the aforementioned two terms furthermore — from the inner Old-Continent point of view — there was in fact no "European Civil War", as the small ethnicities were also fighting against the big powers, not just following their interests. Specifically, the term "fraternal war" should perhaps be limited to the experience of the Jews and Poles in 1914 living within the territories of the three empires and thus serving in armies whose aims were in contrast with their own, and indeed fighting against representatives of their own nations. WWI initiated the "postcolonial constellation" in two ways. The first, from a global perspective, is generally understandable. The second is less obvious, being related to the selfperception of the small nations or ethnicities which perceived the global or European conflict as a "foreign war", whilst at the same time seeing it as their historical opportunity. Inspired by 19th century ideals of Romanticism and national awakening, they opposed

six completed and two other planned volumes: I *Die Zeit ist reif* (1957), II *Junge Frau von 1914* (1931), III *Erziehung vor Verdun* (1935), IV *Der Streit um den Sergeanten Grischa* (1927), V *Die Feuerpause* (1954), VI. *Einsetzung eines Königs* (1937), VII *Das Eis bricht* (unpublished fragment), VIII *In eine bessere Zeit* (not realized project).

19 Panikkar (1953).
20 Markó/Schmidt (2014: 270).

state citizenship of the great empires. Creating national legions/riflemen units, and using propaganda, they conducted their "own war", the war of liberation, a passage to independence.[21]

More than ten new states — constituting not just political but ethnic organisms — emerged in the 1914–1918 period, some only for a short time, like Ukraine and Transcaucasian republics, whilst others — such as "Yiddishland", "Tartarland", and smaller states like Wendland, Sorbia (where the Lusatian Sorbs live), or Catalonia — were never formed at all. In the consciousness of many nations — Russia, Ukraine, even Germany,[22] to mention a few — WWI is a "forgotten war" as their experience of the time is overshadowed by local conflicts, including revolutions, and WWII, while from the Southern European perspective the Balkan Wars of 1912 and 1913 had already reframed the political map of the continent.[23]

Patriotic attitudes were widespread among artists of various small nations, who cherished hopes for their countries' independence. It formed the image of WWI art and *interbellum* as "a sea of dominant national cultural scenes, dominated by texts and images full of romantic pathos and myths, realism, religiousness and patriarchal idyll [...]".[24] This remains true despite particular patriotic narrative, less relevant for the *post factum* perspective, being regarded now less within the modernism and avant-garde discourse and more in a local context. It consists of thousands of soldiers' self-portraits and — predominantly allegoric or symbolic compositions — evoking the feeling of dead or wounded men's trauma. Significantly images of suffering civilians, mothers, wives, and children are almost entirely missing, and their rare existence are mostly actualizations of Christian iconography, such

21 See: texts by Oksana Dudko, Ginta Gerharde-Upeniece, and Lidia Głuchowska (*The Great War and the New Art...*, and *Jewish Artistic Networks...*) in this volume.

22 Raev (2014: 317–338); Janeke (2015); Hrytsak (2014: 270). Hrytsak states, that WWI doesn't exist in the common memory of his fellow countrymen, and the Ukrainian national consciousness of this time focuses on the Polish-Ukrainian War 1918-1919. See: text by Oksana Dudko in this volume. See: Krumeich (2013: 7–9).

23 See: texts by Irina Genova, Erwin Kessler, and Petar Prelog in this volume.

24 Šimičic (2006: 141).

"The War to End all Wars"...
(A)Nationalism and Cosmopolitanism in the Avant-Garde and Modernist Studies in Visual Culture and Literature. Introduction

as *pietà* or vague apocalyptic visions of the burning *shtet-lach* (plural of *sthetl*) of Central-Eastern Europe. There are also relatively few modernist abstract works related to war's inferno. The "massacre of forms", depictions of the decay of the "old world's" structure and values, only suggested by the painterly materia or the destruction of the classical artistic conventions, were maybe the most adequate means to express the inexpressible, but they were not effective in propagating the futurist visions of "small nations'" revival, nor supporting selfidentitication of the new states. Under the conditions of the global conflict, more efficient for both oppressive superpowers and the representatives of dominated nations hoping to achieve independence, was the war of images, namely propaganda, operating with schematic and demagogic anti-images of the enemy. Next to them, several exoticized depictions of civilian and bucolic life within occupied territories were produced by so-called war painters. The occupied nations, conducting their particular liberation wars, with similar means but operating, of course, on a limited scale, established their own national myths.

The Birth of a "New World"

In European and global history, WWI is perceived as a turning point in political, cultural, social and economic milieus, the formative period of a "New Europe"[25] and "new world", even if the latter term, popular in avant-garde circles, was not primarily used in the context of "postcolonial constellation", but more in the sense of creating a stateless transborder platform of aesthetic exchange.[26] Due to Gertrude Stein it was WWI which "made Modernism readable".[27] The emancipation of national minorities, the assimilation of many thousands of Jews and the evolution of feminism, all became increasingly apparent. The war and its immediate aftermath sparked numerous revolutions, including those in Russia, Finland, Germany, Hungary, as well as national uprisings, e.g. in Poland. In its wake, democratic principles were also adopted,

25 Masaryk (1920).
26 Głuchowska (2013d: 184–186).
27 Tate (2002: 13); see: Kurc-Maj/Polit/Saciuk-Gąsowska (2018: 14–15).

NATIONALISM AND COSMOPOLITANISM IN THE AVANT-GARDE AND MODERNISM
The Impact of the First World War

whether in the theoretical/juristic sense or in socialist/ communist avant-garde circles. In any case, such goals were the earnest intention of the new states, created from the remains of the Austro-Hungarian, German and Russian Empires. Advancements in technology, infrastructure and planning underpinned the designers' visions of the modern city. The progressive narrative of WWI eyewitnesses described the construction or birth of a "new world" and corresponded, on one side, with the anational utopia of the transborder avant-garde universum and on the other, with the idea of creating an international federation of democratic new states, defining their identity and establishing their self-representation. Within each concept, being to some extent at odds with each other, the new universally comprehensive art/architecture and rational typography seem at this time to be effective components in the establishment of a new social order, at least in a primary sense. As such they have been incorporated into the national narrative as national modernization projects.[28]

Centenary of the Great War

The centenary of WWI provided the framework for innumerable events, exhibitions, conferences and publications devoted to the commemoration and evaluation of its political and sociocultural history. Several related research projects were conducted between 2014–2018, including the *Mission of the Century 14–18* (*Mission du Centenaire 14–18*) project,[29] or the *Europeana* website,[30] presenting sections such as *News from the Front*, *People in Documents* or *Propaganda* containing letters, photos, and memorabilia. As for the artistic record of WWI and the time shortly after it, numerous organized exhibitions showcased the contribution of painters and designers in military service and the creation of national uniforms, flags or symbols, such as e.g. the show devoted to František Kupka in the

28 Turowski (2000); Schuler/Gawlik (2003); Bartetzky/Dmitrieva/ Troebst (2005); Szczerski (2010); Störtkuhl (2013: 117–130); Monkiewicz (2018); Pravdová/Hubatová-Vacková (2018).

29 For *Mission du Centenaire 14–18* [Mission of the Century 14–18], see: http://www.centenaire.org (accessed: 12.10.2021).

30 See: http://www.europeana.eu (accessed: 12.10.2021).

"The War to End all Wars"...
(A)Nationalism and Cosmopolitanism in the Avant-Garde and Modernist Studies in Visual Culture and Literature. Introduction

Fig. 1

Overview of the *Riflemen* section at the *1914* exhibition (11.01.–20.04.2014), held in Exhibition Hall Arsenāls, Latvian National Museum of Art, Riga

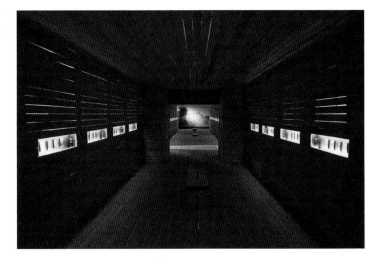

Fig. 2

Overview of the *Eyewitnesses* section at the *1914* exhibition (11.01.–20.04.2014), held in Exhibition Hall Arsenāls, Latvian National Museum of Art, Riga

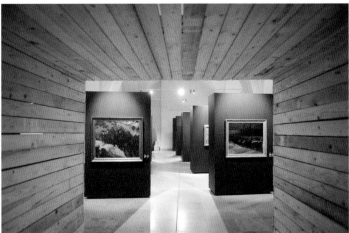

Prague Museum Kampa.[31] In this context a number of international exhibitions merit special attention in the presented volume.

The *1914* exhibition at the Latvian National Museum of Art (2014) — part of the celebration of Riga as the European Capital of Culture in 2014 — was intended to show the impact of WWI on visual culture in Europe from a new perspective, namely some of the "small nations". It was divided into two main sections. The first — *The War* — devoted to the phenomenon of war, highlighted three aspects of a conflict considered more European than global: conflict in the temporal dimension, loss

31 Havlová (2018); see also: text by Ginta Gerharde-Upeniece in this volume.

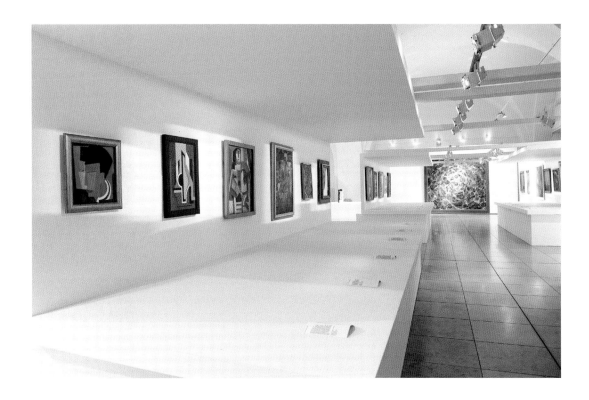

Fig. 3

Overview of the *Eyewitnesses*
section at the *1914* exhibition
(11.01.–20.04.2014), held in
Exhibition Hall Arsenāls, Latvian
National Museum of Art, Riga

of a traditional value system and reference point, internal
conflict related to the sacrifice of personal life for patriot-
ic duty, and the conflict in a geographical terms, leading
to the birth of the new Europe. Numerous maps, photos
and works of art, related mostly to Latvian history and
cultural heritage, were presented to a wider international
public for the first time, similar to the *œuvre* of artists
belonging to the Latvian Riflemen units.[32]

The second section of the Riga *1914* exhibition — *Eye-
witnesses* — was a rich panorama of little-known examples
of painting, sculpture and art prints from the Baltics, the
Nordic countries, and Central and Eastern Europe (Latvia,
Estonia, Lithuania, Czech lands, Slovakia, Poland, Slove-
nia, Serbia, Croatia, Hungary, and Finland; significantly —
Ireland was missing; see Figs. 1, 2 and 3). In this way the
presentation contributed to the general understanding
of "peripheral" modernism in Europe,[33] and the volume

32 Gerharde-Upeniece/Jevsejeva (2014: 15–19); see: text by Ginta
 Gerharde-Upeniece in this volume.
33 The debate regarding "centers" vs. "peripheries" has been ongoing
 since the 1960s, and more intensely since c. 1989. The concept

"The War to End all Wars"…
(A)Nationalism and Cosmopolitanism in the Avant-Garde and Modernist Studies
in Visual Culture and Literature. Introduction

documenting three accompanying conferences complemented this image with essays concerning other nations e.g. the "forgotten war" in Germany, monumental restoration projects in France and other countries, esoterics, and the question of woman during the war.[34]

The concept of *The Great War* exhibition organized in Łódź (2018/2019) at the end of the WWI centenary celebrations differed crucially from that of Riga. Due to its content complementing the contributions in the presented volume, it requires extensive commentary. Prepared in the Museum of Art as a successor to the International Collection of Art initiated and created by the artists themselves in 1931 (among them Władysław Strzemiński and Katarzyna Kobro, Jan Brzękowski and Malevich's former student, Wanda Chodasiewicz-Grabowska/Nadia Léger),[35] the Łódź exhibition was focused on the avant-garde's heritage. As such it belongs to the group of exhibitions like *¡1914! La Vanguardia y la Gran Guerra* [Avant-Garde and the Great War, 2008/2009] in the Museo Thyssen-Bornemisza in Madrid, *Die Avantgarden im Kampf* [Avant-Gardes in Fight, 2013/2014] in the Bundeskunsthalle in Bonn, and the Tate London *Aftermath: Art in the Wake of World War One* (2018).[36] Yet the Łódź show was a far cry from the occidental perspective of the other cities, in which the image of the war was nearly exclusively represented by the experiences of the Western Front while the East, if presented at all, was limited to the record of the Russian avant-garde. On the other side, the Łódź *The Great War*[37] belonged to the monumental series of exhibitions organized to mark the centenary of the (Polish) avant-garde, encompassing shows devoted to nature, design and stage design, choreography and montage, but also the relation between the avant-garde and the state or idea of the specific museum of this

has been highly criticized in the last twenty years, e.g. in the publications quoted in this essay. See e.g.: Piotrowski (2009); Bru (2009); Bäckström/Hjartarson (2014).

34 Cēbere (2015).

35 Piotrowski (2003: 211–218); Ludwisiak (2011: 548–553); Suchan/Pindera (2020). See: text by Michał Wenderski in this volume.

36 Arnaldo (2008); Schneede (2013); Chambers (2018).

37 Kurc-Maj/Polit/Saciuk-Gąsowska (2018).

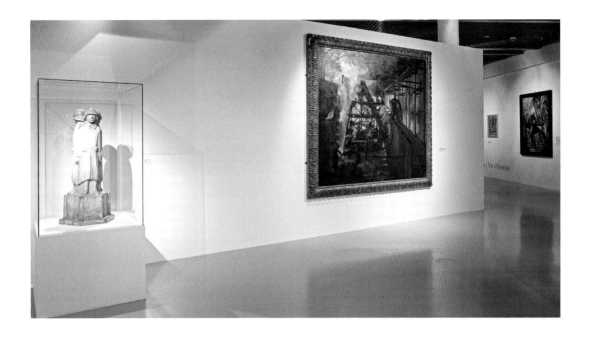

Fig. 4

Overview of *The Offensive* section at the *Wielka Wojna* [The Great War] exhibition (23.11.2018–17.03.2019), held in Museum of Art in Łódź

formation, from the supranational point of view.[38] The focus of the exhibition, with its clear anti-war message, was to underline the difference between the common experiences and memory culture in the west and east of the Old Continent, and in a local Polish context (represented with only little, rather uncanonical, anti-traditionalist works), transcending the ultrapatriotic, romantic "Ulans' western", with the myth of the Polish Legions and victorious cavalry fulfilling the dream of national independence and the memory culture of "forgotten war" trauma[39] (comparable with other local narratives in the new states, being somehow the beneficiaries of the war).

Divided into four parts, the *The Great War* show started with depictions of a fervour for conflict and belief in its purifying potential in the section *The Offensive*, with references e.g. to the Futurist paintings (e.g. Gino Severini's *Synthèse plastique de l'idée: Guerre*), and Russian

38 Jach/Kurc-Maj (2017); Strożek (2017); Bojarov/Polit/Szymaniak (2017); Andrew/Baxmann/Elswit (2017); Kurc-Maj/Saciuk-Gąsowska (2017); Monkiewicz (2018); Jędrzejczyk/Słoboda (2019); Suchan/ Pindera (2020).

39 See: Szymański (2019: 106–119). Commenting on several exhibitions from both Polish and international celebrations of WWI, the author refers to paradigamtic texts by the noted Polish literary historian, Maria Janion. See: Janion (1998: 28–31, 36–43).

"The War to End all Wars"…
(A)Nationalism and Cosmopolitanism in the Avant-Garde and Modernist Studies in Visual Culture and Literature. Introduction

war propaganda (cocreated by Vladimir Mayakowsky,
see Fig. 4).

The second part — *The Apocalypse* — including realistic
sketches and prints (e.g. Otto Dix's portfolio *Der Krieg*)
the unprecedented scale, totality, and technologically advanced nature of warfare, with the horror of positional
battles, and devastation of the landscape (e.g. in collages
by the American autodidact, Henry Darger, who never visited Europe, but created imaginary images of a cataclysm
whose victims are children, Félix Vallotton's coda like series of woodcuts *C'est la Guerre!*, and Natalia Goncharova's
lithographs inspired by a Christian iconography) leading
to the artistic reflection on the super-individual or even
metaphysical sense of Europe's trauma. A film documenting the praxis of the English neurologist, Dr. Arthur
Hurst, treating the psychosis of soldiers who had experienced months of deadly fighting in the trenches.

The third section — *Mutilation and Decay* — featured
predominantly Expressionist works, focused on individual life stories, as well as collective attitudes and the
ethical aspects of military service. The most unglamorous
paintings, photographs and sculptures depicted soldiers
wounded, attacked with gas and experiencing a slow agony on the battlefield, while thematically exceptional works
by Christopher R.W. Nevinson and one of the first female
war painters employed by the British government, Anna

Airy, featured women replacing men at factories, among them welder-girls (Fig. 5), and the symbolical model for Ernst Barlach's *Momument for Güstrow* (*Güstrower Ehrennmal*) — a wingless Angel with the features of Käthe Kollwitz, whose son was killed on the WWI front.

The last section of the Łódź *The Great War* exhibition — *The New Order* — presented the functional, rational, and ordered attempts at the reconstruction of the world, related to compensationary needs and associated with an idea of abstract new art. Also in this part of the exhibition the "conspicuous" lack of women appealed, as due to the post-war world vision of *retour à l'ordre* depicted by men (affirmatively by e.g. El Lissitzky, Sándor Bortnyik, Fernand Léger, and critically *inter alia* by the German Dada and New Objectivity artists, such as George Grosz, Raoul Hausmann, Heinrich Hoerle and Franz Wilhelm Seiwert), "[...] it is the men who are suffering from enduring war trauma, and it is their own wounded bodies that must be healed."[40]

The catalogue, which Maria Poprzęcka called the best book of 2018[41] and which includes over 150 reproductions of little known artworks by artists rarely featured in the international studies of the avant-garde (among them Belgians, like e.g. Anne-Pierre de Kat and Achille van Sassenbrouck, Frenchmen adapting influences of Cubism, Orphism and Simultaneism like Pierre Albert-Birot, Englishmen and Irishmen, like Paul Nash, Christopher R.W. Nevinson and William Orpen, Russians, such as Tatiana Glebowa, Hungarians and Ukrainian Jews like Solomon Nikritin) is a valuable supplement to the canon of European art history (not only concerning the art in the "peripheries"). The Essay-section, with additional visual material, including works from the Central-Eastern and Nordic "peripheries" of Europe or Bulgaria, encompasses contributions on the Futurists concept of war as total work of art, the ambiguous Expressionists' stance on WWI, the relationships between art and war propaganda in the British context, the cultural background of war in relation to the emergence of Dada, as well as the pacifist approach put forward by individual Polish artists and

40 Kurc-Maj/Polit/Saciuk-Gąsowska (2018: 15).
41 Szymański (2019: 114); see: Poprzęcka (2018).

"The War to End all Wars"...
(A)Nationalism and Cosmopolitanism in the Avant-Garde and Modernist Studies in Visual Culture and Literature. Introduction

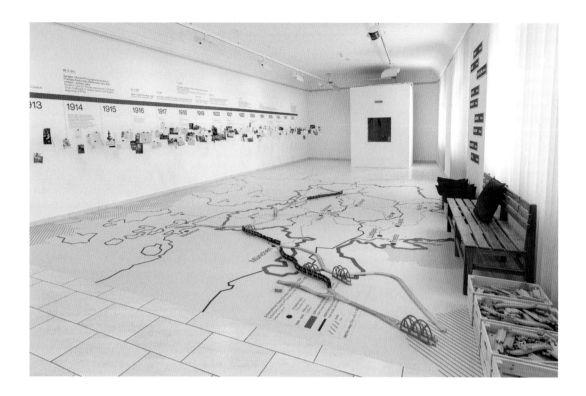

Fig. 6

Overview of foyer with map and chronology at the *Rozlomená doba 1908–1928. Avantgardy ve střední Evropě* [Years of Disarray 1908–1928. Avant-Gardes in Central Europe] exhibition (21.09.2018–27.01.2019), held in Olomouc Museum of Art

present in their manifestos. The conclusion of the contribution to the different modes of representation of the war in Western and Polish art regarding the absent visions of war trauma in the latter could also be applied to the art of other nations perceiving WWI as their chance for independence.

Two other exhibitions important in the context of the visual culture of WWI should be mentioned here, although their titles do not directly refer to the war. In the first, *Years of Disarray 1908–1928. Avant-Gardes in Central Europe*, staged in Olomouc Museum of Art, International Cultural Centre in Cracow, Bratislava City Gallery/Mirbach Palace, and Janus Pannonius Museum in Pécs from September 2018 to April 2020 (Fig. 6), only one of 12 thematic sections — *Battles* (with a short related excursus in the extensive catalogue)[42] — dealt directly with the issue of the war, and this only in context of the former Austro-Hungarian Empire, however the presentation of artworks by artists who experienced the

42 Srp (2018). See also: the extended review of the publication by
 Rampley (2020); Gryglewicz (2015); Szczerski (2015); Trávníček (2018).

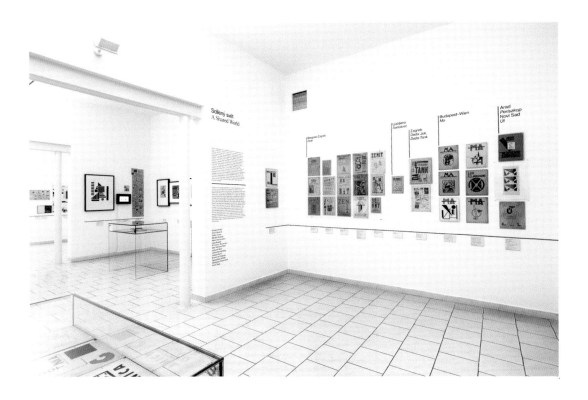

Fig. 7

Overview of *Shared World and Visual Speech* sections concerning the international magazine network at the *Rozlomená doba 1908–1928. Avantgardy ve střední Evropě* [Years of Disarray 1908–1928. Avant-Gardes in Central Europe] exhibition (21.09.2018–27.01.2019), held in Olomouc Museum of Art

military conflict personally and were often of multinational identity — Otto Gutfreund, Marcel Iancu/Janco, Anton Jasusch/Antal Jaszusch, Ludwig Heirich Jungnickel, Andor/André Kertész, Stanisław Kubicki, Artúr Lakatos, Ladislav Medňanský/László Mednyánszky, László Moholy-Nagy, Béla Uitz or Stanisław Ignacy Witkiewicz (Witkacy) surely contributes to extending modernism and the constituting of the new topography of art of the war and interwar period. As for the idea of the internationality of the avant-garde, this was conveyed in *Shared World* and (international) *Visual Speech*, referring to the "worldwide network of magazines"[43] as well as the Constructivist universal visual code of the avant-garde that illustrated it most thoroughly (Fig. 7).

The reason to pay special attention to a particular presentation in comparison to those previously mentioned — the exhibition *Expressions of Freedom: Bunt and Yung-Yidish — an Exhibition That Never Was...* held at the Museum of the City of Łódź (2019), being an important supplement to the celebrations of the centenary

43 Berlewi (1922: 2).

"The War to End all Wars"...
(A)Nationalism and Cosmopolitanism in the Avant-Garde and Modernist Studies in Visual Culture and Literature. Introduction

Fig. 8

Pola Lindenfeld, *Frauentorso*
[Female Torso], c. 1922. Private
collection, Berlin

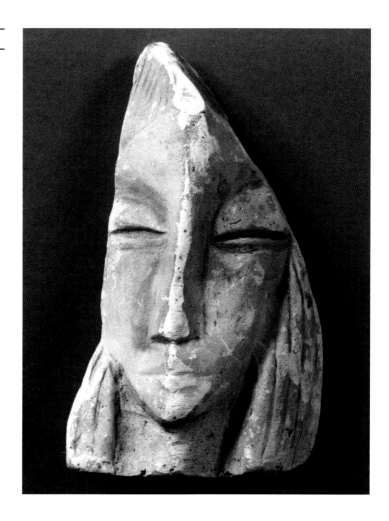

of the Polish independence and Polish avant-garde[44] —
is the fact that it was perhaps unique in presenting art
which represented a nation considered devoid of art,
indeed without its own statehood in the discussed peri-
od. Poland gained its independence as a result of WWI,
and until WWII the nation's avant-garde artists lived
in many of the new states in Central-Eastern Europe.
However it was inhabited by many national minorities,
among them Jews. With the coming of Nazism these
Jewish artists would lose their traditional European base
and its modern token of identification — Yiddish as me-
dium of everyday communication and modern aesthetic

44 *Ekspresje Wolności* (2019); Klimczak/Głuchowska/Śmiechowska (2019).

expression.[45] While the exhibition organized in 2014 at the Museum of the History of Polish Jews POLIN in Warsaw *Pole, Jew, Legionary 1914–1920* (*Polak, Żyd, legionista 1914–1920*, 2014)[46] emphasized the contribution of Jews in the fight for Polish independence, the display in Łódź presented — for the first time in so focused a way — the network of artistic circles from Poznań and Łódź, as well as their influence on the development of new art at the end and shortly after WWI. What's more, as the title *Expressions of Freedom: Bunt and Yung-Yidish — an Exhibition That Never Was…* suggests, it was a kind of (fragmentary) reconstruction and commemoration of the common plans of the representatives of these two important artistic centers that had not been realized a hundred years earlier.[47] The profile of both groups, *Bunt* [Rebellion, 1918–1922] and *Yung-Yidish* [Young Yiddish/ Jung Jidysz, 1919–1923] were ambiguously split between national and transnational aims and strategies, between patriotic tradition and international liberalism, as well as between esoteric and political inspirations.[48] The special contribution of this show was also the fact that it not only presented artworks created during WWI and the early interwar period (*inter alia* by numerous female artists belonging to the Łódź artistic circle; see Fig. 8), but also paid homage to *Bunt* and *Yung-Yidish* — contemporary art prints reflecting the aesthetic and programmatic message of both groups. The reprint of the almanac *Yung-Yidish* published on this occasion includes translations into Polish and English, which for the first time make this outstanding publication of the Yiddish avant-garde accessible to international readership.

The exhibitions and publications discussed above, together with others realized around the centenary of WWI or shortly before, such as the monumental *Electromagnetic. Modern Art in Northern Europe, 1918–1931*,[49]

45 See texts and images in: Głuchowska (2020a: 81–119); Głuchowska (2020b: 116–181); Głuchowska (2022a). See also: texts by Lidia Głuchowska, *The Great War and the New Art…*, and *Jewish Artistic Networks…* in this volume.

46 Tanikowski (2014).

47 *Yung-Yidish* (1919: [28]); Gadowska/Klimczak/Śmiechowska (2019).

48 Głuchowska (2009c: 306–327).

49 Fabre/Hansen/Mørland (2013); Lamberga (2014: 146–155).

Wien — Berlin. Kunst zweier Metropolen [Wien — Berlin. Art of the Two Art Metropolises, 2014],[50] *Beyond Klimt: New Horizons in Central Europe* (2018),[51] as well as anthologies *The Search for Cultural Identity in Central and Eastern Europe 1919–2014* edited by Irena Kossowska,[52] and *The Routledge Companion to Expressionism in a Transnational Context* edited by Isabel Wünsche[53] cocreated the research context and the methodological framework of the presented volume. A recent example of a representative work referencing the actual discourses on cultural history is the book *Degrees of Separation. Bohumil Kubišta and the European Avant-Garde*, compiled by the international research team led by Marie Rakušanová.[54] Extended studies referring to the visual culture of the Nordic countries, among them Estonia, Finland, Iceland and Sweden,[55] or e.g. Bulgaria,[56] Latvian-Belgian artistic relationships[57] and the international artistic networks established in Portugal and Spain during the war,[58] offer even the relatively well informed reader closer insights into the local narratives of the "close others", while the reports on modern art in Greece, cradle of European culture, remain few and little known.[59] The aesthetic production of the "small nations"/ethnicities around WWI, dominated by the former Ottoman Empire or representing national/ethnic minorities or "quite others"[60] (like e.g. Sinti and Roma, Sami and Northern Africans or Caucasians) for nearly all "outsiders", even neighbours within the European Union, seems still to be a *terra incognita*. Marginalized and exoticized they were still foreign to the majority of the world, including the residual states or colonizer's citizens in the discussed period.

50 Husslein-Arco/Köhler/Burmeister (2013).
51 Klee/Rollig (2018).
52 Kossowska (2015).
53 Wünsche (2018c).
54 Rakušanová (2021).
55 Pählapuu/Hennoste/Lahoda (2012); Ahlstrand/Reinhardt (2000); see also: series of books edited by European Network for Avant-Garde and Modernism Studies.
56 Genova (2013).
57 Braşlina (2014).
58 Rypson (2015); Vasconcelos (2015).
59 See e.g.: Kargiotis (2013: 165–182).
60 Piotrowski (2009: 49–58).

Difficult Terms. National Modernism and International Avant-Garde. Cosmopolitanism, (A)Nationalism, Universalism?...

About ten years after *anno mirabilis 1989* — the fall of the Iron Curtain — the discourse about globalization became intense and the political scientist David Held together with sociologist Roland Robertson recognized the second half of the 19th century as the first stage of this process.[61] Similarly Jürgen Habermas described the political situation of 1998 — in which much authority had been already relegated from nation-states to supranational governing and policymaking bodies such as the European Union, the IMF, NATO and the United Nations — as a "post-national constellation",[62] and some ten years ago the aesthetic avant-garde, at least on a cultural level, could be with affirmative approach, perceived as its utopian anticipation.[63]

Bearing in mind the world expositions held in Paris, London and other capitals with global aspirations, the Futurist obsession with scientific and technical innovations (cars, planes and trains ascending the highest mountains and transcending the barriers of time and space), as well as the extent of the international network of the avant-garde, as visualized, for example, in the diagram featured on the cover of Timothy O. Benson's seminal 2002 book on the subject,[64] one could assume that the art world of 1914 was already very cosmopolitan. It was, of course, but only in a certain limited sense.

Looking at modernism and the avant-garde, not in general terms, but with respect to their diachronic and synchronic diversity, with a focus on WWI and from today's viewpoint, with criticism of globalization and the institution of the European Union due for e.g. to the so-called *Flüchtlingskrise* [refugee crisis] ongoing since 2015, or military and economic conflicts in the world at large, changes the perspective, alas provides too wide a topic to be adequately discussed here.

61 Held/McGrew/Goldblatt (1999). In some earlier studies the starting point of globalization was dated at the end of the 19th century. See e.g.: Robertson (1992); Waters (1995); see also: Cuddy-Keane (2003: 539–540). The noun "globalization" first appeared in the *American Merriam Webster Dictionary* in 1961. See: Aijmer Rydsjö/Jonsson (2013: 61).

62 Habermas (1998); Habermas (2001).

63 Van den Berg/Głuchowska (2013a: XIX).

64 Benson (2002).

"The War to End all Wars"...
(A)Nationalism and Cosmopolitanism in the Avant-Garde and Modernist Studies in Visual Culture and Literature. Introduction

"Cosmopolitanism", the term coined by ancient Greek philosopher Diogenes in the 4th century BC, was at the time the broadest basis of social identity among Greeks either in the individual city-state or within the culturally and linguistically homogenous Hellenic group. It referred to "world citizenship", or more precisely, to the "citizenship of the universum", corresponding with an idea of "universal community" as the basis for the sociality of universal moral standards, mutual cultural expression and tolerance.[65] This concept was also promoted by Immanuel Kant, who in his 1795 essay *Perpetual Peace: A Philosophical Sketch* (*Zum ewigen Frieden. Ein philosophischer Entwurf*), advanced ideas that have later been associated with democracy, and staged a *ius cosmopoliticum* [cosmopolitan law/right] as a guiding principle to lead the global society to a permanent, enduring commercial and institutional peace.[66] In the writings of Emmanuel Levinas[67] and Jacques Derrida, cosmopolitanism was bounded with the idea of hospitality and openness for others and open dialogue, apart from any form of written laws or codes.[68] The Chinese term *tianxia* [all under Heaven] used as a metonym for empire,[69] has also been reinterpreted as a concept of cosmopolitanism, and used by 1930s modernists as the title of a Shanghai-based, English-language journal of world arts and letters, *T'ien Hsia Monthly.*[70] Also acknowledgment of the crimes against humanity such as the Holocaust, which became a generally accepted category in international law is a part of cosmopolitan thinking.[71] For the researchers of avant-garde and modernism the term cosmopolitanism however probably primarily evokes associations with 18th century aristocratic frameworks and the cultural hegemony of Paris,[72] which due to Pascal Casanova's *The World Republic of Letters*

65 Appiah (1997: 617–639).

66 Kant (1795); Kant (2016); Russett/Oneal/Davis (1998: 441–467); Deudney (2007: 10, 155–156); Taylor (2010: 1–24); Nussbaum (1997: 1–25).

67 Levinas (1999).

68 Derrida (2014); Derrida (2021).

69 Beck (2006: 45).

70 Shen (2009).

71 Beck (2006: 45).

72 Hunkeler (2006: 203–216).

at the turn of the 19th and 20th centuries, with French in a dual role as the local literary language and *lingua franca*, had a status of the "world literary space",[73] which might be renamed "world cultural space". On the other side, the linguistic sense of the term refers not exactly to this single paradigmatic metropolis, but also to other *loci* of artistic exchange in the Old Continent and other parts of the world, which emerged as such within the first decades of the 20th century. In the positive sense cosmopolitanism could be then understood as respect for the equality of different art centers, of the polycentrism of the cultural world. And paradoxically, *genius loci* of *cosmopolis* makes possible something seemingly less obvious: "When [...] in the twentieth or twenty-first centuries [artists] associated themselves with cities such as New York, London or Hong Kong they had not necessarily conquered the virus of nationalism — they merely attempted to explore the potential of the transnational *metropolis* asthe place where such a virus could be transcended without losing any sense of identity."[74] In this context to be cosmopolitan means in a sense to be somehow indifferent to questions of nationhood, though not exclusively.

During WWI the term cosmopolitanism was argued *inter alia* by the future first President of Czechoslovakia, the philosopher Tomáš Garrigue Masaryk, who in 1918 wrote in English and French a treatise *New Europe: A Slav Standpoint*[75] (which also later appeared in Czech and German). Masaryk perceived it as anachronistic and limited basically to the Francocentric culture. But not only that. It is essential to understand what he meant by contrasting "aristocratic cosmopolitanism", restricted to the nobility and the educated, and the 20th century "democratic internationalism", also clearly addressing the question of nation:

> Between nationality and internationality there is not conflict, but agreement; nations are the natural organs of humanity. Humanity is not something supranational, it is an organisation of individual nations. If, then, individual nations are striving

73 Casanova (2004: 4).
74 Buelens (2013: 59).
75 Masaryk (1918a).

"The War to End all Wars"...
(A)Nationalism and Cosmopolitanism in the Avant-Garde and Modernist Studies in Visual Culture and Literature. Introduction

for independence and are trying to break up the states in which they have been hitherto, this is not a fight against internationality and humanity, but a struggle against oppressors who have misused states for the purposes of equalisation and political monotony.[76]

In his explication Masaryk points out the crucial difference between the cosmopolitan (mondial, metropolitan, nationally indifferent, elitarian) and international, as he states: "The nationality principle applies simultaneously with the international (interstate) one."[77] In the term internationalism the existence of nationalism is pregiven, while cosmopolitanism refers more to world openness, world citizenship, or just the cultural plurality of life in the *metropolis*.

Among the intellectuals and artists of modernism/the avant-garde around WWI there was no consensus on what was meant by participating in events and publications labelled international. And how was it exactly during WWI? It seems that before it started, the artists primarily participated in international, or rather cosmopolitan events or adapted international styles only to manifest their access to modernity, without inter-national aims or, probably in the case of the representatives of dominated nations, without foundation in the national states, but merely to manifest their universal artistic quality and, maybe partly, patriotism and a national question in order to gain a wider audience. Was it artists resident abroad before WWI, especially those from the foreign dominated areas, who started patriotic awareness and promotion of the national idea? Most of them just followed individual self-promoting strategies. Their cosmopolitanism/internationality was in many cases just a modern *modus operandi*, a means of pursuing individual goals on the international scene. Those who managed to achieve success beyond their locality didn't divert their works from the national issues themselves. To gain acceptance abroad, one needed to show something in common with an already established specific *loci* of supposedly higher cultural status.

76 Masaryk (1920: 91–92). Quot. after: Vojtěch Lahoda's text in this volume.
77 Masaryk (1920: 91).

Significantly, art groups of the pre-war period didn't manifestly use the term "international" in the names of their periodicals. They either defined themselves as cosmopolitan with reference to their *locum operandi*, e.g. *Pragers* [Prague citizens] — in case of the *Osma* [The Eight, 1907–1908], with Czech, German, and Jewish members[78] — or to mention a better known example, *Der Blaue Reiter* (including artists of four nations, Germany, Russia, Austria and Switzerland). In the case of the latter it's worth mentioning that its main spokesman, Franz Marc, described the circle using the French term *Fauves* or its translation *Die Wilden* instead of the German connotated *Expressionists*.[79] Access to the new art seemed sufficient proof of modernity, and the notion of internationality mostly associated implicitly. The situation changed with WWI, as contradictory strategies of practical internationality became apparent — the one applied in Friedrich Naumann's book *Mitteleuropa* (1915)[80] can be described as hegemonial, the Futurist's magazine *Noi. Raccolta internazionale d'arte d'avanguardia* (launched in 1917) anticipatorily chauvinist (with respect to future connections to fascism and the concept of *Le Futurisme Mondial* of 1924), *Der Sturm*'s program of promoting modern art in neutral Scandinavian countries and The Netherlands whilst simultaneously serving as a secret service of German imperialism, and *Die Aktion*'s series of exhibitions and publications dedicated to the partly non-state based or Allied nations — as anti-state and anti-imperialist. In 1916 the Zurich Dada manifested its internationality with a pacifist approach, and in 1917 the Cracow based *Ekspresjoniści Polscy* [Polish Expressionists, 1917–1922] referred to a universal (international) modern style (as labels such as Cubism, Futurism and Expressionism were still used interchangeably).[81] The aforementioned

78 Rakušanová (2021: 16).
79 Van den Berg (2013: 37).
80 Naumann (1915); Henschel (2008).
81 Kubicki St. K. (2003: 80–95); van den Berg (2013: 31); Jelsbak (2013: 103–104); Buelens (2013: 49–50). The most acknowledged early instance of programmatic internationalism is probably Dada, with its activities in Zurich, Berlin, Paris, Hanover, Barcelona, Cologne or Geneva (as well as a few cities outside Europe). See: Hjartarson (2014: 276–278). See: text *International Expressionism…* by Lidia Głuchowska in this volume.

examples imply that internationality and nationalism could be opposites without necessarily being mutually exclusive. They were, of course, understood differently by the representatives of the imperial, dominated and reemerging or neutral nations respectively. For the latter an example are the Danes who, in a cultural sense, generally followed the anti-German and pro-French policy during WWI.[82]

The term "internationality" as used by Masaryk in 1918 seems to be a product of the increasing tension of nationalism, lending validity to nationhood during WWI.[83] However, as many of Masaryk's contemporaries had espoused, nations and nationalism are not something "natural". Subsequent scholars, such as Eric Hobsbawm and Benedict Anderson, have claimed the constructs emerged increasingly during the 18th and 19th centuries. But while Hobsbawm perceives nationalism as the waning of globalization, Anderson regards it as more akin to religion and the family than to political ideologies and as such, destined to persist.[84]

Nationalism entails a tendency to express imagined stories, to visualize myths which, with a certain sentimentalism, affirm a pre-modern ethnicity in the form of ethnosymbolism.[85] Anthony D. Smith claims that: "Nationalism emerged and became so successful mainly as a result of the growing gulf between the rational (absolutist) state and civil society in the period of early modernity, which led to a strong sense of alienation among educated classes."[86] According to Herder and Hegel, literature and the arts historically forged the manifestation of the nation. But modern art, which Polish sociologist Florian Znaniecki described in his 1918 book *Zmierzch cywilizacji zachodniej* [The Fall of Western Civilization]

82 Jelsbak (2013: 115).

83 In fact, Masaryk's views on the discussed questions were more complex. His 1895 book *Česká otázka* had already announced new universalism as opposed to historicizing nationalism, which was typical for the Czech National revival of the 19th century. See: Masaryk (1895). For this remark I would like to thank Marie Rakušanová.

84 Smith (2002: 73); see: Hobsbawm (1990); Anderson (1991); Gellner (1983).

85 Smith (2002: 78–80); see also: Golan (1995).

86 Smith (2002: 72).

as too sophisticated and simultaneously too elitist for the wider public, led to the fragmentation of society, and a few years later, in 1925, Ortega y Gasset claimed it to have become dehumanized.[87] This was surely the reason it had to be filled with narratives evoked by images of local landscapes and references to folk culture, or at least justified by a national ideology to support constituting or strengthening the collective self (Max Weber),[88] which resulted in the phenomenon of the nationalization of modernism and nationalization of modern form e.g. in Latvia, Poland or Czechoslovakia.[89]

Shortly after WWI, national modernism as the manifestation of new state(s) coexisted with an international avant-garde correlated with the utopian ideal of a borderless "new world" (which in fact could be compared with an archipelago or the diaspora). Paradoxically this utopia, as the reverse side to national modernism, also had its roots in the need to overcome the *Entfremdung*, the alienation of progressive artists and intellectuals. The efforts of the international avant-garde in establishing the transborder new community expressed a "discourse of marginalized" in the "world of locals" as aesthetically, politically too radical for most of society and/or representing multilingual and multinational identity.[90]

During WWI the use of the term internationality grew and in the 1920s internationality — one might call it cosmopolitanism — became widespread. It was reflected in the visualizations of the avant-garde network with extensions in different countries and continents, such as real or imaginary maps of its archipelago, and in the titles of artistic magazines or *tableaux*, presenting links to other reviews in different countries, but also reflecting in the circulation of artists, works of art and artistic concepts and ideas.[91] It also served on a programmatic level, in what Pierre Bourdieau much later and with reference to

87 Znaniecki (1921); Ortega y Gasset (1925).

88 Smith (2002: 70); see: Weber (1948: 176).

89 See: texts by Ginta Gerharde-Upeniece, Lidia Głuchowska (*The Great War and the New Art*...), Vendula Hnídková and Vojtěch Lahoda in this volume.

90 Głuchowska (2012b: 143–147, 155, 165); Głuchowska (2013d: 195–197).

91 Šimičic (2006: 141), Głuchowska (2013d: 184–186); van den Berg (2013: 27).

39

"The War to End all Wars"...
(A)Nationalism and Cosmopolitanism in the Avant-Garde and Modernist Studies in Visual Culture and Literature. Introduction

another context called the "symbolic capitalism of the cultural field",[92] as an affirmative emblem of modernity.

Before, during and after WWI, especially in the early postwar period, the understanding of the term "internationality" became as complex and confusing as the usage of labels concerning new art in the *avant-guerre* period. The main instance of this was at the *Congress of the International Union of Progressive Artists* in Düsseldorf — then under French occupation — taking place between 29 and 31 May 1922, accompanied by the *1st International Exhibition of Art* (May 28–July 3, 1922, with over 800 works, by artists from nineteen countries, including Japan, Egypt, Finland, and Ireland).[93] Separatists of the Congress, including Berlin Dadaist (with Hannah Höch, Raoul Hausmann, Otto Dix, and George Grosz), Zurich *Artistes Radicaux* (Hans Arp, Viking Eggeling, Marcel Janco, and Hans Richter) and the Berlin ephemeral group *Die Kommune* [The Commune, 1922] contested it because of the false understanding by the organizers of the idea of modernity, progressiveness and internationality ("moral bankruptcy of Europeanism" and ignoring panhuman values). *Die Kommume* members, harboring anarchist sympathies, declined to participate at the exhibition, criticizing the presence of Herbert Eulenberg (who signed the pro WWI nationalist petition of ninety-nine intellectuals) on the honorary committee, labelling it "commercial parasitism", (meaning e.g. art dealers Alfred Flechtheim and Karl Nierendorf) with the aim of the centralization and bureaucratization of artistic life and founding of the national sections.[94] In opposition to them Henryk (Henoch) Berlewi (linked to *Yung-Yidish*, *Der Sturm* and later to the Warsaw *Blok*) enthusiastically reported both events in his review, being probably the most consistent document of them, stressing the validity of an international network of art magazines and the difference between the new idea of "material-constructive" currents against the "individual-destructive".[95] The Exhibition and the Congress led to

92 Bourdieau (1999).
93 Von Wiese (1985: 54); Müller (1992).
94 Kubicki et al. (1922b: 396); Kubicki et al. (1922a: 395); Mantis (1975: n.p.).
95 Berlewi (1922: 399).

the founding of the Constructivist International — Creative Union (*K. I. — Konstruktivistische internationale schöpferische Arbeitsgemeinschaft*, which arose from the International Faction of Constructivists/*Internationale Fraktion der Konstruktivisten*), which no longer focused on the international cooperation, but emphasized the notion of a universal new aesthetics, as stressed in Berlewi's review, and the idea of semantic internationalism in abstract art including functional typography and different forms of visual and arational poetry becoming the modus to overcome the limitations of language and nationality.[96] But the sociopolitical or ethical sense of internationality for many remained more relevant than any aesthetics, as it was expressed in the manifestos of *Die Kommune*. The notion of the more precise clarifications of the term in a programmatic sense came a little later.

The debate concerning the meaning of the term "international" became more evident shortly after the Düsseldorf Congress with the emergence of a clear antinationalist stance, and some novel attempts to cast it aside. In the second issue of the magazine *Merz* (1923–1932) in April 1923 Kurt Schwitters expressed his objections to a "particular sense of nationality", contrasting it with the "general humanitarian sense" and "sense of global nationality", marked by "supranationality", rather then internationality.[97] From his perspective the idea of nationality contradicts the nature of art as a sphere of unrestricted freedom, which of course also corresponds with the rejection of the notion of transmission of national myths in a narrative, (Dada and) pre-Constructivist way. His claim seems to have close similarities to Karel Teige's article "Internacionála umění" ["The International Art"] from 1924: "[...] there is no [more] isolated national art. There is only one, multi-faceted, rich and diverse, complex yet uniform, contemporary European or world art. [...] Art knows no boundaries,"[98] but the latter has a slightly

96 Hjartarson (2014: 280).

97 Schwitters (1998: 196–197), quot. and transl. after: van den Berg (2013: 27–28).

98 See: Gwódź-Szewczenko (2011: 166), quot. after: Hjartarson (2014: 280–282).

44

"The War to End all Wars"...
(A)Nationalism and Cosmopolitanism in the Avant-Garde and Modernist Studies in Visual Culture and Literature. Introduction

different undertone, as Teige mentions Europe as a point of reference.

There were also strong claims towards the idea of anationality or even antinationality, first expressed in context of the German Revolution in November 1918 with Franz Pfemfert's (*Die Aktion*'s editor, who followed his aforementioned WWI course) "Proclamation of the Antinational Socialist Party" ("Aufruf der Antinationalen Sozialisten Partei") and mocked by Raoul Hausmann and Johannes Baader in a Dada performance as Anational Council of Unpaid Workers (*Anationaler Rat unbezahlter Arbeiter*).[99] Already around the outbreak of WWI there appeared other manifestations of anationalism, such as a collection of Ego-Futurist poetry *Intima parolad'* [Intimate Speech], translated into Esperanto and published in 1914 by Nikolaj Borisov, under the pseudonym of Ilarij of Robis (with poems *inter alia* by Igor Severyanin and Anna Akhmatova).[100] As documented in Benedikt Hjartarson's innovative study on Esperantism and the European avant-garde, both movements "represented a radical response to the growing impulse of nationalist ideology in Europe and aimed, in different terms, at the creation of a new universal or 'anational' language."[101] Esperanto, invented by Ludwik Lejzer Zamenhof, born in a Białystok (today Poland) marked by ethnic conflicts between Russians, Poles, Germans and Jews, who promoted the idea of *homaranismo* [humanitarianism], aimed at constructing a universal language that would enable a peaceful dialogue between different nations.[102] A stronger institutional foundation was introduced with the World Anational Association (*Sennacieca Asocio Tutmonda*), founded by Eugène Lanti in 1921, who in 1922 under the pseudonym Sennaciulo [The Anational One] published the manifesto *For la Neŭtralismon!* [Away with Neutralism!], and in 1931 *Manifesto de la Sennaciistoj* [Manifesto of the Anationalists]. The literary-artistic fori of the movement were the journals *Esperanto Triumfonta* and *Literatura Mondo*. In

99 Benson (2013: 14–15).
100 Hjartarson (2014: 288).
101 Hjartarson (2014: 267).
102 Hjartarson (2014: 288, 275, 289). See: text *Jewish Artistic Networks…* by Lidia Głuchowska in this volume.

the latter in the 1920s and 1930s texts and reproductions of works by avant-garde linked personalities, *inter alia* Amédée Ozenfant, Sergey Yesenin, Giorgio de Chirico, Pablo Picasso, Jules Romains, Henri Matisse, Rubén Darío, Oskar Kokoschka and Henryk Berlewi were published, while in the anthologies devoted to the literature from Bulgaria (1925), Belgium (1928), Catalonia (1931), Estonia (1932), Hungary (1933), Sweden (1934) and Czechoslovakia (1935) can be found poems by Lajos Kassák, Karel Čapek, and Vítězslav Nezval.[103] "In the literary system of Esperanto, authors working in the geographical and linguistic periphery [such as e.g. Estonia or Iceland — L.G.] had the opportunity to see examples of the latest trends in European literature and art."[104] But one fact appears more significant. In 1933 the Polish poet, the aforementioned Jan Brzękowski (linked to the Cracow *Zwrotnica* [The Switch, 1922–1923 and 1926–1927] magazine, edited by the pope of the avant-garde, Tadeusz Peiper, and *Linja* [The Line, 1931–1933], to the Antwerp Michel Seuphor and Jozef Peeters' *Het Overzicht* [The Overview, 1921–1925] and to *Abstraction-Création* and *Cercle et Carre* [1931–1936 and 1929–1930]), one of the main co-founders of the International Collection of Modern Art together with the Esperantist Salomon Grenkamp-Kornfeld published a book *Pri l'Moderna Arto* [On Modern Art, 1931]. The work seems to be a *postscriptum* to the anthologies of the new art shaped within the Constructivist tradition of the 1920s, the best known works being *Buch neuer Künstler* [Book of New Artists; with its Hungarian title *Új müvészek könyve*, 1922] by Kassák and Moholy-Nagy, and *Die Kunstismen/Les Ismes de l'art/The Isms of Art* (1925) by El Lissitzky and Hans Arp.[105] The presentation of the avant-garde's development from Cubism to Constructivism is not linear, but following the categorizations used earlier by Brzękowski in *Kilométrage de la peinture contemporaine 1908–1930* (and its variants appearing in the Polish magazine *Praesens* [1926–1930] and Polish-French *L'Art Contemporain — Sztuka współczesna* [1931; three issues, coedited

103 Hjartarson (2014: 293).
104 See: Hjartarson (2014: 275, 289, 293).
105 Leilach/Rypson (2011); Ludwisiak (2011: 548–553); Strożek (2011: 102–107); Hjartarson (2014: 292–293); Kurc-Maj (2015: 335–336, 340, 346).

"The War to End all Wars"...
(A)Nationalism and Cosmopolitanism in the Avant-Garde and Modernist Studies in Visual Culture and Literature. Introduction

by him together with Wanda Chodasiewicz-Grabowska],
with the subtitles "Les Ismes", "Deformation", "Construc-
tion", "Expression Litteraire", and "Interpretations").[106]
Pri l'Moderna Arto containing around seventy black and
white reproductions of avant-garde works (e.g. by Georges
Braque, Fernand Léger, Umberto Boccioni, Gino Severini,
Kazimir Malevich, Piet Mondrian, Max Ernst, Hans Arp,
Van Doesburg, Kassák and Moholy-Nagy), with its layout
resembling Jan Tschichold's standard work on the new ty-
pography from 1928,[107] as well as concepts by Karel Teige,
Lajos Kassák, Emil Szittya and Marco Ristić, can be seen
as a means of their extension and emulation. The publica-
tion of this book in Esperanto was a significant venture.
Two years after the International Collection of Modern
Art was placed in the Museum of the City of Łódź, what
could be seen as an approach in the institutionalization
of the avant-garde,[108] the publication of *Pri l'Moderna
Arto* stressed the roots of the movement in a non-state
based, anational context. The followers of Esperanto and
other modernist and avant-garde artists and intellectu-
als were partly the advocates of anationalism, but surely
many of them identified with slightly more moderate ten-
sion, today broadly called transnationalism, and different
from the idea of internationality and internationalism,
generally promoted around WWI. In opposition to the
politically connotated term internationalism in certain
local contexts, alternatives such as "pacifist Christian
(Orthodox) humanitarism" (e.g. for Bulgaria), "short term
cosmopolitanism" (e.g. for Finland) or "cosmopatriotism"
(for Sweden) could be mentioned.[109]

Trying to summarize the concept of transcending the
national or local and traditional during and shortly after
WWI, one could formulate the following conclusion:

> Comparable and to some extent compatible with the concurrence
> of different versions of the nation, nationhood, nationality
> and nationalism — based, for example, on the occurrence of
> single-state territories, linguistic division lines, some supposedly

106 Leilach/Rypson (2011: 133–140).
107 Tschichold (1987: 74–75); Hjartarson (2014: 292).
108 Piotrowski (2003: 211–218)
109 See: texts by Irina Genova, Harri Veivo, and Annika Gunnarsson
 in this volume.

distinctive cultural homogeneity or ethnic or racial chimera —
several versions of internationality which transcend the
national in one way or another can also be found, sometimes
expressed by different, yet frequently overlapping and even
synonymous labels such as cosmopolitanism, internationality,
transnationality, supranationality and anationality, which
all imply the transcendence of the national as a pre-given
framework. To avoid any terminological inflation, one might
use "internationality" as a general term for the broadening and
overcoming of a national perspective.

Regarding the avant-garde, at least three related, but not
identical, phenomena might be distinguished: firstly, the
previously outlined, practical internationality facilitated by
the first wave of globalisation in the nineteenth century: the
avant-garde as an international network. Secondly, this practical,
material form of internationality was often ideologically
flanked by a mode of internationality considered as an emblem
of modernity. As described above, the general recognition
of internationalisation and globalisation as basic features
of modernity led to their idolisation as insignia of the new
times. The obsession of the avant-garde with the idea of being
more modern and more advanced than others paved the way
for an ostentatious, showy internationality, which corroborated
the practical international dimension of the avant-garde
without questioning as such the national as a viable concurrent
framework. Thirdly, alongside this internationality as a sign
of one's modernity, another mode of internationality might be
distinguished, for which the term "internationalism" could be
used. This is the same internationalism as found in the socialist
workers' movement, an internationalism that opposes
nationalism and rejects the nation as a viable concept.[110]

In examining the verbal manifestations of the modernist
and avant-garde protagonists one is faced not only by the
different abbreviations of internationality, but an even
grander ambition — the claim for universality and pan-
humanism. Yet how were these terms understood around
WWI and in the interwar period? The modern labels uni-
versal and panhuman were mostly synonyms of pan-Eu-
ropean or, to some extent, extra-European (North and
Latin American or Japanese). Since the 17th and 18th cen-
turies, *chinoiseries* and *japonisme* were common haughty
incrustations of cosmopolitan European tastes and the

110 Van den Berg/Głuchowska (2013a: XXVIII).

"The War to End all Wars"…
(A)Nationalism and Cosmopolitanism in the Avant-Garde and Modernist Studies
in Visual Culture and Literature. Introduction

perfunctory Enlightenment, but does it mean that Asian culture was understood or perceived as equal to the European? Surely their inclusion within the context of the Old Continent was an attraction, but as such it clearly acquired a stigma of *conquista*. Paul Gauguin's fascination for Polynesian culture or Cubist and Expressionist idolation of African art (besides the aesthetic creations of children and of the "mentally ill") garnered respect for their primodial or totemic power, and were somehow anti-imperial and anti-academic statements (as the anti-"French" *Les Demoiselles d'Avignon* by Picasso), whilst generally remaining mere symbols of rejuvenation of the "decadent", "old" culture.

Around WWI the term universal art was mostly used as a synonym for European works. African masks and other extra-European artifacts presented at the famous galleries of the avant-garde (such as Neue Galerie in Berlin) and belonging to the less known collections (such as Emil Filla's collection of African and Oceanian sculpture)[111] connoted more the cult of the primal force of the "primitive"[112] and the need of aesthetic innovation with pretension for demonstration of some ethnographical knowledge (as progress in research), but how often could they provide documentary evidence of this diversity? The cult of the "primitive", still demonstrated in Art Deco, was mainly a voyeuristic and hegemonic, though presumably unintentionally. As progressive as they wanted to be, modernists and avant-garde protagonists in general, even the radical Dada aiming to transcend all "-isms" (including nationalism), failed in their effort of transcending the limits of Europeanism. Perhaps there were individual exceptions.

Even if the idea of universalism was widespread among the modernists, some of them acknowledged its limits and tried to establish smaller transnational communities, examples of such are the 19th century logocentric concept of Pan-Slavism, semi-hegemonial ideas, such as Herwarth Waldens' concept of Berlin as "capital of the 'United States of Europe'",[113] and a peculiar mixture

111 Benson (2013: 8, 12); Pravdová/Hubatová-Vacková (2018: 112–117).
112 Rubin (2002); Madeline (2006).
113 Głuchowska (2012a: 215–355)/*Centropa* 12 (2012), No. 3.

of internationalism and a radical form of nationalism (anti-European) in the *Zenitists* efforts in Balkanization of Europe.[114]

Modernist universalism remained Eurocentric, even if many of its proponents idolized African and Oceanian masks, imitated Islamic ornaments (as in Louis Joseph Cartier's design)[115] and studied Eastern philosophy. The extra-European artists and intellectuals did not (or did only exceptionally) participate in the progressive discourse of the 1910s and 1920s. Only in recent years, e.g. with the Berlin-Paris exhibition *Dada Africa* as part of the celebrations of the centenary of WWI[116] did they express in Europe, the center of imperial domination, their sense of earlier idolization by the modernists, yet still decontextualized and exoticized artifacts in a spirit of postcolonialism. Colonialism remained the reality of the *interbellum* and beyond, and even those who were themselves semi-colonialized by the three influential imperial powers — Russia, Germany and Austria-Hungary — failed to learn sufficiently to avoid the yearning to colonize others.[117] This, then, was the unfortunate reality of the years following WWI.

114 Passuth (2003: 168); Čubrilo (2012: 234–252); see: texts by Nina Gurianova and Petar Prelog in this volume.
115 Ecker/Henon-Reynaud/Possémé (2022).
116 Burmeister/Oberhofer/Francini (2016).
117 See e.g.: Hunczak (1967: 648–656); Bujkiewicz (1998).

"The War to End all Wars"…
(A)Nationalism and Cosmopolitanism in the Avant-Garde and Modernist Studies in Visual Culture and Literature. Introduction

Polyphony of Memory Cultures, Contradictions of National Narratives and the New Art History of WWI. Instead of a (Post) Manifesto

With its transregional perspective the volume *Nationalism and Cosmopolitanism in the Avant-Garde and Modernism. The Impact of the First World War* presents a series of case studies focusing on the development of art and society during and shortly after the global conflict which marked a watershed moment in the history of mankind. Some are panoramas of cultural life under pressure from political oppression and military action, or efforts in the national liberation and creating supranationally interconnected political movements.[118] Some refer to the policy of aesthetic neutrality in certain countries or regions.[119] Others focus on stylistic phenomena, particular aesthetic objects and their transborder circulation,[120] as well as philosophical concepts and public discourses concerning the trauma of the war,[121] the idea of nationhood and variants of internationality with connection to specific mystical and religious traditions,[122] the dissemination of certain styles and the emancipation of various ethnic and social groups.[123] In the presented volume, respect was given also to the meaning of certain political or cultural traditions (Latin, Celtic, Hispanic/Spaniard, Germanic, Anglo-Saxon, or local, folk-oriented ones) in the creation of national identities as well as manifestations of belonging to bigger, transnational communities, identified with confessional or linguistic (e.g. Slavic) backgrounds.[124] The contributors, using a diverse methodology of the "new art history", offer close insights into the process of artistic evolution initiated by the explosive impulses of the

118 See: texts by Oksana Dudko, Irina Genova, Ginta Gerharde-Upeniece, Nina Gurianova, Benedikt Hjartarson, Petar Prelog, Bela Tsipuria, Michał Wenderski, and Lidia Głuchowska (*The Great War and the New Art in Poland...*) in this volume.

119 See: texts by Torben Jelsbak and Dorthe Aagesen, and Annika Gunnarsson in this volume.

120 See: texts by Vojtěch Lahoda, Naomi Hume, and Lidia Głuchowska (*International Expressionism...*) in this volume.

121 See: texts by Éva Forgács, Harri Veivo, and Emilio Quintana Pareja in this volume.

122 See: texts by Benedikt Hjartarson, Irina Genova, and Lidia Głuchowska (*Jewish Artistic Networks...*) in this volume.

123 See: texts by Vendula Hnídková, Erwin Kessler, and Lidia Głuchowska (*Jewish Artistic Networks...*) in this volume.

124 Anderson ([1983] 1991). See: texts by Irina Genova, Emilio Quintana Pareja, Petar Prelog, and Lidia Głuchowska (*Jewish Artistic Networks...*) in this volume.

war,[125] catalyzing, stimulating and reflecting the profound transformation of society and reframing the map of Europe and the world.

In the mirror of the presented contributions, written with sensitivity to both local memory cultures and awareness of the universal analytical concepts — to the perspective of the "village"[126] and the "global village"[127] — the image of the global conflict appears in a new light. It becomes evident how differently it was understood in the imperial and neutral countries as well as within nations who fought for their independence. In a sense WWI seems often to be a "forgotten" or "foreign" war, as in the historical narrative the emphasis is given to "own" war, the war of independence and, much more, to the optimistic discourse of the then re/emerged new states. As it appears, national minorities — Sinti, Roma, Jews, Tartars, Sorbs, and many "close others" — are generally omitted from the heroic art historical narratives. The case for detailed discussion of the patriotic contribution of the Aromanian minority from the Pindus Mountains and Macedonia in regions disputed by Greeks, Bulgarians and Serbs to the creation of the Romanian national identity, belongs to exceptions in the context of the multinational states.[128] Even more evident is the fact that general knowledge of the experience of thousands of soldiers fighting in the French, Belgian, British and German Armies — the Canadians, Hindus, Senegalese, Australians, Irishmen and South Africans is still very limited in contemporary art publications not focused specifically on the war, during which struggles for a new form were accompanied by a "war of images" (visual propaganda), one seems to derive an even stronger sense of nationhood in the modernist sense.

Certain questions related to WWI deserve special attention. It was called the *Great War of the White Men*, and it is mostly males who are perceived as its heroes. Only few women, such as the Ukrainian Olena Stepaniv,

125 Vojvodík (2018: 23).
126 Nádas (2002: 23–33).
127 McLuhan (1962); Porter (2015); see also: Mitter (2014).
128 Piotrowski (2009); see: texts by Benedikt Hjartarson and Erwin Kessler in this volume.

49

"The War to End all Wars"...
(A)Nationalism and Cosmopolitanism in the Avant-Garde and Modernist Studies in Visual Culture and Literature. Introduction

are celebrated in the national narrative. In many instances women were not permitted to join national units (as in the case of the Polish Legions) and could only participate in armed combat disguised as men, like the paintress Zofia Plewińska and the sculptress Zofia Trzcińska-Kamińska.[129] Those who replaced men at the factories are only seldom depicted in war paintings, like the rest of the suffering civil society — exploited economically, pushed to relocation, refuge, exposure to violence and even genocide. Yet female artists, poets and political activists are still mentioned relatively rarely in studies of this time. The same applies to artistic couples' contribution to the international understanding and artistic exchange. Sonia and Robert Delaunay, and Margarete and Stanisław Kubicki[130] belong to the few to whom closer attention has thus far been given.[131] And very little is known of the lot of children. Their works were an inspiration for Expressionists (similarly like those of the supposedly mentally ill).[132] But how seriously were they treated as members of society during the world conflict and its aftermath, when modernization and democratization became the slogans of the "new world"?

The influence of WWI extends the discourse on "nomadic modernism", symbolized by such paradigmatic collages as El Lissitzky's *Shifskarta* (1922) and Karel Teige's *Travel Postcard* (1923), connoting artistic travels as well as politically and economically affected emigration, and the utopia of a conflictless world.[133] Around WWI artists themselves were mobile firstly on professional grounds,

129 See: texts by Oksana Dudko, and Lidia Głuchowska (*The Great War and the New Art...*) in this volume.

130 Vasconcelos (2015); Głuchowska (2007); see: texts by Ginta Gerharde, Annika Gunnarsson, Torben Jelsbak and Dorthe Aagesen, and Lidia Głuchowska (*The Great War and the New Art...*) in this volume.

131 See also e.g.: Hubert (1994); Berger (2001).

132 Before WWI, works of art by "mentally ill" patients were merely a point of interest to artists, but with the onset of military action with its physical and mental consequences, such as morphine addiction, the subject came into sharper focus, in both artistic biographies (e.g. Ernst Ludwig Kirchner) and artworks themselves. See e.g.: Röske/Guratzsch (2003); Głuchowska (2015f: 28, 46, 118, 147).

133 Benson (2006: 125–142); Głuchowska (2013d: 195–197, 200–201); Lipińska (2017). See images in: Hazan-Brunet/Ackerman (2009: [cover]); Głuchowska (2012b: 148); Passuth (2003: 134).

but also as soldiers — traumatized, seriously wounded, or indeed deceased. For some the military conflict even became a lucrative affair. War painters under orders from various governments were also contributors to the war of images linked to propaganda. The masters of the latter genre were Germans, who registered or rather staged their impressions from Central-Eastern Europe in the paintings and photographs published as war postcards or in movies supporting the image of their "civilizing mission" and democratic idealism in the "debased" regions.[134] Their works document a peculiar exotization of their citizens and as such can be sarcastically compared to the souvenirs of contemporary tourists.

Among the questions concerning the impact of WWI on the globalized world is one of the special validity in the contemporary discourse: That nature, idolized by the artistic colonies, such as Worpswede, Ascona, Skagen, St. Ives, Nagybánya, Balcic or Nida/Nidden,[135] by *Die Brücke* Expressionists, and within the national narratives, was utterly devastated by military action. This is recorded in many artworks, e.g. such resembling photos taken from aeroplanes by Paul Nash, Christopher R.W. Nevinson, and German war painters such as Max Wislicenus.[136] How did such destruction affect society in general and artists in particular regarding man's custodianship of the ecosystem? This issue was either practically non-existent in the written statements of the war generation, or its avoidance is a mark against international research up to now. "Das Verhältnis des Menschen zur Schöpfung" ["Man's Relation to the Creation"][137] published in 1932 by Stanisław Kubicki in the Cologne *Gruppe progressiver Künstler* [Group of the Progressive Artists] magazine *a bis z* [a–z, 1929–1933] and related to God's laws presented in the *Book of Genesis* belongs to the early statements made by artists, anticipating today's ecological movement.

Early modernism and classical avant-garde, terms having both qualitative and chronological connotations

134 See e.g.: images in: Brade (2015: 156, 169–172).
135 See: Andriušytė-Žukienė (2012: 269–286), and text by Erwin Kessler in this volume.
136 See images in: Kurc-Maj/Polit/Saciuk-Gąsowska (2018: 110–112, 160–164); Brade (2015: 150).
137 Kubicki (1932: 81–83).

54

"The War to End all Wars"...
(A)Nationalism and Cosmopolitanism in the Avant-Garde and Modernist Studies in Visual Culture and Literature. Introduction

and used often like twins, do not of course mean exactly the same thing.[138] Both however are, to different degree, associated with the crisis of representation. The end of art belonged to the prognosis or proclamations of the radical avant-garde, understood as negation of the validity of painting and the postulate of the integration of art and life. And of course, plenty of functional solutions were introduced shortly after WWI. One hundred years later, however, the state of semi-academic art still seems to be in good health. One could perhaps pitch the reversed hierarchy of the avant-garde multimedial and praxis-oriented art genres against the previously highly estimated traditional aesthetic expression. There is a human need for possession of objects with haptic quality, portraits, still lifes or landscape depictions (perhaps more often presented through the medium of amateur photography, whilst existing beside folk or stylistically conventional, neo-academic art). More generally, artifacts as status symbols, had still not been overcome if favour of utilitarian or non-figurative experimental creativity, such as design, architecture or abstract art as emanation of the universal and spiritual values. They just belong to the parallel circulation's systems.

What was the *opus magnum* of international modernism and avant-garde? Requesting their testimony Steven Mansbach has recently suggested, it was poetry,[139] while Wolfgang Asholt and Walter Fähnders some 30 years ago argued for the manifesto(mania).[140] Both, in their condensed form, had the potential of instant, direct, oral and performative expression,[141] as well as establishing a bridge between high and low culture, being vehicles for the integration of art and life.

Around WWI poetry certainly offered various complex approaches to extend the modes of social communication, and was not merely a depiction of the laboratory of modernist and avant-garde aesthetic experimentation, but had its own social mission. Of course, due to linguistic limitations, its effects have only recently been

138 Magerski (2011); see: texts in this volume.
139 Mansbach (2018: 33–45).
140 Asholt/Fähnders (1995); Asholt/Fähnders (2000).
141 See e.g.: Głuchowska (2015e: 15–36).

considered from the postcolonial perspective as an international phenomenon, as e.g. in the case of the literary production of the *Ultraists* with transborder and transcontinental aspirations, including Latin Americans such as Rubén Darío or Vincent Huidobro[142] or the manifesto-like poetry published in multilingual avant-garde and modernist magazines.[143]

Generally however, it has been recognized that it was paradoxically the language-based medium of poetry which around WWI contributed strongly to the idea of universal communication. While the Futurists, with concepts of occult oriented *Zaum* [Beyonsense] or Dadaists (like Schwitters) with their *Urlaute* [Primodial Sounds], similar to the multilingual performances of Dada Zurich, explored the potential of irrational, fatic expression,[144] the Constructivists searched for means to transcend other limitations of natural languages. Visual poetry, associated with Kurt Schwitters' *Versgestaltung* and correlated with collage and photomontage, represented by Mieczysław Szczuka's *poezjoplastyka* and Lajos Kassák's *Képarchitektúra* [Picture Architecture], endeavoured to establish a multifaceted universal code, intuitively comprehensible without the need of translation. Created in symbiosis with the functional typography (today identified with layout) as a multimedial genre, it was a part of the functionalists' approach constituting *iconosphera* of modernity. Reproduced in art magazines and artistic books, circulating in the international context, along with collections of art prints, they expressed the efforts of the democratization of art with use of reproductive media. In the transborder or even transcontinental way, poetry was an integral part of the Constructivist "corporate identity" system, prefigurated by the triangle of the *Wiener Werkstätte* [Vienna Workshops, 1903–1933], *Warsztaty Krakowskie* [Cracow Workshops, 1913–1926] and the Prague *Artěl* (1908–1935). Slightly later, Cubist magazines such as e.g. *Umělecký měsíčník* [Artistic Monthly,

142 Bonet (2015: 76–108); Phillips/Pérez Alonso (2017: 66–89); see also: Poliwka (2015). See: text by Emilio Quintana Pajera in this volume.
143 See: text by Harri Veivo, and Michał Wenderski in this volume.
144 Hjartarson (2014: 285); see: texts by Nina Gurianova, and Irina Genova in this volume.

"The War to End all Wars"…
(A)Nationalism and Cosmopolitanism in the Avant-Garde and Modernist Studies in Visual Culture and Literature. Introduction

1911–1914], *Pražské umělecké dílny* [Prague Artistic Workshops, 1912–1914], or Expressionists revues such as *Die Aktion* (1911–1932), *Der Sturm* (1910–1932), *Zdrój* [Source, 1917–1922] or *Ma* [Today, 1916–1925] became "non human agents"[145], next to the exhibitions,[146] posters and flyers,[147] through which the international avant-garde network operated. *Poetism*, understood not only as the program of the Prague-based artistic association *Devětsil* [Butterbur, 1920–1931],[148] but more generally, as a tendency of transferring ideas, emotions and aesthetic patterns in a condensed way, also served commercial purposes as in the case of the *Mechano* advertising office founded in 1924 in Warsaw by Henryk Berlewi, Stanisław Brucz and Aleksander Wat.[149] These signified both *modus vivendi* and *modus operandi* of the progressive representatives of the young generation shortly after WWI. Text integrated with image, or text replacing and becoming image as such, from the cover of the Berlin issue of the Yiddish magazine *Albatros* in 1923,[150] the covers of Georgian avant-garde magazines,[151] or in the case of the Southeastern European examples designed with Cyrillic characters, were generally not linguistically comprehensible for international readers, but can be instinctively perceived as attempts at modern non-verbal communication, as visual idioms of a universal modernity combining national and transnational components. There were always two ways of reading this poetry — the universal and the particular. Which was more comprehensive? As a universal hieroglyph they were "anational, because one hardly has to

145 Latour (2005: 75); Rakušanová (2021: 23); Lahoda (2014b: 187–194); Joyeux-Prunel (2017: 1–19); Joyeux-Prunel/DaCosta Kaufmann/ Dossin (2015: 183–201).

146 Passuth (2002: 226–246); Eigl (2018: 194–201); see also remarks on the *The Baltic Exhibition* in the text by: Annika Gunnarsson in this volume.

147 See e.g.: Kurak (2020); Głuchowska (2016); Głuchowska (2020b).

148 Srp (2002: 110–131).

149 Frankowska/Frankowski (2010: 63–75); Głuchowska (2013b: 306–327).

150 Głuchowska (2012b: 159–160); Głuchowska (2013b: 313); Głuchowska (2013d: 202); see: text by Lidia Głuchowska, *Jewish Artistic Networks...* in this volume.

151 Digitized versions of Georgian modernist/avant-garde books, periodicals, and posters are available at: http://www.modernism.ge (accessed: 06.07.2020). See: text by Bela Tsipuria in this volume.

learn anything to understand it."[152] They anticipated such universal emblems of popular culture as contemporary communication devices — pictograms or emoticons.

Perceiving the manifesto as a crucial emanation of the phenomenon of modernism and avant-garde in an aesthetic context one can state, in comparison to poetry it was at first glance, more precise and supraindividual in content, and often part of a collective work. Its authors — patriots, exiles and translators — mediated the sociopolitical and cultural discourse, simultaneously redefining their role evolving from the postromantic demiurgs to the engineers of the social imagination. As Asholt and Fähnders characterized the manifesto, it expressed the self-doubt of the avant-garde (and modernism), which itself was reflected in the fragmentary character of innumerable manifestations and programmatic proclamations of the aesthetic movements around WWI. By analogy to Friedrich Schlegel's theory of the fragment, the manifesto, seen as a fragment of a more complex and sociopolitical discourse, could be considered here as an attempt to present a sketch of the future, with the knowledge that this sketch can only represent an anticipation of a potential development, which cannot be realized as a whole in the present.[153]

The volume *Nationalism and Cosmopolitanism in the Avant-Garde and Modernism. The Impact of the First World War* can be characterized with reference to the metaphors of poetry and manifesto used as *pars pro toto* definitions of modernism and avant-garde. It is on one side based on the polyphony of narratives related to the local memory cultures constituting certain national myths, reconstructions but also constructs of their identity, establishing their validity and expressing efforts of representation in the global context initiated, in the Central European, Baltic and Balkan regions, only 30 years ago. It could be metaphorically compared with poetry — in its extended sense constituted around WWI — adjusted to the contemporary design, the

152 Lissitzky (1967: 358); Głuchowska (2012b: 159–160); Hjartarson (2014: 283).
153 Asholt/Fähnders (2000: 3–4).

55

"The War to End all Wars"...
(A)Nationalism and Cosmopolitanism in the Avant-Garde and Modernist Studies in Visual Culture and Literature. Introduction

metadiscourse of universalist concepts,[154] and the pos-
tulates of transnational, postcolonial and postnational
research. Even within the "poetic", national case studies,
relating to local identities from the viewpoint of the
formative period of nation states, the weight of the glob-
al perspective (not really translatable into the other con-
text) is clearly felt. This is their constructive point: that
they take into consideration the newest methodology, in-
cluding the concept of "horizontal" studies (here exempli-
fied *inter alia* by the perception of WWI in Belgium as re-
flected in Spanish and Spaniard literature[155]), as well as,
wherever relevant and applicable, the comparative view.

The presented book could in many senses be under-
stood as a (post)manifesto of modernism and avant-garde
as a whole. As a collection of grounded studies respecting
the unknown facts and at least internationally unknown
archival sources, it is a variously documented palimpsest
of programmatical texts and interpretations of the works
of artists active at the time of WWI. It is furthermore
a supplement to the existent studies of the aforemen-
tioned period in the context suggested in the title of the
volume. Published at a time when the Gutenberg galaxy
is in its twilight, as its relic and a fundament of classical
(and modern) intellectual culture, it comes as a tribute
to the reproductive and materially present modern me-
dia, as opposed to today's omnipresent digital presenta-
tions, with which it nonetheless coexists. Researchers
contributing to this volume faced a problem of the diver-
sity, selection and comparison of the still growing inter-
nationally accessible archival materials, aware of the need
to present the still unknown or disregarded aspects of
the universal discourse. Such sterling efforts are of course
combined with the consciousness of their fragmenta-
rity — as was typical of the modernist and avant-garde
manifestos.

This book intends to offer an essential contribution
to the new synthesis, or rather comprehensive overview,
of the new art history of WWI, written in a modern
lingua franca, and hence accessible in a global context.
Echoing the discourse on the "unfinished project" of the

154 Geertz (1973).
155 See: text by Emilio Quintana Pajera in this volume.

avant-garde and modernism[156] with respect to the existing research into the aesthetic production of the time, it offers deep insights into the different narratives concerning art and society at the time of the global conflict, which — as it appears in the light of the presented studies — had not only tragic, but also beneficial aspects, redefining man's condition and initiating processes of transformation for humankind and the world we live in, continuing to this day. As such the volume contributes to the decentring avant-garde[157] and extending modernism not just in the reflection on the contradictions of cosmopolitanism, which paradoxically created a foundation for national art, but also on the margins of the margins in the geographical, social and aesthetic sense.

156 Habermas (1994).
157 Mitter (2008: 531–548); Bru (2009: 3–17); Bäckström/Hjartarson (2014).

"The War to End all Wars"…
(A)Nationalism and Cosmopolitanism in the Avant-Garde and Modernist Studies in Visual Culture and Literature. Introduction

International Expressionism as the Style of the Great War?

Remarks on its Adaptation and Evaluation

Lidia Głuchowska
University of Zielona Góra, Institute of Visual Arts. Poland

Abstract

The iconosphere of Expressionism, if one compares the early works of *Die Brücke* and *Der Blaue Reiter* circle with the artistic production of so-called Second Generation Expressionists, spans two opposites — the "Arcadia" and the "Apocalypse". Expressionists, who contested bourgeois standards and created visions of "great spirituality" (*großes Geistiges*), like Wassily Kandinsky, welcomed the outbreak of the Great War with euphoria, regarding it as a Dionysian ritual of rebirth. Spurred by the ultrapatriotic mood, they volunteered to join the army in order to "heal sickly Europe".

Expressionism had been Germanized around 1914, shortly before the Polish-Jewish critic Adolf Basler dubbed it the "universal new style", believing it to have sprung from Parisian Fauvism. If one is assuming that Germany and Vienna were the "centers" of Expressionism where the canonical forms of this style were born, then its hybrid idioms, formerly referred to as eclectic or epigonian and today more often regarded as an emulation of the prototype, developed on the vast "periphery", where the style became popular.

While during the war Expressionists created a universal network, communicating transcontinentally by means of privately distributed magazines and focusing on shaping the international form and *lingua franca*, in local communities the reception of Expressionist achievements was ambivalent, often perceived with suspicion as a foreign, "German import".

To various nationals forcibly conscripted into the German, Austro-Hungarian, and Russian Armies, the military conflict of 1914–1918 was a "foreign war". At the same time, despite enormous human losses, the struggle for the (re)construction of "small nation" states cemented faith in the significance of "our" (own) liberation war, boosting optimism and preparedness to suffer the necessary sacrifice.

Significantly, many representatives of Expressionism almost abstained from any direct depictions of war. The traumatic fate of the civil population on the Eastern Front was broadly documented by the war painters. Moreover, during WWI, numerous artists voluntarily joined the legions (riflemen units) fighting for the

International Expressionism as the Style of the Great War?
Remarks on its Adaptation and Evaluation

national independence of their countries. The narrative imagery of Expressionism in WWI era is limited to a handful of themes, such as field hospitals and scenes of returning prisoners of war, or the wounded from the front. Expressionists also frequently referred to Christian symbolism as a form of metaphorical sacralization of the martyrdom of war. One of the most radical changes appeared in the traditionally aniconical Jewish culture. Full of pathos, evocations in words and images became a response to the war, revolution, and pogroms. The most innovative pictorial convention of Expressionism exemplifying the modern form rather than the traditional martyrological narrative is the so-called massacre of forms, blurring forms to the point of abstraction so that the realities of war can be identified only through titles.

Key words

Expressionism, the Great War, liberation war, Jewish culture, legions, riflemen, new states, emulation

"The Rites of Spring" or the Apocalypse? Expressionists and Militarism

The iconosphere of Expressionism spans two opposites — the "Arcadia" and the "Apocalypse", often associated with the "Metropolis".[1] The equivalent of the former is, on one hand, the *œuvre* of *Die Brücke* group, featuring synthetic depictions of bathers or nudes in nature and reflecting the experimentally practiced "life reform" (*Lebensreform*),[2] and on the other, works by painters associated with *Der Blaue Reiter* circle, characterized by alluringly rich, transparent colours. At the antipode of this anti-civilization, communionist utopia are images of a metropolis contaminated with noise, social crisis and alienation, some completed even before the Great War, such as Ernst Ludwig Kirchner's famous *Potsdamer Platz* (1914) or Ludwig Meidner's self-portrait *The City and Me* (*Ich und die Stadt*, 1912). The Apocalypse anticipated in such paintings was about to become reality.

Expressionists who opposed bourgeois standards and created visions of "great spirituality" (*großes Geistiges*),[3] like Wassily Kandinsky, welcomed the outbreak of WWI with euphoria, regarding it as a Dionysian ritual of rebirth.[4] Spurred by the ultrapatriotic mood, they volunteered to join the army in order to "heal sickly Europe".[5] Some of those who enthusiastically set off for the frontline (such as Max Beckmann, Max Ernst, George Grosz, Oskar Kokoschka and Wilhelm Lehmbruck) were killed not long after enlisting. Among them were August Macke and Franz Marc, drafted during the first days of the war.[6]

Figures from the world of culture often denied the trauma they suffered, even in the face of the unimaginable. Any illness or depression resulting from the war was

1 This article is the result of studies carried out as part of the NPRH project *The Yiddish Avant-Garde in Łódź: Critical Edition of Sources* supervised by Professor Krystyna Radziszewska from the Institute of German Studies at the University of Łódź. Some theses presented here were published in: Głuchowska (2018e). For recent studies on WWI see: http://www.1914-1918-online.net/03_encyclopedia/index.html (accessed: 20.10.2020). See also: Głuchowska (2018b: 379); Głuchowska (2018c); Głuchowska (2018d); Głuchowska (2020).
2 Wolbert/Buchholz/Latocha (2003).
3 Kandinsky (1911).
4 Eksteins (1989).
5 Partsch (2009: 88–90).
6 Hoberg (2015: 6).

taboo, as was the morphine addiction widespread among the wounded (including Ernst Ludwig Kirchner). Alexander Döblin, author of the novel *Berlin Alexanderplatz* (1929), who was also a doctor, continued to prescribe the drug to his patients long after the war.[7]

The steadily growing pacifist mood prompted many Expressionists to sympathize with the revolution which, they believed, would bring about the birth of a "new world" — one without borders, wars, and offices. This was reflected in the catastrophical, martyrological, and Christological iconography employed by artists of the so-called Second Generation Expressionism.[8]

The Universe of Ruins and the Universe of Expressionism

Expressionism is often perceived as a strictly German artistic movement, as it indeed dominated the period of classical modernism in Germany, encompassing all disciplines and affecting the self-awareness of several generations. For this reason, it has been called a "*Gesamtkunstwerk* Expressionism", because of the intensive interdisciplinary artistic and cultural activities of its representatives between 1905 and 1925, especially after 1918 as Expressionist prints, film, and theatre became omnipresent in Europe and other parts of the world.[9] Although the movement had been Germanized about 1914,[10] shortly after Polish-Jewish critic Adolf Basler dubbed it the "universal new style", as ubiquitous as the Gothic style, believing it to have sprung from Parisian Fauvism.[11] Furthermore, the first theory of Expressionism *avant la lettre* was formulated twenty years earlier by the "genius Pole" Stanisław Przybyszewski in relation to the work by Edvard Munch.[12] Expressionism — even in

7 See e.g.: Głuchowska (2015f: 28, 46, 118, 147).

8 Barron (1988); Eberle (1989).

9 Beil/Dillmann (2010); see: Kasten (1990).

10 Wünsche (2018a: 4–6).

11 Basler (1908: 2); Basler (1913a: 210–220; 260–271); Basler (1913b: 23); comp. Wierzbicka (2009a: 216); Wierzbicka (2009b: 115–139). The bicentric vision of Expressionism was presented at the centenary of the outbreak of WWI in the major exhibition *Expressionism in Germany and France: from Van Gogh to Kandinsky* that travelled from Zurich to Los Angeles and on to Montreal in 2014. See: Benson (2014).

12 Kossowski (1995); Głuchowska (2009b); Matuszek (2013);

Germany itself — was an international movement, not only because there were more Russians than Germans in the core set of *Künstlervereinigung München* (from which *Der Blaue Reiter* later arose), but also because the most famous galleries that promoted Expressionism in Berlin — *Der Sturm* and *Die Aktion* — featured works from different countries, often including all the trends within the so-called new art.

As Isabel Wünsche states in the recently-published *The Routledge Companion to Expressionism in a Transnational Context*:

> Expressionism as a current of European modernism is most readily to be seen in central Europe, particularly in those artistic centres that were part of or closely linked with the German, Austro-Hungarian, and Russian empires, such as Bohemia, Poland, and Hungary. On the northern European periphery, in Scandinavia, the movement was most closely associated with French fauvism and the art of Henri Matisse. In the other, more peripheral regions of Europe, including the Baltics and the Balkans, expressionism neither appeared as a clearly defined movement with specific program or ideological background nor succeeded in creating a distinctive and autonomous style. Instead we find a hybrid modernism that linked aspects of expressionism, cubism, and futurism in the prewar period and eventually moved toward more radical avant-garde art (constructivism) or toward traditionalism (new objectivity) during the interwar period. Expressionism in the United States and Canada in the 1910s often intersected with other styles, in particular fauvism but also cubism and abstraction.[13]

Assuming that Germany (first Dresden and Munich, then later Berlin) and Vienna were the "centers" of Expressionism where the canonical forms of this style were born,[14] then its hybrid idioms, formerly referred to as eclectic or epigonian and today more often regarded as an emulation of the prototype, developed on the vast "periphery", where the style became popular.[15] These hybrids include

Głuchowska (2013c); Głuchowska, *The Great War and the New Art...* in this volume.

13 Wünsche (2018a: 26–27).

14 Husslein-Arco/Köhler/Burmeister (2013).

15 See: text by Vojtěch Lahoda in this volume.

e.g. Futuro-Expressionism, promoted by the Romanian artist Max Hermann Maxy, Cubo-Expressionism represented, for example, by Czech Otto Gutfreund, the circle associated with the Danish magazine *Klingen* [The Blade, 1917–1920], and Belgian artists such as Joris Minne and Henri van Straaten from the *La Lumière* group (c. 1920–1922), as well as geometric works by Estonians Märt Laarman and Jaan Vahtra.[16]

The evolution of Expressionism is a contradictory one. Initially in Germany it possessed an international character and then, with the outbreak of WWI, it assumed a more national flavour.[17] Over time, however, it also became a transnational phenomenon and its forms were present in the culture and visual art of nearly all European and North American nations.[18]

The Activist Expressionism of the so-called Second Generation, whose first grouping was the Polish-German Poznań *Bunt* [Rebellion, 1918–1922],[19] developed — apart from Germany — mainly in Hungary and Russia, but also in Finland, Bulgaria, the Baltic states, and the Balkans, becoming a testimony of eyewitnesses to a military conflict of hitherto unknown magnitude, impossible to express in academic forms. Meanwhile, far from the frontline, in the milieu of emigrants in Spain and Portugal (grouped around Sonia and Robert Delaunay), Amadeo de Souza-Cardoso painted optimistic Orphic collages, whose aura was more reminiscent of the earlier "Arcadian" works by members of the groups *Die Brücke* and *Der Blaue*

16 *Otto Gutfreund* (1995); on Gutfreund see: text by Naomi Hume in this volume; Kessler (2014: 134–146); Jelsbak (2013); Mantis (1975); Lahoda (2013); Pählapuu/Hennoste/Lahoda (2012). On *Klingen* see: text by Dorthe Aagesen and Torben Jelsbak in this volume.

17 See e.g.: van den Berg (2013); Buelens (2013); Głuchowska (2013d).

18 Weisstein (1973); Abel (2012); Abel (2014); Abel (2018); Andriušytė-Žukienė (2012); Blum de Almeida (2018); Bogdanović (2018); Botar/Hartel (2018); Brašlina (2012); Cărăbaş (2012); Chytraeus-Auerbach (2018); Čubrilo (2012); Frick (2018); Genova (2018a); Gerharde-Upeniece (2018); Głuchowska (2018d); Głuchowska (2018e); Gronemeyer (2018); Hautala-Hirvioja (2019); Hörstmann (2018); Huusko/Pallin (2018); Imanse/Langfeld (2018); Jankevičiūtė/Laučkaitė (2018); Jelsbak (2018); Kessler (2018); Kiss-Szemán (2018); Jenko (2018); Ólafsdóttir (2018); Prelog (2018); Rakušanová (2018); Sonn (2018); Verleysen (2018); Wallin Wictorin (2018); Weikop (2018); Wünsche (2018a); Wünsche (2018b); Wünsche (2018c); Zwickl (2018).

19 Malinowski (1991: 143).

Reiter than the contemporary evocation of suffering in areas affected by war and occupation.[20] Meanwhile, several modernist artists acted in Spain in the circle around "the pope of the avant-garde", Tadeusz Peiper, who later became editor of the Cracow magazine *Zwrotnica* [Crossover, 1922–1923 and 1926–1927].[21]

Whilst during the war Expressionists created a universal network, communicating transcontinentally by means of privately distributed magazines and focusing on shaping the international form and *lingua franca*, in local communities the reception of Expressionist achievements was ambivalent, as they were often viewed with suspicion as a foreign, "German import". In broader terms, the supra- or post-national and regional perspective in the research on new art dates back only thirty years,[22] and the departure from Eurocentrism in the study of the avant-garde universum is in fact a relatively new development.[23] This also applies to the revision of the art of WWI and the short interwar era.

"Foreign War", "Our War", and the War of Images. Expressionists and Propaganda

To various nationals forcibly conscripted into the German, Austro-Hungarian, and Russian Armies, the military conflict of 1914–1918 was a "foreign war". At the same time, despite enormous human losses, the struggle for the (re)construction of "small nation" states cemented faith in the significance of "our" (their own) liberation war and boosted optimism and readiness to suffer the necessary sacrifice.[24] In most of Europe, where national *new states* were to be established on the ruins of "defect Empires",[25] the sense of a ground-breaking change was therefore a different motivation to that in German society, where "the sons" celebrated the fight against the generation of "the fathers". The borders of these countries had to be

20 Vasconcelos (2015).
21 Rypson (2015).
22 See: Mansbach (1999); Benson (2002); Passuth (2003); Głuchowska (2013d).
23 Głuchowska (2015b); Wünsche (2018c); Lahoda (2014a); Lahoda (2014b); Głuchowska/Lahoda (2022).
24 Eksteins (1989: 93–150).
25 See: Bartetzky/Dmitrieva/Troebst (2005); Kusber (2014).

Henry Ericsson, *Karagusteknu nometne* [Prison Camp], 1919. Finnish National Gallery, Ateneum Art Museum, Helsinki

established and consolidated with armed force, and even long after the war their new boundaries were seen as a compromise between "our" and "foreign" visions.[26] In the collective consciousness, the war did not end in November 1918; in Poland, Czechoslovakia, Finland, Ukraine, and the Baltic and Balkan countries, the struggle for independence continued through both military and diplomatic means.[27]

One of the references to the Polish-Soviet war in the artistic output of the Poznań-based group *Bunt* is a metaphoric linocut of Polish *husaria* in the 1683 victory in the battle of Vienna, featured on a cover of the magazine

26 Schuler/Gawlik (2003: 10).
27 See: Holeczko-Kiel (2004: 140–141).

Zdrój [Source, 1917–1922].[28] In turn, Henry Ericsson's painting *Prison Camp* (*Karagusteknu nometne*, 1919; Fig. 1) refers to the realities of the civil war in Finland, providing an interesting interpretation of the then-canonical theme of a prisoner-of-war camp. Painted with broad brushstrokes in almost monochromatic tones of faded, earthy colours, individual figures are depicted as if through fog or rain, and the entire unusual, diagonal composition is set within the vertical format of the painting, thus giving the impression of an unreal or dreamlike vision, or maybe memories. Edvard Munch also depicted the events in Finland in his Expressionist sketch (1918) and lithograph (1929) *Execution* (*Henrettelse*), inspired by press photographs. In his woodcuts, he also featured scenes found in the documentation of the war in Serbia.[29]

In such a tense geopolitical situation, strengthening the spirit of societies by means of ideological imagery became a duty that neither artists nor writers could shirk. Soon after the outbreak of the armed conflict, the war of images began. Propaganda usually refers to unambiguous stereotypes of the enemy, so it rarely drew on Expressionist art. However, Kazimir Malevich (Polish: Kazimierz Malewicz, Russian: Kazimir Malevič) painted pro-Russian propaganda posters in the Lubok style, derived from the folk tradition. This is somewhat astonishing given that only a little earlier he had completed his *Black Square*, considered a metaphor of war and a work by its ardent opponent, not to mention that he almost simultaneously manifested his Polish identity, participating at the Polish exhibition and writing a manifesto *Odezwa do młodzieży polskiej* [Appeal to the Polish Youth, 1914].[30]

In 1915, in the occupied areas in the East, German soldiers began a propaganda war against the Russian enemy. One of the early suggestive anti-propaganda exceptions is the painting by Heinrich Maria Davringhausen, *The General* (*Der General*, 1917), showcasing the contrast between the realities of starving soldiers and their sated leaders.

28 See image in: Głuchowska, *The Great War and the New Art...* in this volume.
29 Cullinan (2012).
30 Raev (2014: 303–304); see: text by Lidia Głuchowska, *The Great War and the New Art...* in this volume.

However, such sentiments were expressed mainly among occupied nations, especially in cabarets and later in films. Only a handful of them, like Sergey Eisenstein's famous *Battleship Potemkin* (*Bronenossez Potjomkin*, 1925), can be described as propaganda (in the service of revolution, not war), which does not, however, undermine their artistic value.[31] Before this happened, the most famous gallery of this formation, namely Herwarth Walden's above-mentioned *Der Sturm* in Berlin (known for promoting mainly Expressionism),[32] was involved in war propaganda. Although it was regarded as a politically neutral center for new art, unlike Franz Pfemfert's left-wing pacifist *Die Aktion*, in fact it was a secret national German Central Office for Foreign Services (*Zentralstelle für Auslandsdienst*), for several years. What made this possible was the diplomatic posting service used for transferring works of art to exhibitions between Berlin and later Sweden, where Walden's second wife Nell was born.[33]

War Painters and the "Forgotten War" in the East

Whilst the Vosges, Dolomites, Somme, Marne, Sochi, and Verdun are considered to be the major battles of WWI, chlorine gas was actually used for the first time in Bolimów on the Rawka River in December 1914, although there was almost no mention of this in the international press.[34] A similar attack in April 1915 in Ypres, Belgium, was condemned worldwide as a violation of the Hague Convention. At the end of May of the same year, gas was used again on the German-Russian front along the Rawka and the Bzura. The war continued to bring increasing misery and suffering to the civilian population.

The traumatic fate of the civil population on the Eastern Front was broadly documented by the war painters. One of them was the German Max Wislicenus, who in his paintings, both traditional and Expressionist, documented the war experiences of the inhabitants of Polish

31 See: text by Lidia Głuchowska, *The Great War and the New Art...* in this volume.
32 Von Hülsen-Esch/Finckh (2012); Głuchowska (2012d).
33 Winskell (1995); van den Berg (2008); van den Berg (2009). See also the article by Dorthe Aagesen and Torben Jelsbak in this volume.
34 Brade (2015: 16, 17, 147); Weger (2015: 241); Liulevicius (2013).

Fig. 2

Max Wislicenus, tapestry
St. Georg (realized by **Wanda
Bibrowicz**), 1917. Schlesisches
Museum zu Görlitz

territories under Russian rule. This position of the war
painter was sought by many because the demand for ci-
vilian works of art was declining and artistic activity on
the frontline was considered an expression of patriotism
and, as such, promised fame.[35]

Before becoming a correspondent for the newspaper
Schlesische Zeitung [Silesian Newspaper], Wislicenus
demonstrated his patriotic stance in two Expressionist
paintings from 1914. The first, depicting the Erinyes, the
Greek goddesses of anger, revenge and hatred, can be as-
sociated with the assassination of the heir to the throne
of the Austro-Hungarian Empire and his wife in Sarajevo.
The second, featuring the vast landscape above the Masu-
rian lakes from a bird's eye view, depicts a symbol of mo-
dernity — an airplane — in reference to the Battle of

35 Weger (2015: 253).

Fig. 3

Max Wislicenus, *Ruinen von
Konstantinów bei Kalisch*
[Ruins in Konstantynow near
Kalisz], c. 1915. Schlesisches
Museum zu Görlitz

Tannenberg (Grunwald, 1410), celebrated by propaganda
as the second battle of Tannenberg (1914), this time won
by the Germans.[36]

From 1914–1916, Wislicenus visited the Eastern Front
several times, reaching as far as Warsaw and creating
numerous sketches and nearly fifty paintings and oil
studies. Many of them suggest he treated his mission
as a kind of *grand tour*, allowing him to document archi-
tecture and picturesque exotic themes (such as Jews in
kaftans and peasant women in colourful dresses), often
reproduced on postcards issued by the German field post
office. The works reflect the perception of the world in
ethnic terms and the fascination with the image of "the
other". Journalists saw in them, on one hand, an aston-
ishing contrast between the poverty of cottages and the
beauty of clothes, and on the other — for example, in
Wislicensus' portraits of beggar women from Częstocho-
wa — confirmation of the stereotype of the so-called pol-
nische Wirtschaft (in other words: Polish wastefulness).[37]
The painter himself denied such prejudices, claiming
that Poland was an interesting country and, although
agrarian and poor, by no means squalid. His involvement
in promoting Poland's positive image was undoubtedly

36 Brade (2015: 148–150).
37 Brade (2015: 159).

influenced by his relationship, both personal and professional, with Wanda Bibrowicz (with whom he created the tapestry of *St. George* (*St. Georg*, 1917; Fig. 2)). Another reason was the respect he had for Fryderyk Pautsch, his Polish colleague from the Breslau Academy of Arts (*Staatliche Akademie für Kunst und Kunstgewerbe*)[38] and also a war painter, albeit in the service of the Austro-Hungarian Army, as well as speculation about his own alleged Polish ancestry.[39] For this reason, Wislicenus' war paintings are far from demagogical. Neither are soldiers portrayed as heroes, nor prisoners of war as men without honour. Apart from painterly documentation, which to some extent was contrary to the official propaganda, Wislicenus completed some highly regarded Expressionist works, such as the depiction of ruins in Konstantynow near Kalisz (*Ruinen von Konstantinów bei Kalisch*; Fig. 3), burning houses in Sochaczew, or a destroyed bridge over the Vistula (Wisła) in Warsaw.

Inter Arma Silent Musae

Contrary to the expression *inter arma silent Musae* (in other words: when society is under any kind of stress or in an extreme situation, creativity suffers), WWI was a time of intensive artistic productivity and exchange. Significantly, many representatives of Expressionism almost abstained from any direct depictions of war. Even though Otto Mueller fought on both the Western and Eastern Fronts, there are only four works referring to the realities of the era in his *œuvre*. At the same time, even while taking part in military operations or during recovery, Mueller fervently sought to present his paintings at exhibitions and gave precise instructions as to how to send them to his wife Maschka.[40] Other artists acted in a similar way. The Berlin show of *Bunt's* artistic output, held in June 1918 and entitled *Polnische Kunst* [Polish Art], was prepared by the only woman and only German in the group — Margarete Kubicka, while her colleagues

38 Between 1791–1911: *Königliche Kunst- und Gewerbeschule Schule*.
39 Brade (2015: 167, 168).
40 Brade (2015: 99); Pirsig-Marshall (2018).

were serving in the army.[41] The exhibition took place within the premises of *Die Aktion* magazine, whose pacifist outlook was demonstrated by their covers featuring the woodcuts *Save Yourself, People* (*Rettet Euch Menschen*, 1917) by Conrad Felixmüller and *Hell* (*Die Hölle*, 1919) by Max Beckmann. In the gallery, a series of exhibitions was organized, devoted to new art from different countries.[42]

During the war, drastic works, such as the lithograph by Willy Jäckel, *Memento*, were rarely shown. After *Memento* was presented in Dr. Neumann's Gallery (Galerie Becker-Neumann, 1915–1916) and by the *Berliner Secession* [Berlin Secession] in 1916, it was probably censored because of its "anti-patriotic" appeal. Although it is listed in the catalogue of the *Kestner Gesellschaft* [Kestner Society] in Hanover, it was probably never exhibited there.[43]

Expression of Introspection, or Wartime Self-Portrait

If one considers the painting by Ernst Ludwig Kirchner featuring himself in uniform and accompanied by a model in the studio (1915) to be a paradigmatic wartime self-portrait, then the iconographically-related painting of Max Pechstein (*Selbstbildnis mit Artillerie-Helm*, c. 1914), participant in the Battle of the Somme, showing the author with a cigarette-smoking prostitute and a skeleton, reminiscent of medieval moralistic representations, is a self-retrospection. In 1914–1915, Otto Dix also obsessively depicted himself as a soldier, wearing an artillery helmet, with his bloodied face against a bright red background, in a gunner's uniform. However, his most evocative image is his self-portrait as Mars, with cosmic paraphernalia typical of the metaphysical faction of the avant-garde, referring both to the spirit of theosophy and the perception of war as a total experience and an element of nature.[44]

Some intimate war self-portraits, composed of mutually complementary words and images, such as those by Witold Hulewicz, co-founder of the first Expressionist

41 Głuchowska (2018c: 97); Głuchowska (2018e).
42 Kubicki St. K. (2003).
43 Brade (2015: 91–97).
44 Rüdiger (1991: 51–56).

magazine in Poland, the Poznań-based *Zdrój* [Source, 1917–1922],[45] belong among the countless documents of the international military conflict. They are usually rushed notes, such as the photographs of Otto Dix (who even sent his pictures from the trenches as postcards), Franz Marc, Heinrich Tischler, and Ludwig Meidner in uniform. Jāzeps Grosvalds, a Latvian Expressionist, took a more formally ambitious photographic self-portrait in 1917,[46] reminiscent of a convention developed earlier by Wacław Szpakowski, Umberto Boccioni, and Marcel Duchamp, among others. Witkacy presented himself in a similar way in his evocative *Multiple Self-Portrait* (*Autoportret wielokrotny*, c. 1917) in a Russian uniform from the same year.[47] While self-portraits of Russian artists in uniform were rare at that time, as the most famous of them were released from military service,[48] artists of other nations took many such photographs and depicted themselves and their companions in various sketches and paintings.

Among the images from that era, a peculiar *memento mori* is deserving of mention: a gloomy, primitivist mask of an introvert with eyes turned away from reality, reminiscent of the trauma of wartime. Between 1918 and 1919, this poignant self-portrait in a pose of melancholy, created by Stanisław Kubicki from the *Bunt* group, was featured twice in *Zdrój* (including once on the cover) and once in Berlin-based *Die Aktion*. At the same time the artist's wife Margarete Kubicka portrayed herself in a diametrically opposed manner. As a witness to the suffering of mothers and wives, which she expressed in pacifist poems published in the same journal, she directs her punishing gaze directly at the viewer as the accuser of the militaristic machine.[49]

The artists belonging to the Latvian, Polish, Ukrainian, and other Legions (Riflemen) produced almost a thousand images of soldiers and officers of these units. They were valued less for their artistic quality than for their

45 See image in: Głuchowska, *The Great War and the New Art…* in this volume.
46 Jēkabsons (2014: 43).
47 See: Głuchowska (2014a: 293–294).
48 Raev (2014: 322); Głuchowska, *The Great War and the New Art…* in this volume.
49 See: Głuchowska (2007: 322–329).

ideological worth, as testimonies of the self-aware volunteer fighters standing in opposition to the occupying armies.[50]

It is significant that some artists, like Otto Mueller, destroyed their wartime self-portraits, perhaps as a consequence of Germany's defeat and the need to erase the memory of war. On the other hand, it is worth mentioning that other German soldier-painters openly, and even long after the end of WWI, ironically documented unheroic or unhuman experiences of the war. Examples of this are scenes like *Front-line Soldier in Brussels* (*Frontsoldat in Brüssel*, 1924) and *Storm Group goes into the Gas* (*Sturmgruppe geht unter Gas*, 1924) by Max Beckmann.[51]

Legions of Europe: The Prose of Suffering and the Legend of the Great War

During WWI, hundreds of painters and sculptors voluntarily joined the legions fighting for the national independence of their countries, for example the Polish and Ukrainian[52] Legions at the side of the Austro-Hungarian Empire, the Latvian and Lithuanian Legions (Riflemen units, formed in Russia and fighting on the Northern Front against Germany),[53] and the Czechoslovakians[54] who fought in France, Italy, and Russia (on the Russian/Soviet side).[55] Legionaries from different countries left behind paintings that are surprisingly similar. Their ethos is illustrated in sketches of trenches, soldiers' graves and military scenes, and a portrait gallery. In the case of the Latvian Legions, the latter consists mainly of photographs. The painterly chronicle was created mainly by Expressionist Jāzeps Grosvalds who immortalized, among others, the Christmas battle of 1917.[56]

50 See: texts by Oksana Dudko, Ginta Gerharde-Upeniece, and by Lidia Głuchowska, *The Great War and the New Art...* in this volume.

51 See reproductions in: Sabarsky (1991: 73–75).

52 See: texts by Oksana Dudko, and by Lidia Głuchowska, *The Great War and the New Art...* in this volume; Hausmann (2014).

53 Jēkabsons (2014: 33); Šmite (2014); Balkelis (2014); see also: text by Ginta Gerharde-Upeniece in this volume.

54 See: text by Vojtěch Lahoda in this volume.

55 See: Nolte (1999: 167).

56 See: Lamberga (2014), Jēkabsons (2014), Šmite (2014), and text by Ginta Gerharde-Upeniece in this volume.

For obvious reasons, there were not many works of symbolic dimension that would provide a synthesis of the events of that time. However, with their paintings and drawings, legionnaires began to form their own legend in words and images while the fighting was still in progress, at the same time glorifying the Great War.[57]

Express the Inexpressible: From the "Massacre of Forms" to the *Pilgrimage of Souls*

Wartime paintings, among all Expressionist works, reflect not only an astonishing mixture of fascination and resentment, but also the struggle for an artistic interpretation of drastic experience. In December 1914, Paul Westheim, a well-known art critic, wrote in the magazine *Die Kunst für alle* [Art for Everybody] that the war was "a godsend of an unfathomable subject" for art.[58]

In his documentary drawings from 1916–1918, Ivo Hauptmann, son of the famous playwright Gerhart Hauptmann (*nota bene* war apologist),[59] depicted the drama of battles, explosions, and the remains of those killed and horses thrown into the air with poignant dynamism. Such artwork created at the front was rarely presented to the public, as it usually contradicted the official propaganda. Exceptions included the publication of drastic scenes, such as Ludwig Meidner's series *War* (*Krieg*), portraying mass death and destruction, and published at the end of 1914. The artist completed another series, *Sea of Stars Behind* (*Im Nacken das Sternenmeer*, published in 1918), when working as a translator at the POW camp in Cottbus and struggling with the trauma he experienced, documenting it in notes and drawings. Another selection of prose illustrated with lithographs, entitled *September Scream. Hymns, Prayers, Curses* (*Septemberschrei. Hymne, Gebete, Lästerungen*), was not published until 1920.[60]

Some brutal images of fighting were published in the periodical *Kriegszeit. Künstlerflugblätter* [The Wartime. Artists' Flyers] albeit under titles that made it possible to

57 Segel (1999: 65–68).
58 Westheim (1925: 81).
59 Brade (2015: 61–83).
60 Brade (2015: 85–89).

International Expressionism as the Style of the Great War?
Remarks on its Adaptation and Evaluation

Fig. 4

Tone Kralj, *Na razvalinah* [Among the Ruins], 1922. Božidar Jakac Art Museum, Kostanjevica na Krki

interpret them as crimes committed by other nations, as in the case of Willy Jäckel's works. This was arguably not his own initiative, however, since in his portfolio *Memento* (1914–1915), inspired by the style of Francisco de Goya's famous series *The Disasters of War* (*Los Desastres de la Guerra*, 1810–1814), produced a century before, Jäckel mercilessly disclosed the common attacks against the civilian population, the mass death toll, and the destructive impact of the war on the psyche of those involved in it. The narrative imagery of Expressionism in WWI era is limited to a handful of themes, such as field hospitals and scenes of returning prisoners of war or the wounded from the

NATIONALISM AND COSMOPOLITANISM IN THE AVANT-GARDE AND MODERNISM
The Impact of the First World War

front, as seen in the works of Wislicenus and Grosvalds.[61] The former painted such works with careful attention to detail, while the latter approached the topic more synthetically, with blurred contours and unrecognizable facial features. The picture by the Hungarian artist János Vaszary featuring soldiers in the snow (*Katonák a hóban* [Soldiers in the Snow], 1915–1916) is similarly blurred.[62]

Graves, refugees, ruins… the repetitive *staccato* of themes, recurring like an eternal cycle of nature and rarely characterized by innovative forms. Among the paintings of this kind is one that stands out, namely the original composition of the Slovene artist Tone Kralj, *Among the Ruins* (*Na razvalinah*, 1922; Fig. 4), the theme of which turns out to be revenge. Fragments of human bodies depicted in a narrow frame and in unnatural poses blend in with the cubic stone blocks crushing them. The monochrome colour scheme gives the impression of organic unity of all presented forms. Inscribed into an ideal square, this metaphorical image emanates with an anxiety typical of works of Magical Realism.

The wartime output of painters from occupied countries conveys melancholy rather than any expression of drama. In works concerning the fate of civilians, these artists depicted fugitives and exile (for example, the Latvian artist Jēkabs Kazaks or Fran Tratnik from Slovenia), only rarely turning the theme into a timeless parallel, as for example in *Flight to Egypt* (*Flucht nach Egypten*, 1918; Fig. 5) by German-Lithuanian artist Pranas Domšaitis/ Franz Domscheit.[63]

References to ancient and medieval iconography, in turn, can be found in the excellent painting by Bulgarian artist Ivan Milev, who presented mothers mourning their sons,[64] achieving a remarkable, relief-like effect through the use of *chiaroscuro*. The torso by Oskar Schlemmer, made after he met a man whose leg had been amputated, is another work reminiscent of classical sculpture and

61 See reproduction in: text by Ginta Gerhrade-Upeniece in this volume.
62 See reproduction in: Szücs (2014: 185); see: https://commons. wikimedia.org/wiki/File:Vaszary_J%C3%A1nos_(1869-1939)_ Katon%C3%A1k_a_h%C3%B3ban,_1916.jpg. (accessed: 20.10.2020).
63 Andriušytė-Žukienė (2012); see reproductions in: Lamberga (2014: 58–61), and in: Smrekar (2014: 171).
64 See reproduction in: text by Irina Genova in this volume.

sublimation of the war trauma. Later it served as a proto-
type for his figurines.[65]

Expressionists often referred to Christian symbolism
as a form of metaphorical sacralization of the martyr-
dom of war. In 1914 and 1916, respectively, Croatian Ivan
Meštrović and German Otto Lange both used the icono-
graphic theme of the *pietà*, as did the Latvian Jāzeps
Grosvalds in his painting *Dying Soldier* (*Mirstošais ka-
reivis*, 1917).[66] In turn, *John of Carniola* (*Krajinas Janis*,
c. 1918) by Slovenian painter Ivan Vavpotič is a reference
to the iconography of the Crucifixion.[67]

65 Eberle (1989: 111–137).
66 See image in: Gerharde-Upeniece/Jevsejeva (2014: 49).
67 See reproductions in: Lamberga (2014: 49); Smrekar (2014: 166).

A frequent projection of the suffering of anonymous soldiers was the figure of St. Sebastian, who inspired a number of works, not only by German Expressionists, such as Willy Jäckel in 1916, but other artists too, as evidenced by the linocut by Jan Jerzy Wroniecki, member of the *Bunt* group, published in 1918 in the aforementioned magazine *Zdrój*. Its thematic association with war is revealed by Adam Bederski's poem "Działa biją na Wogezach" ["Cannons Roar in the Vosges"], thus demonstrating the complementarity of the word and image in Expressionist magazines.[68]

Heroic, glorifying stylization was less frequent in the art of wartime Expressionism than the depiction of martyrdom. One example is the peculiar interpretation of Orthodox iconography in Wojciech Jastrzębowski's lithograph entitled *Józef Piłsudski — Commander-in-Chief of Poland* (*Józef Piłsudski — Wódz Polski*),[69] evocative of folk images of St. George fighting the dragon, reminiscent of the painting *Saint George the Dragon Slayer* (*Święty Jerzy pogromca smoków*; Fig. 6) by Jerzy Hulewicz from 1917[70] or the aforementioned tapestry by Wislicenus and Bibrowicz.

Contrary to popular belief, references to Christian iconography were even more frequent after the war than during it, as exemplified by Walter Jacob's painting *Last Judgement* (*Das Jüngste Gericht*, 1920) and Max Pechstein's famous portfolio of coloured woodcuts *The Prayer of Our Father* (*Das Vater unser*) from 1921, as well as numerous works featuring the *pietà* theme, including paintings by Otto Dix and sculptures by Karl Albiker (1920) and Theodor von Gosen (1924).[71]

One of the innovative pictorial conventions of Expressionism that exemplifies the modern form rather than the traditional martyrological narrative is the so-called massacre of forms, blurring depicted shapes to the point of abstraction so that the realities of war can be identified only through titles. These works symbolize the aforementioned explosion of positive energy — fulguration[72] — as

68 Bederski (1917: 68); Wroniecki (1917: 68).
69 See reproduction in: Głuchowska, *The Great War and the New Art...* in this volume.
70 Bartelik (2005: 15); Monkiewicz (2018: 3).
71 See reproductions in: Brade/Weger (2015: 51), and in: Barron (1988: 33).
72 Białostocki (1986).

Fig. 6

Jerzy Hulewicz, *Święty Jerzy pogromca smoków* [Saint George the Dragon Slayer], 1917. Museum of Art in Łódź, private deposit

in Franz Marc's painting *War* (*Krieg*, 1914) and in some of Otto Dix's works, in contrast to the destructive element featured in George Grosz's *œuvre*. This form of expression is by no means exclusive to German artists. For example, around 1917 the Swede Gösta Adrian-Nilsson painted in a similar fashion, depicting machine-like silhouettes of soldiers thrown into the air,[73] as did the Czech Bohumil Kubišta in his painting *Coastal Cannons in the Battle with a Fleet* (*Pobřežní děla v boji s loďstvem*, 1913–1915; Fig. 7), the Englishman Wyndham Lewis, and the two Russian artists Pavel Filonov and Aristarkh Lentulov.[74] Although these representations seem to some extent the most appropriate way of expressing the inexpressible, the lack of factual bluntness and abstraction

73 See reproduction in: Ahlstrand (2013: 99).
74 See reproductions in: Głuchowska (2018d: 62); Raev (2014: 331, 321).

NATIONALISM AND COSMOPOLITANISM IN THE AVANT-GARDE AND MODERNISM
The Impact of the First World War

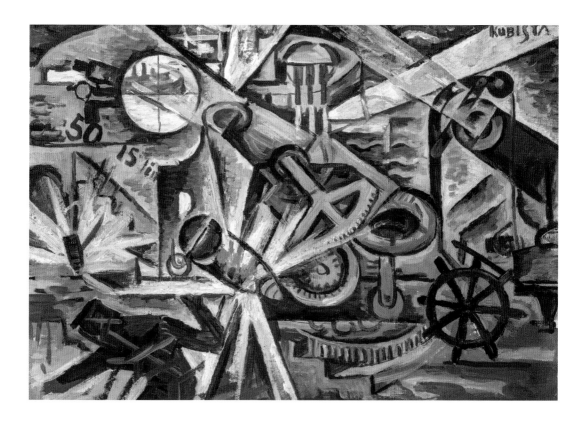

Fig. 7

Bohumil Kubišta, *Pobřežní děla v boji s loďstvem* [Coastal Cannons in the Battle with a Fleet], 1913–1915. National Gallery in Prague

are also ways of sublimating the subject. Stylistically similarly are the works of Natalia Goncharova and Olga Rozanova, both of whom used the fragmentation technique while including attributes of modernity, such as airplanes or angels (as if straight from folk art), protecting the beams that support the world.[75]

Stylistically related post-war symbolic representations, which are a kind of compensation for mass death, such as *The Life Cycle — Migration of Souls* (*Kolobeh života — Putovanie duší*, 1922–1924) by Slovak-Hungarian artist Anton Jasusch/Antal Jaszusch, were a deliberate synthesis and glorification of the wartime patriotic sacrifice.[76]

75 See: text by Nina Gourianova in this volume.
76 See reproduction in: Bajcurová (2014: 160).

Pogroms and Lamentations

During WWI, one of the most radical changes appeared in the traditionally aniconical Jewish culture. Full of pathos, evocations in words and images became a response to the war, revolution, and pogroms. They became a part of a new, secular, transborder Yiddish culture created mainly in Eastern and Central Europe, including formal and religious syncretism, among other adaptations of Christian iconography.[77] Apart from the members of this movement, Western European Jewish artists also documented the war and pogrom[78] experiences in various visual conventions. Several new key studies on the topic of the "Jewishness of Expressionism" have been published recently.[79]

Among the Jewish artists serving in the German Army, particularly noteworthy is Heinrich Tischler from Upper Silesia. Like many other Expressionists, he immortalized himself not only in war photographs but also in a melancholic self-portrait in uniform *Self-Portrait as Soldier* (c. 1915), depicting himself against a background of levitating iconic signs: decimated infantry and scattered cavalry units.[80] His other works feature similar representations of the fallen under the cross, railway lines, explosions, and multiplied military formations, as well as riders knocked into the abyss by galloping horses. In 1915, he made his first war-themed linocut portfolio, composed of colourful images of horse riders, marching recruits, supply battalions, and a nighttime view of the battlefield. What is striking is the style of these works, sometimes purposefully infantile in a seemingly ludic-decorative character (e.g. in the scene featuring a soldier in a Pickelhaube abducting cattle), which is presumably meant to provoke associations with a military "play-in-the-sandbox" mentality. Interestingly Tischler, like his Breslau-based colleagues Eberhard Loch and Hans Leistikow, experimented with a narrative typical of Asian woodcuts (Fig. 8); his work is intended to be read from top to bottom. Another peculiarity of his works in this technique

77 Szymaniak (2005: 11, 21); Roshwald (1999: 102); see: text by Głuchowska, *The Jewish Artistic Networks...* in this volume.

78 Novikova (2014).

79 E.g. Sandqvist (2012); Ksiazenicer-Matheron (2012); Głuchowska (2012b); Sonn (2018); Stolarska-Fronia (2018).

80 See reproduction in: Brade (2015: 98).

is the shifting contour, resembling the effect of mannerist
chiaroscuro. This specific movement of the image, as in
a blurred photograph, most likely symbolizes the world
of anomalies, a world that has fallen out of its frame.

In 1916, Tischler created two pacifist series: *People* (*Men-
schen*) and *Prayers* (*Gebete*; Fig. 9). The latter is especially
original. Four coloured linocuts, referring to prayers at
different times of the day and created in protest against
the discriminatory register of Jews created by the German
Army in October 1916, are a visual variant of Jewish ap-
peals for peace or lamentations. It is not known whether

Tischler, like Hermann Struck, Jacob Steinhardt (from
Berlin's *Die Pathetiker* [The Pathetics] milieu), and Ernst
Oppler, found his way to the Eastern Front. He did, how-
ever, complete images of the *Martyrs of the East* (*Märtyrer
des Ostens*, 1916), likely inspired by Max Liebermann's
and Willy Jäckel's pogrom-stigmatizing lithographs repro-
duced in the press, as well as crayon drawings featuring
Jeremiah (1919), a central figure in Jewish identity.[81] Many

81 Brade/Weger (2015: 98–145).

of Tischler's works show poignant lamentations, as do Ludwig Meidner's aforementioned lithographic series. In the iconographic sense, they are akin to the works of the Polish-Jewish group *Yung-Yidish* (Young Yiddish/Jung Jidysz, 1919–1923) that address the theme of war and pogroms, pointing to the distinctive stylistic and iconographic quality of the so-called Jewish Expressionism, different from its Christian counterpart.[82]

The Agony of Expressionism and Dadaist Absurdity

In 1922, at the *Congress of the International Union of Progressive Artists* (*Kongress der Union internationaler fortschrittlicher Künstler*) in French-occupied Düsseldorf, Henryk (Henoch) Berlewi complained that "Expressionism is obsolete in Germany" and noted the agony of this style and ideological formation which, according to him, was manifested by Dadaism.[83] It was in this latter stylistic convention that the photograph featuring Czech artists Jindřich Štýrský and Toyen (Marie Čermínová) in gas masks and protective suits was taken.[84] While Expressionists often showed themselves or others mutilated, as if in a Christological gesture of ostentatious demonstration of wounds (like Guillaume Apollinaire),[85] Štýrský and Toyen's ambivalent semi-Dadaist act can be regarded as both an anti-war protest and as "breaking the spell" of the demonic image of war.

The Dadaist protest, initiated by immigrants in Zurich in 1917,[86] exposed not only the absurdity of the war, but also the theatricality of Expressionist pathos. Following a year's delay, it spread to Berlin and other artistic centers in Europe and North America, becoming, among other things, a grotesque recapitulation of the global military conflict. An example of this can be found in photomontages by artists such as John Heartfield, Hannah Höch, and László Moholy-Nagy, who made use of the

82 See e.g.: Stolarska-Fronia (2018: 366–377); Głuchowska (2020: 104–108); Głuchowska, *The Jewish Artistic Networks…* in this volume.

83 Berlewi (1922: 2); see: Głuchowska (2018a: 144–145).

84 See reproduction in: Passuth (2003: 138, 277–281).

85 See reproduction in: Głuchowska (2014a: 313).

86 Smith (2013); Sloterdijk (2018).

fragmentation technique, alluding to the illogicality and disintegration of the world.[87]

The spirit of both Zurich and Berlin Dadaism was also familiar to Stanisław Kubicki. He may have come across the former through Marceli Słodki, associated with *Die Aktion*, who designed the poster for the evening organized by Cabaret Voltaire.[88] Amongst Kubicki's collection of international periodicals, essential for the avant-garde network, were included several issues of the Zurich-based magazine *Dada*. The first one featured *Note sur l'art* by Romanian author Tristan Tzara, in which the birth of the "new community" was proclaimed, and which Kubicki reprinted in the issue of *Zdrój* that he edited at the beginning of 1919. He also published a pacifist-grotesque manifesto "Panującym" ["To Those in Power", 1916/1919] in Poznań, and in 1918 he co-initiated the performances of *Bunt*, which began with the group's first exhibition in a truly Dadaistic spirit. Kubicki also created *The Tower of Babel* published as the poster for this exhibition, famed as a *succès du scandale*. This linocut became an icon of the radical avant-garde, which wanted to revolutionize not only the image of art, but also society. Despite its Expressionist form, this ambiguous work (symbolizing either the collapse of the "old world" and the construction of an internationalist "new community" or the Polish new state) can be considered a self-contradictory Dadaist anti-manifesto.[89]

In the context of the end of Expressionism, it is worth mentioning two more pieces by Kubicki from 1919, inspired by the works of his friends George Grosz and Raoul Hausmann and also reminiscent of Otto Dix's *War* (*Krieg*) from 1914. The first of these, a drawing titled *Where to Go?* (*Wohin?*; Fig. 10), contains an inscription with a bitterly sarcastic diagnosis of the post-war and post-revolutionary situation. The pessimism of the verbal message corresponds to the image of a collapsing world and people falling into an abyss. Chaos is also suggested by encrypted abbreviations of words and

87 Witkovsky (2007: 27–37, 185).
88 Głuchowska (2009/2010: 38–40).
89 See reproduction in: Głuchowska, *The Great War and the New Art...* in this volume; Głuchowska (2015f: 150).

Fig. 10

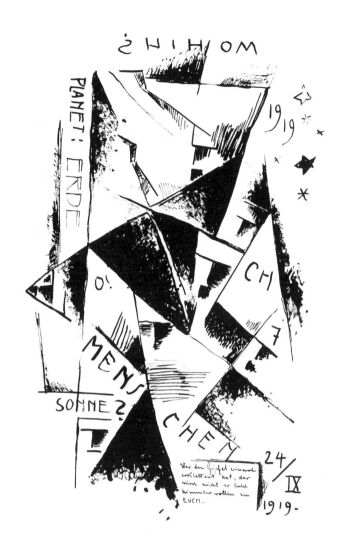

numbers corresponding to the silent screams of those
who are falling.

A pendant to *Where to Go?* is the painting entitled
The Entering One (*Der Eintretende*; Fig. 11). The vision
of a catastrophe in the former work corresponds to
the disintegration of personality in the latter. It features
a figure entering one of Berlin's more snobbish pubs, the
Café des Westens, called by its regulars self-mockingly
Café Größenwahn [megalomania]. In the background are
newspaper titles and street advertisements reflected in
the revolving door, albeit not real ones from Kurfürsten-
damm but fictitious French advertisements, including
words such as "Café" and "Rue", as well as clusters of

International Expressionism as the Style of the Great War?
Remarks on its Adaptation and Evaluation

Fig. 11

Stanisław Kubicki,
Der Eintretende II
[The Entering One II], 1919.
Museum of Art in Łódź

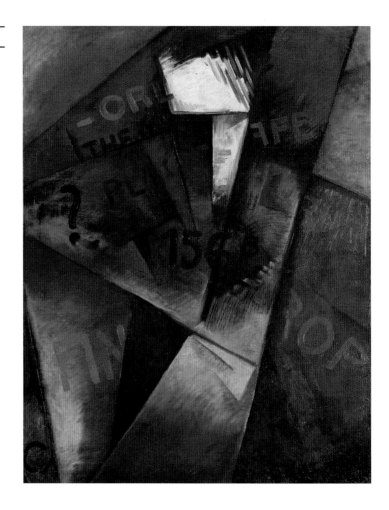

letters suggesting "Pl(a)tz" and "Guer(re)." Some of them
refer to current political events that were important for
Kubicki, such as the war ("Guer[re]") that had just ended
("Fin") and the utopia of a world without borders, nations
and offices ("[Eu]ropa?"). In this composition, the title
character and the background are equally important.
The man entering is a contemporary *flâneur* — a dandy,
whose individuality is dominated by foreign elements
he indiscriminately assimilates. His silhouette, broken
into fragments, symbolizes the crisis of the human con-
dition in a world dominated by politics and the post-war
depression.[90] Experiments with geometric abstraction
were a more radical form of departure from Expression-
ism than Dadaism.[91] Their authors were representatives

90 Głuchowska (2015f: 28–46, 120, 149).
91 Meyer/Hossli/Bolliger (1994); Janecek/Toshiharu (1998); van den

NATIONALISM AND COSMOPOLITANISM IN THE AVANT-GARDE AND MODERNISM
The Impact of the First World War

of the radical avant-garde from Hungary and Soviet Russia, who came to the *Bauhaus* or Berlin, the latter elevated to the rank of a world art center in the post-war climate of galloping inflation and left-wing cosmopolitanism.

Nationalization of the New Form and Rehabilitation of Expressionism

The outbreak of WWI turned out to be a turning point in the history of Expressionism. Its representatives from Germany and the "other Europe" had different goals. As the enthusiasm for the renewal of Kaiser Wilhelm's empire waned with continued defeats on the front, the hitherto oppressed nations saw an opportunity to regain their statehood. Consequently, a different poetics of Expressionism developed at its "center" rather than on the "periphery". While German literary output during the pacifist protest at the end of the war was characterized by sarcastic understatement, at the other extreme the euphoria of patriotic duty and tautological overstatement dominated. The sudden turn of some German Expressionists, headed by Franz Marc, from internationalist ideology to nationalism at the outbreak of WWI, in time became the cause of the widespread defamy of the movement outside its homeland. Gradually it was rejected as an aesthetic and ideological idiom of modernity.

In Poland, artists associated with the Poznań *Zdrój* made a vain attempt to Polonise Expressionism, trying to adapt its "foreign" (i.e. German) aesthetics. Nevertheless, this was neglected in the artificial genealogy of new art.[92] In the aftermath of the war, artists in other parts of Europe, such as Estonia, began to tire of the Expressionist narrative of martyrdom, which was considered "masochistic".[93] The need for more optimistic art, born of the euphoria of (re)building new states, contributed to the nationalization of modern forms not just in Poland, but also in other countries, such as Latvia (from where many artists travelled to Paris to study), Denmark,

Berg (1999); Eram (2008); Głuchowska (2009/2010); Głuchowska (2015a: 221–224, 230); Głuchowska (2015f: 137–145); Sandqvist (2006); Machnicka (2008); Kurc-Maj/Polit (2017).

92 See: text by Lidia Głuchowska, *The Great War and the New Art…* in this volume.

93 Pählapuu (2012).

Sweden, Finland, Slovenia, and Serbia, with the nationalization of modern form[94] oscillating between decorative classicism in the spirit of Art Deco and *retour à l'ordre*, and moderate Functionalism.

The image of war in wartime works by (former) German Expressionists was far from heroic. John Heartfield exposed the demagogy of propaganda. A particularly striking conclusion regarding the cyclical nature of the militaristic "rites of spring" is that the artist included his accusations not only in the photomontage *Fathers and Sons* (*Väter und Söhne*, 1924), featuring a general in a Pickelhaube, with countless medals on his chest in front of a number of skeletons, but also in its replica *Twenty Years Later* (*Zwanzig Jahre später*, 1934), with the addition of a battalion of children mobilized by the Nazi regime.

Another artist who exposed the behind-the-scenes view of the patriotic staffage was Otto Dix, who recapitulated the myth of total experience from 1914–1918, which he initially disseminated, confessing *post factum* that it turned into a persistent nightmare. He juxtaposed his lofty auto-identification with Mars, god of war, with a self-portrait in a brothel in Belgium (1922), as well as other paintings starkly depicting the poverty and moral collapse of post-war society. The veristic etchings from his *War* (*Krieg*) portfolio (1923–1924) further documented this nightmare, featuring, for example, the deformed faces of the wounded, and mental illness in the aftermath of traumatic experiences. He returned to this subject matter obsessively, even in his monumental academic works, such as the triptych *War* (*Krieg*, 1932). His anti-war message was condensed in countless images of cripples and bodies torn by bullets, which were later displayed at the Nazi exhibition *Entartete Kunst*, alongside works by other Expressionists, as well as his self-portrait as a prisoner of war, in which he emphasises that the roles of oppressor and victim are interchangeable.[95] In the new states, where Expressionism was marginalized, the centers of the imaginary avant-garde archipelago were in fact lonely

94 Piotrowski (2002); Szczerski (2010); Głuchowska (2022b).
95 See reproductions in: Herzogenrath/Schmidt (1991).

islands in a sea of national art, full of pathos, myths, and patriarchal realism.[96]

In Germany the rehabilitation of Expressionism began in the 1960s. In the countries of the so-called former Eastern Bloc, where the trend was radically criticized by György Lukács, the movement is viewed with ambivalence to this day, its revisions now presented in more recent studies that implement the postulate of a "horizontal art history".[97]

96 Šimičic (2006: 141).
97 Piotrowski (2009); see also e.g.: Lahoda (2006a); Lahoda (2009).

The Russian Avant-Garde and the Great War

Visions and Utopias

Nina Gurianova
Northwestern University, Department of Slavic Languages
and Literatures. Chicago, United States of America

Abstract

Russian culture during the years 1913–1916 was engaged in an active process of self-definition and "self-cognition". A deeper understanding of avant-garde ideology — on social, political, and aesthetic levels — appears when contextualized in relation to the First World War. The avant-garde movements sought to become a cultural event equal in significance to the war, but in the cultural field. Despite a strong sense of national identity and cultural autonomy, early Russian avant-gardists were able to view themselves as a part of an international avant-garde tendency in Europe. Thus we can regard the early Russian avant-garde as firmly within a general European context. In the course of this essay I invite the reader to compare the major theoretical and critical issues of the early Russian avant-garde with those informing such pan-European movements as Cubism, Futurism, and Expressionism because the Russian avant-garde, I believe, provides a window on theoretical issues generic to other radical art movements. Indeed it would not be far-fetched to conclude that in the early Russian avant-garde, the concept of war was associated more with resistance than destruction, with the fight not against but for.

Key words

war, avant-garde, Futurism, Russian, utopia, WWI

The Russian Avant-Garde and the Great War
Visions and Utopias

Aesthetics and Politics

The interrelationship between concepts of culture and politics has undergone an extremely complex and interesting development over the past century. The first applications of the term "avant-garde" in relation to culture were quite direct and politically charged (it was originally, after all, a military term), but by the 20th century, it had acquired a new, stable, autonomous meaning, without direct reference to political movements. Donald Egbert asserts that "the application of the term 'avant-garde' to artists as well as to leaders of a social movement first occurred within early French socialism."[1]

Even though the terms "avant-garde" and "modernism" are often taken as synonyms, the Russian and European avant-gardes of the early 20th century were not merely more aggressive and radical forms of modernism. Unlike modernism, according to most recent critical interpretations, they presupposed historical awareness of the future. Antoine Compagnon points out that there are "two contradictory elements in any avant-garde: destruction and construction, negation and affirmation, nihilism and Futurism."[2] I would add war and utopia to this list of dichotomies, where elements of both nihilism and bliss are prominent. The aspiration to harmony, utopian in its essence, became a distinctive feature in the particular vein of modernist aesthetics interested in constructive principles, which came to the fore after the Russian Revolution (1917) in the mid-1920s, following the years of the horrific experience of WWI, and disillusionment in its immediate aftermath. Another line of interest here, predominant during the war and pre-war years and developed in quite a different direction, is an identifying with disharmony, dissonance, and the absurd. The dystopian and nihilistic traits this identification cultivated left their mark in such

1 Egbert (1970: 61, 62). Matei Calinescu confirms Egbert's account that "the cultural notion of the avant-garde" had been introduced in 1825, under the influence of the utopian philosophy of Henri de Saint-Simon. Calinescu is convinced that although the word developed "a figurative meaning at least as early as the Renaissance," the metaphor of the avant-garde — "expressing a self-consciously advanced position in politics, literature, art and religion, etc. — was not employed with any consistency before the nineteenth century." Calinescu (1987: 97).
2 Compagnon (1994: 32).

"non-constructive movements" of the early avant-garde as Neo-primitivism, Futurism, Alogism, and Dada.

Considering the immense influence of Friedrich Nietzsche on Russian culture during this period, and on modernism in general, it is tempting to define these two tendencies as "Apollonian" and "Dionysian", but doing so would lead to oversimplification and confusion, since in artistic practice they are never clearly defined and hence not in opposition to each other. They coexist, sometimes in the theory of the same group or individual artist or poet — Vladimir Mayakovsky and Kazimir Malevich are good examples — and one tendency can prevail over the other in certain periods. The main ideological criterion separating them is their relation to social, political, and aesthetic utopianism and, consequently, the chosen model of interconnection and mutual responsibility between artist and audience. This rejection of utopia determines the anti-teleological drive in early prerevolutionary avant-garde culture, and this, I suggest, is the crucial difference between the early "anarchic" and late "statist" periods of the Soviet Russian avant-garde, characterized by the struggle for the new social utopia.

From this perspective, it seems too simplistic to argue that the radical status of the cultural avant-garde was directly dependent on politics, and to attribute changes in aesthetic thought directly to social or political causes. Neither the war nor any other external event could substantially alter or directly influence the inner artistic process, but history was variously refracted in the worldview of the artist, in particular having an immense power on shaping his or her social position: Mayakovsky defined WWI as a first social or public "test" of the avant-garde.[3] A deeper understanding of avant-garde ideology — on social, political, and aesthetic levels — appears when contextualized in relation to WWI.

3 Mayakovsky (1959: 41).

The Metaphor of War

The prerevolutionary Russian avant-garde created an aesthetics attuned both to Mikhail Bakunin's anarchist theory of "creative destruction"[4] and to the anti-utopian philosophy of Fyodor Dostoevsky's *Notes from the Underground* (*Zapiski iz podpol'ia*, 1864). A powerful wave of Russian anti-Benthamism pivoted on Dostoevsky's work: the "underground man's rebellion" against utilitarianism and determinism captivated contemporaries and had a crucial impact on intellectual and aesthetic ideas in Russia and beyond. For the early avant-garde generation, the poetics of the underground opposed the creation of any fixed or immutable ideas or absolutes in both social and aesthetic philosophies.

The ideological aspirations and aesthetic tendencies of the early avant-garde are reflected in the non-uniformity of its artistic and literary movements, and in the diversity of groups and tendencies that coexisted within it and spurred one another on; Neo-primitivism, Cubo-Futurism, Ego-Futurism, Rayism, Organicism, and Suprematism among them. This multiplicity of artistic practices and theoretical concepts, compressed into less than a decade, presents a challenge to scholars of the Russian avant-garde. There is only one feature that can be applied equally to all of them: an anti-teleological desire for freedom of artistic conscience, not limited by any pragmatic political, social, or aesthetic goals.

According to the artist and theoretician Ivan Kliun, who worked closely with Malevich, the early Russian avant-garde was mainly concerned with the creation of a "completely real language to express new feelings and concepts."[5] The fierceness and energy of the movement, the destructive side of what I call the early avant-garde's aesthetics of anarchy, came into its own when faced with war. One may justify the obsessive aestheticization of military subjects by the same artistic inner necessity that Wassily Kandinsky considered the principal criterion of art. The metaphor of war in the pre-war avant-garde, often confused nowadays with the outright

4 Bakunin concluded his essay "The Reaction in Germany", published in 1842, with the famous declaration: "The passion for destruction is a *creative* passion, too!" See: Dolgoff (1980: 57).
5 Kliun (1988: 137).

notion of violence in modernist — as well as Postmodernist — culture, was instead paradigmatic to the concept of innovation, and directly linked to the rather symbolic "destruction" of previous achievements.

Bakunin's meta-religious "spirit, the eternal source of life",[6] is reflected in many modernist and early avant-garde writings, but especially in Kandinsky's theoretical works. In his discussion of contemporary art, Kandinsky once called it "truly anarchistic" in that it "embodies the spirit as a materializing force, ripe for revelation."[7] This concept of force complements the idea of the intensity and symbolic violence of creation. When explored as a subject, the entire war narrative, evolving before the war, could be seen as a derivation of the eschatological worldview that was widespread at the beginning of the century.

War, Utopia, and Apocalyptic Premonitions

Kandinsky was one of the first to identify the artist with the warrior. During the first year of the War, he often referred to the figure of St. George, a warrior from another world, in the eternal battle of good and evil. And before the War, in 1913, Kandinsky created his famous *Improvization No. 30* (*Cannons/Improvizatsiia 30*), which was soon interpreted as a prophecy about WWI. But the artist himself wrote that he had a premonition, not of this concrete war, but of a terrible battle in the "spiritual" realm. According to Kandinsky, that intuition compelled him to create the picture. Let us not however forget that it was the same Kandinsky who only seven years later came up with the universal catchphrase of the century, by calling for a theme for the first *Congress of Representatives of All the Arts of All Countries*: "I believe I would not, in fact, be the only one to rejoice if it were given the name The Great Utopia. Let this structure be characterized by its mobility, its flexibility, so as to accommodate not only what is alive today, even if only in dreams, but also what will first be dreamed of tomorrow."[8]

6 Dolgoff (1980: 57).
7 Kandinsky (1989: 158).
8 Kandinsky (2009: 200).

Does it not seem that the 20th century was caught in a vicious circle of great wars chased by great utopias again and again, *ad absurdum*? The poet Anna Akhmatova had a point when she insisted that the century was born through war, and it "began with the War in the autumn of 1914, just as the nineteenth century began with the Vienna Congress. A calendar's dates are insignificant."[9]

And if we decide to follow her logic we will have to agree, I'm afraid, that we are still living on the borderline of the same 20th century, still witnessing a phenomenon which another of Akhmatova's contemporaries, the radical Romanian philosopher and cultural historian Emil Cioran, called "contamination of utopia by apocalypse":

> [...] the heralded "new earth" increasingly assumes the aspect of a new Hell. But this Hell is the one we are waiting for, we make it a duty to precipitate its advent. The two genres, utopian and apocalyptic, which once seemed so dissimilar to us, interpenetrate, rub off on each other, to form a third, wonderfully apt to reflect the kind of reality that threatens us, and to which we shall nonetheless assent with a correct and disabused yes. That will be our way of being *irreproachable* in the face of fatality.[10]

The mass consciousness of the first historical decade of the century was particularly sensitive toward these problems, swept by a "flood of premonitions". The prominent eschatological mood of this period defined war as a metaphysical confrontation, a turning point, a crisis, a catastrophe, followed by a *catharsis*.

Nonetheless, the visual and poetic avant-garde movement did not perceive modern history strictly metaphysically, as a fundamental essence. Nor did they interpret it as *arche*, when the whole *text* of world history is read as nothing more than the pure reflection of ecclesiastical *text*, although apocalyptic allusions are still occasionally present in the discourse of the avant-garde during the war years. For the leaders of this movement, "the metaphor of war" was linked first and foremost to the

9 Akhmatova (1992: 11).
10 Cioran (1998: 97, 98).

NATIONALISM AND COSMOPOLITANISM IN THE AVANT-GARDE AND MODERNISM
The Impact of the First World War

concept of unbounded creativity. In other words, decon-
struct — or "dis-construct" (this is the word David Burliuk
used in 1913) — the old aesthetics in order to give birth
to the new.[11] Even the pre-war discussions and debates
inside the art world were associated with the metaphor
of war, and military epithets such as "soldiers of the new",
"Futurist battles", and so on. All these qualities were not
unique to Russian avant-garde culture, for the avant-gar-
de movements and formations, especially in Europe,
were explicitly interconnected. Writing on Western per-
ceptions of WWI, Milton A. Cohen points out that "be-
yond merely anticipating or even welcoming a new war,
avant-garde artists across Europe drew upon war in its
multiple meanings — war as metaphor and as actuality,
war as language, as imagery, as models of both an organ-
izing and destructive power."[12]

Futurist Battles: from *Victory Over the Sun* (1913) to Contemporary Lubok Series

The notion of war as a spiritual activity, as an overcom-
ing of the *ego*, the human self, was also developed in the
pre-war poetry of Mayakovsky, Velimir Khlebnikov, and
Aleksei Kruchenykh. The 1913 performance of Futurist
opera *Victory over the Sun* (*Pobeda nad Solntsem*) was the
culmination of this idea. This metaphor of infinity and
universality in the opera embodies the quest to destroy
the old for the sake of creating anew, "free from the heav-
iness of universal gravitation."[13]

This drama is probably the first contemporary anti-
utopia about the collapse of human values and civiliza-
tion, which ends by proclaiming that there is no end: "the
world will fall but there is no end for us."[14] The very title
of Kruchenykh's play reveals something that is beyond
the human world and power, and turns upside down the
notion of humanistic progress. In a certain sense, this
anti-teleological concept corresponds to Heideggerian
notion of "dehumanization":

11 Burliuk (1988: 76).
12 Cohen (1996: 35).
13 Kruchenykh (2001: 399). From here on, all excerpts from the opera
 are my translations — N.G.
14 Kruchenykh (2001: 405).

To think against values is not to maintain that everything interpreted as a "value" — "culture", "art", "science", "human dignity", "world", and "God" — is valueless. Rather, it is important finally to realize that precisely through the characterization of something as "a value" what is so valued is robbed of its worth.[15]

In *Victory* the sense of absurdity resists the persistent routine of aesthetic, social, and ideological dogmas and *clichés* by means of parody, of dissonance, of the "apophatic openness" of nihilism.

After WWI started, Kruchenykh commented — "even the enemies of the Russian Futurists give them credit for their feats" — on a curious conclusion in a newspaper article written by the popular journalist Kazimir Barantsevich, who suggested that Futurists "seriously and perhaps not without reason claim the role of prophets in the present war [...] in their prophesy Wilhelm II himself in the opera is the main abductor of the sun." He continues: "It would not be bad if the Futurists would perform their opera again so that the public [...] can suddenly find analogous echoes and colors in our contemporary bloody and nightmarish reality."[16]

Over and above its political impact on Russian avant-garde artists and poets, of course, WWI marked a historical shift of epochs, traditions, and cultures. The world suddenly came to seem alien, frightening, and irrational. The avant-gardists, especially the Futurists, were *attuned* to the modern reality of WWI, which marked the beginning of a new era for many people, and many artists retrospectively sought to connect their works created before 1913 with WWI.

Ideas about the interconnection between life and art, and war and art, were suddenly major topics of discussion among the leaders of avant-garde art and poetry. In October 1914, David Burliuk and Vasily Kamensky lectured on war and art in Moscow. According to the poster advertising his lecture "War and Creativity" ("Voina i tvorchestvo"), Burliuk discussed: "Contemporary war. Literary premonitions of our days. [...] Idea of united Slavs. Wars

15 Heidegger (1993: 250, 251).
16 Newspaper article by K. Barashevich reproduced with Kruchenykh commentary in: Kruchenykh/Malevich/Kliun (1915: 30).

of the past and their reflections in art [...]. Our attitude toward the monuments of art. We protest Teutonic vandalism. [The shelling of] Reims Cathedral."

Russian military success at the very beginning of WWI inspired a wave of politically engaged mainstream art, patriotic postcards, posters, brochures, and albums, all reflecting the subject of war. In turn, Mayakovsky, Malevich, Aristarkh Lentulov, and a few others made a short-lived attempt to revive a folk tradition of the military Lubok genre in the now widely known *Segodniashnii lubok* [Contemporary Lubok] series of awkwardly cheerful and straight-forward flashy propaganda posters and postcards, commissioned by Margarita Sabashnikova's publishing house. These works "for hire" were experimental and unusual, but hardly could be treated as a highpoint in their artistic careers, nor were they so popular and successful in fulfilling their immediate purpose of agitation. But in most cases, the theme of war in avant-garde poetics was not politicized and had little in common with official propaganda.

Images of War: Visions and Visionaries

Natalia Goncharova's series of lithographs *Mystical Images of War* (*Misticheskie obrazy voiny*, 1914), Pavel Filonov's artist book of poems and prints *Sermon-Chant on Universal Sprouting* (*Propeven' o prorosli mirovoi*, 1915), along with his paintings *German War* (*Germanskaia voina*, 1915) and enigmatic *Refugees* (*Bezhentsy*) also known as *Flight Into Egypt (Begstvo v Egipet)* of the same year, Olga Rozanova's linocut portfolio *War* (*Voina*), and Kruchenykh's album of collages *Universal War* (*Vselenskaia voina*, the last two both published in 1916) were among the most profound artistic responses to the war. These unique works represent three different artistic explorations of the theme, as reflected in Neo-primitivist, Futurist, and Suprematist aesthetics.

Goncharova and Filonov undoubtedly shared many features of the Expressionist language. The Expressionist movement produced many artistic works inspired by war. Among them are graphics by the Germans Otto Dix, Käthe Kollwitz, Max Pechstein, and Ernst Barlach, and the French artist Georges Rouault's cycle *Miserere*. Being

receptive to the religious idea of sacrifice and spiritual disharmony, Expressionists were drawn to the metaphysical vision of "war within the human soul", as seen through the eyes of a tortured, suffering human being. In this respect, however, Russian artworks are different, and the artists' intent to avoid any individual, purely psychological focus sets their work apart. Similarly, their artworks cannot be aligned with the Italian Futurist response to WWI, as nothing could be farther from Goncharova's pathos in *Mystical Images* than Italian aesthetic and political glorification of a technological utopia and war.

Filonov and Goncharova eschew the "prose" and "quotidian" realia of war, creating a fascinating amalgam of the traditional and modern, the universal and the particular. In *Mystical Images*, Goncharova combines innovation with a solid foundation in the national tradition, particularly the religious Lubok, instead of a military one, to evoke the sense of a ritual performance. Her series has nothing in common with the adopted pseudo-folk style and propaganda spirit of the *Segodniashnii lubok* mentioned above. In her mystical visions there is no place for depersonalization or mockery of the "enemy image" or trivial glorification of the Allies' imperial powers. Goncharova's keen awareness of history emerges through visual allusions and metaphors. The artist creates her own mythology of war, combining in a single visual text the animate heraldic creatures of the Russian coat of arms (*White Eagle*), symbols of Britain and France (*British Lion* and *Gallic Cockerel*), and apocalyptic images (*The Woman upon the Beast*, *The Doomed City*, and *Pale Horse*). *The Book of Revelations*, Christian myth, classical folklore and epics, and the imagery of contemporary urban primitive, with its memory of the recent, blend with the recognizable details of the "immediate" present — military uniforms, factory smokestacks, and airplanes. This creates a palpitating, living textual fabric — the war as a kind of global theater, a miracle play performed in front of one's eyes.

Goncharova managed to disengage herself from the mainstream ideological *clichés* of nationalism, while at the same time utilizing distinct national imagery and clearly siding with the Russian cause. *Mystical Images* is a very eclectic work in its aesthetics. Paradoxically, it is precisely this quality that makes it so original. By 1914,

Neo-Primitivism was already passé for Goncharova. Indeed, by this time, she had created several Futurist works, was quite experienced in the Rayist style developed by Mikhail Larionov, and had begun to experiment with abstraction. What made her return to the aesthetics of folk art, to the inspiration of Russian icons, as well as to her own earlier works on religious subjects? One of the answers could be that Goncharova always had an ambition to reinvent and to revitalize the grand tradition of Russian and Byzantine religious art, and the subject of war offered an ideal opportunity to turn anew to the eschatological narrative of her painterly series *Harvest* (*Zhatva*, 1911) and *Gathering Grapes* (*Sbor vinograda*, 1911). Several among her lithographed images of war — *Lion* (*Britanskii Lev*), *The Woman on the Beast* (*Deva na zvere*), and *The Doomed City* (*Grad obrechennyi*) — refer directly to the iconography she developed in these earlier painterly series. Goncharova creates her images in black-and-white lithography, a technique she had favored since her work on the Futurist editions of 1912–1914.

Her theme is the "ultimate war", "the apocalyptic war", where human individuality is inconsequential. Her interpretation transcends temporal boundaries and transforms historical fact into archetypal symbol, dangerously teetering on the precipice of descent into *cliché*. Her war is bold, masterfully naïve, simple, but in no way superficial in its Lubok-like visual narrative. Goncharova does not simply present an insight into war; she mimics the mass reaction to war, as reflected in the imperial allegories that saturated contemporary Russian newspapers, journals, and postcards. Such an approach inevitably leads to a certain distancing, if not outright self-parody. Thus, in *Angels and Airplanes* (*Angely i aeroplany*; Fig. 1), the wings of angels and aircraft intertwine in the sky as heavenly and earthly forces. The hieroglyphic figures of human pilots in their machines appear as fragile toys that cannot survive long in the hands of immortal angels. Their connection is strange, gentle, and ironic, as if the angels were fascinated by human intrusion and are protecting them from falling. Her airplanes are animated, admired, not as powerful machinery, but as new, winged mythological creatures, which she wittily compares to angels. This interpretation merges with the purely Russian

Fig. 1

Natalia Goncharova,
Angely i aeroplany [Angels and
Airplanes], 1914, from *Voina:
Misticheskie obrazy voiny*
(1914). Minneapolis Institute
of Art, The Ethel Morrison
Van Derlip Fund

Futurist theme of the humanized machine in the dehumanized world of modernity.

Goncharova blends futuristic objects such as airplanes into the traditional iconography of her series so naturally and whimsically that it evokes the pantheistic cosmology of a Primitive artist, much like the trains, steamships, and airplanes in the pictures of Henri Rousseau and the Georgian Niko Pirosmani. In *The Doomed City* (*Grad obrechennyi*; Fig. 2) the next image in the series, the roles are reversed. The angels, with their fashionable hairstyles and dapper moustaches, are "bombing" the city with stones, looking suspiciously like WWI pilots on an attacking sortie. But Goncharova's perishing city is devoid of people, and in spite of the factory smokestacks in the cityscape background, is yet another transformation of doomed Babylon.

Fig. 2

Natalia Goncharova,
Grad obrechennyi [The Doomed
City], 1914, from *Voina:
Misticheskie obrazy voiny*
(1914). Minneapolis Institute
of Art, The Ethel Morrison
Van Derlip Fund

The historical experience of WWI afforded the
avant-garde an immediate opportunity to infuse a social
content into their formal artistic experiments, and the
creation of new forms was harnessed to the search for an
expressive language in which to portray social cataclysms.
It was a question of the purpose of art, its appropriate
sphere of influence, and the traditional problem of the
interrelationship between the artist and his or her audi-
ence, between the artist and contemporary society. For
contemporaries, premonitions of a "spiritual battle" cruel-
ly clashed with the reality of WWI, with its new technol-
ogy used on a gigantic scale, creating a new, dehumanized
image of war, beyond human pain and passions, where
individual life did not count. In one of his earliest news-
paper articles about the war, Mayakovsky wrote some

terrifying, daringly simple words: "As a Russian, I hold sacred every effort of the soldier to wrench back every piece of Russian land away from the enemy; as a man of art, however, I am obliged to think that perhaps the entire war was invented merely so that someone could write a single good poem."[17]

In Mayakovsky's newspaper "war" articles of 1914–1915, it is possible to follow his ideological evolution from patriotic pride and enthusiasm to disenchantment and humiliating despair. In its first months, WWI did not yet manifest itself as the primitive global slaughter it would later become, with "the idleness, the boredom, the vulgarity" that the Symbolist poet Alexander Blok noted.[18] Inasmuch as Russian Futurists treated the war as an almost abstract "spiritual" event in the beginning, the subsequent disillusionment of an entire generation was all the stronger and harsher.

Rozanova's portfolio of color linocuts *War*, accompanying Kruchenykh's poems, was created by December 1915. Impacted by Futurism, Rozanova's images might be compared to those of Umberto Boccioni, Gino Severini, and Carlo Carrà in Italy, and to Wyndham Lewis' Vorticist art in Britain. However, the conceptual model behind it is different. The Italian Futurists, unlike the Russians, proposed not only an aesthetic but also a political program advocating war as "the world's only hygiene", as the path to national regeneration. Because of their glorification of war in the manifestos and artistic discourse, many of their contemporaries, especially among Russian Futurists, suddenly saw them, not so much as prophets of war, but as its heralds.

In Rozanova's linocuts and Kruchenykh's poetry, war not only spells disaster and destruction, but also represents the agonizing birth of an unknown, violent new epoch. Rozanova draws inspiration directly from the present. In her series, she combines the stringent documentary quality of newspaper chronicles, as in *Fragments from Newspaper Reports* (*Fragmenty iz gazetnogo soobshcheniia*; Fig. 3), with elements of the romantic, grotesque and the tragic, exemplified in *Airplanes over the*

17 Mayakovsky (1955: 304).
18 Blok (1913).

Fig. 3

Olga Rozanova, *Fragmenty iz gazetnogo soobshcheniia* [Fragments from Newspaper Reports], 1915–1916, from **Aleksei Kruchenykh**, *Voina* (1916). Philadelphia Museum of Art, Philadelphia, 125th anniversary acquisition, gift of The Judith Rothschild Foundation

City (*Aeroplany nad gorodom*; Fig. 4). At the same time, the portfolio *War* is not directed at the universal narratives of past traditions, but speaks of the yet unknown. In Rozanova's visualization, eschatological "spiritual battle" and the historical chronology of contemporary war never merge into one. In the portfolio, modernity is treated as an entity that possesses an unknown and unparalleled historical myth of its own. Rozanova draws strength and inspiration directly from the present, not retreating a step from her basic idea of art: "To produce a work of genius the artist must possess an acute awareness of reality and extraordinary will power to be able to

The Russian Avant-Garde and the Great War
Visions and Utopias

renounce the past and avoid confusing its false, decrepit image with emerging newness."[19]

The artist expresses her premonition of the future of Russia which, according to Blok, "rushed out of one revolution to look greedily into the face of another that is perhaps even more terrible."[20] Her symbolism is subjective and elusive, free of superfluous allegorical content. Like a testimony brought to the level of artistic event, Rozanova's and Kruchenykh's *War* strikingly conveys a sense of the author's active participation by means of authentic metaphors without exaltation and patriotic drumbeats. Their antimilitaristic position is subtle.

Two compositions from Rozanova's *War* portfolio, *Fragments from Newspaper Reports*, are inspired by lines

19 Rozanova (2000: 201).
20 Blok (2010: 162).

NATIONALISM AND COSMOPOLITANISM IN THE AVANT-GARDE AND MODERNISM
The Impact of the First World War

taken directly from newspapers. What takes on visual form here is not poetry, but the deliberately impersonal, nameless, laconic documentary discourse of the war chronicle from Russian territories occupied by German forces. The word made visual freezes a composition shot through with dynamics and rhythm, thereby introducing a sense of the eternal and non-transitory into the general context. Taken out of their usual context, these newspaper excerpts compel the viewer to listen to the genuineness of a tragedy that has been restored to the line. In an image reconstructing the execution of peaceful civilians by German soldiers, Rozanova creates an almost cinematic montage of two simultaneously depicted planes, and the path of a bullet fired from a rifle emphasizes the halted eternity of the moment. The artist operates with a dual reflection of reality: the immediate statement of the fact in the newspaper text and her own subjective, emotionally open reading or revelation of the text. It resembles Kruchenykh's "testimony" with eyes shut, which transforms a newspaper report of an execution by a firing squad into poetic metaphor:

> With closed eyes
> I see the bullet
> It silently steals
> toward a kiss.[21]

The theme of the victim and the sacrifice is a central one in Rozanova's *War* linocuts, and it appears again in *Man Leaping from Airplane*, a flattened hieroglyphic-like human figure oddly repeats the outline of the airplane in scarlet, cross-shaped. In the second *Fragment*, it becomes the image of "crucified by the Germans", and a soldier is plunging a bayonet that looks like an ancient spear into his crucified victim.

In Rozanova's work there is an intense inner drama that negates linear, absolute, real time. It is expressed in the juxtaposition of the documented and the imaginary, each of which possesses its own reality and unreality. In the final analysis, it transcends beyond nationality, race,

21 This is one of a few poems printed on separate sheets as parts of the same portfolio *War*. My translation — N.G.

or historical epoch. Thus, a sparsely worded passage from a newspaper report grows into a visible tragedy viewed in horror, and a scene of death is transformed into one of immortality. These reports on executions of unidentified victims, which with time become an ordinary narrative of "any" military chronicle, "anywhere" in the world, are never ordinary, and should never become ordinary events in essence. It is difficult to imagine a more powerful, dramatic, and simple artistic embodiment of this truth.

Although she bases the composition on documentary texts, Rozanova's work avoids becoming a documentary itself, avoids any particular details that point to nationality and contemporaneity of victims and executioners. She successfully resists the allure and false reverence for the topical experienced by artists who turn to current historical documents and witness accounts for their material. In the "open eyes" of the newspapers, Rozanova reads a new myth of modernity. She needs no distant associations, for the newspaper becomes the new *Urtext*, new history, new Bible. The daring and confessional nature of her experimental style here resembles that of the war poetry of Mayakovsky, who doesn't hesitate to insert newspaper reports into poetic visions such as "Mama i ubityi nemtsami vecher" ["Mama and the Night Killed by Germans"], "Ia i Napoleon" ["Napoleon and I"], and "Voina ob'iavlena" ["War Declared"], all from 1914.

Rozanova also finds other formal means of realizing and recreating her subjective vision in her two collages for this portfolio. Her knowledge of Suprematist principles is evidenced in her collages for the cover. The laconicism of the composition and the solemn simplicity of the colors (white, blue, black) and shapes (triangle, square, circle, and rectangle) compare with Malevich's best Suprematist works at the *0–10* exhibition in December of 1915. These Suprematist collages served as the prototype for Kruchenykh's album *Universal War* (Fig. 5), published in 1916. In the foreword to *Universal War*, Kruchenykh noted:

> These collages were born of the same source as *transrational* language — the liberation of creation from unnecessary conveniences (through *nonobjectness*).

Fig. 5

Aleksei Kruchenykh, *Voennoe gosudarstvo* [Military State], 1916, from **Aleksei Kruchenykh**, *Vselenskaia Voina* (1916). Des Moines Art Center, gift of Louise R. Noun

The unity of word and image is embodied in their parallel implementation as equivalent systems that are subject to the same rhythm and combined within the same covers. The transrational word and the sound contained in it seek out an exact equivalent in the abstract geometrical shape, in color, and in the correspondence of units of construction, so that the color form is structured on an analogy to the phoneme.[22]

Here Kruchenykh creates a totally abstract anti-utopian model of the "Universal war of 1985", as he proclaims in his introduction, utilizing pure rhythm, form and color. One of the outstanding merits of this album is its successful implementation of the concept of collage as an artistic metaphor for the "discordant concordance" of the epoch. It appeared at the same time as Hans Arp's first Dadaist collages, and thirty years before Henri Matisse's celebrated *Jazz* series.

This was a time when Russia was experiencing the chaos of a war that erased all boundaries in both

22 Kruchenykh (1916: 1).

a geopolitical and aesthetic sense, and when the first rumblings of the unsystematic aesthetic rebellion soon to be dubbed "Dada" were "in the air". Ever since creating *Victory Over Sun*, the anarchic features of early Russian avant-garde's poetics — the intensity of the nihilist artistic gesture, the poetics of absurdism, and resistance to all common aesthetic values — foreshadowed the problematics of Dadaism. In some respects, the pre-revolutionary Russian avant-garde period was like that of Zurich Dada or the American avant-garde of the 1950s, an era when all the rules were challenged. What I call the "aesthetics of anarchy" in the early Russian avant-garde is also closely related to some aspects of Postmodernist Situationist practice and radical Conceptualism (e.g. Process Art, the work of John Cage, and groups such as Fluxus).[23] The early phase of the Russian avant-garde was "ontologically anarchist": this variant of anarchism was inspired not by a notion of social utopia, which inevitably calls for temporal, epochal "closure", but rather by another byproduct of philosophical anarchism, namely "dystopia", with its paradoxical mixture of nihilism and "openness".[24]

After 1915 the social and cultural discourse was determined by disillusionment. Born out of dystopia and the experience of war, it was summarized by Georges Bataille, who declared, "I myself am war."[25] The avant-garde movements sought to become an event equal in meaning to the war, but in the cultural field. In a sense, *Universal War* is a continuation of the *Victory* theme, dedicated to the "death of modernity" or, rather, the "death of the modern myth". *Universal War* is nothing but a verdict on the historical past and WWI as a part of this past. And it would not be far-fetched to conclude that in the early Russian avant-garde, the concept of war was associated with resistance more than with destruction, with the fight not *against* but *for*.

The same anarchic inspiration that drove Kruchenykh to the language of "Beyonsense" (*Zaum*) was at the roots

23 This essay is partially based on my book, *The Aesthetics of Anarchy*. See: Gurianova (2012).
24 I am applying to aesthetics the philosophical concept of "ontological anarchy" developed by Reiner Schürmann in his original interpretation of Heideggerian ideas. See: Schürmann (1986).
25 Bataille (1994: 48).

of Suprematist nihilism, as found in Malevich's aesthetic theory of the "void". Suprematism was as much an outcome of WWI as the Dadaist anti-aesthetic mentality; both were inspired by philosophical nihilism. Notwithstanding modern progress in science and the resulting conveniences of technology, intellectuals and artists during the 19th and 20th centuries faced looming existential nothingness. WWI shockingly proved that modernization not only was destructive of life on various fronts but also failed to provide any true replacement for what was wiped out in the sphere of "belief". In this context, Maurice Blanchot's reading of nihilism as the permission to know everything seems to correspond most closely to the early avant-garde's paradoxical conception of utopia: "nihilism is an event accomplished in history that is like a shedding of history — the moment when history turns and that is indicated by a negative trait: that values no longer have values in themselves. There is also a positive trait: for the first time the horizon is infinitely open to knowledge, 'Everything is permitted.'"[26]

26 Blanchot (1993: 144, 145), quoting Nietzsche.

Riflemen Art

Visualizing the Ukrainian War

Oksana Dudko

University of Toronto. Canada

Center for Urban History. Lviv, Ukraine

Abstract

Focusing on Ukrainian war art, this article explores how the Riflemen artists shaped the First World War into a "Ukrainian War". In particular, it aims to examine how the artists visualized wartime experiences along national lines. In doing so, it focuses specifically on the *Artistic Handful* (*Artystychna horstka*), a semi-official group of soldier-artists who operated within the Press Bureau (*Presova Kvartyra*), a Riflemen propaganda unit. By discussing major themes represented in Riflemen art, this article argues that by refracting the war through a national lens, the art forged a new wartime reality that subsequently transformed soldiers' lived experiences. In other words, the artists did not merely illustrate the war. They created it by blurring the boundaries between the "real" and "imagined" war.

Tracing Riflemen art during and after WWI, the article pays particular attention to the Riflemen's visual propaganda art, portrait series and cartoons, and depictions of warfare and fallen soldiers. It also explores the successive "recycling" of Riflemen art in nationalistic propaganda during the interwar and the Second World War periods. Finally, sketching the perceptions of Riflemen art over the course of the 20th century, the article discusses the role of Riflemen artistic heritage within Ukrainian art.

Key words

Ukrainian Sich Riflemen, the First World War, Eastern Front, Ukrainian War Art, nationalism, caricature, postcards, Expressionism

Riflemen Art
Visualizing the Ukrainian War

Introduction

When the First World War began, many Ukrainian artists were driven by nationalistic motives to join the Ukrainian Sich Riflemen,[1] a national military unit within the Austro–Hungarian Imperial Army. Although the Riflemen consisted of only a few thousand soldiers, the memory of their wartime experiences greatly exceeded those of more than four million Ukrainian combatants who served in non-national units of the Austrian and Russian Imperial Armies. Widely commemorated within the Ukrainian community after WWI, heroic representations of the Riflemen continue to dominate Ukrainian memory of the war to this day. In particular, the Riflemen legend emphasises that the Riflemen were the first modern Ukrainian Army that fought in "the war for the liberation of Ukraine".[2] These idealized depictions of the Riflemen's valour were both forged and reflected in visual and graphic art. At the same time, Riflemen participation in the Austrian imperial war effort was almost entirely obscured.

Paradoxically, however, the Riflemen's military performance itself did not play a major role in shaping the

1 The term "Sich" refers to the Zaporozhian Sich, an autonomous polity of the Zaporozhian Cossacks in the 16th-18th centuries. The period of the Zaporozhian Sich is considered to be a pivotal time of Ukrainian state-building that inspired future generations to fight for Ukrainian independence. Although the Sich existed in the territory of Central Ukraine, Galician Ukrainians incorporated the history of the Zaporizhian Sich into their national narrative. As stated in the Ukrainian Galician newspaper *Visty z Zaporozha* [News from Zaporizhzhia]: "We associate the word Cossack with the time of our national strength and power, pivotal in our national life, the representation of our Ukrainian Self." See: Shebets' (1912). Indeed, the Ukrainian community in the Austro-Hungarian Empire became a major transmitter of the Cossack and Sich legend via public commemorations, cultural and educational activities, and mass rallies. Moreover, at the turn of the 20th century, a number of Ukrainian gymnastic and paramilitary organizations paid homage to Cossack and Sich history. For instance, the gymnastic society *Sich* and the paramilitary organizations Sich Riflemen I (*Sichovi Stril'tsi I*) and Sich Riflemen II (*Sichovi Stril'tsi II*) directly referred to the Sich in their titles, organizational structure, symbolism, songs, and newspaper names. Drawing from these pre-war paramilitary organizations, the Ukrainian Sich Riflemen unit further incorporated Cossack history into the modern nation-building narrative. For more details, see: Dudko (2013: 184–186).

2 Dumin (1936); Lazarovych (2005).

Fig. 1

Yulian Krajkivski (designer),
postcard *Artystychna horstka*
[The Artistic Handful], 1916.
Private collection

Riflemen legend. Instead, the political and cultural mobilization of the Ukrainian community, which the Riflemen units exemplified, became a foundational component of the Ukrainian war experience. It is true that the gruesome brutality and violence of the war had lasting effects on Ukrainians in both the Habsburg and Russian Empires. Yet it was the staggering number of artistic works, theatre plays and performances, books, poems, and songs developed within the Riflemen units that engendered the idea of WWI as a Ukrainian war for independence. In this sense, Ukrainian cultural representations of the war were not unique. Other national communities within various empires (e.g. the Czechoslovak, Latvian, and Polish Legions)[3] experienced a similar nationalization of the war effort. Thus, by exploring the role of Ukrainian artistic and cultural production during the war, this article complements the rapidly developing field of the cultural history of WWI. Specifically, it contributes to a growing body of work on the impact of arts and culture on the

3 See: contributions by Ginta Gerhade-Upeniece, Vojtěch Lahoda, and Lidia Głuchowska, *The Great War and the New Art…* in this volume.

construction of new wartime communities and national military culture on the Eastern Front.

Focusing on Ukrainian war art, this article explores how the Riflemen artists shaped WWI into a Ukrainian war. In particular, it aims to examine how the artists visualized wartime experiences along national lines. In doing so, it focuses specifically on the *Artistic Handful* (*Artystychna horstka*, c. 1915–1918), a semi-official group of soldier-artists who operated within the Press Bureau (*Presova Kvartyra*), a Riflemen propaganda unit (Fig. 1). By discussing major themes represented in Riflemen art, this article argues that by refracting the war through a national lens, the art forged a new wartime reality that subsequently transformed soldiers' lived experiences. In other words, the artists did not merely "illustrate" the war. They "created" it by blurring the boundaries between the "real" and "imagined" war.

With these considerations in mind, the article is divided into seven sections. The first section traces the *Artistic Handful* milieu and its members. The subsequent five sections explore how through blending different genres, artistic forms, and themes, the artists recast WWI as a Ukrainian war. These sections pay particular attention to the Riflemen's visual propaganda art, portrait series, cartoons, and depictions of warfare and fallen soldiers. The final section outlines the legacy of Riflemen art. Specifically, it considers the successive "recycling" of Riflemen art in nationalistic propaganda during the interwar and WWII periods. Finally, sketching the perceptions of Riflemen art over the course of the 20th century, the concluding section considers the role of Riflemen artistic heritage within Ukrainian art.

The Artistic Handful

Although states played a major role in mobilizing artists for the war effort in many instances, the Ukrainian artists of Galicia were primarily self-mobilized. Considering the war to be an event of tremendous significance for the Ukrainian community, many young artists volunteered to serve in the Ukrainian Sich Riflemen (*Ukrains'ki Sichovi Stril'tsi*). In addition to joining the army, these artists contributed to Ukrainian popular mobilization by

developing propaganda artwork. By and large, this vigorous participation of Galician Ukrainian artists in wartime propaganda reflected general European trends. In most European countries (e.g. Great Britain, Germany, France, and Austria-Hungary), painters, graphic artists, and sculptors joined official national propaganda machines at war.[4]

Over the course of the war, the Riflemen artists immersed themselves in depicting Ukrainian war experiences, heroic mythology, and patriotic messages in their work. Popular within the Riflemen community itself, the body of artistic works created during the war helped the Riflemen make sense of the war and structure their wartime experiences. Their wartime artistic narratives, however, extended well beyond the Riflemen community and became one of the major representations of the Ukrainian world war.

The emergence of Riflemen art as a distinct phenomenon in Ukrainian wartime art was possible due to the establishment of several organizational structures within the Riflemen units that allowed artists to focus specifically on artistic work. This special interest in art and culture as powerful national mobilization tools was not accidental. At the beginning of the war, around 40% of the Riflemen were intellectuals and artists.[5] They viewed cultural mobilization as the core of Ukrainian national mobilization in the Austro-Hungarian Empire.[6] The Riflemen leadership therefore placed special emphasis on ensuring that artists could participate in mobilization and propaganda campaigns.[7] Because they were captivated by patriotic fever, the artists also searched for ways to institutionalize their work within the army.

Shortly after the war began, several grassroots initiatives emerged in favour of creating artistic units that

4 A notable exception in this context is the limited participation of Russian soldier-artists in the war because they were often released from military service. For further details, see: Raev (2014); see also: contributions by Lidia Głuchowska, *International Expressionism...*, and *The Great War and the New Art...* in this volume.

5 Central State Historical Archive in Lviv, fund 353, Inv. 1, file 7, 25.

6 For more details, see: Lazarovych (2007: 75–83); Plekan (2007: 83–85).

7 Kokovs'kyi (1934: 2).

would enhance national propaganda and mobilization.[8] Two Riflemen artists — Ivan Ivanets' and Iulian Butsmaniuk — were among the first who proposed the creation of the Riflemen cultural propaganda unit.[9] Along with several other Riflemen, they established the Riflemen Press Bureau, which had a separate artistic unit — the *Artistic Handful* — within it. Bringing together visual and theatre artists, sculptors, writers, and musicians, the Press Bureau and the *Artistic Handful* became the epicenter of Riflemen art.[10] The Press Bureau operated both on the frontline and at the rear. However, because many artists were active servicemen, they primarily worked on the frontline.[11]

Most members of the *Artistic Handful* were young artists in the early stages of their careers. They began their vocation at a time when contested ideas of traditional and modern art shaped and shared the artistic landscape in Galicia. Specifically, classical painting still dominated the artistic landscape, but modern art techniques were becoming increasingly popular within national art schools on the Austro-Hungarian borderlands.[12] As a result, the Riflemen artists were introduced to a variety of genres during their studies, albeit to varying degrees. Some of them, such as Ivan Ivanets' and Osyp Sorochtei, were more experienced and had studied art in Lviv (Lvov/Lwów/Lemberg) and Cracow whereas others, such as Lev Hets, had no prior formal arts education.[13] Notably, Olena Kul'chyts'ka — the sole female artist associated with Riflemen art — had a distinctive artistic education. Similar to other Ukrainian artists, she initially studied in Lviv.[14] However, she subsequently pursued her education at the Vienna School of Industrial Design (until 1918: *Kunstgewerbeschule des K. K. Österreichischen Museums für*

8 Hnatkevych (2011: 126).
9 Ostroverha (1962: 71–72).
10 Indeed, almost all notable Riflemen artists (Osyp Kurylas, Ivan Ivanets', Osyp Sorochtei, Lev Hets, Iulian Butsmaniuk, Iulian Nazarak, Mykhailo Havrylko, and Ivan Kuchmak) belonged to the *Artistic Handful* milieu. Ripets'kyi (1995: 148).
11 Rozhak-Lytvynenko (2017: 30–31).
12 Rozhak-Lytvynenko (2017: 66).
13 Lazarovych (2005: 238–239); Hnatkevych (2011: 126–127).
14 Kost' (2007: 2).

Kunst und Industrie; since 1919: *Kunstgewerbeschule des Österreichischen Museums für Kunst und Industrie*), where she became interested in modern art and diversified her artistic techniques.[15] Although Kul'chyts'ka did not belong to the core Riflemen artistic milieu, she developed close relationships with the Riflemen during her work with the Ukrainian Women's Committee to Aid Ukrainian Wounded Soldiers in Vienna (*Ukrain'skyi zhinochyi komitet dopomohy poranenym voiakam*).[16] Osyp Kurylas, in comparison, was probably the only artist from the older generation of painters, who developed an artistic style within the classical tradition of realistic art.[17] Despite their different artistic backgrounds, however, all Riflemen artists were shaped by Ukrainian nationalism and popular patriotism.

Committed to creating national wartime art, the *Artistic Handful* set several interrelated goals. First and foremost, the artists wanted to mobilize the Ukrainian community for the war effort. In doing so, they contributed to the creation of powerful visual representations of WWI as a Ukrainian war. While often using themes, visual language, and propaganda practices that were similar to those of general Austro–Hungarian imperial propaganda, the Riflemen artists discarded imperial references, appealing to Ukrainian national particularities. Similar to other national artistic units within the Austro-Hungarian Empire (e.g. Poles and Hungarians), the *Artistic Handful* focused on representing distinctively national wartime experiences, silencing an all-out imperial war effort.[18]

Excluding the imperial war, the artists situated Ukrainian wartime experiences within the idealized national past. They did this by portraying the Riflemen as a vigorous modern Ukrainian Army that was symbolically bonded with the iconic Ukrainian Zaporozhian Cossacks of the 15th–18th centuries.[19] Depicting the Riflemen alongside

15 Voloshyn (2007: 9–10).
16 Kost' (2007: 6).
17 Rozhak-Lytvynenko (2017: 104–106).
18 For further details, see: Stirton (2013).
19 The Zaporozhian Cossacks were military formations that operated in the territory of present-day Ukraine during the 15th–18th centuries. In the mid-16th century, the Cossack military units grew into the Zaporozhian Sich, an autonomous polity with a democratic form

Cossacks, the artists developed mythical continuity between the two armies.[20] In doing so, the Riflemen progressively separated wartime visual narratives from the empire. Indeed, it was national patriotic images rather than imperial propaganda that bolstered mobilization of the Riflemen. The diverse images of the Riflemen as a national army forged a sense of national unity, contributing to further nationalization of the Ukrainian community in the Austro–Hungarian Empire.

The artists not only created imagery of the Ukrainian Army and the national world war but also structured lived experiences along national lines. By collecting artefacts, portraying everyday wartime routines, and taking pictures, they shaped Ukrainian war culture. This production of a national war "archive" was considered no less critical than the war effort itself.[21] Hence, although the Riflemen constantly encountered and interacted with other imperial troops, including Austrian, Hungarian, and Turkish units, Riflemen art provided a focalized account of the war that was confined to the Riflemen perspective. By prioritizing Ukrainian patriotic mobilization, they excluded the experiences of hundreds of thousands of Ukrainian soldiers who served in the Austrian and Russian Armies from visual representations of the war. As a result, in war art, the Riflemen war became a central myth of the Ukrainian war experience; imperial

of governance. Engaged in continuous battles with the neighbouring Polish-Lithuanian Commonwealth and the Russian and Ottoman Empires, the Zaporozhian Cossacks were known for their strong military performance. In Ukrainian historiography, the Zaporozhian Sich are considered to be a precursor of the modern Ukrainian state. Moreover, often depicted in literature, art, and popular culture as fighters for Ukrainian independence who battled oppressive neighbours, the Zaporozhian Cossacks became one of the major symbols of the Ukrainian aspiration for independence. At the same time, they became a key source of inspiration for modern Ukrainian Armies, including the Ukrainian Sich Riflemen, the Ukrainian Insurgent Army, and the present-day Ukrainian Army. For more on how the Cossack myth was fundamental to the Ukrainian nation-building narrative, see: Plokhy (2012).

20 For instance, in the popular image *Hetman Blesses a Rifleman* (*Hetman blagoslovliaye sichovyka*, 1904), a Cossack hetman blesses a Rifleman for an upcoming fight for Ukrainian independence: Monolatii (2007c: 153).

21 Nazaruk (1916: 1–2).

NATIONALISM AND COSMOPOLITANISM IN THE AVANT-GARDE AND MODERNISM
The Impact of the First World War

universalism was overpowered by Ukrainian particular-
ism. Thus, the Riflemen artists not only depicted the war
but also hierarchized wartime experiences. By blurring
boundaries between the "real" and the "imaginary", the
artists forged a new wartime reality.

Artists and Popular Mobilization

Enthusiastic about the war from the outset, the Rifle-
men artists immersed themselves in the mobilization
campaign. Appealing primarily to the young male Ukrain-
ian population of Galicia, the artists framed the war
as a national and patriotic yet adventurous enterprise.
In a series of mass-distributed postcards, they presented
a romanticized image of the young Rifleman that was
aimed not only at mobilizing the Ukrainian communi-
ty for the war but also at illustrating the establishment
of the modern Ukrainian Army. Although the artists used
generic imperial mobilization themes (e.g. soldiers bid-
ding farewell to loved ones when leaving for the war),[22]
they turned them into distinctly Ukrainian experiences
by imbuing them with national iconography. Perhaps
in part because the Riflemen propaganda postcards were
designed to mobilize the male community for the war, the
artists avoided creating graphic representations of the
war itself. Instead, the postcards focused on peaceful
aspects of soldiers' departures. The generic idyllic scenes
of the Riflemen bidding farewell to loved ones became
one of the most common images portrayed on propagan-
da mobilization postcards (Fig. 2). Although the departure
was inevitably a painful experience for both soldiers and
their families, representing the war as a journey rather
than a violent conflict likely reduced families' reluctance
to send their loved ones to war. Indeed, the "I'm leaving
for a foreign land" trope was a common way to describe
Riflemen recruitment to the war.[23]

Never depicted as hypermasculine soldiers, the Rifle-
men embodied romanticized heroes who marched off to

22 See, for instance, Osyp Kurylas' propaganda postcard series:
 Monolatii (2007b: 172, 174).
23 Monolatii (2007b: 172, 174).

Fig. 2

Osyp Kurylas (designer),
postcard "Oi vydno selo, shyroke
selo…" ["Oh, Look Over There,
You Can See the Great Village…"],
1917–1918. Andrey Sheptytsky
National Museum in Lviv

vanquish an invisible enemy (see Fig. 2).[24] This idealized
visual representation of the departure of Ukrainian youth
for the war was consistent with similar narratives in Ri-
flemen poetry, songs, and literature. For instance, one
of the most popular Riflemen songs describes a similar
farewell scene:

> The Rifleman was leaving for a [small] war,
> He was saying goodbye to his girlfriend:
> "Goodbye, girl, goodbye, the only one,
> I'm leaving for a foreign land."[25]

The amalgamation of visual, textual, and oral propaganda
tropes made the Riflemen one of the most recognizable
images of WWI in Ukraine.

Representations of the war were not only stripped
of violence but also nationalized. That is, the "Ukrainian
nature" of the war effort was reinforced through differ-
ent means. For example, the above-mentioned popular
postcard series typically displayed a Rifleman wearing

24 Monolatii (2007b: 172, 174).
25 Sadovyi (2013: 27). All quotation translations are mine. — O.D.

a *mazepynka*, a traditional Ukrainian military hat that was designed by the Riflemen artists and became one of the symbols of the Ukrainian war.[26] Moreover, Riflemen were shown bidding farewell to young girls and women who wore traditional Ukrainian embroidered attire (see Fig. 2). The Riflemen farewell scenes were also typically set in an idyllic Ukrainian rural landscape. Whereas the *mazepynka* emphasized Ukrainian military mobilization, the images of a girl in national attire and a scenic Ukrainian village epitomized the Ukrainian "home front", which the soldiers were supposed to defend. However, this nationalization of the imperial war effort was not a uniquely Ukrainian approach. Although they were tailored to their specific national contexts, images of soldiers bidding farewell to their families in an idyllic rural landscape were ubiquitous throughout the Austro-Hungarian Empire.[27] In fact, many national propaganda movements used transnational mobilization practices to pursue national agendas and forge national armies.

Forging a Modern Army: Heroic Manhood and Womanhood

Over the course of the war, the mythologization of the Ukrainian war in the visual arts was elevated to a new level. Particularly, Riflemen war portraits further expanded nationalistic visual modes of the mobilization campaign. By creating a large body of portraits, artists greatly contributed to establishing a national pantheon of war heroes. Perceived as depicting the core of the future Ukrainian independent state, the Riflemen portraits had to raise national spirits. Hence, the glorification of the Riflemen units became one of the major tasks assigned to the artists,[28] and the creation of this heroic imagery was supported and promoted by the Riflemen Press Bureau. In particular, artists were encouraged to create portraits of individual soldiers and, thereby, contribute to the creation of a collective heroic image of the Riflemen.

26 Hnatkevych (2011: 127).
27 See, for instance, similarities in Hungarian propaganda postcards: Stirton (2013: 186).
28 Rozhak-Lytvynenko (2017: 99).

As a result, most of the artists had several Riflemen portraits in their oeuvre.

Although a few Riflemen artists painted some Riflemen portraits, it was Osyp Kurylas (Fig. 3) who created the most iconic ones. He was, indeed, a lucky find for the Press Bureau. Unlike most of the Riflemen artists, who had just begun their careers, Kurylas was already an experienced painter. Moreover, he was known for his portraits of Ukrainian historical figures, writers, and artists.[29] His interest in the heroization of Ukrainian history and its leaders made Kurylas an excellent fit for the Press Bureau. Hence, when he was conscripted in 1916, the Press Bureau commissioned him to the Riflemen Reserve Unit (*Kish*), where he was assigned to compose a series of Riflemen portraits.[30] His most productive period coincided with a time of relative stability in the Riflemen combat zone in 1916. Remaining in the second line of defence, Kurylas built a field workshop in the small village of Tudynka (in the Ternopil area) where the Press Bureau and the Riflemen regiment headquarters were located at that time (see Fig. 3).[31] Between 1915 and 1918, he created approximately 200 works, many of which were portraits of Riflemen officers and soldiers.[32]

Composing images of stoic and hardy Riflemen, Kurylas greatly contributed to the formation of the visual imagery of patriotic masculinity. In his portraits, the Riflemen radiated confidence and resilience. For instance, his iconic portrait of the legion's officer, Sen' Horuk, served as a visual role model for the Rifleman masculine ideal (1916; Fig. 4). Horuk's military career made him an excellent candidate for heroization. Praised for his leadership during the major Riflemen battles at Makivka and Lysonia, Horuk came to symbolize Riflemen courage and stoicism during the war.[33] Indeed, within the Riflemen community, he was perceived as "courageous, cold-blooded, prudent and […] chivalric".[34] His strong physique, angular masculine face, and confident gaze also made him

29 Rozhak-Lytvynenko (2017: 105).
30 Hnatkevych (2011: 126).
31 Hnatkevych (2011: 126).
32 Lazarovych (2005: 238).
33 Ripets'kyi (1995: 323).
34 Dzikovs'kyi (1967: 235–236).

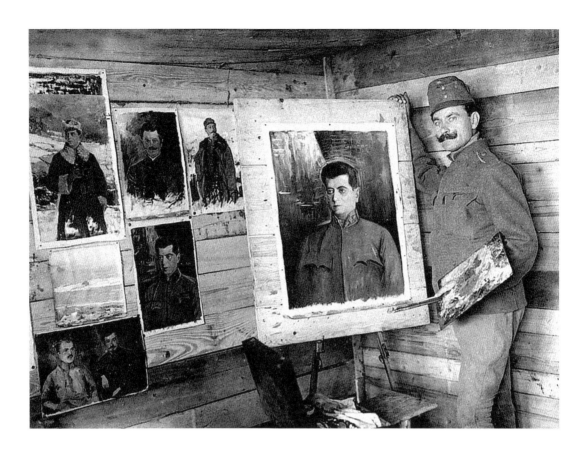

Fig. 3

Photograph of Osyp Kurylas
in Tudynka, 1916

an excellent example of the Riflemen's military power. In Kurylas's portrait, Horuk imposes even more assertiveness and authority than he did in real life. By situating his model in a harsh winter landscape, Kurylas reinforces Horuk's heroic stance. Alluding to the challenging but also formative Riflemen wartime experience of the 1914–1915 winter campaigns in the Carpathian Mountains, the winter landscape in Kurylas' portrait enables Horuk to epitomize the collective Riflemen military-heroic masculinity. Although overidealized, images of resilient Riflemen created powerful narratives that empowered many of the collective. The portraits provided models of patriotic manhood that validated soldiers' wartime experiences. Moreover, because they were widely distributed in the press and as postcards, the portraits communicated the emergence of a valorous modern Ukrainian Army.

Whilst the Riflemen war effort was typically represented by heroic images of male soldiers, there were also some representations of Riflewomen. The fact that several dozens of female combatants, including a few in

Fig. 4

Osyp Kurylas, *Portrait of Sen'
Horuk*, 1916. Andrey Sheptytsky
National Museum in Lviv

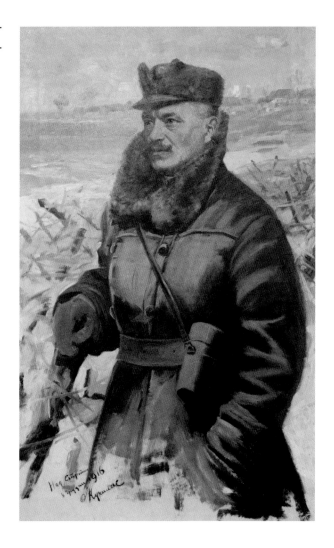

officer ranks, were in active service appealed to those
creating Riflemen propaganda. "Female-in-arms" image-
ry was widely exploited by propaganda units. Moreover,
the idea of both men and women standing shoulder to
shoulder to build an independent Ukrainian state accu-
mulated tremendous symbolic power. Whereas many
Riflewomen were integrated into the Riflemen heroic
pantheon, only certain types of women permeated the
propaganda campaign. Specifically, it was the brave and
independent yet feminine and tender woman who em-
bodied women's participation in the war effort. In com-
parison, women who were not feminine enough, such
as those with more masculine traits, were peripheral
in the propaganda campaign.

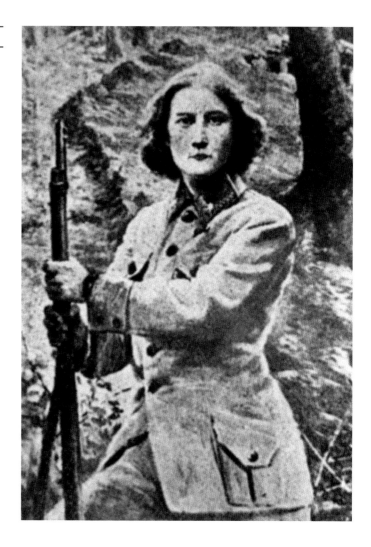

In particular, officer Olena Stepaniv became the female embodiment of the Ukrainian war effort. Actively engaged in the pre-war paramilitary movement in Galicia, she became known for her eagerness to volunteer in Riflemen units.[35] Stepaniv proved herself in combat, became a decorated soldier, and was promoted to the rank of officer. By the time she was captured by the Russian Army during the campaign in the Carpathian Mountains in 1915, she was widely known not only within the Ukrainian community but also internationally. She attracted the attention of the European press for being one of the few female officers in the Austrian Army, and

35 TsDIAL [Central State Historical Archive in Lviv] (fund 359, inv. 1, file 74).

her media popularity made her one of the most recognizable Ukrainian combatants.[36] Stepaniv was determined and courageous, but more importantly, she was young, feminine, and beautiful. In one of his portraits, Kurylas created an idealized heroic image of Stepaniv as a strong and energetic female soldier (Fig. 5). Dressed in uniform and firmly holding a rifle with both hands, Stepaniv projects a focused and self-assured gaze that radiates confidence and determination. However, Stepaniv's heroic image differs radically from those of her male counterparts (see Figs. 4 and 5). In particular, Kurylas still portrays her as predominantly feminine. For example, her frizzy hair frames her head, and her military uniform emphasises her feminine traits. By emphasizing the feminine qualities of the Riflewomen, the artists visualized the Riflewomen's heroism as different from that of Riflemen. Female heroic portraits were pointedly feminine. Moreover, female portraits were far less common than male heroic images. Never intended to mobilize women for active combat, portraits of Riflewomen instead emphasized the Riflewomen's involvement in the war as exceptional cases of female courage.

Depicting Warfare: Between Traditional and Modern Aesthetics

Similar to works created by artists in other belligerent countries, depictions of battlefields were one of the dominant topics in Riflemen art. Mirroring the conflicting wartime lived experiences themselves, Riflemen war art developed contested representations of the war. For the Riflemen, the war was a noble undertaking aimed at fulfilling the dream of an independent Ukrainian state. As the war began, however, the Riflemen had to reconcile their idealistic perceptions of a heroic war with the coldly mundane act of killing. Riflemen art represented this paradox of the Riflemen war experience: still perceiving the war as a heroic endeavour worth dying for, the Riflemen artists struggled to find a new language in which they could also accommodate the horrors of the war. Thus, Riflemen art became a space in which the idea of a noble

36 "Woman…" (1915: 2); Mol'nar (1967: 187).

Fig. 6

Photograph of Ivan Ivanets',
c. 1918

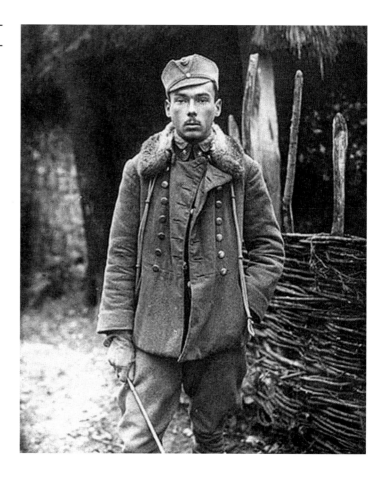

war for national independence coexisted with the sorrow
and pity of soldiers' gruesome lived experiences.

Ivan Ivanets' (Fig. 6), one of the most important Ri-
flemen battle artists, embodied this hybrid character
of Riflemen art. His wartime paintings were still highly
influenced by traditional battle painting; however, they
radically departed from realism and Romanticism and
instead exemplified Impressionism and Expressionism.[37]
Interested in battle painting before the war, Ivanets' de-
veloped as an artist within the Polish classical tradition
of battle painting, studying in a private school led by
Stanisław Batowski-Kaczor in Lviv.[38] His initial fascina-
tion with battle painting continued well into the war,
turning him into one of the most significant and produc-
tive war artists. Close-ups of cavalry skirmishes became

37 Rozhak-Lytvynenko (2017: 69–70).
38 Rozhak-Lytvynenko (2017: 49); Ivanets' (1914: 10–11).

Fig. 7

Ivan Ivanets', *Skirmish*,
c. 1915–1918. Private collection

one of the dominant themes of Ivanets'' wartime art
(Figs. 7 and 8). In his works, vertical cavalry fights show-
cased conventional images of a noble war, which satu-
rated classical battle painting. However, he transcended
boundaries of traditional depictions of warfare.

Over the course of the war, Ivanets' diverged from re-
alistic forms and progressed toward Impressionism and
Expressionism. He believed that Expressionistic angst re-
vealed the dehumanizing nature of the current warfare.[39]
Even though his drawings reflect his fascination with
classic battle painting, his works were stripped of typical
romantic grandiloquence and pomposity. Reflecting on
the nature of WWI art in later years, he noted that: "The
war [was] deprived of its panoramic character [...] the bat-
tlefield lost its plastic and picturesque character."[40] Avoid-
ing traditional, grandiose, multifigured compositions with
clearly defined national heroes, Ivanets' instead immersed

39 Ivanets' (1936a: 1–2).
40 Ivanets' (1936a: 1–2).

Fig. 8

Ivan Ivanets', *Fight*, 1920s.
Private collection

soldiers in intimate face-to-face battles.[41] Moreover, he deindividualized battles, divesting soldiers of their personal traits.

The theme of the deindividualization and dehumanization of warfare aimed to examine the new industrial war. For instance, Ivanets'' works on the gruelling winter campaign in the Carpathian Mountains portray the Riflemen experience of attritional position warfare in 1914–1915. Whereas mud, trenches, and landscapes devastated by artillery fire became one of the iconic representations of the Western Front, it was harsh winter conditions and mountain warfare that were central to the war on the Eastern Front. The images of caravans of emasculated soldiers in his paintings, ravaged by snowstorms and artillery attacks in shell-scarred landscapes provided a radically new

41 For instance, Ivanets'' *Fight* (*Bij*, c. 1920s; Fig. 8), *Encounter* (*Sutychka*, c. 1915–1918), *Assault on Lieutenant Peresada's Battery* (*Naskok poruchyka Peresady na bateriyu*, c. 1914–1920s) works exemplified Ivanets'' battle painting. Rozhak-Lytvynenko (2015: 93–96).

perspective on "what should have been" a heroic war.[42] Indeed, experiencing the war as a soldier in active service, Ivanets' could not limit his portrayal of the war to sterile heroic combat. Exemplified in *In a Typhus March* (*Pokhid u tyfi*, c. 1919–1920s), *In a March to Bershad* (*V pochodi na Bershad*, c. 1920s), and *March* (*Pokhid*, 1919), imagery illustrating the fatigue and futility of the war paved the way for the development of a new visual language.[43] By blurring boundaries between Impressionism and Expressionism, Ivanets" war art emphasized the impersonal and chaotic nature of the industrial war. In doing so, it allowed him to bring a new modern aesthetic to Riflemen war art while still combining traditional tropes.[44]

Cartoons and Caricatures: Forging the Riflemen Intimate Community

Cartoons and caricatures were, perhaps, one of the most intimate forms of Riflemen art. Whereas most war art was created with a wider Ukrainian audience in mind, satirical illustrations primarily targeted the Riflemen community. Disseminated primarily in major self-published frontline newspapers, such as *Samokhotnyk* [Volunteer, 1915–1918], *Bomba* [Bomb, c. 1916], *Samopal* [Machine-gun, 1916], and *Ususu* [For a Rifleman, 1917], the Riflemen cartoons largely depicted inside jokes and stories that were virtually incomprehensible to outsiders.[45] Furthermore, unlike other forms of Riflemen war art, the humorous illustrations created space for comic relief from wartime destruction.

Almost entirely devoid of violence and the horrors of the wartime experience, the cartoons comforted soldiers with depictions of daily routines and mundane activities. Humorous images of peaceful activities, such as food preparation and daily chores, dominated wartime

42 Ivanets' [image] (1935a: 5).

43 Ivanets' [image] (1935: 4).

44 Importantly, Ivanets" fascination with Expressionism was not unique in Riflemen art. In fact, most Riflemen artists embraced Expressionist language to depict the combat experience. It was actually Osyp Sorochtei who "first consciously switched to Expressionism" in his war art. For further details see: Ivanets' (1935b: 1).

45 Dumin (1936: 324); Ripets'kyi (1995: 140).

Fig. 9

"Zavtra v pidofitsers'kii
kukhni pyrohy" ["There'll
be Pierogies in the Sergeants'
Mess Tomorrow"], 1915, cartoon
from self-published frontline
newspaper *Samokhotnyk* 5 (1915)

cartoons.[46] They illustrated their lived experiences but also elevated them to a new level. Specifically, depicting domestic spaces of safety and comfort in soldiers' routine, the Riflemen caricatures normalized wartime life. Many newspaper cartoons also featured reenactments of domestic chores in which male soldiers performed activities that were usually considered female responsibilities (Fig. 9). Presenting Riflemen in atypical masculine roles, the cartoons exposed soldiers' vulnerability and simultaneously revealed the importance of intimate wartime bonding.[47] Furthermore, situated in a humorous context, the cartoons legitimized intimate male interactions.

46 For example, in the cartoon: "Zavtra v pidofitsers'kii kukhni pyrohy" ["There'll be Pierogies in the Sergeants' Mess Tomorrow"]. *Zavtra* (1915: 4).

47 For more on male bonding and the domestication of wartime life, see: Bourke (1996: 126–128, 133).

Fig. 10

"Zhertva kholery v Kamintsi"
["Cholera Victim in Kaminka"],
1915, cartoon from self-
published frontline newspaper
Samokhotnyk 4 (1915)

By turning soldiers' attention away from wartime brutal-
ity, kitchen life became one of the most popular themes
of Riflemen visual humour.[48]

In addition, because they often condemned the poor
food supply available to soldiers, the cartoons were also
a means of both mocking and praising the crafty and
witty soldiers who were able to acquire food in the most
challenging circumstances.[49] Among the clever Riflemen
characters who attracted the caricaturists' attention,
Teodor Mrochko was the most popular. Mrochko was
a founder of the Riflemen shop and canteen.[50] Filling

48 Kurylas [caricature] (1917: 13).
49 Savchuk (2007: 161).
50 Mrochko's frequent appearance in soldier newspapers also resulted
 from his active support of artistic activities. For instance, he donated
 the paper on which humorous visual and written stories about him
 were published in the soldiers' newspaper *Samokhotnyk*. Moreover,

single-panel cartoons, soldiers' jokes, poems, and short stories, Mrochko's humorous images epitomized wartime entrepreneurship and resourcefulness.[51] In a similar fashion, Mrochko's shop and canteen captivated caricaturists. For example, some of the illustrations show the canteen being guarded by the Riflemen and an angel to emphasize its almost semi-sacred meaning to soldiers (Fig. 10).[52]

Similar to the canteen and shop, soldiers' field kitchens were featured in many satirical illustrations. Cartoons even illustrated how the topic of the kitchen triggered arguments between the Riflemen command and soldiers. For instance, in *Bomba's* cartoon *The Triumphal Return from the Battle of Vyshenka* (*Triumfal'nyi v'izd po pobidi pid Vyshenkoiu Maloiu*, a field kitchen — an object of admiration and envy — becomes the main trigger for a *battle*.[53] The cartoon was a sarcastic response to the command's communication that soldiers would fight only for a kitchen. Although the cartoon conveys that soldiers were dissatisfied with how the command perceived the soldiers' priorities, it also reveals that field kitchens were critical spaces for social bonding.

Overall, showcasing the Riflemen's everyday life, the cartoons not only reflected soldiers' experiences but also extended their lived experiences into the symbolic space. In doing so, they provided both a sense of belonging and marked the boundaries of the Riflemen community. Although only the Riflemen community could decipher the underlying meaning of the caricatures, the satirical nature of the Riflemen cartoons became popular beyond the soldiers' community. As a result, the caricature of the wry and joyful soldier became one of the most popular representations of the Riflemen. It also went on to become an intrinsic part of the Riflemen legend of the witty, relaxed, and easygoing soldier.[54]

Mrochko's canteen became one of the centers of Riflemen cultural life. Uhryn-Bezhrishnyi (1935-1: 6); Dumin (1936: 324); Lazarovych (2005: 242).

51 *Po zakupy* [Going Shopping] cartoon (1915: 10).

52 The caricature might suggest that the angel represented a guard against the spread of cholera. *Zhertva* [Victim] and *V borot'bi* [In Struggle] cartoons (1915: 5–6).

53 Ivanets' [cartoon] (1936b: 9).

54 Ripets'kyi (1995: 140).

The Fallen Soldiers: Heroization of Unheroic Death

Due to its enormous cruelty, violence, and destruction, the war was a traumatic event. It had never, however, been a meaningless endeavour for the Ukrainian community. Although short lived, the two independent Ukrainian states that emerged from the war served as a justification for the wartime sacrifice.[55] Therefore, even though wartime death was predominantly inglorious, the dead and fallen soldiers were sacralized as national martyrs. Yet due to the use of mass, and predominantly anonymous, industrial killing methods during the war, a commemoration of individual soldiers was hardly possible on a larger scale. War art adapted to this new nature of warfare and, therefore, transfigured the visual language of mourning the fallen. As Jay Winter notes: "As war has changed, so has its artistic configuration."[56] As a result, images of unknown Riflemen became the predominant trope in visual narratives of the fallen.

Developing into the new wartime heroes, unknown rank-and-file soldiers replaced generals or military commanders, who had previously dominated heroic wartime representations. Particularly, images of dead bodies of unknown Riflemen framed imagery of the Ukrainian wartime sacrifice. Artists also frequently depicted dead bodies near unknown Riflemen graves. For instance,

55 On the eve of WWI, the territories of present-day Ukraine were divided between two empires: most Ukrainian territories were part of the Russian Empire whereas a smaller, Western portion was part of Austria-Hungary. After the 1917 February Revolution in the Russian Empire, the newly formed Ukrainian government — the Central Council — announced the creation of the Ukrainian People's Republic (UNR) in November 1918. This was followed by a declaration of independence on January 22, 1919. Simultaneously, Ukrainians in Austria-Hungary seized power in Lviv and proclaimed the creation of the Western Ukrainian People's Republic (ZUNR) on November 1, 1918. The two Ukrainian republics — the UNR and ZUNR — officially united on January 22, 1919. The creation of the Ukrainian states was accompanied by multiple civil wars and military conflicts that resulted from the collapse of the Russian and Austro-Hungarian Empires. Thus, Ukrainian territories were flooded by Ukrainian, Polish, Bolshevik, White, Green (peasant), and Entente Armies, each of which pursued their own interests. After a series of military defeats, Ukrainian territories were incorporated into four states: the Soviet Union, Romania, and newly formed Poland and Czechoslovakia.
56 Winter (2017: 11).

1914 – 1915

Fig. 11

Olena Kul'chyts'ka,
The Unknown Rifleman
(also known as *The Fallen
Rifleman*), 1915, from
Olena Kul'chyts'ka,
woodcut series *Ukrains'ki
sichovi stril'tsi* (1915)

by illustrating buried and fallen soldiers together, Kul'chyts'ka's *The Unknown Riflemen* (*Nevidomyi strilets'*, 1915; Fig. 11) and Kurylas' *The Dead Rifleman Near the Cross* (*Unknown Rifleman*) (*Vbytyi strilets' bilya chresta* (*Neznanyi strilets'*), c. 1915–1916; Fig. 12) embody the continuous struggle and perseverance that defined the Riflemen's self-sacrifice. Moreover, art depicting soldiers laying down next to their peers' graves created a powerful image of the camaraderie and strong social bonds between soldiers that endured even after death. At the same time, the anonymity of soldiers further elevated the universal spiritual unity of the Riflemen community. Representations of ordinary soldiers also provided a new egalitarian mode for the heroization of wartime death. Set in desolate landscapes on the Eastern Front, the nearly invisible bodies of dead soldiers epitomized the transformation of ideas about wartime heroism. Specifically, a readiness to humbly sacrifice his life for the national cause became a distinctive feature of the new unheroically heroic wartime hero.

Fig. 12

Osyp Kurylas, *The Dead Rifleman Near the Cross* (also known as *Unknown Rifleman*), c. 1915–1916. Andrey Sheptytsky National Museum in Lviv

Although dead soldiers dominated Ukrainian war art, the bodies themselves never became primary objects of the artistic gaze. Indeed, decomposed or mutilated bodies were virtually absent in the Riflemen's bodies of work. Instead, different variations of a fallen soldier's tomb were the most common tropes of wartime visual narratives of the fallen. The majority of war artists, including Olena Kul'chyts'ka, Lev Hets, Ivan Ivanets', and Osyp Kurylas, created a few works of wartime graves (see Figs. 11, 12 and 13).[57] Although they used different artistic techniques, a significant portion of their works showcased the same visual narrative: images of hand-crafted wooden crosses protruding from isolated graves and set in dystopic landscapes. Similar to the unknown soldiers, the graves emphasized the anonymous nature of warfare and deindividualized wartime sacrifice. Indeed, the graves depicted were rarely marked by tombstones with the soldiers' names. Strewn across the battlefield

57 Rozhak-Lytvynenko [images] (2017: 256, 293/image A.2.66, 294/image A.2.67, 348).

NATIONALISM AND COSMOPOLITANISM IN THE AVANT-GARDE AND MODERNISM
The Impact of the First World War

Fig. 13

Olena Kul'chyts'ka, *Life Wins*
(also known as *After the
War* and *Birch Cross*), 1915.
Andrey Sheptytsky National
Museum in Lviv

haphazardly, the real graves of soldiers were not often
visited by mourners. Nevertheless, omnipresent in the
Riflemen's artistic works, images of graves created a sym-
bolic space in which the soldiers' deaths could be both
glorified and mourned.

Legacy and Aftermath

The Ukrainian Riflemen artists created a powerful visual narrative of the world war as a Ukrainian war that continues to shape Ukrainian memory of WWI to this day. Inspired by the Ukrainian national project and eager to contribute to the formation of modern Ukrainian military units, the artists volunteered both their bodies and professional skills to the war effort. Drafted to active service themselves, the artists also created a romanticized image of the Ukrainian war effort that encouraged many young men to conscript. Reinforcing the Ukrainian nature of the war, the visual narratives of mass-distributed propaganda conveyed a message about young, vigorous soldiers who were departing for a noble endeavour. However, these visual narratives did not frame the war only as a nationally meaningful cause; they also portrayed it as an adventurous endeavour. The idea of a purposeful and romanticized war resonated with many young Ukrainians, fuelling conscription rates.

The Riflemen artists, however, were not passive reproducers of Ukrainian national discourse. Instead, they actively forged a new visual language of the Ukrainian wartime experience. In a practical sense, they institutionalized their work during the war by establishing the *Artistic Handful*. Operating with the propagandistic Press Bureau, the Handful promoted the Riflemen's deeds through their art. The emergence of a designated art institution allowed the artists to create a massive body of work that rendered war experiences along national lines. Symbolically conquering wartime reality with their paintbrushes, they created a focused image of a national war in which not only people but also spaces and daily practices were Ukrainized.

The visual narrative of the Ukrainian war combined both traditional and modern artistic languages. The hybrid nature of traditional and modern industrial warfare invoked the fusion of artistic approaches. On the one hand, the classical tradition still remained powerful in constructing the heroic Riflemen mythology. For example, Osyp Kurylas' series of Riflemen portraits affirms the continuing significance of traditional approaches for constructing imagery of a stoic and committed Ukrainian Army. Moreover, using the traditional language of battle painting, the artists continued to visualize the war in

heroic terms. However, the war was also chaotic, unexpected, and violent. To embrace the nature of these new war experiences, the artists appropriated the languages of Expressionism and Impressionism. As a result, the new wartime heroism was stripped from the pompous glory intrinsic to classical war art. For example, by transfiguring classical battle painting through the lens of Expressionism, Ivan Ivanets" battle paintings can be seen as a link between traditional and modern approaches.

Finally, the artistic imagery of dead and fallen soldiers had arguably the most enduring impact for constructing post-war narratives of WWI. The images of young fallen Riflemen contributed to the nationalistic drive. Strong and powerful, post-war radical Ukrainian nationalism recycled images of the Riflemen soldiers into an influential message for a new mobilization of the Ukrainian national community.[58] Moreover, it was during the interwar period and WWII that the Organization of Ukrainian Nationalists (*Orhanizatsiia ukrains'kykh natsionalistiv* [OUN]) radicalized the Riflemen legend, further emphasizing the Riflemen's patriotic sacrifice. By blending images of the Riflemen and the WWII Ukrainian Insurgent Army soldiers, the Ukrainian nationalists amalgamated the experiences of two world wars into one powerful legend about the continuous war for Ukrainian independence.

— — —

The Riflemen artists not only contributed to developing visual imagery of the Ukrainian war effort, but their art also manifested the transformation of visual languages in Ukrainian art. Hence, although traditional and modern art forms coexisted during the war, the war significantly advanced the proliferation of Impressionism and Expressionism in Ukrainian art. As a result, these art forms became the dominant styles in Ukrainian art in Poland during the interwar period. In particular, some Riflemen artists joined the art school of the most renowned Ukrainian painter of the time, Oleksa Novakivs'kyi, where they experimented with modern art forms after the war.

58 See, for instance: visual propaganda created by the Organization of the Ukrainian Nationalists, Myzak (2015).

Riflemen Art
Visualizing the Ukrainian War

For instance, Osyp Kyrylas, Novakivs'kyi's old friend from the Cracow Academy of Fine Arts (*Akademia Sztuk Pięknych w Krakowie*), became the deputy director of the school. At the same time, two other Riflemen painters, Ivan Ivanets' and Lev Hets, continued their education there. The school became the center of Ukrainian Post-impressionism and Expressionism art in interwar Poland. Superseding traditional battle painting, Expressionism also became a dominant genre of battle painting during the interwar period. As art critic Vasyl Khmuryi points out, "Expressionism became the sole style of battle painting in the 20th century."[59]

Although the Riflemen artists tried to promote their art after the war, their work was never fully integrated into the Ukrainian art canon. Instead, it remained a local Galician phenomenon. During the interwar period, when Eastern Galicia was incorporated into a newly emerged Polish state, Riflemen art enjoyed limited interest and never transcended the boundaries of the Ukrainian community in Poland. Moreover, local attempts to promote Riflemen art through the establishment of a museum of Ukrainian war art never came to fruition.[60] Riflemen art was also overshadowed by Ukrainian art in Soviet Ukraine, to which the majority of the Ukrainian territories were incorporated.

With the establishment of Soviet power over Galicia after WWII, Riflemen art was labelled as "bourgeois" and "nationalistic" and further stigmatized. Although the majority of Riflemen artists were not persecuted by Soviet authorities,[61] some aspects of their artistic legacy — especially those considered nationalistic — were silenced whereas others were adjusted to fit the dominant Socialist Realism style. As a result, works that represented ethnographic Ukrainian culture became widely commemorated, but the Riflemen's wartime artwork was virtually excluded from art history.[62] Moreover, recognizing

59 Khmuryi (1931: 28).

60 Ivanets' (1935b: 1).

61 For instance, Osyp Kurylas and Olena Kul'chyts'ka continued their work well into the Soviet period.

62 See, for instance: Popov (1983).

that their art would be labelled as nationalistic, some artists censored themselves by hiding their "war work".[63]

In 1952, a large portion of Riflemen war art, which was located in Andrey Sheptytsky National Museum in Lviv (*Natsional'nyi muzei u Lvovi imeni Andreia Sheptytskogo*), was destroyed by Soviet authorities as part of the anti-bourgeois campaign.[64] The campaign was part of a larger assault on the Ukrainian nationalistic movement that remained powerful in Western Ukraine well after WWII. Over the course of the campaign, officials targeted artwork that directly or indirectly promoted the Ukrainian nationalistic movement. Many works of art were even burned right on the spot in the museum stoves. Although there are official lists of artworks that were predesignated for destruction, it remains unclear how many works were obliterated during this full-fledged campaign against Riflemen art.

Whereas Riflemen art was denied public exposure in Soviet Ukraine, the Ukrainian diaspora in North America, which skyrocketed after WWII, became the only audience of Riflemen art. Even in this case, however, Riflemen art attracted attention primarily because it illustrated the Ukrainian struggle for independence. Its artistic value, in comparison, was not widely recognized. When Ukraine gained independence in 1991, there was some revival of interest in Riflemen art. Nonetheless, war art continues to receive relatively little attention in Ukrainian art history. Riflemen art therefore remains a regional curiosity that has yet to be incorporated into the general history of Ukrainian art.

63 Zalizniak (without date).
64 Hakh (2012: 157–158).

Riflemen Art
Visualizing the Ukrainian War

War as Psychological, Social and Intellectual Experience

The Concept of "National Art" and the First World War in Hungary. Lajos Fülep and the Dynamics of "National" and "International"

Éva Forgács
Art Center College of Design. Pasadena, United States of America

Abstract

Before the First World War, Hungary had a thriving cosmopolitan culture as well as an internationalist group of artists. Prior to the war Hungarian artists considered art no more national than mathematics: they travelled to study and live in Paris or Munich, but always returned to their native country that they perceived, at least as far as culture was concerned, no less European than any other part of the continent.

The war introduced another voice to public discourse, that of the socialist avant-garde. The independent art critic and theorist Lajos Fülep, once associated with the liberal intellectuals and a participant in their Free School of Humanistic Studies (1917–1918), made a solitary effort to spell out the dynamics of the concepts of "national" and "international" art. Fülep and his more internationally renowned colleague Georg Lukács, published a journal of aesthetics together, A szellem [The Spirit, 1911], a forum for art and literary theory, regardless of where the works in question originated.

The war experience was portrayed as both psychological shock and social catastophe in the artists' written and painted works. Cosmopolitan became a pejorative word after the war, expressing the opposite of national pride. The liberals vanished from Hungary, resulting in a great drain of Hungarian culture. The socialist avant-garde also emigrated, although its leading figures returned after the 1926 general amnesty. Fülep withdrew from public life and worked as a protestant priest in a small village, while studying the history of the arts with regard to the dialectical interconnection of national and international features. His studies prompted him to examine several questions: what exactly makes art national? What can be the particular, unique contribution of a nation to the art of humankind? Are there specific forms, styles, or contents that characteristically distinguish Hungarian art from all other arts? Is the national feature folkloric or historic, or something beyond all that? Fülep saw form as the national component of art and found that "contents" — if the two may be separated — are common, regardless of where art originates from. He also hoped that the war, destructive as it had been, would open new ways of thinking and new opportunities for previously marginal cultures like Hungary's.

Key words

national art, Lajos Fülep, Georg Lukács, Lajos Kassák, national, international

War as Psychological, Social and Intellectual Experience
The Concept of "National Art" and the First World War in Hungary.
Lajos Fülep and the Dynamics of "National" and "International"

The First World War and its Immediate Aftermath in Hungary

The events of the First World War and its immediate results for Hungary — the disintegration of the Austro-Hungarian Empire and the Versailles peace treaty that truncated Hungary to a third of her former territory — generated three different cultural responses in Hungary among progressive thinkers and artists. More exactly, the experience of the war and its ramifications functioned as catalysts to articulate and deepen the differences between various interpretations of the historical facts. In the wake of the war a revolution inspired by returning soldiers led to the declaration of the Republic in October 1918. This evolved into a quasi-socialist takeover headed by Count Mihály Károlyi, who ceded power to communists on March 21, 1919, whereupon communist leader Béla Kun established the short lived Hungarian Soviet Republic.[1] These events shaped the fate and the views, outlooks, artistic and art historical activities of various sociologically and culturally disparate groups of artists and intellectuals in Hungarian society.

The best established among these social groups in pre-WWI Budapest was the European-oriented liberal intellectuals, while the most radical group, both ideologically and aesthetically, was the emerging socialist avant-garde. The third consisted of a solitary figure who, having learned the lesson of "national" versus "international",[2] attempted to achieve an elevated vantage point and construct an independent, purely cultural theory that would supersede both, pointing out their dialectical relationship.

Of the circle of liberal thinkers, the most progressive at the time was headed by Georg Lukács and included

1 The official name of the political formation usually referred to as the "Hungarian Commune" was *Magyar Tanácsköztársaság* [Hungarian Republic of Councils], where the word "Council" came from its Russian equivalent: "Soviet". This is even more significant for the fact that its leaders, Béla Kun and Tibor Szamuely, served in WWI and became POWs in Russia, where they converted to Communism and joined the Red Army, fighting in it in the Russian Civil War. They became personally acquainted with Lenin and other Bolshevik leaders.

2 Lajos Fülep's "Európai művészet és magyar művészet" ["European Art and Hungarian Art"] was originally a talk that he gave in 1916 at the *Szellemi Tudományok Szabad Iskolája* [Free School of Humanistic Studies] in Budapest. Published in: Fülep (1971: 22).

NATIONALISM AND COSMOPOLITANISM IN THE AVANT-GARDE AND MODERNISM
The Impact of the First World War

a number of artists such as the poet, writer, and essayist Béla Balázs, textile designer-artist and writer Anna Lesznai, composers Béla Bartók and Zoltán Kodály, and, occasionally, painter József Nemes Lampérth. Lukács was vocal in supporting the nascent modern art group *The Seekers* (*Keresők*) later renamed *The Eight* (*Nyolcak*), 1909–1918, that included Neo-Impressionist, Fauve, Expressionist, and early Neoclassicist painters. Since the ideas and activities of these intellectuals have been thoroughly described in excellent publications in English,[3] it is suffice here to underline that they entirely disappeared from Hungary in the wake of the Commune. Some of them turned communist like Georg Lukács, or socialist like Arnold Hauser; some remained left-wing liberal and joined such international forums as the *Bauhaus* like László Moholy-Nagy. All, however, including their scientist friends, disappeared from Hungary in 1919–1920, fleeing from a conservative-nationalist political power that hunted down activists and even sympathizers of the Commune. This hastened emigration, which was, if indirectly, the consequence of the war, marking the end of cosmopolitan liberalism in Hungary for many decades. The right-wing political regime that followed the defeat of the Commune in August 1919 caused a "collateral damage" of the war unique in Europe: the loss of an entire generation of thinkers, scientists and artists,[4] most of whom never returned to Hungary, inducing a never-healed break in the country's cultural history.

The activist avant-garde movement led by the socialist Lajos Kassák was younger, more emotional, and harsher in tone. Launched in 1915 it was, to a great extent, both a response to the war and a result of its provocation. Outrage, compassion, and the socio-anarchist political views that Kassák had learned from fellow social democrats, drove him to follow the example of Franz Pfemfert's internationalist anti-war Berlin circle and journal *Die Aktion* (1911–1932). This influence and kinship manifested itself in the title of Kassák's first periodical, *A Tett* (1915–1916), Hungarian for "Action". Unlike the liberal intellectuals who came from the upper middle-class and

3 See, for example: Gluck (1985); Congdon (1991).
4 For details, see: Frank (2009).

War as Psychological, Social and Intellectual Experience
The Concept of "National Art" and the First World War in Hungary.
Lajos Fülep and the Dynamics of "National" and "International"

were highly educated, Kassák and his group were recruited from the proletariat. They represented the suffering crowds whose pain they undertook to express. Kassák and his group had a strong anti-war stance and expressed their radical views in intensely politicized literary and artistic works. They gave voice to the poor in dramatic, dark, powerful visual and poetic language. This group also had to emigrate after the defeat of the Commune, but they returned to Hungary from the Vienna exile after the general amnesty of 1926.

The leading figures of the two trends, Lukács and Kassák, found each other mutually unacceptable. Following his 1918 conversion to communism, Lukács did not believe in non-communist left-wing activism and dismissed Kassák's poetic endeavors as crude and half-baked, a far cry from his erudite literary heroes. Kassák, meanwhile, thought of Lukács as bourgeois, detached from the masses and the social reality on the ground. However, they shared more than they might have believed: both rejected nationalism and its rampant, raging tidal waves in the war, and both believed in an ideal world of social equality.

Distanced from both viewpoints, yet formerly associated with the cosmopolitan Budapest intellectuals, was art critic and theorist Lajos Fülep who, never tempted by left-wing political concepts, retired to a village in south-west Hungary after the defeat of the Commune. Working as a protestant clergyman, he continued to make attempts to fathom the notions of "nation" and the "community of nations". Most of all he was interested in the dynamics of these interrelated concepts. Fülep set the goal to theorize the meaning of the concept of "national art" at a time — in 1916, in the middle of WWI — when both the terms "cosmopolitan" and "international" became, as in each country at war, derogatory terms in Hungary, and judgment in aesthetic and every other question was subject to identifying with Austria-Hungary's war effort. Prior to the war, progressive Hungarian artists and art writers did not think that art could be any more national than mathematics. They had travelled all over Europe, studied in Paris, Munich, Heidelberg, and Florence respectively — Fülep himself lived in Paris from 1904 to 1906, then in Florence until 1912 — and they always returned to a Hungary that they perceived, at least as far as her

culture was concerned, not less European than any other part of the continent.

Considering the impact of WWI, and the beliefs and emotions it generated in artists — those beliefs and emotions which coagulated over time into political views — I would like to briefly present two case studies as examples of the psychological experience of the war on one hand, and the emotional-turned-sociopolitical experience on the other.

The War as Cathartic Experience

The painter József Nemes Lampérth[5] was a natural talent who gained entry into the group of progressive painters in 1911. He spent time in Paris in 1913–1914, but at the outbreak of war had to return to Hungary. He was conscripted and fought at the Eastern Front. Wounded and discharged, he returned to Budapest and occasionally joined the so-called *Sunday Circle* (*Sonntagskreis*/*Vasárnapi Kör*) of the liberal Budapest intellectuals (Fig. 1).[6] Nemes Lampérth also got in contact with Kassák and his group, so that Kassák, who recognized his originality and expressive power, organized an exhibition of his works and published reproductions of some of them in his journal. Although he had ties to both important Budapest groups, Nemes Lampérth remained a solitary figure with a particular sensitivity to, and account of, the war experience. In a letter that is now in the collection of the Institute of Art History of the Hungarian Academy of Sciences, dated "July 26, in God's 1915th year at the Great Galician Front", he described an attack by his unit that resulted in the recapturing of a village from the enemy. This is an unique document examining the psychological experience of the war, and is worth quoting at length:

> The village caught fire after the first artillery attack and lit up the night as if it had been daylight. We started the attack as the moon came up. Our machine guns were rattling away. I can say that it was a miraculous concert, a balm to the nerves. [...] All of a sudden, a mighty "Hurrah!" was shouted on the right wing.

5 For detailed discussion of his life and career, see: Mezei (1984).
6 Karádi/Vezér (1985).

War as Psychological, Social and Intellectual Experience
The Concept of "National Art" and the First World War in Hungary.
Lajos Fülep and the Dynamics of "National" and "International"

Fig. 1

Postcard with some members of the *Vasárnapi Kör* [Sunday Circle] in Budapest, 1917. Petőfi Literary Museum, Budapest

There was something tremendously powerful in that cheer, something majestic, divine! The tremendous energy that is scattered in the individuals who are separated from each other, was all funneled into one fantastic, unbreakable whole and turned into a horrendous strength […]. We all jumped up into the air and were yelling a "Hurrah!" with the force of a hurricane […] and the light was glimmering on the bayonets of our guns and we went straight ahead to attack the Russians. We took a bunch of prisoners and accomplished a wonderful attack. I observed many interesting things there. […] For example, when the big "Hurrah!" was shouted, everyone suddenly changed. Each of them, all of a sudden […]. As if the gods of war and fighting had occupied their souls, and they were all running ahead as if they were drunk, and mesmerized. Fear of death dissipated, they did not care about anything. This was a marvelous thing beyond anything upon this earth, as if again miracles had visited upon us! Among the houses on flames and the smoking ruins we chased the enemy for a long time.[7]

7 József Nemes Lampérth: Letter to János Wilde, July 26, 1915, published in: Forgács (1986: 135–136). Transl. by: É.F.

Fig. 2

József Nemes Lampérth, *Kolzsvár (Cluj)*, 1920. Nancy G. Brinker's collection, USA

As this account of terrible fascination with collective action reveals, the inferno of a battle was a catharsis for Nemes Lampérth and his fellow troopers. Against the nocturnal background of fire and smoke, freely acting out unconscious drives, the painter experienced community with men who were strangers to him, collectively breaking all the taboos they had been raised to respect. Had his candid description not been written in a private, personal letter, it would certainly have touched a nerve with many fellow soldiers who suppressed similar memories. Nemes Lampérth reflected on this experience in some of his later works in which he repeatedly returned to images of houses or constructions in orange, like the flames he had seen that night. Visions of red skies and flame-colored houses haunted him for the rest of his life and appeared in his works (Fig. 2).

War as Psychological, Social and Intellectual Experience
The Concept of "National Art" and the First World War in Hungary.
Lajos Fülep and the Dynamics of "National" and "International"

War as the Burden of the Poor

Béla Uitz, one of Kassák's closest collaborators, was close to the *Die Brücke* Expressionists in conveying personal emotional war experience and outrage elevated to political statements and accusation. His 1916 painting *Recruitment (Sorozás)* reflects on soldiers as objects, bodies to be processed for use in the war effort, similarly to Kirchner's faceless crowd of naked recruits in his 1915 painting *Soldatenbad*. Uitz's blurred rendering of *Soldiers (Katonák)* underlines the anonymity of the fighters as well. Uitz, unlike Nemes Lampérth, used pathos and the compositional patterns of Christian art to express the suffering caused by the war. His 1916 ink drawing *Mourning (Siratás*; Fig. 3), a classic triangular composition representing a couple weeping for their son who was killed in battle, was consistent with the messianic stance of Kassák's circle where Christian, socialist, and anarchist ideas were blended in an outcry against the horrors of the war. Anti-war determination implied anti-nationalism; this led to Kassák's rebellious move to include, in a summer 1915 issue of his journal *A Tett*, reproductions of works made by artists from countries that were Hungary's war enemies. Kassák followed Franz Pfemfert in this but had to pay a bigger price because *A Tett* was immediately banned. Internationalism — that is, recognition of the shared interests of all who were forced to put their lives on the line, crossing national boundaries and witnessing social fault lines instead of national ones — became the core agenda of the Hungarian avant-garde during and after WWI.

In light of the expression of the psychological trauma of the war and the avant-garde's vocal and artistic resistance to it, as well as its commitment to passionately alert the population to the injustice of the war and the unnecessary suffering it brought to all in the interests of war profiteers, the theoretical conclusions concerning the dynamics of nationalism and internationalism drawn by Lajos Fülep were worked out in an ivory tower.

Fig. 3

Béla Uitz, *Siratás* [Mourning],
1916. Museum of Fine Arts,
Budapest

War as Psychological, Social and Intellectual Experience
The Concept of "National Art" and the First World War in Hungary.
Lajos Fülep and the Dynamics of "National" and "International"

Lajos Fülep's Dialectical Approach

Fülep started his career in the early 1910s as a witty, sharp-tongued art critic who mercilessly lampooned conservatism. He ridiculed the establishment's favorite painters, and pointed out why some of the young, unknown artists were the most valuable ones. One of them, Lajos Tihanyi, produced an angular, stylized portrait that accurately characterizes the uncompromising critic (Fig. 4). In 1911 Fülep launched a periodical together with Georg Lukács, *A szellem* [The Spirit, 1911],[8] a theoretical journal aspiring to survey the aesthetic views of their time, but only two issues could be published. As the title of the journal indicated, Lukács and Fülep sought a higher spiritual comprehension of the meaning of art. They engaged in an examination of artistry from an aesthetic viewpoint, anticipating their later position of dismissing the concept of a national art, which gained importance during WWI. It was in 1916, in the middle of the war, that Fülep wrote an essay titled "European Art and Hungarian Art" ("Európai művészet és magyar művészet"), in which he inquired into the theoretical possibility of correlating "the aesthetically absolute and the historically relative."[9] This pair of concepts translated, in his essay, as the correlation between the objective values of the broad, three thousand-year old European art canon and the subjective vision of the young, hundred-year old art of Hungary. He examined how the "community of nations" and the culture created by them through history related to one specific nation's art — if, as he asked, there is indeed such a thing as national art. Like his 18th and 19th century predecessors, he too saw the origins of the history of European art in ancient Greece because he similarly acknowledged a universal, all-inclusive quality in Greek antiquity that he more-or-less identified with the concept of European art. He concurred with the classic view in art history that Western art had originated in Greek antiquity because Greek art had absorbed and mediated the arts of ancient Egypt, Persia, and other Middle Eastern cultures for European posterity. Fülep concluded that Greek antiquity was as national as it was supranational, ideal, and symbolic, while it also embodied the specific ideals

8 See: Gluck (1985: especially 18–20).
9 Fülep (1971: 22).

Fig. 4

Lajos Tihanyi, *Lajos Fülep*, 1915.
Museum of Fine Arts, Budapest

and characteristics of the Greek people.[10] This theory led him to the idea of the primacy of form as the quintessentially national component of art because, he stated, the "contents" are common in the art of all people in all cultures. To construct form that conveys what he called the "national genius" was, he claimed, the mission of every national culture, because form was the vehicle that "transferred national or ethnic-national particularities into the universal."[11]

One has to be reminded, at this point, that the terms "national" and "European" resonated with a particular ring during WWI. While he occasionally used the hyphenated term "ethnic-national", Fülep differentiated between "national" and "ethnic-national" latter being a higher,

10 Fülep (1971: 25).
11 Fülep (1971: 27, 28).

War as Psychological, Social and Intellectual Experience
The Concept of "National Art" and the First World War in Hungary.
Lajos Fülep and the Dynamics of "National" and "International"

more inclusive, and even more idealistic concept uniting and superseding the merely ethnic components. In that restricted sense "national" was, in his usage, a progressive category.

When it came to the concept of "Hungarian art" Fülep pointed out that it was so interconnected with various European currents that it was a valid question whether or not there existed such a thing as "Hungarian art". There was no way, he argued, to demonstrate that there existed a Hungarian art that represented a particular Hungarian reality in the way that 17th century Dutch art represented Holland, and the life of the people of Holland.[12] So he took the question to a higher, abstract level: is there an aesthetic problem that Hungarian art — and only Hungarian art — has revealed? Does Hungarian art have a national character and, if so, does this national character also contain universal features? "Does it have a unique mission in the larger community of Europe — or the World?"[13] He gave a positive answer to this question, referring to architect Ödön Lechner who had developed "folk art into national art"[14] and, more than any other artist, the sculptor Miklós Izsó,[15] whose *Dancing Peasants* (*Táncoló paraszt*; maquettes c. 1865–1870) were, according to Fülep, the true materializations of the Hungarian national genius.[16] The mission of such quintessentially Hungarian art, according to Fülep, serves the enrichment of the common culture of mankind with local, individually national colors.

In Fülep's theoretical ambition it is hard not to see the aspiration to transcend the reality of the war. The war meant the practical impossibility of bridging the gap between nationalism and internationalism; however, by theorizing the dialectical relationship of the national and the international, the particular and the universal, Fülep chose the vantage point of timeless philosophical abstraction, trying, paradoxically, to argue for the accuracy of the timeless viewpoint by pointing out

12 Fülep (1971: 33).
13 Fülep (1971: 33).
14 Fülep (1971: 33); for Lechner's career and works, see: Gerle (2003).
15 For detailed discussion, see: Goda (1993).
16 Fülep (1971: 60–76). An excerpt of this sub-chapter was published in John Bátki's translation in: Benson/Forgács (2002: 71–72).

NATIONALISM AND COSMOPOLITANISM IN THE AVANT-GARDE AND MODERNISM
The Impact of the First World War

the specificity of the times he was living in. "The unwanted suspension of artistic activity caused by the war is an uncanny moment that signals the end of the age that is coming to an end, and the opening of a new age. Perhaps such a moment is a good opportunity for self searching,"[17] he wrote. "The war," he said, "may take us closer to the construction of a new *Weltanschauung*, and may bring us [Hungarians] as a nation a more important role in the universality of European culture. Not the war itself (which is highly negative), but that it dumps a lot of old things and makes room for the new."[18]

It has to be added that he was an optimist. The terms "Hungarian art" and "national art" gained different meanings during the postwar nationalism that followed Fülep's attempts at unbiased thinking. Fülep was sitting out this period of right wing, increasingly xenophobic Hungary in Zengővárkony, a village in south-west Hungary, where he worked as a protestant clergyman. In the 1930s he taught philosophy of art, aesthetics, and Italian literature at the University of nearby Pécs. He returned to Budapest in 1946 and was appointed full professor at Department of Italian Studies at Budapest University, where he became chair of the Department of Art History in 1951. He was inducted to the Hungarian Academy of Sciences and is one of the most respected art historians in Hungary.

17 Fülep (1971: 36).
18 Fülep (1971: 130).

War as Psychological, Social and Intellectual Experience
The Concept of "National Art" and the First World War in Hungary.
Lajos Fülep and the Dynamics of "National" and "International"

Respect and Triumph

Intentions and Meanings of Czech Architecture before and after the First World War

Vendula Hnídková

Institute of Art History, Czech Academy of Sciences. Prague, Czech Republic

Abstract

Architecture always presents a compelling reflection of the social, economic, and political context in which it is created. The architecture of the Czech lands before 1914 and after 1918 vividly manifests an extraordinarily turbulent period of change. Through a number of selected examples, I describe a new approach to the Cubist and National style in architecture, which represent two almost contradictory positions from cosmopolitanism to nationalism.

A fundamental distinction separates pre and post-war Czech architecture, namely the Cubistic and National styles. While the first is determined by a close interaction with the recent Cubist movement in Paris, the latter follows the opposite objective and is programmatically based in the local tradition. The war period might be perceived as a catalyst for this radical shift. I support the theory of a change in the architects' attitude during this time. The examined artistic intentions might be marked by the terms "respect" for historical heritage for the period before 1914 and "triumph" after 1918, based on the founding of Czechoslovakia. Thus the new political situation had a direct impact on architecture, which changed its focus from the international movement to national celebration.

Key words

Czech lands, Czechoslovakia, Cubism, Rondocubism, modern architecture, National style

Respect and Triumph
Intentions and Meanings of Czech Architecture
before and after the First World War

Introduction — Hidden Conflict Cubism and National Style

The First World War as a fundamental historical milestone catalyzed dramatic changes in the development and production process of the proponents of modern Czech architecture. The political development in Central Europe, as well as the personal experiences of modern artists and architects in military service and other extreme situations during the war, caused a radical shift in articulated artistic values. The general tendency in the visual arts, typical of this period, applied too to the Czech lands.[1] During the war in particular, architects altered their vision along an imaginary line from cosmopolitan ambitions to nationally motivated manifestations.

The progressive stream of Czech architecture, formerly labelled Cubism before WWI, and Rondocubism or the National style[2] in the period after the war, connects two leading architects, Pavel Janák and Josef Gočár. This personal continuity contrasts sharply with the discontinuity of the ideological starting points of both artistic styles. During the relatively short period of one decade, the almost contradictory character of these artistic aims, which reflects the political development, seems to be significant for the general development of architecture in the Czech lands.

It is well known from numerous studies that Czech architectural Cubism emerged from several inspirational sources, including the refusal of utilitarian principles by one of the best-known architects and designers of the late Austro-Hungarian Empire, Otto Wagner, who believed in the meaning of modern architecture as the mere fulfilment of purpose, construction, and poetry.[3] Wagner's concept was critically approached by his former student at the Academy of Arts (*Akademie der bildenden Künste*) in Vienna, Pavel Janák, in his essay "Od moderní architektury k architektuře" ["From Modern Architecture to Architecture", 1909–1910], which was considered by his contemporaries to be revolutionary. Regarding Wagner's definition as an obsolete stage of development, he labelled the representatives of this period mere "modern

1 Lahoda (1998: 101–103); Císařovský (1962: 58).
2 Liška/Švestka (1991); von Vegesack (1992); Švácha (2000); Hnídková (2013); Novotný (2013).
3 Wagner (1896).

technicians with taste", whereas the design of real architecture, according to Janák, requires "a creative artist".[4]

This programme diversion from the Viennese center can be interpreted as an important indication of the emancipation of Czech architectural production from foreign influences. Despite that, architectural Cubism is usually accepted as an important cultural phase, when the Czech scene reflected the recent artistic trends predominantly in Paris and represented cosmopolitan ambitions.[5]

When the leading theoretician of Cubist architecture, Pavel Janák, in his already cited essay "Od moderní architektury k architektuře", requested that modern architects become creative artists, the fulfilment of his theoretical demands would ultimately come close to the definition of Cubist architecture as one of the manifestations of *l'art pour l'art*, for which this stylistic expression was also often criticized.[6] However, during the years of WWI, Janák intensively reflected upon the political, social and economic events unfolding, which affected his concept of the scope of an architect.[7]

He moved away from a belief in the individualistic role of the architect as an entirely autonomous creator, and gradually began to integrate into the profession a greater regard for the requirements of the Czech nation. In his later important article "Národní věc a čeští architekti" ["National Issue and Czech Architects"] from 1918, he formulated a new task, namely for architecture to penetrate into the "national life, into the national ideals".[8] Through this lens, Janák then reassessed the importance of local architects at the beginning of the 20th century when he stated that "the Czech modern architect [...] was a ruthless warrior, [and] noncommittal maverick."[9] According to Janák, however, architects faced entirely new requirements after the war. The slogan of the day became the cry that

4 Janák (1909–1910: 105–109). All the translations are by Sean Mark Miller.
5 Lamač (1988: 169–175).
6 Teige (1930: 94).
7 Josef Gočár was a prolific architect but no theoretician. A limited number of his writings are almost exclusively focused on his competition projects.
8 Janák (1918a: 295, 305–306).
9 Janák (1918a: 295, 305–306).

Respect and Triumph
Intentions and Meanings of Czech Architecture
before and after the First World War

"the law of life is greater for us than the law of aesthetics."[10] Janák subsequently identified two central problems in existing architectural production and local residential standards which architects had to address as priorities. Firstly he stated that it would be necessary to resolve the typological arrangement of the dwelling from the "typical Czech room" to the "typical Czech town".[11] Secondly, these practical tasks should be resolved by architects in some kind of idealistic fervour, in permanent enthusiasm for the national issue, which far exceeded superficial practice. The architect was to become a "poet of the home".[12]

Both presented categories of this approach to architectural operations can be separated by a further fundamental characteristic. The contradictory artistic starting points were naturally reflected in different aesthetical forms, but both epochs surprisingly diverge in their relation to local cultural heritage.

It is a certain paradox, yet remains a well-established fact, that one of the characteristic features of pre-war Czech culture is the close interconnection of progressive architects and art historians with the effort to preserve historically significant houses and urban complexes. They followed this objective as members of an influential association called *Klub Za starou Prahu* [Club for Old Prague; still in existence today]. Among other professions, architects formed a focused collective, dating back to its foundation in 1900.[13] The atypical relationship produced a number of unique results in the form of a high quantity of architectural studies and featured buildings. However, when the same architects resolved important building contracts after the war, their approach to cultural heritage brought completely different results. Instead of the original reverence, a surprising retreat from the pre-war concern for the preservation of monuments resulted in favour of drastic interventions into the historical context.

In order to demonstrate this radical change of approach I will use the example of five famous buildings by Janák and Gočár, the central protagonists of both the

10 Janák (1918b: 81–86).
11 Janák (1918b: 81–86).
12 Janák (1918a: 295, 305–306).
13 Pavlík (2000).

NATIONALISM AND COSMOPOLITANISM IN THE AVANT-GARDE AND MODERNISM
The Impact of the First World War

Fig. 1

Dům U Černé Matky Boží
[House at the Black Madonna]
(built 1912) in Prague by
Josef Gočár

Cubist and National styles. Whilst not a universally valid
principle applicable to any building of the given styles,
relationship to the urban context and preservation values
still reveals a fundamental shift in the thinking of archi-
tects before and after WWI. To illustrate this problem
one should consider the history of construction of the
most representative buildings of both periods and their
typical features.

Respect and Triumph
Intentions and Meanings of Czech Architecture
before and after the First World War

Fig. 2

The main square in
Pelhřimov with *Fárův dům*
[Fára House] (built 1913–1914)
by **Pavel Janák**

One of the most characteristic pre-war architectonic
monuments of Prague, *Dům U Černé Matky Boží* [House
at the Black Madonna] by Josef Gočár from 1912, covers
an important corner of Celetná Street (Fig. 1). It is a space
where in the past the coronation marches of the kings
of Bohemia passed. In this exposed location, the merchant
František Josef Herbst planned to build a modern trading
house and for this task appointed the architect Gočár. But
his initial design was met with resistance from a conserva-
tive member of the club *Za starou Prahu* [For Old Prague],
Luboš Jeřábek.[14] The architect decided to take into ac-
count some of Jeřábek's critical comments and set to
work on another design. As a result, he enhanced the ex-
pression that we call Cubist today, although the reworked
version primarily respected the irregular disposition
of the originally developed area. In the final realization he
preserved the imprint of the previous historical layers. At
the same time, the modelling of the mansard roof entered
into an effective dialogue with the surrounding houses
in the Baroque style, although it is distinctly higher than
them. Ultimately, Gočár's new building succeeded in

14 Švácha (2000: 76).

blending sensitively into the surrounding area whilst still accenting its important corner position, and managing this through an originality of expression.[15]

Another well-known example of Cubist architecture is located in Pelhřimov[16] and presents a singular example of the introduction of entirely contemporary artistic trends to the historical space of a small town. In 1913, Pavel Janák was entrusted with the adaptation of an originally Baroque house on the main square (Fig. 2). The house of the physician Vojtěch Fára (*Fárův dům*) from 1913–1914 was to include the retail space, private apartment, and office of its owner. Based on an analysis of the characteristics of the local developed area, Janák identified its typical features. As such, he evaluated the opening of the homes to the square through gables and further embellishment of the façade surface by balconies and bay windows. Janák subsequently abstracted these defined elements when he removed the forms of specific historical styles from them. The result was a decorative interpretation of contemporary requirements in a relief-executed, pitched dimension. At the same time, the architect did not try to eliminate the past, but on the contrary attempted to create a respectful contextually sensitive realization of the traditional elements which would harmoniously inhabit the historical square. Today, in the context of Czech architecture, we label these interventions into architectural substance in general as Cubism.[17]

After the war, Gočár and Janák significantly asserted themselves in professional circles in the newly-founded Czechoslovakia. If they entered the scene before the war and provoked discussion and criticism, then after 1918 they confirmed their status and reinforced their position. Gočár and Janák took prestigious academic posts at Prague schools of architecture and, in addition, both reached the top levels of influential professional associations. Close personal ties to art historians in high state posts assured them prestigious commissions, although such work was often treated in the form of architectural competitions.

15 Švácha (2000: 78).
16 A rather small town, some 110 km south-eastwards of Prague.
17 Švácha (2000: 150–153).

Respect and Triumph
Intentions and Meanings of Czech Architecture
before and after the First World War

The elevated social status granted Gočár and Janák license to implement their visions of ideal forms of architecture, and with it create the new expression of Czech towns. After WWI the Czechoslovak Republic, as one of the successor states of the Austro-Hungarian Empire, found itself on the winning side, and the historical experience of freedom and intoxication with power heavily dominated Czech society at first. It sparked a building euphoria. The prevailing political climate discriminated against many nationalities and religious groups, but it allowed Czechs to fulfil the ideals of power ignited during the national revival in the 19th century.

In the production of Josef Gočár and Pavel Janák a specific artistic expression soon developed, which is often labelled as Rondocubism and can be, as aforementioned, considered a National style, which seems to be a more concise term.[18] Its protagonists did not diametrically oppose recent developments abroad, but on the contrary searched for formal sources programmatically within the local folk tradition and also in the archetypical models of the historical styles. However, their designs in the form of the National style were often radical in an urban context. The architects no longer attempted a sophisticated engagement of new buildings with the surrounding milieu, but often created a rather dramatic form of domination. The cosmopolitan character of Czechoslovakia's capital city was created with violent interventions into local cultural heritage. Although Pavel Janák, as the main theoretician of the National style, formulated programmed efforts for the construction of typically Czech towns, paradoxically the precise representatives of this locally anchored style become the liquidators of the original cultural layers. This approach could be demonstrated in the following examples.

The Bank of the Czechoslovak Legions (*Legionářská banka/Legiobanka*) was an important financial institution, its influence closely related to the historical role of the Czechoslovak military during WWI, a time when the independent Czechoslovakia did not yet exist. The importance of the legions became the supporting argument of future president Tomáš Garrigue Masaryk in

18 Hnídková (2010).

NATIONALISM AND COSMOPOLITANISM IN THE AVANT-GARDE AND MODERNISM
The Impact of the First World War

Fig. 3

Legionářská banka or *Legiobanka*
[Czechoslovak Legions Bank]
(built 1922–1923) in Prague by
Josef Gočár

dialogues with foreign statesmen, when attempting to convince them of the claim of the Czechs and Slovaks to their own state, because its inhabitants were fighting against the Austro-Hungarian Empire. After the war, the legionnaires were celebrated in this spirit, and their banking institution was to manifest these values through its architectural representation.

The management of the Bank of the Czechoslovak Legions created its central headquarters from Josef Gočár's 1922–1923 design on the site of a former brewery (Fig. 3). The banking palace encroached onto Na Poříčí Street and significantly retreated from its original width to allow a new urban thoroughfare to emerge. Into the open space created, Gočár wanted to place a column holding the statue of a shield bearer, to define the striking element in its

Respect and Triumph
Intentions and Meanings of Czech Architecture
before and after the First World War

Fig. 4

Model of the *Riunine Adriatica di Sicurtà* palace in Prague by **Pavel Janák**, 1922–1925

public space. The placement of a column or a statue was not realized, but despite this the bank successfully managed to attract the attention of passers-by anyway. To this day the significantly elevated building draws one's vision with the rich plastic and sculptural decoration of its façade that becomes a distinctive advertising bearer. The façade integrates the motif of a triumphal arch as a classical element, referring to the victory not only of the legionnaires but of Czechoslovak society as a whole.

Another monument in the National style asserted itself more problematically into the structure of historical Prague. The *Riunione Adriatica di Sicurtà* palace firmly dominated the position on the corner of Národní třída [National Avenue] and Jungmannovo náměstí [Jungmann Square] (Fig. 4). The commission for the Czechoslovak central office of the Italian insurance company was originally assigned to the architect Josef Zasche, a Czechosolvak citizen whose German nationality however, and the artistic expression associated with it, proved too critical a factor for a project in such an important urban area.

After a harsh media campaign, the insurance company retreated from its original plan and announced an invitational architectural competition for the exterior of the building, the design of which was won by Pavel Janák.[19]

The fundamental problem, however, lay in the fact that the locality selected was not any vacant building plot, but the site of the Empire-style palace of Count Thun of Hohenstein (Tuscany). The preservation of the original building became the subject of the battle of the preservationists from the club *Za starou Prahu*, who faced a powerful adversary: not merely the financial institution in its role as investor, but also the State Regulation Commission which decided on the enlargement of Národní třída. This urban-planning intervention contributed to the transformation of the historical city into a modern metropolis. The foundation of an avenue in the case of the palace *Riunine Adriatica di Sicurtà* only intensified the overall monumental impression of Janák's new building. The large palace hence entirely dominated the corner of Národní třída and Jungmannovo náměstí, overiding one of the arguments in favour of the division of Národní třída, namely to highlight the position of the Gothic church of Our Lady of the Snow (*Panny Marie Sněžné*). The modern palace of the financial capital entered into open competition with the historic buildings, if not swallowing them entirely.

This process escalated at the Prague headquarters of the Škoda Works, located in the immediate vicinity of Riunione. Pavel Janák elaborated an architecturally remarkable design which integrated the original Baroque palace of Thun-Salm into the body of the new building. From today's perspective, such alterations of architectural monuments is perhaps disputable. Indeed, the Baroque palace in Janák's design still limited the efficient suitability of the new headquarters, and thus the architect was forced to abandon his vision under pressure from the investor. Eventually he sacrificed the historical palace and replaced it with a modern one.

19 Hnídková (2013: 129–133, 181–183).

174

Respect and Triumph
Intentions and Meanings of Czech Architecture
before and after the First World War

Conclusion — Towards the Czech Metropolis

The examples given of the pre-war and post-war buildings illustrate the dramatic transformation of the relation of the leading architects Janák and Gočár, the protagonists of the Cubist and the National style, to historical monuments. Although it is not possible to consider the present approach in both periods as a generally binding rule, it represents a marked shift on the practical level. The explanation of this discrepancy may partially arise from the economic motivations of the investors, but also from the attitude of society in general. The war created a heady feeling of triumph and historic satisfaction in the Czech nation, and these intense experiences of the winners were reflected in the relation to their cultural heritage. After 1918 the process of the building of Prague as a modern metropolis began, and some examples of the destruction would correspond to the vision of the rising representatives of later functionalism, rather than to the architects whose career began in the club *Za starou Prahu.*

Transnational or National Cubism?

Vincenc Kramář on Cubism

Vojtěch Lahoda[†]
Institute of Art History, Czech Academy of Sciences. Prague,
Czech Republic

NATIONALISM AND COSMOPOLITANISM IN THE AVANT-GARDE AND MODERNISM
The Impact of the First World War

Abstract

In 1918 the first President of Czechoslovakia, the philosopher and university pedagogue Tomáš Garrigue Masaryk, wrote a short treatise, first in English and French in 1918, then in Czech and in German, entitled *New Europe: A Slav Standpoint*, in which he raised the question of the standing of the Czechoslovak nation in Europe. According to Masaryk, between nationality and internationality there is not conflict, but agreement; nations are the natural organs of humanity. Three years after the aforementioned publications of Masaryk's *New Europe*, the Prague art historian Vincenc Kramář, who studied art history in Vienna, published a book entitled *Kubismus* [Cubism], in which he extensively explained the epochal significance of the works of Picasso and Braque. Kramář declared that "national art" would not be just the "pure fruit of domestic soil", but must also be "comprehensible abroad" and "panhuman". Kramář wrote these words in 1921, at a time when the young state had only three years of independent existence behind it and its dramatic problems barely resolved; these were daring ideas, and decidedly did not convey what enthusiastic nationalists (patriots) wished to hear. The author shows that Kramář's defence of Cubism as a synthesis of national and transnational significance was both a gesture and a manifestation.

Key words

nationalization of Cubism, Czechoslovakia, *Mitteleuropa*, New Europe, national romantic movement, new state, aristocratic cosmopolitanism, democratic internationalism, emulation, national style, Legiobanka style

Transnational or National Cubism?
Vincenc Kramář on Cubism

The Nationality and Internationality of *New Europe*

In 1918 the first President of Czechoslovakia, the philosopher and university pedagogue Tomáš Garrigue Masaryk, wrote a short treatise, first in English and French in 1918, then in Czech in 1920 and German in 1922,[1] entitled *New Europe: A Slav Standpoint*, in which he raised the question of the standing of the Czechoslovak nation in Europe. In this book he developed ideas that he had already presented in the weekly periodical *New Europe*, which he co-founded together with Robert William Seton-Watson in London in 1916.[2] Masaryk stressed that a world war must culminate in the independence of those nations that wish to exist in their own sovereign state, but which are currently oppressed within pre-existing larger states. He saw the future of Europe as a federation of democratic states. He pointed out that the opponents of "small nations" emphasise the value of internationality and condemn small nations and states as an "embarrassing obstacle" to internationality and "worldwideness".[3] According to Masaryk, however:

> The nationality principle applies simultaneously with the international (interstate) one. [...] Between nationality and internationality there is not conflict, but agreement; nations are the natural organs of humanity. Humanity is not something supranational, it is an organization of individual nations. If, then, individual nations are striving for independence and are trying to break up the states in which they have been hitherto, this is not a fight against internationality and humanity, but a struggle against oppressors who have misused states for the purposes of equalization and political monotony.[4]

Masaryk's *New Europe* sounded like the antithesis of the great German concept of *Mitteleuropa*, proclaimed by Friedrich Naumann in his 1915 book of the same title.[5]

1 Masaryk (1920). See: Masaryk (1918a); Masaryk (1918b); Masaryk (1922); Masaryk (1991: 6). See also: Funda (1978); Hain (1999); Ersoy/Górny/Kechriotis (2010).

2 See e.g.: Viefhaus ([1960] 2008); Seton-Watson H./Seton-Watson Ch. (1981); Głuchowska (2013d: 186–190).

3 Masaryk (1920: 90). All translations are by the author unless otherwise indicated — V.L.

4 Masaryk (1920: 91–92).

5 Naumann (1915). See also: Bennhold (1992: 977–989); Henschel (2008). Similarly, like the Polish politician Roman Dmowski (1864–1939),

Naumann's ideal consisted of the closest possible connection of the German Empire with the Austro-Hungarian monarchy, naturally under German hegemony. Today's internationality is, according to Masaryk, something completely different from the cosmopolitanism of the 18th century, which was basically French; in itself it was "aristocratic cosmopolitanism", restricted to the nobility and the educated,[6] while in the 20th century "democratic internationalism" is strengthening.

Although Masaryk spoke of the national character of the new state, in *New Europe* he dealt with categories of "nationality" and "internationality". He did not see any contradiction between them. To him the nationality principle was simultaneously an international principle.

Is Cubism National or Transnational?

Three years after the English and French publication of Masaryk's *New Europe*, the Prague art historian Vincenc Kramář (Fig. 1), a pupil of Alois Riegl and Franz Wickhoff in Vienna, published a book entitled *Kubismus* [Cubism, 1921], in which he extensively explained the epochal significance of the works of Pablo Picasso and Georges Braque.[7] Vincenc Kramář was a major collector of the work of Picasso, who had studied at the Vienna school of art history and was an art theorist who considered Cubism the most contemporary and eloquent art trend of his time. In 1913 he published his first substantial text on Cubism "Kapitola o -ismech" ["A Chapter on -Isms"],[8] which was a reaction to Henri Le Fauconnier's exhibition in Munich. In it he compares the derivative and, in his opinion, dated expression of Le Fauconnier, with a Picasso exhibition of the same time at the *Moderne Galerie Heinrich Thannhauser* in Munich. According to Kramář, Picasso represented "painting in the fullest sense of the word", painting as a play of colour and form,

Masaryk expressed his protest against the German *Drang nach Osten* during WWI. See: Lemberg (2003: 33–38).

6 Masaryk (1920: 92).
7 Kramář ([1921] 1983: 91). French translation: Kramář (2002). See: Lahoda/Uhrová (2000); Claverie/Klein/Lahoda (2002); Lahoda (2013: 137–139); Lahoda (2014b: 188–191); Lahoda (2018).
8 Kramář (1913: 115–130). See: Cottington (2004: 277).

177

Transnational or National Cubism?
Vincenc Kramář on Cubism

Fig. 1

Vincenc Kramář as a soldier, 1916

which was interpreted by epigone formalists (so-called Cubists) as inartistic geometry or philosophy. In his aforementioned book *Kubismus*, Kramář regards the Cubism of Picasso and Braque as a "pure demonstration of plasticity and spatial relations", writing elsewhere that the principle of Picasso's image was "the lyricism of the whole". Cubism's emphasis on the values of form and shape points to its universal and thus transnational character. It was certainly contemporary pressure that forced Kramář to express himself on the topical theme of national art immediately after WWI, when it became almost the motto of the time and when the experiments of Cubism were considered in certain circles out-dated,

artificial, and art for art's sake. In France during the war, Cubism was seen as "foreign" or "German", as a "German invention" of gallerists like Henry Kahnweiler and Wilhelm Uhde. Kramář considered it necessary to state that it is untenable to understand "national art" as:

> [...] the pure fruit of domestic soil, even though I know that the period of the war, which disrupted our artistic life so profoundly, again revived, with unwonted strength, this phantom of romantic thought and brought to influence reactionary elements giving priority to domestic patriotic art, however inferior, before the intensive works carried out in connection with world creativity. The consequences of this very soon appeared in practice. This really was the irony of fate; whereas we were winning and won political independence and escaped from subjection into direct contact with the world, our art withdrew cautiously into a quiet backwater, protecting itself against possible foreign influence as if it were poison, and even in the past post-war years it has languished as though in a distant province [...]. National art in the full sense of the word and artistic value of world standard are two inseparable concepts, and there does not exist any valuable national art, which would not be comprehensible abroad, or in other words, a declaration to the contrary covers mediocrity and possibly even monstrosity. Truly important national art always is and was panhuman.[9]

The statement that the "national art" would not be just the "pure fruit of domestic soil", but has to be "comprehensible abroad" and "panhuman" is significant and — in the local conditions — could be perceived ambiguously. If we take into account that Kramář wrote these words in 1921, at a time when the young state had only three years of independent existence behind it and its formative problems were barely resolved, these were daring ideas and they decidedly did not convey what enthusiastic nationalists (patriots) wished to hear. From the first quarter of the 16th century, the entire Crown of Bohemia was gradually integrated into the Habsburg Monarchy, alongside the Archduchy of Austria and the Kingdom of Hungary. The Protestant Bohemian Revolt (1618–1620) against the Catholic Habsburgs led to the Thirty Years' War, after which the monarchy consolidated its rule, reemployed

9 Kramář ([1921] 1983: 91).

179

Transnational or National Cubism?
Vincenc Kramář on Cubism

Catholicism, and adopted a policy of gradual Germanization. With the dissolution of the Holy Roman Empire in 1806, the Bohemian Kingdom became part of the Austrian Empire and the Czech language experienced a revival as a consequence of the widespread national romantic movement. The outcome of this national revival was the founding of a new state in October 1918: Czechoslovakia.[10]

Defense of the New State

At the end of 1918, Czechoslovak troops occupied the Sudetenland with its German majority population, and in January 1919 military conflict broke out between Czechoslovakia and Poland over Těšín/Cieszyn Silesia, referred to by many Czech sources as the Seven-Day War (*Sedmidenní válka*, January 23–30, 1919). After an unheard protest against the Polish occupation of part of Těšín, which was at variance with the concluded treaty, the Czechoslovak units attacked the occupying forces to prevent the holding of elections to the Polish Sejm (parliament) in the disputed territory and the conscription of local inhabitants to the Polish Army.[11] The advance of the Czechoslovak units was only stopped by pressure from the Triple Entente.

At the beginning of November 1918, conflicts started between the Hungarian and Czechoslovak military units, in an effort to drive Hungarian troops out of the Slovakian (Upper Hungary) territory, which according to the agreement was to become part of Czechoslovakia. The Hungarian-Czechoslovak War, also known as the War over Slovakia, was a conflict between Czechoslovakia and Romania on one side and the Hungarian Republic of Councils on the other, unfolding within the framework of a wider conflict, which also included the fight for Transylvania and Sub-Carpathian Russia. This lasted from 1918 until August 1919. In April 1919 there was a Bolshevik putsch in Hungary, after which the Hungarian Army tried

10 Agnew (1993). On Czech National movement, see: Havránek (1967: 223–26); Hoensch (1997); Orzoff (2009).
11 Holeczko-Kiel (2004: 141). See: Głuchowska (2014: 296). See also: contribution by Lidia Głuchowska, *The Great War and the New Art...* in this volume.

to seize Slovakia and Transylvania, provoking a war with Czechoslovakia and Romania. The defeat of the Hungarian Republic of Councils and the Romanian occupation of Budapest in August 1919 brought the conflict to an end. Czechoslovakia gained control of the territory of Slovakia, which had belonged to Hungary before the war.[12]

Defence of the Transnational Character of Cubism

Only on March 2, 1920 was the constitution of the Czechoslovak Republic approved as the first constitutional charter of one of the new European states. In the atmosphere of the military defence of the new state and its Czechoslovakian nationhood values, Kramář's defence of Cubism as a synthesis of national and transnational significance was both a gesture and a manifestation.

In his book on Cubism, Kramář stated that before the war it appeared — and here he emphasized in particular the role of architecture (meaning Cubist architecture) — that the Czechs were freeing themselves of ties to the small-mindedness of former conditions, and that Prague had become an artistic center that was attracting attention abroad.[13] As is generally acknowledged nowadays, Cubist architecture and Cubism in the applied arts were not the product of the Parisian artistic culture, but were a genuine Czech invention.[14] Kramář had intuitively recognized the starting point of this artistic process and tried to underline the original Czech contribution to the international or transnational style, of which he was probably very proud. Nevertheless, the war put a halt to this promising development. According to Kramář, art was declared to be only a matter for "ourselves" (namely, for Czechs/Czechoslovaks). The ideal thus arose of "humble art for the broad strata of the people and anyone who wanted something more and aimed at a pure solution to creative problems risked being declared un-Czech."[15] All this was the foundation for the good citizen, who in

12 See: Hoensch (1997: 410); Sayer (1998); Mueggenberg (2014).
13 Kramář ([1921] 1983: 93).
14 See e.g.: Švestka/Vlček/Liška (1991); von Vegesack (1992); Lahoda (2013: 131–137).
15 Kramář ([1921] 1983: 93).

184

Transnational or National Cubism?
Vincenc Kramář on Cubism

the pre-war period was scandalized by new art, which he naturally did not understand because he did not have a deeper and more constant attitude to artistic creativity. For Kramář: "This art was a mistake from the viewpoint of national art and art in general."[16] Cubism and any kind of new art were thus allegedly rejected as *passé*.

In brief, Kramář just could not accept the transformation of the prevailing mentality during the war, which emphasized only "domestic values" and saw anything foreign as an intrusion. Because such a viewpoint would mean the necessary condemnation of Cubism as something foreign, Kramář stubbornly tried to argue for the interconnection of the national and the transnational.

When Transnational Becomes National: Translation and Emulation

From Kramář's viewpoint we could, on the contrary, look at transnational Cubism as a kind of national art. A similar element of nationalisation, of Czechisation, was probably present in the Czech Cubist architecture of Pavel Janák or Josef Gočár, although from the beginning these architects considered the international impact of their work. From around the beginning of the 1970s to the end of the 20th century, Western art history gradually revised the geographical concept of Cubist "activities" by adding "Czech" regions to it.[17] This state of affairs is best attested to in Neil Cox's book *Cubism* in 2000, which devotes considerable space to Czech Cubism, including architecture.[18] The sharp edges and diagonal forms of Cubist buildings were something palpably "different" in comparison with Viennese Art Nouveau, German Post-Rococo, or Neo-Biedermeier architecture. However any local approach, according to the dominant Western art history, is inappropriate. If the artwork is too close to its original source, it reflects a slavish mentality. If, on the other hand, the imitation is imperfect, it represents

16 Kramář ([1921] 1983: 93).
17 The ever-stronger recognition of the formerly ignored Czech Cubism and its incorporation into the canon of Western art history is substantiated by the reference to the subject made in the entry "Cubism", in: Chilvers (1999: 147–150).
18 Cox (2000). See also: Blau/Troy (1997); Veselý (2005); Głuchowska (2014b: 167–168, note 52); Głuchowska (2016).

a failure. We should establish a new, more appropriate concept to define the difficulties of transmitting Cubism from Paris to Prague. I call it emulation or remake. This concept, expressing a form of transferral (recycling) of an original film (screenplay, story line, plot), is for some people simply a film based on another film. What is more fundamental for our case is "the illusive duality of remake — that indeed there is much that is untranslatable about the 'seed or nucleus of the text' or film, so that its ability to be remade is more about cultural fertility than about textual fidelity."[19] In this way I would like to indicate that the translation of a style (Cubism)[20] from one environment to another is also "untranslatable" and, just like a remake "[...] is simultaneously a rich site for critical analysis precisely because its derivative status — its very secondariness and duplicity — forces a certain theoretical stock-taking of conventional notions of authorship, authenticity, and originality."[21]

Emulation is also an assiduous striving to equal or excel another, and is thus a kind of rivalry.[22] The "Picassism" of Czech Cubist painter Emil Filla is an attempt to preserve the timeliness of Czech art, to keep abreast of the world, to fill gaps of specific cultural epochs. But from a psychological point of view, there was an important theme of emulation: by capturing Picasso's methods, Filla appropriated them. It was as if Filla, a native of a small village in Moravia, proved to the famous Catalan that he could practice (Cubism) well, and at the same level. It is a form of mimetic antithesis of modern art: Filla conquered Picasso's space (Cubism) by his artistic means, by his own weapons. Later Filla wrote as if he wanted to rehabilitate such a procedure: "[...] but it can happen — and it happened often — that [one] finds somewhere a clear finished path that had impressed him [...]. He has the right to appropriate this already discovered way for his

19 See: Ragona (2003: 50).
20 See: Lahoda (2010: 223–238).
21 Grindstaff (2001: 274).
22 Vojtěch Lahoda, "Affinity, Emulation or Adaption? 'Cubism Remake' on the Eastern Orbit", keynote lecture on November 20, 2009 at the conference *Historizing the Avant-Garde* at the University of Copenhagen, November 18–22, 2009. See also: Głuchowska (2013d: 199).

183

Transnational or National Cubism?
Vincenc Kramář on Cubism

business to run out then on until his destiny and to its base."[23]

In order to reach some conclusion about the role of Filla's Cubism in relation to Picasso, let us take the example of Filla's picture *Head of an Old Man* (*Hlava starce*, Fig. 2) from 1914,[24] painted in Rotterdam. The painting shows traces of the strong influence of Rembrandt in the treatment of light. The affinity of Rembrandt and Cubism is mentioned two times by Kramář in his book *Kubismus* (1921).[25] The delicacy and fragility of the painting, applied to unusually finely woven canvas, is interesting. It is as though a magical meeting of precision painting were

23 Filla (1947: 186).
24 Marked on the reverse in the center in ink: "Emil Filla/Rotterdam 14."
25 Kramář ([1921] 1983: 74, 96).

Fig. 3

taking place, perfectly observed from the paintings of the Old Masters, especially the Dutch. The fragmentary waves of long hair, as well as the round cap on the crown of the head and part of the moustache, suggest the idea that Filla might have been thinking of an imaginary Cubist portrait of Jan Amos Comenius, whose work interested him greatly at the beginning of his stay in Holland. Comenius was an important Czech scholar who had to go into exile in 1628 (he spent part of this time in the Netherlands). Portraits of Comenius became a frequent part of the Czech book and periodical culture, which meant that for Emil Filla it was not difficult to create an ideal visual impression of the famous thinker on the basis of portraits he had observed. If that is indeed the case, then the painting has a clear national and historicizing subtext, all the more so as it was painted following his immigration

185

Transnational or National Cubism?
Vincenc Kramář on Cubism

Fig. 4

Vincenc Kramář's apartment in Prague with a part of his art collection (works by **Picasso** and **Braque**)

to Holland. The allusion to Comenius is, let us say, one local cultural-historical context of the painting.

What is the state of the external context: the classification of Filla's painting in connection with Picasso's work? It is useful to compare the *Head of an Old Man* with Picasso's famous painting *The Poet* (*Le Poète*, 1912; Fig. 3), which Filla knew well from the Kahnweiler's Gallery in Paris, where it had a strong effect on him when it was quite new. The picture was exhibited at the Pablo Picasso Exhibition in the *Moderne Galerie Heinrich Thannhauser* in Munich in 1913 and was simultaneously reproduced in the catalogue.[26] The exhibition was visited by Vincenc Kramář and from it he purchased another canvas by Picasso — *Violin, Glass, Pipe and Anchor* (1912). Kramář, as one seriously interested in Picasso (Figs. 4 and 5), also owned a catalogue of the exhibition.

26 *Ausstellung Pablo Picasso* (1913: Cat. No. 76). See: Lahoda (2018).

Fig. 5

Vincenc Kramář's bureau in Prague with works by **Picasso**, **Braque**, **Gutfreund**, and **Kubišta**'s *Pierrot*.

The Head of an Old Man repeats the basic Picasso composition of the head in the form of a slanted triangle, the lowest point of which merges with the chin. The pointed moustache and chin in Picasso's painting *The Poet* is replaced in Filla's *Head of an Old Man* by curly strokes of a comb in the paint, creating a special counterpoint to the lively colour. In Picasso's painting the crown of the head and the hair dominate, whereas in Filla's head the crown is unusually smooth and small. It looks like a priest's cap.

Filla understood the principle of Picasso's Cubism excellently and he accepted it and donned it as a topical overcoat. For the Czech milieu, Filla's relationship to Picasso was, and is, especially sensitive. From time to time

187

Transnational or National Cubism?
Vincenc Kramář on Cubism

it is described as "epigonic". The epigone is an imitator and follower, sometimes even second-class. In this definition it is already a negative evaluation trait. In the ancient world an epigone was also a continuer. "Continuer" has a different connotation from second-class follower.

What, then, is the nature of Filla's work in relation to Picasso? Is it affinity, adaptation, or emulation? Is there an element of competition and rivalry in his approach? I think that the concepts of influence or epigone do not help us very much. We need a far more differentiated verbal strategy. Michael Baxandall already realized this when he wrote of the relationship of Cézanne to Picasso:

> "Influence" is a curse of art criticism primarily because of its wrong-headed grammatical prejudice about who is agent and who is the patient: it seems to reverse the active/passive relation which the historical actor experiences and the inferential beholder will wish to take into account. [...] It is very strange that a term with such an incongruous astral background has come to play such a role, because it is right against the real energy of the lexicon. If we think of Y rather than X as agent, the vocabulary is much richer and more attractively diversified [...].

Baxandall writes dozens of expressions declaring how he would replace the word "influence".[27]

Cubism as National Style

The "Czech" aspect, then, came to the fore in the houses built by the Domovina collective (*Družstvo Domovina*) in Znojmo (German: Znaim) from 1920 (Fig. 6). For this town, in which before 1918 there was an almost exclusively German-speaking population, Otakar Novotný designed houses in a Cubist style for Czech office workers and teachers, as a clear signal of the Czech present.[28] Cubism thus did not even have to work with national symbols and themes. However the houses were clearly recognized

27 Baxandall (1992: 58–59). See also: Lahoda (2009: 417–426); Lahoda (2018); Pravdová/Hubatová-Vacková (2018: 112–117).

28 The Domovina collective in Znojmo was initiated in 1919 by Dr. Karel Polesný, director of the local Czech Gymnasium. Within 6 years the collective built 6 Cubist houses, with 77 apartments, 1 workshop and 1 café.

Fig. 6

Cooperative Housing *Domovina*
(built 1919–1921) in Znojmo by
Otakar Novotný

by local German-speaking habitants as a manifestation
of "Czechness".

In this context, the reflection of the literature histori-
an Pascale Casanova about Franz Kafka and his connec-
tion with politics seems to be significant. When Kafka
described the complex mechanisms through which all
new national literatures pass at their birth he became,
according to the Italian author, a spontaneous theoreti-
cian of what is known as "small literature". On the basis
of Kafka's famous passage on Jewish literature in Warsaw
and on incipient Czech literature, Casanova reaches the
conclusion that all the texts of these "small literature"
"have a political (collective) character, because there is
an effort here to politicise (or 'nationalise'), to reduce the

189

Transnational or National Cubism?
Vincenc Kramář on Cubism

boundary that separates the subjective [...] from the collective."[29] Kafka says this distinctly: "the requirements, which national self-awareness in a small nation imposes on the individual, mean that each person must be constantly prepared to know, to bear, to defend, in every case to defend, that part of literature, which falls to him, even if he does not know it and does not bear it."[30] We might view the Cubist new art cultivated in Prague before WWI by the group of artists, including Janák and Gočár, as an example of this kind of "small literature" and its "texts". The Czech Cubist artists actually defended the idea of national modern art (Cubism), doing so within the framework of "small modernism", without presenting this idea in any manifest way in their works. It was only Janák's and Gočár's National style of the early 1920s — also described as the Legiobanka style, the curved style or, most unfortunately, as Rondocubism[31] — which became the intentional building block of Czech national culture on the state platform. It was intended to imprint a clearly palpable domestic and Slavonic character of artistic expression, as demonstrated by Gočár's Bank of the Czechoslovak Legions (*Legionářská banka/Legiobanka*) in Prague dating from 1921–1923.[32] The climax, and simultaneously the conclusion, of this artistic trend was the Paris *Exposition internationale des arts décoratifs et industriels modernes* of 1925, at which the creators of the National style presented their products on international soil for the last time.[33]

29 Casanova (2012: 247). Transl. from Czech by: Čestmír Pelikán.

30 Kafka ([Dec. 25. 1911] 1997: 186–187). Transl. by: Josef Čermák.

31 Hnídková (2010); Hnídková (2009: 74–84, 112); Hnídková (2013); see also: contribution by Vendula Hnídková in this volume.

32 See: Fig. 3 in contribution by Vendula Hnídková in this volume. On the legions see: contributions by Oksana Dudko, Ginta Gerharde, and Lidia Głuchowska, *The Great War and the New Art...* in this volume.

33 Hnídková (2013).

Cut & Paste in Exile and War

Otto Gutfreund's Parisian Collages

Naomi Hume

Department of Art, Art History and Design, Seattle University.
United States of America

NATIONALISM AND COSMOPOLITANISM IN THE AVANT-GARDE AND MODERNISM
The Impact of the First World War

Abstract

Prague artist Otto Gutfreund produced several complex collages while in Paris in the summer of 1914. By the time war broke out in August, he had come to see collage as a tool for exploring the impact that national identity has upon an exiled individual's subjective experience during an international crisis. When Gutfreund traveled to Paris in spring 1914, he had already developed a sophisticated theory and practice of sculpture. He had moved on from his earlier Expressionist approach in which he conveyed psychological states through physical gestures and distortions. In 1914 he was experimenting with confusing the perception of two- and three-dimensional form in reliefs and freestanding sculptures to engage viewers on a metaphysical level. In his theoretical writings at this time, Gutfreund developed his goal to change the relationship between the work and the viewer. He wanted viewers to question their assumptions about three-dimensional objects and to recognize how much of our perception depends on subjective projection. In Paris in early 1914, Gutfreund began experimenting in pasted paper collages, responding to works he had seen in Picasso's studio, and further manipulating the viewer's attention to stress how subjective experience constitutes a large part of a work's meaning.

Scholars continue to debate whether the content of the news matters in Picasso's collages, and if it does, how it relates to the artist's own views. My discussion of Gutfreund's collages demonstrates that in his works the content of the news is indeed crucial, but that it does not straightforwardly represent the artist's views or allegiances. Gutfreund visited Picasso's studio in April of 1914 and produced the collage *Head*, that same month. In *Head* Gutfreund offers the viewer the same experience as that of the depicted figure, of distraction by the ephemeral information offered on the sports page of a daily newspaper. In Gutfreund's as in Picasso's collages the sense of the text competes for the viewer's attention with the visual appearance of the newsprint as depicted object. To understand Gutfreund's collages, the viewer must be aware of these shifts in her own attention. As European tensions rose in the summer of 1914, these strategies for both directing the viewer and emphasizing

subjectivity became central to Gutfreund's attempts to evoke the conflict between his national awareness and international allegiances. The increasingly strident lead-up to the war exaggerated the divide Gutfreund perceived between his own everyday experiences in Paris and those of French citizens. He became increasingly self-conscious of his status as an Austrian — and therefore enemy — national, despite his preferred self-identification as Francophile and Czech. He became acutely aware that nationality and subjectivity were lenses that filtered everyone's experiences. Consequently, Gutfreund's collage, *Still Life with Bottle*, evokes multiple subjectivities attending to the news in different ways, suggesting the relativity of a single point of view. This uncertainty, this awareness of multiple experiences, becomes itself the subject matter of the collage. Gutfreund used the dislocations of cut-and-pasted newspapers to register the conflicts of national identity in a time of war.

Key words Cubism, Cubist collage, Czech Cubism, modern sculpture, relief sculpture, still life, nationalism, Otto Gutfreund, Pablo Picasso

Fig. 1

Otto Gutfreund, *Kubistické poprsí* [Cubist Bust], view from the front, 1913–1914. National Gallery in Prague

Introduction

Otto Gutfreund left Prague to work in Paris at the beginning of April 1914, a few months after his latest sculptures had been prominently displayed at an exhibition in Prague put on by *Skupina výtvarních umělců*, the Group of Fine Artists.[1] Painter Vincenc Beneš hailed Gutfreund's sculptures, and his *Cubist Bust* (*Kubistické poprsí*, 1913–1914) in particular, as demonstrating the real concerns of the new art, describing their "composite of accumulated surfaces" as provoking the viewer to abstract thought beyond the material form of the art object (Fig. 1).[2] After encountering Picasso's works in Paris that spring, Gutfreund further developed these ideas in drawings and collages. While directly responding to works he saw in Picasso's studio, Gutfreund continued to explore the concepts that he had been pursuing in Prague. Adding

1 Šetlík (2012: 159). The exhibition took place Feb.–Mar. 1914 at the Municipal House in Prague. Gutfreund's sculptures dominate the room in an installation photograph published in *Umělecký měsíčník* [Art Monthly] 2/12 (1913: 323).
2 Beneš (1914: 328). All translations are my own unless otherwise indicated — N.H.

Fig. 2

Otto Gutfreund, *Hlava* [Head],
1913–1914. Gallery of Fine Arts
in Ostrava

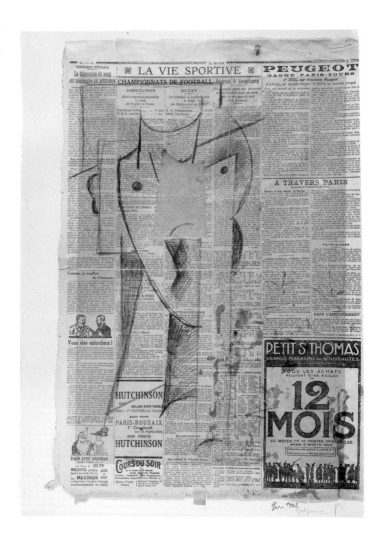

to the larger theoretical concerns of the Czech artists in
these works, Gutfreund also reflected on the particularity
of his situation as an Austrian national in France during
the build-up to and outbreak of war. In this essay I will
show how the collages, *Head* (*Hlava*, 1914) and *Still Life
with Bottle* (*Zátiší s láhví*, 1913–1914), are connected to
Gutfreund's earlier work and yet also incorporate new
ideas he encountered in Paris (Figs. 2 and 3).[3]

Gutfreund's circumstances in 1914 were not unusual
for a young European artist. The avant-garde owed its

3 While the sophistication of the extant collages suggests Gutfreund
 may have made many, to my knowledge these are the only two that
 survive. Lahoda reproduces *Koláž* [Collage, 1914–1915] by Gutfreund,
 but its dimensions and location are unknown. Lahoda (1996: 100).

Fig. 3

Otto Gutfreund, *Zátiší s láhví*
[Still Life with Bottle], 1913–1914.
Gallery of Fine Arts in Ostrava

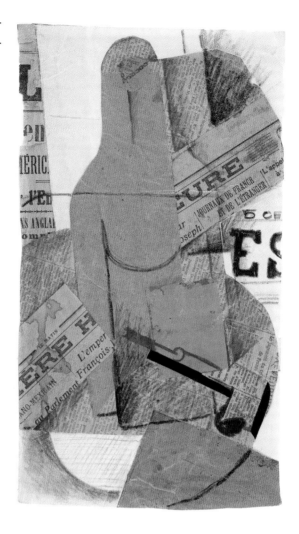

international character and dissemination of ideas in the early 20th century to the many artists and writers who traveled to Paris from elsewhere in Europe to study, bringing new ideas with them when they returned home. Progressive artists and critics from Prague stressed the modernity of a cosmopolitan outlook in art and culture, but this stance conflicted with the dominant nationalist narratives of the time about artistic development.[4] The nuances of the Czech artists' simultaneous commitment to international ideas and to their local culture were lost on conservative critics in Prague who saw only an alien

4 For an in-depth discussion of this combination of the Group's local, national and international outlooks, see: Hume (2012: 516–545).

style in their work.[5] Supportive critics, like painter Bohumil Kubišta, still couched their discussions in nationalist terms, declaring in 1912, for example, that their work demonstrated that "Czech art has caught up with the French."[6] Influential Czech critic František Xaver Šalda defended the young artists' work and their interest in French developments against the argument levelled against them that artists had a responsibility to represent reality while celebrating the Czech nation.[7] The young Prague artists argued that their work used ideas they encountered in Paris to reinvigorate what they called "native elements" inherent to the Czech artistic sensibility.[8] Yet Gutfreund must have confirmed traditionalists' worst suspicions, for when the war pitted Austria against France, he joined the foreign legion to fight against his own countrymen.

Gutfreund's Sculpture: Abstraction and Embodiment

When he left for Paris in 1914, Gutfreund was intent upon immersing himself in the most dynamic art center at the time and on bringing the most progressive ideas he found there to bear upon the issues he and the Group were already grappling with in Prague. Gutfreund's theoretical questions were about human perception, reality versus illusion, and how the artist can engage the viewer in considerations that go beyond the material form of the work of art. He wanted to make sculptures that would lead the viewer to metaphysical or spiritual thought. As he wrote in 1913, "the ideal for the sculptor [is] that the abstraction that has been embodied in concrete form becomes abstraction again for the viewer."[9] But for the Czech artists, it was important that abstract works function in a logical or legible way to lead the viewer beyond material reality. They insisted that mere personal expression was not sufficient motivation for a work of art. For example, they

5 Mádl (1912: 83). Unattributed transl. of Mádl reprinted in: Larvová (1996: 83).
6 Kubišta (1912: 58–60). Reprinted in: Lamač (1988: 183).
7 In a review of one of the Group's early exhibitions, Šalda defended their work against Mádl's criticism. Šalda (1911: 161–165, 202–207). Reprinted in: Lamač/Padrta (1992: 15–18).
8 Janák (1912: 163).
9 Gutfreund (1913: 137).

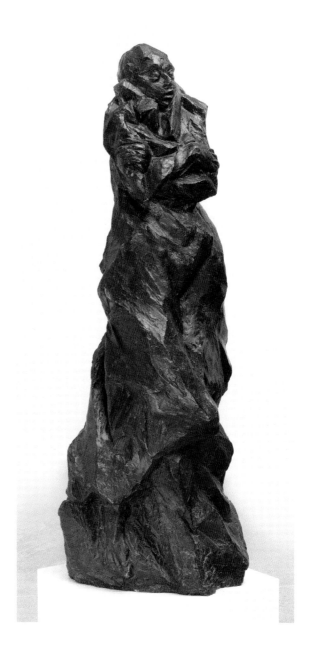

thought Kandinsky's work was too "freely personal and
subjectively conditioned", without the "causal sequence
of thought and expression" that was critical for them.
They insisted that a work had to do more than express an
individual's feelings. It had to communicate metaphysical
ideas.[10] For them, the art object must prompt the viewer
to "lose himself" in the work, invite him to transcend

10 Čapek (1912: 269–270); Beneš (1912: 262).

his mundane, material experience and enter the realm of metaphysics or spirit.[11]

We can see these ideas at work in Gutfreund's sculpture from late 1913 and early 1914. His *Cubist Bust* quite frankly pushes the viewer to abstract thought regarding her assumptions about three-dimensional objects (comp. Fig. 1). Earlier works by Gutfreund had departed from mimetic representation by exaggerating physical gestures of emotion. In *Anxiety* (*Úzkost*, 1911–1912), for example, he emphasized the figure's head and arms, augmenting and repeating the protective angular constriction of the arms around the torso (Fig. 4). The jagged mass of the figure's body extends that gesture and thereby transmits to the whole figure the anxiety to which such a posture is a reaction. In these early works, Gutfreund used the physical form of the sculpture to give the viewer a visceral experience of emotion.

The *Cubist Bust*, however, doesn't rely on the viewer's recognition of gesture or emotion as a catalyst to abstract thought or feeling. With his *Cubist Bust*, Gutfreund wanted to change the relationship between the work and the viewer, pushing him to abstractly question his assumptions about three-dimensional objects.[12] *Cubist Bust* reminds the viewer that we experience objects through a continual process of testing what we see against what we know. We see only part of a cube at any moment in time, but from experience we project the cube's shape and volume from that partial view. Gutfreund wanted to upset this process so that the viewer would recognize how much of our perception of three-dimensional objects is our own subjective projection:

> As soon as I take away from the viewer the ability to control the depth ratio by touch and by the tangible movement of the eye, the sculpture loses its materiality for the viewer and becomes just a subjective concept again. And I take away this ability to control the depth ratio when, instead of a real, tangible form, I provide the visual concept of it — that is, relief.[13]

11 Gutfreund, manuscript for essay "O starém a novém umění", in: Šetlík (1989: 235). Qout. after: Lahoda (1995: 124).
12 Gutfreund (1913: 137).
13 Gutfreund (1913: 137).

Fig. 5

Otto Gutfreund, *Kubistické poprsí* [Cubist Bust], view from the right, 1913–1914. National Gallery in Prague

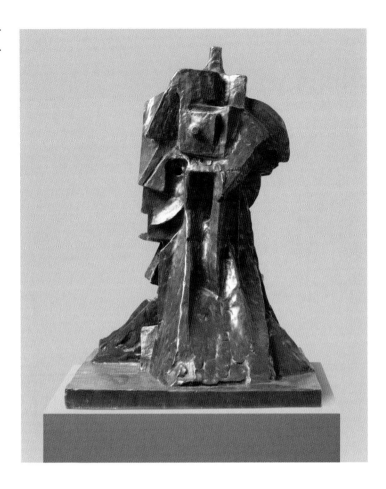

Relief, for Gutfreund, was a way of manipulating the relationship between work and viewer.[14] Even though *Cubist Bust* is a freestanding object, Gutfreund built part of its mass up from a series of vertical slabs, layering flat planes over each other as in a relief. From the front, it is difficult to judge the depth relationship of each surface, so the viewer makes assumptions — the sculpture looks shallow (comp. Fig. 1). From the right or left side, however, the sculpture appears either massively constructed or full of hollow depth. The contradictions of *Cubist Bust* make the viewer aware that his visual perception of volume is illusory. The surface provokes the viewer to make assumptions about the volume of the whole and then to recognize that much of what the viewer thinks he sees is produced by his own imagination. Gutfreund wanted his works to access inner experience — the artist's and

14 Gutfreund (1913: 137).

Cut & Paste in Exile and War
Otto Gutfreund's Parisian Collages

Fig. 6

Otto Gutfreund, *Kubistické poprsí* [Cubist Bust], view from the left, 1913–1914. National Gallery in Prague

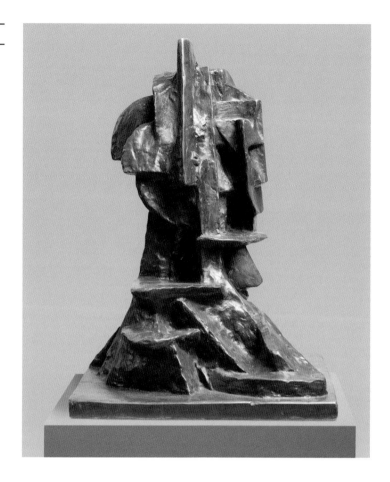

the viewer's — without using subjective content, that is, avoiding the personal and the confessional. He believed one of the basic components of sculpture was that it is constructed with an audience in mind. Unlike an object in nature, he wrote, "that has grown independently of a viewer," sculpture "unfolds before and for us." A sculpture's "dramatic expression is generated by its particular relationship to the viewer."[15] Gutfreund recognized that his role as an artist was to make use of that relationship, to manipulate the viewer's attention to his works as constitutive of their meaning.

As the viewer moves around *Cubist Bust*, her expectations of its shape and volume are repeatedly unsettled. To further call our attention to this, the dislocations also generate representations of very different psychological states. From the right side, the overall impression is of an

15 Gutfreund (1913: 137).

abstracted, but sturdy, solid sculpture of a human bust (Fig. 5). The figure seems stiff and unemotional, standing at attention, perhaps even armored. But from the front, the perforations suggest a more fragile figure and although it is still abstract, there is a melancholy air to the face that seems somehow suspended from an irregular armature (comp. Fig. 1). From the left we see behind the two-dimensional surface of the sad face we saw from the front (Fig. 6). That surface now appears to be a mask that hides yet another face, this one with a serious set to the jaw. This grave face is not martial, however, as the right side was, but rather somehow reserved, sitting back as it does over the shelf-like protrusions that exaggerate the figure's shoulder. As we move around Gutfreund's sculpture, not only are our expectations about mass and volume repeatedly upset, but the character of the represented figure changes. Gutfreund shifts the figure's psychology right before our eyes. He undermines psychological continuity simultaneously as he denies our assumptions about the figure's physical dimensions.

From Dimensional Confusion to Perceptual Subjectivity: Gutfreund's Drawings and Collages

Gutfreund experimented with how to suggest unstable forms in drawings as well as sculpture.[16] In the drawing *Cubist Composition — Head* (*Kubistická kompozice — Hlava*, 1912–1913) vertical planes seem to lie parallel with the page, each of them separate, perhaps containing a facial feature, but some simply blank (Fig. 7).[17] None by itself would suggest a face, but layered one over the other they coalesce to depict a head. Each element looks like a two-dimensional plane lying over the others, but this contrasts with suggestions elsewhere of three dimensions, such as a cube at the top and a cylindrical base. Gutfreund played with two and three dimensions in numerous drawings of both heads and still lifes at this time. He used shading in some areas to insist on the illusion of three-dimensions but other lines contradict this illusion.

16 None of his sculptures from this period survive, but Emil Filla later described seeing remarkable sculptures probably modeled in wax in Gutfreund's Parisian studio. See: Šetlík (1989: 276).

17 Šetlík (1989) dates this drawing to 1913–1914.

Fig. 7

Otto Gutfreund, *Kubistická kompozice — Hlava* [Cubist Composition — Head], 1912–1913. National Gallery in Prague

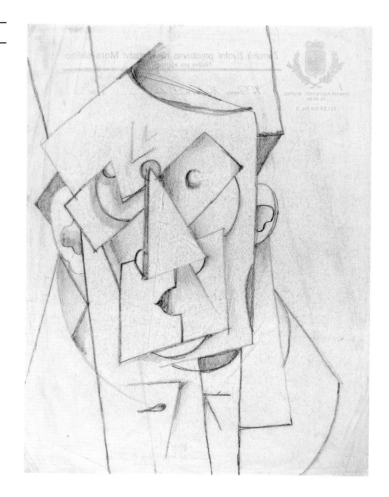

Gutfreund simplified the cylinder shape down to a rectangle with a semi-circle cut out of its base and he reduced the suggestions of the neck or brim of a hat down to abstract angles or sharp triangles. He also inverted these geometric forms in still lifes: the semi-circle became the opening at the top of a pitcher and triangles became its spout or foot (Fig. 8). In fact, in 1988 Miroslav Lamač reproduced this watercolor, oriented so that we see a still life, and called it *Still Life with Jug* (*Zátiší se džbánem*, 1913–1914), while a year later, Jiří Šetlík reproduced it the other way up and called it *Study of a Head* (*Studie hlavy*).[18] Gutfreund simplified his forms to the extent that they can refer to both head and jug. In drawings, Gutfreund

18 Lamač (1988: 405); Šetlík (1989: Fig. 111, n.p.). In his 2012 book on Gutfreund, Šetlík reproduced it the other way up but still called it *Study of a Head*. Šetlík (2012: 136).

Fig. 8

Otto Gutfreund, *Hlava (Kubistická kompozice)* [Head (Cubistic Composition)], 1911–1913. Olomouc Museum of Art

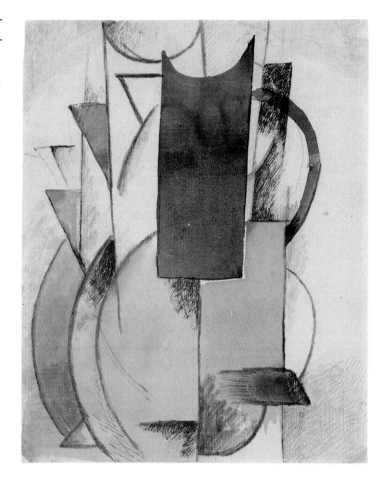

continued to use formal, not emotional, means to get the viewer to think about how we project meaning onto marks on paper or onto objects in space. As does *Cubist Bust*, the drawings lead us to produce "subjective concepts" of objects or people in the world, and to recognize them as projections of our own minds.[19] Gutfreund stresses the subjectivity of point of view, how we continually construct our versions of reality from a combination of past experience and current vantage point. But he didn't want merely to depict this idea, he wanted his works to generate and call attention to a viewer's experience of it.

Gutfreund visited Picasso's studio in April 1914.[20] The collages he began to make that month are visually related

19 Gutfreund (1913: 137).
20 Gutfreund, letter to his mother, undated (likely end of April 1914), in: Šetlík (1989: 122).

Cut & Paste in Exile and War
Otto Gutfreund's Parisian Collages

to a series of drawings of heads and café still lifes in ink and charcoal with pasted papers, that Picasso made in late 1912.[21] Using collage and especially lowly newsprint in art was unprecedented and would have seemed outrageous to most viewers in 1912.[22] Unsold, many of these works were still in Picasso's studio in early 1914.[23] Like Gutfreund, Picasso repeatedly used a half-circle at the base of his *Heads* to suggest neck or shoulders, and he used circular shapes at the base of rectangles to indicate the bottoms of bottles or glasses in the still lifes. Despite the fact that his 1912 works simplified forms and included both figures and still lifes, however, Picasso didn't blur the lines between head and still life as Gutfreund did.

Gutfreund used a full newspaper page as the ground in *Head* (*Hlava*) to wittily suggest the ephemera — sports and *faits divers* — filling the mind of the metropolitan man (comp. Fig. 2). Picasso also used the full sheet of newspaper in his *Bottle on a Table* (*Bouteille sur une table*) and similarly contrasted pasted blank paper with a sparing use of drawn straight lines and curves (Fig. 9). In *Head*, the newspaper content stands abstractly for ideas in the mind, but Picasso's still life suggests how newspapers permeate the café space. One of the enduring debates over Picasso's collages is whether the content and context of the news matters.[24] Patricia Leighten asserts the centrality of contemporary political developments to Picasso's collages of 1912–1914, given that over half of the newspaper texts refer to the contemporaneous Balkan wars or European economics and politics.[25] Rosalind Krauss argues that his collages engage issues

21 Daix (1979: 291, 294). Seven of the drawings are of the head of a man or woman, Daix (1979: no. 532–534, 536–539), while 13 are still lifes of tables with bottles and glasses.
22 Leighten (1989: 131).
23 Leighten (1989: 126). Leighten cites Michael Baxandall on other decisions by Picasso in this period that "cannot be presented as a commercially directed strategy." Baxandall (1985: 53–55). Several of these papiers collés were not sold until the 1920s and one (no. 551) was still in the Picasso estate in 1979. Picasso made about 80 collages in 1912 and 1913, but by the end of that year he had returned to painting. He used newsprint in only 4 collages in 1914. Leighten (1989: 128–129).
24 Cottington (1998: 123–127).
25 Leighten (1989: 121).

NATIONALISM AND COSMOPOLITANISM IN THE AVANT-GARDE AND MODERNISM
The Impact of the First World War

Fig. 9

Pablo Picasso, *Bouteille sur une table* [Bottle on a Table], 1912. Musée national Picasso-Paris, Paris

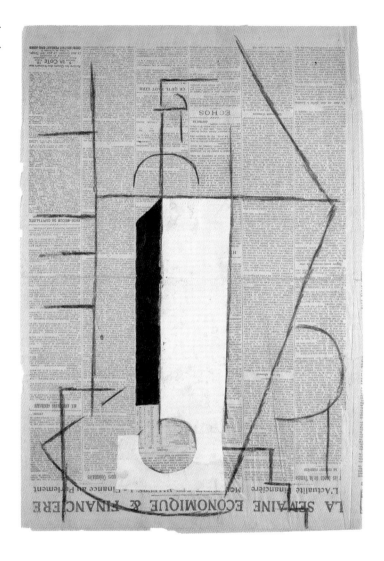

of "reference, representation, and signification", and that to attend to the content of the newsprint is reductive. She objects to the urge to decode the works using the pasted text to identify objects or ideas and claims the newsprint in the collages both stands in for and signals the absence of space.[26] Picasso's inversion of the newspaper page and his use of it as ground for this still life do encourage us to think of it as surrounding space rather than focal point. Yet the consistent content in so much of the newsprint he used suggests a function of the text beyond the formal. And in this case, despite inverting the page, Picasso maintained the legibility of the text as he did in the majority

26 Krauss (1986: 32–33).

Cut & Paste in Exile and War
Otto Gutfreund's Parisian Collages

of the collages. Here, he used the financial page from *Le Journal* of December 3, 1912, the date of the armistice that ended the First Balkan War. The financial news reported the economic impact of the treaty and described stock markets plunging while the great powers met in London to balance conflicting Balkan interests.[27] Scholars who do think the newspaper content matters, however, still disagree about how the content relates to Picasso's point of view. For example, Leighten argues that this collage shows Picasso's concern about the direct connection between war and the economy. David Cottington argues that we can't identify Picasso's stance so easily. In Gutfreund's collages, I argue that the content of the newspaper is indeed crucial, but it does not straightforwardly represent the artist's views or allegiances.

Using blue, purple, and green chalk or crayon, Gutfreund uses a minimum of lines to conjure the head and neck of a top-hatted man (comp. Fig. 2). He indicates an ear with a small double curve on the left, and the cylinder that seems to emerge from the forehead cleverly calls to mind the Czech word for top hat — *cylindr* — while also contrasting with the apparent concavity of the shapes below that nevertheless suggest a neck. Gutfreund's drawing on the newspaper contains the elements of both head and still life jug that we saw in his drawings — the curves for rounded head or handle, the angle jutting out for neck or spout (at bottom left, but also top right), the various rectangular elements with curves cut out of them. By using these shapes, Gutfreund abstracts the head, downplaying the psychological element of naturalistic portraits and emphasizing this figure's existence as both person and object.

In Gutfreund's *Head*, it is a sports page from April 20, 1914, that serves as the ground. Reports on competition results under the headings, "Automobilisme" and "Cyclisme", must have almost farcically reminded Gutfreund of the ever-expanding invention of art world "-isms". He draws the head to the left side of the page, filling it with sports results and centering "automobilisme" on its chin. He wittily fills the head with the trivial data city-dwellers encounter daily. He also appears to have composed the

27 Leighten (1989: 127–128).

head with a view to the graphic composition of the whole newspaper page, which already features four other heads, all of them far more representational than his drawing.[28]

The newspaper page Gutfreund used for his head includes the sections "À travers Paris", and "faits divers", collections of reports forming the odd juxtapositions — car-racing and colds, payment plans and theft — that the cosmopolitan urbanite encounters daily without a second thought.[29] To the left of Gutfreund's drawing a headline asserting that we need to "Cleanse the Blood in Spring", leads into a series of ads for doctors' cures. Gutfreund fills his head with modern diversions, leaving to the side the physical body and its ailments, from which the metropolitan man is distracting himself. In many collages after 1912, Picasso also incorporated news texts about illnesses and cures and other personal issues.[30] Some scholars read this as a retreat from political engagement while others see it as an indicator that the content matters, but that its relationship to the artist's beliefs remains ambiguous.

Gutfreund chose to draw his head on this page perhaps to take advantage of the juxtaposition of mental diversion and physical being. Maybe he wanted to contrast his abstract head to the printed heads already on the page. Gutfreund's interest in the viewer's experience of an artwork suggests that the page is not arbitrary. News fragments' visual and textual components compete for the viewer's attention in Picasso's collages. The continuing debate over the relative importance of collaged newspaper's formal appearance and textual information testifies to the effectiveness of this competition. Gutfreund's experience of Picasso's collages intrigued him enough to try to produce his own in which, as I will show, he emphasizes the dual purpose of the newspaper

28 In one, a doctor consults with a patient about his cold and in another, a large monocled, cigar-smoking man buys his girlfriend — a diminutive woman in an enormous hat — jewellery and fine cars because that's "what it takes to be happy."

29 The right side of the page, which Gutfreund leaves unmarked, includes the section "À travers Paris", containing short pieces about minor incidents throughout the city — a young American caught stealing to repay gambling debts, a conference of the Parisian furniture makers' union, and other "faits divers".

30 Leighten (1989: 121).

as object and purveyor of ideas. I think he understood the newspaper to function analogously to the simplified forms he had developed to refer to aspects of both objects and people. Gutfreund brings his ambiguously drawn facial elements into conversation with the specificity of newspaper reports and four clearly representational heads. He draws all these elements together in a witty representation of the modern man's mind and body. The viewer is as mentally engaged with car racing, theft, unions, and advertisements as is the portrayed figure. Gutfreund offers the viewer the same experience as that of the depicted figure — that of distraction by ephemeral information. But the construction of this head from the attributes of an object — a jug — reminds the viewer that he is looking at an object, that he has projected his own mental experience of the news onto a few minimal lines sketched on newsprint.

While the *Head* collage seems lighthearted, it serves a serious purpose for Gutfreund. In collage, he discovered a way to both depict objects and to generate subjective experience in the viewer. He offers for the viewer the distracted leisure pursuits of the modern man as distractions from the ostensible subject of the image — the head. He leads the viewer to experience shifts between image and text as embodying the disconnect between mind and body, abstract thought and concrete form. To make sense of Gutfreund's collages, the viewer needs to be aware of the shifts in her own attention between the content of the newspaper and its visual appearance. Gutfreund's belief that the viewer's experience generates meaning makes it clear that, while the content of the newspaper text matters, it operates independently from the artist's voice.

In one of his most ambitious newspaper collages, *Still Life with Bottle* Gutfreund uses the newspaper to further complicate the issues of experience and attention (comp. Fig. 3). The newspaper here represents itself as an object on a café table but its content also generates an awareness of multiple subjectivities. Gutfreund carefully cuts out headlines to preserve their legibility, and the content of the newspaper matters, but he demonstrates how ambiguous the relationship is between what the text says and what the artist thinks. While wittily playing with the means of representation, Gutfreund uses newsprint

to conjure the experience of an Austrian citizen in Paris upon the outbreak of war, a vantage that includes an awareness of alternate experiences within that context.

A blank piece of paper in the shape of a bottle dominates the image. Various curves — drawn or cut — suggest the outline of a round café table. The newspaper headline at the center of the collage includes "L'empereur François-Joseph", but the bottle prominently cuts the emperor's name in two. We know that on August 1, just four days before war was officially declared, Gutfreund registered his residence in Paris with the police. He joined the foreign legion on August 28 to fight on the side of France and the allies against Austria.[31] So it is tempting to read this gesture as violent, as a severing of ties with the empire, or as its metaphorical destruction through its figurehead.

But Gutfreund did not want to base his art on subjective expression. He wanted to lead viewers to abstract thought.[32] And in fact, it is the bottle that severs the headline. Perhaps Gutfreund is referring to the way liquid in a glass container distorts and appears to sever objects seen through it. So we can read the break in the emperor's name as an accidental illusion created by the bottle sitting on the paper. And this is a clever way of reminding us of an optical illusion that Gutfreund hasn't actually rendered here. It is also a way to raise the issue of his shift in national allegiance without personalizing it. This collage is not a subjective expression of an individual's anxiety about the outbreak of war. Gutfreund privileged the determining role of the viewer in constituting the meaning of an artwork and he deploys newspaper text in a way that reminds us of how meaning is generated differently in both the writer's and the reader's minds.

The most prominent headlines in *Still Life with Bottle* are pasted diagonally, with the text oriented toward the artist, or at a reader sitting on this side of the table. If we imagine this collage as representing the artist's viewpoint, his experience of reading a newspaper in a café, then we read the large headlines as the news stories of most significance to the artist, such as the article

31 Šetlík (1989: 291).
32 Šetlík (1995: 13).

about the emperor of the country from which Gutfreund has exiled himself. But the headlines also refer to newspapers themselves, the objects with which Gutfreund is experimenting. He includes a headline about French and foreign newspapers, reminding the viewer that a paper's origin shapes its content and views. The large lettering, oriented toward the viewer, suggests the experience of someone for whom the headlines of the daily news jump out, for whom reading the news is to be confronted with the big issues of the day, to be reminded that one is reading a French newspaper and that one is foreign.

The large text and bold letters of the newspaper headlines draw our attention right away. But the smaller text that forms the majority of the newsprint in the collage is angled the other way, and cut so we see it as visually constituting the table top. But we could also understand it as oriented toward someone sitting on the opposite side of the table. This text is small and varied and concerns such topics as the judgement of a French tribunal, something primitively designed, travel, a car accident. There is mention of an aviator and of someone fainting. This selection of newspaper suggests the experience of a person browsing through the news, reading stories of greater and lesser importance. This is the experience of someone for whom the emperor of Austria has little immediate importance, someone who is not self-conscious about reading French rather than "foreign" newspapers. These newspaper clippings suggest a reader with an entirely different experience of the news and indeed, of the contemporary world.

What Gutfreund produces in this collage, then, is an evocation of multiple experiences of a morning at a café. The image offers the viewer a scene of still life objects, but also generates an awareness of other subjectivities experiencing those objects differently. Newspaper allows Gutfreund to evoke objects and subjects simultaneously, stressing the experience of an artwork (like the experience of reading a newspaper) as dependent upon the viewer. Whether prompted by the newspaper as object or by the news as ideas, the collage evokes the conflicted experience of a foreigner in Paris upon the outbreak of war as one acutely aware of alternate experiences of that event.

Conclusion

The collages Gutfreund made in Paris register a response to Picasso's collages that emphasizes the content of the newspaper while highlighting the ambiguity of the relationship between the artist and the newspaper's content. Gutfreund casts the newspaper content as distracted thought and reminder of the body in *Head*, and makes the viewer self-conscious of projecting his or her own experience onto marks on paper.

The newsprint is also both physical entity and generator of experience in *Still Life with Bottle*. In each, the news is something both artist and viewer absorb and reconfigure. Gutfreund's artistic ideal was for the "abstraction embodied in concrete form [to] become abstraction again for the viewer."[33] Newspaper collage offered him a way to embody his abstract experience in a concrete object that generates abstract experience again in the viewer.

These collages show how one contemporary viewer understood Picasso's collages after seeing them with the artist in his studio. This could impact how we approach Picasso's collages. But more importantly, Gutfreund's Parisian collages testify to a Central European artist's direct response to new ideas and shows him engaging with those ideas on his own terms, putting new techniques to work to further explore issues he had long been concerned with. *Cubist Bust*, *Head* and *Still Life with Bottle* are all non-mimetic works whose form isn't just arbitrarily generated by personal feeling. And though they do so in different ways, all of them prompt the viewer to abstract thought and suggest the relativity and unreliability of a single point of view.

33 Gutfreund (1913: 137).

The Great War and the New Art in Poland

Between Patriotic Ethos, Nationalization of Modernism, and International Attempts in Aesthetics

Lidia Głuchowska
University of Zielona Góra, Institute of Visual Arts. Poland

Abstract

During the Great War the annexationist armies — Russian, Prusso-German, and Austro-Hungarian — recruited about two million Poles. Artists fighting in foreign uniforms left ambiguous records as to their patriotic duty, an example of which are the five self-portraits by Witkacy, who served in the elite Tsarist unit, and whose accompanying paintings depicted ironic roles.

As the Polish issue was marginalized in European political debates, many Poles perceived the world military conflict as a "foreign war". Following the aim of national liberation, Polish politicians advocated different views of the shape of the new state, which had lost its independence in 1795. While Józef Piłsudski referred to the frontiers of the former Republic of Nobles and planned to recreate it with the aid of the Polish Legions created on the Austro-Hungarian side, Roman Dmowski wanted to establish a nationally homogenous country and insisted on recovering the land to the West — alluding to the medieval tradition of the middle-aged Piast dynasty — and to realize that vision with the support of Russia.

As the "foreign war" came to an end, "our" one continued. The military conflicts with Ukraine, Czechoslovakia and Soviet Russia lasted until 1922. Polish dominance in the Vilnius region from 1920 to 1939 was the cause of permanent conflict with the Lithuanians.

The Soviet invasion of Poland was opposed not only by military action, but also through the "war of paintings", e.g. carricatures, in which defending Christian Europe against the infidels was associated with the legendary victory of Polish King Jan Sobieski III over the Turks in Vienna (1683). Earlier, the German occupants used popular culture for propaganda purposes, especially film, for example the famous anti-Tsarist movie *The Devil's Pawn* made in the Jewish quartier of Warsaw and featuring the future Hollywood star, Pola Negri.

During WWI the voluntary enlistment of almost two hundred artists into the Polish Legions to fight for Austria-Hungary against Russia was an exceptional phenomenon on a European scale. They represented the national spiritual elite and created their legend in both

The Great War and the New Art in Poland
Between Patriotic Ethos, Nationalization of Modernism,
and International Attempts in Aesthetics

word and image. Women were not allowed to join the military service, however some female artists served in these patriotic units thanks to masculine disguises and pseudonyms. The legions' artistic output consisted mostly of portraits, but there were also more symbolic compositions, such as the parareligious depiction of Piłsudski as St. George fighting the dragon, or the legions' Nike, whose provocative nudity typified the freeing of Poland and rejection of all oppression.

Most of the war exhibitions by Polish artists took place in Paris to illustrate the solidarity of the Poles with the allies, however it is one organized in April 1916, in Moscow's gallery Lemercier, with other contributions from Russians, Lithuanians, Latvians, Belarusians, Ukrainians and Czechs, which merits particular attention, as Kazimir Malevich, descendant of the Polish nobles' family displayed his works within the Polish, not Ukrainian or Russian section, and drafted his unpublished manifesto to artistic youth written in Polish, the mother tongue in his family home, thus establishing himself as the representative for many artists of multiple national identity at this time.

While artists and literarians supported politicians developing concepts of the new state and creating works for uplifting spirits — such as the national style in architecture — some monarchists tried to realize their retrospective utopia, for example the unfinished construction of the royal castle planned as a residence of Olgierd Czartoryski and his wife Mechthildis von Habsburg-Lothringen in Stary Sielec near Jutrosin (Western Poland).

Around the end of WWI three groups representing new art emerged in Poland *Bunt* [Rebellion] in Poznań (western part of occupied Poland), *Ekspresjoniści Polscy* [Polish Expressionists] in Austro-Hungarian Cracow, and *Yung Yidish* [Young Yiddish] in Łódź, the former Russian dominated territory. All the members of *Bunt* had earlier belonged to patriotic Polish conspiracy organizations, but they also manifested the pacifist international spirit of the "new community", organized their second exhibition in Berlin *Die Aktion*'s editing house, and later cooperated with *Yung Yidish*. *Ekspresjoniści Polscy* (founded 1917), following Polish folk art patterns, changed its name to

the *Formiści* [Formists] in 1919, to detach itself from the leftist-radical political orientation of the "German" Expressionists and to highlight their pursuit of the new form, which they also espoused through close contact with the *École de Paris* and the Jewish-Polish art critics' embracing of this milieu.

In the interwar period in Germany, national-socialists called Poland the "seasonal country", and Polish public opinion was shaped by the legends of heroic national martyrology. Sentimental pictures preserved the myth of the Polish Legions and glorified the Great War. Polonization of Expressionism and modernism in its entirety followed. The flagship of the new state became the official style, referring to folk art and Art Deco. The members of *Formiści* have been celebrated for decades as its anticipators.

At the onset of WWII, Stanisław Kubicki from *Bunt* joined the Polish resistance movement and was subsequently murdered by the Nazis. Jankel Adler from *Yung Yidish* served in the Polish Army, lived in England for many years after communism took hold in Poland, but never renounced his Polish citizenship. Neither group would be honoured with a common retrospective exhibition until 2019, following the centenary celebrations of the avant-garde and the independence of the Polish new state.

Key words

the First World War, Poland, war of independence, national style, Art Deco, new state, international identity, multicultural tradition, national minorities, war, propaganda, popular culture

The Great War and the New Art in Poland
Between Patriotic Ethos, Nationalization of Modernism,
and International Attempts in Aesthetics

The "Foreign War" and the New State

"En Pologne. C'est-à-dire Nulle Part"
["In Poland. That means nowhere"]
Alfred Jarry on the setting of his play *Ubu Roi* (1896)

The Great War was a time of innovation as well as references to tradition in Polish art. Artists and writers transposed their experiences of military service into art, not only in order to document the war, but also as a means of looking back on a revival of the romantic utopia of the Polish-Lithuanian Republic of Nobles (*Rzeczpospolita Szlachecka*). At the same time, these artists and writers supported politicians in clarifying their vision of the new state. Although the debates regarding a new form in art took place in Poland, the unfavorable geopolitical location of the new state, which in the early 1920s fought to establish new borders, led to the nationalization of the modern form in Polish art and literature. The international avant-garde never became fashionable and the new country's hallmark became the national style, which alluded to folk art and Art Deco.[1]

In a Foreign Uniform

The First World War left a deep scar on art in Poland, a country which in 1795 lost its national independence and was divided between Russia, Prussia, and Austria (Austria-Hungary). Numerous artists were drafted into the armies of the annexationist countries and regarded the role they were forced to play with ambivalent feelings. One of them was the co-founder of the first early avant-garde art magazine of Poland — *Zdrój* [Source, 1918-1922] — Witold Hulewicz. In its pages he published translations of poems from the front, which were originally published in the pacifist literary art magazine from Berlin, *Die Aktion* (1911–1932). It is probable that the letters from the front addressed from an anonymous soldier to his mother were also written by Witold Hulewicz. They

1 This article is the result of studies carried out as part of the NPRH project *The Yiddish Avant-Garde in Łódź: Critical Edition of Sources* supervised by Professor Krystyna Radziszewska from the Institute of German Studies at the University of Łódź. Some theses presented here were published in: Głuchowska (2014a) and in Głuchowska (2015c). See also: Głuchowska (2020a); Głuchowska (2022a).

were published as documents of trench warfare during the war under the title "Listy z Belgii" ["Letters from Belgium"] in the *Kurier Poznański* [Courier of Poznań]. In one from April 14, 1916, the author writes in a distinctly dry tone: "Rats are elbowing in more and more. In the meantime we got used to sharing bread, sausage and milk with them. [...] However that's not enough for them. They throw such orgies that you can't sleep. Sometimes when I sit over my book and I read: a rat's maul comes out from a hole... that's how we look at each other questioningly."[2] Two days later he reflected with sarcasm: "My wound dressing was changed, I was given something to drink and to eat — morphine and cigarettes for dessert." One sentence from a letter he wrote at the Somme in September 1916 — "I find a helmet, put it on and look like Lohengrin in it"[3] — seems to correspond with Hulewicz's photo from the front (Fig. 1).

In his provocatively stylish self-portrait[4] *Multiple Portrait in a Russian Infantry Uniform* (*Portret wielokrotny w mundurze rosyjskiej piechoty*, 1917) Stanisław Ignacy Witkiewicz, later known under the pseudonym Witkacy,[5] posed in melancholic self-reflection, facing his patriotic duty and participation in the battle for Poland's independence with mixed feelings.[6] At the war's onset, Witkiewicz participated in an ethnographic expedition to New Guinea and did not manage to make his way to Cracow. Because he was unable to join the Polish Legions, he left for St. Petersburg and from September 1915 served in the Tsarist elite Pavlov Regiment until July 1916, when he was badly wounded. Later he applied to the Polish rifle division which had been formed in Kiev, but was not accepted because of a surplus of officers.

At a time when self-portraits of Russian officers in uniform were exceptional, as the most illustrious of them

2 Karaś (2004: 15).
3 Karaś (2004: 17, 18, 22).
4 See: text by Lidia Głuchowska, *International Expressionism...* in this volume and the reproduction in: Głuchowska (2014a: 293).
5 Witkiewicz was an ex-dandy who later became famous as a member of the *Formiści* [Formists, 1917–1922] group and as the "*pontifex maximus* of catastrophism". See: Piotrowski (1989: 92, 114); Geron (2012); Strożek (2013); Geron (2015).
6 Jurecki (2003: 280–281).

The Great War and the New Art in Poland
Between Patriotic Ethos, Nationalization of Modernism,
and International Attempts in Aesthetics

Fig. 1

Witold Hulewicz at the
Western Front, c. 1916

were able to obtain exemption from military duty,[7] Wit-
kacy made at least five self-portraits during the war,[8]
adopting ironic roles in some. In the earliest example
(from September 19, 1917), he presented himself in pa-
rade uniform, likely alluding to his famous 18th-centu-
ry ancestor Wallenrod who made his name as a Polish
national hero–conspirator in the Tsar's army. In the
painting *Self-Portrait as a Sick Soldier* (*Autoportret jako
chory żołnierz*, February 17, 1917), created shortly after
Witkacy was wounded at the front, the artist included
the inscription "Uprasza się nie zawracać głowy talentem"
["You are kindly requested not to bother the head with
talent"]. This indicated Witkacy's bitterness regarding the

7 See: Raev (2014: 322).
8 *Autoportret w gwardyjskim czaku* [Self-Portrait in the Guardsman
 Chuck], Sept. 19, 1917, copy from Jan. 9, 1919, Muzeum Narodowe,
 Cracow; *Autoportret z samowarem* [Self-Portrait with a Samovar],
 Feb. 17, 1917, priv. coll.; *Autoportret w mundurze* [Self-Portrait in the
 Uniform], July 24, 1917, Muzeum Narodowe, Cracow; *Autoportret*
 [Self-Portrait], c. 1915–1918, Muzeum Jacka Malczewskiego, Radom.
 See repr. in: Niedziałkowska (2014). In the self-portrait *Ostatni
 papieros skazańca* [The Condemned Man's Last Cigarette], 1924,
 Muzeum Literatury, Warsaw. Witkacy references his experiences
 of the war and revolution. See: Głuchowska (2018c: 402–404).

impossibility of reconciling art and war,[9] a feeling also expressed in the famous saying *inter arma silent Musae* (in other words: when society is under any kind of stress or in an extreme situation, creativity suffers). The bitter fate of Polish soldier-artists who served in the Tsarist, Prussian, and Austro-Hungarian Armies and in the Polish units in France are reflected in, for example, the first verses of the poem by Edward Słoński:

> Evil fate has divided us, my brother,
> and stands guard —
> in two hostile trenches
> we stare death in the face.[10]

Very popular at this time, the poem was also quoted by the mother of another artist associated with the aforementioned magazine *Zdrój*, Stanisław Kubicki, in one of her letters to his brothers who had also been drafted into the German Army.[11] The title of the poem "Tej co nie zginęła" ["That which has not perished" — that is Poland] refers to the lyrics of the Polish anthem, originally the battle song of the Polish Legions in Napoleon's army under the command of General Jan Henryk Dąbrowski.[12] The work, composed in September 1914, expresses the exceptional experience of fratricidal war which became the fate of hundreds of Polish soldiers who were drafted into the annexationist armies. Their fate was shared only with the Jewish people who lived in the areas of the former Polish-Lithuanian Commonwealth in 1914. Nowhere in Europe did they live in greater concentration. And nowhere did their culture — both the traditional and the new, secular Yiddish one — flourish as much as it did there.[13]

9 Niedziałkowska (2013: 369–386); Niedziałkowska (2014).
10 English transl. from: Segel (1999: 63).
11 Sokołowska (2014: 148).
12 Comp. Segel (1999: 63).
13 Roshwald (1999: 90, 97); Simon (1978: 101–102); see: texts by Lidia Głuchowska, *The Jewish Artistic Networks...*, and *International Expressionism...* in this volume; Głuchowska (2012b: 143–145); Głuchowska (2022a: 157–167); Głuchowska (2022b).

224

The Great War and the New Art in Poland
Between Patriotic Ethos, Nationalization of Modernism,
and International Attempts in Aesthetics

"Foreign War" versus "Ours"

The world military conflict of 1914–1918 felt for the Polish people like a "foreign war", because the so-called Polish issue was marginalized in European political debates.[14] Simultaneously, until the end of the war the annexationist armies recruited about two million Poles. Despite the fact that the loss of people incurred in the occupant armies was enormous (statistics say about 400,000 of those killed or lost in action were Poles),[15] Polish society felt the same spirit of rejuvination as other nations who participated in the war.[16] The sense of a breakthrough moment, however, was inspired by different sentiments than, for example, in Germay. Poles counted on the actualization of a national myth: the revival of a retrospective utopia of the former Republic of Nobles, cultivated, at least, since the time of Romanticism.[17] In Polish art and literature during WWI, the turn of perspective typical for avant-garde artists in other parts of Europe arose from the hope for restitution of the independent nation: "When for many avant-garde artists in Eastern and Western Europe the war was a legitimate or 'hygienic' means to destroy the old order, at the Wisła [Vistula] river there were dreams of reconstructing a new order, but one based in tradition."[18] On the eve of WWI many Poles believed that, finally, the prayer of the national poet-prophet Adam Mickiewicz had been answered. In the *Księgi narodu polskiego i pielgrzymstwa polskiego* [Books of the Polish Nation and the Polish Pilgrimage, 1832] Mickiewicz wrote:

> For a great war for the nation's freedom
> We are asking you Lord.
> For the arms and banners for the nation
> We are asking you Lord.[19]

Meanwhile, Polish politicians did not agree on how the historic opportunity should be seized. Their calculations for the future referred mainly to two of the annexationist

14 Mansbach (1999: 83).
15 Rydel (2011: 526, 528).
16 Eksteins (1989: 93–150).
17 Turowski (1986: 181–183).
18 Schuler/Gawlik (2003: 13).
19 Quot. and transl. from: Segel (1999: 64).

NATIONALISM AND COSMOPOLITANISM IN THE AVANT-GARDE AND MODERNISM
The Impact of the First World War

countries: Austria-Hungary and Russia. Only a few assumed that the utopian reconstruction of the Republic of Poland was possible through a coalition with Prussia. The belief in a Polish-German alliance was exceptional, expressed by only some in artistic circles, including the famous Polish-German writer Stanisław Przybyszewski, "the genius Pole" and father of the Polish avant-garde in 1890s Berlin, who wrote in German in his brochure *Polen und der Heilige Krieg* [Poland and the Holy War, 1916].[20]

The debates of the time over the shape of the long-awaited new state took place in an atmosphere of harsh polemic. In his vision for the borders of the future country, the leading Polish politician and later Marshal, Józef Piłsudski, referred to the frontiers of the former Republic of Nobles. He planned to recreate the Polish state with the aid of the Polish Legions created on the Austro-Hungarian side. Contrary to Piłsudski, the leader of the Polish national democracy, Roman Dmowski, wanted to create his future fatherland as a nationally homogenous country and insisted that — in an allusion to the medieval tradition of the middle-aged Piast dynasty — Poland recover the land to the West and realize that vision with the support of Russia.[21]

Meanwhile the facts allowed no delusions: the new borders of the Second Republic of Poland proclaimed on November 11, 1918 had to be consolidated with arms in hand. In the collective consciousness of Poles, WWI had therefore not come to an end, as the fight for national independence had to be continued. The restitution of Poland in an entirely new shape turned out to be a compromise between "our" (Polish) vision and the vision of "others".[22] Bearing in mind the military conflicts with Ukraine (1918–1919), Czechoslovakia (January 23–30, 1919),[23] and Soviet Russia (1919–1921), in reality the shaping of the new state lasted until 1922.[24]

20 Przybyszewski (1916). See: Głuchowska, *International Expressionism...*
21 Kleßmann (2011: 538).
22 Schuler/Gawlik (2003: 10).
23 On the the Seven-Day War (*Sedmidenní válka*) see: text by Vojtěch Lahoda in this volume.
24 Holeczko-Kiel (2004: 140–141).

The Great War and the New Art in Poland
Between Patriotic Ethos, Nationalization of Modernism,
and International Attempts in Aesthetics

Fig. 2

Bogdan Nowakowski, poster for **Stanisław Dzikowski**'s, *"Powrót taty", czyli wojska rosyjskie zajmują Warszawę* ["Daddy's Return", i.e. the Russian Troops Invade Warsaw], 1917. Poster Museum at Wilanów, Division of the National Museum in Warsaw

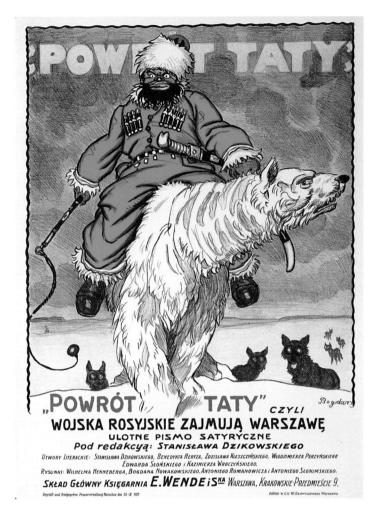

What was hard to achieve through *de facto* political-military actions alone required augmenting on a psychologicall level, with the help of visual propaganda. Shortly after the onset of WWI another war had started: the war of paintings. From 1915, the German occupants had subjected their soldiers to intensive propaganda against the Russian enemy in the former Russian partition. Many initiatives of a similar nature also came from the Poles. A typical example of this is the satirical leaflet titled *"Daddy's Return", i.e. The Russian Troops Invade Warsaw* (*"Powrót taty", czyli wojska rosyjskie zajmują Warszawę*, 1917; Fig. 2). It shows a Cossack riding a polar bear followed by a horde of scared wolves. The purpose of this picture is obvious: a historical enemy — "daddy" Russia — enters Poland once more, this time in the shape

Fig. 3

Jerzy Hulewicz, *Na tle Króla Ducha* [On the Background of the King the Spirit], 1919, front cover of magazine *Zdrój* IX/3 (November 1919)

ZDRÓJ

ROK 2 KWIECIEŃ 1918
TOM III. ZESZYT 1

DWUTYGODNIK POŚWIĘCONY SZTUCE
I KULTURZE UMYSŁOWEJ :-: :-: :-:

ADRES REDAKCYI I ADMINISTRACYI: OSTOJA — POZNAŃ PLAC WILHELMOWSKI 17.

ZESZYT „BUNTU".

TREŚĆ: Czytelniku pobożny — Adam Bederski. Krzyk — Stanisław Kubicki. Wiersze — Jomar Förste (spolszczył Nowina). Groteska moralna — Adam Bederski. Lucifer grzmi — Lech Suchowiak. Balada. Skarga młodzieńca po nocnej mitrędze. Sonet młody. Przeszłości — Adam Bederski. Do świętego Buntownika — Jerzy Hulewicz. Zwycięstwo — Małgorzata Kubicka (spolszczył Stanisław Kubicki). Fragment sceniczny z kantaty uroczystej z tańcem — Franz Werfel (spolszczył Nowina). Z cyklu „Dekadami — Lech Suchowiak. Uwagi o Sztuce — Stanisław Kubicki. Miscelanea. Zapowiedź wystawy „Buntu".

RYCINY: Drzeworyty: Jerzego Hulewicza, Małgorzaty Kubickiej, Stanisława Kubickiego, Władysława Skotarka, Stefana Szmaja, Jana Wronieckiego. Rysunki: Jerzego Hulewicza i Augusta Zamoyskiego.

of the Soviet revolutionary units, cast as ridiculous and primitive weaklings, unable to dominate the country upon the Wisła again.[25] The topos of Poland evoked in that caricature as *antemurale*, the ramparts of Christian Europe preventing the invasion of the infidel Asians (read: Russians), resembles the legendary victory of Polish King Jan Sobieski III over the Turks in Vienna (1683) which constitutes an essential component of the national historical narrative. This idea was resivited — in both traditional and modern depiction — during the Polish-Soviet war, shortly after WWI had officially ended. Jerzy Hulewicz, the main editor of the aformentioned *Zdrój* magazine, displayed on the journal's cover the Polish shock

25 Bartelik (2005: 16–17).

225

The Great War and the New Art in Poland
Between Patriotic Ethos, Nationalization of Modernism,
and International Attempts in Aesthetics

cavalry *husaria* [Polish Hussars/Winged Hussars][26] in an iconographically anachronic yet stylistically contemporary manner, evoking the Expressionist print. It was a metaphor of the win over the "barbaric" Russians which should have followed the win over the unchristian Turks in the 18th century (Fig. 3). The combination of traditional and narrative iconography, and the Expressionist form and medium, is a compromise between fulfilling patriotic duty and paying tribute to modernity — an attempt in this Polonization.[27]

Another example illustrating the "war of paintings" is the anonymous poster *This is How Each [Polish] Mark Given to the Polish Resurrection Fund Works* (*Tak działa każda marka zapisana na polską pożyczkę odrodzenia*, 1920), which is a caricature picture of the representatives of the former annexationist countries, with references to the pickelhaube and Cossack hat (Fig. 4). Equally suggestive is the poster Antoni Romanowicz created for the national referendum campaign in Upper Silesia *Free yourself from your oppressors! Vote for Poland* (*Wyzwól się od swoich gnębicieli! Głosuj za Polską/Befreie Dich von Deinen Bedrückern! Stimme für Polen*, 1920–1921).

While war propaganda was most often utilized by the annexationist and occupant countries, a mainly anti-war propaganda, mostly in the form of cabaret, blossomed under the influence of a local Polish initiative, which since 1922 had been experiencing a true renaissance. The leading Warsaw cabarets were *Sfinks* [Sphinx], *Argus*, *Czarny Kot* [Black Cat] and *Miraż* [Mirage], where Apolonia Chalupec (Chałupiec), later famous as Pola Negri, star of silent cinema, started her career.[28] At the same time the German occupants in Poland used popular culture, especially the attractive film medium, as a tool in the fight against the enemy. Under these circumstances, following

26 Polish Hussars/Winged Hussars: one of the main types of cavalry in Poland and in the Polish-Lithuanian Commonwealth between the 16th and 18th centuries. Modeled on the Hungarian Hussars, the early hussars were light cavalry of exiled Serbian warriors; by the second half of the 16th century and after King István Báthory's (Stefan Batory) reforms, hussars transformed into a heavily armored shock cavalry.
27 See: Głuchowska (2022b).
28 Segel (1999: 77).

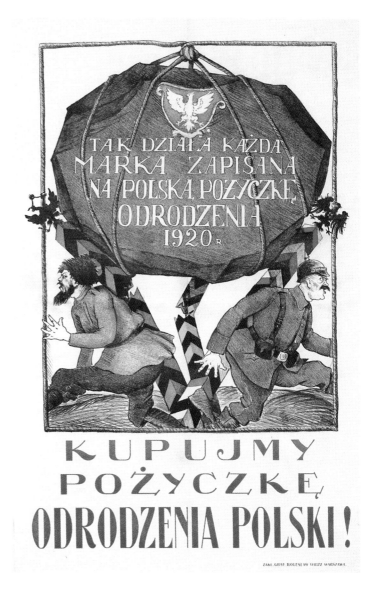

the renouncement of Tsarist censorship regarding the subject of the Jews, the German anti-Russian movie *The Devil's Pawn* (*Der gelbe Schein*, 1918) was made, taking as its topic the forced prostitution of women of Jewish origin in St. Petersburg. The main part was played by the aforementioned Polish-Roma actress Pola Negri (Fig. 5). The movie in fact is *nota bene* a remake of an earlier Polish production *Black Booklet* (*Czarna książeczka*, 1915), in which the main part was played by the same actress. In the years between 1914 and 1916, she acted in eight

The Great War and the New Art in Poland
Between Patriotic Ethos, Nationalization of Modernism,
and International Attempts in Aesthetics

Fig. 5

Josef Fenneker, film poster
Der gelbe Schein [The Devil's
Pawn], 1918. Stiftung Deutsche
Kinemathek — Museum für Film
und Fernsehen, Berlin

Polish films in Warsaw.[29] In May 1918, she made her debut in a German movie by Ernst Lubitsch *The Eyes of the Mummy Ma* (*Die Augen der Mumie Ma*), preceeding her post-war career in Hollywood.[30] *The Devil's Pawn* was one of a series of movies which were made in Warsaw thanks to the support of the Polish film agencies Kosmofilm and Sfinks and the German film companies UFA, BUFA and A.-G. Union. Usually these were propaganda documentaries, which in Polish public opinion were supposed to popularize the image of a liberal German occupant who gives the occupied nation not only cultural but also national freedom. The Germans also tried to use film media to popularize the celebration of anniversaries and national festivals. These events included the anniversary of the 3rd of May Constitution of 1791 (1916), the celebration of the opening of the university and the

29 Roshwald (1999: 119).
30 Szarota (2009: 64).

NATIONALISM AND COSMOPOLITANISM IN THE AVANT-GARDE AND MODERNISM
The Impact of the First World War

polytechnic in Warsaw (November 15, 1916), the ceremonial entry of the legions in the capital (December 1, 1916), and the convening of the Council of State and its first session (December 1916). In the spring of 1917 in Warsaw, a film bureau under the Polish Legions was formed. The same year, in cooperation with the agency Sfinks, it made a documentary commemorating the Polish 3rd of May Constitution of 1791. Amongst other Polish-German co-productions was the historical movie *Under the Yoke of the Tyrants. 125 years of Polish Servitude* (*Pod jarzmem tyranów. 125 lat polskiej niewoli*) which deserves particular attention. The patriotic enthusiasm after the Russians retreated from Warsaw was also expressed in such anti-Tsar movies as *Tsardom and its Servants* (*Carstwo i jego niewolnicy*, 1918) and *Tsar's Favorite* (*Carska faworyta*).[31]

Despite difficult war conditions in Poland, film was used not only for the purpose of propaganda but also for artistic experiments. An example of artistic experimentation with the new medium includes the attempts by Feliks Kuczkowski in Cracow to create the artistic, "colorful symphony" in film.[32] Similar initiatives were continued by other avant-garde artists in Germany and Poland soon after the end of the war.[33]

Meanwhile, the national fight extended further: in the years 1918–1921, military uprisings took place in Great Poland (the western part of Polish territories) and Silesia. In Upper Silesia, Warmia, and Masuria referendums which decided the shape of the border with Germany took place under the Versailles Treaty. As mentioned before, the border with Czechoslovakia was established only after a military struggle. Polish dominance in the Vilnius (Wilno/Vilna/Vilnja/Vilne) region from 1920 to 1939 was the cause of permanent conflict with the Lithuanians.[34] In that exceptionally tense geopolitical situation, cheering up society's spirit with the help of patriotic appeals, became an obligation which neither art nor literature could evade.

31 Segel (1999: 84).
32 Giżycki (2008: 290); comp. Irzykowski (1924: 219).
33 Głuchowska (2013b: 64).
34 Holeczko-Kiel (2004: 140–141).

The Great War and the New Art in Poland
Between Patriotic Ethos, Nationalization of Modernism,
and International Attempts in Aesthetics

The Legend of the Polish Legions in Word and Image

During WWI, the voluntary enlistment of almost two hundred painters and sculptors into the Polish Legions to fight alongside Austria-Hungary against Russia was an exceptional phenomenon on a European scale.[35] The germ of the legions were the riflemen unions started by Józef Piłsudski before the war in Cracow. In 1914 they were joined by numerous, primarily secret, (para)military organizations from all three partitions of Poland.[36] As the poem quoted above suggests, the formations referred to the model of the Dąbrowski's Polish Legions from Napoleon's time, and were soon to achieve legendary status of their own. However official Polish art history and the history of literature during the communist era subsequently doomed them to obscurity.[37]

With varying durations of enlistment, most of the artists who were active in the legions were students and graduates of Cracow's Fine Arts Academy (*Akademia Sztuk Pięknych w Krakowie*); included amongst them were later members of the group *Formiści* (until 1919 — *Ekspresjoniści Polscy*), Leon Chwistek, and the historicizing painter Tadeusz Pruszkowski. Moreover, the representatives of the middle generation, such as Leopold Gottlieb and his followers, did not join in active fighting due to their age. Amongst them was Leon Wyczółkowski, who in 1916 made a cycle of paintings with the legions as their theme. Women were not allowed to join the military service, however there were exceptions. Thanks to masculine disguises and pseudonyms, the painter Zofia Plewińska and the sculptress Zofia Trzcińska-Kamińska[38] served amongst the legion's 20,000 male soldiers. There was a similar case with the Ukrainian Riflemen formation, but the Ukrainian national hero, Olena Stepaniv, didn't have to hide her gender.[39]

The legions represented the spiritual elite of Poland, brought up in the romantic tradition and convinced of their mission in history. Their ethos is depicted in sketches created during breaks between battles, which documented

35 See: texts by Oksana Dudko, Ginta Gerharde-Upeniece, and Lidia Głuchowska, *International Expressionism...* in this volume.

36 Milewska/Zientara (1993: 161); Salamon (2003: 98–99).

37 Segel (1999: 64–65, 87).

38 Milewska/Zientara (1993: 168); Wyganowska (1993: 188).

39 See: text by Oksana Dudko in this volume.

representations of the army graves and military scenes, as well as daily life in the legions and portraits. Leopold Gottlieb alone made almost 1,000 portraits of soldiers and officers. Most of them are signed and dated precisely. Each time the artist also noted the surname, rank, and military unit of the portrayed person. The ideological value of these works was perceived as more important than their formal qualities. They became documents of "our war", a collective self-portrait of the voluntary military unit expressing self-awareness, and proudly manifesting its uniqueness amongst the annexationist countries' armies.[40]

After two years of fighting, in November 1916 the legions were separated from the Austro-Hungarian Army, removed from the front and handed over as the Polish Supportive Corps under German command. When in the summer of 1917 some legionnaires refused to swear allegiance to the Emperor, Piłsudski was placed in protective custody, from where he was freed at the end of the war to take up power in the newly-formed Polish state. The artists — former members of the Polish Legions — began preserving their myth in words and paintings.[41] However, barring a few exceptions, they did not leave artifacts which honored Piłsudski's role as a renowned commander and the embodiment of the national idea. The only artistic depictions of Piłsudski, such as the famous painting by Jacek Malczewski, the bust by Konstanty Laszczka ("Kraków, 1916"), and the watercolor by Julian Fałat ("Warszawa, 1917"), were created far from the front. It is striking that the praise of Piłsudski as a commander leading soldiers to battle was not the main focus. Only Gottlieb portrayed him surrounded by staff officers ("Dolne Tatry, grudzień 1914" [Lower Tatras, December 1914]).[42] Amongst other surviving works on this topic is the lithograph by Wojciech Jastrzębowski *Józef Piłsudski — Commander-in-Chief of Poland* (*Józef Piłsudski — Wódz Polski*) which portrayed the subject in August 1914 (comp. Fig. 6). The painting is a modern interpretation of Orthodox iconography. It depicts the Marshal on a white horse trampling over Russian dragoons, alluding to depictions

40 Milewska (2008: 24).
41 Segel (1999: 65–68).
42 Milewska/Zientara (1993: 182–183).

The Great War and the New Art in Poland
Between Patriotic Ethos, Nationalization of Modernism,
and International Attempts in Aesthetics

Wojciech Jastrzębowski,
Józef Piłsudski — Wódz Polski
[Józef Piłsudski — Commander-
in-Chief of Poland], 1914.
Museum of Independence
in Warsaw

of St. George's battle with the dragon. The parareligious significance of that scene is reinforced by the presence of a peasant family in the background, piously eyeing the panorama.[43] Similar iconography was popular during the war, as seen in works by the German Max Wislicenus and by the Pole Jerzy Hulewicz. It was symbolical, but far from the documentation of the military action.[44]

For obvious reasons those works which synthesized the events of that time were not created at the front. Only the designs of the stained glass windows by Jan Rembowski *Polonia* (1915/1916) and *War and Peace* (*Wojna i pokój*, 1917), have a symbolic dimension as well as the painting by Malczewski, *Polonia — Two Generations* (*Polonia — dwa pokolenia*, 1915), his triptych *Ezekiel's Prophecy* (*Proroctwo Ezechiela*, 1917–1918), and two

43 Bartelik (2005: 15).
44 See reproductions in: Głuchowska, *International Expressionism...* in this volume.

Fig. 7

Jacek Malczewski, *Nike Legionów*
[Nike of the Polish Legions], 1916.
Cracow Society of Friends
of Fine Arts

versions of *Legions' Nike* (*Nike Legionów*, 1916). The second of these in terms of composition and iconography resembles the popular draft posters addressed to the Polish people by the annexationists. The provocative nudity of Nike, which generated a scandal at the time on the other hand, symbolizes the freeing of Poland and rejection of all limitations.[45] Thus, with the help of appellative glorification, the legions' art turned away from the iconographic patterns of the enemy's propaganda (Fig. 7).

45 Wyganowska (1993: 174–175); Nowakowska-Sito (2011: 561).

The Great War and the New Art in Poland
Between Patriotic Ethos, Nationalization of Modernism,
and International Attempts in Aesthetics

Exhibitions, Cemeteries, and Monuments

It is significant that neither during the war, nor in the ensuing emigration, was it possible to organize many exhibitions by Polish artists. Most of them were presented in Paris. In particular they were supposed to illustrate the solidarity of the Poles with the allies. The fact that at one of them, *Exhibition of Polish Painters and Sculptors for the Benefit of the Polish War Victims* (*Exposition des peintres et sculpteurs polonais au profit des mutilés de l'armee polonaise*, November 1918), the presented works had such evocative titles, such as *President Wilson — the Liberator of Oppressed Nations* and *Victory of the Allies*, resulted in a revue describing the event as a "true monument in honor of the Great War".[46]

Amongst the exhibitions organized in Russia, it is worth recalling two in particular. The profits from the *Exhibition of Polish Artists' Works*, organized under difficult conditions in the St. Petersburg Anichkov Palace after the Soviet Revolution (May–June 1918) and including the work of Witkacy, was most probably intended, as in the case of the Parisian exhibition, for the benefit of Polish war victims.[47]

Another exhibition in April 1916, in Moscow's gallery Lemercier aimed at the integration of Polish artists, although it also included works by Russians, Lithuanians, Latvians, Belarusians, Ukrainians, and Czechs.[48] The participation of Kazimir Malevich (in Polish: Kazimierz Malewicz, in Russian: Kazimir Malevič), the heir of a Polish family of nobles, is worthy of attention, as his involvement in the exhibition was a testimony to his multinational identity. That attitude was typical for many artists of the international avant-garde.[49] *Nota bene* in the Polish context, multiethnic individuals included artists from within the orbit of the German gallery and magazine *Der Sturm* (1910–1932). The international identity of the remaining artists was either Polish-German (Franciszek/Franz Flaum and Stanisław Kubicki), Polish-Jewish (Stanisław Stückgold and Teresa Żarnower), Polish-French-Jewish (Ludwik Markus/Louis Marcoussius and Henryk/Henoch Berlewi), or Polish-Austrian-Jewish

46 Bartelik (2005: 44); see: Guillemont (1919).
47 Niedziałkowska (2014: 9).
48 Turowski (2002: 229).
49 Głuchowska (2012c: 456–457).

(Tadeusz Rittner).[50] In the international context there were similar cosmopolitan nomads, for example Romanian Tristan Tzara (Samuel Rosenstock), Marcel Janco (b. Iancu) and Constantin Brâncuși; Hungarian Ernst/Ernő Kállai and László Moholy-Nagy; Czech František Kupka; and Yugoslavian Ljubomir Micić. The phenomenon of multiethnicity did not refer solely to the citizens of the former Austro-Hungarian Empire or the Balkans, but also to the Baltic region from where the Latvians Kārlis Zāle/Karl Zālītis and Andrejs Kurcijs/Andrejs Kuršinskis, and the Lithuanians Pranas Domšaitis/Franz Domscheit hailed.[51]

Concerning the exhibition organized by Polish artists in the gallery Lemercier in Moscow, amongst over 60 works the most prizes were given to paintings by Eugeniusz Geppert, a graduate of the aforementioned Symbolist Jacek Malczewski's Cracow art class. Malevich, meanwhile, exhibited four of his earlier primitivizing paintings (amongst others a self-portrait and still life from 1910–1911), rather than the Suprematist abstract works he had already begun creating. Malevich evidently adjusted his selection to meet the traditionalist profile of the exposition. Despite the bow towards tradition, he was regarded by critics as the most radical artist exhibited.

Most noteworthy is that Malevich displayed his works in the Polish and not the Russian section, which may indicate his contacts in the Polish milieus of Moscow, St. Petersburg, and Kiev, which he most probably owed to his Polish patriotic family. His intense relationships with the initiators of the Polish Constructivist movement, Władysław Strzemiński and Katarzyna Kobro, started the following year.[52] It is even more striking that, most probably in the context of that exhibition, he drafted his unpublished manifesto to artistic youth written in Polish, the mother tongue in his family home. In this vein he encouraged others to break with the Polish romantic and neo-romantic tradition, which explicitly belonged to the canon of education, with which Malevich was familar thanks to his domestic upbringing.[53]

50 See: Głuchowska (2012c: 218); Głuchowska (2012d: 219).
51 Turowski (2004: 195–196); Głuchowska (2013a).
52 Turowski (2002: 11, 244); Głuchowska (2013c: 241–243, 247–248).
53 Quot. in: Turowski (2002: 421, Note 31, comp. 75–87, 229–234).

235

The Great War and the New Art in Poland
Between Patriotic Ethos, Nationalization of Modernism,
and International Attempts in Aesthetics

The ambivalence of Malevich's attitude arises from the duality of his artistic expression at that time. In the same period that he was presenting his work in the Polish section of the Moscow exhibition and writing the Polish manifesto, he was both creating Russian propaganda posters in the Lubok genre to reinforce Russian patriotism and painting his *Black Square*, interpreted as both a metaphor of war and the work of its radical opponent.[54] Incidentally, after the war Malevich followed his two brothers' example in applying for Polish citizenship and left some of his works in Poland, following his exhibitions there.Without a shadow of a doubt, Malevich is regarded by many as the founding father of the Polish avant-garde.[55]

In the same context as the patriotic exhibitions of the war years, the war cemeteries and monuments to war victims have to be classified specifically as monuments of WWI. It is worth highlighting that many of them were erected under the central supervision of the annexationist countries run by, for example, the Galician Management of War Graves (*Galizische Kriegsgräberverwaltung*) with its offices in Przemyśl and Lviv (Lwów/Lvov/Lemberg). In these circumstances not only was the classicist style cultivated, but the so-called Slavic style was also initiated.[56] The modern commemoration of heroes, so popular after WWI, was established.[57]

The most important Polish necropolis created in relation to WWI is the *Cemetery of Eaglets* in Lviv (*Cmentarz Orląt*), dedicated to the young victims of the Polish-Ukrainian war (1918–1919). Similar to the *Pilots' Monument* (*Pomnik lotnika*) in Warsaw, designed by Edward Wittig in 1922, the cemetery was erected in the Polish national Art Deco style, thanks to a commission by the Polish government. The Warsaw monument was a memorial to the Polish and American pilots who died in the war between 1918 and 1922. A similar one was previously erected in a cemetery in Lviv. The sculpture in Warsaw, in which the subject matter displayed an organic melding of pilot and machine, was to become the flagship

54 See: Raev (2014: 324).
55 Głuchowska (2013c: 247, 253-254).
56 Pencakowski (1993: 107, 111).
57 Roshwald/Stites (1999: 2).

of Polish nationalized modernism.[58] In this way, many cemeteries and monuments, erected immediately after the war by the authorities of the new state, drew on the national tradition and contributed to the glorification of the collective patriotic act of Poles, which then spread across various frontiers of Europe.

Futurologist Concepts and Retrospective Utopia

During WWI, Polish artists supported politicians in creating a vision of an, as yet, nonexistent new state. In that sense Polish art was at that time, as during the entire 123 years of national captivity, oriented towards the future. The Polish state did not *de facto* exist until 1918; as a future vision, however, it had established its right to exist for a long time. Many heated debates and polemics carried out in the area of art, literature, and artistic critique had been devoted to that country of the past. They intensified during WWI when the historical chance to recover the nation's independence had to be taken advantage of. Once more artists referred to the long tradition of battles reaching back to the end of Romanticism, during the American War of Independence and like many other Poles during the European Revolutions of 1848.[59]

From the neoromantic ideology also arose such monumental artistic visions as the project of turning Wawel Hill into the *Polish Acropolis* during the renovation and reconstruction of the Royal Castle in Cracow (*Zamek Królewski na Wawelu*, Kraków). The project was created by Stanisław Wyspiański, a multitalented, multimedia artist who was — to use the contemporary term — one of the last heroes of the (late) national Romanticism. The enormous Cubist/Art Deco sculpture piece by Wacław Szymanowski — *March to Wawel* (*Marsz na Wawel*, 1916), featuring dozens of characters from Polish history in a march to the castle hill and recalling the memory of the golden age of the Polish-Lithuanian Republic of Nobles, also falls into the same ideological system. The purchase of the plaster model of that piece by the representative of Polish society in Cracow was supposed to lead to its casting in

58 Nowakowska-Sito (2003: 148).
59 Suchodolski (1986: 208, 201); Omilanowska/Torbus (2011: 420–468).

237

The Great War and the New Art in Poland
Between Patriotic Ethos, Nationalization of Modernism,
and International Attempts in Aesthetics

bronze and exhibition in the Royal Castle. That did not happen, although there was a precedent for such monumental national-romantic projects in Austria-Hungary to which, after all, Cracow belonged. The ideas of gigantic monuments such as the *Millennium Monument* (*Millenniumi emlékmű*, 1896–1929) in Budapest and the *Jan Hus Memorial* (*Pomník mistra Jana Husa*, 1915) in Prague belong to the same tradition too.[60] A sculpture by Xawery Dunikowski, *Grave of Bolesław the Brave* (*Nagrobek Bolesława Śmiałego*, 1916–1917), has a similar purport. It shows one of the first Polish kings who was also descended from the oldest Polish medieval dynasty, the Piast. Paradoxically a futurological vision of Poland was created long before 1914 and was based on the culture of memories, of interpreting Polish history as a symbolic and messianic spirit. In other words, it had its source in the retrospective utopia of the former greatness of Poland.[61]

In the collective consciousness of Poles the time of partition (annexation by Russia, Prussia, and Austria) between 1795 and 1918 was a period of perpetual fighting for freedom, national identity, and a new social order. That interpretation of history was proposed to the nation by the romantic bards Adam Mickiewicz and Juliusz Słowacki, and it was supported by, amongst others, the Polish winner of the 1905 Nobel prize, Henryk Sienkiewicz. The neoromantic historicizing painters at the turn of the century, such as for example Jacek Malczewski, who followed Jan Matejko, fulfilled the social mission of lifting spirits.[62]

One of the most prominent manifestations of the retrospective utopia was supported by structures created in the traditional Polish national style, alluding on one hand to folk architecture (Vernacular Style), commonly called Zakopane art (*styl zakopiański*), and on the other maintaining the style of the nobility, known as the Manor House Style (*styl dworkowy*). The latter grew out of the idea of the independent microcosm of the petty nobility's residences, as well as from the *Sarmatian* tradition postulating the unity of the Polish-Lithuanian Republic of Nobles. Since the time of its existence in the

60 Kotkowska-Bareja (1993: 264, 270).
61 Turowski (1986: 181–183).
62 See: Głuchowska (2018c: 403).

15th–18th centuries it was common to consider that style as the manifestation of opposition towards foreign colonization and later, against Germanization and Russianization forced on the people by the annexationists.[63] Although the last architectural contest for a model design of a landowner residence took place in 1914,[64] the tradition of erecting village manor houses in the *Sarmatian* style survived until the end of the mid-war period. An example is the manor house in Sulejówek, built in the classicist style by Kazimierz Skórewicz, which Marshal Józef Piłsudski received as a "gift from the Polish nation" in 1922.[65]

The retrospective utopia specified above, which dominated Polish society for a significant time, and was at its height immediately before the war, found its expression during the war in the construction of the royal castle planned as a residence of Olgierd Czartoryski and his wife Mechthildis von Habsburg-Lothringen in Stary Sielec near Jutrosin (German: Altsiedel bei Jutroschin). The castle was designed in 1913 with references to the style characteristic of residences for the Polish nobility of the early Renaissance but was, however, never finished, symbolizing the unfulfilled dreams of Polish monarchists.[66]

The *Tower of Babel* and the Polonization of Expressionism

The Expressionist linocut *The Tower of Babel* (*Wieża Babel/Der Turmbau zu Babel*), designed in 1917 by the transborder active visual artist and bilingual (Polish-German) poet Stanisław Kubicki, who was active mainly in Berlin, is one of the most famous works of the early Polish avant-garde and a symbol of the transnational modern spirit (Fig. 8). It aimed to revolutionize not only the image of art but also of society. *The Tower of Babel*, also called *Revolte* (*Revolution/Rewolucja*) by Franz Pfempfert, editor of the Berlin magazine *Die Aktion*,[67] proclaims the fall of the "old world" and corresponds with the Polish language manifesto by Kubicki, *Panującym!* [To the

63 Turowski (1986: 181–183, 231).
64 Jaroszewski (1993: 43–47).
65 Włodarczyk (2000: 31).
66 Jaroszewski (1993: 58); see reproduction in: Głuchowska (2015c: 209).
67 Głuchowska (2015a: 221).

239

The Great War and the New Art in Poland
Between Patriotic Ethos, Nationalization of Modernism,
and International Attempts in Aesthetics

Ruling!, 1916], in which he proclaims the establishment of peace and a new democratic order.

This revolutionary linocut appeared on the poster for the Poznań Expressionist group *Bunt*'s [Rebellion, 1917–1922] first exhibition in Poznań, in the western part of occupied Poland, in April 1918. In the middle of the war it appeared in both Polish and German versions, calling for the feuding nations to reconcile in the spirit of the "new community". The second *Bunt* display was organized in parallel in *Die Aktion*'s editing house in Berlin in June 1918, as one of several provocative displays of the supra-national and pacifist profile of the periodical. The special issues of the early avant-garde magazines presenting the group's program, *Die Aktion* and *Zdrój*, again appeared in both Polish and German versions. There was good reason for this. Kubicki's wife, Margarete Kubicka, was German, so the group was in fact binational, explaining its inter-national and not solely Polish-patriotic profile.[68] The Ber-lin exhibition was accompanied by a special issue of the magazine *Die Aktion* entitled *Polish Art* (*Polnische Kunst*), although it didn't represent the whole of artistic life in Po-land at this time, only its most radical wing. On the cover appeared another linocut by Kubicki, *Bunt* (the word con-taining double Polish-German meaning: rebellion/coloured and flashy), which depicted a man rowing against the cur-rent — a symbol of the young rebel, whose shouting face was reminiscent of Munch's *The Scream* (*Skrik*, 1893). The same inspiration can be seen in other linocuts by mem-bers of the *Bunt* group, such as the aforementioned *Tower of Babel* by Kubicki and *Panic* (*Panika*, 1919) by Władys-law Skotarek.[69] The title of this programmatic print *Bunt* (Fig. 9) stands not only for the collective self-definition of the Poznań Expressionist group, but also for progressive, pacifist, and internationalist tendencies in art in gener-al. Its pendant, called *The Rower* (*Wioślarz/Der Ruderer*, 1918) and depicting the same figure from the back, was published at nearly the same time in both *Die Aktion* and the Polish magazine *Zdrój* (Fig. 10), again to promulgate its programmatic message, both in the international artistic

68 Głuchowska (2015b: 96–97).
69 See: Głuchowska (2013a); Głuchowska (2013c: 191–193); Głuchowska, *International Expressionism…* in this volume.

Fig. 8

Stanisław Kubicki, *Wieża Babel II/Der Turmbau zu Babel II* [The Tower of Babel II], 1917. Private collection, Berlin

milieu of Berlin and in the local Polish context. Such performative and provocative manifestations as the ones of the *Bunt* group[70] were, however, exceptions to the mainstream of both socially and artistically traditional exhibitions and publications of this period.

The message of *The Tower of Babel* is particuarly ambiguous. It is not certain whether it is supposed to express the premonition of the birth of a new Poland, or an internationalist "new world". In the reality of the Polish war it signals the moment of, or a process of, fulguration (Latin: *fulgur* — "a flash"), just as Jan Białostocki specified in regards to the radical paradigm changes in art and social life during WWI which culminated in Expressionism.[71] The breakthrough, which is equated with an explosion in art in Poland, is usually linked to the birth of the new state and therefore dated around 1918. The dating should be moved, however, to 1917, if not earlier.[72] The initial avant-garde works were created long before

70 See: Głuchowska (2015e); Głuchowska (2016a: 107–116).
71 Białostocki (1986: 3–22).
72 Głuchowska (2015b: 113–114).

241

The Great War and the New Art in Poland
Between Patriotic Ethos, Nationalization of Modernism,
and International Attempts in Aesthetics

Fig. 9

Stanisław Kubicki, *Bunt* [Rebellion], 1918, front cover of magazine *Die Aktion* VIII/21/22 (June 1918)

the consolidation of the earliest Polish groups of that movement. As early as 1914, Zbigniew Pronaszko published his manifesto *Przed wielkim jutrem* [Before the Great Tomorrow] in which, alluding to the works of Wassily Kandinsky and Adam Mickiewicz, he spoke of the new form.[73]

The Tower of Babel by Kubicki picks up the issue of a national connotation of that new form, and does so in context of the debate on the Polonization of Expressionism. Indeed, in 1917 in Cracow, a group *Ekspresjoniści Polscy* [Polish Expressionists] was formed. In 1919, they changed their name to the *Formiści* [Formists], to clearly detach themselves from the leftist-radical political orientation of the German Expressionists. The new name also highlighted their pursuit of the (Latin/Parisian) new form,[74] paradoxically supposed to refer to folk art, which over time had become an anticipation of the new

73 Pronaszko (1914: 125–129).
74 "Formiści. Wystawa III" (1919: 98).

national style. Simultaneously, the *Formiści* also manifested its modern, international orientation, sustaining an intensive relationship with the *École de Paris* and the world famous art critics working there who were largely of Jewish-Polish origin,[75] including Adolf Basler, Waldemar George (Waldemar Jerzy Jarociński), Chil Aronson, and also, Wilhelm Apolinary Kostrowicki, more widely-known by his pseudonym Apollinaire.[76]

The Poznań Expressionists' programme was focused on the *Bunt* group which published in the magazine *Zdrój* and, upon closer look, turns out to be even more complex. The radical wing of that group, the leader of which was Kubicki

75 Wierzbicka (2004). Comp. Wierzbicka (2009b).
76 Apollinaire reported for duty in the French Army at the outbreak of the war in August 1914 as a volunteer. He was not admitted — as his Polish grandfather was originally a citizen of Tsarist Russia and thus Apollinaire was not considered French. Only at his second attempt in December 1914, when he received French citizenship and managed to change his surname, was he accepted to serve at the rank of officer. See reproduction in: Głuchowska (2014a: 313).

243

The Great War and the New Art in Poland
Between Patriotic Ethos, Nationalization of Modernism,
and International Attempts in Aesthetics

as its *spiritus rector*, had leftist-anarchist views and main-
tained a constant relationship with the international Ber-
lin avant-garde, of which one of the former representatives
of the Zurich Dada, Marceli Słodki, was an active member.
The Dadaist spirit was likewise not foreign to Kubicki. The
first exhibition of the group *Bunt*, along with the accompa-
nying pacifist-anarchist manifestos, gained fame as a *suc-
cès de scandale*. Kubicki and his artist friends wanted to
make use of that exposure to turn against Poznań's nation-
al-catholic *status quo*. The more traditional wing of the
group focused around Jerzy Hulewicz, brother of the
aforementioned Witold, and supported Piłsudski's politi-
cal idea to create a new federation style of government in
Poland. What's more, most of its members participated
in the Greater Poland Uprising (*Powstanie Wielkopolskie*,
December 27, 1918–February 16, 1919), as well as in the Pol-
ish-Soviet war.[77] So *Bunt* in many ways directly referred to
the national issue. On the iconographic and literary level,
its (politically) more moderate wing referred to the Polish
romantic tradition, namely moving in the same direction
as the *Formiści*, i.e. towards a Polonization of Expression-
ism.[78] All the members of *Bunt* had earlier belonged to Pol-
ish patriotic conspiracy organizations, even Kubicki, who
in his youth wrote Polish-patriotic poems before writing
his Polish-German poems from 1918–1921, the manifest *pars
pro toto* of artistic internationalism. To contribute to the
implementation of the latter idea at the end of 1918 he
went to revolutionary Berlin.[79]

Poznań Expressionists stayed in touch with representa-
tives of the *Yung Yidish (Jung Idysz/Jung Jidysz — Young
Yiddish*, 1919–1923) from Łódź, an association which
represented leftist Jewish Expressionism. At the same
time, *Yung Yidish* supported a tradition of Yiddishism,
cultivated by the Russo-Jewish man of literature and
ethnographer An-sky (Shloyme Zanvl Rappoport), the
founder of the secular, socialist Jewish cultural organiza-
tion *Kultur-lige* [Culture League], which organized famous
Jewish ethnographical expeditions between 1911 and 1917.

77 Malinowski (1991: 41–51); Salamon (2003: 96–118); Głuchowska
 (2015a: 221); Głuchowska (2018a: 148, 163).
78 Głuchowska (2022b).
79 See: Głuchowska (2015f).

Initially privately, An-sky documented in his diary *Der yidisher khurbn fun Poilen, Galitsye un Bukovina fun tagbuch 1914–1917* [The Jewish Catastrophe in Poland, Galicia, and Bukovina. A Diary of the Years 1914–1917].[80] The diary later became a topic of Jewish/Yiddish Expressionist poetry devoted to the Jewish massacres, which was to make Warsaw the center of the Yiddish avant-garde. Since the onset of the war the Jewish theater,[81] similar to the situation in Polish-dominated Vilnius, had enjoyed many successes, yet remained in the shadow of the intellectual-artistic debate in Poland of the time, which focused mainly on the issue of nationalization of the modern form.[82] Even to this day, art and cultural history largely do not include the issue of multicultural tradition and the legacy of the artistic *œuvre* of (national) minorities in Poland.

"Seasonal Country" and the Long-Lasting National Legend

The fact that in German nationalist-socialist circles at the end of WWI Poland was named the "seasonal country"[83] upon the Wisła, was seen as a real threat. The tense geopolitical situation in which the new state existed — practically surrounded on all sides by neighbors with whom they were in either military or political conflict — almost automatically led to the peculiar nationalization of the modern form in the visual arts and in literature. Hence the transborder and internationalist-by-nature avant-garde never became fashionable in Poland. Local public opinion was shaped by the legends of heroic deeds in the fights which took place from Great Poland to the Tiber, from Lithuania to Serbia and Dalmatia. Sentimental pictures preserved the myth of the Polish Legions and at the same time glorifying the Great War (e.g. the painting by Adam Bunsch, *Machine Gun Bullet* [*Kula karabinowa*], 1929; Fig. 11). The flagship style of the new state became the national style, referring to folk art, the representatives of which, at the *International Exposition*

80 Roshwald (1999: 102); Głuchowska, *Jewish Artistic Networks...* in this volume.
81 Głuchowska (2012b: 162–163).
82 Piotrowski (2002: 313–326); see also: Leśnikowski (1996); Luba (2004).
83 Kleßmann (2011: 538).

The Great War and the New Art in Poland
Between Patriotic Ethos, Nationalization of Modernism,
and International Attempts in Aesthetics

of *Modern Industrial and Decorative Arts* (*Exposition internationale des arts décoratifs et industriels modernes*) in 1925 in Paris, won as many as 172 prizes, including 36 *Grand Prix*.[84]

The cult of Piłsudski culminated in 1934, on the twentieth anniversary of the creation of the legions. After Adolf Hitler took power in Germany in 1933 and the international avant-garde there collapsed, even Kubicki, devoid of delusions, returned to Poland. The same man who around 1918, through his bilingual poetry, fought for the "new world" without borders and nations — which contributed to the marginalization of his achievements in Polish artistic life — now, near Poznań, was erecting on commission a monument in the style of classicism to the honor of the heroic commander of the legions and its representatives from Great Poland.

At the onset of WWII, Kubicki joined the Polish resistance movement. At the same time, a few years after the national socialists burned avant-garde books at Bebel Square (Bebelplatz) in Berlin, in one of the print workshops in Poznań almost the entire Polish edition of his poetry went up in flames. In 1942 he was murdered by the Gestapo as a courier of the Polish underground to the embassies of the neutral countries in Berlin.[85] He was not the only one for whom the ethos of conspiracy also meant death. "Lohengrin" Witold Hulewicz, the enthusiastic translator of Rilke and German poetry at the time of WWI, also died at the hands of the national socialists.[86] Witkacy, who in 1917/1918 at the birth of Bolshevism proclaimed the end of metaphysical feelings and humanist values, committed suicide in September 1939 after learning that the Soviet Army had entered Poland. One of the previously internationalist artists of the *Yung Yidish*, Jankel Adler, served in the Polish Army during WWII. While he lived in England for many years after communism took hold in Poland, he never gave up his Polish citizenship. The fate of these artists — witnesses and participants of WWI — is representative of the battles of the whole new nation. The "Great History",

84 Piotrowski (2002: 326); see also: Luba (2012).
85 Głuchowska (2015a: 236–239); Głuchowska (2018a: 164).
86 Karaś (2004: 135–136).

Fig. 11

Adam Bunsch, *Kula karabinowa* [Machine Gun Bullet], 1946. Replica of the original painting from 1929. Private collection, Poland

without any respect for the sacrifice of human or artistic loss, treated their achievements and their lives as disposable objects.

The members of *Formiści* — in testimony to Władysław Strzemiński's tendenciously-described genealogy of the Polish avant-garde (and paradoxically also the national art) — have been celebrated in Poland for decades.[87] The rediscovery of *Bunt* and *Yung Yidish* has been, in a deeper sense, an achievement of the centenary of the avant-garde and the independence of the Polish new state, restituted in 1918.[88]

87 Strzemiński (1934: 59); Turowski (2000: 15).
88 See e.g.: Głuchowska (2015b); Monkiewicz (2018); Kurc-Maj/Polit/ Saciuk-Gąsowska (2018); Klimczak/Głuchowska/Śmiechowska (2019); Głuchowska (2020b); Gadowska/Świętosławska (2022); Głuchowska (2022a: 157–167); Głuchowska (2022b); Głuchowska, *The Jewish Artistic Networks…* in this volume.

The Great War and the New Art in Poland
Between Patriotic Ethos, Nationalization of Modernism,
and International Attempts in Aesthetics

Uncanonical Impulses to the Canon

Polish and Belgian Contributions to International Constructivism

Michał Wenderski
Adam Mickiewicz University in Poznań, Faculty of English. Poland

NATIONALISM AND COSMOPOLITANISM IN THE AVANT-GARDE AND MODERNISM
The Impact of the First World War

Abstract

This paper discusses chosen formations from Poland, Belgium, and the Netherlands that considerably contributed to the development of Constructivism, yet were not granted comparable status in modern art history. The post-war historiography, for example, has canonized only certain movements and groups, for instance *De Stijl*, which became synonymous with Dutch avant-garde art, while other Dutch-speaking formations and their counterparts from Poland or other countries were not taken into international account and were moved to the sidelines of the art historical canon. Notwithstanding such historiographical views on Constructivism, it was actually characterized by striking simultaneity in its supranational interactions, exchange, and collaboration within the entire network. Artists from across the network corresponded with one another, exchanging letters and viewpoints, and sharing texts and works which they had received from other magazines. Such direct relationships — regardless of apparent cultural, linguistic, and geographical differences — existed also between Constructivist groups and magazines from Poland and the Low Countries. Contrary to historiographical assumptions, e.g. the "center-periphery" paradigm, limiting the artistic influences to a one-sided transfer from canonical formations — in this case *De Stijl* — to their "peripheries", I will argue that Constructivist magazines such as *De Stijl*, *Het Overzicht*, *Cercle et Carré*, *Blok*, *Praesens* and *Zwrotnica* exerted mutual, reciprocal influence on each other, postulating a substantial revision of the status of their contribution to the development of the European avant-garde network.

Key words

Constructivism, Poland, Belgium, the Netherlands, De Stijl, "center-periphery" paradigm

Introduction

As with other artistic movements emerging during or after the First World War, Constructivism did not originate in one particular country, but was shaped in a parallel manner by various formations belonging to a supranational avant-garde network. Most parts of this network had a difficult relationship with contemporary mainstream artistic conventions, yet a number of formations were granted a pivotal role in modern art history. As for Constructivism, this is notably the case with the Dutch group *De Stijl* [The Style]. Contrarily, other Constructivist initiatives were given more limited roles in art historiography and consequently became marginalized and "peripherized".[1] My aim is to revise the historiographical status of Constructivist groups active in Poland and in the Low Countries, as well as the often assumed, one-sided transfer from allegedly central formations to their sidelines. Instead I shall point to the reciprocal character of mutual relationships and influences between groups and artists from Poland and the Low Countries, analyzing how they enhanced the development of Constructivism — regardless of their current historiographical status as "centers" or "peripheries". I will describe the dynamics between Dutch, Belgian, and Polish avant-gardes in relation to their shared similarities and key differences, such as geographical proximity, cultural and linguistic affinity, and the posterior historiographical East-West and "center-periphery" categorizations.

Avant-Gardes in the Low Countries and Their Historiographical Status

Dutch Constructivism is often equated with *De Stijl*,[2] a journal propagating new ideas about literature, visual arts, and architecture, published quite regularly between 1917 and 1928, with its final issue published in 1932 in commemoration of its late editor Theo van Doesburg. The journal had many contributors over the years — among others Piet Mondrian, Jacobus J.P. Oud, Cornelis van Eesteren, Gerrit Rietveld, and Georges Vantongerloo. However, often unable to collaborate with Van Doesburg, they

1 In this paper terms such as "center" or "peripheries" serve as reference to the "center-periphery" paradigm characterizing art historiography.
2 Comp. van den Berg/Dorleijn (2002: 10–11).

left the group to participate in other Dutch (e.g. *i10* published in Amsterdam in 1927–1929 by Arthur Müller-Lehning) and international initiatives, such as the *Bauhaus* (1918–1933), *Der Sturm* (1910–1932), and *ABC* (1924–1928). On one hand Van Doesburg was an active organiser, theoretician, and inspirer, on the other he had a difficult personality, which often gave birth to hostilities and conflicts. Furthermore, Van Doesburg's actual artistic accomplishments have often been questioned, especially when compared to other *De Stijl* artists such as Piet Mondrian and Anthony Kok.[3] Yet the Dutch avant-garde scene was not limited to *De Stijl*; other Dutch periodicals such as *The Next Call* (ed. Hendrik Nicolaas Werkman, Groningen, 1923–1926) and *Het Woord* [The Word; ed. Jean Demets, The Hague, 1925–1926] functioned independently of *De Stijl*, whose influence on these journals was only partial.

Somehow, following the famous chart of Cubism and abstract art created by Alfred Barr in 1936, the post-war historiography of the Dutch avant-garde became first and foremost focused on *De Stijl*, which became synonymous with Dutch (contribution to) modern art — as coined by Hans L.C. Jaffé in 1956.[4] The history and artistic production of *De Stijl* and its members were extensively described, first in Dutch and soon in English and other languages, which gave it the status of a pivotal node of European Constructivism.[5] Other Dutch, or neighbouring Dutch-speaking formations, including Dutch-written periodicals from Belgium, received less attention from foreign art historians, for example *The Next Call*, where one can find unique examples of innovative layout and audacious typographical experiments. The journal had a limited outreach — Werkman hand-printed all the copies and spent much of his life in Groningen without travelling, and was somewhat closed to other initiatives.[6] Due to the fact that — unlike *De Stijl* — the historiography

3 See: Tuijn (2003: 21–24).
4 Comp. Jaffé (1956); Rickey (1967); Bann (1974); Chipp (1975); Kostelanetz (1993); White (2003); Foster (2004).
5 Early publications on *De Stijl* include among others: Jaffé (1956); Seuphor (1956); Seuphor (1962); Joris (1957); Milner (1968); Overy (1969); de Jongh (1972).
6 Both Peeters and Seuphor tried — in vain — to involve Werkman in the activities of *De Driehoek*, *l'Esprit Nouveau*, and *Cercle et Carré*.

of other Dutch-speaking avant-garde formations was mostly written from a local perspective, and primarily in Dutch,[7] the contribution and impact of *The Next Call* and other journals remained overlooked for a long time.

WWI marked a visible change in the historiographical perception of Belgian contributions to the development of modern art and architecture; whilst the *œuvre* of, for instance, Victor Horta or Henry van de Velde are well acknowledged in international accounts, the undertakings of modern Belgian interwar artists have not achieved the same status. Moreover, the linguistic split between Dutch and French-speaking parts of Belgium intensified the divide between not only Belgian avant-garde milieus themselves, but also their historiography, hindering their proper description. Nationalistic flamingant tendencies were especially visible in the first volume of Antwerp-based *Het Overzicht* [The Overview; edited by Fernand Berckelaers and Geert Pijnenburg, 1921–1925] which became more internationally-oriented in November 1922 when Jozef Peeters replaced Pijnenburg as its co-editor. In 1925 Peeters launched a publishing company and a new magazine *De Driehoek* [The Triangle; Antwerp, 1925–1926] and Berckelaers moved to Paris where he adopted the pseudonym Michel Seuphor (an anagram of Orpheus). Somehow, as counterparts to the Dutch-written journals, French-written reviews *Ça Ira!* and *7 Arts. Journal hebdomadaire d'information et de critique* were published respectively in Antwerp (1920–1923) and in Brussels (1922–1928). *7 Arts* was one of the most consistent Belgian avant-garde magazines — it appeared regularly and numbered 156 issues covering a wide range subjects including poetry, visual arts, architecture, and music.

Having settled in Paris, Berckelaers (hereinafter Seuphor) got involved in numerous French initiatives, which provoked a certain resentment amongst the Dutch-speaking avant-garde artists. In 1926, when he visited Antwerp with plans to organize an international

7 For French and English-written works on the Belgian avant-garde see e.g.: Weisgerber (1991); Leen (1992); Lambrechts (2002); Aubert (2007); Paeanhuysen (2007); De Smet (2013). With regard to *The Next Call*, worth mentioning are two bilingual works: Martinet (1977), Martinet (1995) and chosen studies on modern printing: Belleguie (1984); Lustig Cohen/Lupton (1996); Spencer (1987); Spencer (2004); Heller (2003).

congress of modern art, he had to face some hostile reactions from such artists as Paul van Ostaijen. The latter saw Seuphor as an "ex-patriot"[8] who hid under a French pseudonym and wrote mostly in French. At first, Seuphor unsuccessfully planned to establish a new journal *Code* with Theo van Doesburg[9] and in 1927 he co-edited one issue of *Documents Internationaux de l'Esprit Nouveau* with Paul Dermée. Two years later, together with Joaquín Torres-García, Seuphor founded an international group *Cercle et Carré* (1929–1930), featuring a plethora of European avant-garde movements and artists (three issues of the journal under the same name appeared in 1930). The work of *Cercle et Carré* was continued by a newly established group *Abstraction-Création* (1931–1936), which managed also to involve Van Doesburg, who had refused to collaborate with the previous group and instead tried to launch the magazine *Art Concret*. Its single issue appeared in 1930 in Paris, after which Van Doesburg cooperated with *Abstraction-Création* until his death in March 1931.

Van Doesburg was not eager to cooperate either with *Cercle et Carré* or with previous formations associating the representatives of the Belgian avant-garde — hence, in *De Stijl, Het Overzicht* and *De Driehoek* one finds very few traces of mutual exchange. Their initial cooperation — Van Doesburg supplying Peeters with a number of addresses to various magazines and artists in order to organize two congresses of modern art in 1920–1922, and Peeters inviting Van Doesburg to give a series of lectures in Belgium in 1920[10] — soon turned to hostility and rivalry for the leadership of the Dutch-speaking avant-garde. Competition between the Dutch-speaking formations was reflected in their magazines, which practically ignored each other.[11] According to Michel Seuphor, *Het Overzicht* "had some distribution in Holland. [...] It somehow competed with *De Stijl*".[12] Van Doesburg demonstrated

8 Paenhuysen (2010: 195–196).

9 Den Boef/van Faassen (2013: 136).

10 Fabre/Wintgens Hötte (2009: 15–17).

11 *De Stijl* mentioned *Het Overzicht* three times (Anonym (1921: 187); Anonym (1922a: 12); Anonym (1922b: 142)), and *vice versa* only once (Anonym (1923: 76)).

12 Den Boef/van Faassen (2013: 77–78). Unless stated otherwise, all translations quoted in this paper are mine. — M.W.

Fig. 1

Fictional dialogue ridiculing the Belgian avant-garde, from magazine *Mécano* 3–4 (1924)

...waar de maes K

en Scheldwoorden vloeien...

O. — »...... van Doesburg.«

P. — »Pardon VON doesburg!«

O. — »Hoezoo? von Doe...?«

P. Ruim. — »Weet u dan niet, dat van Doesburg een duitscher is?«

O. — »Oh, natuurlijk. Kan men dan nog iets anders zijn dan duit‑ scher?«

P. Elagie. — »Zeker.... dada bv.«

O. — »Und Herr von Thoesburg ist auch noch dada?«

P. P. P. (Jef en Pel in Ario). — »Ja, Ja, Ja.« Daarom staat hij on‑ zuiver en heeft hij reeds 36 maal geweigerd mijn individueel‑collec‑ tivistische, nationalistische gemeenschapbeelding (thans in mappen à fr. 5.– verkrijgbaar) in »De Stijl« op te nemen.

P. Ruim (thans alleen). — »Maar het onmaandelijksch tijdschrift« Poverzicht, gewijd aan de belangen van de pro‑antisyphiliscultuur, dat absoluut zuiver staat (herinnert U slechts de »Herakles« van den Astraal‑dyonistische P) en met de oudste Oudclichés gedécoreerd verschijnt, zal hem (ich meine von Doesburg, de commisvoyageur in het zuiver néo‑Mondriaan‑plasticisme) doen pruimzien dat hij absoluut onzuiver staat en dat hij niet rijp is voor de produitsche, nationalistische, flamingantische, internationale, collectivistische, ge‑ meenschapsesthetiek van Jef P.

Voor het giwawa pro habhab komitee:

Cornelis Nelly MESENS

cache‑sexe.

his negative attitude towards the Belgian avant-garde in his Dadaist magazine *Mécano*, which published a fictional dialogue ridiculing *Het Overzicht*, *7 Arts* and J.J.P. Oud who, having left *De Stijl* in 1921, began to cooperate with Peeters (Fig. 1).[13] Due to its irregular appearances, *Het Overzicht* is here referred to as an "onmaandelijksch tijdschrift Poverzicht", suggesting that it gives a "poor view" rather than an "overview".[14] The text also mocks the reproductions of Oud's works by calling them "de oudste

13 Oud's projects and texts were published in *Het Overzicht* and *De Driehoek* (Oud (1923: 41); Oud (1925: n.p.); Berckelaers (1924: 123)).

14 Mesens (1924: n.p.).

NATIONALISM AND COSMOPOLITANISM IN THE AVANT-GARDE AND MODERNISM
The Impact of the First World War

Oudclichés". Traces of these hostilities may also be found in the artists' letters; for instance in the correspondence with the Polish architect Szymon Syrkus, the editor of the magazine *Praesens* (1926–1930), Oud expressed his harsh critique of Theo van Doesburg's viewpoints on architecture and pointed to his absolute lack of professional experience in this field.[15]

Mutual Influences between Avant-Gardes in Poland and the Low Countries

Most avant-garde movements — including *De Stijl* — functioned alongside main artistic currents and exerted marginal influence without any substantial recognition inside their local literary and artistic field;[16] hence the groups needed to broaden their reception and develop new relationships within the European avant-garde network. This network crossed national, linguistic, and social borders, and grouped artists from all parts of Europe and beyond, despite political and cultural differences, and national backgrounds. Contrary to the fact that some Constructivist formations (like *De Stijl*) were granted a pivotal role in modern art history,[17] the actual links between them and their alleged "peripheries" were closer than sometimes thought, and in essence they shared a mutual character. Moreover, such relationships and exchanges — although based in the intermediate languages of French and German — took place directly between artists from Poland and the Low Countries.[18]

Constructivist formations in Poland appeared in the first years of the 1920s when Tadeusz Peiper founded *Zwrotnica* [Switch; Cracow, 1922–1923 and 1926–1927]. He had previously studied and lived abroad and was in touch with recent international trends in literature and

15 Oud (1926).

16 Comp. van den Berg/Dorleijn (2002: 137–155); van den Berg (2006b: 151); traces of opposition towards avant-garde aesthetics can also be found in Constructivist magazines, see for instance: Anonym (1925a) and Anonym (1925b).

17 See for instance: Turowski (1979); Turowski (1990); Passuth (1988); Ex (1996); Ex (2000).

18 For a more detailed description of Polish-Dutch and Polish-Belgian relationships, see: Wenderski (2015a); Wenderski (2015b); Wenderski (2016); Wenderski (2019a).

Uncanonical Impulses to the Canon
Polish and Belgian Contributions to International Constructivism

the arts. In many aspects Peiper could be compared to Van Doesburg — both were passionately devoted to their magazines and formed a network of associated artists and congenial titles, which was nevertheless often overshadowed by their difficult personalities and reluctance to participate in other initiatives such as *Cercle et Carré* or *L'Art Contemporain*. In 1923 a group exhibition of Polish Constructivists was held in Vilnius, after which the major Polish Constructivist magazine *Blok* [Block; Warsaw, 1924–1926] was established. It later turned into *Praesens*, in which architecture stood at the center of attention (only two issues appeared in 1926 and 1930). At the end of the 1920s, serious conflicts appeared on the Polish avant-garde scene, which consequently led to its profound defragmentation. Thus during the same period there were a number of short-lasting and competing groups and magazines, namely *a.r.* (Łódź, 1929–1936), *Europa* [Europe; Warsaw, 1929–1930], *L'Art Contemporain — Sztuka Współczesna* (Paris, 1929–1930), and *Linja* [Line; Cracow, 1931–1933].

Proper description of Polish contributions to the development of the avant-garde network has been impeded by the historiographical "center-periphery" paradigm and the East-West political division of Europe, which reinforced the exclusion of many Polish artworks and artists from international accounts.[19] In the case of Polish (as well as Flemish) formations, major linguistic limitations played a significant role, especially with regard to primary sources — for a long time single English and French translations of Polish avant-garde writings were only to be found in exhibition catalogues or specific monographs.[20] However, Constructivism was in fact marked by a remarkable simultaneity in its supranational interaction, exchange, and collaboration within the entire network. Polish artists — just like Belgian and Dutch artists — were active

19 Significantly, recent attempts to describe and map European avant-garde art in a wider and more objective manner have shed some new light and begun to reshape and redefine the European canon of art history. See for instance: Benson (2002); DaCosta Kaufmann (2004); Lahoda (2006); Piotrowski (2009); Dickerman (2012); Holm (2012); van den Berg/Głuchowska (2013); Bäckström/Hjartarson (2014).

20 For instance: Jeleński (1965); Stanisławski (1973); Baudin/Jedryka (1977); Levine (1981); Carpenter (1983); Bless/Jedliński (1989).

Fig. 2

Front covers of Constructivist
magazines from Poland and the
Low Countries, 1917–1926

protagonists on the avant-garde scene, and their view-
points, works, and ideas were constantly exchanged and
circulated between different parts of the Constructivist
network, from Leiden to Warsaw and from Cracow to
Antwerp, between journals like *De Stijl*, *Het Overzicht*,
Cercle et Carré, *Blok*, *Praesens*, and *Zwrotnica* (Fig. 2).

The representatives of particular formations corre-
sponded with each other, exchanged contacts with other
artists and congenial groups, and informed one another
of their activities. Avant-garde journals regularly referred
to other titles such as *Der Sturm* (1910–1932), *Ma* [To-
day, 1916–1925], and *Zenit* (1921–1925), as well as to Polish,
Dutch, and Belgian magazines. Also *Blok* (1924–1926) fre-
quently referred to 7 *Arts*, *De Stijl*, or *Mécano*, and *Zwrot-
nica* mentioned 7 *Arts* and *Het Overzicht*. At the same
time Polish titles were named in *De Stijl*, *Het Overzicht*,
and *The Next Call*, for example in a list of avant-garde
journals called *Het Netwerk* [The Network] published in
Het Overzicht in January 1924 (Fig. 3). In this supranation-
al constellation of artists, groups, and periodicals, *De Stijl*

Uncanonical Impulses to the Canon
Polish and Belgian Contributions to International Constructivism

HET NETWERK

Antwerpen :	(Berckelaers-Peeters) " Het Overzicht „
	(Jozef Muls) " Vlaamsche Arbeid „
Amsterdam :	(Wijdeveld) " Wendingen „
	(Groenevelt) " Het Getij „
Berlijn :	(Walden) " Der Sturm „
	(v. Wedderkop) " Der Querschnitt „
Brazilië :	(Serge Milliet) " Klaxon „
Brussel :	(Bourgeois, enz.) " 7 Arts „
	(Verwilghen) " La Cité „
	(Hellens) " Le Disque Vert „
Lyon :	(Malespine) " Manomètre „
New-York :	(Andersen) " The Little Review „
	(Thomas Mann) " The Dial „
Parijs :	(Beauduin) " La Vie des Lettres „
	(Ozenfaut-Jeanneret) " L'Esprit
	[Nouveau „
Polen :	(Haddie Peiper) " Zwrotnica „
Rome :	(Prampolini) " Noi „
	(Bragaglia) " Cronache d'Attualita „
Weenen :	(Lajos Kassak) " Ma „

The Next Call

onderhoudt internationaal verkeer met redacties van onderscheidene Tijdschriften van de avant-garde en neemt abonnementen aan op:
Het Overzicht, F. Berckelaers en Jozef Peeters, Antwerpen. De stijl, Theo van Doesburg, Leiden. Mécano, I. K. Bonset, Parijs. Merz, Kurt Schwitters en L. Lissitzky, Hannover. La Zone, A. Cernik, Brünn Julianov, Zenith, L. Mitzitch, Belgrado. Blok, H. Stazewski e.a. Warschau. Disk, K. Teige, Praag, en vele andere.

Redact.-Uitgever H. N. Werkman,
Lage der A 13. Groningen, Holland.

Fig. 3

Lists of "congenial avant-garde magazines":
↑ from magazine
 Het Overzicht 20 (1924)
↗ from magazine
 The Next Call 6 (1924)

was indeed one of the most established avant-garde magazines and Van Doesburg managed to involve many prominent artists to cooperate with it — however in most cases only temporarily. Its historiographical canonization reinforced the view that *De Stijl* was the only source of inspiration and artistic stimuli for formations such as Polish *Blok* or *Praesens*, thus overlooking the exchange which took place in the reverse direction.

Polish magazines did include numerous articles and reproductions of works by *De Stijl* artists such as Mondrian, Van Doesburg, and Oud. Their impact was reflected in several Polish programmatic statements; for instance *Blok*'s main manifesto "Co to jest konstruktywizm" ["What is Constructivism"] quoted Van Doesburg's viewpoints on color, which had appeared in his article published earlier in *Blok*,[21] and Stażewski's theoretical writings were strongly inspired by Mondrian's theory of Neo-Plasticism.[22]

21 Anonym (1924a: n.p.).
22 See e.g.: Stażewski (1924: n.p.) and Stażewski (1926: 2–3).

Nevertheless, texts and reproductions circulated in a reciprocal manner between Polish and Dutch avant-garde magazines and other (e.g. architectural) periodicals. Just as Polish journals — be it *Architekt* [The Architect, 1900–1929] or *Architektura & Budownictwo* [Architecture and Building, 1925–1939] — reported on the development of modern Dutch architecture, also new architectural solutions in Poland were described by Theo van Doesburg in three articles published in *Het Bouwbedrijf* [The Building Industry] in 1930–1931.[23] Van Doesburg stayed in direct contact with Polish artists whom he asked for information on Polish modern art and architecture — he received, for instance, a manuscript of Szczuka's article from 1924 entitled "Le mouvement artistique en Pologne" published later in *Anthologie du Groupe Moderne d'Art de Liège*.[24] What is more, since 1925 Warsaw was listed as one of *De Stijl*'s cities (with Leiden, Hanover, Paris, Brno, and Vienna) on the cover of this magazine, serving first and foremost as the magazine's propaganda, it also confirmed the status of Warsaw as a fully-fledged node of the avant-garde network. Significantly, Van Doesburg was also to hold a series of lectures in Warsaw, which did not come to fruition for financial reasons.[25]

Direct relationships between Polish and Belgian avant-gardes have also left traces in their magazines and private correspondence, for instance between Tadeusz Peiper and Michel Seuphor or Victor Bourgeois. Their letters reveal mutual interests in the activities of their respective environments, and eagerness to share each other's works. Consequently, *Het Overzicht* was one of the few international journals informed about the Vilnius exhibition in 1923, and which published an article discussing modern Polish art. The article was originally to be written by Peiper, who at that moment was busy publishing a book, and had asked the Polish poet Jan Brzękowski to write it.[26] Brzękowski's French text was translated into

23 Van Doesburg (1930a: 358–361); van Doesburg (1930b: 401–403); van Doesburg (1931: 87–90).
24 Szczuka (1924) and Szczuka (1925).
25 See Van Doesburg's correspondence with Polish artists: van Doesburg (1926a); van Doesburg (1926b); Syrkus/Stażewski (1926a); Syrkus/Stażewski (1926b); Syrkus (1926).
26 See: Peiper (1923) and Peiper (1924).

Dutch and published following a delay in April 1924,[27] which in turn led to animosities on the Polish scene due to the fact that Brzękowski's text did not include *Blok* — not yet in existence when the article was written. Also *7 Arts* included several reproductions and texts of Polish provenance as well as a quotation form Peiper's letter from March 10, 1926, where he congratulated *7 Arts* on their 100th issue; he emphasized there that "Braque needs Peiper as much as he needs Picasso",[28] reflecting the unique supranational character of the European avant-garde network.

Supranational cooperation and relationships between various parts of the avant-garde network are especially visible when it comes to international initiatives, such as *Cercle et Carré*, *Abstraction-Création*, and *CIAM*, where writers, artists, and architects from Poland and the Low Countries, e.g. Stażewski, Seuphor or Oud, played key roles (Fig. 4). Having established *Cercle et Carré*, Seuphor sent invitation letters to Werkman and Van Doesburg saying: "I hope that you will not refuse to figure side by side with [Piet] Mondrian, [Georges] Vantongerloo, [Henryk] Stażewski, [Fernand] Léger, [Amédée] Ozenfant, [Joaquin] Torres-García, Léonce Rosenberg and others [...]."[29] One after the other Seuphor listed artists from Holland, Belgium, Poland, France, and Uruguay who were joined in their pursuit of modern avant-garde art and shared common artistic values, no matter which background or nationality they represented. Within these groups, artists from various countries formed long-term and close relationships — lasting much longer than the groups themselves and evidenced in the post-war exchange of letters and books — for instance between Brzękowski and Seuphor, or Helena and Szymon Syrkus, and Cornelis van Eesteren. A remarkable example of avant-garde international cooperation is the International Collection of Modern Art established by Władysław Strzemiński and other members of the *a.r.* group [revolutionary artists/l'avant-garde radicale] in Łódź in 1929–1932. It was

27 Brzękowski (1924: 155). A slightly longer version of this article was also published in French in *Pasmo* I:3.
28 Peiper (1926: n.p.).
29 Seuphor (1930a). See also: Seuphor (1930b).

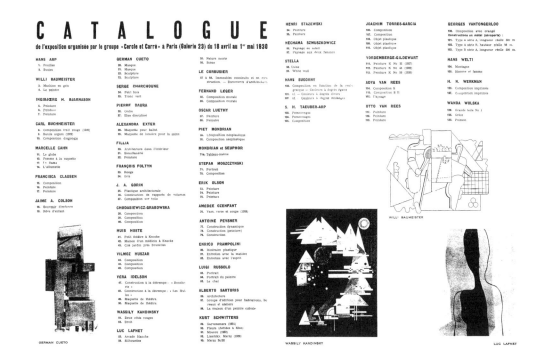

Fig. 4

Catalogue of the first *Cercle et Carré* exposition, from magazine *Cercle et Carré* 2 (1930)

an unprecedented collection of modern European art housing numerous avant-garde artworks from various countries.[30] Through the wide connections of Stażewski and Brzękowski, works of the most prominent European artists were obtained (among others Seuphor, Vantongerloo, Werkman, and Van Doesburg) to form an exceptional tangible example of the supranational, cross-cultural network of European avant-garde artists.

Internationalism and universalism were fundamental features of Constructivism — this was underlined in the founding proclamations of the *Constructivist International*[31] and the *Union of Progressive International Artists* (1922) which stated: "Art must become international or it will perish."[32] The international idiom[33]

30 See: text by the catalogue of Łódź Collection (Strzemiński (1932)).
31 Van Doesburg (1922: 113–115).
32 Das Junge Rheinland et al. (1922: 49–52); see: Głuchowska (2018a: 143–148).
33 See also: contribution by Benedikt Hjartarson in this volume.

Uncanonical Impulses to the Canon
Polish and Belgian Contributions to International Constructivism

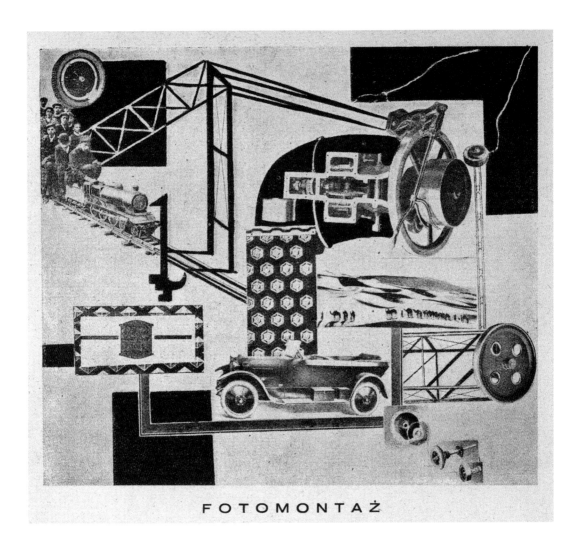

FOTOMONTAŻ

of non-figurative art, experimental poetry, and modernist architecture facilitated their rapid exchange within the supranational network of avant-garde journals. Simultaneity and interdependence of various artistic undertakings are also visible in the artistic and literary production of Constructivist formations in Poland and the Low Countries. As mentioned before, Polish magazines reflected the activities of *De Stijl* and its contributors — reprinting texts and reproductions, and referring to Van Doesburg's viewpoints in *Blok*'s programmatic statement. The artistic and theoretical exchange, however, took place not only from the Netherlands to Poland;[34] reciprocally Polish artists also influenced Dutch and Belgian Constructivists.

34 For more examples of such exchange, see for instance: Turowski (1979), Kleiverda-Kajetanowicz (1985), Passuth (1988), Ex (2000).

Fig. 5

Examples of Polish influence
within the avant-garde network:

← **Mieczysław Szczuka**, *Collage*,
1924, from magazines *Blok* 3–4
(1924) and *Dźwignia* 5 (1927)

→ **Hendrik Nicolaas Werkman**,
*Compositie met letters
en haken* [Composition
with Letters and Hooks],
1932. Municipal Museum
Amsterdam

One of the examples of Polish influence within the
avant-garde network is Mieczysław Szczuka and Hen-
drik Werkman, the editors of *Blok* and *The Next Call* re-
spectively. That Werkman was acquainted with the devel-
opment of avant-garde movements in Poland is doubtless:
Blok figures as one of *The Next Call*'s subscribed mag-
azines listed on the cover of the 6th issue, as well as on
Werkman's list of addresses to foreign journals and art-
ists.[35] I would argue that Werkman's *Compositie met let-
ters en haken* [Composition with Letters and Hooks] from
1932 shows notable resemblance to Szczuka's photomon-
tage, which Werkman saw either in the 2nd issue of *Blok*
from April 1924 or in the 5th issue of *Dźwignia* [Lever]

35 See: Werkman's list of addresses to 23 magazines and 21 artists,
 serving for the mailing of *The Next Call*, WA, inv. nr. 110.

magazine from November 1927.[36] Werkman's composition reflects a part of Szczuka's work where the crane motif was pictured — the layout of particular elements and the way they are related to each other are strikingly similar (comp. Fig. 5). Moreover, Werkman's typographical composition from the 9th issue of *The Next Call* (November 1926) resembles another work by Szczuka published in the 3/4th issue of *Blok* in June 1924 (especially with regard to their diagonal layout, and the use of letters and perpendicular lines).[37]

Influences exerted by Polish artists on their colleagues from the Low Countries were acknowledged by the artists themselves — for instance in his letter to Przyboś from 1930 Strzemiński claimed that "in 1929 [Georges Vantongerloo] did what [Katarzyna Kobro] had already done in 1926".[38] Moreover, in an article from 1934 Strzemiński noticed that the 1930 publication of *Kompozycja przestrzeni* [Composition of the Space; wrongly dated, actually 1931] had had a major influence on Western European art as it enhanced the evolution of Neo-Plasticist sculpture. As one of the examples of this postulated influence, Strzemiński referred to the works of Vantongerloo which at that time had indeed evolved from volumes-masses towards less compact sculptures with more relationship to the surrounding space (as in Kobro's works).[39] Importantly, there is no doubt that Vantongerloo knew of modern Polish art of the period. Long before the publication of Kobro and Strzemiński's book, Vantongerloo had been in touch with Polish avant-garde artists; for instance in 1927 he himself designed the cover for the Polish edition of *Art et son Avenir* which was to be published by *Praesens*, and in a manuscript written in

36 *Dźwignia* was a magazine launched by Szczuka in 1927. Werkman undoubtedly received its 5th issue which is housed among other received periodicals in his archive in Amsterdam, inv. nrs. 114–115. Comp. Wenderski (2020) for more details.

37 Hubert van den Berg pointed to this fact in his unpublished paper "Historische avant-garde tussen Noordzee en Wisła. Nederlands en Vlaams constructivisme in de Tweede Poolse Republiek" presented in January 2013 at the University of Wrocław, Poland.

38 Letter quoted in: Turowski (1973: 231–232). See reproductions of the works in question in: Strzemiński/Kobro (1931: n.p.).

39 Strzemiński (1975: 219). See also: Ceuleers (1996: 132) and Grislain (2007: 107).

1930 he explicitly praised the sculptural achievements of Katarzyna Kobro.[40]

Summing up, contrary to the historiographical assumptions of the central role of *De Stijl* and its one-sided impact on other Dutch, Belgian, and Polish avant-garde formations, the aforementioned examples illustrate that the relationships between those groups had a more complex, mutual nature. Hence, the contributions of the "uncanonical" nodes of the network to the development of European historical avant-gardes need considerable revision and a more objective mapping, regardless of any posterior categorizations and assumed linguistic or cultural divisions which are still hindering the proper description of Constructivism and its remarkable cross-border, cross-cultural character.

40 Ceuleers (1996: 94, 132). For a detailed analysis of Kobro's influence on Vantongerloo, see: Wenderski (2019b).

Uncanonical Impulses to the Canon
Polish and Belgian Contributions to International Constructivism

Cosmopolitanism, Nationalism, and the Reconfigurations of the Map of Europe in the Discourse of Modernity in Finland in the 1920s

Harri Veivo
Université de Caen Normandie, ERLIS. France

Abstract

The time between the two World Wars has been considered a "narrowly nationalistic" period in the arts in Finland. This was the result of a series of changes introduced by Finland's Declaration of Independence and the Civil War in spring 1918. After the war, the victorious bourgeois "Whites" imposed upon the young nation a set of conservative values and a mythical discourse of sacrifice and national unity, thus narrowing the potential interest for international art movements. The young generation of intellectuals that made its debut after the war in the 1920s claimed, however, that the "ways of feeling and seeing" had fundamentally changed, making it impossible to paint and write as before; this group felt that the country was lagging behind in evolutionary terms and wanted to "open up the windows towards Europe" so that fresh air could flow in. This position was shared by many of the young intellectuals, writers, and artists from the early 1920s until the end of the decade, generating the general interest in cosmopolitanism and a de- and re-centering of the cultural map of Europe in favour of freshly independent countries like Estonia and Czechoslovakia. This article looks in detail at these shifts in imagined and real geographies in 1920s Finland by analyzing the discourses that justified the new orientations and negotiations of nationalism and cosmopolitanism this process gave rise to. The search for new orientations was motivated by Finland's status as a new state, looking for its place on the global map, as well as by the overall questioning of the notion of "Europe" caused by the First World War. It created the circulation of certain texts and images, often from the other new countries which had gained their independence in the late 1910s or early 1920s. In a period when the general cultural climate was marked by conservatism and patriotic nationalism, they played an important role in introducing the Finnish public to European modernism and avant-gardes, and in expanding the old Paris- and Western Europe-centered cosmopolitanism to include new areas in Central Europe and the Baltic countries. The article focuses on the discourse of modernity as it was developed in art, literary and cultural magazines in articles on modernity,

267

Cosmopolitanism, Nationalism, and the Reconfigurations of the Map of Europe
in the Discourse of Modernity in Finland in the 1920s

modern and avant-garde painters, reports on exhibitions, discussions of recent movements in the arts, images of modern and avant-garde artworks, and inventive uses of illustrations and layouts. This is the corpus in which the "spirit of the time" was particularly visible in the 1920s and where the visual arts, literature, modernity, nationalism, and cosmopolitanism were brought together in reflections and tensions serving to define their meanings. The actual visual arts, conversely, were marked by "hesitation and insecurity", leading to a widening gap between Finland and the European avant-garde in the 1930s, as Finnish artists were generally more interested in the figurative and realistic tendencies within modern art than in formal experimentation or the avant-garde.

Key words modernity, cosmopolitanism, Europe, Finland, literature, visual arts

Introduction

"Our movements, our suits, our houses, our street-views, our ways of speaking, our weapons, our sport are 'Cubism'."
Olavi Paavolainen in "Nykyaikaa etsimässä"
["In Search of Modern Times"], 1929[1]

When the 23-year-old poet Olavi Paavolainen (pen-name: Olavi Lauri) published his poem "To the Old Pullover" ("Rikkinäiselle pulloverille"; Fig. 1) in the modernist album *Tulenkantajat* [The Torch Bearers; later published also as a magazine] in 1926, he framed it with a collage that can be read as a joyful reconfiguration of geographical relations motivated by the desire for movement, modernity and exotic "otherness". Foreign words and place-names glued together from different sources establish here new and surprising connections: "Bombay" bridges the Gulf of Bothnia and connects Finland to Sweden, while "Port Said" reaches out from Sweden to the Baltic states. Given the author's interest in the European avant-gardes, we can say that Futurism's "parole in liberta" and Dada's cut-and-paste precepts are here placed in the service of a cosmopolitan project that seeks new connections beyond old borders, decentering and recentering the cultural map of modernity in reality and imagination.

In this article, I will look in detail into these shifts in imagined and real geographies in 1920s Finland by analyzing the discourses that justified the new orientations and the negotiations of nationalism and cosmopolitanism this process gave rise to. The search for new orientations was motivated by Finland's status as a freshly independent country since 1917, looking for its place on the global map, as well as by the overall questioning of the notion of "Europe" caused by the First World War.[2] It created the circulation of certain texts and images, often from the other new countries that had gained their independence in the late 1910s or early 1920s. In a period when the general cultural climate was marked by conservatism and patriotic nationalism, these texts and images played an important role in introducing the Finnish public to European modernism and avant-gardes and in expanding the

1 Paavolainen ([1929] 2002: 22). All translations from original sources by the author of the article — H.V.
2 See: Bru (2009: 6–10).

Cosmopolitanism, Nationalism, and the Reconfigurations of the Map of Europe in the Discourse of Modernity in Finland in the 1920s

Fig. 1

Olavi Paavolainen (text and layout), poem "Rikkinäiselle pulloverille" ["To the Old Pullover"], from album *Tulenkantajat* 4 (January 1927), pp. 126–127

old Paris- and Western Europe-centered cosmopolitanism to cover new areas in Central Europe and the Baltic countries. At the same time, they were interpreted in critical and creative ways typical for the peripheral countries.[3] I will focus on discourses of rupture and renewal stemming from the experiences of WWI and the 1918 Civil War in Finland, as well as on the new kind of cosmopolitanism that the 1920s and the specific situation of the freshly independent Finland gave rise to. In doing this, I am addressing the central questions in this volume pertaining to the dissemination and translation of avant-garde languages in the peripheral regions, the expression of cosmopolitanism in the post-war avant-garde in a newly founded state, and the articulation of avant-garde with nationalism. I will not focus on singular artworks or the visual arts as such, but rather on the discourse of modernity in magazines such as *Valvoja-Aika* [The Supervisor-Time, 1923–1943], *Ultra* (1922), *Aitta* [The Storehouse, 1926–1930], *Quosego* (1928–1929) and *Tulenkantajat* (album

3　See for example: Bäcktröm/Hjartarson (2014).

1924–1927, magazine 1928–1930 and 1932–1939). This discourse was developed in articles on modernity, modern and avant-garde painters, reports on exhibitions, discussions of recent movements in the arts, images of modern and avant-garde artworks, and inventive uses of illustrations and layout. This is the corpus where the "spirit of the time"[4] was particularly visible in the 1920s and where the visual arts, literature, modernity, nationalism, and cosmopolitanism were brought together in a commonality of reflection and tension serving to define their meanings. The actual visual arts, conversely, were marked by "hesitation and insecurity",[5] leading to a widening gap between Finland and the European avant-garde in the 1930s, as Finnish artists were generally more interested in the figurative and realistic tendencies within modern art than in formal experimentation or the avant-garde.[6]

The Impact of WWI and the Civil War of Finland

The years between the two World Wars have been considered a "narrowly nationalistic"[7] period in the arts in Finland. This was the result of a series of changes introduced by Finland's Declaration of Independence in 1917 and the Civil War of January–May 1918, both of which had a major impact. Before the war, Finnish artists often completed their education with studies in Paris. Even though their experiences of living in the great metropolis were varied — some mingling within cosmopolitan circles, some staying mostly in their cheap attic rooms, some spending time with other Finnish and Nordic painters — they were all eagerly following the recent developments, looking for techniques and ideas they could appropriate for their own work. As in many other European countries under foreign rule, following the international movements was not antagonistic to nationalistic aspirations.[8] In a period when literature, music, and the visual arts participated actively in the construction of the Finnish nation and

4 Haapalainen (2002: 286).
5 Nummelin (1987: 278).
6 Valjakka (2009).
7 Ojanperä (2002: 231).
8 See: Mansbach (1999).

Cosmopolitanism, Nationalism, and the Reconfigurations of the Map of Europe in the Discourse of Modernity in Finland in the 1920s

identity, the professionalization of the art field coincided with the birth of national art, and "national sentiments were expressed and accepted in contemporary realist, naturalist, impressionist and symbolist styles."[9] From the 1880s up to the 1910s, there was a mutually beneficial situation in which Finnish artists could use the latest inventions to create artworks that gave a visual identity to the national awakening in Finland, and where the use of national themes and motifs brought attention to Finnish artists in the international field, the best example of this being the success of the Finnish pavilion at the 1900 *World Exposition* in Paris. At the regional and local level, Finnish artists could also transform their knowledge of the Parisian art world into symbolical capital that assured them esteem and success. This was particularly evident in the 1898 and 1899 exhibitions organized by Sergey Diaghilev in St. Petersburg, where the artworks by Finnish painters such as Axel Gallén-Kallela, Magnus Enckell, and Pekka Halonen played an important role in the early aspirations to modernize Russian visual arts, contributing to the founding of the *Mir Iskusstva* [The World of Art, 1898–c. 1927] circle.[10] Starting with the first Edvard Munch exhibition in Helsinki in 1909, the recent movements arrived directly in Finland in the early 1910s when visiting lecturers such as Jens Thiis gave talks on Neo-impressionism and Cubism, the young art historian Onni Okkonen presented Wassily Kandinsky's *Über das Geistige in der Kunst* and Albert Gleizes and Jean Metzinger's *Du "Cubisme"*, and the galleries Salon Strindberg and Salon Stenman organized exhibitions on Expressionism and Cubism, showing works by Kandinsky, August Macke, Heinrich Campendonck, David Burliuk, Natalia Goncharova, Pablo Picasso, and Juan Gris, among others.[11] This coincided with a transformation of the local art world through which the autonomy of the art field was momentarily strengthened, art dealers and critics acquired more power, and the old system of state patronage lost its importance. During the first years of WWI Finland, not

9 Huusko (2012: 557). On the simultaneous birth of professional art and national art, see: Waenerberg (2006: 53–55).
10 Sinisalo (2002).
11 See: Savolainen (1967: 18–20) and Valkonen (1990: 180–204).

directly affected by military operations, also saw an economic boom, offering thus an interesting prospect for the international art market suffering from the limitations set by the war.[12]

Finland's Declaration of Independence from Russia and the Civil War changed the situation profoundly. Many artists, writers, and intellectuals were directly affected by the events. At the end of the war in May 1918, the writer Algot Untola (pen-names: Ilmari Rantamala and Maiju Lassila), a reporter for the leading socialist newspaper, was killed by the "Whites" in uncertain circumstances in Helsinki, and the young composer Toivo Kuula was shot after a fight at a party given by the "Whites" following the conquest of the city of Viipuri. Once the immediate post-war years were over, the country was in a state of profound internal tension. On the one hand, WWI and the Civil War had polarized the fields of art and literature, pushing figures like Gallén-Kallela and the poet Bertel Gripenberg to adopt more radically conservative and nationalistic positions than before. The victorious bourgeois "Whites" imposed upon the young nation a set of conservative values and a mythical discourse of sacrifice and national unity, thus narrowing down the potential interest for international art movements. They promoted national art that would express the greatness of the nation with refinement, grace and sophistication, and considered avant-gardism in general and Expressionism in particular in hostile terms as degenerated, primitive and Bolshevist.[13] Even though trips abroad were frequent, Finnish painters remained "locked in spiritual isolation" and foreign to "new thoughts and theoretical reflections."[14] When Ilmari Aalto, the most promising Cubist of the 1910s, travelled for the first time to Paris after the war in 1920, his interest was mainly oriented towards Vincent van Gogh and later, in a trip in 1928, towards classical art.[15] In a similar fashion, Edwin Lydén moved from abstract works spurred by the art of Paul Klee and Kurt Schwitters at the beginning of the

12 Valjakka (2009: 42); Valkonen (1990: 211–212).
13 See: Huusko (2012: 565–569).
14 Reitala (1990: 224).
15 Savolainen (1967: 23).

Cosmopolitanism, Nationalism, and the Reconfigurations of the Map of Europe in the Discourse of Modernity in Finland in the 1920s

1920s towards religious art, retiring to the town of Turku after the hostile reception of his work in the capital Helsinki.[16] On the other hand, the young generation that made its debut after the war in the 1920s claimed that the "ways of feeling and seeing"[17] had fundamentally changed, making it impossible to paint and write as before; it felt like the country was lagging behind in evolution and wanted to "open up the windows towards Europe",[18] so that fresh air could flow in. This position was shared by many of the young intellectuals, writers, and artists from the early 1920s up to the end of the decade, generating the general interest for cosmopolitanism expressed in essays, exhibition reports, layouts and illustrations rather than in the visual arts in the narrow sense. It took, however, different forms depending on the protagonists' particular position in the political and cultural field; this factor also affected their perception of the avant-garde and modernistic movements in the arts and literature.

The bilingual (Finnish and Swedish) revue *Ultra* argued that since Finland had lost contact with the contemporary times, one had to "import German, French, Swedish and English [poets] who had it."[19] For the main authors of *Ultra*, internationalism and cosmopolitanism were above all a "positioning strategy"[20] in the local field in Finland, transforming knowledge of the foreign movements into cultural capital in Finland. They were not particularly interested in the individual arts or literary movements as such, paying most attention to Expressionism in the visual arts and poetry. The coexistence and concurrence of several "-isms" were rather perceived as negative symptoms of the restless times of rupture epitomized by WWI; "the voice of the new generation" would silence them with its "visionary clarity"[21] and speak to all

16 Valjakka (2009: 33); Reitala (1990: 226–229).
17 Olsson ([1920] 1953: 26).
18 Diktonius (1922: 25). Interestingly, this slogan seems to have been used by Czech modernists during the same period, see: Lahoda (2006a: 14). It would be interesting to know how this trope that apparently originates from Pushkin has circulated between the different nodes in the network of the avant-garde and modernism.
19 Diktonius (1922: 25).
20 Nygård (2012).
21 Anonym (1922: 15).

NATIONALISM AND COSMOPOLITANISM IN THE AVANT-GARDE AND MODERNISM
The Impact of the First World War

nations without being trapped in the superficiality of the "-isms" or the weakness of national art, considered as an early stage in the development towards "objective" and "international" art.[22]

In a time still marked by the harsh battle over cultural hegemony between the old Swedish-speaking cultural elite and the rising Finnish-speaking middle-class, *Ultra*'s bilingualism was a difficult position to hold on to; the revue actually discontinued its activities after only 8 issues were published in 1922. The Swedish-speaking intellectuals generally continued the positioning strategy initiated in *Ultra*, yet worked in a more isolated position as the gap between the young ultramodernists and the older generation grew wider, especially during the short life of the revue *Quosego* at the end of the decade. Even though the revue was published in only four issues in 1928–1929, it was an important channel for the Dada poetry of Henry Parland and especially Gunnar Björling, who could not publish his controversial work through the conventional channels at the turn of the decade. In the visual arts, the revue defended a modernist conception that emphasized the role of "lines and surfaces" as the "painter's only material",[23] defending Cubism and Expressionism against mimetic art theories. At the same time, the young Finnish-speaking intellectuals proceeded to reevaluate Finland's position in Europe, which had a wide impact on strategies of internationalization and on the discourse of modernity in the arts and literature. The main forum for this work was *Tulenkantajat*, published as a yearly album from 1924 to 1927 and as a magazine from 1928 to 1930 and 1932 to 1939, but it was also visible in the more popular and less artistic magazine *Aitta*. The more nationalist intellectuals writing in *Tulenkantajat* argued that Finland had to be emancipated from the paternalistic "mediation"[24] imposed by Sweden in communications with the European "centers". This will to establish direct contacts with Paris, London, and Berlin was accompanied by a de- and recentering of the geography of European modernism that placed new states such as Czechoslovakia, Poland and Estonia in

22 Pingoud (1922: 37–38).
23 Ringbom (1928: 45).
24 Enäjärvi (1928: 11).

Cosmopolitanism, Nationalism, and the Reconfigurations of the Map of Europe in the Discourse of Modernity in Finland in the 1920s

central focus. These countries that could be characterized with Piotr Piotrowski's[25] notion of horizontal "close other" were perceived as dynamic alternatives to the old Europe that was stuck in "ossified traditions"[26] and as examples to follow in the sense that they had appropriated the new art movements earlier and in a more profound way than Finland. These assumptions justified new orientations in international contacts and produced circulations of texts and images that gave the arts, literature, and architecture from the new states an important role in the visual discourse of modernity.

At another level, this orientation was conditioned by a city-focused interpretation of modernity on the one hand and by a Cubism-focused interpretation of art history on the other. The young intellectuals of *Tulenkantajat* assumed that the fundamental effects of modernity — the transformative power that new forms of technology, transport, communication etc. have on living conditions, psyche, and identity — were felt above all in big cities like Paris, New York, and Berlin. While they had a pronounced concern for the modernization of the cultural and social life in small towns and the countryside also, modernity was above all an urban phenomenon and images representing skyscrapers, public transport, neon advertisements, and crowded streets had a central role in its iconography. Cubism, present in Finland since the 1910s, was considered in the 1920s as having given the modern times their own language in the arts, "a kind of a steel skeleton upon which the skyscrapers of fantasy could be constructed".[27] It had taught the art of observing with admiration "the world that was born following the 'Cubist' laws — a world functioning with mathematical precision, mechanical force and speed and geometric regularity."[28] Even though the movement as such was over, this contribution was permanent, and Cubism was even considered a modern form of Classicism.[29] Thus in the discourse of modernity, Cubist elements in a broad

25 See: Piotrowski (2009: 52).
26 Vala (1929: 113).
27 Okkonen (1924: 472–473).
28 Paavolainen ([1929] 2002: 22).
29 Ahtola-Moorhouse (1996); Reitala (1990: 238).

sense — geometrical compositions, planes and surfaces, multiple points of view — were widely present, often in free combination with elements from the other languages of the avant-garde, the general opinion preferring efforts for synthesis over differentiation and stylistic purity.

In the following part of the article, I will analyze this discourse of modernity in the 1920s through a few exemplary cases, giving specific attention to the processes of negotiation that draw art, visuality, cosmopolitanism, and nationalism into the same orbit.

Negotiating Nationalism and Cosmopolitism in the Discourse of Modernity

In 1927 Olavi Paavolainen published the essay "Nykyaikaa etsimässä" ["In Search of Modern Times"; Fig. 2] in *Aitta*. The text was later published in a book of the same title. The book was a big success at the time, widely appreciated for the imaginative and zealous style of the author and for the vision of modernity he offered. The *Aitta* essay starts with the description of three symbolic figures of modernity in their everyday life: the hotel lift-boy, the typist, and the subway conductor. What is common for these three is the fusion of their work with technology and the absolute irrelevance of their personality that this fusion entails. What counts is how they manipulate the machines, not their thoughts or feelings. Modernity, however, is not only the end of the individual subject, but also the emergence of new ways of feeling and knowing and of new combinations of old elements that transcend traditional categorizations and frontiers. This, Paavolainen argues, can only be found in big cities abroad, not in Finland. Therefore he has decided to leave the "thousand lakes" and "cool forests" of Finland behind in search of the "new poetry that our *own* time has created and which is appropriate for *it* alone."[30] The illustrations on the first page of the article are significant for this reason. They bridge Paavolainen's sociological observations with artistic representations of modernity. The anonymous image on the left thematizes the fusion of the human and the machine, the departure for elsewhere, and the anti-sentimental and rationalistic attitude of the modern subject. The image

30 Paavolainen (1927: 25).

277

Cosmopolitanism, Nationalism, and the Reconfigurations of the Map of Europe in the Discourse of Modernity in Finland in the 1920s

Kirj. Olavi Paavolainen

Kuvitussuunnitelma kirjoittajan

— pohjakerroksessa — sitten taas kuudennessa — sitten neljännessä —. Vuorot sekaantuvat. Häntä soimataan ylhäällä, häntä soimataan alhaalla, matkustajat valittavat, hovimestari uhkailee. Hän hymyilee kohteliaasti, nostaa kätensä lakinlipan reunaan, avaa oven, sulkee oven, painaa nappulaa, avaa oven... Kellot kilisevät. Hissi kulkee ylös — alas — ylös — alas. Koko päivän.
— Meluisan keskikaupungin kadun varrella olevassa konttorissa istuu konekirjoittajatar. Sormet hyppivät näppäimistöllä, lyövät syrjään rivinvaihtajan, kiskovat täyttyneet liuskat irti, kiertävät puhtaita arkkeja rullan alle, alkavat taas hyppiä näppäimistöllä. Hänelle sanellaan, hän kirjoittaa puhtaaksi käsikirjoituksia, kopioi laskuja, laatii situskirjeitä. Kun hän on lopettanut työnsä, muistaa hän kirjoittamastaan tekstistä tuskin mitään. Hänellä itsellään ei ole ollut siihen mitään suhdetta. Kaikki on tapahtunut täysin ajatuksettomasti.

— Suuren hotellin eteishallissa odottaa hissipoika. Matkustaja saapuu. Poika nostaa kätensä lakinlipan reunaan, avaa hissin oven, sulkee sen ja painaa nappulaa, avaa oven, nostan kätensä lakinlipan reunaan, sulkee oven ja painaa nappulaa. Ihmisvirta kasvaa päivän mittaan, kellot kilisevät kuudennessa — kolmannessa

20

AITTA

— Suurkaupungin alla, sähkölamppujen valaisemien betoniholvien läpi, kiitää maanalainen juna. Sen etupäässä, pimeässä, lasiseinäisessä kopissa, istuu kuljettaja silmät kiinnitettyinä etäisessä käänteessä katoavaan kiskopariin. Tunnelin seinillä vilahtelevat ohi nopeusmääräykset: 10 kilometriä — 15 — 22 —, ja hänen kätensä siirtävät voimavirransäätäjää niiden mukaan. Asema saapuu, ja hän kiertää säätäjän kiinni. Matkustajavirta työntyy vaunuihin, vihellys kaikuu, ja hän kiertää sen auki. Taas alkaa tuijotus kiskoparien juoksuun, katoamiseen etäisessä käänteessä ja ohivälähteleviin vihreisiin ja punaisiin nopeusmääräyksiin.
— Jiina kolme nykyaikaista, arkista ihmistä nykyaikaisessa, arkisessa ympäristössään. Kolme ihmistä, joiden jokapäiväisessä työssä ei heidän yksilöllinen tahtonsa ja älynsä, heidän yksilölliset mielihalunsa, tuskinpa edes ammattitaitonsa, merkitse mitään. Nämä ihmiset ovat vain koneita tai koneen osia, materiaa, jonka edustaman energian hyvin voisi korvata jollakin mekanisella laitteella. On mahdotonta ajatella heidän yhteydessään käsitettä työn-ilo. Illalla ovat he läpiuupuneita väsyksissä, mutta missään eivät he näe työnsä tuloksia. Heille maksetaan palkka, mutta riittääkö se korvaamaan toivotonta tunnetta siitä, että päivän ponnistukset ovat olleet täysin hedelmättömät? — Raskaan ruumiillisen työn tekijät katselevat kadehtien näitä koneen palvelijoita, mutta eivät huomaa, että minkä nämä ovat voittaneet ruumiillisessa mukavuudessa, sen he maksavat hermovoimien kulutuksella. Kone

ei saa pysähtyä! — tämä jännittynyt tietoisuus kalvaa alati sen palvelijaa. Hän ei hallitse konetta, vaan kone hallitsee häntä, ja se on täysin tunteeton herra, joka ei kysy, onko palvelijansa väsynyt tai sairas. Jos rautatieaseman sähköttäjä on viettänyt iltansa liian iloisesti ja erehtyy seuraavana päivänä lähettämään väärän aikamääräyksen, toistaa kone sen sydämettömästi seuraavalla asemalla, ja seurauksena on junien yhteentörmäys. Koneen armoton säännöllisyys kasvattaa kalvavan vastuunalaisuuden tunteen, joka ehdottomasti vaatii pitämään hermot tasapainossa, ja pakottaa puhelinkeskuksen hoitajattaria kantamaan laukussaan

»Työhön!» (Ufa-elokuvasta »Metropolis».)

21

Fig. 2

Olavi Paavolainen (text and layout), essay "Nykyaikaa etsimässä" ["In Search of Modern Times"], from magazine *Aitta* 7 (July 1927), pp. 20–21

on the right gives a visual expression for the modern city, with symbolical elements that were frequently put forward, such as the verticality of the high-rise buildings, the night lights, and the flexible combination of sizes and scales that creates a dynamic and slightly chaotic effect. Interestingly, the legend below the image reads "'To work!' (From the UFA-film 'Metropolis')". The still image from Fritz Lang's film is thus primarily related to the topic discussed in text, the working conditions in a modern city, and only secondarily indexed to the artwork it comes from. This shows how Paavolainen's discourse of modernity treats images of artworks as illustrations of general aspects of modernity rather than as representations of singular paintings, sculptures, or movies. In constructing the meaning of modernity, his discourse draws equally on art and reality, detaching symbols from their original context and merging them in a text that feeds itself on hard facts and figments of fiction alike, and proposes at the same time an analysis based on sociological observations and a vision based on art.

"Nykyaikaa etsimässä" presents a clear difference between foreign places where modernity can be found and

Fig. 3

Olavi Paavolainen (text),
Eeli Jaatinen (layout),
text "Helsinki by Night",
from magazine *Aitta* 12
(December 1929), pp. 34–35

experienced, and Finland where it is lacking; this difference makes the cosmopolitan orientation an obligation for the modern artist or writer. Interestingly, two years later in *Aitta* Paavolainen published a 10-page-long text entitled "Helsinki by Night", subtitled "Psykodraama v:lta 1929" ["A Psychodrama from the Year 1929"; Figs. 3 and 4], with Constructivist layout by Eeli Jaatinen, demonstrating that this style had a foothold in design while being practically absent from painting. This photomontage narrative is set in a tourist bus on a sightseeing tour of Helsinki. Producing a very complicated play of irony and seriousness, it reads as an interesting attempt to articulate foreign perceptions of Finland and Helsinki with Finnish ones (and eventually Paavolainen's own), especially from the point of view of modernity. The narrator of the story is a tourist guide who boasts of the modern aspects of Helsinki, such as the intensity of the traffic — "approximately ten accidents a day", "16,000 cars a day",[31] — the new tramways, the neon advertisements, and so on. These aspects connect the Finnish capital with the

31 Paavolainen (1929: 35, 36).

Fig. 4

Olavi Paavolainen (text),
Eeli Jaatinen (layout),
text "Helsinki by Night",
from magazine *Aitta* 12
(December 1929), pp. 36–37

progress taking place in the world metropolises and with the cosmopolitan discourse of modernity (note that the guide speaks in several foreign languages, assuming that all his guests are interested in the same things). Some of the images, especially the cover vignette, support this effort, whilst simultaneously creating ironical effects through contrary information. Looking at the empty streets in some of the pictures, one may wonder where all the 16,000 cars are. Irony is also created when the guide has to react to the foreign tourists' questions concerning more traditional kinds of sights, as exemplified in the two following passages (comp. Fig. 4):

> [...] What magnificent church, sir?
>
> Perhaps the so-called Church of Saint Nicholas.
>
> Built in? Hmm... last century.
>
> The architect? I don't think I remember... The name might start with an "E"...
>
> But the railway station — magnifique!
>
> The public swimming pool — superbe!
>
> The gas station on Heikinkatu — subtile!

> And now, now, NOW — the Union Bank building, the most beautiful modern building in Europe!
>
> [...] You mean castles? Ruins? — mylady [sic!].
>
> Tower, Bastille, Westminster Abbey...
>
> We have a first-class municipal cleansing department, m'lady [sic!],
>
> All ruins are immediately cleaned away. [...][32]

These interruptions confuse the assumption of a shared cosmopolitan discourse of modernity. Not every foreign tourist is seeking symbols of modernity in Finland like Paavolainen and his fellow young Finnish intellectuals were doing abroad; they may rather be looking for historical sights and, through them, for more ancient traces of a common European heritage. The interesting point here is that the foreign tourists' interest in history underlines Helsinki's and Finland's difference in relation to the rest of Europe. If Helsinki can compete with other cities in the number of cars and the beauty of gas stations, it cannot do so with regards to monuments such as Westminster Abbey and the Bastille. This reflects the general temporality of the 1920s cosmopolitanism in Finland: it was oriented primarily to the present and to the near future, the past being perceived in several respects — not only due to the lack of monuments, but also due to the "mediation" by Sweden mentioned earlier — as a handicap, a deficiency that cut the connection with Europe. The psychodrama played out in the text is this collision of opposed expectations where the Finnish strive for international recognition through modernization clashes with the "old Europe's" appreciation of history.

As previously mentioned, intellectuals of Paavolainen's generation were also attracted by new states such as Estonia, the Baltic countries and Czechoslovakia. They were often more nationalistic than Paavolainen (who had a multilingual background, having in childhood spoken German with his mother and Russian with his nannies), their interest in horizontal relations stemming from hostility towards the dominance of Sweden, Russia, and the

32 Paavolainen (1929: 36–37). "The most beautiful modern building in Europe" in English and "magnifique", "superbe" and "subtile" in French in the original text.

284

Cosmopolitanism, Nationalism, and the Reconfigurations of the Map of Europe in the Discourse of Modernity in Finland in the 1920s

Fig. 5

Ludvig Wennervirta (text), article "Virolainen taidenäyttely" ["The Estonian Art Exhibition"], from magazine *Tulenkantajat* 5 (February 1929), pp. 74–75

old Europe during the times before Finland's independence, considered as a period of colonization. Estonia's role was particularly important. Its linguistic proximity with Finnish was ideologically interpreted as "racial and tribal kinship" (this ideology being called *heimoaate* in Finnish). At the same time it was considered a more advanced country, regarding the dynamism and openness towards European influences in art and literature, and the appropriation of modernism and avant-gardism. Estonia thus joined and merged aspirations that could otherwise have been contradictory, such as nationalism stemming from resentment towards the old colonial rule, racial and tribal ideology, "horizontal" cosmopolitism that was supposed to build on a strong national identity, and interest for international modernism and avant-gardism.

These tendencies are clearly visible if we look at reports on Estonian art and literature in *Tulenkantajat*. Issue no. 5 from 1929 contained a three-page article by the art critic Ludvig Wennervirta on the Estonian art

Fig. 6

Ludvig Wennervirta (text),
article "Virolainen taidenäyttely"
["The Estonian Art Exhibition"],
from magazine *Tulenkantajat* 5
(February 1929), p. 76

E. A. BLUMENFELDT: Le combiné noir.

EDFARD VIIRALT: Monotypia.

) 76 (

exhibition in Helsinki (Figs. 5 and 6). The illustrations present works by some of the artists discussed in the text, showing examples of the appropriation of international movements. Arnold Akberg is characterized as "a consistent Cubist and Constructivist", Ellinor Blumenfeldt as a Cubist who has preserved "Naturalistic characters" despite her strive for abstraction in the composition, and Eduard Ole as an artist who has "created an independent decorative style" based on Parisian influences from Auguste Rodin and Léonard Tsuguharu Foujita, while Eduard Viiralt is simply "magnificent".[33] We could discuss whether these characterizations are accurate in strictly art historical terms (I wonder, for example, where the naturalistic characters are in Blumenfeldt's work). More interesting however is to observe how Wennervirta presents these artists as models to follow for their Finnish colleagues, specifically from the point

33 Wennervirta (1929: 75–76).

Cosmopolitanism, Nationalism, and the Reconfigurations of the Map of Europe
in the Discourse of Modernity in Finland in the 1920s

of the articulation of nationalism and cosmopolitanism. He claims that Estonian art is exemplary for Finland in that it shows "what can be achieved in a short time with love, enthusiasm and the spirit of enterprise", Estonian art being "less tied with traditions" than in Finland and the Estonian artists having "a more courageous touch, more fervour and more ardent imagination",[34] than their northern colleagues. This exemplary dynamism, that draws in Wennervirta's discourse on the romantic myth of the artist as genius, is also due to Estonia's closer contacts with Europe and Paris. Referring to the Estonian art and literature critic Rasmus Kangro-Pool and the writer group *Young Estonia*'s (*Noor-Eesti*, 1905–1917) goal of "being Estonian and becoming at the same time European", Wennervirta claims that the new generation in Estonia has put more emphasis on the second and "turned decisively towards Europe".[35] Estonian art is in the process of becoming "European in the good sense of the word", yet it has to make the "national characteristics"[36] more visible and gain more spiritual depth in the future. The ideal art for Wennervirta would thus be both national and cosmopolitan and not tied to any particular "-isms", given that he presents different styles as equally modern. At the same time, while it is not clear what he means by "national characteristics",[37] his discourse, not unlike *Ultra*'s, seems to be indebted to a value hierarchy that assimilates experimentation with techniques to superficiality.

Estonia's role as example is even more important in poet and critic Lauri Viljanen's article "Eestin kautta Eurooppaan" ["To Europe via Estonia"; Fig. 7] in *Tulenkantajat*, issue no. 11–12, 1930. The article argues that Finnish literature after the Civil War exists in a "state of complete decadence" in the "silence of the grave", having lost the European orientation that would widen the national tradition with new ideas and visions.[38] In comparison,

34 Wennervirta (1929: 74, 76).
35 Wennervirta (1929: 75).
36 Wennervirta (1929: 76).
37 Let us point out that the illustrations in Wennervirta's article do not draw on the kind of national motifs that were used in Finnish art, such as supposedly authentic rural or wild landscapes or motifs from national literature, but instead show mundane or Parisian scenes.
38 Viljanen (1930: 150).

Fig. 7

Lauri Viljanen (text), article "Eestin kautta Eurooppaan" ["To Europe via Estonia"], from magazine *Tulenkantajat* 11–12 (June 1930), pp. 150–151

contemporary Estonian literature has an important number of "European talents" who have "a well-developed and broad cosmopolitan interest in literature" and who "have lived through a high-quality modern literary evolution", starting with the Europeanism of the *Young Estonia*, passing through the self-reflexion and criticism of the writers Gustav Suits, Friedebert Tuglas, and Anton Hansen Tammsaare and the Dadaistic contempt for bourgeois values, returning ultimately to sharp social satire, all the while nourishing itself with stylistic experimentation and with Russian, German, French, and English literary culture.[39] This dynamism contrasts strongly with "insular Scandinavism" that has lost the contact with "combative Europeanism"[40] and has therefore become foreign to Finland. Estonia's exemplary position thus stems from both its own specificity and from its position in a network of connections and values where it is related to

39 Viljanen (1930: 152).
40 Viljanen (1930: 151).

Cosmopolitanism, Nationalism, and the Reconfigurations of the Map of Europe in the Discourse of Modernity in Finland in the 1920s

modernity, Europe, and cosmopolitanism, and opposed to tradition, Sweden, Scandinavia, and insular introversion. The layout of the article participates in this production of meaning. The font size in the title emphasises the key words "Estonia" and "Europe", whereas Jaan Vahtra's wood cutting exemplifies at the same time one of the modern languages of art and, through its French title *Blanc et Noir*, the proximity of Estonia with the cosmopolitan capital of Paris. An important role is played also by the Estonian avant-garde poet Johannes Barbarus' poem "The Multiplied Poet" ("Multiplitseerit poeet"), published in Estonian in a text-box next to Viljanen's article on the same page.[41] The text is proposed as a "kind of a 'history of modern literature'" and as an example of the close relations between Estonia and Europe discussed in the article, the magazine's recommendation for the "older writers" in Finland is to become acquainted with the thirty eight writers from East and West mentioned in the poem. Barbarus' text serves thus as a vehicle for channelling information to the Finnish audience, and in this sense as a vector of modernization of literary life in Finland. Yet at the same time it exemplifies, through the use of Estonian in the textual space of the magazine, the new kind of combination of nationalism and cosmopolitanism where small languages and the new states would exist on equal footing with the old centers and big languages.

Cosmopolitanism versus/and Nationalism

The young Finnish intellectuals' cosmopolitanism in the 1920s could be characterized as "portable and episodic" in Janet Lyon's sense.[42] Their cosmopolitanism was not based on a permanent and universalistic project that aimed to launch international careers or create a strong and lasting presence in the European artistic or intellectual centers, but rather on contacts that were by nature short-term, rarely exceeding a few months abroad. It sustained, however, a continuous reflection on the possibility of constructing a community that would transcend the national, ethnic, or racial limits, yet also be founded on

41 Barbarus (1930: 151).
42 Lyon (2012: 402).

NATIONALISM AND COSMOPOLITANISM IN THE AVANT-GARDE AND MODERNISM
The Impact of the First World War

a fully constituted and mature national culture. This cosmopolitanism was above all a strategy to be implemented on the home ground, as a means to achieve cultural capital and as a means to criticise the narrow-minded vision of culture imposed by the reigning conservative forces in Finland. Even though the critical dimension in relation to conservative and patriotic nationalistic ideologies was important, the cosmopolitanism of the young generation shared to a great extent the historical horizon with modern and progressive nationalism. For Paavolainen, Viljanen, and their fellow young intellectuals, cosmopolitanism was related to modernity above all and, in the arts and literature, to modernism and the avant-garde; its temporality unfolded in the present and the near future. Their nationalism was likewise oriented towards the present and near future, the construction of a modern democratic nation being the great project adopted by the young generation of the 1920s, who would not acknowledge the Civil War that had brought the long period of national awakening begun in the mid-19th century to a tragic end. In a period when the old imperial powers were scattered, new states were founded, and the very idea of Europe was questioned, the young intellectuals' efforts to connect with the international world of art and ideas produced a de- and recentering of the cultural map of Europe. Paris remained a strong focal point, but the horizontal connections gained in importance as states like Estonia and Czechoslovakia were taken as examples to follow in the articulation of national traditions with international modern and avant-garde movements.

In the discourse of modernity of the 1920s, foreign artworks — and especially artworks from the other new states — and the inventive use of layout and illustrations, played an important role in the dissemination and translation of avant-garde languages in Finland. They were read as examples of possible articulations of the national and the international in the visual arts and in culture in general, cosmopolitanism being understood not in contrast to, but in continuity with, a well-developed national culture. This idea materialized in the layout of the magazines that sought eventually to transform the page into a multilingual and egalitarian space of modernity, or exposed critical irony towards far-reaching assumptions

287

Cosmopolitanism, Nationalism, and the Reconfigurations of the Map of Europe in the Discourse of Modernity in Finland in the 1920s

about Finland's modernity. Despite these efforts and reflections, the specific modernistic or avant-garde art movements did not really find a role to play in this situation. As we have seen, art critics did not display much interest in their analysis, putting forward rather the tendencies toward synthesis and eclecticism. Cubism was understood as the most fundamental of the recent "-isms", as the provider of the aesthetic and poetic principles for the representation of modernity. This interpretation, however, downplayed the specificity of Cubism in relation to other languages in modern art, assimilating it with Classicism, Constructivism, and eventually even with Expressionism.

Abstract Constructivism and the Case of Finnur Jónsson

Universal Language — National Idiom?

Benedikt Hjartarson
University of Iceland. Reykjavík, Iceland

NATIONALISM AND COSMOPOLITANISM IN THE AVANT-GARDE AND MODERNISM
The Impact of the First World War

Abstract

The early abstract works of Finnur Jónsson have come to play an important role in Icelandic cultural history as emblems of the sporadic, yet untimely breakthrough of international avant-garde art in the early 20th century. The abstract works created by Jónsson during his period of study at Edmund Kesting's private art school *Der Weg* in Dresden between 1922 and 1925, eight of which were shown at an exhibition of *Der Sturm* in Berlin, have thus been seen as a typical manifestation of the notions of a universal language that pervaded the aesthetics of international Constructivism in this period. Yet references to the nationalist and Germanic characteristics of Jónsson's early works were also persistent in the 1920s, which raises questions pertaining to the ideological implications of these works. This article deals with the question of whether the specific visual idiom that can be discerned in Jónsson's early work may be rooted in notions of a specifically Nordic or Germanic tradition of abstraction, which played an important but forgotten role in abstract Constructivism as it evolved in the German setting.

Key words

avant-garde, Constructivism, abstract art, universal language, nationalism, transnationalism

Abstract Constructivism and the Case of Finnur Jónsson
Universal Language — National Idiom?

Introduction

Finnur Jónsson's early works have a prominent status in the history of modern Icelandic art. In the early 1920s, Jónsson became one of a couple of Icelandic artists, along with Jón Stefánsson, who participated directly in activities within the transnational network of the European avant-garde.[1] Jónsson's works from this period can in fact be claimed to be the most obvious case of an Icelandic artist producing works in line with the radical experimentalism of the historical avant-garde. Along with a number of other Nordic students,[2] Stefánsson's engagement with the new art took him to Henri Matisse's private art school in Paris, and later led to strong links with the group connected to the Danish Expressionist journal *Klingen* [The Blade, 1917–1920] and to the artist's engagement with moderate notions of Expressionism predominant in the Nordic countries. Jónsson, on the other hand, entered an emerging tradition of abstract Constructivism in the German setting. More precisely, Jónsson's entry into the avant-garde network can be linked to his studies at the private art school *Der Weg* in Dresden, which he began in 1922, and his contribution of eight works to an exhibition of *Der Sturm* in Berlin in the summer of 1925. Jónsson's participation in the *Der Sturm*-exhibition also marked the end of his direct involvement in the avant-garde project, as he returned to Reykjavík before the exhibition opened and shortly thereafter turned to more conventional painting. Of specific interest are Jónsson's abstract works from the early period, which remained more or less forgotten until the 1970s, but have since then come to stand as an emblem of the sporadic appearance of international avant-garde art in Iceland in the early 20th century. They belong to a period when there was vivid (partly enthusiastic but partly critical) interest in the new art emerging on the European continent. This interest diminished toward the end of the 1920s, which saw a return to more traditional aesthetics and artistic experimentalism disappearing from the cultural horizon.[3]

1 See: van den Berg (2006c).
2 See: Claustrat (2012).
3 See: Hjartarson (2006); Hjartarson (2016).

Formation of an Avant-Garde Artist

Before discussing Jónsson's early avant-garde works, it is useful to take a quick look at his career. The beginning is in many ways typical for a young Icelandic artist in the late 1910s and in the 1920s. After receiving some informal training as a painter and finishing a journeyman's examination as a goldsmith in Reykjavík in 1919, he went to Copenhagen.[4] This was the usual path chosen by young Icelandic artists in the period, due to the lack of possibilities for formal training in Reykjavík, which had replaced Copenhagen as Iceland's capital when the country gained its sovereignty in December 1918. In Copenhagen Jónsson entered the Viggo Brandt Art School, where he received some training in Naturalist painting before moving to the private Olaf Rude Art School, whose students had been experimenting with Cubist techniques, although Rude did not belong to the most radical painters in Denmark at the time.[5] The years between 1919 and 1921 were an important period for the emergence of the avant-garde in Copenhagen, the new art becoming a hotly debated topic that polarized the cultural field.[6] Jónsson's acquaintance with Cubism can on the one hand be traced back to his studies at Rude's school, and on the other to his study of Cubist paintings on show in Copenhagen. Of special importance in this context was the publicly accessible private collection of Christian Tetzen-Lund, which presented "one of the major opportunities for artists visiting or resident in Copenhagen" to view works of the new art.[7] The collection contained works by Pablo Picasso, André Derain, Henri Matisse, Paul Cézanne, Vincent van Gogh, Edvard Munch and others, and in a later interview Jónsson discussed his visits to this collection as an important step in his initiation into avant-garde art.[8] Retrospectively, Jónsson also referred to his acquaintance with other strands of the new art, through books and reproductions that he had access to during the years in Copenhagen.[9]

After a short stay in Iceland in the summer of 1921, where he organized a solo exhibition in Djúpivogur, and

4 Nordal (1992: 8).
5 See: van den Berg/Hjartarson (2012: 235–236).
6 See: Abildgaard (1984/1985).
7 Aagesen (2012: 317); see also: Gottlieb (1984).
8 Kvaran (1976: 16).
9 Pálmadóttir (1970: 44).

293

Abstract Constructivism and the Case of Finnur Jónsson
Universal Language — National Idiom?

later in Reykjavík, consisting primarily of portraits and landscape paintings, Jónsson moved to Berlin. This was an unusual step at the time, considering that Berlin had hardly been "on the horizon of Icelandic visual artists".[10] The reasons behind Jónsson's decision are not clear and there are no indications that he had at this time been especially attracted to the new currents of modern art coming from Germany. On a personal level Jónsson's contact with Baldvin Björnsson, who had lived in Berlin from 1913 to 1914 and became the first Icelandic artist to experiment with abstract painting,[11] may have played a role. During his years of training as a goldsmith in Reykjavík, Jónsson had been instructed by Björnsson's father, Björn Árnason, and his two sons.[12] From a broader perspective Hubert van den Berg has pointed out that Jónsson's decision to move to Berlin was the result of social, cultural, and political shifts. Berlin was not only the site of new experiments in the artistic field. Due to a changed political landscape following the end of WWI, the German border had become easier to cross and Berlin in a certain sense replaced Paris as the focal point of young Nordic artists, in part because of the activities of Herwarth Walden and *Der Sturm* (1910–1932) in Copenhagen in the 1910s.[13] One further reason should be mentioned: in the early years of the Weimar Republic notions of German nationalism were increasingly linked to idealized concepts of the Germanic and the Nordic and this contributed to creating an atmosphere favorable for young Nordic artists heading for Germany.

Arriving in Berlin in the autumn of 1921, Jónsson briefly entered the private Carl Hofer Art School, an artist whose works are most properly described as products of an "expressionist with classical leanings".[14] Apparently, it was less Hofer's teachings than the new artworks that he

10 Gottskálksdóttir (1993: 78).
11 Nordal (1992: 7).
12 Nordal (1992: 9).
13 Van den Berg (2006c: 66–67); see also: Aagesen (2002a). On the decentering of the international avant-garde and the shift from Paris to Berlin as a focal point for young artists in this period from a broader geographical perspective, see: Joyeux-Prunel (2017: 107–208).
14 Van den Berg/Hjartarson (2012: 238).

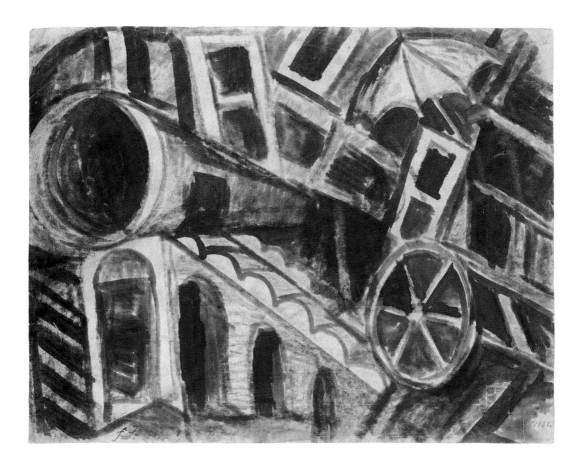

Fig. 1

Finnur Jónsson,
Borgarstemmning
[City Atmosphere]
(also known as *Berlin*), 1921.
National Gallery of Iceland,
Reykjavík

studied in Berlin that pushed Jónsson into an avant-garde direction. An important event was Jónsson's first visit to the *Der Sturm* exhibition in December 1921, where he could study the works of artists like Wassily Kandinsky, Franz Marc, Marc Chagall, Georges Braque, and Picasso,[15] as well as two sections with works of *Bauhaus* artists, among them Lyonel Feininger, Johannes Itten, and Paul Klee.[16] An ink drawing from 1921 (Fig. 1) bears witness to Jónsson's response to these new works.[17] This period in Berlin is poorly documented, but Jónsson seems to have been a frequent visitor to *Der Sturm* exhibitions until he moved to Dresden in February 1922, where he entered the department for foreign students at the Art Academy. One of the professors was Oskar Kokoschka,

15 Kvaran (1976: 16).
16 Gottskálksdóttir (1993: 79–80).
17 Gottskálksdóttir (1993: 80–81).

Abstract Constructivism and the Case of Finnur Jónsson
Universal Language — National Idiom?

a close collaborator of Walden since the foundation of *Der Sturm*.[18] The period at the Art Academy came to an abrupt end when Jónsson moved to a private art school directed by Edmund Kesting, *Der Weg — Neue Schule für Kunst* (1919-1933). This decision was probably a result of the difficult situation during the years of hyper-inflation, *Der Weg* being a more feasible choice than the more expensive Art Academy.[19] More importantly, another Icelandic student, the composer Emil Thoroddsen, who had studied art history in Copenhagen in the years when Jónsson was there, was already studying at *Der Weg* and drew Jónsson's attention to the school.[20] Considering Jónsson's aesthetic preferences during this period, the decision to go to *Der Weg* was quite logical. Kesting was a close collaborator of *Der Sturm*, which had amongst others organized a solo exhibition of his works in Berlin in 1923.[21] His works had also been shown at a number of collective *Sturm* exhibitions between 1920 and 1923 and were reproduced in Walden's journal. He was furthermore the founder of the *Gesellschaft der Sturmfreunde* in Dresden.[22]

There are different anecdotes explaining how Jónsson came into contact with *Der Sturm*, and according to two different accounts of his own it was either Kurt Schwitters or Oskar Kokoschka who encouraged him to contact Walden.[23] A more likely explanation, however, is that it was Kesting who sent Jónsson to Walden, who at this time was in a difficult financial situation and needed young foreign artists willing to contribute works to his international *Sturm* exhibitions without considerable costs.[24] After meeting with Walden, Jónsson sent him eight works that were first shown as part of the *Gesamtschau*, or collective section, of an exhibition of *Der Sturm* in summer 1925.[25] This marked both the beginning and the end of Jónsson's involvement

18 See: van den Berg (2006c: 69-70).
19 Gottskálksdóttir (1993: 80).
20 Nordal (1992: 9). Jónsson explicitly mentions Thoroddsen's role in this decision in a later interview: Kvaran (1976: 16).
21 *Der Weg* (1972).
22 Jacoby (2007: 152).
23 See: Ponzi (1983a: 55); Gottskálksdóttir (1993: 88).
24 Van den Berg (2006c: 70-71).
25 Van den Berg (2006c: 71-72); see also: Ponzi (1983a: 55).

in the activities of *Der Sturm*. A few weeks later he returned to Iceland and thus never saw the exhibition in Berlin. Arriving in Reykjavík in 1925, he put up a solo exhibition of some 40 or 50 works at Café Rosenberg, showing a number of his abstract works as well as works based on more traditional Expressionist aesthetics.[26] Jónsson's return caused a stir back home which preceded his exhibition and led to a public debate on *Der Sturm* in the Icelandic press, with Valtýr Stefánsson — editor of the biggest newspaper, *Morgunblaðið* [The Morning Paper, 1913 — still in publication] — initiating proceedings with a frontal attack against the new art propagated by *Der Sturm*.[27] The responses to the exhibition itself were mixed and can hardly be seen as the catalyst for the radical shift that followed, when Jónsson abandoned abstract Constructivism and turned to more traditional painting in the vein of pictorial Naturalism.

The abstract works from the 1925 exhibition were sporadically shown later,[28] but they did not receive significant attention until 1970 when they were chosen for the exhibition *L'art en Europe autour de 1925* in Strasbourg.[29] Following that exhibition Jónsson's early abstract works gained an important status as landmarks in the history of modern Icelandic art and his exhibition from 1925 became

26 Gottskálksdóttir (1993: 88, 94). The importance of this rather unusual exhibition venue calls for a closer analysis, yet its signfance can at least be hinted at here. Café Rosenberg had opened in 1924 and was one of the new *chic* cafés in Reykjavík that played an important role in the cultural milieu of the upcoming Icelandic bourgeoisie. The choice of venue in one of the café's side rooms, where visitors could also listen to an Austrian *Viennese Art trio* in tuxedos playing live music (see: Melsted (2016: 83–84)), indicates that Jónsson's exhibition was seen as an introduction to one of the "modish" trends from the European art scene, rather than as a progressive avant-garde act of provocation against bourgeois taste.

27 This critical response to Jónsson's return has been explained in different ways. Gottskálksdóttir (1993: 93) has pointed out that it may have been the result of Stefánsson's links to the milieu of Icelandic artists in Copenhagen and the attempt of the painter Jón Þorleifsson to have his works exhibited at *Der Sturm*, which Walden apparently never responded to. It should also be mentioned that discussions of *Der Sturm* in the Icelandic press can be traced back to the late 1910s, as an article on *Der Sturm* as the "main center of 'Futurism'" shows (E.R. (1918: 1)).

28 See: Ólafsdóttir (2013: 99–103).

29 See: Ólafsdóttir (2013: 83).

297

Abstract Constructivism and the Case of Finnur Jónsson
Universal Language — National Idiom?

Fig. 2

Finnur Jónsson, *Model*, 1923.
National Gallery of Iceland,
Reykjavík

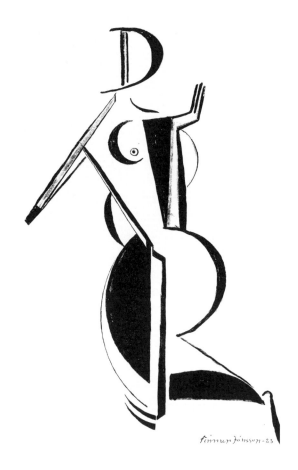

a symbolic chapter in this history, shocking the Icelandic
public, to whom the "unfamiliar and obscure depictions
[...] seemed incomprehensibly foreign".[30] The paradigmat-
ic role of these works was thus related to their (re)dis-
covery in the context of the new geometric abstract art
that dominated the artistic field in the post-war period,
when these works gained the function of "important
historic forerunners".[31] In this context they have come
to stand as signs of an "untimely" or "premature experi-
ment"[32] that demanded too much of the Icelandic public
and marked a failed attempt to introduce international
avant-garde art into the Icelandic cultural field, which at
that time was shaped by notions of national tradition,
and led to critical reactions in the public sphere.

30 Ponzi (1983a: 54).
31 Ponzi (1983a: 55).
32 Gottskálksdóttir (1993: 88).

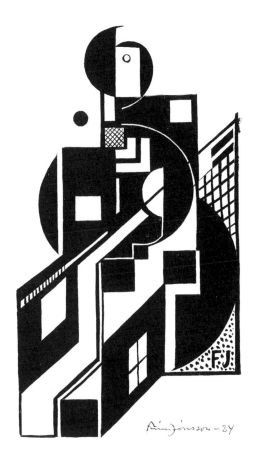

Universal Language — Programmatic Internationalism

When attempting to describe the international language of the new art marking Jónsson's early abstract works it is necessary to take a closer look at Kesting's art school in Dresden. Jónsson's enrollment at *Der Weg* in 1922 was definitely the most important step in his career from an avant-garde perspective. During the years at the school he developed a specific mode of abstract visual expression that bears witness to his involvement in the emerging universal language of abstract Constructivism (Figs. 2 and 3). Art historians have pointed out the affinity of his works from this period with Central and Eastern European Cubo-Futurism and Constructivism, as well as with the works of artists like Kandinsky, Alexander Archipenko, László Moholy-Nagy, and Johannes Molzahn.[33] More precisely, the specific idiom of visual abstraction can be

33 See: Gottskálksdóttir (1993: 82); Ingólfsson/Nordal (1992: 20–22); Ponzi (1983a: 58–59).

299

Abstract Constructivism and the Case of Finnur Jónsson
Universal Language — National Idiom?

Fig. 4

Lothar Schreyer, *Figur des lüsternen Mannes*, 1920. Formerly Ketterer Kunst GmbH und Co. KG

linked to the works of lesser-known artists who were active in the Constructivist enterprise as it developed in the context of *Der Sturm*, such as Thomas Ring, Fritz Stuckenberg, and Paul Joostens.[34] The closest affinity, however, is with the works of artists who were affiliated with *Der Weg* in the 1920s. In this context one might point out the works of Kesting himself or the works of Lothar Schreyer (Fig. 4), a close collaborator of Walden who was associated with *Der Weg* and became the director of a new branch of the school that opened in Berlin in 1926. One might equally point out the strong affinity of Jónsson's early work with the works of Hans Haffenrichter (Fig. 5), a former student of Schreyer who was also associated with *Der Weg* and replaced Schreyer as the director of the branch in Berlin in 1927.[35] Jónsson's works clearly belong

34 Van den Berg (2006c: 67).
35 See for example the reproduced works of both artists in: *Der Weg* (1972)

Fig. 5

Hans Haffenrichter, linocut
Op. 23/37b with seated female
figure, 1923. Formerly Lehr Berlin

to the context of European Constructivism in this period, especially as it evolved in the German setting, where the visual language of abstraction was usually not exclusively geometrical.[36] This seems to confirm the view that in the early 1920s Jónsson entered an emerging tradition of the new art based on ideas of the universal language of abstraction. In the 1920s this universal language was linked to radical notions of internationalism, transnationalism, and cosmopolitanism that came to shape the activities of the international Constructivist movement.[37] Jónsson's abstract works from this period thus seem to be characteristic products of the new language of painterly abstraction which Krisztina Passuth has described as the construction of a "modern *Biblia pauperum*."[38] Jónsson's

36 See: van den Berg (2006c: 67–70).
37 See: Hjartarson (2014).
38 Passuth (2003: 122); see also: van den Berg (2000: 273).

304

Abstract Constructivism and the Case of Finnur Jónsson
Universal Language — National Idiom?

early abstract works further seem to confirm his involvement in a cultural project based on radical notions of internationalism.

This view is confirmed in a number of articles. Margrét Elísabet Ólafsdóttir has discussed Jónsson's early works as the result of his engagement with currents of international avant-garde art in this period, the internationalist scope of his aesthetics provoking critical reactions to his works from a nationalist perspective back home.[39] In an article that I wrote with Hubert van den Berg some years ago we discussed these works along similar lines, describing them as isolated examples of programmatically international avant-garde art in Iceland in the early 20th century. We came to the conclusion, furthermore, that it was primarily the internationalist scope of Jónsson's work that caused the stir in the art scene in Iceland's capital when he organized his solo exhibition in 1925, in "an increasingly hostile cultural field pervaded by the idea of national identity."[40] In my engagement with Jónsson's works in the last years the suspicion has grown, that our understanding of these works as products of programmatic internationalism may not be quite as self-evident as it seems. I believe the main question that needs to be posed when dealing with these works is: how was the idiom of abstract visual expression that can be seen in Jónsson's work coded? This leads to a series of further questions: Which discourses surface in these early works? Is it possible that we are not getting things quite right when we approach them as typical products of internationalist notions of a universal language? Is it possible that within the semiotic space of this universal language we are also confronted with nationally coded idioms or even nationalist ideologemes that have hitherto remained unnoticed? Before addressing these questions, let me stress that the following discussion will not provide any definitive answers. It is merely meant to articulate my doubts and mention some of the signs that I have come across, which indicate that Jónsson's early abstract works were in fact charged with cultural energy linking them to notions of "nationalism" and "national identity".[41]

39 Ólafsdóttir (2013).
40 Van den Berg/Hjartarson (2012: 245).
41 On the notion of "cultural energy", see: Greenblatt (1988).

National Idiom?

In my engagement with Jónsson's early abstract works I have been drawn time and again to one of the reviews of his exhibition in Reykjavík in 1925. One of the striking aspects in the discussion is the predominant role of nationalism on all sides. The discourse of Icelandic nationalism dominated the debate and the notion of nationality played a crucial role in every published review. This may not be striking as such, considering that the Icelandic state had gained its sovereignty from Denmark only in 1918 and in the 1920s Icelandic artists and intellectuals were engaged in the project of establishing a tradition of national culture. Striking, however, is the fact that notions of nationality were at the core of all the reviews. Yet a review by the composer Emil Thoroddsen hits a tone quite different from the other ones:

> Isn't Icelandic art for the most part a bad imitation of bad, Danish painters who themselves are not very original and hasn't art thus arrived in Iceland in outworn copies? I believe that those people who have been sucking skimmed milk from the baby bottle of the artist-clique in Copenhagen, which is nurtured by an outmoded "formalism" and misunderstood French watchwords, don't like the fact that a Germanic taste appears in some of Finnur Jónsson's paintings.[42]

I have tended to regard this passage as a curious attempt to read nationalist ideas into the universal modes of artistic expression that can so obviously be seen in Jónsson's works. The fact seems relevant, however, that Thoroddsen had been one of Jónsson's fellow students at *Der Weg*. The question is whether Thoroddsen's emphasis on the genuine "Germanic taste" expressed in Jónsson's paintings is as far-fetched as it seems, or whether it may possibly be in line with Jónsson's own understanding of his work, as well as with the ideological background at *Der Weg*. Unfortunately we don't have any published writings by Jónsson from this period that might shed light on his position, but we do have quite a few indications that this may be the case. First of all the question should be posed as to whether it was a mere coincidence that two young artists from Iceland were enrolled at Kesting's art school in 1922 — or in fact three, because the

42 Thoroddsen (1983: 50).

303

Abstract Constructivism and the Case of Finnur Jónsson
Universal Language — National Idiom?

artist Tryggvi Magnússon also enrolled at *Der Weg* in the same year as Jónsson.[43] One possible explanation may be that *Der Weg* was an "anti-academic school" based on a program of adult education and students did not need to have a formal art education to enter the program.[44] It was thus obviously easier for young Icelanders with artistic ambitions to enter this institution than many other schools. Furthermore, the tuition fee of 200 marks pro semester was affordable and may thus have been attractive to the Icelandic artists.[45] Finally, Thoroddsen apparently played a central role in Jónsson's decision to go to *Der Weg* and Magnússon's enrollment may have followed a similar path, which led to the three young Icelanders forming a small artists' colony in Dresden. Yet, the presence of three Icelandic students at *Der Weg* also shows that they were at least welcome at the school. The question is whether their national or Nordic background may even have played a role in this context, whether artists with an Icelandic or Nordic background were possibly systematically enrolled at the school on the basis of nationalist visions of Germanic culture and heritage.

Nordic Primitivism

A number of the artists affiliated with *Der Weg* belonged to avant-garde circles with ties to the *völkisch* milieu. Many of the younger collaborators of *Der Weg* were also members of the German youth movement, or *Jugendbewegung*, and participated among others in the exhibition *Das junge Deutschland* at the Schloss Bellevue in 1927. Furthermore, there were links between *Der Weg* and institutions such as the *Freideutscher Werkbund* and the *Hochschule für Leibesübungen* in Spandau which were linked to the *Lebensreformbewegung*.[46] Links to the *Jugendbewegung* and the tradition of *Lebensreform* could certainly be found on both sides of the political spectrum in this period, but they played a specifically important role in the *völkisch* milieu, where they were related to

43 See: Gottskálksdóttir (1993: 97); Kjaran (1960).
44 *Der Weg* (1972: n.p.).
45 *Der Weg* (1972: n.p.).
46 *Der Weg* (1972: n.p.).

ideas about the regeneration of German culture. These links became increasingly strong at *Der Weg* after 1925, but there are indications that ideas of *Lebensreform* and the youth movement already played an important role in the early period. In the concluding remarks of his review from 1925, Thoroddsen specifically praised Jónsson's for having enriched Icelandic art with "an artistic value impregnated by the healthy power of youth", thus linking notions of youthful power to visions of a genuine Germanic taste in a rhetorical gesture characteristic of the *Jugendbewegung*, which can most probably be traced back to Thoroddsen's years in Dresden.[47]

When it comes to analyzing the links between *Der Weg* and the *völkisch* milieu the most important figure, however, would be Lothar Schreyer, who was affiliated with *völkisch* groups and also had a profound interest in Nordic mythology. Schreyer's nationalism took on a more radical form in the late 1920s and 1930s, but already in the early 1920s he was engaged in the project of reinventing the tradition of *Deutsche Mystik*, to quote the title of one of his publications from 1925. As early as 1920 he published an Expressionist adaptation of the *Edda*-poem "Skírnismál" in *Der Sturm*,[48] later using the same poem as the basis for a play published in *Blätter für Laien- und Jugendspiele* (1924–1927).[49] The interest in Nordic mythology that can be seen in Schreyer's work, which in his case was linked to visions of the German mystic tradition as a revitalizing force, was not an isolated case within German avant-garde circles in the early 1920s. Another example is the publication of an edition of *Völundarkviða* by the *Bauhaus*-Verlag in 1923 under the title *Das Wieland-Lied*, with illustrations by the *Bauhaus* artist Gerhard Marcks, who produced ten woodcuts based on the myth. Wieland the Smith was indeed a motif of general interest for European artists and writers, yet in the German context he became increasingly linked to nationalist visions of an individual freeing himself from bondage, departing

47 Thoroddsen (1983: 50). It should be mentioned, however, that further articles discussing the German youth movement and its achievements, linking it to ideas of nationality, can be found in the Icelandic press in this period — see for example: Prinz (1926).

48 Schreyer (1920).

49 See: van den Berg (2012: 24).

Abstract Constructivism and the Case of Finnur Jónsson
Universal Language — National Idiom?

from earth and becoming the embodiment of a Teutonic artisan and "demonic man of action".[50] In Expressionist circles in Hamburg, elements from the *Edda* were used by the dance pair Lavinia Schulz and Walter Holdt as well as in "Eddalieder" by the avant-garde composer Hans Jürgen von der Wense.[51] The interest of avant-garde artists in the *Edda* seems to have been triggered by the publication of Felix Genzmer's *Edda* translations, parts of which also appeared in avant-garde journals.[52] Of interest in this context are also two Expressionist poems by Rudolf Adrian Dietrich, dedicated to Iceland and published in the journals *Die Dachstube* (1915–1918) and *Die Sichel* (1919–1921) in 1918 and 1919.[53] Dietrich was the driving force in the activities of the so-called *Komet-Kreis* in Dresden and the editor of its organ, the journal *Der Komet* (1918–1919), which shows that exotic — if not necessarily nationalistically inspired — notions of the high North were circulating in the city's avant-garde circles shortly before Jónsson's arrival.[54] Further examples could be added to this list, which bears witness to the interest in visions of the North and especially in Nordic mythology and medieval heritage within circles that linked avant-garde aesthetics to *völkisch* ideas. In the late 1910s and early 1920s we can thus find clear traces of a discourse that Hubert van den Berg has described as "Nordic orientated primitivism",[55] which calls for a closer analysis and contests the predominant view that in the German setting interest in the Nordic was exclusively linked to aesthetic traditionalism and reactionary politics.[56]

Links to the discourse of Nordic primitivism can be found in the works of artists affiliated with *Der Weg*. In light of the lack of published material on Kesting's school much is left to speculation, but considering the interest of German avant-garde artists (some of whom were

50 Dusse (2007: 64).
51 Van den Berg (2012: 24).
52 See for example: "Das alte Spruchgedicht aus der *Edda*" (1913).
53 Dietrich (1918); Dietrich (1919).
54 Chapman (2013).
55 Van den Berg (2012: 24).
56 For a discussion of the reception of Nordic mythology and medieval culture in the German context, see: Klaus von See's standard work (1994).

affiliated with *Der Weg*) in notions of the Nordic it seems possible to conclude that the presence of three young Icelandic artists at Kesting's school was not a mere coincidence. There are strong indications that their enrollment at the school was part of a Germanic cultural program, which would call for a critical reexamination of Jónsson's early work and its ideological implications. This may also point toward the necessity of rethinking our understanding of the universal language of abstract Constructivism, which may have been more multi-layered than assumed. Of interest, furthermore, is that neither the work of Thoroddsen nor Magnússon developed in an avant-garde direction after their stay in Dresden, which indicates that the study program at *Der Weg* may have been more open than assumed. Jónsson's claim that he was the only artist at the school engaged in abstract painting should probably be taken *cum grano salis*,[57] but it is noteworthy that he was the only one of the three Icelandic artists who became involved in the visual idiom of the new art. The question is, however, whether this involvement marked his distanciation from nationalism and his engagement in a programmatic project of cultural internationalism.

Abstract Constructivism in Nationalist Terms

Published material about *Der Weg* shows that the program was partly based on the study of composition and geometry. Yet the focus on geometry was clearly linked to the tradition of *Naturmystik* and notions of the occult, "harmonization" being linked to ideas about "the organizing element" and "mysterious power" of nature.[58] The hidden elements of nature were in turn linked to the "primordial power" (*Urkraft*) of man and his "drive to organization" (*Trieb zum Ordnen*) in a search for "hidden connections between matter and order", to quote a text by Kesting from 1926.[59] The aim of the program was the search for "primordial form" and the *Bildung* "or formation of man through art",[60] but little is known about the

57 Pálmadóttir (1970: 44).
58 *Der Weg* (1972: n.p.).
59 *Der Weg* (1972: n.p.).
60 *Der Weg* (1972: n.p.).

Abstract Constructivism and the Case of Finnur Jónsson
Universal Language — National Idiom?

Fig. 6

Finnur Jónsson, *Kona við spilaborð* [Woman at the Card Table], 1925. Yale University Art Gallery, gift of Collection Société Anonyme

ideological and political implications of this program. Based on an analysis of Kesting's works it is possible to draw a clear link to avant-garde concepts, yet there are also indications that the study program at *Der Weg* was not exclusively focused on avant-garde aesthetics. Kesting's own work should not be taken for granted as proof about the contents of the study program at his school. In published material from the archives of *Der Weg* we find general references to the tradition of *Naturmystik* and esoteric currents, to notions of primitivism and compositional principles, and finally to the milieu of *Lebensreform* and the *Jugendbewegung*. Yet we hardly have any indications about the ideological context of these references, which can neither be seen as a clear indication of links to *völkisch* or nationalist ideology, nor as proof of the absence of such links. In fact, we hardly have any clear indications about the ideological context of the

Fig. 7

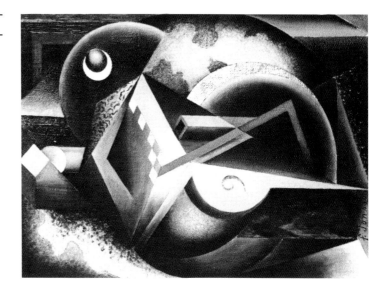

study program at Kesting's art school in the early 1920s. The current references to the Germanic implications of Jónsson's early works in the 1920s seem to indicate, however, that they were linked to notions of the Germanic that were circulating at that time and belonged to a nationalist discourse on the visual language of abstract Constructivism as it developed in the German context.

The most curious reference to the nationalist implications of Jónsson's early abstract works can be found in Katherine S. Dreier's catalogue for the exhibition *Modern Art*, organized by the *Société Anonyme* in 1926. Earlier that year Dreier, who played a key role in bringing German and international avant-garde art to the American public,[61] had bought two works by Jónsson from the *Sturm* exhibition in 1925, *Kona við spilaborð* [Woman at the Card Table, 1925; Fig. 6][62] and *Marglitur heimur* [Colored World, 1925; Fig. 7]. As a part of this exhibition, first shown at the Brooklyn Museum, then at the Anderson Galleries in New York, at the Albright Art Gallery in Buffalo, and finally at the Art Gallery of Toronto,[63] Jónsson's two works became important specimens in Dreier's well-known international collection of the new art. A short note on Jónsson's work in the exhibition catalogue

61 See: Langfeld (2013).
62 See: Gottskálksdóttir (1993: 88); Ponzi (1983a: 55–56).
63 See: Langfeld (2013: 195).

309

Abstract Constructivism and the Case of Finnur Jónsson
Universal Language — National Idiom?

contains a curious statement: "Even Iceland could not escape the influence of these cosmic forces which are now at work and we find a painter of distinction, Finnur Jonsson, who expresses Modern Art in nationalistic terms."[64] The statement seems peculiarly misplaced in a catalogue published in the United States in 1926, which was meant to give a broad overview of the international scene of "universal Modern Art."[65] From Dreier's theosophical perspective, the universal character of the new art had its origin in "the fact that cosmic forces are at work and with such potentiality enter the individual who perceives them that it clarifies his vision and sweeps him upwards to greater heights".[66] In the "Foreword" to the catalogue it was further declared that the new art "is bigger than any one nationality and carries the follower into a large cosmic movement which unites him in thought and feeling with groups throughout the world. Though this is true, it does not mean that it kills that strange quality which each nation stamps on its sons and daughters, but rather that nationality is no longer the whole substance, but a flavor which adds a charm."[67]

The remarks show that Jónsson's two works, with their strong cosmic overtones, fitted perfectly into the framework of Dreier's theosophically-inspired exhibition. They also show that Dreier's ideal of "universal Modern art" still left space for the national, at least as a taste of localism within a universal setting. From this perspective, the reference to the nationalist impetus of Jónsson's paintings could be seen as an attempt to imbue the works of a young artist from a remote country with "a glow of the exotic". On the other hand, Jónsson is only one of two artists — along with Ivo Pannaggi[68] — whose works are linked to ideas of the national in Dreier's catalogue. Another explanation thus seems closer at hand. If we consider how such catalogue texts were usually generated, the conclusion that Dreier's description may have been based on textual material provided either by

64 Dreier/Aladjalov (1926: 58).
65 Dreier/Aladjalov (1926: n.p.). The quotation is from the "Foreword" to the volume.
66 Dreier/Aladjalov (1926: n.p.).
67 Dreier/Aladjalov (1926: n.p.).
68 Dreier/Aladjalov (1926: 62–63).

Jónsson himself, or related to the promotion of his work at the exhibition in Berlin the year before, doesn't seem far-fetched. Again, we don't have any evidence, but there are clear signs pointing in this direction. In light of the indications that keep piling up I find it increasingly difficult to believe that the links that were persistently drawn between Jónsson's works and notions of nationalism in the 1920s are a pure coincidence.

Deciphering Jónsson's Early Works

If the assumption that Jónsson's early abstract works were ideologically coded from a Germanic or nationalist perspective is correct, the question still remains how these codes can be deciphered. It should be stressed that Jónsson did not work exclusively with abstract painting in this period and Thoroddsen's remarks about the inherent "Germanic taste" of his works may possibly [also] refer to the artist's figurative works from this period. Dreier's remarks, on the other hand, show that notions of nationality were explicitly linked to his abstract works.[69] In a later text Dreier again referred to the national characteristics of Jónsson's paintings, describing them as "a revelation of the mental attitude of the Icelanders".[70] In this later description she sees these national characteristics in the artist's use of "glitter of gold and silver paint", which she traces back to Icelandic glaciers and the "effect of glittering ice".[71] This rather crude explanation in a text written in 1949 should probably be seen as a retrospective attempt to reconstruct the national elements of Jónsson's visual idiom. The same accounts for Frank Ponzi's later description of Jónsson's works, which linked them to the "Icelandic Sagas and poems" and the "native northern night-skies, bathed in stellar light and brilliantly revealing their awesome constellations"[72] — a description that hardly seems to apply for

69 In this context it should furthermore be stressed that there is a difference, of course, between references to the Germanic character of Jónsson's works and references to their nationalist implications, although these two aspects may partly overlap.
70 Dreier (1950: 120).
71 Dreier (1950: 120).
72 Ponzi (1983a: 58).

Abstract Constructivism and the Case of Finnur Jónsson
Universal Language — National Idiom?

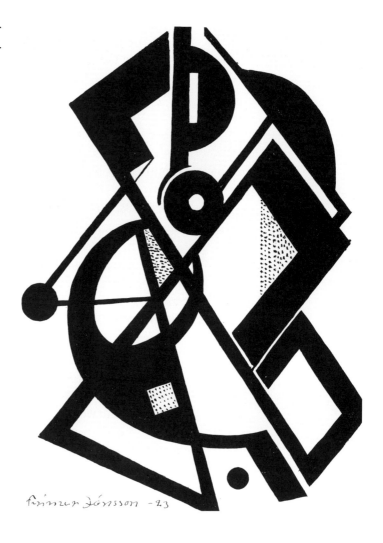

Jónsson's early abstract works. If we look for concrete
examples of Nordic or Icelandic fragments or elements in
the early abstract works we might be drawn to a *Composi-
tion* from 1923 (Fig. 8), in which Jónsson's use of a linguis-
tic fragment — typical for the use of such fragments in
abstract Constructivism in this period — shows a playful
variation on the Icelandic letter "Þ". This isolated exam-
ple, however, does little to provide us with an insight into
the more general aspects of the national or the Germanic
in Jónsson's early works.

Finally, one might point out the strong mystical el-
ements in Jónsson's early works, which might seem
applicable to traditional notions of mysticism often re-
ferred to as an important element of Icelandic culture.
Yet Jónsson's engagement with cosmological themes and

the strong esoteric elements that can be found in these works are less the expression of a specific national tradition or a personal idiom — as claimed for example by Júlíana Gottskálksdóttir[73] — than the expression of mystic ideas that were circulating at *Der Weg*. This accounts not only for the works of Kesting and his "weakness for the mystical",[74] but also for Lothar Schreyer, whose works from the early 1920s bear witness to a profound interest in the mystic tradition, with links to *völkisch* ideology and the milieu of the conservative revolution.[75] It is tempting to search for the Germanic element in Jónsson's early abstract works precisely in the cosmological motifs that came to dominate his works in 1924 and 1925 and found their paradigmatic expression in the two paintings bought by Dreier, as well as in works such as *Óður til mánans* [Ode to the Moon, 1925; Fig. 9] and *Örlagateningurinn* [Dice of Destiny, 1925; Fig. 10]. A closer look at the development of Jónsson's work in the years at *Der Weg* reveals a clear "cosmic shift" around 1924, as references to mysticism, cosmology, and alchemy come to play a central role. It is worth noting that this cosmic shift can be dated to the time when Schreyer gave his first lecture at *Der Weg* in Dresden in 1924.[76] Schreyer's lecture was dedicated to the works of Jakob Böhme, who in this period played an important role in *völkisch* visions of the German mystic tradition, embodying the figure of a "Fürst der Philosophen" and a "philosophikus teutonicus".[77] Böhme was the subject of a number of publications by Schreyer in 1924 and 1925, which discussed his writings as key works of the German mystic tradition.[78] Again much is left to speculation, but it seems likely that Schreyer's lecture on Böhme at *Der Weg* in 1924 and his interest in German mysticism and Nordic mythology aroused the Icelandic student's interest and played an important role in generating the cosmic shift in his work around 1924.

73 Gottskálksdóttir (1993: 84).

74 Jacoby (2007: 147).

75 For a critical discussion of the tradition of the "conservative revolution" and its links to *völkisch* ideology, see: Breuer (1995).

76 Jacoby (2007: 148).

77 Jacoby (2007: 148).

78 See: Głuchowska (2009c: 320–325).

343

Abstract Constructivism and the Case of Finnur Jónsson
Universal Language — National Idiom?

Fig. 9

Finnur Jónsson, *Óður til mánans* [Ode to the Moon], 1925. National Gallery of Iceland, Reykjavík

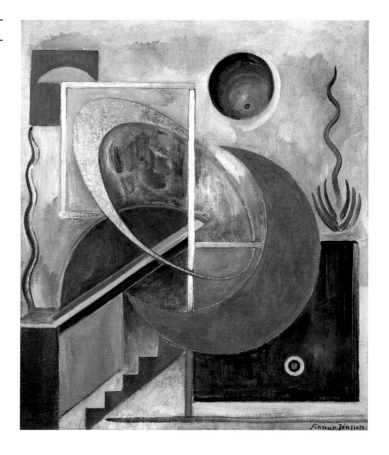

When stressing the importance of Schreyer's role it should also be noted that the links between esoteric cosmology, *völkisch* traditions, visions of the Germanic, and Expressionist and Constructivist aesthetics that surface in his work are not an isolated case in the context of the German avant-garde. The genealogy and the role of ideas that referred to a specifically Germanic or Nordic tradition of visual abstraction still need to be worked out in detail, yet it can be pointed out that the notion of a specific Nordic tradition of abstraction had been formulated in Wilhelm Worringer's *Abstraktion und Einfühlung* as early as 1908. In his influential study Worringer discussed the specific characteristics of the medieval ornament in the Nordic countries and described it as a manifestation of the "absolute predominance of linear-geometric form", which resulted in an "inner disharmony" and a "nebulous mysticism" as the artworks strove to break loose from the

Fig. 10

Finnur Jónsson,
Örlagateningurinn
[Dice of Destiny], 1925.
National Gallery of Iceland,
Reykjavík

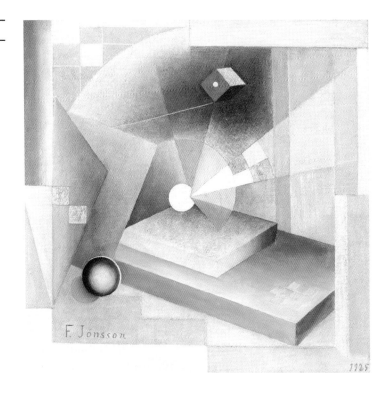

organic forms of a hostile nature.[79] A clear reverberation of Worringer's ideas can be seen, among others, in Karl Peter Röhl's attempts to found a specific "abstract-ornamental 'Nordic' art"[80] in the context of the early *Bauhaus*. Röhl's works from the early 1920s, which were based in part on Ernst Fuhrmann's writings on Swedish petroglyphs and on Johannes Schlaf's "monistic cosmology",[81] reveal a specific visual idiom that brings together abstract and figurative elements in a manner that has strong affinities with the combination of geometrical abstraction and figurative expression in Jónsson's early works. Traces of the search for a specific Germanic or Nordic idiom of visual abstraction can thus be found in the context of abstract Constructivism as it was developed within avant-garde circles with ties to *völkisch* ideas and traditions in the early 1920s, which seem to shed a new light on Jónsson's early abstract works and their ideological implications.

79 Worringer (1959: 148–149).
80 Hofstaetter/Tack (2006: 127).
81 See: Hofstaetter/Tack (2006).

345

Abstract Constructivism and the Case of Finnur Jónsson
Universal Language — National Idiom?

Conclusion

In the preceding discussion I have drawn attention to the potential nationalist implications of Finnur Jónsson's early works, which may call for a critical revision of our understanding of the universal language of abstract Constructivism. A reference to the "Germanic taste" of Jónsson's works in a review by one of his former fellow students at *Der Weg* in 1925 may be a coincidence. The presence of three young Icelandic artists at Kesting's art school in Dresden may equally be a coincidence. The reference to the nationalist elements of Jónsson's works in a text by Dreier from 1926 may also be a coincidence. Finally, it may be a coincidence that interest in Nordic mythology and medieval culture can be found within avant-garde circles in Germany in the period when Jónsson's work was developing in an avant-garde direction. The reference to such a series of coincidences seems unconvincing, however, and appears to reveal the necessity of exploring the visual idiom of Jónsson's early works from a different perspective. Locating these works within the discourse of Icelandic nationalism in the 1920s would also provide us with an answer to the most obtrusive question aroused by these works. The strongest indication that Jónsson's early abstract works were linked to notions of national identity is the fact that the artist has come to stand as an isolated figure in the Icelandic cultural field of the 1920s. He is basically the only artist, author, or intellectual who seems to have been situated outside of the project of Icelandic culture as it was formulated in this period. If we look for consensus in the works of Icelandic artists and intellectuals in the 1920s, it consisted in the programmatic attempt to construct a national culture that would link national tradition to currents of international cultural modernity (be it by means of appropriation, critique, or overt rejection).[82] The notion of national identity always played a central role in this context — except, if we follow the traditional view, in the works of Finnur Jónsson. I do not believe it was possible for an Icelandic artist to step outside of the discourse of nationalism that shaped the whole cultural field in the young nation state. This has always been the riddle of Jónsson's early works from my perspective, the thing

82 See: Hjartarson (2016).

that has increasingly troubled me and aroused my suspicions. This article may not have provided the readers with any clear answers to the questions posed at the outset, but if it has managed to arouse the suspicion that we may not be getting things quite right when we talk about the universal language of abstract Constructivism, it has served its purpose.

347

Abstract Constructivism and the Case of Finnur Jónsson
Universal Language — National Idiom?

Art and the New Latvian State (1918–1920)

Modernism — between Cosmopolitan Inspirations and a Substantive National Factor

Ginta Gerharde-Upeniece
Latvian National Museum of Art. Riga, Latvia

Abstract

The First World War in the territory of Latvia was characterized by intense warfare, the participation of the Latvian Riflemen's units, a destroyed land, and the flight of refugees. The proclamation of the Latvian state on November 18, 1918 can be viewed as a positive outcome. The war, however, did not end in 1918, but was followed by a decisive period of battles for an independent state — called the War of Independence — with the final victory on August 11, 1920, concluding with the Peace Treaty between Latvia and Russia.

This article, continuing an analysis of the relationship between art and society, focuses on the influence of historical events on the development of art in the period, as well as on WWI as a primary resource and catalyst for change. WWI undoubtedly marked the dividing line in the development of Latvian art — an unequivocal introduction to modern art. This period was characterized by the emergence of the new generation, who displayed an innovative, even revolutionary attitude to traditions, and an interest in the pre-war direction of the European avant-garde and their modifications. European cosmopolitanism was the impulse for the manifestation of the new art. Artists like Jāzeps Grosvalds, Jēkabs Kazaks, Romans Suta, Niklāvs Strunke, Valdemārs Tone, Konrāds Ubāns, Ģederts Eliass and others took an active position at a complex time. The language of modernism was not just a new kind of form and aesthetic category, but it also paradoxically expressed national aspirations through the choice of patriotic themes, and attempted to find its place in the creation of a visual image and symbols for the national ideal.

The time around WWI was undoubtedly a turning point in the development of a national identity for society, and in the field of art it influenced and accelerated the development of Latvian classical modernism.

The *1914* exhibition at the Latvian National Museum of Art — part of the celebration of Riga as the European Capital of Culture in 2014 — provided an unprecedented opportunity to present the relationship between WWI and the visual arts in Latvia and Europe from a new perspective.

Key words

the First World War, modernism, cosmopolitanism, the art of Eastern Europe, national identity, new state, *Riga Group of Artists*

Art and the New Latvian State (1918–1920)
Modernism — between Cosmopolitan Inspirations
and a Substantive National Factor

Introduction

Research into Latvia's early 20th century art started after Latvia regained its independence in 1991, when art historians began to study its historical legacy. For example, in her work *Classical Modernism. Early 20th Century Latvian Painting*,[1] art historian Dace Lamberga reveals the stylistic spectrum of artistic trends and art's development until the 1930s; Edvards Kļaviņš, in his monograph *Joe. Life and Art of Jāzeps Grosvalds*,[2] describes the impact of Grosvalds' personality as an artist and interpreter of Europe's new trend on the development of Latvian modernism. The growing interest in Latvia from foreign authors is illustrated by only a few examples; Serge Fauchereau, a researcher of the early 20th century who is particularly interested in modifications in the development of Cubism, has also included Latvian art as a noteworthy episode in the overall development of the movement.[3] Steven Mansbach's wide-ranging study *Modern Art in Eastern Europe. From the Baltic to the Balkans, c. 1890–1939*,[4] which reveals the importance of "local centers" when compared with Europe's art "metropolises", should be highlighted in relation to research into the art of Eastern Europe and the Baltic region.

Continuing the analysis of the relationship between art and society, this article focuses on the influence of WWI on the development of art in the period, and considers this historical event as a primary resource and catalyst for change. Around 1920, artists including those who were eyewitnesses published articles about the important art of their time. Alongside his creative work (Fig. 1), artist Jāzeps Grosvalds' most significant contribution was the development of an understanding of art and the connection between European and Latvian art. In two issues of *La Revue Baltique* (1919),[5] Grosvalds published the first overviews of the development of Latvian art. In addition to explanations about the political situation in Estonia, Latvia, and Lithuania, he wrote about new artists in the section on culture and also described the

1 Lamberga (2004).
2 Kļaviņš (2006).
3 Fauchereau (2012).
4 Mansbach (1999).
5 Grosvalds (1919a: 25–28); Grosvalds (1919b: 59–61).

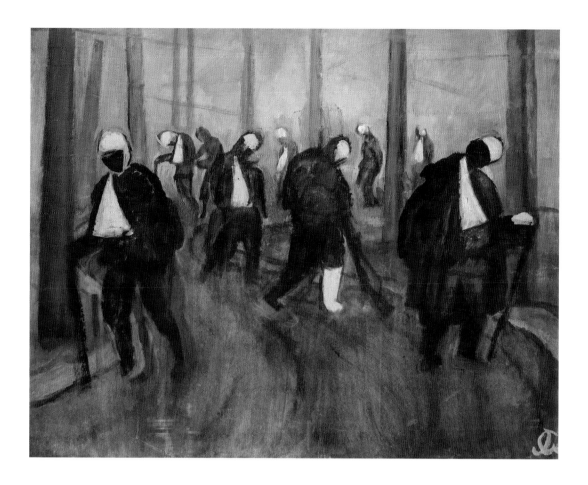

Fig. 1

Jāzeps Grosvalds,
Karavīri bēdājās [Soldiers
Were Grieving], c. 1917. Latvian
National Museum of Art, Riga

early development of Latvian art. During the creation
of the first article, "Latvian Art. The Young Ones" ("L'art
letton. Les Jeunes", 1919), Grosvalds shared his thoughts
with journalist Arturs Tupiņš (Arthur Toupine): "In my
opinion, the article will fit well into the propaganda pro-
gramme: that new Latvian art, casting aside the Munich
school and studying French and Latin culture, expresses
the nation's struggle for freedom, independence and orig-
inal ideals."[6] Artist Romans Suta, describing the direction
of the art phenomenon in Latvia in his 1921 publication
L'Esprit Nouveau, wrote: "New Latvian painting was born
in the brief moments between horrific battles".[7] (Fig. 2)
Consequently, quite a complex issue becomes of central

6 Letter of Jāzeps Grosvalds to Arturs Tupiņš, July 8, 1919.
 JGM-1519.
7 "La jeune peinture lettone est née dans les courts intervalles de
 ces luttes formidables," Suta (1921: 1168).

321 Art and the New Latvian State (1918–1920)
 Modernism — between Cosmopolitan Inspirations
 and a Substantive National Factor

Fig. 2

Romans Suta, *Uzbrukumā*
[Attack], 1919. Private collection

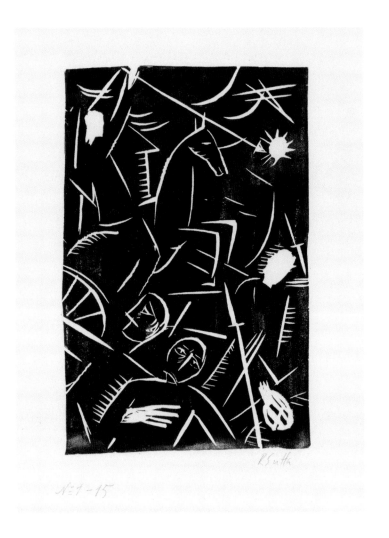

importance in reviewing the interconnections in the men-
tioned period: can war be not just a force resonant with
destruction, but also a factor facilitating the progress
of society and art? What kind of influence did the con-
cept of cosmopolitanism and the national factor have on
the development of modernism in Latvia in the first two
years of the nation's existence?

We could say that Latvian art around the time of WWI
had three mutually connected and variously interpretable
directions: modernism, cosmopolitanism, and national-
ism; a triangular relationship. Modernism encompassed
a new form of artistic expression and aesthetic category,
which was connected in a direct way with the "centers"
of cosmopolitanism — the approbation of ideas from
Paris, Berlin and elsewhere, and their adaptation to local

conditions. It is important to focus again on the influence of WWI on the adaptation of the Western avant-garde language and expressions by the modernist movement in Latvia. Cosmopolitanism served the new generation of artists as a source of ideas, inspiration, and experience too, including a basis for experience that was previously lacking. In this regard, we could highlight the change in scale from the local to the international, comparing artists' achievements with significant trends in the West, other value criteria, experiments, and their uniqueness and search for originality. The language of modernism was not just a new form and aesthetic category; in a paradoxical way, it also expressed national strivings, the choice of patriotic themes, and an attempt to find a use in the creation of visual images and symbols. Modernism was an important form of expression and an original visual code that transformed the 19th-century idea of national awakening into a new stage of evolution when Latvia gained its status as a nation. Classical modernist art developed from the foundations of the events of WWI, where cosmopolitanism and the national factor were not opposites, but rather a unifying original element characterizing the development of the direction in art at the time. In clarifying the expressions of the national factor in a wider way, it should be emphasized that they have not lost their significance in contemporary sociology either. Brigita Zepa and Evija Kļava explain the situation in Latvia in their article "Interpretation of National Identity through Modern and Postmodern Discourses"[8] illustrating the thesis about the link between the discourse and national identity, as well as an understanding about belonging to a nation and state. We can also apply what was written in their article to the creative and artistic environment in a wider context, where post-modern theories of nationalism create an understanding about national identity as an open, changeable, and subjective category. WWI instigated an even more rapid development of "small nations" and the development of consciousness in history, as well as the desire to transform this event into a visual experience.

8 Zepa/Kļava (2012: 9–25).

Art and the New Latvian State (1918–1920)
Modernism — between Cosmopolitan Inspirations
and a Substantive National Factor

The Exhibition *1914* as a Forum for Reflection on National and International Aspects of Modernism

The totality of events during the celebration of Riga as the European Capital of Culture in 2014 provided an unprecedented opportunity to reveal the city's, and all of Latvia's, affiliation with Europe's common cultural values on a new level. The *Force Majeure* programme's thematic line *Brīvības iela* [Freedom Street] ensured discussions about problems in history and art history while reflecting on the one hundred years since the beginning of WWI. The *1914* project — dedicated to the memory of the War — was specially created for the Latvian National Museum of Art's (Latvijas Nacionālais mākslas muzejs) Arsenāls exhibition hall (17.01.–20.04.2014), a historical monument built for military purposes as a warehouse for weapons in 1832. The *1914* exhibition was a story and at the same time an architectonic production, which had three zones of conflict at its center: conflict in the temporal dimension, when a new era irreversibly replaced the previous value system and points of reference; internal conflict, the ability to change one's life, sacrificing it to war and fighting for one's country; and finally conflict in a geographical space, where a balance of new superpowers and political forces announced themselves and the nascent new Europe.[9]

The *Eyewitnesses* section of the exhibition included examples of Latvian modernism — the works of Jēkabs Kazaks, Jāzeps Grosvalds, Romans Suta, Aleksandrs Drēviņš, Valdemārs Tone, Konrāds Ubāns (Fig. 3), and others supplemented by paintings, graphics, and sculpture from the Baltics, the Nordic countries, and Central and Eastern Europe. Overall, seventeen art museums and national galleries from eleven different countries were represented in Riga. The various directions of modernism were also vividly expressed through samples of work from other countries influenced by WWI. For example, among the most important Finnish avant-garde artists one could mention Ilmari Aalto. From the Baltic region we should mention Friedrich Hist from Estonia and the Lithuanian Expressionist Pranas Domšaitis. In Central Europe, Cubist representatives made significant inroads in Czech art; in painting there was Bohumil Kubišta, and in sculpture Otto

9 Gerharde-Upeniece/Jevsejeva (2014: 15–19). See images in: Głuchowska, *The War to End all Wars...* in this volume.

Fig. 3

Konrāds Ubāns, *Bēģļi* [Refugees], 1917. Latvian National Museum of Art, Riga

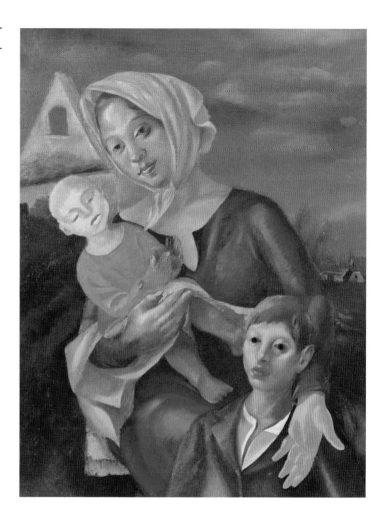

Gutfreund. In Poland, Constructivist ideas were expressed by Katarzyna Kobro, Władysław Strzemiński, and others. In Slovakia the brightest representative of modernism was Anton Jasusch, while in Slovenia, folk art traditions with peculiar signs of the surrealist tradition united Fran Tratnik and the brothers Tone and France Kralj.[10] New trends also developed in Hungary and can be seen in the works of Sándor Bortnyik, while Josip Seissel should be mentioned as a significant representative of the Croatian avant-garde movement.

The *1914* exhibition was only one of the events that explored the complex period of WWI, which was commemorated with many events in Europe, including in Berlin,

10 For Lithuania, Czech lands, Poland, Slovakia, and Slovenia, see: Lidia Głuchowska, *International Expressionism...* in this volume.

Art and the New Latvian State (1918–1920)
Modernism — between Cosmopolitan Inspirations and a Substantive National Factor

Bonn, Paris, Péronne, Ypres, and in many other places. The experiences of the Latvian nation and Latvian artists were part of the dramatic, and at the same time patriotic, fate of a whole generation. The vestiges of WWI and the War of Independence (1918–1920) affected, and to a greater or lesser extent influenced or decided, the inevitable circumstances of practically every Latvian family. Today scientific conferences, publications, and the new display at the Latvian War Museum (2016) bear witness to the time, and serve as a memorial to the fallen soldiers. However, it is the war graves and monuments to the fallen throughout Latvia that are permanent signs of those times. Special mention should be made of the Riga Brethren Cemetery ensemble (sculptor: Kārlis Zāle, architects: Pēteris Feders and Aleksandrs Birzenieks, landscaping: Andrejs Zeidaks), where soldiers from the riflemen battalions had been buried since 1915. The design competition for the ensemble was organized over several rounds. The foundation stone was laid in 1924 but the ensemble was only opened in 1936. With its monumental entrance, sculptural reliefs, city coats of arms, eternal flame, and the allegory of Mother Latvia as the dominating focal point, the Brethren Cemetery is the nation's shrine and place of remembrance.[11]

The Western Modern Art-Influenced *Green Flower* Group (*Zaļā puķe*, 1915)

The constant division of Latvian territory during WWI, the presence of the front line, unbelievable destruction, and simultaneously the desire to reconquer freedom from the great powers of imperial Russia and Germany, created favourable conditions for the acceptance of new ideas in art too. It should be noted that this time was characterized by the entry of a new generation with an innovative, even revolutionary attitude to tradition, and an interest in pre-war directions in the European avant-garde and their modification. Europe's cosmopolitanism was the impulse for the wish to create new art. Artists who had the opportunity and interest to travel around Europe became the mediators between its art "centers" and Riga. Jāzeps Grosvalds and Romans Suta had special significance in the clarification of the latest Western art.

11 Gerharde-Upeniece (2016: 104–107, 250–252).

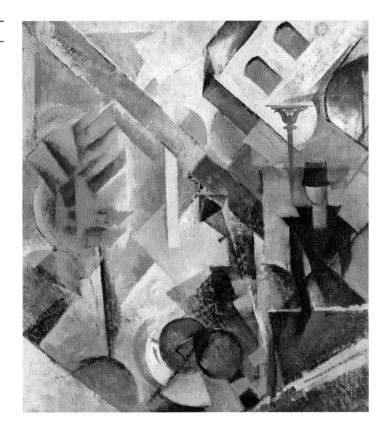

In Riga, the formation of the *Green Flower* group (1915)
for the exchange of ideas (members included Jāzeps Gros-
valds, Konrāds Ubāns, Aleksandrs Drēviņš, Valdemārs
Tone and Kārlis Johansons) was the most significant
event in this complex time. Having gone through a peri-
od of development characterized by comparatively naive
ideals and self-organization, the group expanded and
transformed into the *Expressionists group* (*Ekspresionistu
grupa*, 1919–1920), and was later renamed the *Riga Group
of Artists* (*Rīgas mākslinieku grupa*, 1920–1938). Its mem-
bers — Jāzeps Grosvalds, Aleksandra Beļcova, Marta,
Uga and Oto Skulme (Fig. 4), Emīls Melderis, Kazaks,
Strunke, Tone (Fig. 5), Ubāns, Eliass, Suta, Jānis Liepiņš,
and others — took an active stance in these turbulent
times. St. Petersburg and Moscow were the places to see
the latest art, art exhibitions were often held in these cit-
ies. St. Petersburg (already important for Latvian artists
since the late 19th century), as well as Moscow, Kazan, and

327

Art and the New Latvian State (1918–1920)
Modernism — between Cosmopolitan Inspirations
and a Substantive National Factor

Fig. 5

Valdemārs Tone, *Portreta mets*
[Sketch of a Portrait], 1920.
Latvian National Museum of Art,
Riga

Penza, became the centers for gaining an education.[12]
One of the paradoxes is that in its early stages, Latvian
modern art developed without even a sighting of the
originals by such artists as Pablo Picasso, Henri Matisse,
André Derain, and Georges Braque in Paris, Berlin, and
other Western art centers. A phenomenon developed in

12 Kļaviņš (2016: 33–40).

the consciousness of society at the time of the war: the need to create a new value system as a denial of the period which had passed before. In art, this was expressed in Futuristic manifestos at the invitation of the Dadaists, defining art as an expression of protest. Marcel Duchamp created the first *ready-made* objects (1913–1919), Kazimir Malevich published the *Suprematist Manifesto* (1915) and painted his *Black Square* (1915) on a white background, and Piet Mondrian created *Neoplasticism* (1917–1918). WWI was marked by a beginning full of enthusiasm, followed by a crass condemnation of it.

In Latvian art, we cannot really talk about an avant-garde; instead it can be seen as a pre-war introduction and transformation of the avant-garde idea, as the acquisition of the new art concept, compared with processes in European "centers", had been delayed. Artists who are included among the representatives of the Russian avant-garde are Gustavs Klucis, Aleksandrs Drēviņš and Kārlis Johansons.

Even though a marked Soviet revolutionary disposition and the revolution in St. Petersburg influenced the pace of the process, the majority of artists returned to their native land. They were also to take part in the propaganda work for the Latvian nation with their art, especially in the uncertain times when the nation attained its status as a state (1918).[13]

Artists in the War

An important factor in the influence of the war was the actual participation of artists in it as members of the Latvian Riflemen Battalions (*Latviešu strēlnieku bataljoni*, 1915–1916). In July 1915, the Russian state and army leadership granted permission for the formation of Latvian Army units on the Northern Front (Riga). Nine battalions were formed (one was a reserve battalion). As laid down in the regulations, each active battalion was to have twenty-seven officers, seven medical doctors and officials, and 1,246 non-commissioned officers and men. The military units formed within the Russian Empire's Tsarist army — the Latvian Riflemen Battalions — became a symbol of national identity and the self-confidence of

13 Lamberga (2004b: 122–130); Gerharde-Upeniece (2016: 92–94, 98–103).

Art and the New Latvian State (1918–1920)
Modernism — between Cosmopolitan Inspirations
and a Substantive National Factor

Fig. 6

Jāzeps Grosvalds, *Trīs krusti* [Three Crosses], 1917. Latvian National Museum of Art, Riga

the Latvian people. "We know what we are fighting for. This is known and felt by every Latvian soldier. This war is the people's war. And in this war, the people are leading us,"[14] as the writer and poet Kārlis Skalbe described the riflemen's mission (1924).

It is important to note that Latvian artists were not detached observers, but actively involved. Artists were influenced by the patriotic atmosphere of the time and a desire to fight for one's land as the state did not yet exist. They included Konrāds Ubāns, Jāzeps Grosvalds, Valdemārs Tone, Niklāvs Strunke and Romans Suta, Oto and Uga Skulme, Ludolfs Liberts and Erasts Šveics, who served on the Russian Empire's other fronts.

War themes, life in wartime, and the portrayal of refugees were epically portrayed in painting and graphics. On the

14 Skalbe (1924: 17).

Art and the New Latvian State (1918–1920)
Modernism — between Cosmopolitan Inspirations
and a Substantive National Factor

Fig. 8

Ģederts Eliass, *Vagonā*
[In a Railway Carrriage], 1917.
Latvian National Museum of Art,
Riga

one hand, an important task was undertaken — to capture
the reality of that time — and the language of realism was,
therefore, the foundation for these depictions. However,
the real environment was only the background for achieving
expression, stylization, and synthesis of form in the expres-
sion of the painting, as, for example, in Jāzeps Grosvalds'
Christmas Battles (*Ziemassvētku kaujas*, 1917), *Three Crosses*
(*Trīs krusti*, 1916–1917; Fig. 6), *Soldiers Were Grieving* (*Kara-
vīri bēdājās*, 1916–1917; see Fig. 1), and Romans Suta's graphic
composition *Attack* (*Uzbrukumā*, 1919; see Fig. 2). At the
same time, the war and refugee themes were markedly na-
tional, rising above the specific events painted such as in
Jēkabs Kazaks' *Refugees* (*Bēgļi*, 1917; Fig. 7), Ģederts Eliass' *In
a Railway Carriage* (*Vagonā*, 1917; Fig. 8) and Konrāds Ubāns'
Refugees (*Bēģļi*, 1917; see Fig. 3) or Aleksandrs Drēviņš' *Refu-
gee Women* (*Bēgles*, 1916; Fig. 9).

Fig. 9

Aleksandrs Drēviņš, *Bēgles*
[Refugee Women], 1916. Latvian
National Museum of Art, Riga

Art and the
New State

From the perspective of geographical location, where
the influence of art can be measured on the "metrop-
olis"–"province" scale, Riga can be evaluated as a point
of intersection. Historically, it was influenced by changes
in dominating powers and by the presence of Russian
and Baltic-German culture. The formation of the Latvi-
an new state was a significant turning point in each of
these areas — in politics, economics, social and cultural
fields, and also in fostering the formation and develop-
ment of artistic life at a new level. In a solemn assembly
on November 18, 1918, the Latvian National Provisional
Council (*Latviešu pagaidu nacionālā padome*) proclaimed
the new independent state — Republic of Latvia (Lat-
vian: *Latvijas Republika*). The neighbouring countries
of Lithuania (February 16) and Estonia (February 24) had
already gained their independence against a background
of disagreements between the major powers. The events
of WWI were both tragic and beneficial. The collapse
of empires, the revolutions in Russia and Germany, and
a reassessment of their strength led to a complicated
peace, with the conclusion of the symbolic Peace Treaty

Art and the New Latvian State (1918–1920)
Modernism — between Cosmopolitan Inspirations
and a Substantive National Factor

at Versailles on June 28, 1919. The war was also beneficial for several European states (Finland, Estonia, Latvia, Lithuania, Poland, Czechoslovakia, and Yugoslavia), allowing them to dare to proclaim their territories with common signs of national identity as states.

The period after the end of WWI, from 1918 to 1920, was particularly complicated in Latvia. At the beginning of the formation of the newly established democratic state, Latvia experienced a short interlude with a Bolshevik Soviet government.[15] The Latvian Army also had to win the War of Independence against Pavel Bermondt's army, with the decisive battles occurring in November 1919. The territory of Latvia was only actually liberated after the signing of the Latvian-Russian Peace Treaty on August 11, 1920. The real national stabilization process began only gradually, with the renewal of social and cultural life. Activity in the life of the arts recommenced in the autumn of 1919.

Along with the proclamation of Latvian independence, artists were given a new opportunity: the confirmation of national identity through the language of visual expression. Along with writers, poets, and musicians, who realized their creative expression in honour of Latvia each in their own field, artists took part in the creation of the nation's visual image, which in a direct way continued the development of the idea of national identity in its democratic and patriotic expressions.

The reward for artist-professionals was the development of the symbols of their state — the flag, coat of arms, and currency — which, for the first time, confirmed national identity and at the same time created the first

15 On December 4, 1918, a Temporary Soviet Government of Latvia was installed in Moscow, which assumed power in nearly all Latvia. An Art Department headed by Andrejs Upīts was formed as part of the Commissariat of Education. Artists joined in the work of the nationalized offices, participated in the Commission for the Protection of Works of Art, created new visual attributes (flags, posters, and interior decorations) and sketches for the currency. The proletarian festival of May 1, 1919, turned into an event where the organizing committee mobilized the creative intelligentsia. The culmination of the festival was a decoration created by the artists that did not proclaim their political views, but rather their attitude towards the traditionalists. The Bolsheviks were driven out of the Latvian territory in the spring of 1919. See: Kļaviņš (2016: 44–47).

concept of the nation's visual language. Ethnographic motifs combined with the message of the era also became the codes which addressed, and were understood by everyone.

The complex circumstances of how the Latvian flag came to be so coloured and proportioned should be highlighted as an activity typical of the time. Sketches of the flag with the maroon-white-maroon combination and varying proportions were offered by Oļģerds Grosvalds, Ansis Cīrulis, Valdemārs Tone, Jānis Kuga, and Konrāds Ubāns. Ansis Cīrulis' sketch, which can be recognized from Jānis Rieksts' postcard with the proportions 2:1:2, was adopted as the final version in 1918. The flag of the Latvian nation was enshrined for the first time in legislation on June 15, 1921 by a decision of parliament (the Constituent Assembly).

We can consider artist Burkards Dzenis as the author of the first iteration of the Latvian coat of arms, which included a rising sun with three stars and the letter "L", symbolising the newly-established Latvian nation. The Latvian Riflemen used this letter during WWI, and it could also be seen on the cap badges of soldiers in the Latvian Army. It should be noted that the uniform of the Latvian soldier originated at the same time as the initially incredible idea of the nation's independence. Its author was artist Jānis Sudmalis. Cīrulis' and Rieksts' patriotic postcards, which came out in 1919, have been recorded as being the inspiration for the designs of soldiers' uniforms and military distinctions. The Constituent Assembly held a competition for the new national coat of arms project in autumn 1920. The coat of arms of the Latvian Republic in its current form was approved by the Constituent Assembly on June 15, 1921.[16]

The Latvian Army's highest military award, the Order of Lāčplēsis [Bearslayer], designed by Jānis Aleksandrs Liberts, was established on November 11, 1919. Artists such as Kazaks, Tone, Ubāns, Strunke, Suta, and Šveics, drew sketches for the award, as well as samples for the Latvian Army's cap badge and other military attributes. It should be mentioned that the artists drew these designs in parallel with their active work as artists on the

16 Ducmene (2008).

335

Art and the New Latvian State (1918–1920)
Modernism — between Cosmopolitan Inspirations
and a Substantive National Factor

"modernist front", and coincided at the time with the formation of the aforementioned *Expressionists* — later the *Riga Group of Artists*. For Jāzeps Grosvalds, Strunke, and Kazaks, drawings of the riflemen's battles and the plight of refugees were necessary for them to express themselves through the soldier theme. Their language of expression in this field too can also be considered as a free style of modernist expression. In later years, when the concept of the Latvian soldier-hero was raised by the state, it lost its emotional power and the active interest of artists.[17]

The *Riga Group of Artists*

We can confirm that at this time the cosmopolitanism idea served to provide experience, and the question arose as to which expressions were noteworthy and which had no practical application in Latvia. Latvian artists were directly or indirectly informed about the avant-garde phenomenon in Western Europe. Cosmopolitanism was simultaneously a base for the creation of national art, which integrated modernism in its Latvian interpretation and originality. In this aspect the activity of the *Riga Group of Artists* (Fig. 10) was significant.[18]

If cosmopolitanism among the young artists lost its significance as a field of individual search and inspiration against the concept of patriotism, then paradoxically it was specifically the development of modernism that reached its peak in the 1920s. The desire of artists to get organized and announce themselves to the local public resulted in activities surrounding the *Riga Group of Artists* as a unified core of artists. The year 1920 became significant for the beginning of the real functioning of the state in peace time, during which time the great achievement of the new artists was the *First Exhibition of the Riga Group of Artists* at the Riga City Art Museum.[19] Even though the public, which had been brought up on academic art traditions, did not warm to this exposition and opposition arose within traditional art circles, it was

17 Gerharde-Upeniece (2016: 92–103).
18 Gerharde-Upeniece (2016: 93).
19 Lamberga (2004: 49–71).

Fig. 10

Photograph of the *Riga Group
of Artists* in the *Sukubs* canteen,
1920

still an event that influenced the later period, when mod-
ernism began to flourish. This was a time when visits to,
and studies at, Western centers of art increased, as did
familiarization with classical values at foreign museums.
Certain movements — Fauvism, Cubism, Constructivism,
Expressionism, Futurism, and New Objectivity — peaked
in the mid-1920s, with a return to realist traditions in the
late 1920s. However, there was also a certain *retour à l'or-
dre* in realism.

Conclusion

The time around WWI was undoubtedly a turning point
in the development of a Latvian national identity. In art
it influenced and accelerated the development of Latvian
classical modernism. The feelings of patriotism influ-
enced by WWI, which grew in cultural and art environ-
ment, were also notable in the complex first years of the
nation's existence. With the same commitment as there
had been during wartime, the mobilization of artists,
figuratively speaking, was also important in the creation
of the nation's intellectual and visual representations
after the War of Independence. The feeling of belonging

Art and the New Latvian State (1918–1920)
Modernism — between Cosmopolitan Inspirations
and a Substantive National Factor

to the nation or state through subjective searches in modernism created the original features of local classical modernism in the 1920s. Although it had already been delayed compared to the art current in European centers, it was nevertheless suitable for expressing the spirit and composition of the times in Latvia. We could mention the episode of Latvian Cubism, with its legitimacy and features and at the same time, its undeniable originality, to illustrate this.[20]

The interest in Latvian modernist expression remains active today, as evidenced by the many exhibitions held in other countries. For example, the works by Latvian modernists could be viewed in the *Riga Group of Artists* exhibition in Bordeaux in 2005.[21] The art contours of the Baltic and the Northern European region were revealed in the *Electromagnetic. Modern Art in Northern Europe, 1918–1931* exhibition. Curator Gladys C. Fabre's interest in the metropolises of cosmopolitanism, especially the *École de Paris*, have now been supplemented with exhaustive research on modernism in the local centers of Northern Europe, as well as through a convincing selection of works. The exhibition was shown in Oslo at the Henie Ostand Kunstsenter, Høvikodden, and at the Art Museum of Estonia in Tallinn.[22]

Continuing the topic about the relation between war and art, we may mention three international conferences organized by the Latvian National Museum of Art within the framework of the *1914* project as a research platform. In 2012, as an introduction to the work on the exhibition, the museum, together with its cooperative partners, organized an international conference on *Brīvības iela* [Freedom Street],[23] which was dedicated to the history, literature, music, and art of the period around WWI. In 2013, *The Last Day of Pompeii* conference, dedicated to cultural heritage problems and treasures which have disappeared irreversibly in wartime, was held at the Rundāle Palace Museum. In 2014, researchers into modernism in the context of Eastern European art were invited to

20 Lamberga (2002).
21 Lamberga (2005).
22 Fabre/Hansen/Mørland (2013); Lamberga (2014: 146–155).
23 Cēbere (2015).

an academic discussion at the international conference *1914. War and Modernism.* International discussions in the academic environment are addressing WWI and its consequences in its diverse aspects; museums are creating exhibitions; and monument restoration projects are being initiated together with various events, educational programmes, and joint websites. Mention should be made of the *Mission of the Century 14–18 (Mission du Centenaire 14–18)* project,[24] which was initiated by the French government and provides a comprehensive view of history, sociology, and culture with a diverse programme of events over a four-year period. A summary of untold European stories from WWI can be viewed on the *Europeana* website[25] where letters, photos, and memorabilia can be examined under the heading *News from the Front*, *People in Documents*, *A Soldier's Kit*, *Propaganda* etc. Why is a commemoration/reconstruction of WWI at the center of attention today? The topic of the War in its most diverse aspects is surprisingly contemporary at both a sensory and emotional level, as well as in the category of mental awareness. War is unfortunately not just a lesson about the past but also relevant in the present space, like a regular injection of information from the world's hotspots. With premonitions of Nazism and a new war, the correspondence *Why War?* (1933)[26] between two geniuses, physicist Albert Einstein and psychoanalyst Sigmund Freud, that was published by the League of Nations' International Institute of Intellectual Cooperation, exchanged ideas exhaustively about the enduring hatred and destructive instinct in the human psyche. Unfortunately, this has not been eradicated from the consciousness of mankind even today.

24 *Mission du Centenaire 14–18* [Mission of the Century 14–18].
 See: http://www.centenaire.org (accessed: 29.07.2016).
25 See: http://www.europeana.eu (accessed: 29.07.2016).
26 Einstein/Freud (1933).

Art and the New Latvian State (1918–1920)
Modernism — between Cosmopolitan Inspirations
and a Substantive National Factor

The Aestehtics of Neutrality

The Impact of the First World War on Danish Art and Culture

Torben Jelsbak
University of Copenhagen. Denmark

Dorthe Aagesen
Statens Museum for Kunst. Copenhagen, Denmark

Abstract

During the First World War the Danish capital of Copenhagen witnessed a sudden boom of modernist activity within the art scene. Sheltered by the country's neutrality and supported by a significant economic upturn in certain sectors of society, the art market flourished, and the city boasted a great number of exhibitions and other manifestations of modernist art and aesthetics. The modernist breakthrough during WWI constitutes a well-documented and canonized event in Danish art historiography and yet the relation between the two phenomena has never been subject to a closer analysis. The following article investigates the impacts of the war on the artistic culture of early Danish modernism by focusing on the specific character of Danish neutrality and its consequences for artistic production and the critical reception of art in the period.

Key words

Denmark, France, Gemany, modern art, neutrality, caricature, Scandinavia, *Der Sturm*, WWI

The Aestehtics of Neutrality
The Impact of the First World War on Danish Art and Culture

The First World War — The Modernist Moment in Danish Painting

During the First World War the Danish capital of Copenhagen witnessed a sudden boom of modernist activity within the art scene. Sheltered by the country's neutrality and supported by a significant economic upturn in certain sectors of society, the art market flourished, and the city boasted a great number of exhibitions and other manifestations of modernist art and aesthetics. Not wholly unlike Zurich in neutral Switzerland, which became the epicenter of Dadaism in 1916, for a brief time Copenhagen gained the status of "Paris of the North",[1] serving as a meeting point for Nordic artists and as a melting pot and showcase for the latest trends and innovations in European art. During the war the Berlin *Der Sturm* Gallery, under the direction of the art dealer and impresario Herwarth Walden, was present in the city with two shows of European avant-garde artists: in November 1917 an exhibition of *Der Sturm Artists* was organized on the premises of the Copenhagen cabaret *Edderkoppen* [The Spider], including drawings, watercolors, and graphic works by Wassily Kandinsky, Paul Klee, Oskar Kokoschka, Franz Marc, Lyonel Feininger, and Gabriele Münter, and in November 1918 Walden returned with a major show entitled *"Der Sturm". International Art. Expressionists and Cubists*, presenting 133 works by German, Russian, French, Spanish, Czech, Dutch, and Swedish avant-garde artists associated with his gallery. Other exhibitions in Copenhagen during the war featured works by leading Swedish and Norwegian modernist artists, among them former students of the Matisse School in Paris. Furthermore, the period saw the emergence of local avant-garde groups of young and up-and-coming Danish painters, such as *Grønningen* (established in 1915) and the group of young radical painters and poets gathered around the magazine *Klingen* [The Blade, 1917–1920] The activities reached their climax at the 1918 *Artists' Autumn Exhibition* (*Kunstnernes Efterårsudstilling*, the Danish *Salon des Indépendants*) which became a *succès de scandale* in Copenhagen, resulting in long and heated debates as to the causes and meanings of the new art.[2]

1 Abildgaard (2002); Aagesen (2012).
2 Abildgaard (1994); Abildgaard (2002).

The reasons for this sudden heyday of modernist activity, which was to die out, and be replaced by different agendas more or less simultaneously with the end of the war, were of course manifold. In many regards WWI may be seen as a "Futurist moment" in Danish art, to borrow a term from Marjorie Perloff.[3] Yet compared with the brief and utopian moment of artistic innovation and experimentation characterizing early European modernism before the war, the modernist breakthrough in Danish art happened in the midst of WWI. The "Futurist moment" of early European modernism as Perloff describes it was closely linked to the peculiar cultural situation of *avant-guerre* Europe — a situation "when artists felt themselves to be on the verge of a new age that would be more exciting, more promising, more inspiring than any preceding one [...]."[4] In Perloff's account, the Futurist moment was the ecstatic, optimistic and utopian part of the avant-garde rupture — before the heroic patriotism and aesthetic worship of war and violence expounded by Filippo Tommaso Marinetti and his fellow Futurists were rendered obsolete against the industrial mass murder of WWI. In the Danish case, the two phenomena coincided. The emergence of Danish modernism occurred simultaneously with events of the war, or more precisely, took place during the war, albeit in neutral circumstances. The fact that this situation offered particularly favourable conditions for artistic production and experimentation makes the Danish case unique in a European perspective.

The modernist breakthrough during WWI constitutes a well-documented and canonized event in Danish art historiography[5] and yet the relation between the two phenomena has never been subject to a closer analysis. What were the impacts of the war on the artistic culture of early Danish modernism and what role did Denmark's neutrality play in the cultural and intellectual discourses surrounding the breakthrough? These are the questions and issues to be addressed in the following article. In order to understand the specific character of Danish

3 Perloff (1986).
4 Perloff (1986: 36).
5 See: Abildgaard (1994); Aagesen (2002a); Gottlieb (2012).

The Aestehtics of Neutrality
The Impact of the First World War on Danish Art and Culture

neutrality and its consequences for the art field it is necessary to briefly describe the political situation in wartime Denmark and to explain how this affected cultural and intellectual life in the country. In the second part of the article we shall return to some of the aesthetic aspects and manifestations of early Danish modernism[6] and consider how these relate to the political conflicts and power structure of wartime Europe.

The Policy of Neutrality

Like its two neighbouring Scandinavian countries, Sweden and Norway, Denmark remained neutral during the war. Yet for several reasons the character of Denmark's neutrality was a politically delicate and controversial issue. One obvious explanation for this was Denmark's central geographic position as a link between the North Sea and the Baltic Sea, which gave the country a particular geopolitical and strategic importance to the belligerent nations. Another important aspect was Denmark's close proximity to Germany. In terms of national security Denmark was strongly dependent on its great southern neighbour and even more so as the two countries had a common prehistory of warfare. This history went back to the Second Schleswig War of 1864 where Denmark was defeated by the Prussian and Austrian Armies and had to cede two-fifths of its territory to Germany, including the southern duchies Schleswig, Holstein, and Lauenburg. 1864 represents a pivotal turning point not only in the common history of the two countries but also in the construction of modern Danish and German national identities. From a Danish perspective, the humiliating defeat in the Second Schleswig War marked the end of the country's dreams of regaining its former status as a regional power and its final transformation into its present role

6 In current Danish scholarship the terms "modernism" and "avant-garde" are used more or less interchangeably to describe the aesthetic innovations of Danish painting taking place around WWI. However, in correspondence with an international trend, formalist-oriented scholars tend to prefer the term "modernism", whereas "avant-garde" is mainly employed by scholars theoretically informed by cultural studies and cultural history. See: Abildgaard (1994); Aagesen (2002a); Aagesen (2002b); Gottlieb (2012).

NATIONALISM AND COSMOPOLITANISM IN THE AVANT-GARDE AND MODERNISM
The Impact of the First World War

as a small state. Yet the war of 1864 was important in a German and European context too, since it constituted one of the first steps in Bismarck's plan for a unified German Empire. Germany's victory in the Second Schleswig War belongs to a series of events leading up to the unification of Germany into a politically and administratively integrated nation state in 1871.

As a consequence of the events of 1864, furthered by the subsequent defeat of the French in the war against Germany in 1871, Danish politicians and government officers developed the so-called policy of neutrality that was to govern Denmark's approach to security into the 20th century. This policy was based on the acknowledgment that Denmark's national independence and very existence as an autonomous state were dependent on Germany, and this basic acknowledgement served as the guiding line for Danish foreign policy during WWI. Just before the outbreak of the war, King Christian X published a statement reminding the Danish people as well as the belligerent powers of this principle: "Our country has a friendly relationship with all nations. We may be confident, that the strict and to all sides uniform neutrality, which has always been maintained as the foreign policy of our country and which will invariably also be followed now, will be respected by everyone."[7]

The Danish policy of neutrality was founded on a significant anti-militarism: under no circumstances would Denmark enter into war. The strategy entailed persistently declaring Denmark neutral in relation to the conflicts of others and calling for this status to be recognized, even guaranteed, by the belligerent powers. At the same time however, the Danish government displayed a great willingness to adjust to German interests and needs; for instance, accepting the German navy mining Danish territory in 1915. As the historian Carsten Holbraad concludes in his analysis of Danish security policy, Danish neutrality was in fact clearly pro-German.[8] The Danish government pursued a strategy of adapting as much as possible

7 "Kongeligt Budskab" (1914). Quoted after: Sørensen (2014: 289). This and all other translations from Danish are made by the authors — T.J./D.A.
8 Holbraad (1991: 51).

Høker Jensens Fødselsdag 1914 Garden-Party Gullashfabrikant Jensens Fødselsdag 1915

Fig. 1

Axel Thiess, *Gullasch Capitalism*, 1915, illustration from satirical magazine *Blæksprutten* (1915)

to Germany while simultaneously trying to exploit the advantages of being a neutral state. One of the advantages of this status was economic, as Denmark could reap substantial benefits from shipping and commerce. Danish merchants were able to trade food or other stock with both England and Germany, a situation resulting in the so-called "Gullasch Capitalism" (Fig. 1), named after the favourable, Danish export of low-quality, tinned food products to the belligerent nations, and a much-discussed theme in public wartime discourse from 1915.

Among the political establishment was a high level of consent as to the rationale of the policy of neutrality pursued by the Danish minority government. Yet within the general public, feelings were strongly divided between supporters of the Entente and the Central Powers. The conservative press in general supported the Entente and frequently criticized the government for its pro-German course, whereas the Social Democratic party journal *Socialdemokraten* was overtly pro-German. To support the

official Danish policy of strict and impartial neutrality and to avoid this position being obstructed by either pro-Entente or pro-German agitation in the press, the government made a series of declarations urging Danish citizens to avoid announcing non-neutral statements, or to agitate in favor of any of the belligerent powers. In 1915, a law made it punishable to agitate against or make statements that could offend a belligerent nation. Thus, the politics of neutrality also implied a reduction of the freedom of speech.

In this regard it must be remembered that WWI was the first total war in which whole nations and not just professional armies were locked in mortal combat. WWI was also the first "media war" in which propaganda was used on a major scale to influence opinion, both nationally and internationally.[9] One of the functions of war propaganda was to mobilize hatred against the enemy and to convince the population of the justness of the cause. Another important aim was to enlist support and cooperation of neutral countries. In this struggle to gain control over international public opinion, British and French propaganda promoted a perception of the German military advances on the Western Front (including its invasion of neutral Belgium) as instances of an unforeseen brutality and barbarian ruthlessness. The Entente propaganda's depiction of Germany as an uncultured, uncivilized military state was further nourished by the German shelling of Reims Cathedral in September 1914, which provoked one of the most intense and vociferous international press campaigns of the period.

These developments made it difficult for Danish intellectuals to stand by the doctrine of a strict and impartial neutrality. A prominent example of this is the debate between the Danish Jewish literary critic Georg Brandes and the French Radical Republican politician and publicist Georges Clemenceau that took place in French and Danish media in the early spring of 1915. At the time, Brandes was a prominent European intellectual. Having received part of his intellectual formation in France, and being a great devotee of French liberal traditions, during the 1870s and 1880s Brandes had built an international

9 Paddock (2014).

reputation as a literary critic and a tireless advocate of liberal, left-republican and cosmopolitan ideas. He was known for his sharp pen, his moral engagement, and his fearless commitment to criticism of suppressive political powers. However, the outbreak of WWI had placed him in a difficult position as he was also the brother of the Danish Minister of Finance Edvard Brandes. Edvard Brandes occupied an important role in the political life and power structure of wartime Denmark. In addition to his position as Minister of Finance in the social-liberal minority government, he also had close contacts to King Christian X. Hence, it is a well-known fact that Edvard Brandes was the man behind the official statement of neutrality issued in 1914. As a consequence, Georg Brandes was forced into a role of unofficial international spokesman for Denmark and had to adapt his status as a critical intellectual in relation to the Danish policy of neutrality.

Georges Clemenceau, on the other hand, was a leading character in the historical annals of WWI. As one of the initiators of the patriotic *union sacrée* [sacred union] against the Germans, he was a driving force in the mobilization of the French nation in the early years of the war. Moreover, in his position as French Prime Minister from 1917 to 1920 he was to gain importance as the *Père la Victoire* [Father of Victory] and as the principal architect of the Treaty of Versailles. Brandes and Clemenceau were personal friends — members of the same generation and sharing the same ideological beliefs and political views (both liberal, left-republican, anti-clerical and allied in the Dreyfus-debate of the 1890s) — yet the outbreak of WWI was to cause a definitive break in their relationship.

The debate was inaugurated with two articles by Clemenceau in his journal *L'Homme enchaîné* (established in 1913 as *L'Homme libre*) — "L'Ennemi du Genre humain" and "Réflexions de Neutres" — written under the influence of German military advances on the Western Front during the early stage of the war, in February and March 1915. Here Clemenceau expressed his fundamental point of view: that WWI was not just a European civil war, but a war between good and evil, civilization and barbarism. To him, the German Army's brutal invasion of neutral Belgium and its bombing of northern France constituted the

final proof of the barbarism of the German nation. These events, he argued, demanded the peoples of the neutral countries to make up their minds and take a "moral" position in the war.[10] This appeal was especially addressed to the Scandinavian countries and, in particular, the Danish people, whom Clemenceau polemically evoked as a "people without pride, managing to make a profit by putting themselves at the disposal of the enemy".[11]

This was not only an attack on the Danish policy of neutrality for its supposed opportunism and cynicism in a situation where Germany appeared as the main aggressor; it was also a barely concealed attack on Georg Brandes, who was quoted for apparently pro-German statements in a Russian newspaper (quotations which Brandes in his initial reply would disclaim as mere manipulations and instances of Entente war propaganda). As the debate proceeded it soon became clear that the reason for Clemenceau's attack on his old friend was his disappointment in Brandes' silence and lack of public condemnation of Germany's military aggressions on the Western Front in the early months of the war.

Brandes reacted promptly to Clemenceau's malicious denunciation of the Danish nation and his own person and role as intellectual. In the first of two open letters to Clemenceau, he rejected the Frenchman's request to the neutral peoples to take a position in the war by expressing the fundamental rationale of the Danish policy of neutrality: to interfere in war would be mere suicide for a small state like Denmark. Clemenceau was not at all satisfied with this response and riposted with a highly emotive and inquisitorial letter in which he demanded Brandes to consider the following questions: "Who is responsible for the war? Who is fighting for justice? Who has offended international conventions? Who has disgraced himself by frightening cruelties? Who do you wish shall win the war?"[12]

Brandes refused to take part in any national-chauvinist conversation and maintained his basic point of view: that both parties were responsible for the war and

10 Clemenceau (1915b). Quoted from: Brandes (1966: 104).
11 Clemenceau (1915a). Quoted from: Brandes (1966: 103).
12 Clemenceau (1915c). Quoted from: Brandes (1966: 104).

The Aestehtics of Neutrality
The Impact of the First World War on Danish Art and Culture

that war crimes had been committed on both sides of the front. War as such was the problem. Furthermore, Brandes defended the pragmatic — and in the perspective of 20^{th}-century European history, somewhat prophetic — position that he did not wish a humiliation of Germany as this would only destabilize the power balance on the continent and cause the emergence of future wars.[13]

Clemenceau's answer to what he saw as a total capitulation to German aggression was a definitive gesture of goodbye, "Adieu Brandes!", announcing that no common understanding between the two former friends was possible. Clemenceau's character assassination of Brandes reverberated in the Entente countries and fostered a widespread perception of his position of neutrality as an expression of cowardice and indifference. The debate resulted in great personal cost for Brandes, who as a consequence lost a substantial part of his reputation as a leading European intellectual and nearly all of his friends in France.

Nevertheless, Brandes tirelessly continued to defend his (and the Danish) position of strict and impartial neutrality as well as his critique of nationalism and militarism as the main responsible factors in the misère of WWI. In an essay published in the American journal *The Atlantic Monthly* in 1915, he described his position:

> As for myself, I believe in the bestial cruelty of each party. I know that the Germans are civilized, the Russians good-natured, the Austrians elegant, — the war brutalizes all. When you once make murder and devastation of the so-called enemy's villages and fields a laudable, nay, even a sacred deed, you have given free course to bestiality. [...] Each nation is fighting for the fatherland, and this justifies everything. In this naturalistic age of ours we have succeeded in proclaiming patriotism and nationalism the highest virtues, compared with which the cosmopolitanism of old times can only be regarded with deepest contempt.[14]

13 See: Brandes (1915b).
14 Brandes (1915c: 851–852).

A Paris of the North

As already mentioned, the political and economic situation in neutral Denmark provided favourable conditions for cultural and artistic creativity. An important aspect of Copenhagen's attraction as a Nordic art center during the war was the presence of a number of wealthy industrialists and merchants who acted as private collectors and patrons of young experimental art. According to the later memoirs of the then-young painter Svend Johansen, the opportunities for selling contemporary art at high prices were extraordinarily favorable at the time:

> Then came the glorious days of profiteering, when it was possible to sell pictures that hadn't even been painted yet. It was usually done like this: you would dress up in your nicest outfit, go to Wivex [Wivel, a fancy Copenhagen restaurant at the time — T.J./ D.A.] where you would always meet the rich — there was never a night there without a least fifty-odd shipowners or fledgling stockbrokers, and being an "artist" of all things, you would be sure to be summoned to some table laden with cups overflowing with champagne. I had painted a large picture called *War*, which I sold no less than five times at what eventually amounted to a rather substantial price.[15]

One should not overemphasize the prosperity of the war period, however. For the general population, the war years were marked by high costs of living, scarcity of goods, price restrictions, growing unemployment, and social inequality — a situation not so different from life in the belligerent countries. Yet in small sectors of society the wartime economy created great fortunes, some of which were invested in art.

A particularly prominent and exemplary figure among private art collectors was the merchant Christian Tetzen-Lund, who in the years leading up to the war had already created a significant collection of international, mostly French, modernist art, comprising a substantial number of masterpieces by Paul Cézanne, Henri Matisse, André Derain, and Pablo Picasso, among others. Tetzen-Lund's collection has been described as one of the most important private collections of modern art in the world around 1920.[16] The collection contained more than

15 Johansen (1957: 29).
16 See: Monrad (1999: 137); Gottlieb (1984: 25).

The Aesthetics of Neutrality
The Impact of the First World War on Danish Art and Culture

20 paintings by Picasso — including Cubist masterpieces such as *Céret et Sorgues* [Violin and Grapes, 1912, today at the MoMA, New York] and *Violin — Jolie Eva* [Violin, 1912; Staatsgalerie Stuttgart] and a corresponding number of seminal works by Matisse — among them *Le Bonheur de vivre* [The Joy of Life, 1905–1906; The Barnes Foundation, Philadelphia]. Tetzen-Lund's collection, installed in his private residence, was opened to the general public once a week from 1917 and remained accessible until 1924, thus offering Copenhagen audiences an opportunity to gain a firsthand experience of some of the most important artistic innovations in early 20th-century art. In addition to his role as collector of international avant-garde art, Tetzen-Lund also supported the emergence of a local modernist milieu, by acting as patron for a number of young, experimental Scandinavian artists, including the Swedish painter and leader of the Swedish group of Matisse students Isaac Grünewald, the Norwegian painter Per Krohg and young up-and-coming Danish painters such as Vilhelm Lundstrøm and Karl Larsen, to whom we shall return shortly. Another significant private collector was the Danish insurance agent and councillor of state Wilhelm Hansen, who also built up an important collection during the war, mostly of French 19th-century naturalism and Impressionism, including major works by Camille Corot, Eugène Delacroix, Gustave Courbet, Paul Cézanne, and Paul Gauguin. Hansen's collection was made public with the establishment of the Ordrupgaard Museum in 1918. This museum, situated north of Copenhagen, still exists today, whereas the Tetzen-Lund collection was dissolved and sold in the 1920s.[17]

17 On the history of the Wilhelm Hansen collection, see: Asmussen (1993) and Kjærboe (2016); on the history of the Tetzen-Lund collection comp.: Gottlieb (1984).

French versus German

The emergence and particular bias of the two above-mentioned collections point to a fundamental characteristic of the cultural orientation and aesthetic taste of wartime Denmark, namely its strong preference for French art and culture and, conversely, its rejection of anything German. Whereas in political terms, Denmark's policy of neutrality could be said to be in some sense pro-German, the cultural discourse of the time reveals that in artistic terms Denmark was nothing but an "aesthetic province" of France, to use a notion from the French literary sociologist Pascale Casanova.[18] Although challenged in part by an internationalist stance that was promoted especially by Herwarth Walden's *Der Sturm* Gallery, the majority of Danish artists and other members of the Danish cultural elite still viewed the tradition of French art and culture as superior to any other. Hence, it was a normal procedure of contemporary Danish art criticism to evaluate every art exhibition according to the extent to which it met the ideals and standards of French art (examples include the Danish reception of painters from the artists' group *Die Brücke* in 1907 and the reception of the Futurist painters in 1912, which were both disdained for their formlessness, bad taste, and lack of "Gallic grace").[19] Paris was considered the unchallenged artistic center of the world, and Paris was the compulsory place for young artists to go to pursue their artistic training.

In reality, the inspiration for the modernist breakthrough in Danish painting came from many sources, including Germany, with which Denmark had long-standing traditions of cultural exchange. Yet the critical discourse of early Danish modernism was guided by a strong emphasis on French or Parisian sources and by a particular formalist way of addressing and discussing the aesthetics of modernist painting. From a political perspective, this strong emphasis on the superiority and brilliance of French art may be interpreted as a way of proclaiming a form of cultural autonomy of Denmark *vis-à-vis* Germany. Since it was officially prohibited to make public statements that could offend a belligerent nation, the cultural field provided an unofficial arena for expressing political

18 Casanova (1999: 148).
19 See: Werenskiold (1975); Raaschou-Nielsen (1992: 95–99).

The Aestehtics of Neutrality
The Impact of the First World War on Danish Art and Culture

sympathies or antipathies in a more indirect manner. More than any previous art movement, the abstract language of early modernist painting was declared an object of disinterested pleasure and purely visual perception; however as we have learned, for example from the history of post-war American Abstract Expressionism,[20] even the most abstract or formalist art discourses are still embedded in political contexts and power structures. This was equally true for the generation of young artists that contributed to the modernist breakthrough in Danish art during the war.

Danish Wartime Expressionism

The pictorial style of early Danish modernism may best be described as a fusion of Expressionism and Cubism. In the public discourse of the time, Expressionism was used as an overarching and non-discriminative term for the various schools in pre-war European avant-garde art.[21] A significant example of Danish Expressionism is the young painter Karl Larsen's debut work *En trappegang* [A Staircase; Fig. 2], which received much attention at the Copenhagen *Artists' Autumn Exhibition* (*Kunstnernes Efterårsudstilling*) of 1917 and was subsequently canonized as *tableaux illustré* for early Danish Expressionism. Larsen's work depicts the silhouetted figure of a violinist in the process of climbing a staircase, the perspective distorted so that banisters, steps, and walls seem to lean in all directions. Cubism and Expressionism are used in conjunction to restructure representation and challenge the perception of pictorial space.

Larsen's picture was just one of several attempts to explore new aesthetic devices. The intensity and optimism of the Copenhagen art scene encouraged experiments and unprecedented formal innovations — splintered forms, powerful colours, and the introduction of new materials into painting. The most experimental and provoking

20 CIA's targeted use of American Abstract Expressionism as components in its Cold War propaganda program was exposed in the 1970s and 1980s by Kozloff (1973), Cockroft (1974), and Guilbaut (1983).
21 See: Werenskiold (1984); Jelsbak (2005); Stounbjerg/Jelsbak (2012).

of the Danish Expressionists, Vilhelm Lundstrøm, went
all the way to developing his own variant of the Cubist
counter-relief in a series of constructions consisting of
rough materials such as frayed pieces of wooden crates.
Lundstrøm's "crate-wood-pictures" (as they were called in
the contemporary press) challenged all familiar criteria
of assessment and caused a public scandal at the *Artists'*
Autumn Exhibition (*Kunstnernes Efterårsudstilling*) of
1918. Contemporary critics saw Lundstrøm's counter-re-
liefs as a gesture of vandalism against the very rules
of art, and during the exhibition the works themselves

Fig. 3

Vilhelm Lundstrøm,
Composition 2, 1918. National
Gallery of Denmark, Copenhagen

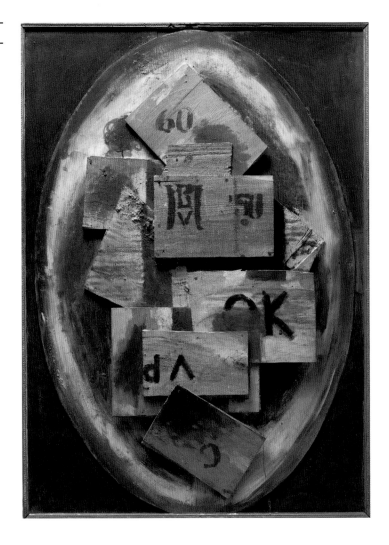

were vandalized by visitors who removed pieces of the
compositions, thus forcing the artist to repeatedly patch
up his work. In a later interview Lundstrøm explained
the intention of this and other works by himself and his
Expressionist colleagues (Fig. 3) as an attempt to employ
Cubist principles in order to render the pictures "entirely
anonymous or impersonal, because we believed that the
personal, like the narrative, was of no consequence to the
impact of the image, and so it was something to be avoid-
ed. We sought to work our way towards simplicity and
painterly order."[22]

22 Lundstrøm in conversation with Aksel Rode, 1939. Quoted after:
 Abildgaard (1993: 45).

In other words, the poetics of early Danish Expressionism reflected a strongly formalist approach to painting, stressing the autonomy of the art work. This general modernist concern with form instead of content may also help to explain the almost total absence or neglect of war as subject matter in the art works of this group of painters. The Danish Expressionists only very rarely depicted war scenes, and on the rare occasions where they did — as in the case of Svend Johansen's *The War* (*Krigen*, 1916), previously mentioned — the topic was treated in a somewhat theatrical and superficial manner far removed from the industrial mass murder in the trenches of WWI. Johansen's depiction of the war as a theatrical scene of chivalrous duelling indicates the general feeling of distance from the actual events of the war that characterized cultural life in Copenhagen. However, the detached superficiality of Johansen's representation of war also provoked critical reactions by some of his contemporaries who found the picture improper and disrespectful to the victims of the war, which was still raging.

The only artist of the Copenhagen circle who experienced the war directly was one of the Scandinavian visitors, the Norwegian painter Per Krohg who had volunteered for a Norwegian ski ambulance squad in the Vosges in the winter of 1915–1916. In spite of this, Krohg's painting of the *Grenade* (*Granaten*, 1916; Fig. 4) may also be described as a somewhat decorative rendering of the battlefield, depicting a spectacular vision of exploding grenades unfolding like flowers. In a newspaper interview in 1916, Krohg gave his own interpretation of the work as a modern vision of the sublime: "When one has been in it and seen the unyielding humour with which these Alpine fighters went forth [...] then it seems neither ugly nor good, it is simply *mighty*. So incomprehensibly mighty that one would not miss seeing it for anything in the world."[23] To the Expressionist artists of the Copenhagen circle, the war was neither ugly nor good; it was a subject of fascination and a source for artistic creation and innovation. Krohg's *Grenade* was presented at the Copenhagen *Artists' Autumn Exhibition* (*Kunstnernes Efterårsudstilling*) of 1916, where Krohg featured as a special guest,

23 Quoted from: Abildgaard (1994: 105).

Fig. 4

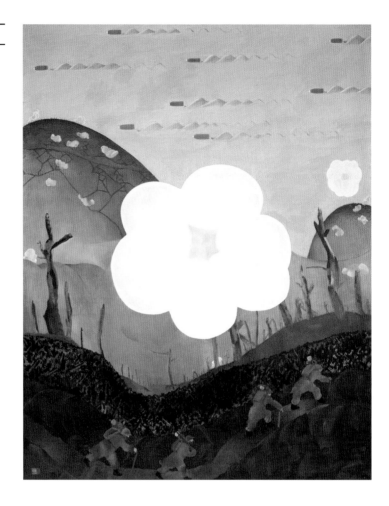

and his work became highly inspirational for the sub-
sequent development of Danish modernism, including
Svend Johansen's work.

Karl Larsen, Vilhelm Lundstrøm, Svend Johansen,
and Per Krohg all featured prominently in the pages of
the aforementioned art magazine *Klingen*, which became
the programmatic mouthpiece of the Copenhagen group
of young radical painters as well as an important chan-
nel for the diffusion of European avant-garde aesthetics
into the Nordic countries. The magazine was founded
by the Danish painter and graphic artist Axel Salto and
ran in three volumes from October 1917 to November
1920. The publication was inspired by Amédée Ozenfant's
Parisian Cubist magazine *L'Elan* (1915–1917) and entailed
many striking similarities with the Parisian precursor
in terms of layout, rhetorical style, and artistic agendas.
In addition to European material, each issue included

articles, poetry and an abundance of images (among them original etchings, wood-cuts, and lithographs) by Copenhagen-based artists and poets from Denmark, Sweden, Norway, Iceland, and the Faroe Islands, most of whom were of Salto's generation. The 2nd issue of *Klingen* from October 1917 included a forceful statement indicating the artistic agendas and international orientation of the Copenhagen modernist circle:

> Like a powerful phalanx the "new art" advances: Frenchmen, Russians, Germans, Scandinavians, Poles, Spaniards, artists of all countries are on the march. Art stands at the entrance to the new, rich land of plenty, that means it is about to rediscover the lost land.
> The "new art" cultivates the absolute decorative use of colour, the purity of form, the severity of drawing — the strength of the eye and the skill of the hand. Expressionism, Simultanism, Cubism, Totalism are the inscriptions on the flags that are flying in honour of the great, old art, of the Antique and the Renaissance. It is becoming more and more obvious that artistic ability is on the increase among young art in this country. The fortuitous, non-artistic naturalism of the 1880s is now being brushed aside by our art.[24]

Besides the perception of the European avant-gardes as a joint international force uniting artists and "-isms" across the frontiers of the war, we may again notice the strong emphasis on formal questions ("the decorative use of colour, the purity of form [...]") as the main distinctive features of the new art movement. The somewhat peculiar, classicist conception of "the new art" (*den Nye Kunst*) as a kind of restoration of "the great, old art" (*den gamle, store Billedkunst*)[25] of the Antique and the Renaissance may seem odd in the context of an avant-garde manifesto. It can be explained, however, by the local context in which *Klingen* made its intervention, as the journal was conceived in opposition to the naturalist aesthetics dominating the leading institutions of the contemporary Danish art field, such as the Royal Danish Academy of the Fine Arts (*Det Kongelige Danske Kunstakademi*), the public art criticism, and the established salons.

24 Salto (1917: n.p.).
25 Salto (1917: n.p.).

Fig. 5

Mogens Lorentzen, front cover
of the war issue of magazine
Klingen I/8 (May 1918)

Klingen presented its mission as an endeavour to promote a truly international art — a *mis-en-position* very similar to the one occupied by Georg Brandes within the literary and intellectual field, and yet there were striking differences between Brandes' cosmopolitanism and that of the young generation of radical artists. First of all, *Klingen* was no anti-war magazine and neither did it reflect a position of impartial neutrality like the one articulated by Brandes. As we have seen, the young artists did not address the subject of war from a political or even moral standpoint, but rather first and foremost in aesthetic terms — as a vibrant source of inspiration for artistic creation. In a special war issue of *Klingen* (Figs. 5 and 6), published in May 1918, this dimension was explicitly expressed. As Bjarne Bendtsen has put it, this issue may be seen as the expression of "a rather offensive bout of belated pro-war enthusiasm".[26] Salto himself

26 Bendtsen (2012: 391–400).

MIN SABEL

Pres mod det nøgne Staal din skønne nøgne Læbe,
grusom lig Staalet, lig Staalet streng og ren;
da vil dit Kys, naar Klingen skal drages for at dræbe,
springe ud som en Rose af en staalhaard Rosengren.

Kys den kolde Klinge her lige under Heftet,
spejl dit Øjes Blaa i dette staalblaa Spejl;
da skal det Minde lyse, naar mit Løfte er bekræftet,
klart, saa hverken Døden eller Gud kan tage fejl.

Mærk det blanke Staal med din bløde Mund, o Kvinde;
Kysset vil efterlade et kongeligt Sigil.
Og Gløden af dit Kærtegn skal, ulmende dybt inde,
gøre Sværdet, naar det svinges, til et Sværd af Ild.

Bland et Hulk af Elskov i Heltedigtets Smerte,
føj til Dødens Kys dit Kys et kort Minut;
da skal min Kaarde hvile paa min Grav, som i mit Hjerte
Kærligheden hviler, stolt og sønderbrudt.

Dø kæmpende, det er Drømmen, hvis Tone aldrig tier.
Døden er Vasal kun, Konge det frie Mod!
Kys blidelig, du kære, det Glavind, der befrier
det Land, som for mig først, du gav Kød og Blod.

Jacques de Choudens.
Faldet.

Fig. 6

Lithograph by **Kurt Jungstedt**
and **Jacques de Chouden**'s poem
"Min Sabel" ["My Sword"], from
magazine *Klingen* I/8 (May 1918)

contributed an enthusiastic account of the Bastille Day parade in 1916, while Per Krohg — appearing here as both writer and visual artist — was represented by a one-act play *Nervøsitet eller En stille Nat ved Fronten* [Nervousness or A Quiet Night at the Front, 1918][27] and a drawing *Mitrailleusen* [The Mitrailleuse, 1918], both reflecting a proto-Futurist fascination with the sceneries and sensations of war. Other contributions to the issue included images of soldiers with weapons and flags (the Tricolour being particularly well-represented) and patriotic, classicist poems by fallen French soldiers. Here, in the last hour of the war there was no doubt that the sympathy of the young artists was resting with the French. Yet the sympathies of the *Klingen* artists were not always clear, as is made clear by their somewhat ambiguous and shifting attitude towards the German-based, cultural enterprise of Herwarth Walden.

27 Krohg (1917).

Herwarth Walden in Copenhagen

The significance of the German gallery owner and magazine editor Herwarth Walden as a "key player" in the field of European avant-garde art between 1910 and 1920 is well known. His activities as an art dealer and impresario of travelling exhibitions all over Europe included the Nordic countries from the very beginning. In 1912, Walden organized his first exhibition in Copenhagen, presenting the Italian Futurist painters (a show taken over by Walden after its initial displays in Paris and London and subsequently sent on tour to several European cities),[28] and in 1913 he returned with an exhibition of *Cubists and Expressionists* (*Kubister og Ekspressionister*), featuring Gabriele Münter, Marianne von Werefkin, Henri Le Fauconnier, and Raoul Dufy. After the outbreak of the war, the neutral countries Scandinavia and Holland became increasingly important spheres for Walden's activities, offering opportunities to exhibit and sell the stock of his gallery while the European art market was suffering a decline. As previously mentioned, Walden organized two exhibitions in Copenhagen during the war: a small-scale show of *Der Sturm Artists* (*Der Sturm Kunstnere*) taking place at the premises of the Cabaret *The Spider* in November 1917 (featuring graphic works by Kandinsky, Klee, Kokoschka, Marc, and Münter) and a grand-scale exhibition of *"Der Sturm". International Art. Expressionists and Cubists* (*"Der Sturm". International Kunst. Ekspressionister og Kubister*) held in Kleis' Art Gallery in December 1918 (featuring 133 works by 24 artists from 8 different countries).[29]

To the Scandinavian public Walden was known as a tireless advocate for "pure" and "autonomous" international art, including several new movements from Futurism and Orphism to Cubism and Expressionism — all labelled "Expressionism" in his expanded definition of the term. To support the promotion of his activities Walden had put forward his own esoteric and rather idiosyncratic concept of Expressionism inspired mainly by Wassily Kandinsky's theory of the "spiritual" contents of modern abstract art and Wilhelm Worringer's psychological theory of visual style. According to this theory, the

28 See: Jelsbak (2016).
29 *"Der Sturm". International Kunst. Ekspressionister og Kubister* (1918).

Expressionist art work was generated by "inner necessity" and should be conceived as an expression or "vision" of the artist's inner feelings.[30]

Only later scholarship has revealed that Walden's activities in Scandinavia during WWI also included a targeted use of his autonomous "Expressionist" art as a medium for a subtle kind of wartime propaganda. In an article from 1995 based on findings in the newly opened state archives of the former DDR (German Democratic Republic), Kate Winskell revealed that from 1915 onwards, Walden had clandestine contact with the so-called Central Office for Foreign Services (*Zentralstelle für Auslandsdienst*), a department under the German Ministry of Foreign Affairs responsible for distributing pro-German materials in neutral countries while also monitoring political discussions. Together with his wife, the Swedish born artist and journalist Nell Walden (b. Roslund), Walden ran a news agency supplying Scandinavian and Dutch media with news articles to balance the Entente dominance on the flow of news in the Scandinavian countries.[31]

Some of this may not have been known to the young artists associated with *Klingen*, who saw Walden as a possible ally in their battle for new art. A short commentary in *Klingen* written by the leading Danish modernist painter Harald Giersing on the occasion of the aforementioned first of Walden's shows in Copenhagen — *Der Sturm Artists* in 1917, suggests a certain sympathy for *Der Sturm* among the *Klingen* artists. Provoked by the "naïve nonchalance" and negligence of the Danish press, Giersing stated his support.[32] This rapprochement on behalf of the *Klingen*-group may have encouraged Walden to instigate a cooperation between the *Der Sturm* and the Copenhagen milieu of painters. Hence, in continuation of a show of *Schwedische Expressionisten* [Swedish Expressionists] held in the Berlin Gallery in 1915, Walden planned a similar exhibition of young Danish painters of the *Klingen* circle.[33] The event was scheduled for March 1918, and the exhibition was announced in the newspapers as well as

30 See: Stounbjerg/Jelsbak (2012: 466–467).
31 See: Winskell (1995).
32 Giersing (1917).
33 See: Ahlstrand/Reinhardt (2002).

in *Klingen*. In March, however, *Klingen* announced that the exhibition had been postponed, and in the end it was cancelled, presumably because of the Danish painters' anxiety about the political connotations of such a venue. In general, much evidence points to the fact that one main reason for Walden's relative lack of success in propagating his internationalist synthesis of Expressionist art in Denmark was because *Der Sturm* was seen foremost as a "German enterprise". To what extent the Danish art milieu was actually aware of Walden's activities as an undercover agent for wartime Prussia, or whether it merely reacted intuitively against the esoteric pathos of his Expressionist discourse, remains unanswered.

As a response to the failed joint venture with *Klingen*, Walden contacted Germany's ambassador in Denmark and suggested that an exhibition be sent to Copenhagen instead. The result of this endeavour was the also aforementioned exhibition *"Der Sturm". International Art. Expressionists and Cubists*[34] in November 1918, which was to become Galerie *Der Sturm*'s largest and most ambitious exhibition held in Scandinavia. As mentioned, the exhibition featured 133 works by 24 artist from 8 different countries, thus reflecting the international scope of Walden's Sturm organization and enterprise. The exhibition list included pre-war works by prominent Russian, German and Czech *Sturm* artists such as Wassily Kandinsky, Marc Chagall, Alexej von Jawlensky, Franz Marc, Gabriele Münter, Georg Muche, Rudolf Bauer, Heinrich Campendonk, and Otakar Kubín, Parisian Cubists Pablo Picasso, Albert Gleizes, Jean Metzinger, Robert Delaunay, and Fernand Léger alongside works by Scandinavian artists Gösta Adrian-Nilsson, Sigrid Hjertén, and Walden's wife, Nell Walden.

The exhibition was made possible due to support from the German Central Office for Foreign Services, which provided Walden with the necessary import and export concessions to realise the show. As Kate Winskell has shown, Walden conceived of the exhibition as an act of cultural propaganda that would reveal to the Danish

34 *"Der Sturm". International Kunst. Ekspressionister og Kubister* (1918).
On the exhibition and its reception, see: Aagesen (2002a: 165–167);
Aagesen (2012: 318–320).

public the cultural liberalism and freedom of artistic expression in wartime Germany.[35] To reassure the German authorities, Walden even argued that the exhibition was composed in a way that highlighted the German works (Bauer, Muche, Münter, and Marc) as the most important.

However, in its attempt to propagate a more positive perception of Germany in Denmark, the exhibition was doomed to fail. The increasingly hostile attitude to Walden in the Copenhagen milieu became explicit in *Klingen*'s critical response to the exhibition. In a detailed commentary on the exhibited works, the critic Poul Henningsen praised the small section of Parisian Cubists and the Russian artists presented. Mostly, however, he was concerned about the "lack of talent" and "bad taste" in the major part of the exhibited works, especially those by the German and Swedish artists: Bauer, Muche, Münter, and Walden. These observations led the critic to the following conclusion: "Once more, one has rich opportunity to wonder at how highly superior French art is to German or Swedish art, and one is led to ponder how much the arts depend on great people, as people depend on the arts. The soil is definitely not favourable to talented painters in Germany."[36]

Despite the scepticism towards Walden's initiative in artistic circles, the show attracted a large Copenhagen audience. Hence, a notice in the Copenhagen daily *København* (Copenhagen) from December 2, 1918 could report that 1,400 guests had visited the exhibition on the opening day of the show.

35 See: Winskell (1995).
36 Henningsen (1918: n.p.).

The Aestehtics of Neutrality
The Impact of the First World War on Danish Art and Culture

Conclusion

The history of the 1918 *Der Sturm* exhibition of *International Art* in Copenhagen points to the impossibility of maintaining the modernist theory of the autonomy of art in the historical-political context of wartime Europe. Even in a neutral country like Denmark, the aesthetic discussion of modern art was infiltrated by political concerns. Modernist Danish artists conceived of themselves as riders in the realm of beauty and as partisans of pure form and colour, and yet art as an institution was not freed from the social and political structures of the surrounding society. It is a rather ironic sign of the times that Herwarth Walden, as one of the originally most eager proponents of the theory of pure art, would end up becoming an undercover agent for wartime propaganda. Henningsen's rather chauvinistic refusal of Walden's attempt to promote modern German art as being equal to contemporary French and Russian artists was just one of many examples of the strong anti-German sentiment prevalent in the Danish cultural milieu at the time. This culturally motivated antagonism towards Germany was of course not only (if at all) a question of good and bad taste and aesthetics. It also reflects the international political situation and power structure in Europe by the autumn of 1918, at which point Germany had not only lost the war but was also held as the main party responsible for causing the loss and damage of WWI.

Cosmonational

Neither National nor Cosmopolitan — but a Tinge of Avant-Garde Modernism

Annika Gunnarsson
Moderna Museet. Stockholm, Sweden

Abstract

The Moderna Museet in Stockholm, Sweden, contains art by national and international artists from the modernist period onwards. From around the turn of the 19th century a growing number of artists travelled throughout Europe, including a number of Swedes. They headed to hotspots such as France, Germany, Italy and Spain, up until the outbreak of the First World War. As members of the avant-garde in a burgeoning modernism, some of the artists blazed their way directly into art history. Others trailed in the fringes. Over time positions have swopped and discourses have changed. This article intends to give a brief review of how early modernism (seen as stylistic period) and the epithet avant-garde (which connotes being in the forefront) have been discussed in connection to events and exhibitions at Moderna Museet around the turn of the 21st century. Its focus will be on the reception of the concept of being part of the avant-garde, as well as on how the works of its representatives have made their way into the collection, then and now.

Swedish artists who attended the school of Henri Matisse in Paris are still discussed as his pupils, and their works exhibited together with those of Matisse, the master, to show the linkage between national and international. This way of displaying art history is a more than two hundred year old way of nominating who is part of a school or movement. The common denominator in this particular case with Matisse and associates would be the connoisseurship based upon the use of the *fauve* palette. Yet there is more to be said about the use of colour than is ever discussed. The same goes for the oriental figurines or cloth that were incorporated into some of the artists' works, which inherently gave the work an oriental theme and the artist the epithet of being "cosmopolitan".

A rash description of the Swedish avant-garde artists from a contemporary point of view would be that they were acting as cosmopolitans within a national setting, but were truly national when out in the "wider world", i.e. Western Europe. One way to look upon their works would be to discuss the adaption of the definition of what constitutes modernism from a national art institution's point of view, but also to frame what actually constituted the

Swedish avant-garde movement, and how a more contemporary agenda affects how the visuality of the works is discussed today.

Boris Groys stated in his 1997 text upon the logic of the collection that art history has for too long focused on the individual achievements of the artists, and that the so-called historical relevance is only representative of the museum's logic.[1] Museum professionals do define the compulsion to differentiate the new from the old and singularity from plurality, in the way artworks are displayed and discussed in museums. In museums today, visual and verbal narratives often focus on international coherence viewed from a national perspective. Though the national and local is situated selectively within the so-called international context.

Focus is often placed upon a minority of artists who have put themselves and their art, often a close collaboration with other actors such as professors, curators and art critics, at the forefront of a period. Dan Karlholm (b. 1963), professor in art history at Södertörn University, Sweden, has written that: "[...] the autonomy of art is being relativized by representing a number of broader contexts at the museum" and "[...] the so-called originals also illustrate a more overall object or original: Art History."[2] A hundred years after the avant-garde, artists started their walk into fame, and art history the "historically relevant", may be "another story".

1 Groys (2012: 132).
2 Karlholm (2013: 21), transl. by A.G.

Key words Sweden, *Baltic Exhibition*, fauve, avant-garde, modernism, *De unga*, *Opponenterna*, Siri Derkert, Sigrid Hjertén, Nils Dardel, female artist

Around the Year 1900

At the beginning of the 20th century, there was a group of young men who stood against everything they conceived as old. They fought, from their point of view, the battle of the new against the old with words, paint and brushes. The looming ghosts of the Academy, teachers and professors, stout, old, or middle-aged as they were seen by the students, were summarily swept off their feet with fiery speeches and colorful paintings. But the angry young men were hoisted. Being named *The Young Ones* (*De unga*) by their contemporary critics seems a bit ironic from a contemporary point of view, both then and now. The old guard had once called themselves the *Opponents* (*Opponenterna*) when they were just as angry, some twenty years before.

In the 1880s the *Opponents* raised their voices against the formal structures of academic education and art students and artists travelled *en mass* to Paris. One of them, Anders Zorn, who travelled extensively, achieved international fame at the time. In America he came to paint the portraits of the rich and famous, and of three presidents — Grover Clevland (1899), Theodore Roosevelt (1905) and William Taft (1911). On returning to Sweden, some of the artists joined the same old academic system as before, for example Carl Larsson, who became teacher at Valand Art School in Gothenburg. He also became Sweden's most well-known "home-styler" at the time through his illustrations of his and his wife Karin Larsson Bergöö's home in Sundborn, Dalarna. Most of the artists just spent a few months, or at most, a few years on the continent, mainly focused on France but also to some extent Germany, Italy, Spain and England. Most artists remained unrecognized and did not become part of the so-called Art History, either internationally nor nationally, at the time of their whereabouts. The same goes for the generation of *The Young Ones*, who from a national perspective, had their forerunners the *Opponents* to face.

The national careers of the *Opponents* peaked at the end of the 19th and beginning of the 20th centuries, subjecting the younger generation to acidic comments and smirks for the most part, yet occasionally standing up for them. From an avant-garde point of view the most strategic battle for *The Young Ones* was to fight the oldies from the perspective of contemporaneity. A battle that

semantically threw out the old realism and ushered in the new decorative, whilst the positions *The Young Ones* assumed were the same, though they consolidated themselves as "the avant-garde". The old structures were copied with a little stylistic twist. Landscapes, portraits, still lifes and good old history painting still pertained to the general idea of what "art" was supposed to thematize for another fifty years in Sweden. Put simply, Moderna Museet (MM) began as a pronounced concept around the year 1900.[1] In 1915 the artist Richard Bergh became museum director at Nationalmuseum (NM).[2] He was deeply engaged in the *Artist's Society* (*Konstnärsförbundet*) that emanated from the the *Opponents* movement, and was more concerned in including his friends and colleagues in the collection than the international and national avant-garde artists at the time. He met with the latter at his *sejours* in Paris. Bergh had ambitious plans to create a Swedish National Gallery, but national in this sense did not include the works that have represented the beginning of Swedish modernism in art history, either then or now.

The idea of a modern museum crystallized into something tangible in the 1950s, emanating from the department for modern paintings and sculptures at Nationalmuseum. It finally developed into a museum of its own, Moderna Museet, in 1958. At that time abstract art and pop art reigned. Modernism was old-school, and the museum director, Pontus Hultén, was interested in mobile art, Marcel Duchamp and the so-called new art forms, such as film, sound and dance. The only two Swedish artists from the early modernist avant-garde to exhibit at the museum during Hultén's years were Siri Derkert in 1960 and Sigrid Hjertén in 1964 (among mostly renowned male artsist). The ladies were neither angry men, nor angry women, though Siri Derkert's son, Carlo Derkert worked at Moderna Museet as educator and curator, and Sigrid Hjertén was once married to the self-named leader of the group of *The Young Ones*, Isaac Grünewald.

1 For further reading of the history of Moderna Museet, see: Tellgren/ Sundberg (2008).
2 The Royal Museum from 1792, and then from 1886 Nationalmuseum (NM). For further reading of the history of Nationalmuseum, see: Bjurström (1992).

NATIONALISM AND COSMOPOLITANISM IN THE AVANT-GARDE AND MODERNISM
The Impact of the First World War

Around the Year 2000

Let us move ahead to the beginning of this century. The scene has changed again since the heyday of the 1960s, when Moderna Museet acquired its international reputation as one of the most modern museum institutions. On stage today, as one of the avant-garde paintings *par preference*, you will find the large scale painting *Studio Interior*, from 1916, by Sigrid Hjertén.[3] As her main companion stands Nils Dardel, with *The Dying Dandy*, from 1918.[4] These two works are very often used to illustrate modern times, the Matisse color scheme and a cosmopolitan living, when hung to present the collection's more or less "iconic" works from this period. But neither of these two works were museum acquisitions at the time of their creation.[5]

The mentioned painting by Hjertén was bought from her son Iván Grünewald in 1953. He is portrayed as a little boy in the righthand corner. The artist herself sits on a sofa in the background, between male colleagues. The painting has in recent years been accompanied by introductory texts (by the author), when being presented at the museum, pointing towards Sigrid Hjertén's triple function as artist, mother and modern woman, here depicted as the *femme fatale* in the foreground of the painting. But the most fatal tragedy for Hjertén was her struggle with mental illness, which led to a lobotomy that caused her death in 1948. When she painted the scene from her atelier, women were not expected to express themselves as artists; they were not supposed to express themselves at all. Together with her male avant-garde colleagues she exhibited at the newly built exhibition center *Liljevalchs*, Stockholm, in an Expressionist exhibition in 1918. The critique was scathing, not only because the artists painted the way they did, but most derogatively for Hjertén — for being a woman.

Sigrid Hjertén had her first solo-show at The Art Academy (*Konstakademien*) in 1936. The painting *View over Slussen* from 1919 was acquired by the museum directly

3 NM = Nationalmuseum inventory, NM 5032, Sigrid Hjertén, *Ateljéinteriör*, 1916.
4 MOM = Moderna museet inventory, MOM 604, Nils Dardel, *Den döende dandyn*, 1918.
5 For further reading of the history of the early acquisitions, see: Brummer (2002).

from the exhibition.[6] The picture has been interpreted as a reflection of the restrictions women faced in society, such as not being able to walk freely on their own in the bustling city without being approached by the police, who could place them in custody and sentence them to institutional care if they felt like it. Men could stroll around unopposed, women could not. Men could fool around too, while women should attend to their husbands lovingly, chastely and devotedly, not seeking to work, and certainly not as artists.[7] Placed next to *The Dying Dandy* it becomes perfectly clear that subject matters had and still have a stronger hold on storytelling, than say an innovative technique or expression seen from a national context.[8]

Dardel's painting was bought in 1993 from the financier and publisher Tomas Fischer. But before it ended up in the museum it served as a trophy. It was one of the most expensive artworks in Sweden during the 1980s and changed owners on a speculative financial market. The dandy at the turn of the century 1900, Nils Dardel himself, came from a noble family, and was probably one of a number of Swedish artists in Paris who met with the French avant-garde artists and Cubists Pablo Picasso and George Braque. The other *Paris-Suedes* only saw Henri Matisse once in a while when he passed by to give some advice to the eager students that attended his art school. In the exhibition of Dardel's *œuvre* at Moderna Museet in the spring of 2014, the critic Sverker Lenas (b. 1974) described Nils Dardel as an artist who embraced modernity without being a modernist.[9] Nils Dardel was somewhat eclectic and tried different kinds of expressions, but it is, I would say, *The Dying Dandy*, in saturated colors, that has become the closest thing at the museum to a hallmark of today's Swedish modernism.

6 NM 3126, Sigrid Hjertén, *Utsikt över Slussen*, 1919.

7 Artist couples like Karin Larsson Bergöö — Carl Larsson and Sigrid Hjertén Grünewald — Isaac Grünewald were not unusual around 1900. In most cases one of two artists — one had to quit working when they married, and just as in the rest of the society, they were most often the women. Not to marry therefore became a way of holding on to your profession if you were a woman.

8 *The Dying Dandy* is often described as a symbolic portrait of Nils Dardel just before he left a carefree single life and got married.

9 Lenas (2014).

Branded as the pupils of the school of Henri Matisse, the Swedish avant-garde is considered just a handful of artists whose chief achievements in a contemporary context were that they followed the great master, himself a follower of Paul Cézanne. A Swedish artist not considered avant-garde, but who has often been described as the greatest colorist in Sweden, Karl Isaksson, wrote in a letter to his friend the Danish artist Karl Schou, that Pablo Picasso is more interesting than Henri Matisse and Kees van Dongen, though Paul Cézanne is the best.[10] "What a rest his [Cézanne's] paint is to the eye; Van Dongen and Matisse among others make you nervous; pleasant perhaps but it tastes of the city."[11] Isaksson then continues: "[...] but the Spaniard is good. He is a lunatic at first glance and by the way impossible to describe."[12]

Moderna Museet was fortunate to have a Matisse painting *Paysage Marocain* (*Achanthes*) from 1912 donated in 1917, by Walter Halvorsen, the Norwegian painter and art critic interested in dealing with French art.[13] Halvorsen attended Matisse's school himself in 1909–1910 and also befriended Picasso and Braque. The first painting by Pablo Picasso entered the collection thirteen years later in 1930. It was a watercolor entitled *St Antoine*, from 1906.[14] The work was bought from the Swedish artist Georg Pauli, one of the above-mentioned *Opponents*. This work is reminiscent of the so-called pre-Cubism of Cézanne, which was transferred to pure Cubism in for example Picasso's painting *Joueur de guitare* from 1916, which was donated to the museum in 1950 by Rolf de Maré (1888–1964), founder of the Swedish Ballet (Svenska baletten), and close friend of Nils Dardel.[15]

Matisee's painting *Passage Marocain* is defined as a key work in the collection from this period. Its companion in contemporary displays since 2013, *Le Jardin* from 1920, has the nimbus of lost and found.[16] This painting was donated to the museum in 1977 by Nora Lundgren,

10 Gunnarsson (2004: 58). See also: Engwall (1944: 124–125).
11 Gunnarsson (2004: 58), transl. by: A.G.
12 Gunnarsson (2004: 58), transl. by: A.G.
13 NM 2017, Henri Matisse, *Marockanskt landskap* (*Akantus*), 1912.
14 NMB 1246, Pablo Picasso, *St Antonius*, c. 1908.
15 NM 4621, Pablo Picasso, *Gitarrspelaren*, 1916.
16 MOM 94, Henri Matisse, *Trädgården*, 1920.

and stolen, early on a Saturday morning in 1987, to be returned to the museum twenty five years later in January 2013. It is interesting that the blue, green and lilac in the landscape from Morocco have come to envisage wild and crazy newness, the *fauve*, while the greenness of the French garden painted by Matisse at the age of fifty, more often is described as a *somber* and *petit* landscape.

Moreover when you place Sigrid Hjertén's *The Red Curtain*, from 1916, next to Henri Matisse's *Deux odalisque*, from 1928, you can easily start to ponder constructions such as master and pupil, national and international, Fauvism and Expressionism, male and female.[17] Sigrid Hjertén's painting was first shown in 1964 at her solo exhibition at Moderna Museet, and was donated to the museum in 1987 by Iván, Rebecca and Rakel Grünewald. The painting is definitely innovative seen from many different perspectives, but time was not up to speed with this kind of new creation, when Hjertén painted the scene. The master narrative did not hold a place for her languid looking woman, which transgressed the ubiquitous Swedish avant-garde quest for the decorative, besides everything else that she was transgressing as a woman.

Neither did time hold a place for a woman described as arrogant and self-assured. The Swedish artist Maj Bring (1880–1971) wrote about this in her memoirs in the 1960s when recapturing the respect Sigrid Hjertén had for Matisse and the respect he had for her as a truly gifted and talented artist attending his class.[18] When Maj Bring returned to France in 1946, after the Second World War, she met with Matisse and talked about the Grünewalds. According to Maj Bring Henri Matisse said that: "Elle [Sigrid Hjertén] étatit très douée."[19] Was the most experimental artist in the Swedish avant-garde alas a woman? Who could tell? Another artist, whose career peaked 1969, when she was in her nineties.

Some fifty years later Swedish author and literature critic Anneli Jordahl (b. 1960) wrote: "What is it she [Sigrid Hjertén] wants to get at with this naked woman

17 MOM 390, Sigrid Hjertén, *Den röda rullgardinen*, 1916; NM 2738, Henri Matisse, *Två odalisker*, 1928.
18 Bring (1960: 61).
19 "She was very gifted." Transl. from Bring (1960: 85) by: A.G.

NATIONALISM AND COSMOPOLITANISM IN THE AVANT-GARDE AND MODERNISM
The Impact of the First World War

that has pulled down the red blind? Ecstasy or suffering?"[20] Sigrid Hjertén's visual world has, as mentioned earlier in this text, been interpreted as a reflection of her life. Jordahl concludes in her text:

> Women working with introspection are still more exposed than men out in the same errand. Women confess, as known, and they set themselves off in a more self-centered way. While men depart from themselves to proclaim something universal. Still today critics and biographers tend to keep work and originator apart to a higher degree when it comes to interpreting men, it accounts for both art and literature. And what you have lived will not be perceived as degraded by the intrinsic artistic value."[21]

This becomes perfectly clear when you read the following passage of the text accompanying Matisse's odalisque, *Harmony in Red*, from 1926–1927, from the Collection Online on the website of The Metropolitan Museum of Art, New York, USA:

> The model's sculpturesque body, languorously stretching on the couch, exudes sensuality and carnality, enhanced by the warm rosy red color scheme. The mood of *luxe, calme et volupté* is clearly palpable. Yet, contemplating the work, one gets the impression that the artist somehow distanced himself from the erotic content of the picture while leaving the excitement of recognition to the viewer. Despite their attempt at authenticity, the paintings appear carefully staged and full of theatricality.[22]

Storytelling

Here I find reason to pose the rhetorical question: Is the whole Swedish contemporary avant-garde discourse a bit staged? Let us look at another example seen from a contemporary discourse of feminism. Tora Vega Holmström's painting *Strangers*, from 1913–1914, was donated to the museum in 2005 by Birgit Rausing (b. 1924), art

20 Jordahl (2007: 137), transl. by: A.G.
21 Jordahl (2007: 139), transl. by: A.G.
22 The Metropolitan Museum of Art, The Collection Online, see: http://www.metmuseum.org/collection/the-collection-online/search/489997?rpp=30&pg=1&ao=on&ft=MAtisse&pos=10 (accessed: 29.12.2014).

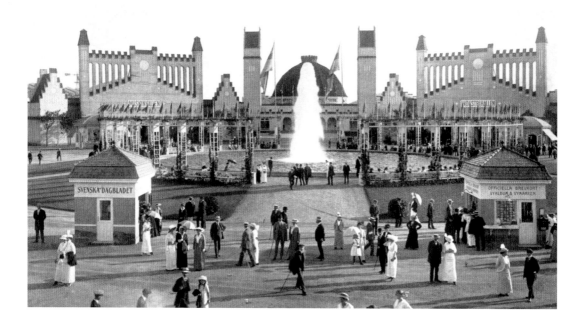

Fig. 1

View on the area of the *Baltic Exhibition* in Malmö, 1914

historian and chief biographer of Tora Vega Holmström.[23] *Strangers* was one of a handful works that the museum acquired in the bold venture *The Second Museum of Our Wishes* (*Andra Önskemuseet*), which was intended to shed light upon women artists.[24] Tora Vega Holmström was already represented in the collection with eight works, for example *Boy with Seashell*, from 1922.[25] This work was transferred to the museum from the Artist Fund (*Konstnärshjälpen*), a political commitment in Sweden from 1922 to 1926, that used surplus lottery funds to acquire art by Swedish artists.

The boy has not been interpreted yet, but the woman and child in *Strangers* have been described as follows by art critic Bengt Lagerkvist: "Here is a mother and child quite different to Carl Larsson's idealized pictures of Karin: her eyes [the mother's] do not look at the child or the viewer, but to her right. Her countenance sullen, not a glimpse of a happy smile. The boy does also look away,

23 MOM/2005/88, Tora Vega Holmström, *Främlingar*, 1914.

24 For further information, see: Nilsson (2010).

25 NM 2440, Tora Vega Holmström, *Pojke med snäcka*, 1922.

somewhere, but not with any expectation."[26] In this description the negations place the avant-garde in position facing their opponents as their immediate counterpart. Remember, Carl Larsson was one of the male artists that opposed the academic structures in 1880. His portrayals of his wife Karin Larsson Bergöö and their children, still resonate as authentic images of a happy family and home. Compared to this, the *Strangers* stands in stark contrast, both in content and visuality.

Perhaps it is the historical background, with links to the author and poet Rainer Maria Rilke that gives these strangers their contemporary position together with the fact that the painting was exhibited at the *Baltic Exhibition* (*Baltiska utställningen*; Figs. 1, 2 and 3) in Malmö in 1914.[27] An exhibition that closed when the First World War

26 Lagerkvist (2007: 96), transl. by: A.G.
27 May 15, 1914–October 4, 1914. The event showcased the industry, art and culture of Sweden, Denmark, Germany and Russia — the four countries then bordering the Baltic Sea. The predominantly represented styles were Art Nouveau and Expresionism. The Åhléns Pavilion, relocated to the town of Insjön in Dalarna, is one of the few structures to survive. See: Christenson/Ericsson/Pehrsson (1989); Rausing (1989).

Fig. 3

Ernst Norlind, Poster of the
Baltic Exhibition, 1914. Malmö
City Archive

broke out. Holmström and Rilke met when he was visiting
Sweden in 1904, and just as with Paula Modersohn-Becker,
Tora Vega Holmström corresponded with Rilke who, in-
cidentally, was described by Lagerkvist as a man with
a weak spot for ruined castles with nobel women own-
ers.[28] Tora Vega Holsmtröm wrote to Rainer Maria Rilke
about the painting, with which Rilke became acquainted
from a black and white photo. One sentence in his re-
sponse: "the child that after all gazes into an unknown
world, without even knowing it or recognizing it" has been
cited as a prophetic reference to WWI.[29]

28 Lagerkvist (2007: 96–97).
29 Rausing (1989: 107–109). See also: Widenheim (2014); Nilsson
 (2010: 60–61); Steorn (2012: 158).

Tora Vega Holmström has, in a contemporary context, been defined as a regional artist from the south of Sweden, an artist who decided not to have a husband and children: a woman artist.[30] All the epithets define different discourses that intersect in the somewhat odd perspective of a political agenda. That works by Tora Vega Holmström were bought shortly after completion and transferred to the collection is a story seldom told, nor is the visuality of the works discussed, or the fact that she also studied in Germany.[31] The political commitment to help Swedish artists, buying their art in the 1920s just after WWI is a discourse that departs from the modernism narrative of colorful avant-garde paintings. The art bought by the Artist Fund establishes another context. A context that speaks of an interest to stay national in a world that just had been turned upside down.

The national at that time held a blonde pale palette.[32] Not like the colors Vera Nilsson used when she painted her *Spanish Landscape* (*Coin*), from 1919–1920, or *Street in Malaga II*, from 1920–1922.[33] The first was bought in 2004 with special funding and the second was donated as a testamentary gift in 2010 by Vera Nilsson's daughter Catharina Nilsson Gehlin and her husband Nils Gehlin. Nor did Maj Bring's two works *Sunrise in Vallda*, from 1913, and *The Fast Train*, from 1923, both of them bought in 1973, also with special funding, hold the right avant-garde color scheme.[34] The landscape is reminiscent of works by Bring's teacher at Valand, Carl Whilhelmsson. He has often been described as a teacher who treated women and men as equals, making no distinction between genders or class. In the contemporary discourse Nilsson's and Bring's respective works illustrate the landscape converging into a city built by bold perspectives, and borrowing from the paradigmatic shift that art critic Arthur C. Danto places

30 Rausing (1981); Lagerkvist (2007); Steorn (2012).
31 Steorn (2012: 159).
32 For further reading about the Swedish blonde, see: Werner (2014).
33 MOM/2004/8, Vera Nilsson, *Spanskt landskap* (*Coin*), 1919–1920; MOM/2010/138, Vera Nilsson, *Gata i Malaga II*, 1920–1922.
34 NM 6490, Maj Bring, *Soluppgång i Vallda*, 1913; NM 6491, Maj Bring, *Snabbtåget*, 1923.

in the knee of Pablo Picasso and his painting *Les Demoiselles d'Avignon*, from 1907.[35]

At the birth of modernism artists like Vera Nilsson, Maj Bring, Siri Derkert, Siri Meyer and Tora Vega Holmström, to mention just a few, were not much thought of as part of any "-ism". Still these five women are presented in the museum context as part of the avant-garde modernism. Most of their paintings in the collection hold a blonde pale palette, but have reminiscent streaks of Cubist "light". These works were all accessioned in the second half of the 20th century and at the beginning of the 21st. Just one still life by Tora Vega Holmström was bought by fundraising in 1924, when modernism took its stance after the WWI, to be transferred into the accessioned museum collection first in 1981.

For a handful of men who were actually a core part of the avant-garde troupes at the time, *The Eight* (*De åtta*), *The Young Ones* and *The Men of 1909* (*1909 års män*), the fate is just the opposite. For example Tor Bjurström, Carl Palme, Birger Simonsson and Sigfrid Ullman painted respectively: pears on a leafy branch in pale grey and green, green apples on a garden table in green and bluish grey, blond boy by a fireplace mainly in blue, and a rocky grey landscape with a summer blue sky, all motives in a national pale setting. They were painted between 1907 and 1922 though purchased or transferred to the museum around 1950.

Most of these works were, and still are, placed as long-term loans in other stately financed institutions. What a fate for an avant-garde generation! Hidden from the museum audience, or you could say, more secretly exhibited for thousands and thousands of viewers with not much knowledge of, or perhaps interest in the avant-garde battle. These works are exposed to its audiences from diametrically different art historical reasons. The works on long-term loan were from the beginning placed as aesthetic educative examples of modern art, and the museum works are today put on show to tell the story of modernism and its avant-garde from a contemporary point of view.

35 Danto (2013: 4).

Backtracking

Can modernism be backtracked? My last example of how the more contemporary avant-garde narrative has been constructed, from a national context connected to the European/American avant-garde construction, will be the *œuvre* of the artist Ivan Aguéli. Aguéli was an artist in between the two generations that saw modernism take hold around the turn of the 20th century. Neither was he an *Opponent* nor was he an avant-garde artist, but he was perhaps the most cosmopolitan of the Swedish artists of his time traveling extensively, living outside Sweden for most of his adult life.

Aguéli followed a line of more solitary artists that made worldwide grand tours, for example the Swedish artist Egron Lundgren, who in 1858 travelled to India with the British Army to depict the Sepoy revolt. At that time Lundgren was currently living in Britain. Aguéli has often been described as a restless soul who furrowed his own way through Europe and North Africa. In this sense Aguéli fits perfectly into the contemporary narrative of international art, which makes him a given subject for today's new art world projects that deals with the idea of "another world".

Seen from a national context, Aguéli's landscape paintings from Egypt are seemingly like Swedish nature in early spring (pale, grayish and washed-out blue), but are described as sun-drenched with desert light when talked about in a contemporary museum context. And Aguéli's *Study*, from 1890, is, in a sense, inverted in Isaac Grünewalds painting of *Iván by the Armchair*, from 1915.[36] Depending on what you pick as a reference point and the questions you would like to find an answer to, you can always construct "other stories". No wonder that national art history describes Ivan Aguéli as "pre-modern" today. In 2011 an exhibition consisting of a thousand photographs, from the wake of photography until today, from the collection at Moderna Museet was titled *Another Story*. Daniel Birnbaum (b. 1963), the museums director, said: "We want to show the museum collection from a new perspective, but also to present an alternative art history,

36 NM 5006, Ivan Aguéli, *Studie*, 1890; NM 5308, Isaac Grünewald, *Iván vid fåtöljen*, 1915.

not one that is more true, but simply another perspective."[37]

The author Stefan Zweig wrote in *Die Welt von Gestern, Erinnerungen eines Europäers*, from 1939–1941, about the new spirit that flourished in Europe before WWI.[38] A spirit that erased old historical boundaries and liberated people from gender structures and national borders. But according to Zweig the war changed the scene and other borders were set up. For example, the Swedish borders consisted more of financial and intellectual limitations than national demarcations. Swedish artists were to a great extent middle-class or from the sociocultural strata (the so hated) *bourgeoisie* and travelled because they could. Back in Sweden they adhered to the national setting. They were neither cosmopolitans, nor were they part of nationalism in a strict sense.

The question of class was and still is masked as part of a so-called "majority discourse". The context of the Swedish avant-garde that has been presented most often, has been based solely upon one category of art works, namely paintings. Other expressions, for example sculptures and drawings, have rarely been taken into account in earlier avant-garde research. So what are the alternative stories permitted in a contemporary global transnational world? What perspectives do we have today and what borders do we set up to keep within or infringe? I think one of the more interesting questions to address when discussing the "modern" as an "-ism" from any perspective is to dissect "who's modern". The discussion of avant-garde modernism is still framed in a political discourse that focuses upon questions dealing with hierarchical structures. So-called minorities are placed within, or tied to the master narrative as new findings. But are they new? Or are the findings rather a symptom of how the questions are asked and construed, in sometimes quite artificial settings?

37 See: http://www.modernamuseet.se/en/Moderna-Museet/
 PressRoom/Press-releases/Stockholm1/Another-Story1000-
 Photographs-from-the-Moderna-Museet-Collection
 (accessed: 29.12.2014). The exhibition presented photography
 from the 1860s to 2000s.
38 Zweig (2011); see: Głuchowska, *"War to End all Wars"*... in this
 volume.

Conclusion

In this presentation I have put forward some ideas on how terms like "modernism" and "avant-garde" have been adapted and formulated in a national art institution at the beginnings of both the 20th and 21st centuries. One reflection is that the symbolic order of so-called established interpretations tend to be more and more simplified over time. Another reflection is that the discourses avoid the versatile. This gives a twofold purpose in relation to what things seem to be and what they actually are deemed to be. Art historians should also, I believe, discuss the visual competence needed to set free from dichotomies like "male-female" and "center-periphery" to name a couple of the parings that frame the discourse of modern and contemporary art today. Can Pablo Picasso for example be thought upon as a pure national artist or is he forever doomed to be just international? My choice of combining cosmo- in cosmopolitan with national as an opposite of international — is a way of playing around with the discourse of settings and semiotics. What I have put forward is no groundbreaking research. That would rather be to take a closer look at those artists and expressions who were, so to speak, invisible, and did not make it into art history's modernism either then or now. A new take upon the question of cosmopolitan avant-garde before WWI would perhaps be to focus upon to what extent the "mapping" of what we take for granted can change.[39]

39 Torkel Klingberg, professor in cognitive neuroscience, writes about the mapping of the brain and concludes: "Maps describe something unchangeable. Mountains and rivers are placed where they are. Just lately research has focused upon to what extent these maps can change." Transl. from Klingberg ([2007] 2013: 89) by: A.G.

Modernism and the National Idea — Reflections of the First World War

The Case of Bulgaria

Irina Genova
New Bulgarian University/Bulgarian Academy of Sciences. Sofia, Bulgaria

Abstract

The First World War was a traumatic experience, which changed the artistic predispositions and thinking in art. The European map was redesigned. After the war borders changed, and new states emerged. In Southeastern Europe Albania appeared before the war, and after WWI concluded, the Kingdom of Serbs, Croats and Slovenes followed, whilst Romania significantly expanded. Some states acquired while others lost territories; some qualified the consequences of the wars as national catastrophes (Bulgaria, Greece), while others saw them as an expansion and consolidation (Romania). The remains of the Ottoman Empire were turned into the secular national state of Turkey. Beyond the national differences, WWI and the local wars accompanying it claimed innumerable lives, left ruins behind and led to devastation. Without solving the old problems, the wars gave rise to new ones, which were to trigger further conflicts in the decades to come. The artists from the young and middle generations were mobilized on the front — some of them did not return, others were severely wounded.

In the countries in Southeastern Europe the period from the end of WWI until around the mid-1920s was characterized by the intense activity of the modernist and avant-garde movements. Their protagonists returned to their home countries. The artists with multiple identities, having been formed and belonging to more than one cultural milieu (Georges Papazoff and Nicolay Diulgheroff from Bulgaria, and many others), were a common phenomenon in the post-war years. However, few Bulgarian artists, having found themselves in the influential artistic "centers", openly embarked on the adventures of modernism. The very selectivity of their interest in European art reveals the characteristics of the art scene in Bulgaria. The common tendency towards the primitive in the 1920s, for instance, interacted to varying degrees with the interest in the folk art and icon painting (Ivan Milev, Ivan Penkov, Ivan Lazarov, Vasil Zahariev, Pencho Georgiev, Sirak Skitnik, etc.).

The aspirations of the "new wave" in Bulgarian art in the 1920s were not limited to just the mediation of the lost native. This wave swung between the "native" and the "universal", between the "handmade" and the "unique"

on one hand, and the "industrially manufactured" and "mass distributed", on the other; it created a new attitude to be applied, as well as to mass visual culture. Since the end of the 1920s the interest in this local visual culture, intertwined as it was with modernism in the previous years, began to be seen more often in a commonly acceptable imagery of nationalist pathos.

The article is focused on the topics: images of the war and modernity, images of the war in the mass visual culture, and images of the war and Christian symbolism during and after WWI with examples from Bulgaria.

Key words art in Bulgaria, national idea, images of the war, war and modernity, modernism and Christian symbolism

NATIONALISM AND COSMOPOLITANISM IN THE AVANT-GARDE AND MODERNISM
The Impact of the First World War

Introduction

The First World War was a traumatic experience which changed the artistic predispositions and thinking in art.[1] The European map was redesigned. After the war, borders changed and new states emerged. In Southeastern Europe the Kingdom of Serbs, Croats and Slovenes appeared; later, in 1929, it was renamed as the Kingdom of Yugoslavia. Albania emancipated itself from the Ottoman Empire in 1912. Romania significantly expanded, in cultural terms too, as it acquired Transylvania and Bessarabia. Western or Aegean Thrace was separated from Bulgaria and was annexed to Greece. After WWI there followed a war between Greece and Turkey (1919-1922) concerning territories in Asia Minor. Some states acquired while others lost territories; some qualified the consequences of the wars as national catastrophes (Bulgaria, Greece), while others saw them as an expansion and consolidation (Romania) or as the beginning of the modern state (Albania). The remains of the Ottoman Empire were turned into the secular national state of Turkey during the rule of Mustafa Kemal.[2] Beyond these differences, WWI and the local wars accompanying it claimed innumerable lives, left ruins behind and led to devastation. Without solving the old problems, the wars gave rise to new ones, which were to trigger conflicts in the decades to come.

The artists, poets, and writers from the young and middle generations were mobilized on the front and assigned the task of covering military events and glorifying the victories of their national armies. Some of them did not return — among them from Bulgaria the poet Dimcho Debelyanov,[3] and the artist Goshka Datsov.[4] Others were severely wounded: the poet and art critic Geo Milev[5] lost one of his eyes;[6] the art critic and artist Sirak Skitnik[7] was

1. This article was published earlier in the magazine *Sledva* 38 (2018), under the title "Reflections of World War I: Modernism and the National Idea in Bulgaria". See: Genova (2018b).
2. Regarding the history of the Balkans in this period, see: Manchev (2000).
3. About Dimcho Debelyanov, see: http://bgmodernism.com/Nauchni-statii/Sabourin (accessed: 12.10.2016).
4. *Encyclopaedia* (1980: 221-222).
5. Milev (1964: 9-75)
6. Milev (1964: 273-312).
7. Krustev (1974).

wounded in the chest and in the right hand.[8] There were prisoners of war too: the Romanian artist Nicolae Tonitza[9] fell prisoner to the Bulgarians in the Battle of Tutrakan/Turtucaia. The female Bulgarian artist Elisaveta Konsulova-Vazova[10] worked as a volunteer Samaritan in military hospitals during the Second Balkan War.[11] Few protagonists of modern art managed to evade the war experience.

Images of the War & Modernity

Modern Times in the Balkans began with military action — fighting for independent states and national autonomy. Across Europe the modern era was replete with wars between nation states which disputed territories, but the Balkans seemed to be synonymous with war. The initial period of the modern independent Bulgarian state began with the Russo-Turkish War (1877–1878), included the Serbo-Bulgarian War (1885), the two Balkan wars (1912–1913), and ended with WWI (1914–1918; Bulgaria entered the War in 1915).

The representation of war, with the associated extreme trials on the battlefields, everyday experience behind the frontline, and triumphant marches through the capitals' boulevards, as well as of imaginary scenes of historic battles and victories, constitutes an important aspect of modernity. The expression of ideas and desires, of a wide range of attitudes and emotional states related to war, is an integral part of modernist and avant-garde practices.

Modernity as a social practice and a way of life manifested itself in many different fields of activity. The word "modernity" in relation to culture first appeared around 1850 in the writings of Théophile Gautier and Charles Baudelaire. According to Jean Baudrillard, that was the point at which an increasingly "self-aware society" came to regard "modernity as a cultural model".[12] In the field of culture, Anthony Smith highlights — among other

8 Krustev (1974: 19); Sirak Skitnik (Orphan Wanderer, pseudonym) (2014: 66–68).
9 Şorban (1965).
10 *Encyclopaedia* (1980: 469–470).
11 Konsulova-Vazova (2002: 50–56).
12 Baudrillard (1996: 552–554).

NATIONALISM AND COSMOPOLITANISM IN THE AVANT-GARDE AND MODERNISM
The Impact of the First World War

characteristic features that have a positive or negative impact — the importance of the connection between modernity and nations.[13]

The topic of represented modernity was first introduced in 1863 by Baudelaire in his essay "The Painter of Modern Life" ("Le Peintre de la vie moderne") in the magazine Le Figaro.[14] The artist, according to Baudelaire, "is looking for that quality which you must allow me to call 'modernity'; for I know of no better word to express the idea I have in mind. He makes it his business to extract from fashion whatever element it may contain of poetry within history, to distil the eternal from the transitory."[15] It seems that only painters, poets and writers have the means (metaphors, symbols, the effects of form) to keep hold of these elusive elements of modernity, as if modernity can only be observed/discussed in terms of representation.

Baudelaire paid special attention to the images of war as an important part of the "imagery of modern times". In chapter VI of "The Painter of Modern Life", entitled "The Annals of War", one can read:

> Bulgaria, Turkey, the Crimea, and Spain have all in turn ministered lavishly to the eye of Monsieur G. — or rather to the eye of that imaginary artist whom we have agreed so to call [...]. I have studied his archives of the Eastern War — battlefields littered with the débris of death, baggage-trains, shipments of cattle and horses; they are tableaux vivants of an astonishing vitality, traced from life itself, uniquely picturesque fragments which many a renowned painter would in the same circumstances have stupidly overlooked. [...] I am ready to declare that no newspaper, no written account, no book has unfolded so well, in all its painful detail and melancholy scope, the great epic poem of the Crimea.[16]

In all Europe, the modern era was associated with, among other images, the uniforms of a multitude of nations involved in war. The representation of men in military uniform and accoutrements, of heroes of national and bourgeois revolutions, of struggles for civil rights, forms an

13 Smith (2002: 68, 70).
14 Baudelaire ([1863] 1868: 51–114).
15 English transl. from: Baudelaire (1964: 12).
16 Baudelaire (1964: 18).

important part of the idea of modernity in the Balkans, as elsewhere in Europe.

Among the early Bulgarian representational examples of men in European military uniforms I would like to mention an extremely curious 19th-century drawing of three men in military uniform in the *Album of Drawings by Painters/Zografs from Elena*, in the National Art Gallery in Sofia. The drawing is to be found among preparatory sketches for, and copies of, church mural and icon compositions: a burst of interest in topicality and involvement with modern times.[17] Another example is a mural painting from 1864 in the house of the artist Stanislav Dospevski[18] in Pazardzhik, Bulgaria, representing soldiers and officers in the yard of the Military Academy in St. Petersburg.[19]

The artist Nikolay Pavlovich[20] created a series of small paintings and lithographs representing imaginary scenes of a glorious history of the medieval Bulgarian Kingdom. Victorious battles and war heroes constitute the main line of this visual narrative with a didactic ambition. In terms of artistic skills and impact, Pavlovich's series could not be compared with the large historic paintings, which the artist had the opportunity to see during his training at the academies of Vienna and Munich.[21] In Bulgaria, the academic genre of historic battles as an integral part of the imagined history of modern nations[22] was introduced by foreign artists educated in influential (at that time) academies in Europe. Many of them were Polish and Czech artists who stayed in Bulgaria for a shorter or longer period. Among them were the Polish artists Tadeusz Ajdukiewicz[23] and Antoni Piotrowski[24] or the Czech artists Emil Holárek[25] and Jaroslav Věšín.[26] Jaroslav Věšín was appointed as a military artist at the Ministry of War.

17 For the reproduction, see: Sokolova (2004: 76).
18 *Encyclopaedia* (1980: 262–263).
19 For the reproduction, see: Bozhkov (1978: 72–74).
20 *Encyclopaedia* (1987: 281–283).
21 Gerhart/Grasskamp/Matzner (2008: 174–178).
22 See: Anderson (1991).
23 Bozhkov (1978: 174–176).
24 *Encyclopaedia* (1987: 387); Gerhart/Grasskamp/Matzner (2008: 180).
25 Bozhkov (1978: 130–132); see: http://matrikel.adbk.de/05ordner/ mb_1841-1884/jahr_1884/matrikel-05056 (accessed: 12.10.2016).
26 *Encyclopaedia* (1980: 144–145); Gerhart/Grasskamp/Matzner (2008: 181).

NATIONALISM AND COSMOPOLITANISM IN THE AVANT-GARDE AND MODERNISM
The Impact of the First World War

The Images of WWI by Bulgarian Artists

The images of WWI, as well as of its predecessors — the two Balkan wars — by Bulgarian artists reveal a large range of artistic practices between representation and expression, between official narrative, individual stories and personal artistic expressiveness. The experience of Academism, 19th century Realism, Symbolism, Expressionism, and Futurism, often in different hybrid versions, can all be observed and discussed. One can find festive fanfare, critical echoes, nightmarish visions, and even exalted poetics of destruction. The art and literary magazine *Crescendo*, 1922, issue 3–4, published part of Marinetti's poem "Zang Tumb Tumb", the one that deals with the Bulgarian aeroplane, as well as part of his article "Geometric and Mechanical Splendor and the Numerical Sensibility" (1914) in Bulgarian ("Geometrichno I mehanichno velikolepie").[27] Hastily made sketches on the war terrains, during breaks or in the trenches, provide a close observation of individuals and their behaviour.

The exhibition of German, Austro-Hungarian, and Bulgarian military artists at the Royal Academy of Arts in Berlin in May and June 1917 gave an official perspective of an unique joint exhibition of the Central Powers. The forum, according to the catalogue,[28] exhibited 481 works — paintings, sculptures and drawings — by 117 artists. Most of the works were by German artists (309), 107 were by artists from Austria-Hungary and 65 were by Bulgarian artists. Works of different intentions and artistic experience were exposed side by side: official kings' and army generals' portraits in sculpture and painting, panoramas of battlefields, and ecstatic human conditions. In landscape views, we can see the geography of Europe assimilated in the experience of war. A continued interest in the images is that of "otherness" — a landscape or a human being represented through the foreign ally or the captive.

Who were the Bulgarian artists who exhibited in Berlin? All of the artists were participants in the war, with the exception of the painter of official portraits

27 Krustev (1988: 41–45).

28 *Ausstellung deutscher, österreichisch-ungarischer und bulgarischer Kriegsbilder*, Berlin 1917.

Modernism and the National Idea — Reflections of the First World War
The Case of Bulgaria

Nikola Mihailov.[29] Among them were some of the most influential artists of the succeeding period (the 1920s), who endeavoured to adapt the experience of European modernisms: Boris Denev,[30] Nikola Tanev,[31] Hristo Kavarnaliev,[32] and Stoyan Raynov.[33] Some of these painters and sculptors had participated in the broad *Movement for Native Art* (*Dvizhenie za Rodno izkustvo*) during the 1920s: Vladimir Dimitrov-Maystora [The Master],[34] Ivan Lazarov,[35] and Nikola Kozhuharov.[36]

The group included artists who in different periods of their career were in agreement with the official authorities, or at least did not publicly appear in opposition. In the Bulgarian context, however, the distinction of the artists associated with the institutions of power in the 1920s, and especially in the 1930s, from the protagonists of modernisms and avant-garde movements is not as easy as, for instance, in Germany.

It is noteworthy that some of the outstanding participants in the aforementioned exhibition of military artists at the Royal Academy of Arts in Berlin in 1917 were German artists such as Ludwig Dettmann,[37] Fritz Erler,[38] and Franz Eichhorst,[39] who later cooperated with Hitler's authorities.

Images of the two Balkan wars and of WWI appeared in group and solo exhibitions in Bulgaria.[40] Iconic compositions like *They Were Victorious* (*Te pobedikha*, 1913)[41] by the sculptor Ivan Lazarov entered text books in history and literature as reproductions.

29 Kisseler/Nikolaeva (2009: 110–113).
30 Mihalcheva (1964); Christova-Radoeva (2013).
31 Marinska (2000); Rangelova/Dimitrova (2010).
32 *Encyclopaedia* (1980: 391–392).
33 *Encyclopaedia* (1987: 480).
34 Avramov (1989).
35 Boshev (2007); Kisseler/Nikolaeva (2009: 164–167).
36 Dobrev (2007: 56–61).
37 *Allgemeines Künstlerlexikon*, Band 26 (2000: 489).
38 *Allgemeines Künstlerlexikon*, Band 34 (2002: 399).
39 *Allgemeines Künstlerlexikon*, Band 32 (2002: 504).
40 One of them is the *1ˢᵗ Bulgarian Army's Exhibition* in Sofia in 1918.
41 *Catalogue Sculpture* (2007: 76).

NATIONALISM AND COSMOPOLITANISM IN THE AVANT-GARDE AND MODERNISM
The Impact of the First World War

Circulation of Images: Postcards, Stamps, Calendars, and Images in the Press as Implementation of National Propaganda During the War in the Field of Visual Mass Culture

The images of WWI in the visual mass environment have been the subject of research and debate in recent years.[42] The practice of photographic documentation gained importance for Bulgaria in the two Balkan wars and WWI,[43] although it had been utilized earlier — in the late 19th century during the Russo-Turkish War.[44] Restorations of military scenes for photography and film purposes were made during the First Balkan War[45] and WWI, shortly after victorious battles (such as the conquest of Edirne by the Bulgarian Army in 1913) and in the course of the military operations themselves. This practice of re-staging a battle for the purpose of photography was due, on the one hand, to the limited possibilities of photographic equipment (number of frames per minute, range of lens and so on), as well as to the impossibility for photographers to occupy privileged viewpoints in the dynamics of the military actions. On the other hand, though, this practice implemented the idea of creating a photo or film image, which could be perceived as a document forming the visual narrative of the national history.

In fine art exhibitions, many images of war — fighting, panoramas of battlefields, military commanders and so on — were produced using staged photographs. The archive of the artist Jaroslav Věšín contains a large number of such photographs and negatives.[46]

Thus the creation of history in images extended from the mass-circulated visual culture to unique high art. The fact that textbooks in Bulgarian history and literature reproduce fewer photographs than they do paintings created with the assistance of photography, is worth mentioning.

Another part of the mass visual environment — drawn postcards,[47] drawings in the press, and other circulated typographic images — deserves special attention in terms of the opposition of "my nation" and "the enemies".

42 See: the whole issue of the journal *Bulgarska etnologiya* [Bulgarian Ethnology, 2014] dedicated to this topic; Kaser (2014: 332–348).

43 Boev (1983: 140).

44 Boev (1983: 78–81).

45 Kardjilov (2006).

46 Exhibition in the National Art Gallery, Sofia 2013, without the catalogue.

47 For the Bulgarian postcards, see: Barnev/Yurukov (2006).

Modernism and the National Idea — Reflections of the First World War
The Case of Bulgaria

Naïvely drawn postcards — glorifying images of their own army and grotesque images of the enemy army, committing atrocities or defeated/in captivity — were widely circulated. Comparing this type of image — preceding in certain respects the "comics' imagery" — one could recognize visual similarities (characters, situations, compositions and so on) in the Balkan context. Mostly the insignia of the armies changes.

Caricatures are particular images of war. They are not involved in the invention of national history, at least not in the highest accolades of the solemn and the heroic: in this panegyric, whimsy can hardly be accepted. Generally, the topic of laughter and war is challenging. What did caricaturists ridicule? Mainly situations of everyday life in the capital in wartime. Political caricatures in the press addressing the policy on the participation of Bulgaria in the Balkan War and WWI did not suggest doubt in the cause of war. Most often, they represented King Ferdinand, his ministers, and their diplomatic mistakes. Alexander Bozhinov was the most influential Bulgarian caricaturist of that time.[48]

— — —

At that time the images of WWI and the two preceding Balkan Wars were mostly images taken with the intention of "creating/inventing national history". Suggestions of the heroism and self-sacrifice of Bulgarian soldiers in glorious battles against the treacherous and cruel enemies, and insinuations of the patriotic cause of wars for recuperating the unjustly taken Bulgarian lands, were manifested in a wide range of images, from circulated visual propaganda to the works of art in exhibition halls, public collections, and representative spaces of state institutions.

The motive for the unfair loss became an important part of the official Bulgarian history. The widely propagandized idea of the injustice inflicted on Bulgaria brought about revanchist feelings and created the utopia of a supra-individual community. "The wars were the first situation in modern Bulgarian culture that had created 'the mass person,'" wrote the historian Ivan Elenkov,

48 *Alexander Bozhinov* (1957); Nikolaeva (1999).

"[...] huge human masses, overcoming their traditional isolation, united — rationally organized and using technologies, acting in synchrony [...]."[49] After 1918, the lived experience of wars and their consequences led to the foundation of common places of collective integrity.

Modernism, Christian Symbolism, and Orthodox Icon after WWI

The traumatic experience of WWI was expressed in poetic and artistic images that affirmed the value of human life beyond national causes and political achievements. Particularly expressive in this regard are the verses by Geo Milev, written after he had been seriously wounded in the head and lost his right eye as a result:

> MY HEAD...
> My head —
> a lantern sunk in blood and smashing glass,
> gone with the wind and rain, and fog
> in the midnight field.
> I am dying under elevation 506
> to resurrect in Berlin and Paris.
> There is no century, no date — just today![50]

Another poem — "One Dead" — by Dimcho Debelyanov ends with the verse: "the dead is our enemy no more."[51] Debelyanov was killed in battle on October 2, 1916, aged 29.

After WWI new periodicals appeared, among which was the famous modernist oriented magazine *Vezni* [Scales, 1919–1922] published by Geo Milev. In *Vezni* almanac, 1923, Geo Milev wrote an essay entitled "In Memoriam: Dimcho Debelyanov", accompanied by a graphic portrait made by himself.[52]

One could say that it was difficult to reconcile humanistic values beyond national causes with the idea of "native art" (*rodno izkustvo*) from the early 1920s, which referred to the local visual culture and its revision in modernist versions. The first impression might be that local practices

49 Elenkov (1998: 38).
50 Milev (1920), transl. by: Albena Vitanova.
51 The poem found out by the writer Georgi Raychev and published posthumously for the first time in: Debelyanov (1920).
52 Milev (1923: 63–64).

Василъ Захариевъ
Голгота
(гравюра на дърво)

Fig. 1

Vasil Zahariev, *Golgotha*, 1915–1918, illustration from magazine *Vezni* I/9 (1919–1920)

of modernism/avant-garde, not only in Bulgaria but in other peripheral European artistic milieus, were juxtaposed with the universal utopias of the avant-garde because of the intertwining with local/national identification strategies.[53] In personalities like Geo Milev, however, these two perspectives coexisted without contradiction. One could read the following in his "Appeal to the Bulgarian Writer" ("Vazvanie kum bulgarskiya pisatel", 1921):

> [...] This is your life — and from it you draw your poetry. You! — That means first and foremost: A human above all! Because there is something bigger than your writers' community — the society outside; there is something bigger than society — the nation; there is something bigger than the nation — the community of nations; there is something bigger than the community of nations — humankind.[54]

53 More on this topic in: Genova (2013).
54 Milev (1921: 58).

Fig. 2

Vladimir Dimitrov-Maystora,
Razpyatie [Crucifixion], 1920–1921.
National Gallery, Sofia

And more, the article in "Native Art" ("Rodno izkustvo"),
Geo Milev wrote:

> By Bulgarian native art [...] we mean: art that is created by the
> Bulgarian artist so as to manifest his Bulgarian soul through
> it — so as to introduce the values of Bulgarian soul to the
> treasure-house of the World Soul.[55]

The reconsidering of human values is a vital aspect
of the reflections of WWI. It separated the artistic phe-
nomena of the first half of the 1920s from the images
of the nation/of the Bulgarian people after the mid-
1920s, suggesting the conservative values of the invent-
ed national history. Even if some works of art from the
1930s — representing images and characters as specif-
ically national — employed formal modernist idioms,
their suggestions and impact were of different meanings

55 Milev (1920: 46).

Modernism and the National Idea — Reflections of the First World War
The Case of Bulgaria

Fig. 3

Sirak Skitnik, *Placheshti mayki*
[Mourning Mothers], 1920–1921:
↑ from magazine *Vezni* I/5
 (1919–1920)
↗ from **Teodor Trayanov**,
 Bulgarski baladi (1920)

and emotions. During the 1930s a nationalist vein be-
came present.

Regarding the impact of WWI on artistic ideas, I would
prefer the term "humane/pacifist" rather than "interna-
tional" in opposition to "national values". In terms of art,
the term "international" does not help to distinguish the
notion of man in the "Christian humanist" sense from the
concept of the human being in the world of nations.

Justifying the use of one or another concept requires
much deliberation. Here I will mention briefly that the
concept of internationalism was central to the socialist
ideas of Karl Marx and Friedrich Engels. All of us know
the appeal to the "proletarians of all countries [...]".
But branches of the labour movement were drawn into
nationalist trends in the 1930s.[56] The anti-war statements
in the modernist/avant-garde works of art from the early
1920s could not be carefully approached and interpreted
through the term international.

In terms of a clearer understanding of the disposi-
tions against war, the term "universal" is unhelpful as
opposition to "national". A better term is "particular".
The paradigm of a human being imbued with love and
pity requires mediation through powerful stories and
images. The great Christian narrative for the love of God
gave grounds to Christian humanism, represented and
expressed through Christian symbolism and iconography.
Human life is sublimated. It transcends the earthly life's

56 *Encyclopædia Universalis*, Vol. 12 (1996: 491–495).

Fig. 4

Ivan Lazarov, *Placheshti zheni* [Mourning Women], 1922. National Gallery, Sofia

limits. The divine love for the human being can be transformed into human love and *vice versa*.

After WWI, images with iconography of *pietà* and Crucifixion appeared in the exhibition halls, and on the pages of literature collections and artistic magazines. Elsewhere in Europe, in Paris, the artist Georges Rouault created the graphic cycles *Miserere et Guerre* (1916–1917; 1920–1927). His works stand slightly apart from the manifestations and transfers of avant-gardes, but I mention them here because they are a powerful reflection against WWI, and against war generally. The miserable human condition, suffering, death, and redemption are central for Rouault's world image. For German Expressionists, Christian symbolism and iconography were also linked with reflections of WWI, particularly in graphic prints. Käthe Kollwitz and Karl Schmidt-Rottluff are just two examples, both of whom were known to the Bulgarian modernist artists.

Shifting from direct comparisons, I would like to draw attention to dozens of works of art — representations and expressions of inconsolable grief and mourning — created during the 1920s in Bulgaria. The most influential of these followed the iconographic patterns of Orthodox imagery. Works of art like *Golgotha*[57] (1915–1918; Fig. 1) by Vasil Zahariev[58], *Crucifixion*

57 Reproduced in: *Vezni* 9 (1919–1920: 274–275).
58 *Encyclopaedia* (1980: 325–326).

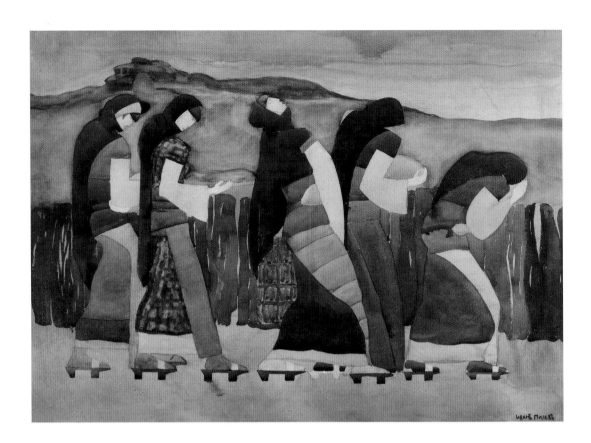

Fig. 5

Ivan Milev, *Nashite mayki vse v cherno hodyat* [Our Mothers are Forever in Mourning], 1926. National Gallery, Sofia

(*Razpyatie*, 1920–1921; Fig. 2) by Vladimir Dimitrov-Maystora[59], *Mourning Mothers* (*Placheshti mayki*; series of drawings, 1920–1921; Fig. 3)[60] by Sirak Skitnik[61], the relief frieze *Mourning Women* (*Placheshti zheni*, 1922; Fig. 4) by Ivan Lazarov[62], *Our Mothers are Forever in Mourning* (*Nashite mayki vse v cherno hodyat*, 1926; Fig. 5) and *Crucifixion* (*Razpyatie*, 1923; Fig. 6) by Ivan Milev,[63] and *Pieta* (1920s; Fig. 7) by Pencho Georgiev[64] are exemplary in this respect.

59 Avramov (1989).
60 See three versions of the same composition repr. in: *Vezni* 5 (1919–1920: 138–139); Trayanov (1921: n.p.); *Krustyo Sarafov* (1921: n.p.).
61 Krustev (1974); Iliev/Petrov (2014).
62 Boshev (2007).
63 Marinska (1997).
64 Genova (1992).

Fig. 6

Ivan Milev, *Razpyatie* [Crucifixion], 1923. Sofia City Art Gallery

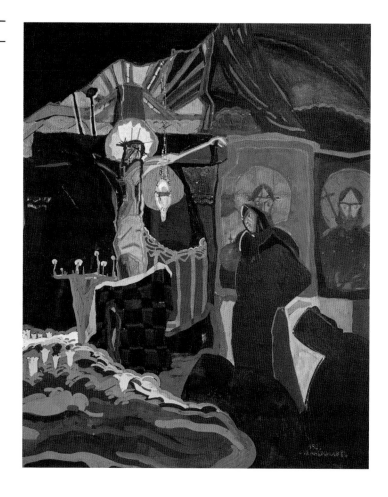

The postwar modernist/avant-garde manifestations in Bulgaria were characterized by a hybridization of the interest in Expressionism and late Symbolism, but also in the experience of Constructivism, Futurism, Primitivism, etc. The practice of different European trends was mixed with the traditional visual culture called "native art". This situation is reminiscent of the crossings of artistic trends in the major European centers before WWI. Wassily Kandinsky is only one of the best known examples, with the transition of images created under the impact of the icon and Russian Lubok during his first period, to Expressionism and abstraction at the time of *Der Blaue Reiter* and after.[65] One could find other lesser-known examples of crossings between modernist/avant-garde trends and

65 Petrova (2003).

Fig. 7

Pencho Georgiev, *Pieta*, 1920s.
National Gallery, Sofia

local, pre-modern practices in Latvia, Finland, Greece and elsewhere.

In the case of the Bulgarian art scene, as in other similar cases, the integration of icon and folklore imagery was quite common in the period from the end of WWI until the mid-1920s. Ivan Milev created a fantastic world of images referring to the icon and the Orthodox murals, as well as to the visuality of folklore, with the experience of Symbolism, Secession and Constructivism (Fig. 8). The symbolic foundation and the formal stylization of his images, as in the works of other artists at that time, including Sirak Skitnik, Vladimir Dimitrov-Maystora, and Pencho Georgiev, integrate the local traditions (pre-academic legacy: the icon, woodcut, fabrics and the song and folklore tale) with the experience of modernism/avant-garde in the influential artistic milieus of Europe.

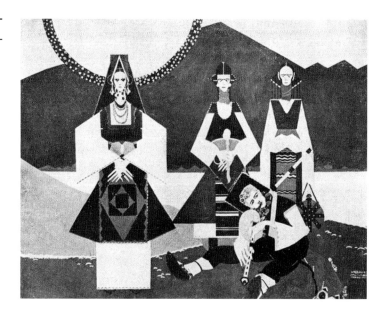

The End of the 1920s

At the end of the 1920s and in the 1930s, the return
to figuration and to the images of an objective environ-
ment in Bulgaria were part of the general tendencies in
the influential artistic "centers": New Objectivity (*Neue
Sachlichkeit*) in Germany, the return to order (*le retour
à l'ordre*) in France, and the subsequent Neoclassicism
wave in the whole of Europe.

Artists distanced themselves from the traumatic expe-
rience of WWI. There were very few examples of in-depth
and radical problematizing of the human condition and
war, as there were during the 1920s. The idea of the total
artistic intervention and the practices of the synthesis
of the arts lost their position and gave way to the new
topicality of the picture. The experience from the 1920s
seemed to have been forgotten. The most intense period
in terms of modernist manifestations in new Bulgarian
art was over.

Although from a local perspective the decade of the
1930s was of particular importance for the acquisition
of modernist practices, that period cannot be separated
from the common events and dispositions. In Europe,
National Socialism gained impetus; in 1933, the trial for
the arson of the Reichstag was held. In 1934 there was
a military *coup d'état* in Bulgaria, as a result of which
all political parties were banned. The artistic life — solo

and joint exhibitions, foreign visits and lectures on modernisms — existed in parallel, but not always in an obvious connection with what happened in politics. In 1939, for instance, the year when WWII broke out, the *New Artists Society* (*Druzhestvo na Novite Hudozhnitsi*) organized a celebration and issued a newspaper to mark the 100th anniversary of the birth of Paul Cézanne.

Arranged in this way, sometimes the events look puzzling, although in the artistic community there were signs indicating the changes in society. One such sign was the centralization of artistic society and the organization of annual union exhibitions brought about by the *Union of the Artists' Societies in Bulgaria* (*Sŭyuz na druzhestvata na khudozhnitsite v Bŭlgariya*), founded in 1932. Another clear political sign was the closing of the exhibition of the *Caricaturists' Society* (*Druzhestvo na karikaturistite*) in 1935 because of caricatures against the police regime imposed after the *coup d'état* in 1934. Without knowing the diplomatic, military, and economic relations we would not be able to understand why the *Exhibition of the Seven* (*Izlojba na sedemte*) — Bulgarian artists — was organized in Belgrade in 1933, why the exhibition of the *Oblik* [Shape] Group from Belgrade was organized in Sofia in 1934, or why the *Techni* [Art] Group from Athens had their exhibition in Sofia in 1936. It seems that the only meeting point for the narratives of the political and artistic events from that time was the space of the press, the newspapers, and magazines. In 1934, for example, on these press pages, the announcements and reviews of the *Oblik* Group exhibition and of the joint exhibition of the *Zemlya* [Earth] Group and the *New Artists* (*Novite hudozhnitsi*) in Preslav Exhibition Hall, Sofia, cohabited with the solemnly announced visit of King Alexander I and Queen Maria in Sofia, with materials on the educational reforms of the new Bulgarian government, with coverage of the Balkan sports games in Zagreb, with information about the *Byzantine Studies Congress* in Sofia, and with a photograph of village women wearing Croatian national costumes.

The administration of artistic life in Bulgaria at the end of the 1930s lacked drastic manifestations against modernist art and its protagonists. The modernist-oriented artists were not perceived as a threat to the authority

of the state. Some of them were professors at the Fine Arts Academy or occupied managerial positions in the *Union of the Artists' Societies in Bulgaria* and in the *Art Work Purchase Committee* at the Ministry of Education. That situation showed the special status of a whole generation of gifted and highly educated artists, placed between the echoes from the rebellion of European modernisms and the patronage of the national state.

Conclusion

Reflections of WWI in Bulgarian art were multiple and contradictory. The most commonly expressed themes sought the invention of national history/mythology or expression of humanistic ideas, often through Christian symbolism and Orthodox iconography, related to the local visual culture. Exaltation of destruction and admiration of the machine reality through the experience of Futurism and Constructivism were more rare responses. The practices of Surrealism remained distant for the Bulgarian milieus.

During the late 1920s and in the 1930s, in the European context of the return to order, the suggestions and impact of the exhibited and circulated images of war most often occupied the common places of collective entity.

The so-called "native art" from the first half of the 1920s, as assimilation and adoption of modernist experience hybridized with local visual culture, had the most lasting impact in Bulgaria. During the 1930s a part of this modernist response was turned into easily recognizable idioms in the national artistic canon. This approach endured through the communist epoch as well. Different critical interpretations were part of every new usage of the artistic experience. Unfortunately, even today, on the anniversary of WWI, a certain nationalist vein remains.

War as Inverter in Romanian Art between 1912 and 1924

Erwin Kessler

Institute of Philosophy, Romanian Academy. Bucharest, Romania

NATIONALISM AND COSMOPOLITANISM IN THE AVANT-GARDE AND MODERNISM
The Impact of the First World War

Abstract

Romania experienced a prolonged and distinct war regime throughout the first two decades of the 20th century, and the First World War has literally shaped the modern country and nation. Following thirty-five years of peace after gaining independence in 1877, Romania intervened in the Second Balkan War in 1913 and entered WWI in 1916, following extensive and excruciating debates about the merits of joining one side or another. The death of Carol I in October 1914 precipitated the decision. King Ferdinand was pressed to go along with the Allied Powers. Rapidly defeated and occupied by Germany, Romania was devastated. After the war, Romania remained militarily engaged until late in 1919, when it was summoned by the Allied Powers to put an end to the Hungarian Soviet Republic, in August 1919.

The wars of 1913–1919 had contradictory effects. Before 1912, Romania was on track to modernity. It was a small country with large artistic prospects. Artists like Constantin Brâncuși, Arthur Segal, Tristan Tzara, and Marcel Iancu (Janco) appeared. A subsequent cultural shift in the visual propaganda system favored the scientific-leaning, but politically engaged, photographic and cinematic rendering of the ongoing situation in the Balkans, displayed in the pioneering work of the Aromanian brothers Ianaki and Milton Manakia, the first filmmakers in the Balkans. Under their spell, the greatest modernizing cultural enterprise of the years 1911–1912 was the production in Bucharest of the 2-hour-long feature movie *Independența României* [Romania's Independence], which had a tremendous impact on the cultural, national, and political consciousness of the Romanians, but also moulded the representations of war in the public consciousness. Starting in 1913, following its participation in the Second Balkan War, Romania extended to the South and there developed its own legendary art colony, in Balchik, a (recuperating) modernizing move, but no longer an avant-garde one. The intervention of WWI, from 1916 onwards, completely shifted the local artistic *forma mentis* for the years to come. After 1918, Romania became a much expanded country, but one with reduced artistic prospects. Back from the war, artists like Nicolae Tonitza revealed a new, Expressionist, gloomy, traumatic

outburst, which dominated the early 1920s. From 1924 onwards, the local avant-garde rhetorically reloaded war as a modern instrument of evolution.

Key words

Balkan Wars, WWI, modernity, photography and film pioneers, avant-garde

NATIONALISM AND COSMOPOLITANISM IN THE AVANT-GARDE AND MODERNISM
The Impact of the First World War

La belle époque: Modernization versus Tradition — a Conflictual Platform

Prior to this long war period, Romania had entered a course of rapid modernization. The association *Tinerimea Artistică* [Artistic Youth, 1901–1947] was founded in Paris, in 1901. The well-known Romanian sculptor Constantin Brâncuși was one of its members. Many younger artists flocked to study in prominent European art schools, most of them in Paris and Munich. Upon their return, Symbolist, Secessionist, Impressionist, Fauvist, and Expressionist elements permeated the local art scene, disseminated by major artists like Ștefan Luchian, Iosif Iser, and Nicolae Tonitza. Personal connections with prominent international artists fostered innovation. In Bucharest in 1909, Iosif Iser organized the first ever exhibition involving a foreign modernist forefront figure, André Derain. In March 1910, Arthur Segal's show in Bucharest was heralded as "the first exhibition of modern art in Romania" launched by a Romanian-born artist.[1] In April 1910, Constantin Brâncuși exhibited with *Tinerimea Artistică* his seminal *Cumințenia Pământului* [Wisdom of the Earth, 1907], a crucial modernist direct-carved stone sculpture. In 1911, the influential literary Bucharest magazine *Rampa* [The Ramp, 1911–1948] launched a wide-ranging inquiry into the state of Romanian culture facing the prospect of modernization. Well-known intellectuals answered questions related to innovation, foreign imports, and influences in Romanian culture. Urbanism, cosmopolitan lifestyle, industrialization, and the libertinism of *la belle époque* stamped a society eager at least to mimic synchronicity with the international trends.[2]

An opposing cultural current devoted to nationally specific art emerged at the beginning of the 20th century too. Prompted by influential magazines such as *Sămănătorul* [The Sower; edited in Bucharest, 1901–1910], and *Viața Românească* [Romanian Life; issued in Iași, 1906–1916] the converging *Sămănătorist* [Sowering] and *Poporanist* [Popularian] traditionalist currents focused on the supposed uniqueness of the Romanian, vernacular, rural civilization, aspiring to a paradoxical combination of developing village and peasant life while simultaneously preserving authentic traditions. Followers of the 19th century's major

1 Brănișteanu (1910: 9).
2 Omăt (2008: 14).

figure in local painting, the Barbizon-School representative Nicolae Grigorescu, dominated the early 20th century, with saccharine depictions of village life, idyllic peasantry, and bucolic landscapes. In architecture, a similar combination of medieval and folk motifs, and building solutions with neo-Romantic Historicism and Secession-like mythical fantasies laid the foundation of the neo-Romanian style, elaborated by major architects Ion Mincu and Petre Antonescu. These apparently regressive trends, focused on national tradition and village life, evoke modernization too, through their programmatic and manifesto-like endeavors which resulted in innovating tradition by mixing past and present, vernacular and international elements, a move typical then in Central and Eastern Europe.

The traditionalist trends focused on the rural and ethnic Romanian constituency of the local culture, seen then as endangered by the rising multicultural urbanism associated with rapid modernization. Preserving Romanianness appeared as a patriotic act with historical relevance, favoring the value system of a closed, rural civilization. In its turn, the modernist trend, dedicated to developing urbanization and industrialization, boosted cosmopolitanism. It endorsed the benefits of a progressive society open to various cultural influences, attuned to the beat of change in every field. This was also experienced and promoted as a patriotic engagement. Either past-oriented or future-oriented, the two competing trends assumed a similar missionary, patriotic task, taking Romania as the subject of benevolent cultural engineering. Their shared (though competing) patriotic cultural ethos and the feeling of being submerged in a time of urgent change and confrontation was (at least partly) accountable for the compatibility of the local cultural scene and war rhetoric. War was perceived by both camps as a legitimate means of development.[3]

Participation in the war was seen by traditionalist currents as an accomplishment of national ideals and interests, a necessary engagement by a unique statehood for the benefit of the whole of the cultural, national body. The modernist trends saw the involvement in wars as

3 Boia (2014a: 20).

a historical obligation on the part of Romania; war was perceived as a resource of progress and civilization in the Balkans, a region presented as a savage, poverty-hampered, and "culturally retarded region" in need of attuning to the European beat, eventually by means of war. There was a certain historical logic behind these standpoints. The modern, independent Romania was a direct outcome of the last big European war of the 19th century, during which Russia and Romania were opposed to the Ottoman Empire, in 1877–1878.[4] The war demonstrated the weakness of the Ottoman Empire but also the tensions, discontent, and disagreement of the great European powers over the management of its heritage. The Independence War of 1877–1878 was copiously depicted in Romanian media and visual culture of the time by most of the prominent artists, who had been sent to the front as war correspondents. Nicolae Grigorescu, Sava Henția, and Carol Popp de Szathmari turned Romania's participation in the war (which actually took place only across the Danube, in present-day Bulgarian territory) into a "painterly epos" of mythological courage, dedication, and sacrifice on the part of the Romanian soldiers. Representations of pain and despair were scarce, largely surpassed by elation. This approach would heavily stamp the future representations of war in the local art of the early 20th century.

After that conflict, Romania entered an accelerated process of modernization and development, turning into the most powerful country in the Balkans. Education, industry, and infrastructure boomed for decades.[5] Seeing war as modern-making machinery in the Balkans was understandable given the backwardness of the provinces in the Ottoman Empire, which exerted an inefficient, bureaucratic authority over vast regions crumbling under corruption and national tensions. When the First Balkan war started in 1912 between resistant Balkan countries and the ruling Ottoman Empire, traditionalist cultural magazines such as the aforementioned *Viața Românească* backed interventionism, taking war as an opportunity for Romania to protect the large Aromanian minority from the Pindus Mountains and Macedonia, in regions

4 Hupchick/Cox (2001: 31–38).
5 Constantiniu (2002: 181).

disputed by the Greeks, Bulgarians, and Serbs. The acclaimed traditional and pastoral "Romanian civilization" (a historical phantasm) stretching from the Carpathians to the Balkans eventually boosted a bellicose stance.

Manakia Brothers: New Artistic Means, Old Political Targets. Photography and Cinema at War

Tradition and modernization fused to prompt cultural-political protectionism for the Aromanian minority in the Balkans during the first decade of the 20th century. Early photography and film in the Balkans bear the name of the two Aromanian brothers of Greek/Macedonian origin Ianaki and Milton Manakia. Sons of a wealthy landowner involved in the resurgence of the Romanian national movement among Aromanians, the Manakias opened photographic cabinets in Aromanian towns across the Balkans — Ioannina, Avdella, and Bitola — documenting the figures, manners, clothes, and ceremonies of the various peoples around them, but especially the traditions of their fellow Aromanians. In their earliest *Atelierul de artă fotografică* [Atelier for Photographic Art] established in 1904 in Bitola/Monastir,[6] they portrayed the powerful self-determination of the Balkan people. The individuals rendered by Manakias are behavioral archetypes, icons of local, national identities rather than particular individuals (Fig. 1); as with August Sander, in Manakias' ethnographic portraits social surface and deeper personality of the models fuse in one piece. They display national status, erected on ethnic-stylistic foundations, different from the professional status so striking in the portraits of Sander. During the interwar period, their huge database of photographic portraits, sent to the Romanian Academy, was used by local sociologists and ethnographers from Dimitrie Gusti's School preoccupied with the "sociology of the nation". They used Manakia-inspired ethnographic films in the 1920s to pinpoint ethnographic research on the habits of local and minority populations. The Manakias also made a groundbreaking move in news photography. The photos sent in 1903 by Ianaki Manakia to the Romanian newspaper *Universul* [The Universe, 1884–1953], including a series illustrating

6 Țuțui (2007: 74–88).

Fig. 1

Milton and **Ianaki Manakia**,
Cobza Fiddler, c. 1905

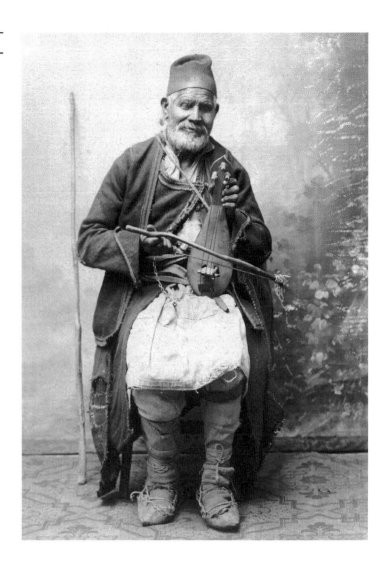

the Saint Elias Uprising (*Răscoala de Sfântul Ilie*) of
the Macedonians against the Ottoman Empire in August
1903, are among the very first printed photos in Roma-
nian mass media. Their *Macedo-Romanian Ethnographic
Album. Vlach Typology, Costumes and Places* (*Albumul
etnografic macedo-român. Tipuri, porturi și localități ale
aromânilor*),[7] published in 1903 by the editing house Louis
Dyle in Paris (probably helped by the Romanian govern-
ment), made Manakias into a widely known Balkan mas-
ter of ethnography and news-photography.

The Manakias sided with their own ethnic constit-
uency, participating in nationalist organizations and

7 Țuțui (2008: 16).

documenting rebellions. In 1905, their homeland Avdella was burnt by Greek nationalists. The priest and two prominent pro-Romanian Aromanians were killed. They made one of the earliest photographic reports of the events, showing the funerals of the three victims. The widely publicized killings led Romania to break diplomatic relations with Greece. In 1905 the two brothers went to Bucharest; having seen film cameras while there, they looked for, and finally purchased, one during a trip to London, a 35-mm Bioscope 300 camera from Charles Urban Co., with which they would produce the very first motion picture in the Balkans, the 60-second filming of their 114-year old grandmother Despina weaving, in 1905. In the same year they made a documentary, an ethnographic motion picture 60 seconds in length, entitled *The Household Life of the Aromanian Women in the Pindus Mountains* (*Obiceiuri casnice la aromâncele din Pind*).[8] Back in Bucharest in 1906, they participated in the international photographic competition in Sinaia, patronized by the Royal House of Romania. They received the gold and silver medals in the competition, and became Official Photographers of the Romanian Royal Court. The Manakias became instrumental in the Romanian offensive in the Balkans.

The brothers photographed and filmed several events during the Young Turks Revolution (1908), including military parades and demonstrations, but also the repression (rebels hanged by the Ottomans), all of which now constitute the only motion picture resources for major events in the Balkans at that time. Their political commitment increased, combining the documentary with propaganda: in 1909 they filmed the highly symbolic visit of the royal Romanian court to Bitola and the Aromanian territories in the Balkans, a major political step towards the Romanian authorities exercising sovereign rights over the Aromanian minority. The Manakias also participated in, and taped, the Balkan expedition of a huge delegation of Romanian military, politicians, and cultural figures who crossed the Danube in 1911, journeying through the mountains toward the Aromanian areas and displaying Romania's support for the appropriated ethnic minority.

8 Țuțui (2008: 18).

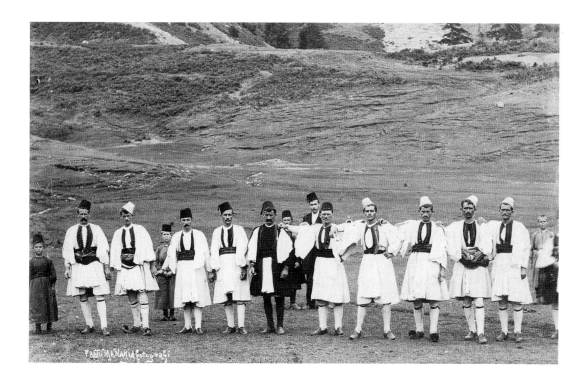

Fig. 2

Milton and **Ianaki Manakia**,
Circle Dance in Avdella, 1903

The delegation was accompanied by Ottoman authorities, who encouraged Romania's stance to counterbalance the pretensions over the same territories, concomitantly raised by Greeks, Bulgarians, and Serbs. The enthusiastic, military-like journey of the large delegation, cheered on by the elated population, evoked the reception of a liberating army. The brothers (well-versed in capturing and constructing the crucial historical events while they unfolded) produced, in this highly artistic propaganda film, a convincing paragon of masses moving "freely" in a symbolic manner. The sense of urgency and fateful dynamism of the delegation's painstaking, but persistent, progress through the harsh landscape, as well as the precipitation of human masses towards the camera and the collapsing of the Romanian delegates with the welcoming Aromanians into a *hora* (the typical group Romanian round-dance; Fig. 2) foresee Sergey Eisenstein's thrilling images of the symbolic dynamism of human masses unfettered by historical events. Like Eisenstein, the Manakias skillfully employed the physical movement of the masses to convey the political movement of history.

Apt to turn events into dynamic historical icons as motion pictures, the Manakia brothers achieved a major

step forward in 1911, with their longest to-date 16-minute feature movie of the Ottoman Sultan Mehmed V visiting the same Aromanian areas of Bitola. It was a highly symbolic gesture of political interest, complementing the visit of the Romanian delegation the same year. Similar to the strategy adopted in constructing the visit of the Romanian delegation, they shaped the motion picture as an ongoing, developing story, not as a static recording of a ceremonial reception. Milton went firstly to Salonica (Saloniki/Selânik/Thessaloniki) and filmed the Sultan arriving by boat, then on to Macedonia by train, and his welcoming at the Bitola railway station and further ceremonies during his visit. Conceiving the film as a dynamic rendering of an actual unfolding story was a keystone in the Manakias' cinematic concept. For Sultan Mehmed V, they focused on the subliminal insertion of technological achievements of the Ottoman Empire (few as they were); the Sultan was bound to the navy and railways, symbolic tokens of modernization brought into the region by Turkish rule, consonant with Manakias' icon of modernization: the film camera. The rhetorical strategy conversely mirrored their Aromanian and Romanian-linked motion pictures, highlighting mainly ancient, ethnographically traditional and religious backgrounds, stressing a transtemporal, cultural attachment of their own people to the area they had inhabited since antiquity.

Perfectly attuned transmission pieces in confrontational propaganda scaffolding, the Manakias seized the moment, refined their skills, and gained visibility. They were named Official Photographers of the Ottoman Sultan, adding to the similar title obtained from the King of Romania. In 1912 they made a film recording the entry of Serbian King Alexander in Bitola, ensuring the title of Photographers of the Royal House of Serbia. Also in 1912, they recorded the reception of the Greek King in Bitola. WWI was catastrophic to them, as in 1914 Ianaki was sent by the Bulgarian authorities to a prison camp in Plovdiv for allegedly plotting against their occupation. In 1916, their photography atelier in Bitola was destroyed by Bulgarian-German bombardments. Resilient, Ianaki opened a photo studio in Plovdiv from 1917 to 1918. In 1921 in Bitola, the Manakias opened a cinema garden, and in 1923 a cinema theatre with more than 500 seats.

The Manakia brothers' influence over cultural and political perception in Romania and in the Balkans was huge. They fed newspapers with up-to-date depictions of the almost permanent Balkan bloodshed, starting in 1903. Documenting the present through showing the state-of-war as a daily event, and the military or diplomatic "menace-cum-negotiations" as the norm, was one of their skills. They fed scientific, modern ethnographic research with accurate documentation of human types and customs from all over the Balkans. This apparently neutral, artistic, and scientific documentation was one of the critical cultural instruments for politicians when negotiations over the fate of various Balkan populations started; it was used to trace nation-states' frontiers in the ethnically fluid, ex-Ottoman territories. They created a politically symbolic platform for artistic-propaganda motion pictures, intuitively drafting strategies of ideological appropriation of "simply" recorded events. Despite going bankrupt in the 1930s after their cinema theatre burned down, they experienced the lucrative side of cinema business too. Unsurprisingly, the oldest cinema festival in Macedonia, taking place every year in Bitola, bears the name *ICFF Manaki Brothers*.[9]

Propaganda in a Modern Artistic Key: The First Romanian Blockbuster

Modernization evolved in Romania around 1910. The first "modern" art exhibitions were launched and the earliest agenda-setting cultural campaign of the *Rampa* magazine started.[10] But the model set by the Manakias in matters of information and artistic construction of the present was more powerful: in 1912, director Gheorghe Ionescu-Cioc's documentary film *Deschiderea Expoziției Tinerimea Artistică* [The Opening of the Tinerimea Artistica Exhibition] loaded art into a lifestyle news feed. The modernization of traditional artistic disciplines was surpassed by the eruption of modern artistic techniques. Consequently, the biggest local, cultural endeavor of the

9 Established in 1978 as *Manaki Encounters*, the name of the festival was changed into the *International Cinematographers' Film Festival Manaki Brothers*, Bitola.

10 Cruceanu (1911: 4).

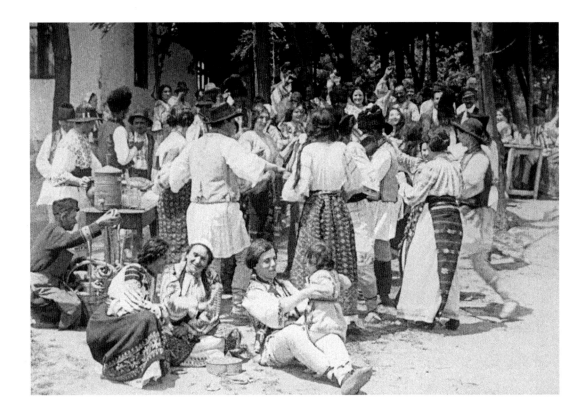

Fig. 3

Still from **Aristide Demetriade**'s movie *Independența României: Războiul Româno-Ruso-Turc din 1877* [Romania's Independence: Romanian-Russo-Turkish War of 1877] depicting round dance, 1912.

time was dedicated to the film industry, into which information, art, propaganda, history, and business coalesced. In 1911, a feature film dedicated to the Independence War of 1877–1878 was drafted. The movie was conceived in a similar vein to future historical productions like David Wark Griffith's *The Birth of a Nation* (1915), artistically linking past and present, violence and national consciousness, to cohere into an all-encompassing panorama of the process leading to the emergence of a nation. The very first Romanian feature film was an historical war film. There was a sketchy love story in it, but the bulk of the movie was preoccupied with the military: 40,000 extras (the film's poster claiming it was 200,000!), including fully armed and active military regiments. *Independența României: Războiul Româno-Ruso-Turc din 1877* [Romania's Independence: Romanian-Russo-Turkish War of 1877], to give its full title, was produced between 1911 and 1912 by a team of famous actors from the National Theatre in Bucharest, including Constantin Nottara and Aristide Demetriade. Although diplomatic sources referred to

War as Inverter in Romanian Art between 1912 and 1924

Fig. 4

Theodor Aman, *Hora de la Aninoasa* [Round Dance at Aninoasa], 1890. The National Museum of Art of Romania, Bucharest

that last war of the 19th century in Europe as a Russo-Ottoman war, neglecting Romania's place, the film presented it foremost as a *Romanian-Russo-Turkish War*. The title reframed the events, acknowledging Romania's decisive contribution to the 1877 war,[11] but also its military strength in the looming Balkan hostilities of 1912.

The screenplay of the film was sparse. It was not finished when shooting started in February 1912 (ending in May 1912). Scenes were added while the film was shot. Typical for the traditionalist cultural ideology of the time, the action starts in a Romanian village during a round-dance *hora* feast, when romance sparks between a future soldier and a peasant girl, the whole scene being constructed like a canvas by the early modernist painters Nicolae Grigorescu and Theodor Aman, *Hora de la Aninoasa* [Round Dance at Aninoasa; Figs. 3 and 4]. The next scene is in Bucharest, where the Crown Council decides upon Romania's entry into the war. Then the call to arms

11 Carol of Romania (1899: 274–275).

breaks up the village dance. The conscripted young peasants leave while peasant girls cry. In the first war scenes the Russians (who initiated the war but couldn't crush Ottoman resistance, and therefore asked for Romania's intervention, promising to recognize its independence) are defeated, and the entry of the Romanian troops under fire causes heavy losses. The lengthy Danube passage of the army received a minute depiction. The battles to conquer the Ottoman fortresses Plevna and Grivița are expansively presented, as well as the granting of war medals to dying soldiers in hospitals by the King and Queen of Romania, and the final capitulation of Osman Pasha, the Turkish general. In the end, the now heavily-wounded, loving young peasant from the first scene is on his way back to the village, when a Russian platoon met on the road gives him the salute of honor. The film finishes with a documentary-, but also propaganda-shooting of the actual military parade of May 10, 1912, in Bucharest on the *National Independence Day*.[12]

The film was first shown on September 1, 1912, with the background of the Balkan crisis, including the Albanian uprisings in Spring 1912, which were preceded by the alliances between Serbia and Montenegro, then between Serbia and Bulgaria (in March), and then between Bulgaria and Greece (in May), all of which were made under the guidance of Russian agents. Romania kept out of this Balkan League (shunned by most European great powers), fearing its menacing ex-ally and actual neighbour, Russia, more than its ex-enemy, the Ottoman Empire. On October 8, 1912, the First Balkan War broke out. Romania's diplomatic position was the paradoxical result of both fear for its own integrity and ambition for a bigger (but safer) role in Balkan politics.

The film *Romania's Independence* was the perfect instrument to incorporate this standpoint. It stated that Romania was the only country in the area which had inflicted a serious defeat on the Ottoman Empire in recent history, made with huge sacrifices. While the paintings illustrating the war in the last decades of the 19th century depicted no suffering or pain, the 1912 film dedicated to the thirty-five-year old event, from the crying peasant

12 Căliman (2000: 35–42).

woman at the beginning, to the wounded peasant soldier at the end, presented both. A rhetorical shift towards a more prudent view on war occurred in the film. On the other hand, the film evoked and reinterpreted the previous military collaboration between Romania and Russia. Russia and its Balkan allies, especially Bulgaria, Serbia, and Montenegro (whose independence was also a direct outcome of the 1877–1878 war, although they didn't participate) were exhorted to be thankful for Romania's contribution in their liberation.

Besides goading Balkan nations, the film was designed as a major means of discouraging military engagement. The passage of the Romanian troops over the Danube in 1877 evoked a similar future passage in the event of a Balkan confrontation (which did happen in 1913 and also in 1916). The striking, innovative insertion of the May 10th 1912 military parade into the body of a film evoking the victories of 1877–1878 brought the current troubled times into sharp focus. This was transparent in newspaper presentations:

> Maestro Nottara is on his way to a patriotic masterpiece rendering Romania's Independence War in a film, in a way that will allow the current population to learn the history of the battles of 1877, while presenting a vivid picture of Romanian courage to future generations.[13]

The film was historical because of its actuality. The first feature movie ever produced in Romania was more realistic than any love story, thriller, or comedy. It was conceived as a military rehearsal for a future Balkan invasion, especially through the employment of real soldiers and officers as extras for the numerous battle scenes, when real weapons and real maneuvers were shown using thousands of soldiers. The battle scenes were fully controlled by the army officers, not by film director Aristide Demetriade.[14] The movie was made "with the help of the Romanian Army", mentioned on the cast list. But it was also largely paid for by the military. The Bucharest *Gazeta*

13 *Gazeta Ilustrată* (1912: 4). This and all other translations are my own unless otherwise indicated — E.K.
14 Gheorghiu-Cernat (1971: 39).

Ilustrată [The Illustrated Journal, 1912–1941] maintained that the Defense Ministry contributed because "Nicolae Filipescu, the Defense Minister appreciated the patriotic utility of the enterprise [...]."[15] A puzzling story stressed the propaganda employment of the movie by the political establishment. Negotiations for producing the movie by the actors of the National Theatre in Bucharest started earlier in 1911. The shooting was supposed to begin on December 1, 1911. Yet, the Bucharest branch of the French Gaumont cinema studios rapidly engaged to produce their own variant of the same subject, neutrally titled *Războiul de la 1877–1878* [The War of 1877–1878]. The film was made quickly, with low-rank actors and extra troops commanded by a general in Pitești. The film was expected to be shown on December 29, 1911. One day before, the Bucharest Chief of Police saw the production and interdicted its projection, which "didn't fit the historical truth".[16] The producers were fined and the general from Pitești was penalized.

Censorship clarifies the propaganda aims of the authorities in encouraging and producing the official variant of *Romania's Independence: Romanian-Russo-Turkish War of 1877*. The movie became a matter of technological, national prestige. Besides being the first "fiction" movie in the Balkans, the original length of the film was amazing. Its 2 hours surpassed by far the normal 45-minute length of a current movie show. Released in May 1912, the exceptional 1-hour long *Oliver Twist* was the longest American movie to date. As for Romania's neighbors, the first Hungarian feature movie (under French brand Pathé) was produced in 1913, while *Gaffo*, the first Greek feature movie was ready in 1914, and one year later Bulgarian and Turkish feature movies were produced too. All of them were much shorter comedies or melodramas. None of them rivaled the Romanian historical epos. For three years running the movie was sold out in Romania. Journalists saw it as a major means of cultural and historical propaganda: "the film of the Independence will serve Romania, making the world on both continents understand the whole emotional course of Romanian history towards

15 *Gazeta Ilustrată* (1912: 4).
16 Căliman (2011: 55–56).

a free state, and an important actor in Balkan politics."[17] Others reflected upon the aesthetic impact of the film: "We witnessed something rare: the entire cinema hall was delirious, clapping hands when the movie presented the heroism of our soldiers attacking the fortress Grivița, their assault on the first fortification, then losing it, and conquering it again, and then taking the second fortification too. Our public is usually cool and indifferent. Well, this time it vibrated with enthusiasm."[18]

Immediately after its previewing in Paris by *Alter-Ego* film house in June–July 1912, the French *Ciné-Journal* (1908–1938) spoke on June 29, 1912 of a "beautiful model of cinema's noble virtues", stressed by the prodigious masterpiece produced in Romania by the actors and directors of the Bucharest Film Society,[19] while *Le Figaro* claimed that "this production is tremendous, marking an era in cinema."[20] French and Russian film industry representatives in Paris negotiated copies of the film, while the Hungarian *Apollo* film house acquired it in 1913, distributing it throughout the big cities of Transylvania, where its impact stunned. The journal *Revărsat de zori* [Daybreak, 1913] in the town Lugoj observed: "before, there has been nothing similar to the enthusiasm raised by this movie among us, Romanians from Transylvania",[21] while *Drapelul* [The Flag; edited in the same city, 1901–1920] estimated the huge influence of the film in the peasant oral culture: "these last two days the public flooded the *Olympia* theatre which presented the film 4 or 5 times a day. Especially on Tuesday, a fair day, many peasants came, and they brought back to the villages the news of the wonder they saw."[22] Its presentation in the town Brașov was such a success that Petra Popescu considered it "worth more than 10 treatises, for the people here. The representation sent people into delirium [...]."[23] In a study of the film's reception, Manuela Gheorghiu-Cernat maintains that "the elation of the Transylvanian Romanians was enormous:

17 Fagure (1912: 6).
18 *Gazeta ilustrată* (1912: 4).
19 Căliman (2011: 56).
20 Căliman (2011: 57).
21 *Revărsat de zori* (1913: 6).
22 Munteanu (1913: 3).
23 Onciu (2012: 8).

they turned into street demonstrations upon exiting the cinema halls."[24] The movie's boost of Romanian consciousness was sizable. Its contribution to the outcome of WWI, the referendum-like unification of Transylvania with Romania in December 1918, should not be neglected.

Images Stirred to War: Politics, Culture, and the Arts

The foreseen war acted as a catalyst in making many cultural initiatives converge with propaganda. In the context of the national emancipation of Romanians by the end of the 19th century, the Cultural League for the Unification of All Romanians (*Liga Culturală pentru Unitatea Românilor de Pretutindeni*) was founded at the University of Bucharest in 1890. The League formed a bridge with Romanian intellectuals abroad, especially in Transylvania. Around 1911–1912, the League became extremely active. Its *raison d'être* was geopolitical. For months, since autumn 1912 until spring 1913, the League organized more than 120 reunions across the country, focusing on the cultural, social, national, and finally political situation of the "Southern Romanian" population, the Aromanian groups in the Balkans.[25] Prominent researchers affiliated with the League, Vasile Pârvan, Virgil Arion, Pericle Papahgi, and G. Bogdan-Duică, edited in 1913, under its brand, the politically charged volume of studies *România și popoarele balcanice* [Romania and Balkan Peoples].[26] In February 1913, Vasile Pârvan edited the symptomatically titled magazine *Românismul* [The Romanianess, 1913–1914], publishing texts like "România și criza balcanică" ["Romania and the Balkan Crisis"].[27] The public "cultural" meetings and the "scientific" contributions complemented the 'artistic' pressure exerted in the visual and media realm by the Manakias' photographs and films, and the enthusiastic reception of *Romania's Independence*. The hijacking of the cultural debates by war rhetoric was overwhelming. The main aforementioned traditionalist magazine, *Viața Românească*, stirred bellicose sentiments, exploiting the

24 Gheorghiu-Cernat (1971: 39).
25 Zbuchea (1999: 94).
26 Franga (2013: 28).
27 Pârvan (1913: 97–99).

difficult situation of Romanian populations under foreign rule. Founded by prominent intellectual and revolutionary figure Constantin Stere, defender of the "integral peasantrism" and Rector of the University of Iași between 1913 and 1916, the magazine published biased political-cultural analyses by Nicolae Iorga and Constantin Stere, including the latter's *Războiul balcanic și România* [The Balkan War and Romania][28] and *România și perspectivele războiului austro-rus* [Romania and the Perspectives of the Austro-Russian War].[29] Iorga, Stere, Pârvan, and other contributors to *Viața Românească* called every Romanian cultural magazine and publisher to focus on war as a matter of political urgency, as Romanians, supposedly sharing a similar cultural profile throughout a vast area, were endangered by the Balkan warring factions.

An isolated response to the bellicose fomentation in culture appeared in an editorial note of the magazine *Simbolul* [The Symbol, 1912], issued in Bucharest between October and December 1912 by three adolescent friends: Eugen Iovanaki (future avant-garde pillar Ion Vinea), Marcel Iancu (future Zurich Dada figure Marcel Janco), and Samuel Rosenstock (future Dada leader Tristan Tzara). *Simbolul* argued for a thoroughly autonomous art and totally non-combatative cultural politics. Under the pseudonym S. Samyro, Tristan Tzara inserted in the third issue of *Simbolul* a true editorial statement, claiming that "We take to heart the advice given to us by the magazine *Viața Românească*, which recommends, it seems, that we write only patriotic tirades, as the foreign policy circumstances do not allow another genre."[30] Sarcasm was already a powerful literary weapon for the 16-year old Tristan Tzara: in fact, his other editorial notes in *Simbolul* abounded in purely cultural references to current poetry or to the intellectual moves of the time, like the recommendation he made for the "new book on Cubism, written by Metzinger and Gleizes, two of the foremost representatives of the new movement."[31] Tzara's paraded, seemingly snobbish aestheticism should be projected onto

28 Stere (1912a: 379–387).
29 Stere (1912b: 265–280).
30 Samyro (1912: 48).
31 Samyro (1912: 48).

the screen of the almost exclusively warmongering discourse invading the cultural magazines. Concomitantly, one must not overlook the purely strategic choice of the three adolescent would-be writers and artists to issue their *Simbolul* magazine precisely in October 1912, at the outbreak of the First Balkan War. The whole country was eager in that context to hear opinions, especially politically engaged opinions. The three wannabees aptly played against expectations (as future Dada would, four years later), but also took advantage of the climate of acute perception — no wonder the main attraction of *Simbolul* was the publication of an anti-autochthonous and anti-Orthodox short novel by their collaborator Emil Isac, *Protopopii familie mele* [The Archpriests of My Family],[32] which stirred up the fury of the most prominent historian and nationalist politician Nicolae Iorga.[33] Interventionists and pacifists should be seen against the background of the same political and military events. Traditionalism was a political instrument, as was modernist aestheticism. They uncovered political positioning in a propaganda war prefiguring the one engendered by the nation-state's redistribution of fallen empires after WWI.

The First Balkan War ended with the defeat of the crumbling Ottoman Empire, and with a powerful, but unsatisfied Bulgaria. The feeling that a second confrontation was hovering over the Balkans was so strong that the Romanian milieus entered into more fervent activity than a year previously. A convergent press campaign targeting Bulgaria's aspirations to an empire-like power status made the future Romanian intervention appear as sanitary, resembling that of the film dedicated to the Independence War of 1877. Newspapers like the Bucharest *Conservatorul* [The Conservative, 1901–1914] eulogized Romania's position in the Balkans, assimilating Aromanians and Romanians into a single ethnic-geographic block, comparing it to an island of culture and civilization amid a sea of barbarians: "[...] at the heart of the Balkans there is a sage and vigorous nation which, in the name of justice and civilization, imposes the peace. Europe is in the

32 Isac (1912: 2).
33 Călinescu (1941: 623–624).

NATIONALISM AND COSMOPOLITANISM IN THE AVANT-GARDE AND MODERNISM
The Impact of the First World War

position to appreciate the cultural superiority of the Romanians facing all the other Balkan nations."[34]

Romania's entry into the Second Balkan War, in June 1913, mirrored its entry in the 1877–1878 Russo-Ottoman engagement: Romanian troops again crossed the Danube (almost as they had in the movie launched six months before), this time asked to intervene against Bulgaria by the cornered Serbian-Greek coalition. The conflict was much more straightforward than in 1877; the Romanian Army outnumbered Bulgarian troops, rapidly reaching the capital Sofia, and thus ending the war. The subsequent Bucharest Peace Treaty concluded the Second Balkan War, consecrating the dissolution of the Balkan League and the bankruptcy of Russian Balkan politics, and witnessing the rise of a more powerful Serbian state, now supported by the Russian Empire, capable of contesting the Austrian-Hungarian influence in the Balkans. Frustratingly, the settlement prepared all the conditions for the next confrontation: WWI.

Romania's participation in the Second Balkan War was tricky. Visually wrapped in the modern and traditional myths developed during the past decade, it wasn't able to do more than realize its own propaganda and cultural projections. The conflict itself was a fiasco. The clashes with Bulgarian troops were sporadic and insignificant as far as the military was concerned. In a few weeks of war, hundreds of Romanian soldiers died, but not in the battle. Cholera ravaged the poorly equipped Bulgarian camps, later penetrating the Romanian side. The inadequacies of the military medical services turned the disease into a disaster, which was completely concealed by the propaganda machinery. The latter concentrated on fabricating acts of heroism (ones they actually lacked), established by the 1877 Independence War movie. To fit the already constructed model of bravery, propaganda employed similar means, photography and film, duplicating in the 'reality' of 1913 the actions presented in the motion picture of 1912.

The second objective of the propaganda machinery was to eulogize Cadrilater, the southern part of Dobroudja, taken by Romania from Bulgaria as war reparation after

34 *Conservatorul* (1913: 21).

Fig. 5

Iosif Iser, *Tartar Odalisque*, 1933.
Tulcea Fine Arts Museum

the Bucharest Peace Treaty. The press, mesmerized by the bellicose rhetoric only a few months before, changed to praising the pacifist profile of Romania, presented still as the only civilized nation in the region, able to bring equilibrium to a fervid part of Europe. Photographs of the freshly annexed territory, of the seaside and mountain towns, of the amazing mixture of Turkish-Tartar-Jewish-Bulgarian-Romanian nationalities within the new province, deeply impressed the psyche of the exulting population. Among other artists and cultural figures, painter Iosif Iser, one of the proponents of modernization in art, was conscripted in 1913. This influenced his further work, leaning toward a solar, Neo-Impressionist Expressionism under the spell of the sunny, French Midi-like light quality in the mountain-cum-seaside region

of southern Dobroudja. He became a dedicated portrait-
ist of Turkish and Tartar inhabitants of Cadrilater. His
interest rapidly spread to other Romanian artists like
the aforementioned Nicolae Tonitza, Ștefan Dimitrescu,
and Camil Ressu. Against the background of an emerging
colonial perspective on inland exoticism, the romantic
cliché of the Muslim *Odalisque* (fantasized by Matisse
too) was revived, with striking success on the Romanian
art market (Fig. 5). A powerful interest amongst Romani-
an artists in primitivism and exoticism was an outcome
of Romania's participation in the Second Balkan War. It
now obscured the pitiable Cadrilater under Bulgarian rule,
presented by the Romanian propaganda prior to the war.
After the war, Cadrilater appeared as a picturesque,
blessed province, a paradise for artists. The picturesque
attention given to the inhabitants by the artists thwart-
ed social matters. The inhabitants appeared like exotic
aboriginals inadvertently living on land belonging to
a civilized culture, whose representatives were the artists,
acting as if they imaginarily and visually wielded the pow-
er. *Joie de vivre*, laziness, a certain poetry and analytical
clarity in depicting a world at hand, characterized numer-
ous painters who prompted the cultural and mainly artis-
tic attraction of Cadrilater throughout the decades until
the late 1930s. It is not by chance that in that very area
a cultural-touristic resort was established (by Queen Ma-
ria of Romania, who "discovered" it in 1914) at Balchik,[35]
where a palace (still existing today) hosting grandiose
gatherings was erected. Throughout the inter-war period,
Balchik was the most famous summer artists' colony in
Romania, its Barbizon or Worpswede, the place where
mostly post-Cézannian, neotraditionalist, but also classi-
cal modernists flocked, delineating a model of bourgeois,
relaxed and aestheticized painting, focusing on (seaside)
landscape and (mostly Tartar or Turkish) portraiture.

35 Mandache (2014: 18).

Back to Pain: WWI as Inverter of Political and Cultural Perspectives

The whole cultural-political construction and visual representation of the possible participation of Romania in a real war, built as patriotic propaganda during the first decade of the 20th century, was based on the converging myths of Romania as a progressive, civilized, pacifist country located in the barbarian Balkans, and on its endangered traditionalist culture, stretched over an area much larger than the current statehood covered. The cultural wrap of politics thinned as war drew closer: in 1914, the aforementioned Cultural League for the Unification of All Romanians abruptly (but correctly) changed into the League for the Political Unification of All Romanians (*Liga pentru Unificarea Politică a Românilor de Pretutindeni*). This drafted the future national argument behind the entry into the war as a defensive gesture.

Still, the participation in WWI was as politically disputed in cultural circles as the intervention in the Second Balkan War one year before. Although the two confrontational trends propelled conflicting readings of tradition and modernization, neither fundamentally opposed war. The modernists, with leading figures such as the Symbolist poet Tudor Arghezi, attacked the conservative, traditionalist establishment. Arghezi sided with the Central Powers, which eventually brought him imprisonment when war concluded with the victory of the Allied Powers. Contrariwise, the main theorist of modernization in Romania, advocating the theory of the "synchronous" cultural development of Romania with European-global culture, Eugen Lovinescu, published in September 1916 a text asking for 'concentration camps' in Bucharest for ethnic Germans.[36] Both warring factions numbered modernists and traditionalists equally. War was consensual, no matter the style. Constantin Stere pleaded adamantly for Romania's intervention alongside the Central Powers, while his prominent traditionalist collaborator, Nicolae Iorga, favored the Allied Powers.

Once again, Tristan Tzara argued in *Chemarea* [The Call, 1915], the second magazine he edited (in Bucharest between October–November 1915), for a total refraining from bellicose propaganda, and for exiting the trap

36 Lovinescu (1916: 5).

of divided camps, as each of them vowed for war. His premonitory last poem-manifesto published in Romania was clear and poignant:

> The light of the bomb shells has burst out
> and lightning hits our wrath [...] we crush the corpses
> discarded in the snow... We shelter from fear of storms
> And someone starts to speak nonsense [...]
> I enter the gorge of far away
> While under the teeth of fortresses the others
> Wait
> Darkness is all, the words only illuminate.[37]

Days after its publication Tzara left for Zurich, foreseeing Romania's entry into the war in just few months, but maybe also his concomitant launching of Dada.

The contradictory conjunction in cultural-political propaganda of paraded pacifism and explicit geopolitical interests; of modernization and ideological attachment to tradition; of visual construction of national identity around historical wars (without making serious preparations for the actual, looming conflict); and especially, the experiencing of the participation in the Second Balkan War as if in mere representation of war, not battle itself, were basically responsible for the catastrophe facing Romania upon its entry into WWI in August 1916. In only five days, the Romanian Army defending Cadrilater was crushed by the Bulgaro-German-Turkish Army led by General August von Mackensen. In local military literature, Turtucaia is considered to be Romania's worst defeat ever.[38] The fate of more than 33,000 Romanian soldiers, badly organized and disastrously led, was either death, captivity, or shameful retreat over the Danube, covering with ridicule the supposed modernity of the Romanian war machine, as claimed by the preceding propaganda. The Turtucaia disaster completely demoralized the Romanian Army. Despite some rapid victories against Austria-Hungary in Transylvania, it was quickly forced to pull back. Romania was then crushed under German attacks and accepted a humiliating armistice. It took more than

37 Tzara (1915: 26–27).
38 Boia (2014b: 41).

Fig. 6

Nicolae Tonitza, *Turtucaia Prisoners*, 1920, engraving from **G. Millian-Maximin**, *În Mâinile Dușmanului. Însemnările unui Prizonier* (1920)

one year for the Romanian Army to reorganize, train hard, and regain vigor. The drawback at Turtucaia in September 1916 was a blow for Russian military operations too, contributing to its further losses and despair, which would lead to revolution in 1917.

Few prominent artists and writers participated in the military campaign. Painter Nicolae Tonitza fought at Turtucaia. Max Hermann Maxy participated in the dramatic 1917 campaign in Moldova. Francisc Șirato experienced the painful retreat of the army and administration in the northern part of Romania in 1918. A deep change in the means, shape, and target of representing the war occurred after 1916. Photography and film — modern means fueling propaganda before the war — gave way to caricature, drawing, and painting. Photography documented the disaster; its use as a propaganda tool diminished. There was no longer place, time, and money left for motion pictures. Art in its traditional means rapidly occupied the

78 G. Millian-Maximin

Câțiva țărani bulgari se apropie cu căruțe cu pepeni verzi, ne iau câte 2 lei pe câte unul, mic cât pumnul, dar câți din miile de prizonieri, pot cumpăra, câți mai au parale, când bulgarii i-au jefuit aproape pe toți la Turtucaia?

Ah, zilele petrecute — ce amară petrecere! — la Razgrad — zilele fierbinți, cu lupta lor pentru o picătură de apă nopțile în cari nu te puteai odihni, înțepat de un frig pătrunzător! Ele nu se uită, nu se pot uita, și de-or trece anii

Când pornim, în după amiaza zilei de Luni 20 August, după ce ni s'a dat câte o jumătate de pâine — par'că am fi scăpat din iad — și nimeni nu bănuește că această etapă din lunga cale — din care mii nu s'au mai reîntors—a suferințelor noastre, nu era din cele mai dureroase! Alte etape ne așteptau în cale, mult mai triste, dar în clipa plecării din Razgrad toată lumea e veselă, bucuroasă c'a pornit...

Seara, ajungem într'un sat turcesc, sărac, murdar, cu casele de pământ năruite, înconjurate de câte un zid înalt pentru a nu lăsa să străbată privirile „ghiaurilor", pentru a păstra neprihănite, cadânele — o, acele cadâne zdrențuite cu picioarele goale și murdare — atât de departe de plăsmuirile imaginației noastre, căreia îi era drag să vadă în fiecare cadână un chip dulce, diafan, o întruchipare de mătăsuri, de parfumuri, de ochi mari, frumoși și visători!

Poposim afară din sat, pe câmp. Aceeași noapte cețoasă, rece, ne înfășoară. Focuri sclipesc în întuneric, și în jurul lor camarazii își trec orele grele, povestindu-și, cu glas scăzut, impresiile, nevoile și... nădejdiile, dacă în turma noastră neno-

O, acele cadâne zdrențuite, cu picioarele goale și murdare!

Fig. 7

Nicolae Tonitza, *Oh, Those Frayed Odalisques…*, 1920, engraving from **G. Millian-Maximin**, *În Mâinile Dușmanului. Însemnările unui Prizonier* (1920)

scene. As in the case of the Independence War of 1877–1878, in WWI, painters again took the lead.

An exemplary case was Nicolae Tonitza. Expecting to be a successful correspondent of a victorious campaign, he crossed the Danube in September 1914, only to be seriously wounded and taken prisoner in Bulgaria until the end of the war. He was one of the few thousand survivors out of more than 28,000 Turtucaia prisoners. Disease, starvation, and ill-treatment constituted the material for his illustrations in a book published in 1920 by his fellow inmate, journalist G. Millian-Maximin.[39] Tonitza was educated in Bucharest, Munich, and Paris. His previous work was specific to a peripheral, hedonistic, *la belle époque* mixture of Impressionism and Secessionism. His graphic work and painting after WWI changed in view: the engravings for Millian-Maximin's book are, as it is expressly posited on the cover of the book, "drawn after nature";

39 Millian-Maximin (1920).

they render scenes lived by both writer and artist, starting from the blessing of the army by an Orthodox priest at the beginning of the campaign, to the flood of wounded soldiers in Turtucaia, the fights, the surrender, the march to captivity in the camp (Fig. 6), and the sick and dying prisoners. They reflected another perspective of war and of existence too. There is no room for distant observation in them, no place for propaganda or charm. Everything is lived and felt, painful, subjective, depressing. A new, rather Expressionist sensibility emerged from the confrontation with real war, although in Romania there was absolutely no trace of the *bellicose Expressionism* prior to the war, similar to the one of Lovis Corinth or Otto Dix.

The stark, black-and-white illustrations of Tonitza, with the incised, heavy black contours of the figures and the bleak, barren landscape, convey an overwhelming sense of solitude and abandonment. One of the illustrations for the book represented two Tartar or Turkish completely veiled women encountered on a road in captivity, precisely those fantasized before as *odalisques*, who now look wretched, desolate and frightened, as the caption under the illustration reads: "Oh, those frayed odalisques, with their bare, dirty feet!" (Fig. 7). In his first exhibition after repatriation, in 1918, made together with the group *Arta Română* [Romanian Art, 1918–1928], Tonitza exhibited works inspired by the war and captivity. He did the same in 1919, in the second exhibition with the same group, where he extended his cycle dedicated to scenes like *Din viața celor umili* [From the Life of the Humble Ones]. He tried helping war orphans, opening an exhibition in Govora in 1919, and published texts and political drawings extensively in socialist newspapers and magazines, taking a stance in favor of those deprived of means and against the *nouveaux-riches*. His subjects were taken from his life in the prison camp, as if the trauma was perpetually reenacted. Whenever he got out of those specific subjects, similarly inspired ones came forth, like *Coadă la pâine* [Queuing for Bread, 1920], *Văduve la cimitir* [Widows at the Graveyard, 1920], *Nebunii* [Mentally Ill Patients in a Hospice, 1920] etc., as if the reality around him was perceived through a darkening glass. Tonitza was not the exception, as future avant-garde pillar Max

Hermann Maxy started his career immediately in 1918, representing similar themes: exclusively portraits of soldiers and peasants in dark, depressing colors. Francisc Șirato, a prodigious colorist in the 1930s, was, in the years after WWI, submerged in a "dark" period, especially in his drawing series *Refugiul satelor* [The Refuge to the Villages, 1916], which rendered the double suffering of peasants during the war, as the villages were deserted by young, conscripted males, while women and old people were expected to feed the amassed urban population and government administration forced out of Bucharest.

Painting, seemingly a more distress-attuned artistic means than the modern, technological innovations, took revenge against the progressive techniques backing the propagandistic, positive image of war before 1916. But painting had to reconfigure itself too, abruptly shifting to a crisis-mongering Expressionism. It took a few years until balance was regained. By the mid-1920s, Nicolae Tonitza, as well as Francisc Șirato, Iosif Iser, and many other artists flocked back to the artists' colony in Balchik, in Cadrilater, recuperating the peaceful, bourgeois colonialism, quintessentially concentrated in the ever-mysterious figure of the Tartar *odalisque*, still in demand. Furthermore, once the avant-garde set foot in Romania in November 1924, a reconsideration of the wars, and especially of WWI, was under way, with an understanding and representation of the war as salutary (not so paradoxically echoing the larger European tendency). In the avant-garde magazine *Integral* (1925–1928), founded by Maxy, his main theoretical acolyte Ilarie Voronca claimed that: "It's not by chance that the recent sensibility got its shape around the First World War when… an abundant blood-spill saved Europe from an imminent apoplectic attack."[40] War was once again artistically inverted into progress. The mental conditions for a new war were gearing up.

40 Voronca (1927: 2).

In Pursuit of National Identity

Croatian Modern Art before and after the Great War

Petar Prelog
Institute of Art History. Zagreb, Croatia

Abstract

This essay discusses various strategies of Croatian modern art in formulating national identity, with a special emphasis placed on the impact of the Great War. Considering that the main consequence of WWI on Croatian cultural space was of a geopolitical nature — namely, the creation of a new multinational state within a part of the former Austro-Hungarian Empire and the Kingdom of Serbia — the continuity of a close relation between art and national identity was established. Specifically, the building of a stable national culture — which emphasizes national particularities, but also affirms its inclusion in the European cultural space — established itself as an important objective of cultural elites in Croatia in the pre-war, as well as in the post-war, period. First and foremost, this essay emphasizes the importance of the painter Vlaho Bukovac who, by introducing the echoes of French art and the spirit of cosmopolitanism into the traditional cultural surrounding, played a key cohesive role in formulating the Secession movement in Croatia. At that decisive moment in the creation of Croatian modern art began a discussion regarding the need to articulate its national features as an important part of national identity. In the years immediately preceding the onset of WWI, the duality of Croatian art became evident. On one side, there was a group of artists gathered around the sculptor Ivan Meštrović, who sided with the Yugoslav idea as a viable political solution for the Croatian part of the Empire. Accordingly, Meštrović was preoccupied with themes inspired by South Slavic heroic folk poetry; whereby he was also taking into account the formulation of a "national style with South Slavic features". On the other side, there was a group of painters who studied at the Munich Academy and spent time in Paris. They derived their influences from French painting; whereby their views on art were not in any way related to the postulates of cultural nationalism. One of them — Miroslav Kraljević — would exert a strong influence with his work by introducing the values of cosmopolitanism into the Croatian art scene. With the end of the war begins the process of transforming avant-garde incentives (primarily, Expressionism) and the creation of a general artistic atmosphere of "moderate modernism". Given the fact

that the Croatian cultural space, upon the end of WWI, ceased to be part of one multinational state and became part of another, the cultural nationalism remained very much alive in that period. In addition, the dissatisfaction with the political and economic situation in the Yugoslav multinational state had quickly erupted, so Croatian art felt the need to give its response to the emerging social circumstances. The need to emphasize Croatian cultural and artistic distinctiveness was continuously elaborated by Ljubo Babić, one of the most significant artists in the interwar period. The strategy of creating "our expression" was, from the very beginning, a part of his projection on the advancement of national art. Although Babić's "cultural nationalism" possessed highly pronounced traditional features, his views were not isolationistic. Having gained extensive knowledge of European cultural heritage and being aware of transnational values of modern art, he aimed to be a kind of cosmopolite, but at the same time also a nationalist, with a desire to formulate a national style which would affirm the inclusion of Croatian art into modern European culture.

Key words Croatian modern art, national identity, cultural nationalism, Ivan Meštrović, Miroslav Kraljević, Ljubo Babić

Introduction: Strategies of Cultural Nationalism in Croatian Art

During the 1960s and early 1970s — in the momentum of systemic analysis and evaluation of national modern art — the Great War was perceived in Croatian art history as a blank slate of sorts, a period in which there were no artistic occurrences of paramount importance. Art historian Božidar Gagro thus claimed that a generation of artists or prominent individuals who could, with the strength of their artistic convictions, articulate a significant idea or create a relevant art movement did not exist at that time.[1] On another occasion, the same author concluded that, when considering the continuity of Croatian art, the year 1914 is to be understood as an "interruption" conditioned by a severe civilizational disturbance.[2]

Can we, therefore, in the case of Croatian modern art, truly talk about a complete break in continuity caused by the war, or is the situation — if examined carefully and from multiple perspectives — somewhat different? Although it is an indisputable fact that the war — having a strong impact on the general political, economic, and social circumstances — caused a disturbance in cultural and artistic life, and thwarted the educational plans of many artists,[3] this was, nonetheless, a very productive period in Croatian art. First of all, it can be concluded that the actual break in the stylistic and conceptual continuity did not occur: at that time, the emergence of Expressionism in Croatian painting — preceded by the long-lasting and productive achievements of Symbolism and the local variant of Secession style — was becoming evident. Secondly, some of the key works of Croatian modern painting were created precisely at that time, and one should not forget the founding of the *Spring Salon* in 1916 — in the midst of war — an exhibition event that would, until 1928, bring together almost all prominent Croatian artists, promoting diverse stylistic and poetic orientations.[4] Finally,

1 Gagro (1966: 46).
2 Gagro (1972: 35). On continuity or discontinuity in Croatian modern art, see: Prelog (2018).
3 On many Croatian artists who directly — as soldiers and officers — participated in the war, while creating works of exceptional documentary value, see: Bregovac Pisk (2014), Maković (2018).
4 On the importance of the *Spring Salon* in the history of Croatian modern art, see: Prelog (2007a).

the consequence of WWI was of the outmost importance in maintaining the continuity of engagement of Croatian artists in formulating national identity. Given the fact that Croatian cultural space, upon the end of the war, ceased to be part of one multinational state (the Austro-Hungarian Empire) and became part of another (the Kingdom of Serbs, Croats and Slovenes), the cultural nationalism in the interwar period remained very much alive. Specifically, before WWI — in the period of general disintegration of the Austro-Hungarian Empire — art had an important role in creating national culture and formulating national identity, while a group of Croatian artists, through their work, promoted the Yugoslav idea as one of the possible political solutions for the Croatian part of the Empire. After the war — due to the pronounced political upheavals in the new state, but also as a response to the growing influence of the avant-garde — many Croatian artists remained preoccupied with formulating the national identity, however, this time by articulating the idea about the Croatian national style as "our expression" in art; the term created by painter and art historian Ljubo Babić. Therefore, it is necessary to examine the characteristics of the pursuit of national identity in Croatian art within the context of different strategies of cultural nationalism during the time after the war, but also during the time that preceded it.

Before the Great War: Modern Art and National Identity at the Time of the Empire's Disintegration

In the period between 1898 and the beginning of WWI, visual arts had become an indispensable part of Croatian society and assumed an important role in shaping the national modern culture. The process of its institutionalization was finalized with the establishment of art associations, the emergence of exhibition spaces, the activities of private art schools, and the establishment of the Academy of Fine Arts in Zagreb (1907). This resulted in increased artistic production and the intensification of group and solo exhibitions. Specifically, the acceleration of the information flow and the increase in quality of artistic dialogue in the whole of Europe were beneficial for the development of artistic life in Croatia; whereby it should be kept in mind that,

within the Austro-Hungarian Empire, this dialogue was primarily dependent upon the relations between Vienna and other urban centers. These relations — among other things — can be viewed as a constant juxtaposition of cultural values imposed by the empire and many national traditions which gained a new impetus in the process of formulating national identity at the turn of the century.[5] At that time, the visual arts throughout Europe, and especially in the Austro-Hungarian Empire, exercised one of the key influences over the creation of national consciousness: its role was to formulate and promote national identity from different perspectives.[6] It was, without doubt, the manifestation of cultural nationalism whose main goal was to emphasize the distinct features of individual national cultures, to create a specific national art based on traditional values (national history, national landscape, folk art etc.) and, thus, formulate an important part of national identity. However, as Éva Forgács noted: "[...] endeavours to create national art were, paradoxically, the first step towards the creation of internationalism, because these early movements sought to confirm national pride and consciousness in order to elevate the nation to becoming a full-fledged member of Europe and integrate the national culture into the European cultural heritage."[7] The strategies of affirming national identity in Croatian modern art were closely related to the process of building a stable national culture, which emphasized national particularities but also, at the same time, affirmed its inclusion into the

5 The structure of artistic dialogue between Vienna and other urban centers of the Empire at the turn of the century has been thoroughly elaborated by Emil Brix, therein emphasizing the importance of the concept of "national emancipation" in attempts to interpret art around the year 1900. See: Brix (1999).

6 "Although political and ethnic entities were operating under similar pressures to arrive at a 'goal' of national identity, they differed markedly not only in how they conceptualized what that identity was, but also in the frequently contentious manner in which they attempted to express and realize it. Despite this diversity, they all turned to the visual arts — from folk art to architecture and exposition displays — to embody and announce their newly formulated national identities at home and abroad." Facos/Hirsh (2003b: 1).

7 Forgács (2002: 48).

In Pursuit of National Identity
Croatian Modern Art before and after the Great War

European cultural space. In other words, the relation between visual arts and national identity in Croatia was expressed through the constant intertwining of the two, but also through the confrontation between the desire to find a specific national style or expression and a strong need to integrate into the European modernist context. One wanted to be simultaneously a nationalist who emphasized national distinctiveness, and a cosmopolite, conscious of the transnational qualities of modern culture, with one's gaze directed to Paris, Vienna, or Munich. It was precisely on the basis of these assumptions that Croatian modern art, in the period of advanced disintegration of the Austro-Hungarian Empire, built its own identity.

In the late 19th century, Zagreb became — due to the activities of the painter, art historian, and politician, Izidor Kršnjavi[8] — a representative center of art with sufficient economic power to attract many artists. One of those was Vlaho Bukovac, a painter who, by the virtue of authority of his Parisian education and his reputation earned in Paris and London as a portrait painter, played a key role as the element of cohesion in the process of modernizing Croatian art space at the turn of the century. After completing his education at the Paris Academy in the class of Alexandre Cabanel and in the eclectic surroundings of neoclassical history painting, Bukovac not only became a respected portrait painter, but also became acquainted with the spirit of *plein air* painting. Bringing the echoes of French art and the spirit of cosmopolitanism into the environment which had been traditionally oriented towards an education in Vienna or Munich, Bukovac brought together artists of the younger generation with whom he would collaborate until the 1898 *Croatian*

8 Izidor Kršnjavi was a versatile intellectual and an ambitious public official who, in the last two decades of the 19th century, due to his political functions and social prestige, had formulated the life of an entire culture. He was a long-standing secretary of the *Art Society* (*Društvo umjetnosti*, established in 1868), a professor at the University of Zagreb, the head of the Government Department of Religious Affairs and Education; he founded the Museum of Arts and Crafts in 1880 and the Crafts School in 1882; he dedicated himself to the building of art studios, mediated and devised large art orders, and organized art education and scholarships.

Salon exhibition. Held at the Art Pavilion in Zagreb, this exhibition can be considered the inaugural event of Croatian modern art.[9] A year before that, a group of artists led by Bukovac left the Art Society (*Društvo umjetnosti*, established in 1868; today Croatian Association of Arists — Hrvatsko društvo likovnih umjetnika), the official professional association whose program, for the last few decades, was formulated by Izidor Kršnjavi. This group founded the Association of Croatian Artists (*Društvo hrvatskih umjetnika*, 1897-1903) in order to emphasize their disagreement with the established tradition of academism. Thus, the Secession movement, as a conceptual conflict between the "old" and "young" artists, with the proclamation of individual values and the freedom of artistic creation, occurred almost at the same time as in Vienna, and only a few years after Munich. From that moment onwards, resulting from the rejection of academic norms, the echoes of Symbolism and indications of Secession style began to emerge, while Bukovac's painting started to show influences of French art. Nonetheless, the exhibition also featured examples of history painting and national landscape, thus taking into account the revival of national consciousness and contributions to national identity. Despite this fact, the fiercest attacks on the *Croatian Salon* were precisely those which denounced it for its lack of patriotism and for acting against national interests.[10] At that decisive moment in the creation of Croatian modern art, a heated discussion began regarding the need to articulate its national features as an important part of national identity, which — in its various modalities — lasted for several decades.

At the beginning of the 20th century, the cultural and artistic collaboration between the Slavic neighbours intensified, so the issues of identity with a national inflection were beginning to fit into the context of the Yugoslav idea. Thus, as a result of the artists' gathering at the

9 On the interpretation of this important moment in the history of Croatian art, see: Reberski (1998).

10 On the disagreement around the *Croatian Salon* in the context of Croatian art criticism of that time, see: Galjer (2000: 44-60).

In Pursuit of National Identity
Croatian Modern Art before and after the Great War

Yugoslav Exhibition in Belgrade in 1904,[11] the Association of Yugoslav Artists *Lada* (*Savez jugoslavenskih umjetnika Lada*, 1904–1912) — the international art association which brought together Croatian, Bulgarian, Slovenian, and Serbian artists — was founded. Most of the members of the Croatian branch of *Lada* were artists who had displayed their works at the Croatian Salon, and since they had failed to experience the complete transformation into the bearers of modernist values, they were immediately characterized as successors to the conservative faction in Croatian art. Therefore, after a few years, there was another divergence between Croatian artists leading up to the founding of the Association of Croatian Artists *Medulić* (*Društvo hrvatskih umjetnika Medulić*, 1908–1919). Specifically, the *Third Yugoslav Exhibition* was held in 1908, in Zagreb, where the works of *Lada* artists were also exhibited. However, Croatian artists from Dalmatia refused to participate in that exhibition and organized, in Split, the *First Dalmatian Art Exhibition* (*Prva dalmatinska umjetnička izložba*, 1908), on the occasion of which the Association of Croatian Artists *Medulić* was founded. Thus a disagreement arose between Dalmatian and Zagreb artists, which was primarily centered upon the character and the intensity of their Yugoslav convictions. In fact, political beliefs acted as the cohesive force of the newly founded association and, above all, the idea of the unification of South Slavic nations in opposition to the politics and objectives of the Austro-Hungarian Empire. On the artistic level, this idea was articulated by the themes inspired by South Slavic heroic folk poetry. As fierce supporters of the Yugoslav idea, Croatian artists from *Medulić* Association — after failing to acquire a separate Croatian exhibition space in the Hungarian Pavilion at the *International Exhibition* in Rome in 1911 — exhibited their works in the Pavilion of the Kingdom of Serbia. This was how the art practice, through the desire to formulate cultural identity with a Yugoslav inflection, gained direct political connotations.

11 Six Yugoslav exhibitions were held: three in Belgrade (in 1904, 1912 and 1922), and one in Sofia (1906), Zagreb (1908) and Novi Sad (1927), respectively.

NATIONALISM AND COSMOPOLITANISM IN THE AVANT-GARDE AND MODERNISM
The Impact of the First World War

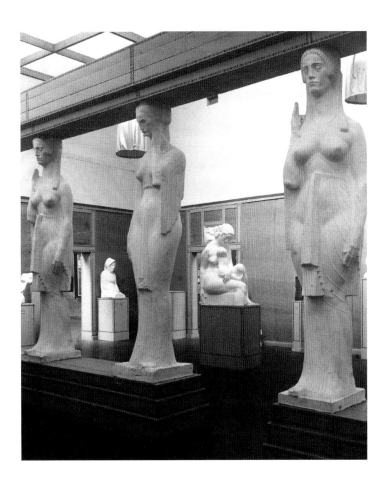

Fig. 1

Photograph of *Caryatids of Vidovdan Temple* by **Ivan Meštrović** on the 35th *Exhibition of the Vienna Secession*, 1910. Ivan Meštrović Museums — Meštrović Gallery, Split

Ivan Meštrović — as an artist of international stature — asserted himself as the leading figure and an ideologue of that association. Meštrović, besides his political aspirations, fostered ideas of creating a "new national style with South Slavic features". As a matter of fact, after his departure for Paris in 1908, Meštrović began to be preoccupied with the theme of national myth, which he embodied in a series of works with a stylized form and powerful symbolic expression. The idea of creating a cycle which symbolizes the struggle for freedom of South Slavic peoples, as well as the aspiration for its articulation in a monumental work of art which would combine architecture, sculpture, and painting, brought together *Medulić* members on a project which would give a pronounced narrative component — along with the engaged political overtones in the time of conceptual dominance of the unification of South Slavic nations — to the complex of Croatian pre-war art. This refers to the series of

Fig. 2

Ivan Meštrović, wooden model of *Vidovdanski hram* [Vidovdan Temple], 1908–1912. Ivan Meštrović Museums — Meštrović Gallery, Split

sculptures and paintings *Kosovo Cycle* (*Kosovski ciklus*, 1908–1912) and unfinished architectural project *Vidovdan Temple* (*Vidovdanski hram*)[12] commemorating the 1389 Battle of Kosovo between the Serbs and the Turks (Figs. 1 and 2). Meštrović thus conceived a nationally character-ized artistic expression as a kind of synthesis of Secession style and mythological narrative patterns transposed into stylized monumental forms. This stands as an important example of the incorporation of certain key elements of a widespread international style into the complex of national tendencies.

At the same time, in the decade preceding WWI, a small informal group of painters, whose views on art were not in any way related to the postulates of cultur-al nationalism, was also receiving recognition. These

12 This comprehensive project, as a vivid example of the role of art in formulating national identity, was never executed in its entirety, while its fragments have been exhibited on several occasions.

NATIONALISM AND COSMOPOLITANISM IN THE AVANT-GARDE AND MODERNISM
The Impact of the First World War

were four painters — Josip Račić, Vladimir Becić, Oskar Herman, and Miroslav Kraljević — who are known in Croatian art history under the name of the Munich Circle (*Münchnenski krug*). The brief period of their joint practice is restricted to the time they spent at the Academy in Munich, where they succeeded in articulating their aspirations towards modern painting. As they studied for a while under Professor Hugo von Habermann, who had a reputation for being liberal at the generally conservative Munich Academy, they were inclined towards a strain in German painting, led by those who shared the views of Wilhelm Leibl and whose roots stemmed from French art, mainly Gustave Courbet's painting. Under such circumstances, Croatian painters directed their interest towards the work of yet another great French painter, Édouard Manet. Thus, it is not surprising that Munich, the city of their formal art education, was only a "window" to Paris, where they all spent at least several productive months.[13] Courbet, Manet, and also Paul Cézanne for Kraljević, had become their role models on the basis of which they would consciously, and not only on the declarative level, adopt the basic principles of modern art. Introducing the spirit of cosmopolitanism into a small cultural environment on the edge of the empire, their work opened up new horizons for many Croatian artists. In this sense, the most significant impact on the future developments in Croatian painting was realized by Miroslav Kraljević (Fig. 3). His exhibitions held in Zagreb's Salon Ullrich, and particularly the one held posthumously in 1913, had a strong impact on the Zagreb art scene. His work showed support for resistance against any kind of traditionalism and contained multifaceted meanings. Moreover, after the end of the war, a few young painters who recognized Kraljević's interpretations of Cézanne's painting and his elaborations on the problem of expressivity of form as important contemporary art trajectories used those foundations to define features of Croatian painting.

While writing about Kraljević in 1913, Croatian writer Antun Gustav Matoš was the one who recognized the duality of Croatian pre-war art. The first tendency — with

13 On Paris as the ultimate goal of Croatian students in Munich, see: Prelog (2008).

In Pursuit of National Identity
Croatian Modern Art before and after the Great War

Ivan Meštrović as its most prominent representative — Matoš named "nationalist", claiming that it is traditional and that it uses the national (Yugoslav) ideal, with inspirations found in folk poetry and primitive art expressions. The second tendency — represented by Kraljević — Matoš named "European" and concluded that it was modern, that it served the ideal of the refined creation of individual artistic vision, and that it was akin to the spirit of Paris.[14] By introducing into the interpretation of the latest phenomena in Croatian art the category of "nationalism" on one hand and of "cosmopolitanism" on the other, Matoš actually addressed the pervasive

14 Matoš (1913: 69).

identity issues of that time. Although the debate on the role of art in formulating national identity would become more concrete in the interwar period and would culminate in the demands for "our expression", it would continue to be characterized by mutual permeations, but also confrontations between nationalism and cosmopolitanism, which Matoš — just before the onset of the war — identified and described so inspiringly through the example of Meštrović and Kraljević.

After the Great War: Towards "Our Expression" as the Basis of National Identity

The situation in Croatian art immediately after WWI was characterized primarily by Expressionism, which on the local cultural scene took the undisputed avant-garde position. Its comprehensive affirmation in Croatian culture began in wartime with the emergence of magazines that advocated the revolt against traditional aesthetic forms.[15] As a consequence of fundamental existential uncertainties triggered by a major world conflict, a specific variant of Expressionism dominated by a general impression of anxiety began to formulate in the painting of Jerolim Miše, Zlatko Šulentić, and Ljubo Babić. The post-war rise of Expressionism can be credited to the younger generation of painters who had established themselves by displaying their works at the *Spring Salon* exhibitions. Milivoj Uzelac, Vilko Gecan and Marijan Trepše derived their short, diverse, but intense Expressionist episodes from multiple sources. One of those sources was certainly the painting of Miroslav Kraljević, while the others can be attributed to their stay in Prague,[16] where they found the incentives for their individual stylistic and poetic orientations. Furthermore, they were well acquainted with the Expressionism of the German cultural circle.

This was a very important moment in the history of Croatian modern art: with the end of the war began

15 These were, primarily, magazines edited by writers: Ulderiko Donaldini's *Kokot* [The Rooster, 1916–1918] and Antun Branko Šimić's *Vijavica* [The Snowstorm, 1917–1919].

16 Milivoj Uzelac, Vilko Gecan, Marijan Treše and Vladimir Varlaj, during or immediately after the war, spent more or less time in Prague, so Croatian art historians named them the *Praška četvorica* [Prague Four]. On the subject, see: Maković (2013).

the process of transforming avant-garde incentives and the creation of a general artistic atmosphere which we could call "moderate modernism".[17] The receptive abilities of the Croatian public were limited so, in that sense, the acceptance of transnational avant-garde idioms was partial. As Steven Mansbach pointed out: "[…] Eastern European modernists were obliged to reconfigure progressive styles to accommodate local needs, just as they endeavoured to conform to international expectations of how modern art should appear."[18] The aforementioned local needs entailed intense efforts in dealing with identity and the process of the nationalization of modernism; thus, accordingly, the international avant-garde postulates in Croatia immediately after the war were unable to take root firmly.[19] In this regard, one should be reminded that the most important avant-garde episodes — which enabled the local visual culture to advance on the basis of mostly Constructivist aesthetics — were also burdened by relations between the local and universal, national and international. Ljubomir Micić — who, in Zagreb, initiated the creation of an international network around the avant-garde magazine *Zenit* (*Zenith*, 1921–1926) in 1921 — advocated for "regional", Balkan values, embodied in an authentic *Barbarogenius* (*Barbarogenij*), as opposed to the universal idiom upon which other Western European avant-gardes were based.[20]

Micić's opposition of Balkan *Barbarogenius* to the entire Western European art complex — articulated in numerous texts published in almost all issues of *Zenit* — emerged, among other things, from a simple frustration with the fact that this part of Europe was on the edge of innovative cultural and art developments, and was thus forced to gather influences from major art centers, adapting them to the local context. In this sense, Micić was often critical of the contemporary local art

17 On the term "moderate modernism", see: Šuvaković (1999: 194).

18 Mansbach (2002: 299).

19 On the complex relation between nationalism and transnationalism, as basic features of the avant-garde practice in the first half of the 20th century, see essays in the related anthology: van den Berg/ Głuchowska (2013).

20 For more on *Zenit*, see the comprehensive monograph with complete bibliography and summaries in English: Golubović/Subotić (2008).

NATIONALISM AND COSMOPOLITANISM IN THE AVANT-GARDE AND MODERNISM
The Impact of the First World War

production.[21] The writer Miroslav Krleža — an important figure on the Croatian interwar cultural scene — even before Micić, also harshly criticized Croatian art, accusing it of epigonism and eclecticism, referring primarily to the uncritical acceptance of avant-garde influences.[22] Therefore, it can be concluded that the awareness of belonging to a traditional culture — which was doomed to receive influences, without a great potential for original creation which would contribute to the advancement of European art — is what marked the first post-war years.

In addition, with the creation of a new multinational state — the Kingdom of Serbs, Croats and Slovenes, which would be renamed in 1929 as the Kingdom of Yugoslavia — the engagement of artists associated with the Yugoslav idea had disappeared. The political goal had been achieved, while the potential of creating art with Yugoslav features — based on mythological forms in the pre-war period — was not substantial. There were attempts to create a unified Yugoslav art space,[23] but given the fact that the consistent unifying Yugoslav cultural politics did not develop and that these attempts were left to individuals, national arts — Croatian, Serbian and Slovenian — continued to exist as separate entities in the interwar period. In addition, the dissatisfaction with the political and economic situation in the multinational Yugoslav state had quickly erupted, so Croatian art felt the need to give its response to the emerging social circumstances. In this context, the pursuit of national identity would also be continued.

The idea of "our expression" in art was created, therefore, in response to the post-war crisis of national identity. On one hand, it resulted from an increasingly strong

21 In this respect, Micić — provoked by the *Spring Salon* exhibitions — writes about the "inferior position" and "slavish dependence" of the local art scene in relation to Europe. See: Micić (1921: 11).

22 Krleža (1919).

23 The art historian Ješa Denegri, with regards to the new permanent exhibition at the Museum of Contemporary Art in Belgrade, in 2002, writes about the concept of Yugoslav art space and explains its characteristics, arguing that it was a decentralized, but at the same time, unified art space whose existence did not call into question separate national art scenes with different cultural and historical backgrounds. See: Denegri (2011: 5).

In Pursuit of National Identity
Croatian Modern Art before and after the Great War

influence of the international avant-garde, and on the other, the need to emphasize Croatian cultural and artistic distinctiveness within the new multinational state. This need was continuously elaborated by Ljubo Babić, one of the most significant artists in the interwar period. The strategy of creating "our expression" was, from the very beginning, a part of his projection on the advancement of national art.[24] This former student of Franz von Stuck — a painter, critic, art historian, and a versatile intellectual — received the initial impulse for the need to formulate a nationally distinct art from Meštrović's art circle which propagated the Yugoslav idea. In the years before the war, Babić created his works in Secession style and in accordance with Meštrović's ideas, most elaborately expressed in the cycle *Widows* (*Udovice*, 1912; Fig. 4). As a direct participant in this art-political complex, he inherited from it the idea of the need for establishing cultural particularities of all nations. During the 1920s and 1930s, he developed that idea into the carefully elaborated theory of "our expression", which implied the formulation of Croatian national style.

With the end of his Expressionist episode in 1920, Babić went on a study tour to Spain, where he became acquainted with the artistic heritage which developed into, as he would point out, an important mainstay of his work. It was during this trip that he created one of the pinnacles of his *œuvre*: these were small watercolours in which he captured the urban scenery and monumental landscape, all while studying the works of great Spanish painters whom he copied. The watercolour *Castilian Landscape* (*Kastiljanski pejzaž*, 1921), and the oil painting under the same name created a year later, demonstrate the way in which the painter regarded the landscape as the incentive worthy of the greatest attention, and represent the structural and compositional formula on the basis of which he would approach the artistic treatment of the Croatian landscape (Fig. 5). The experiences from Spain were of the utmost importance for Babić's cycle from the 1930s named *Land of My Birth* (*Moj rodni kraj*), through which he sought to find specific structural elements which

24 On the interpretation of Babić's activities in the context of creating "our expression", see: Prelog (2007b).

Fig. 4

Ljubo Babić, *Udovice* [Widows], 1912. National Museum of Modern Art, Zagreb

formulated "our expression" and were typical for the individual parts of the national landscape (Fig. 6).

The development and the basic elements of Babić's strategy for formulating "our expression" — conceived immediately after WWI — can be traced to a number of texts which he published in the next twenty years.[25] First of all, he set as his primary objective the formulation of a style which was national and, as such, completely original, while simultaneously also appropriate in modern European art. Furthermore, he regarded the painting of the Munich students — Račić and Kraljević — and their change of focus away from the Central-European cultural circle to Paris and French painting, as an important reference point in his work. In addition,

25 The most important elements of Babić's strategy were outlined in the essays: Babić (1929a), Babić (1929b), Babić (1943).

Fig. 5

Ljubo Babić, *Kastiljanski pejzaž*
[Castilian Landscape], 1920–1921.
National Museum of Modern Art,
Zagreb

he considered the heritage of Spanish painting, espe-
cially Francisco Goya's and Diego Velázquez's works, to
be extremely important. He was also thinking in terms
of a regional model, akin to the deterministic theory
of Hippolyte Taine, who stated that all works of art were
conditioned by the circumstances specific to the places
of their conception. In that sense, he believed that the de-
sired formulation of "our expression" could primarily be
achieved by landscape painting. At the end of the 1930s,
he introduced folk motifs into his painting and studied
the range of colours used in folk costumes from all parts
of Croatia. By analyzing Croatian folk art, he endeavoured
to find ways for its incorporation into the individual ex-
pression of trained artists, and thus formulate the nation-
al style as a substantial part of national identity.

It can be concluded that Babić's "cultural nationalism"
possessed highly pronounced traditional features. His
views, congruent with the deterministic assumptions

Ljubo Babić, *Moj rodni kraj*
[Land of My Birth], 1936. National
Museum of Modern Art, Zagreb

developed in the 19th century, can also be associated with the interpretations of the perennialist paradigm of nations (in opposition to the classic modernist paradigm), which regarded the nation primarily as a cultural community with ethnic continuity.[26] However, Babić's views on the matter were not isolationist in character. Having obtained extensive knowledge of European cultural heritage and being aware of the transnational values of modern art, he aimed to be a kind of cosmopolite, but at the same time also a nationalist, with a desire to formulate a national style which would affirm the inclusion of Croatian art into the European modern culture.

26 On the modernist paradigm of "nations" and "nationalism" and its alternatives, see: Smith (1998).

In Pursuit of National Identity
Croatian Modern Art before and after the Great War

Final Remarks

The strategies of affirming national identity in Croatian modern art were conditioned by complex social, economic, and political upheavals. Considering that the main consequence of WWI on Croatian cultural space was of a geopolitical nature — namely, the creation of a new multinational state within a part of the former Austro-Hungarian Empire and the Kingdom of Serbia — the issues of national identity were still topical, thus leading to the conception of the idea of "our expression". In the following two decades, this was one of the key issues in Croatian culture. Therefore, we can conclude that — constantly torn between its gaze directed towards big art centers and its desire for the affirmation of its own peculiarities — Croatian modern art was mostly characterized by the continuity of a pursuit for national identity.

Don Quixote in the Trenches

The Birth of Avant-Garde Poetry in Spanish Language between Civilization and Barbarism

Emilio Quintana Pareja
Instituto Cervantes. Stockholm, Sweden

NATIONALISM AND COSMOPOLITANISM IN THE AVANT-GARDE AND MODERNISM
The Impact of the First World War

Abstract

The 300th anniversary of the death of Miguel de Cervantes, the iconic national writer of Spain, took place in 1916, in the midst of the Great War. The war profoundly affected the conscience of Spanish and Latin American writers in a transnational way. The "rape" of Belgium, homeland of Maurice Maeterlinck, Émile Verhaeren and Georges Rodenbach, poets who inspired the Spanish *modernista* poetry, enabled the projection of the figure of Don Quixote as a mythical defender of an outraged Latin nation. The decline of cavalry during WWI, outmoded by tanks and poison gas, meant a new death of Don Quixote ideals, specifically the end of *arielismo* (intellectual and political project defended by *modernistas*), and was at the same time indicative of the progress of modernity and the artistic avant-garde as a new paradigm for Spain and Latin American countries. The Peruvian Futurist poet Alberto Hidalgo wrote two poetry books defending Germany, including poems that reverse the *modernista* rhetoric from a polysystemic point of view. Meanwhile, the Nicaraguan poet Salomón de la Selva, enlisted in the British Army, was "enjoying a privileged observatory" from the trenches of Flanders, which led him to write one of the masterpieces of Hispanic poetry in the 20th century: *El soldado desconocido* [The Unknown Soldier, 1922].

Key words

Great War, modernism, civilization, *Kultur*, Spanish

461

Don Quixote in the Trenches
The Birth of Avant-Garde Poetry in Spanish Language
between Civilization and Barbarism

Introduction

The 300th anniversary of the death of Miguel de Cervantes took place in 1916, in the midst of the Great War. The war profoundly affected the conscience of Spanish and Latin American writers already immersed in overcoming the *modernista* rhetoric. Although Spain was not militarily involved in the conflict, many agreed that a parallel intellectual battle was taking place, defending Latin civilization against German barbarism. Certain poems published in the *Revista Mensual Ibero-Americana Cervantes* (1916–1920) in Madrid are relevant to this topic.

The "rape" of Belgium, homeland of Maurice Maeterlinck, Émile Verhaeren, and Georges Rodenbach, enabled the projection of Don Quixote as a mythical defender of an outraged Latin and Catholic nation. This coincided, however, with the decline of cavalry in Europe, outmoded by tanks and poison gas. The decline of cavalry during WWI meant a new death for Don Quixote, specifically the end of *arielismo* (the project for intellectual idealism, defended by *modernistas*), and at the same time, was indicative of the progress of modernity and the artistic avant-garde as a new paradigm in the Latin countries.

From Peru, the Futurist Alberto Hidalgo wrote two poetry books in defence of Germany,[1] with poems that reversed the *modernista* rhetoric, in line with recent studies on models and polysystem theories. Meanwhile, from the trenches in Flanders, the Nicaraguan poet Salomón de la Selva, enlisted in the British Army, "enjoyed a privileged observatory", which led him to write — as a result of his participation in WWI in the Flanders trenches — one of the masterpieces written in the Spanish language in the 20th century: *El soldado desconocido* [The Unknown Soldier, 1922].

1 Hidalgo (1917).

Don Quichotte est le plus grand des poilus [Don Quixote is the greatest *poilu*]

In 1916 the *Centre d'Etudes Franco-Hispaniques de l'Université de Paris* published an *enquête littéraire* compiled by Ventura García Calderón, with the title of *Don Quichotte à Paris et dans les tranchées*. In this book, 59 francophone writers replied to a questionnaire with 3 questions: 1. "Did you read *Don Quixote* when you were young? What are your memories of that reading?"; 2. "What is the symbolism of *Don Quixote* to you?"; and 3. "Is the Spanish hero in some way like a French knight?".[2]

Some of the writers who answered the *enquête* were Guillaume Apollinaire and Francis Jammes, who speaks of Don Quixote as a fighter against the underground hell of the German trenches, Valery Larbaud, Maurice Maeterlinck, and Émile Verhaeren. But the most significant statement came from a lesser-known writer, Étienne Rey: *Don Quichotte est le plus grand des poilus* [Don Quixote is the greatest *poilu*].[3]

The *enquête* was part of the celebration of the third centenary of the death of Miguel de Cervantes, which took place in the middle of WWI, an event that deeply affected the thinking of Spanish and Latin American writers and intellectuals, a real *Krieg der Geister* by some authors involved in the liquidation of the Hispanic *modernista* rhetoric.[4]

I will not analyze the impact of WWI on the great Hispanic intellectuals, which many scholars have studied with thoroughness.[5] Nor will I analyze the Latin/Saxons dialectic, which Lily Litvak has studied with equal distinction,[6] although I do intend to examine the evidence that,

2 There is a whole contemporary literature on the topic, including books like *Don Quijote en la guerra* by Elías Cerdá or *Don Quijote en Francia* by André Suarès. See: Cerdá (1915); Suarès (1916).

3 See: García Calderón (1916: 81).

4 The translations of all patches quoted, including all poems, from Spanish into English were made by the author and Patricia Hedenqvist. The term *modernismo* and *modernista* is used in Spanish, with reference to the artistic movements that at the end of the 19th and the beginning of the 20th centuries challenged the premises of Realism. The use of the term "avant-garde" has some of the Anglo connotations for "modernism".

5 See e.g.: Díaz-Plaja (1973); Varela (1998); Navarra Ordoño (2014); Fuentes Codera (2014).

6 Litvak (1980); Litvak (1992).

Don Quixote in the Trenches
The Birth of Avant-Garde Poetry in Spanish Language
between Civilization and Barbarism

with the outbreak of WWI, cultural controversy would continue to persist under the *aliadófilos/germanófilos* division.[7]

In August 1916, in conjunction with the Cervantes tercentenary, the magazine *Cervantes. Revista Mensual Ibero-Americana* (1916–1920) appeared in Madrid, promoted by the *modernista* author Francisco Villaespesa and a few Mexican poets like Amado Nervo and Luis G. Urbina. The journal *Cervantes* was at first presented as yet another piece in the *nacionalización castiza* [purist nationalization][8] of the poetic system of *modernismo* in Ibero-America (hence an icon for Cervantes).[9] In it, poems about the war were published, including some by a pair of second-rated poets, Emilio Carrere and Alfonso Teja Zabre.

In May and August 1917, the Madrid-based Emilio Carrere published pastiches of dialogued *romances*, with metric and vocabulary that corresponded to what José-Carlos Mainer called *voluntad casticista* [purist willingness].[10] Dialogues were written in verses of eight, nine, or fourteen syllables and predominantly in Hispanic *romance* form, a very traditional and characteristic form of popular poetry in Spain. The *romance* in the *eneasílabos* [nine-syllable verse] "La gloria de la guerra" is the dialogue of a mother

7 There was a resurgence of *modernismo* in the declining support of France which Rubén Darío had sung in his famous sonnet "A Francia" ["To France", 1893]. In this composition, France represents the continuity of the civilizations of Greece, Rome, and Byzantium, while Germany is linked to epithets as "barbarians" ["The barbarians, dear Lutecia!"], "ferrous Berlin", "imperial helmet". This dialectic is specified in the election of Victor Hugo like "the great Paladin" of civilization (always Latin). The Germans, therefore, have constructed a dissociation between "civilization" and "culture".

8 Mainer (1988); Ara Torralba (1996).

9 In a way, the traditionalist reaction from previous years was redirected to the new support for France. The model was the Franco-Prussian War of 1870. José Martínez Ruiz "Azorín", who published four fundamental books at this time: *Lecturas españolas* (1912), *Clásicos y modernos* (1913a), *Los valores literarios* (1913b), and *Al margen de los clásicos* (1915), prepared with articles published in the periodical press, immediately joined the cultural battle of the war with his book *Entre España y Francia (Páginas de un francófilo)* (1916).

10 Mainer (1988). As early as 1907, the *modernista* literary journal *Renacimiento* (1907) was founded, whose name was an evident opposition to "decadence" and saw the "regeneration" of Spain as the answer to "decadence", the opposite.

and her daughter, in the form of a pastiche of the traditional Spanish poetry of this literary genre. The Germans are likened to barbarians who seek to destroy the Latin civilization. Carrere focuses on what the war embodies as destructor of the European artistic heritage:

> Madre, ¿por qué echan a vuelo
> las campanas de la iglesia?
> ¡Es que han entrado los bárbaros
> a sangre y fuego en Florencia! [...]
>
> Cuadras son de sus bridones
> las naves de las iglesias;
> los lienzos de Leonardo
> arden en pública hoguera [...][11]

"El Diablo y la Muerte" ["The Devil and Death"] is another dialogue, this time in alexandrines. It is an anti-German allegation, which is charged directly at Guillermo de Prusia (Kaiser Wilhelm II) as being a *demonio en la tierra* — demon on earth —, besides being also the direct cause of the barbarity of war.[12] "Diálogo heróico" is a dialogue with similar characteristics displayed between Rocinante (Don Quixote's horse), Babieca (El Cid's warhorse), and the dog of Diogenes. Carrere brilliantly joins modernity with barbarism, and denounces the failure of technical progress in preventing war.[13]

> Yo pienso tristemente,
> por qué cuándo el progreso baña el orbe en su gloria,
> al rodar de esta rueda sangrienta de la Historia
> han de volver los bárbaros... irremediablemente?[14]

11 "Mother, why are/ the bells of the church ringing?/ Because the barbarians entered/ by fire and sword in Florence!/ Stables are for their horses/ the naves of the churches;/ the paintings by Leonardo/ in a public bonfire burn." Transl. from: Carrere (1917: 21).

12 This *balada* connects directly with "The glory of war": a dialogue between child and mother, Hispanic *romance* form, archaic medieval tone (readable in such expressions as: *la mi madre*; *malhaya la guerra*; *diz*) and execration of the evils of modern weapons. The new nuance in this poem is the murder of the girl's boyfriend; war destroys love too.

13 This intuition is in tune with the relevant book by Modris Eksteins. See: Eksteins (1989).

14 "I think sadly,/ Why when progress bathes the globe in its glory,/

Don Quixote in the Trenches
The Birth of Avant-Garde Poetry in Spanish Language
between Civilization and Barbarism

Fig. 1

Luis Bagaría, *Los moralistas en la otra vida* [The Moralists in the Afterlife], 1915, illustration from newspaper *La Tribuna* (June 30, 1915)

LOS MORALISTAS EN LA OTRA VIDA

Muerto primero.—Qué dolor, chico; he muerto «bárbaramente» ahogado por los gases asfixiantes.
 Muerto segundo.—Pues yo he sentido el placer de morir «civilizadamente» destrozado por una granada.

(*Caricatura de BAGARIA*)

With cynicism, Diogenes' dog condemns — *los hombres se asesinan muy... científicamente* [men are murdered very... scientifically] — in an image reminiscent of Luis Bagaría, a cartoonist that filled the Spanish symbolic imagery with bloody and apelike Germans soldiers (Fig. 1).[15] Not to be disregarded is the importance of cartoonists

in this bloody rolling wheel of history/ do the barbarians have to return... irredeemably?" Transl. from: Carrere (1917: 26).

15 In these poems Carrere defended Latin civilization and associated the Germans with the old "barbarians", destroyers of the artworks and of coexistence. He also recreates the identification of the Germans with the Devil and the Antichrist. This position is not unusual; rather it is the same as that of many other Latin American *modernistas* poets of the time, many examples of which can be found in the magazine *Cervantes*.

Fig. 2

Francisco Sancha, "Madness
is the sickness/ for which there
is no cure", 1917, illustration
from **Francisco Sancha**, *Libro de
horas amargas* (1917)

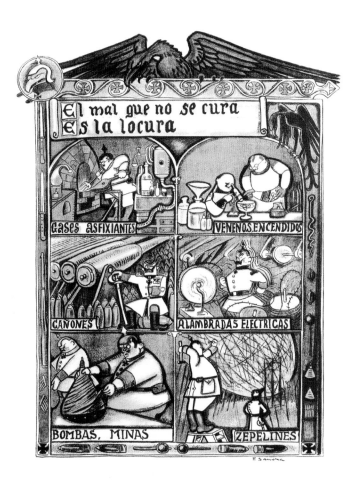

like Bagaría in feeding the operant paradigms in the
Spanish imaginary of WWI.[16]

Carrere's vision involved a late claim of the social func-
tion of *modernismo*, observable in flamethrowers, tanks
or poison gas, all consequences of the 19th-century faith
in human evolution based only on scientific progress.

In September 1917, the Mexican poet, Alfonso Teja Za-
bre published in the magazine *Cervantes* the poem "París
en el Marne" ["Paris in Marne"] in the section "Las can-
ciones de la guerra" ["Songs of War"], which was a chron-
icle of this important battle between the German and the
French. The epic archaism used when speaking of the
French Army is striking:

16 Quintana Pareja (2011).

Don Quixote in the Trenches
The Birth of Avant-Garde Poetry in Spanish Language
between Civilization and Barbarism

No; no es juego de ansiosa fantasía
la aparición de una ciudad que avanza;
era que el sexto ejército salía,
vibrante de valor y de esperanza
para tomar su puesto en la porfía.[17]

This archaic rhetoric, which humanizes a *modernista* and traditionalist poetic code, contrasts with the form that Teja Zabre used to describe the German *máquina de muerte* [death machine], through a technical and dehumanizing vocabulary. The Germans are thus lexically dehumanized: *lubricando resortes y cadenas* [lubricating tensors and chains], *tentáculo* [tentacle], *reflectores* [reflectors] and *monstruoso mecanismo...* [monstrous mechanism...]. In this vision, barbarism is identified with Germany, i.e., with mechanization and with scientific-technical modernization (Fig. 2).

In Teja Zabre's poem, there are multiple allusions to the Belgian martyr, always linked to the poets of Symbolism, uniquely Rodenbach, Maeterlinck, and Verhaeren:

El humo brota y el acero cruje;
Lieja, Verhaeren, Maeterlinck, Bruselas,
Son trigo de oro bajo rudas muelas![18]

17 "No; is not an anxious fantasy game/ the appearance of a city that progresses;/ it was the sixth army that came out,/ vibrant of courage and hope/ to take its place in the dispute." Transl. from: Teja Zabre (1917: 79).
18 "Smoke grows and steel creaks;/ Liège, Verhaeren, Maeterlinck, Brussels,/ They are golden wheat under rude millstones!" Transl. from: Teja Zabre (1917: 78).

The Question of Belgium

When on August 4th 1914 German troops crossed the Belgian border, the idea of "barbarian Germany" extended to the "new Germanic Huns". The destruction of cathedrals such as Reims, of cities like Leuven, or of artwork, put Rubén Dario's verse back on its feet: "The barbarians are back."[19] In the manifesto of French intellectuals, "Mémoire des Cent", these already-collected accusations appear.[20]

The two most used epithets with respect to Belgium were "martyr land" and "rape", referring to a religious metaphor and sexual abuse. The "rape of Belgium" was conceptualized as an outrage against a defenceless virgin; in a way, the spirit of Don Quixote — which embodied the spirit of Spain, neutral in the war, and of Latinity — revived the idea of the defender of the underdog and of the abuses in defence of the weak. This symbolic image of Don Quixote became stronger in view of Spain's true military disability which, in the absence of modern regiments, could only send a Knight of the modernist ideal, as Darío imagined it.

I will not detail the aftermath in Spain of the invasion of Belgium, which was huge. It was essential to the undertaking by Valle-Inclán, for example, for whom the war was then transformed into a clash of civilizations: the Latin — defender of law and religion — and the Germanic — forged from strength and aggressiveness.[21]

The "rape" of Belgium gave new impetus to the rhetoric of "civilization"/"barbarism" which was in the *arielista* vision of the Uruguayan José Enrique Rodó, the *maestro de la juventud hispano-americana* [master of the Latin-American youth]. The attack on Belgium, including the destruction of cities, gardens, churches, homes, and the sufferings of its people, posed a direct attack upon one of the fundamental symbols of the *modernista* kind of *Weltanschauung*.

19 Rubén Darío refers to Leuven in his poem "Pax", read at Columbia University, which invited Darío to give a lecture on campus. The lecture, entitled "The Horrors of War, The Necessity of Peace and The Means of Obtaining It", took place at Havemeyer Hall on February 4, 1915. See: Beardsley (1967).
20 See: Nothomb (1915a); Nothomb (1915b).
21 See: Vidal Maza (2001).

469

Don Quixote in the Trenches
The Birth of Avant-Garde Poetry in Spanish Language
between Civilization and Barbarism

The Belgian sacrifice (like the French suffering) was also seen as redemption of a decadent, secular, and pornographic France, which had been heavily criticized by the Spanish traditionalism of the *belle époque*, in books like *El frente espiritual* [The Spiritual Front] by Gabriel Alomar, or in articles by Miguel de Unamuno, for whom the war of 1914 would already have been worthwhile simply for having saved France from its "immoral" one-child regime and alcoholism. "The poison", writes Unamuno, "is not the poisonous gas, but 'the moral gases' of the old cosmopolitan and artificial Paris."[22]

From Belgium — "the spiritual reservoir of France", if I may use the expression — poets and intellectuals disembarked in the land of Don Quixote, who arrived through patriotic advertising campaigns.[23] This was the case with Maeterlinck, who visited Spain in December 1916 and gave a pretty resounding conference at the *Ateneo de Madrid*, defending two ideas.[24] First, that the Dutch Revolt against Spain and the Belgian Resistance against Germany were different; Spaniards had "an ideal" in the 17th century. Second, that the Flemish were not Germans, but rather Germanized Celts, like the Celts of Ireland and Britain, who looked to France as their spiritual homeland.[25]

In this sense, we must not forget the role played by Belgium in the literary war in favour of the nationalization of Spanish *modernismo*. Let us think of a play like *En Flandes se ha puesto el sol* [In Flanders the Sun Has Set, 1909], by Eduardo Marquina, in which three lines of force intersect:

22 See: Unamuno (1915); Unamuno (1917).

23 Émile Verhaeren was immediately called to defend the homeland, and made his position clear before he died in Rouen Station.

24 Conference in Madrid on December 9, 1916. The visit of Maeterlinck, a well-known author thanks to the translation of his most important works, had great impact in Spain. There were chronicles in various media, also in *Cervantes*, run by the Ecuadorian writer César E. Arroyo.

25 The Belgian Symbolist poets and painters were a source of inspiration for the first Spanish *modernismo*. This applies, for example, to the short novel *Bruges-la-Morte* [The Dead City of Bruges] by Rodenbach (1892), who created the myth of the "motionless city". See: Cuvardic García (2013).

The wars of Flanders had marked the breakup of Spain with
Europe, leading the country to decline and secular isolation.
Flanders as the incarnation of modern Belgium could be used
as an alternative to French "satanism",
i.e. like a kind of healthy and peasant "third way" to the
Babylonian *modernismo* of Paris.
This healthier *modernismo*, alternative to the decadent, could
be acceptable when nationalizing the modernist rhetoric
in Spain, much publicized by the Spanish press, especially
the conservative faction.[26]

Marquina's work was an attempt to *create* homeland
against *inherited* homeland. The premiere was supported
by the Spanish King, Alfonso XIII, who called Marquina to
the balcony, and can be considered part of the project of
doma de la quimera [taming the chimera], as labelled by
Mainer,[27] in favour of a purist Europeanization of Spain.[28]

However, Flanders was not the only path to modernity
of the symbolic discourse of Spanish culture. Not to be
forgotten is that England had launched itself from the
start into battle with the words of Rudyard Kipling: "The
Huns are at the gate."[29] What happened was that the de-
fence of the Anglo-Saxon was given only in some poetic
circles directly related to British mercantilism, especially
through the commercial ports: the Canary Islands (Tomás
Morales), Santander (José del Río Sainz), and Portugal.
This was the case with intellectuals like Ramiro de Maez-
tu, the Portuguese Guerra Junqueiro,[30] and Teixeira de
Pascoaes, who converted London into a holy city: *Grande
Jerusalem no meio de calvarios* [Great Jerusalem in the
middle of calvaries].[31]

In the case of Santander, José del Río Sainz and his
great poems stand out: *La belleza y el dolor de la guer-
ra* [The Beauty and Pain of War, 1922]. On the Canary

26 Marquina, *En Flandes se ha puesto el sol* [In Flanders the Sun Has
 Set, 1909].
27 See: Mainer (1988).
28 Quintana Pareja (2007).
29 "For all we have and are/ for all our childrens' fate/ stand up
 and take the war./ The Huns are at the gate." Rudyard Kipling,
 Verse: 1885–1918 (1922: 174).
30 Guerra Junqueiro (1918).
31 Teixeira de Pascoaes (1925: 4).

Don Quixote in the Trenches
The Birth of Avant-Garde Poetry in Spanish Language
between Civilization and Barbarism

Islands, Tomás Morales was able to combine his Anglophilia with a purist sense of patriotism. In "Los himnos fervientes" ["The Fervent Hymns"], a section in his book *Las rosas de Hércules* (1919) he regarded England as heir to imperial Spain. In this context, he published a poem called "Britania Máxima", along with "Oda a las glorias de don Juan de Austria" ["Ode to the Glories of Don Juan of Austria"], but, at the same time, he tried to reconcile both points of view with a poem titled "Elegía de las ciudades bombardeadas" ["Elegy of Bombed Cities"], and a song of peace. After all, these Anglophile poets argue that English free trade promotes peace.[32]

In the case of the "Ode to the Glories of Don Juan of Austria", Morales presents to the British, as new defenders of the Mediterranean, the Latin sea. In the same way as the Spanish — commanded by Juan of Austria and with the participation of Miguel de Cervantes — had stopped the invasion of Turkish "barbarism" in Lepanto, the British would be the heirs of Hispanic civilizing imperialism, aimed at stopping German barbarism. This was a culturally intelligent way to answer the German propaganda against England.[33] Otherwise, one could not miss Tomás Morales' Belgian note:

> Esta tarde he leído a Rodenbach.
> El día ha sido el más propicio que hubo en todo el verano [...].[34]

32 See: Morales (1914: 227–230).

33 We have to consider the pamphlet by Werner Sombart, *Händler und Helden* (Leipzig, 1915), that identifies German culture with a tendency toward absolute and heroic sacrifice in the name of high ideals, against the individualistic materialism of the Anglo-Saxon "culture of shopkeepers" and of the French ideas of 1789. See: Buruma/Margalit (2004: 49–73).

34 "This afternoon I read Rodenbach./ The day has been the most propitious there was all summer [...]." Transl. from: Morales (1919: 49).

In the Trenches of Flanders

The positions of two young Hispanic poets educated in the *modernismo rubendariano* [Rubén Darío's *modernismo*] draw attention in this regard: the Peruvian Alberto Hidalgo — defender of Germany and the Kaiser — and Nicaraguan Salomon de la Selva — enlisted soldier in the British Army sent to Flanders.

For Alberto Hidalgo, the exaltation of Germany represented a way to eliminate the *modernista* rhetoric, an attitude of avant-gardism — in a literary and military sense — in a Futuristic style. In poems like "Canción de la guerra" ["Song of War"],[35] he exalts warmongering and the figure of Kaiser, elements that in his opinion (rightly) foreshadow the arrival of modern times, pulsating, full of vigour and energy. It is an act of avant-gardism and rupture:

> Canta la guerra el torvo clarín de mi lirismo
> en este siglo de civilización,
> el Siglo en que los hombres despiertan de su sueño,
> el Siglo en que ha perdido la táctica de Dios [...]
> el Siglo en que a las Razas las va seleccionando
> el *superdreagnout* i el cañón
> i las bombas de incendio del bravo aeroplano
> i del obús 42
> i el corazón sonoro del kaiser, que arde como
> volcán en erupción,
> i el espíritu recio de la raza germana,
> de esa raza que tiene los cabellos de Sol.[36]

Hidalgo configures himself as a counterpart of Ruben Darío and *modernismo*, in a Futurist-iconoclastic exaltation of war as "the world's only hygiene". He uses the same words and rhetoric of *modernistas* — for example in "Oda a Roosevelt" ["Ode to Roosevelt"], by Darío — so

35 Hidalgo (1917: 131–134).
36 "Sing the war the fierce clarion of my lyricism/ in this age of civilization,/ the Century in which men awaken from their sleep,/ the Century in which has lost the tactic of God [...]/ the Century in which Races are being selecting/ by the *superdreadnought* and gun barrels/ and fire bombs of the brave airplane/ and of the howitzer 42 [so the German Big Bertha — E.Q.]/ and the sonorous heart of the Kaiser, burning as/ an erupting volcano,/ and the mighty spirit of the German race,/ of that race which has the hair of Sun." Transl. from: Hidalgo (1917: 131–132).

Don Quixote in the Trenches
The Birth of Avant-Garde Poetry in Spanish Language
between Civilization and Barbarism

it can be very useful to analyze his poems in Spanish using the concept of "models" and the "polysystem theory", according to Even-Zohar.[37] Hidalgo, like Carrere, identifies Germany with modernity and its catastrophes, but in a Futurist and unusual attitude for the time, embracing a provocative avant-garde spirit:

> La Guerra es como un brazo del Progreso. La Guerra
> purifica las Razas con férreo poder.[38]

Hidalgo wrote from the comfort of his home in Lima. However, Salomón de la Selva — who was secretary for Rubén Darío in the United States in 1916 — wrote, or maybe took notes regarding what he saw, in the trenches, since he fought in Flanders as a volunteer soldier in the Royal North Lancashire Regiment, out of which experience came the journal of the poetic campaign titled *El soldado desconocido* [The Unknown Soldier; Fig. 3].

Salomón de la Selva was enrolled at the end of the war, when the hopes of a quick conflict had long since vanished, and the war had had time to show its true face; the myth of the early days had been transformed into a nightmare of horror. In *The Unknown Soldier*, the frontman of Rubén Darío sees the future approaching with the speed of a bullet:

> La bala que me hiera
> será bala con alma.[39]

The war provokes Salomón de la Selva to get rid of the *modernista* wardrobe, whose "lyre" had been twisted into "barbed wire", and instead to create a new poetry in touch with reality, touching the crown of thorns of a modernity that was still expected to bring some redemption to the world:

37 Even-Zohar (1997: 15–34).
38 "War is like an arm of Progress. War/ purifies races with ferrous power." This exalting war Futurism connects with German militarism but enters into conflict with many of the German avant-garde poets, who saw in war a disaster. Transl. from: Hidalgo (1917: 133).
39 "The bullet that hurt me/ will be bullet with soul." Transl. from: de la Selva (1922: 34).

NATIONALISM AND COSMOPOLITANISM IN THE AVANT-GARDE AND MODERNISM
The Impact of the First World War

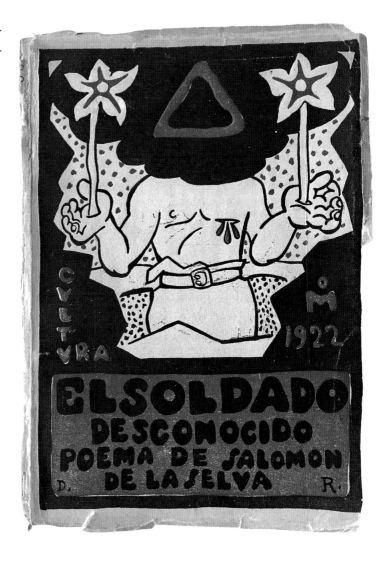

La lira es cosa muy barata.
¡Quién no tiene lira!
Yo quiero algo diferente.
Algo hecho de este alambre de púas; [...]
Aunque la gente diga que no es música,
las estrellas en sus danzas acatarán el nuevo ritmo.[40]

The new rhythm was the rhythm of reality and the prosaic, already cured of the *modernista* madness: "Ya me curé

40 "The lyre is a very cheap thing./ Who does not have a lyre!/ I want
 something different./ Something made with this barbed wire; [...]/
 Although people say that is not music,/ the stars in their dances
 abide the new rhythm." Transl. from: de la Selva (1922: 42–43).

Don Quixote in the Trenches
The Birth of Avant-Garde Poetry in Spanish Language
between Civilization and Barbarism

de la literatura" ["I have already recovered from literature"] reads the quixotic poem called "Carta" ["Letter"]:

> Ya me curé de la literatura.
> Estas cosas no hay cómo contarlas.
> Estoy piojoso y eso es lo de menos.
> De nada sirven las palabras.[41]

The renovation of the *modernista* spirit of Salomón de la Selva bypassed the avant-garde iconoclasm, but tried to save the best of the modern tradition through a rational analysis of reality. In his prodigious poem "Prisioneros" ["Prisoners"] we see the two Germanys eye to eye that the Pío Baroja spoke of:

> Son gente.
> De eso no cabe duda.
> Gente como nosotros.
> que come, que duerme, que se entume, que suda,
> que odia, que ama.
> Gente como toda la gente,
> Y sin embargo diferente.
> Como les hemos arrancado
> todos los botones,
> caminan agarrándose
> los pantalones,
> y llevan el cuerpo doblegado.
> Pudiera ser cansancio,
> pero no es eso.
> Pudiera ser vergüenza…
> En fin, qué nos importa:
> ¡Son nuestros prisioneros!
> Está prohibido darles cigarrillos.
> Bien. Se los daré a escondidas.
> Alguno de ellos debe de haber leído
> a Goethe; o será de la familia de Beethoven
> o de Kant: o sabrá tocar el violoncelo…"[42]

41 "I have already recovered from literature./ It's not possible to tell about these things./ I'm lousy and it's of no concern./ Words are useless." Transl. from: de la Selva (1922: 69).

42 "They are people./ That's for sure./ People like us./ eating, sleeping, getting numb, sweating,/ who hate, who love./ People like all people,/ And however different./ As we have plucked/ all their buttons,/ they walk clutching/ their pants,/ and carry the body bent./ It may

NATIONALISM AND COSMOPOLITANISM IN THE AVANT-GARDE AND MODERNISM
The Impact of the First World War

He recognizes in the German prisoners the nation of *Dichter und Denker*, of poets and philosophers who had opposed Napoleon (Goethe, Kant, Beethoven…). Recognizable is the idealistic Germany of *Kultur*, preceding the Prussian militarism and *Kulturkampf*,[43] the Germany to which he will leave the idealization of Don Quixote as romantic hero (Schelling).[44]

Code

Knights and myths in the war, or war as cause of the emergence of the avant-garde in Spain? The modern warfare that Salomón de la Selva experienced had little to do with the first months of the conflict, when the clash of civilizations sought their reference points in founding and "premodern myths". These were myths such as that of the French Joan of Arc, of which Spanish writer Ramón del Valle-Inclán reminded readers repeatedly, or the myth of the "Angels of Mons" for the English.

"The Bowmen" (1914) is a short story published by Arthur Machen in the *London Evening News* that was taken by the public as an account of real events on the battlefront.[45] The story tells how St. George had saved British soldiers by calling in the aid of the archers of Agincourt, who descended from heaven shooting arrows on the Germans in the Belgian city of Mons in August 1914. Immediately, the story spreads as a war legend by word of mouth. Many claimed to have seen the emergence of the "angels"

be fatigue,/ but that's not it./ It could be shame…/ In the end, what matters to us:/ They are our prisoners!/ You may not give them cigarettes./ All right. I'll give them secretly./ Some of them must have read/ Goethe; or be of the Beethoven family/ or of Kant's: or know how play the cello…" Transl. from: de la Selva (1922: 64–65).

43 To cope "Kultur" vs. "Civilization", see: Pick (1993) and Steiner (1971).

44 "De Alemania salieron la filosofía, la ciencia y la música.
De Inglaterra, el derecho del más fuerte, la opresión y el látigo.
De Francia, la morfinomanía, el aborto y el volterianismo.
De los Estados Unidos, la ley de Lynch." ["From Germany came philosophy, science and music. From England, right of the strongest, oppression and whip. From France, morphinomania, abortion and voltairianism. From the United States, lynch law."]. See: *Renovación Española* 30 (August 22, 1918: 4).

45 Machen (1915: 23–31).

Don Quixote in the Trenches
The Birth of Avant-Garde Poetry in Spanish Language
between Civilization and Barbarism

at Mons, fighting alongside the British soldiers. War censorship contributed to the extension of the legend.

This episode of the British Santiago Matamoros [Saint James Matamoros] from the story by Machen effect is part of the struggle of cultural myths related to the pre-modern past of the combatants which took place at the beginning of WWI. In this context we can place the figure of Don Quixote — elevated after the Spanish military defeats of the 19th century — as a symbol of the Latin and Hispanic, one that could remove the decay of the Latin nations by way of the ideal.

However, what began as a war of nations fighting under the epic sound of military marches, ended as a conflict that finally pushed the world into modernity through a huge bloodbath. In Spain the war was a boost to modernization, and not only from an economic standpoint. War ultimately was the direct cause of the outbreak of the avant-garde in Spain and Hispanic countries.

Georgian Modernism, National Expectations, and the First World War

Bela Tsipuria
Ilia State University. Tbilisi, Georgia

Abstract

Located on the borderline of Europe and Asia, and being then a part of the Russian Empire for more than a century, Georgia was set apart from the flames of the Western and Eastern Fronts of the First World War. Despite this, as members of the troops of the Russian Empire, 300,000 Georgians, 13% of the Georgian population, participated in WWI. While the Russian Empire was taking part in the war, and Georgian servicemen were giving their lives, the Georgian public did not really support the Russian imperial propaganda, and until 1917 the war did not have any direct impact on Georgian social consciousness. However, there were still some expectations that the war might change the imperial order and Georgia might be given an opportunity for independence. This indeed happened with the October 1917 Bolshevik Revolution and the collapse of the Russian Empire. For the next few years, Georgia enjoyed a free statehood as the Democratic Republic of Georgia (1918–1921).

These few years became for Georgia an intense period of self-identification in the changed world on one hand, and a time for the most passionate modernist/avant-garde activities on the other. Georgian modernism openly supported and further developed the idea of the Georgian nation's self-identification and self-establishment in the rapidly changing world. With the annexation of Georgia by Russian Bolsheviks in 1921, modernist activities were cut short; however, until the end of the 1920s Georgian modernists somehow continued working within a modernist aesthetic. A few texts by Georgian modernists recalling the experience of WWI appeared in the early 1920s: Paolo Iashvili's poem "Evropa" ["Europe"], Mikheil Javakhishvili's novella "Lambalo da Kasha" ["Lambalo and Kasha"] and Grigol Robakidze's novel *Gvelis Perangi* [The Snake's Skin] are among them. All three texts recall WWI and the historic circumstances preceding the Georgian reality of the 1920s with some regret, since the war could not prevent the rise of Bolshevik power in Russia and its control over neighboring nations.

Key words

Georgia, Transcaucasia, modernism, Symbolism, avant-garde, imagined community, literature

Georgian Modernism, National Expectations, and the First World War

The First World War, Europe's Political Map, Georgia

By the time the First World War started in 1914, Georgia had been a part of the Russian Empire for more than a century;[1] by the time the War was over, the country was given a chance of being decolonized and established as a free democratic state. The historic circumstances which developed during WWI caused the collapse of four empires, the Russian Empire among them. The war also made possible two revolutions in Russia in 1917: the February Revolution and the Bolshevik October Revolution. After the Revolutions, for a while the Russian center lost control over a few national territories, including Georgia.[2] These few years became for Georgia an intense period of self-identification in the changed world on one hand, and a time for the most passionate modernist/avant-garde[3] activities on the other. These mutually influential tendencies had an impact on Georgia's establishment as a free state. On the map of Europe, fundamentally changed during and after WWI, the Democratic Republic of Georgia (May 26, 1918–February 25, 1921) appeared. The state was, though, short-lived and existed only until the Bolshevik

1 Russian colonization of Georgia started in 1801 when the Georgian Kingdom of Kartli-Kakheti was colonized by the Russian Empire. See: Bendianishvili (2008); Rayfield (2012: 250–264).

2 New states were formed after the fall of the Russian Empire: Finland, Poland, Lithuania, Latvia, Estonia, Azerbaijan, Armenia, and Georgia. Georgia's statehood is rooted centuries Before Christ. In the late medieval period, as an Orthodox Christian country surrounded by Muslim super-states, it struggled to preserve its own identity, and established a military partnership with the Russian Empire in 1783. However, for Georgia this resulted in 1801 with loss of sovereignty and incorporation into the empire. In May 1918 Georgia, as well as two other Transcaucasian nations, Armenia and Azerbaijan, announced its independence. However, within a few years, Bolshevik Russia restored imperial power in Transcaucasia, and all three states were annexed from 1920 to 1921. On February 25, Bolshevik Russian troops occupied Georgia. In December 1922, all Transcaucasia became integrated into the newly formed USSR, and from 1936 they were formed as Soviet Socialist Republics within the USSR, see: Urushadze (2005); Urushadze (2009); Rayfield (2012: 339–366).

3 Modernist/avant-garde cultural style quickly became dominant in Georgia in the 1910s, thanks to strong interest among young Georgian poets. In 1917–1921 they were joined by poets and artists in exile from the former Russian Empire. In the 1920s, despite Bolshevik-Russian power gaining control over culture, modernism and the avant-garde still prevailed in Georgia. See: Magarotto (1982); Magarotto (2006: 73–91); Tsipuria (2011: 299–322).

Russian annexation. However, this created the precedent of Georgia's establishment as a European-style democratic republic, and in 1991, after the collapse of the USSR, this legacy was used as a foundation for the new independent state of Georgia.[4] At the same time, the cultural legacy of Georgian modernism/avant-garde was clearly seen as a ground for Georgia's reestablishment within the Western cultural space from which, thanks to this experience, and to ongoing interest towards synchronic processes in Western culture, it was not fully detached even in Soviet times.[5]

Georgian Modernism, WWI, and National Expectations

Why is the modernism/avant-garde experience so important for Georgia? In part, it exposes the nation's aspiration towards a modern Western cultural integrity and devotion to the aesthetical and philosophical views of modernity and modernism. Moreover, Georgian modernism openly supported and further developed the idea of the Georgian nation's self-identification and self-establishment in the rapidly changing world.

In Georgia, efforts to retrieve national independence from the Russian Empire started right after the colonization. Georgian literature, namely the works of the Georgian

4 Just before the formal dissolution of the USSR in December 1991, in October 1990 multiparty and democratic parliamentary elections were held in Georgia. After the March 1991 referendum on independence, independence from the Soviet Union was declared on April 9, 1991, announcing the restoration of the Democratic Republic of Georgia, and the readoption of the Georgian constitution developed and adopted during those years. See: Rayfield (2012: 381–401).

5 The chronology of Georgian modernism — the decade of its flourishing in 1916–1926 and, after that, more than five decades of Soviet ban — is greatly impacted by historical processes. In the 1930s, with the establishment of Stalinist/Soviet cultural reality, modernism/avant-garde was banned in the whole USSR, and it was also erased from Georgia's cultural memory. Studies of Georgian modernism/avant-garde have only emerged in recent years. See: Lomidze/Ratiani (2016); Bregadze (2013). In some way this is relevant to the position which is traced throughout the book by Madelyn Detloff: "[…] the historical development and redeployment (in patched form) of a modernism that is not 'absolute', but rather dynamic and co-evolving with (neo)imperialism and its violent effects." Detloff (2011: 4–5).

Romanticists, was the major area for developing national ideas. This process was advanced by the generation from the 1860s under the leadership of poets, prose writers, and national leaders, Ilia Chavchavadze and Akaki Tsereteli. Ilia Chavchavadze envisaged Georgia's perspective in the context of European approaches to nationalism, adopting the experience of various European nations in the development of their national identities as a part of the paradigm of modernity and the formation of nation-states in Europe. While Georgia was still part of the Russian Empire, Chavchavadze drew the imaginary borders of the future Georgian state, and established an "imagined community" (to evoke Benedict Anderson)[6] of Georgians. Thus, he asserted for Georgians a separate cultural and social space within Georgia's historic territory, set apart from the Russian imperial context and closer by means of values to the context of European integrity.[7] He developed the modern understanding of national identity and social responsibility in Georgian society. He was setting the nation's goals for self-organization, development as a modern society, unification towards a better future, and preparedness for the prospect of freedom from the empire and establishment as a nation-state. This opportunity was presented to Georgians by the historic changes caused by WWI. It was the next generation of Georgian writers, Georgian modernists, who picked up the baton and carried forth the task of the nation's self-comprehension.

Located on the borderline of Europe and Asia, Georgia was set apart from the flames of the Western and Eastern Fronts of WWI. However, as Russia was the first to announce full military mobilization in July 1914, 300,000 Georgians, 13% of the Georgian population, participated in WWI as troops of the Russian Empire.[8] As the Russian

6 Anderson ([1983] 1991).
7 This was achieved by Ilia Chavchavadze not only through his influential literary texts but also his social activities as a public figure and, of course, through his numerous public essays, which he was publishing almost daily in the 1870s–1890s, which often contained observations on the social development of European countries, the national aspirations of European nations, and relations between the super-states and small nations.
8 On Georgia's participation in WWI see: Tsitaishvili (2014: 9–21); Gotsiridze (2014: 150–158).

Fig. 1

Above the fold of the
Georgian newspaper *Sakartvelo*
[Georgia] 8 (May 31, 1915)

Empire was also involved in the Caucasus Campaign,
the armed conflict with the Ottoman Empire, Georgian
military units of the Russian Army participated in the
Campaign. The Georgian cities of Tbilisi and Batumi were
also part of the home front. Georgian newspapers (Fig. 1),
of course, covered WWI, and Tbilisi social circles were
actively involved in charity organizations in support of
Georgian soldiers.[9]

Interestingly, a very productive journalist Mikheil Java-
khishvili[10] from July to August 1915 published almost dai-
ly war reports in the newspaper *Sakartvelo* (საქართველო

9 Nino Tabidze, the wife of Georgian Symbolist poet Titsian Tabidze,
 mentions in her memoirs that during the War a charity Chaikhana
 Bazar café (ქართული ჩაიხანა [The Georgia Tea House]) functioned
 in Tbilisi in support of Georgian servicemen. This café was
 a gathering place of the Georgian elite, including young Georgian
 modernists. See: Tabidze N. (2016: 28).

10 See: Javakhishvili (2001: 477–536).

[Georgia], 1915–1921).[11] He had debuted with his short stories in 1903, but soon took a long artistic pause until 1920, when he established himself one of the most famous Georgian writers, praised for his modernist psychological prose.[12] Most of Javakhishvili's reports give detailed information on the latest happenings in the war scene, as well as brief but logical explanations of the motivations or tactics of different states and protagonists in the war.[13] As we learn from the reports, his observations were based on regular telegrams delivered to staff at the headquarters. Most of the reports describe current military operations, however occasionally Javakhishvili also published his analytical essays on the topic. For example, in the essay "Omis Bedi" ("ომის ბედი" ["Destiny of War"]) he tries to see the nature of unavoidable conflict in the wider context of humanity and human psychology.[14] In 1915 Javakhishvili worked in the Red Cross office in Tbilisi, and in January 1916 himself joined the war effort and served in the Persian Campaign, beginning as an administrator at the 5th Red Cross hospital in Salmas County, Iran (Fig. 2) and, for a while, as an attorney of the Georgian corps of the Russian Army.[15]

However, WWI did not actually become widely depicted or analytically approached in Georgian literature; within literary circles we cannot see any clear messages reflecting the public attitudes of Georgian society or culture of that time towards the war.[16] We may assume that the war was not actually accepted with patriotic feelings by the

11 This daily newspaper covered politics, economics and also literature.
12 Mikheil Javakhishvili was one among a number of Georgian writers and cultural figures to be executed by the Soviets during the Great Purge in 1937. See: Elbakidze/Ratiani (2016). On Mikheil Javakhishvili see: Rayfield (2010: 237–249); Tsikarishvili (2002: 339–356).
13 These reports have been only recently republished in the collection of his essays in 2001. See: Javakhishvili (2001).
14 Javakhishvili (2001: 485–488).
15 Javakhishvili K. (2000: 138–142).
16 We cannot say the same about WWII, or the Great Patriotic War as it is named in Russia and previously in the USSR. The number of literary text and films dedicated to the war in Georgia is impressive. The war is always approached with Soviet patriotism; however this can be explained by strong Soviet propaganda, ongoing official orders, and budgetary support from the center, as the depiction and commemoration of the Great Patriotic War was an essential part of the Soviet cultural and ideological agenda.

Fig. 2

Photograph of Mikheil
Javakhishvili (left) as the
administrator of the 5ᵗʰ Red
Cross hospital in Salmas County,
1916–1917

Georgians, since those feelings would be, logically, reflected in Georgian literature or printed media. Although the Russian Empire was taking part in the war, and Georgian servicemen were giving their lives, the Georgian public did not really support the imperial agenda of the war, and until 1917 WWI did not have any direct impact on Georgian history or social consciousness. However, through a few notable mentions we may assume that some expectations of political changes and liberation from the empire did occur among Georgians.

Mikheil Javakhishvili, in his obituary for Akaki Tsereteli, who died on January 27, 1915, reconstructs a dialogue between them that occurred two months earlier. Akaki Tsereteli admitted that he hoped that God would mercy him with another couple of years of life, enabling him to see the "TIME"; he was hoping that during the world thunder. As he said: "[...] our bell would also ring, and when the total flame will be gone, our candle may lighten."[17]

17 Javakhishvili (2001: 475). All translations from the Georgian and
 Russian are by the author, unless otherwise indicated. — B.T.

In 1917, two revolutions happened in Russia, which had a great impact on Georgia. As the Russian Army was weakened in WWI and the monarchy became overwhelmed by the resultant political and military challenges, under pressure from the February Revolution Tsar Nikolas II abdicated and governance was taken over by the multiparty Provisional Government. This was greeted by Georgians. The poem "Droshebi Chqara!" ("დროშები ჩქარა!" ["The Flags, Fast!"], February 1917) by Galaktion Tabidze, aesthetically affiliated with Symbolism and the greatest Georgian poet of the 20th century, reflects the strive for freedom and excitement at the prospective liberalization of the Russian Empire and the independence of Georgia.[18]

By the end of 1917, Russia's multiparty government had been forcibly substituted by the one-party Bolshevik government led by Lenin, following the Bolshevik Revolution of October 25, 1917. After that, Russia left the international theater of the war and became immersed internally in civil war. These few years of chaos created the chance for a new order for Georgians and several other nations. In November 1917, together with Azerbaijan and Armenia, the Transcaucasian independent government was formed in Tbilisi, and in May 1918 they split and all three nations were established as independent states. May 26 was the day when Georgia's independence was proclaimed in Tbilisi. Two days later, on May 28, both Armenia and Azerbaijan proclaimed their independence; these events also occurred in Tbilisi. The Democratic Republic of Georgia was established, a historic benchmark for a nation with deep historic and cultural roots, willing to be a part of the modern world.

Georgian modernists were, of course, major figures that supported the narrative of modernization in Georgia. Although the new state had its political leadership, the tradition from the 19th century, when Georgian poets were accepted as national leaders, was still active. Now it was the turn of the new generation of Georgian writers to

18 See: Tabidze G. (1977: 171). Soviet literary criticism, while following the agenda of Sovietizing Galaktion Tabidze, suggested a misinterpretation, or ideologized interpretation, of this famous poem, insisting that the poet is greeting the rise of Bolshevism and the Bolshevik revolution in Russia. See: Tsipuria (2016: 50–70).

NATIONALISM AND COSMOPOLITANISM IN THE AVANT-GARDE AND MODERNISM
The Impact of the First World War

gain a voice, and to verbalize the new postcolonial goals of the nation. By that time, this new generation was already coherently formed as the Georgian modernists. In their essays and poems, they had already started to find formulations and approaches to the ideas of nationalism, cosmopolitanism, to Georgia's national reestablishment, and cultural integration with European culture. Georgia's political choice of being formed as a Western-style state was indeed based on values familiarized through Georgian culture. While the leading Social-Democrat (Menshevik) Party was propagating the ideas of transnational and cosmopolitan politics, Georgian modernists were articulating national ideas and seeing their own cultural mission from the angle of developing a new national identity. The language of modernism was actually applied to the aspirations of Georgia's spiritual and national renewal. The fact that modernist aestheticism and philosophy was activated towards national goals may not seem particularly relevant to the concept of modernist individualism and the initial role of modernism in big European nations. However, the Georgian case, as with many other national cases, can prove that for nations on the peripheries of Europe, modernism could serve the goals of national self-identification, strengthening the processes of the establishment as a modern nation-state, and inclusion in the European cultural and political integrity.[19]

Although literary texts addressing the issues familiar to modernist philosophy appeared earlier, the publication of the first issue of the Symbolist literary journal *Tsisperi Qantsebi* (ცისფერი ყანწები [Blue Horns])[20] edited by Paolo Iashvili in winter 1916 is considered the formal launch of modernism in Georgia. The name of the magazine was the homonymous literary grouping of the young Georgian Symbolists. During the next couple of years, they

19 The same can be said of many other countries, and not only of smaller ones. For example, the emergence of multicultural modernism is seen as a ground for America's transformation by Werner Sollors. See: Sollors (2008: 10–12). Ukrainian modernism is now discussed from the angle of nationhood and identity. See: Snodgrass (2007).

20 Just two issues of the journal appeared in 1916, although the homonymous group of poets continued publishing other literary journals and newspapers.

managed to change the cultural atmosphere in Georgia, turning Tbilisi into an active modern city.[21] In the first issue of the journal, in his feature essay "Tsistperi Qant-sebit" ("ცისფერი ყანწებით" ["With Blue Horns"]) one of the leaders of the group, Titsian Tabidze, presents the group vision regarding the future of the Georgian nation in the global context. Quoting another leader of the group, the poet, essayist, and prose writer Grigol Robakidze, Tabidze argues that Georgia is on its way to revival, and emphasizes the importance of Georgia's cultural renewal in the context of WWI, ongoing political changes in the world, and the prospective independence of the Georgian nation:

> Grigol Robakidze in his letter to *Golden Aries*[22] wrote: "Georgia's renaissance has started. I feel the truth of these words daily. At this stage, the renaissance is revealed through the battle between the chaos and the form. And still, time is needed for the form to conquer the chaos. These are my thoughts while seeing the growth of Georgian art." We want to believe that the renaissance has started, although the battle of form and chaos will be prolonged.[23]

It is notable that Georgian modernists agree on points that Georgia's revival should be based on new artistic achievements, and that modern Georgian culture should synthesize national and European-modernist features in order to carry a new cultural and national mission:

> [Shota] Rustaveli and [Stephane] Mallarme should meet in the future great Georgian artist. I see Rustaveli as the collective unit of Georgian language, and Mallarme as the collective unit of European Presentism and Futurism. This way is indispensable. Whatever will be the result of the War, it's clear that Europe will enter the door of Western Asia, and we should be ready for this, fully equipped with the national consciousness, with fastened buttons of national

21 This group of Symbolist poets and prose-writers which dominated the Georgian literature in the 1920s. It was founded as a coterie of young talented writers in the Kutaisi city in 1915 and was suppressed under the Soviet rule early in the 1930s. See: Ram (2004: 367–382).
22 This literary journal published in 1913 in the Georgian city Kutaisi, five issues, edited by young Paolo Iashvili. It is considered a predecessor of Georgian modernist journals.
23 Tabidze T. (1916, part 1: 26).

culture, which will be a main pivot, being wrapped with new ideas. We shall do it. Then it will be a real renaissance, and I seriously toast to this national revival with blue horns.[24]

This position of the leaders of *Tsisperi Qantsebi* was shared not only by the group but also by the whole artistic community in Georgia. Grigol Robakidze later developed his thoughts in a more romanticized manner in his essay "Kartuli Renesansi" ("ქართული რენესანსი" ["Georgian Renaissance"]).[25] The founder and the leader of the group Paolo Iashvili in his manifesto "Pirveltkma" ("პირველთქმა" ["The First Word"]) also clearly links the ideas of national revival to the aesthetical renewal, believing that the main force for fulfilling this mission is *Tsisperi Qantsebi*.[26] From the essays by Georgian modernists we also learn that the global changes taking place in Europe and in the world were seen as profitable for Georgia, since political transformations could lead the nation to liberation and restoration of statehood.[27]

Within a year, the main aspirations of the Georgian modernists came into being: Georgia indeed earned a chance of independence with the February Revolution, 1917, and officially restored its statehood on May 26, 1918. While the Bolshevik Revolution and the civil war

24 Tabidze T. (1916, part 1: 26).

25 Robakidze (1917: 2).

26 Paolo Iashvili clearly refers to the ideas of national/state revival through aesthetical renewal and represents the *Blue Horns* as the carrier of this task. Through the clues given in the manifesto we can reconstruct the image of Georgia as seen by Georgian Symbolists at the time of WWI cataclysm in Europe: Georgia is eternal, but now it is a ghost country deep in silence; Georgian people are sparkless and abandoned, but they deserve to be crowned with glory; false preachers have captured the country, but Georgian youth will be unified in the name of the future, and their ideas and energy will bring the revival. See: Iashvili (1916: 3–5).

27 Titsian Tabidze again emphasized the expectations towards restoring statehood in the second part of his essay published in spring 1916: "Today starts the essential transformation of Georgian mentality. The past, shadowed for centuries, is now being revitalized, Georgian tradition of statehood is being revived, the enslaved spirit is getting back to its own nest. The more national consciousness grows, the more we embrace our own past and better shape the national idea. The future of Georgian art will be measured through the development of this idea." Tabidze T. (1916, part 2: 28).

were raging in Russia, Georgia was trying to develop into a peaceful democratic state, ensuring democratic values, like equality and freedom of speech, with laws and in practice.[28] The same year, modernist/avant-garde activities in Georgia grew into an intense multicultural process, as poets, artists, and actors of different nationalities joined the movement, having fled from Russian capitals after the Bolshevik revolution. From the end of 1917 until 1921, the date of the country's next Russian annexation, Tbilisi became a "cultural oasis", the "promised land" to Russian modernists.[29] The free political situation, and the fact that Georgia was separated from Bolshevik and civil war chaos in Russia, announcing its aspirations towards establishing a democratic state organized on the basis of progressive thoughts and modern values, served as an important factor in making Tbilisi attractive for poets and artists from former Russian Empire cities. But it is obvious that the most important factor was the cultural openness of the capital of free Georgia, and the fact that modernist/avant-garde artists from different Russian cities were welcomed by Georgian modernists, and especially by the group *Tsisperi Qantsebi*. Those in Tbilisi were indeed enjoying the free cultural atmosphere and the possibilities to realize even very elite projects, such as book and journal publications, salon gatherings, and various joint activities.[30] The liberal atmosphere of the First Georgian Republic stimulated cultural processes in Georgia. Although the first Georgian modernist texts, journals, and groups appeared one or two years before the country earned its independence, the period of state independence activated a new cultural situation in Georgia. Georgian literature at that time clearly demonstrated its modernist nature and intensified the country's potential of integrating itself with European cultural reality, thus establishing itself as a modern Western-oriented state.

28 See: Urushadze (2005: 21–22).

29 Detailed description and analysis of Tbilisi's multicultural situation and Russian avant-garde developments here is given in Magarotto's and Nikolskaia's books. See: Nikolskaia (2000); Magarotto (1982); Magarotto (2006).

30 Digitalized versions of modernist/avant-garde books, periodicals, and posters are available at: http://www.modernism.ge (accessed: 06.07.2017)

The most active Georgian and Russian modernist/avant-garde groupings in Tbilisi during the multicultural period were *Tsisperi Qantsebi* (ცისფერი ყანწები [The Blue Horns], Georgian), *Tsekh poetov* ([Poets' Guild], 1918–1921, Russian), and *41°* (mixed). An impressive number of literary journals and newspapers were published, and intense poetic discussions, lectures, and declamations were held at various artistic soirees and cafe gatherings. However, it is surprising how fully focused this multicultural community was on their pure artistic goals, and how detached they felt from international or local politics. While Europe was still reeling from WWI and Russia was being reddened with the Revolution and civil war, Georgian, Russian, Polish, and Armenian avant-gardists in Tbilisi were reciting their poems, and discussing the differences between Symbolism, Futurism and Dadaism, or the specificities of *Zaum* poetry.[31] In numerous literary journals published by these groups political and social issues are not addressed at all and European politics and war is simply disregarded, while European literary tendencies or even the smallest poetic nuances are regarded as the most important issues.[32]

31 Alongside chronicles from literary journals, still-preserved posters inform us of various multicultural activities started in early 1918. For example, on January 19, 1918 at the dining hall Imedi a *Zaum* poetry soiree was reported: the lecture "Zaum Poetry or Poetry in General" was delivered by Ilja Zdaniewicz/Ilia Zdanevich, followed by the recital of *Zaum* poems, and in the dispute moderated by Sandro Kancheli the following people participated: Zygmunt Waliszewski/Sigizmund Valishevsky, Sergey Gorrodetsky, Vladimer Gudiev (Lado Gudiashvili), Yuri Degen, Lado Japaridze, Grigol Diasamidze, Kara Darvish, Grigol Robakidze, Titsian Tabidze, Nikolay Cherniavsky, and Paolo Iashvili. On February 11, 1918, at the same hall the Tiflis Branch of Futurist Syndicate introduced a soiree of avant-garde artists. Kiryl Zdaniewicz, Vladimer Gudiev, Ilja Zdaniewicz, Sergey Gorodetsky and Aleksei Kruchenykh delivered speeches, artists drew portraits of guests, walls were decorated, and guests could win some artworks in a lottery. At the end of February 1918, Ilja Zdaniewicz delivered four lectures on Italian Futurism at the *Fantastichesky kabachok* [Fantastic Tavern] etc.

32 Although Kiryl Zdaniewicz/Kirill Zdanevich and Zygmunt Waliszewski, active members of the Tbilisi avant-garde, were mobilized in the Russian Army, the war is not actually recalled in their works or essays. Only Kiryl Zdaniewicz's fellow member of the Tbilisi avant-garde community, Yuri Degen, analyzing Zdaniewicz's artistic biography, believed that the three years (1914–1917) during

Georgian Modernists Recalling WWI

A few important texts reflecting WWI were developed by Georgian modernists. These texts clearly show that for the authors this was "not a Georgian war", and Georgian protagonists were even shown to be somehow detached from the war spirit.

Paolo Iashvili, in his poem "Evropa" ("ევროპა" ["Europe"], 1922),[33] recalls his dramatic feelings experienced during the war when he escaped from Paris in January 1915, quitting his studies at the École du Louvre. Iashvili expresses his devastation at seeing the "chaos of Europe" and "deluge of Europe", and the war is represented from the angle of harm done to people and also to culture, since it is seen as a pillar of European identity: the image of Paul Verlaine appears weeping in Luxembourg Gardens, whilst songless Paris and damaged Reims Cathedral are observed with pain equal to seeing the city in blood. The poem is marked with contrasting images of war and peace, for example while fleeing from blazing Europe, seeing a herd of white cows elicits in the poet a half-crazed smile.[34] In the final lines of the poem something of personal importance is mentioned: the grave at Père Lachaise Cemetery of Alexander (Buchuta) Abashidze — a Georgian officer in the French Army. A special mention of this Georgian who died for France in 1914 near Marne can be seen as a tribute to Georgia's participation and contribution to Europe's survival in troubled times. At the same time, this grave symbolizes some part of Georgia left in Europe, from which the Sovietized country is now disconnected (Fig. 3).

"Lambalo da Kasha" ("ლამბალო და ყაშა" ["Lambalo and Kasha"], 1925)[35] by Mikheil Javakhishvili, depicts the WWI scene in Iran, in the surroundings of Lake Urmia, while the troops and religious missions of super-states like Great Britain, the USA, Russia, and Turkey are

WWI that the artist spent in entrenchments as an officer in the Russian Army, drawing and making sketches, had a significant impact on his perfection in the area of graphic arts. See: Degen (1919: 1–2).

33 Iashvili (1965: 67).

34 The contrasting imagery of the poem is relevant to the poetics of English modernist poetry depicting WWI, and is characterized by dramatic contrasts between England and the front, or pastoral and martial, as analyzed by Steven Matthews. See: Matthews (2004: 71).

35 Javakhishvili (2004: 309–386).

competing for their dominance in Western Asia and in
the world. The writer uses his personal experience and
notes taken while working in Iran during the Persian
Campaign. The narrator and protagonist, a Georgian
military doctor, is sent to serve at the Russian Red Cross
in Iran. While seeing the decline of Persia, a former East-
ern power that was dominant in Georgia in the past, he
observed the changes in history and the struggle of new
powers to gain control over the East and the West. The
Russian Empire is represented as the most ambitious, and
its imperial ideology and colonialist thinking the most
brutal. One of the characters of the novella, Russian Bish-
op Pavel, trying to legitimize Russia's presence in Iran,
insists that if the sacred blood of a Russian soldier is shed
at any place on earth, then the place already belongs to
the empire; it is already a Russian territory. The fact that
in the novel the Russian bishop is represented as a hold-
er of imperial ideology reveals the nature of relations
between the Russian Empire and the Russian Orthodox

Christian church, which has become an imperial institution supporting the empire, and no longer supporting true Christian values. This approach, shown by Mikheil Javakhishvili, emphasizes the frustration of the Georgian nation towards the question of common faith, which, at the end of the 18th century, was the major argument for Georgian kings seeking international military partnership with the Russian Empire, with the hope of preserving the nation's sovereignty and religious faith, and which actually led the country to Russian colonization. By the time the novella is developed, the Russian Empire has collapsed, although the new Russian state has already regained most of the national territories that were previously parts of the empire. Georgia is already Sovietized and Russian-dominated again; the August 1924 Uprising[36] has also been brutally suppressed. Thus, through addressing the issues of Russian imperialism, Javakhishvili represented the unchanged nature of Russian power. Since the novella was written in 1925, the author could represent the historical realities from that time-perspective, but he still did not mention the results of WWI and the Russian Revolution in his narrative. The story itself focused on the fates of characters — or fates of people — who are chased by the destiny, by the history, by the roles of the nations they belong to, and, of course, by their own sins. However, the dramatic process of WWI is shown as the chaos from which the new world order will soon be formed.

Another modernist text, a novel depicting the fate of an individual in the tumultuous time of WWI is *Gvelis Preangi* (გველის პერანგი [The Snake's Skin], 1926) by Grigol Robakidze.[37] The novel can lead us to the assumption that the war was seen by the author as the dissolution of imperial order in the world, leading to a process of self-determination for many nations, including Georgians. The protagonist of the novel, Archibald Mekesh, a modernist artist raised by an English aristocrat

36 The August 1924 Uprising was aimed at restoring the independence of Georgia; it was the culmination of a three-year struggle against the Russian Bolshevik regime. The Uprising was suppressed by the Russian Red Army. About 3,500 Georgians were killed in fighting, and about 12,000 executed or exiled.

37 Robakidze ([1926] 1988).

(his adoptive father), tries to unveil the truth about his ethnic background, which was at that stage kept secret by his natural father. It is significant that the protagonist starts the journey to the truth, to his homeland and his identity with the impulse provided by WWI; when the war begins, all artists gathered in the villa on the Mediterranean Sea of the rich American maecenas, take off to their home countries. Only Archibald Mekesh stays for a while, surprising the host with the response that although everyone has gone back to their roots, he did not go anywhere, since he does not have roots.[38] His mysterious destiny takes Mekesh first to the Middle East and then to Georgia, where he is to learn he is the Georgian Archil Makashvili. He rediscovers his homeland, his paternal family, meets his half-brother, falls in love with his future wife, restores his faith and, thus, regains his identity thereby achieving inner peace and harmony with the outer world. Georgia is shown as a place where the West and the East meet not only geographically, but also spiritually; Western intellectualism and Eastern intuitivism are connected here, enabling an individual to fulfill his or her goals of perception. Through this approach, Grigol Robakidze addresses the philosophical issues of Western and Eastern ways of perceiving the truth, actualized within modernism. However, he also shows how conceptual issues turned into the material problems of state domination and division of power. The chaos in the Western world is seen with great regret, and WWI's global desolation is sketched. This is how Grigol Robakidze depicts Europe and the war in his exquisite manner:

> Three years. Unbearable. Calling from the villa: "The new race" — somewhere far away: as though elaborated. Now the other password: "Genius of Latin" — "Idea of Slavs" — "German spirit" — "The British authority — the dealer or the conciliator of the world"; and many others. And also: Blood. Slaughter. Hunger. Cut legs, separately buried. The crying of cut legs when making mechanical legs. Melancholy of the latter. Buried together with legs. The death of the fetus. The crying of mothers' breasts. The loss of the brother. The death of the father. Friend's disappearance. Farewell to the soldiers' trenches.

38 Robakidze ([1926] 1988: 24).

One eye is blinded. The crying of orphaned soldier. Return of the blind fiancée. The crying of the bride, and despair deepened from the crying. Moans at the station — where postcards are expected. No more cards from one of them. And no more from another. No more from the third. And scream. Scream: of the mother, the father, the sister. The list of the killed. The list of the wounded.[39]

It is significant that the above mentioned texts were developed by Georgian modernists in the early 1920s — the time when WWI was over, the Russian Empire had collapsed, Georgia had enjoyed a few years of independence and free development, relying on the support of European states and British and German troops in Transcaucasia, but the Russian state had regained its power and returned to dominate Transcaucasia. In this historic context, all three texts recall WWI, the historic circumstances preceding the Georgian reality of the 1920s, with some regret, since the war could not prevent the rise of Bolshevik power in Russia and its control over neighboring nations.

It was not really difficult for Soviets to identify anti-Soviet/anti-imperial attitudes in the works of these Georgian modernists, which never really proved their full obedience to the Soviet power. Like many others, they would not survive the Soviet repressions. Grigol Robakidze was forced to escape from Soviet Georgia and spend the rest of his life in Germany and Switzerland; his name and his writing banned in Georgia throughout the Soviet period until the end of the 1980s; before that, the photocopies of his *Gvelis Preangi* were secretly distributed among Georgians.

Paolo Iashvili committed suicide as an act of protest against the regime in July 1937, in the building of the Georgian Writers' Union; Mikheil Javakhishvili and Titsian Tabidze were executed during the Great Purge of 1937. Their writings were banned only until 1956, when Destalinization took place.

Modernism in Georgia, as in the whole USSR, was harshly eliminated by the Soviet power beginning at the

39 Robakidze (1988: 25).

end of the 1920s.[40] Not only aesthetical, but also thematic links to modernist culture were officially restricted, and this was controlled not only by Soviet critics but also by Communist party leaders. Socialist Realism, introduced as a new Soviet cultural style, suggested thematic priorities to writers, such as the Bolshevik Revolution, Soviet collectivization and industrialization, and later WWII. Naturally WWI, as the war of the Russian Empire and not of the USSR, as well as of the formation of nation-states inbetween the Russian Empire and the Soviet-Russian state, was not among these priorities. The cultural tendencies developed by Georgian modernists still continue to serve as an important factor and argument for Georgia's current European cultural and political choices.

40 Although the poets and artists in exile left Tbilisi after Sovietization, Georgians still continued with their work; in 1921–1928, some modernist/avant-garde group activities and publications were still possible in Georgia. See: Tsipuria (2011: 299–323).

Jewish Artistic Networks Around the Great War

The Voice of "Others" and the Utopia of "Yiddishland"

Lidia Głuchowska
University of Zielona Góra, Institute of Visual Arts. Poland

NATIONALISM AND COSMOPOLITANISM IN THE AVANT-GARDE AND MODERNISM
The Impact of the First World War

Abstract

During the Great War, the establishment of a "Yiddish-land" was subject to speculation within circles of the German secret service, but the idea was never realized. This foreign concept considered an underground structure of non-existing political organisms with its tripartite foundation — the traditional religious way of life, the Hebrew language — the medium of men's prayer and study — and Yiddish, the language of daily communication. The Jewish population was dispersed across the length and breadth of Europe and the world. However it was in the lands of the former Polish-Lithuanian Commonwealth, at various times from the late 18th century part of the Russian, Austrian, and Prussian (German) Empires, that by 1914 was home to most Jews. While in Germany and Austria-Hungary, Jews possessed equal legal and civic status almost a half a century before WWI. Under the Tsar's rule, they were exposed not only to political and economic discrimination, but also violent anti-Semitic riots. Under German domination, the major Yiddish and Hebrew dailies, forbidden by the Tsar, were reintroduced in Poland and the secular Jewish system of education was also established in other occupied territories.

The generally assimilationist German Jewish elites established relief organizations to support "uncultivated brothers" in the Central-Eastern European territories. One minor example, the "Intellectual's Club", contributed to a specific "cult of Ostjuden", promoting their culture in the West.

The most radical concept of the Jewish national revival since the beginning of 20th century — Yiddishism specifically promoted by the Kultur-lige — was the idea of establishing a modern secular culture, including visual art, until the Haskala renaissance in the 19th century perceived it a taboo. Representatives of other political movements hoped to create an independent Jewish state in Erec Israel with Hebrew as the national language, integrated with cultural and religious autonomy (Zionists), or radical assimilation. An anational linguistic utopia also emerging within Jewish culture — Esperanto — intended to enable a dialogue between different nations on an equal basis. The significant achievements of Yiddishism were establishing Yiddish literature, with its center in Warsaw (and Paris, Berlin and New York serving as its satellites) and theatre, although under Western influence, the latter lost a part of its authenticity.

As Jews didn't intend to achieve national liberation through military action, their record in WWI does not consist of documents of battles, but of pogrom poetry and paintings. In the avant-garde network, Jewish artists participated on two levels — international, cooperating with groups in the singular household countries and their representatives abroad, and national, or hermetic. While the most specific, syncretic and mimicking aspect of the new visual culture was Jewish Expressionism (close to the Slavic one) flourishing in Paris and Berlin, a second generation invented a specifically Jewish idiom of modernity — typography consisting of only Hebrew letters and creating their own kind of *retour à l'ordre*, a return to the "culture of the Book", e.g. within the "worldwide network of periodicals". Significantly, before this happened, some of them, such as *Makhmadim* and *Yung-Yidish*, consisted of more images than text. During the Great War and in the interwar period Jews as "outsiders acting as insiders" also promoted in Europe and America such cultural novelties as (abstract) film, animation, jazz or tango.

While Jews facing anti-Semitism wherever they lived were perceived as "universal others", the women were doubly suppressed. During WWI and shortly after, they did however manage to establish organizations promoting emancipation and modernization, including marriage customs. Some of the Jewish female designers or art promoters, such as Grete Schütte-Lihotzky and Debora Vogel, established professional positions. The outstanding representation of female artists was the one connected to the Łódź-based circle of *Yung-Yidish*.

During the Nazi regime the Central-Eastern Europe the culture of *sthetl* perished. In 1948 modern Hebrew (Ivrit) was established in Israel, but as a consequence of its delocation and secularization Jewish culture lost its continuity. Nowadays Yiddish literature has a status comparable with ancient Greek, Latin or even Old-Church-Slavic ones, albeit in a more specific sense. Is this not for Central-Eastern Europe a sense of lost cultural diversity?

Key words

Judaism, Yiddishism, *Haskala*, aniconism, *Kultur-lige*, Jewish Expressionism, internationalism, anationalism, Esperanto, multiligualism, assimilation, emancipation, feminism, typography

Jewish *retour à l'ordre* and the Utopia of "Yiddishland" in the Context of International Research

The First World War, being a turning point in European history, served to both intensify the efforts of "small nations" in self-definition, and to accelerate the crystallization of new forms of cultural expression into political action.[1] Several new states re/emerged on the continent, however one significant national project of the period was never realized. A state which established neither national boundaries nor political or international recognition, yet until the Second World War existed as the underground structure of existing political organisms,[2] was not only the dream of its inhabitants, but also the subject of speculation within, for example, circles of the German secret service.[3] This was the "Yiddishland",[4] the *Fatherland* of the new, secular Jewish culture of the Central-Eastern European Diaspora. Efforts to establish it were undertaken by transborder, multilingual and migratory Jewish intellectuals and artists, being in a sense paradigmatic representatives of the international avant-garde and "nomadic modernism".[5] They developed pluralistic concepts of national revival, representing on one side a return to traditionalism, a kind of *retour à l'ordre*,[6] whilst on the other its transformation; more profoundly than in any of the re/emerging European states, as its essence was to break the taboo of mimetic paintings, in other cultures already existing and accepted, in some cases, over thousands of years. A special condition in the establishment of modern Jewish identity and culture around WWI, compared to other "small nations", was the

1 This article is the result of studies carried out as part of the NPRH project *The Yiddish Avant-Garde in Łódź: Critical Edition of Sources* supervised by Professor Krystyna Radziszewska from the Institute of German Studies at the University of Łódź. The references to non-English, German or French publications have been partly omitted, due to their limited accessibility and the size of this contribution. They can be found in other texts by the author related to the similar topic, e.g. in: Głuchowska (2012b); Głuchowska (2012d); Głuchowska (2013f); Głuchowska (2020); Głuchowska (2022a); Głuchowska (2022b).

2 Szymaniak (2005: 18); Geller (2010: 25–32).

3 See: the correspondence by Harry Count Kessler and Eberhard von Bodenhausen. See: Simon (1978: 101–102). For the contemporary usage of the term see: Geller (2010); Głuchowska (2012b).

4 Pollack (2006); Geller (2010: 25–32); Brossat/Klingberg (2016).

5 Benson (2006: 127–142); Lipińska (2017).

6 Ksiazenicer-Matheron (2012: 132).

fact that none of its concepts could be negotiated and promoted within the framework of the local context, the traditional *sthetl* (little town in Central-Eastern Europe), with its tripartite foundation — the traditional religious way of life, the Hebrew language — the medium of men's prayer and study, and Yiddish, the *mame-lushn* [mother tongue] used for daily communication and the language in which most women prayed, wrote, and read.[7] The initiators of its reframing had to operate even more exterritorialy than the representatives of the artistic avant-garde from other nations. In this sense their efforts, as a special "unfinished project of modernism" merit particular interest in the context of the current discourse on aspects of pre-national ethnic formations and the processes of acculturation, assimilation, and the decentering of canons and cultural syncretism, as well as a re/construction of the artistic geography and transfer,[8] whilst remaining a desideratum of the international research in this field. The protagonists are still mainly viewed as specialists, and only seldom in a broader transnational and interdisciplinary sense.

The Central-Eastern European Jews and the Great War

At the time of WWI the Jews did not have their own state and their population was dispersed across the length and breadth of the Old Continent. Nearly every country had a Jewish minority, however it was in the lands of the former Polish-Lithuanian Commonwealth where the greatest concentration of European Jewry lived in 1914. This political organism had been divided among the Russian, Austrian, and Prussian (German) Empires in the late 18th century. After the Congress of Vienna in 1814–1815, the western regions (with its capital Poznań/Posen) and Eastern Pomerania became domain of Prusso-German control, and Galicia (with Lemberg/Lwów/Lwiw/Lviv) part of Austria. The rest of the territory of the old Polish Nobles' Republic was incorporated into Russia. The latest region (including present day Lithuania,

7 Roshwald (1999: 90).
8 Habermas (2001: 13); Kocka (2000: 159–174); DaCosta Kaufmann (2004a: 51–64); Benson/Forgács (2002: 18–20).

part of Belarus and Ukraine, Bessarabia/Romania and Moldova, and parts of Southern Russia), comprised the Pale of Settlement, where most of the Russian Empire's Jewish population was confined by law. Jews also lived in the Kingdom of Poland (Congress Poland) — the former Polish center, under the rule of the Russian Tsar. Only a small well-off minority was authorized to live in the Russian heartland. As a consequence of such political constellation, with the outbreak of WWI Jews were pushed into the service of each of the belligerent armies. In the period of 1914–1921 they became victims of all the ethnic conflicts, revolutions, and civil wars taking place within the region.[9]

Jews faced anti-Semitism in every country in which they lived. However in Germany and Austria-Hungary they attained full legal and civic equality almost a half a century before WWI, while under the Tsar's rule they were exposed not only to political and economic discrimination, but also to violent pogroms (anti-Semitic riots) following the assassination of Tsar Alexander II in 1881.[10]

The outbreak of the world conflict in 1914 brought matters to a head. German and Austro-Hungarian propaganda promised the Jews liberation from Tsarist oppression, which had become even worse during the war. Jews were perceived as a fifth column, accused of collaboration with the Central Powers, and in the Spring of 1915 were deported to Russian territory from the front. With Russian occupation of Eastern Galicia in 1914–1915 the Jews there were exposed to extremely harsh treatment and as Germans and Austrians advanced into these territories and into Russian Poland in the Summer of 1915, the Russian defensive campaign was distinguished by a "scorched earth policy" and systematic pogroms.[11] In the second half of 1915 most parts of Galicia, the Polish heartland and areas to the northeast, became zones of German and Austro-Hungarian occupation, and the similarity between Yiddish and German led to the absorption of Jews into the lower, clerical ranks of the German administrative organs. Jews benefited from the elimination of legal discrimination, of

9 Roshwald (1999: 89, 90, 125); Geller (2010: 26–28); Sonn (2018: 332).
10 Roshwald (1999: 92); Sonn (2018: 332).
11 Roshwald (1999: 92).

which they were victims under the Tsar, and the more liberal conditions stimulated activization of their different political movements, while the successful British military campaign against the Ottoman Empire and the November 1917 Balfour Declaration opened perspectives for the Zionist enterprise in Palestine.[12]

German occupants undertook a kind of civilizing mission, imposing strict sanitary standards among the *Ostjuden* [Eastern Jews] and administration, however their interventions also caused violation of Jewish religious law, such as the breaking of rules of ritual cleansing and burial tradition, or the requirement that all adults remove their headgear for the official snapshots of identification cards.[13]

Tokens of Identity. The "Portable Fatherland"

Jews are often called "Nation of the Book", as the *Torah* and related manuscripts played a pivotal role in the system of traditional religious education. The poet Heinrich Heine defined Judaism of the Diaspora as a "portable Fatherland".[14] Its culture had a tripartite linguistic system, the components of which remained almost completely unscathed throughout the "Yiddishland" (apart from the Soviet Union where old and new Hebrew literature was barely tolerated) until WWII. Since the 1908 conference in Chernivtsi (Tschernowitz/Cernăuți/Czerniowce), Yiddish was recognized as the authentic medium used in everyday life on a par with Hebrew — the language of religion — as the prime token of identity, while languages of residential states, e.g. German, Russian, Romanian or Polish, were the means of communication of assimilated Jews.[15]

In Western Europe Yiddish begun to disappear in the second half of the 18th century, but in Central-Eastern Europe at the beginning of the 20th century it was established as a literary medium by Mendele Moykher Sforim — the grandfather of this process, Isaac Leib Peretz — father, and Sholem Aleykhem — the son. The

12 Roshwald (1999: 101–102, 104, 124).
13 Roshwald (1999: 104, 105).
14 Heschel/Baker (2010: 1).
15 Shmeruk (1989: 285–311); Szymaniak (2005: 221); Głuchowska (2012b: 157).

NATIONALISM AND COSMOPOLITANISM IN THE AVANT-GARDE AND MODERNISM
The Impact of the First World War

multilingual Jewish world of letters of the older generation included bilingual (Hebrew and Yiddish) writers like Peretz, while the younger authors wrote exclusively in one language or another (be it Yiddish, Hebrew, or e.g. Polish).[16] The final phase of the existence of the Jewish modernization experiment was marked by the activity of the "great three" — Peretz Markish, Uri Tsvi Grinberg, and Melekh Ravitsh — in Warsaw, which acquired the status of European center for Yiddish literature, with Paris and Berlin serving as its satellites.[17]

In the time of WWI the society of "Yiddishland" was divided into a number of political movements promoting competing or even mutually exclusive visions of Jewish cultural-political identity. Each of them — from the conservative anti-Zionist *Agudat Isroel* [Society of Israel] on the right to the proletariat Zionists' objective of emigration to Palestine, the members of *Bund* [Federation] and the *Folkspartei* [People's Party] voting for Jewish cultural autonomy on the left — was convinced it held the key to the definition of Jewish modernity. While the most Zionist (with the *Mizrahi* [Oriental Jews] group) organizations and *Agudat Isroel* opted for Hebrew, the others preferred Yiddish as the language of the working man and modern communication.[18] From the current point of view the most revolutionary experiment of the Jewish revival around WWI seems to be the movement of Yiddishism, and its goal to establish an autonomous, modern, secular culture. A special role in promoting this idea was played by the *Kultur-lige* [Culture League; established in Kiev in late 1917 during the early Soviet period, having its dependencies in Białystok, Odessa, Vilnius (Wilno/Vilna/Vilnja/Vilne) and later the special settlement, independent from the communist party, in Warsaw].[19]

16 Shmeruk (1989); Roshwald (1999: 125).
17 Rozier (2011); Szymaniak (2005: 11–13); Katz (2004: 103–107).
18 Some followers of Zionism, such as the *Tseirei Zion* [The Youth of Zion], also accepted Yiddish as an authentic mode of expression and part of Jewish identity in Eastern Europe. During the Third (Polish) Zionist Conference in October 1917 Yiddish was considered as "a complementary language, from which one must pass in stages to Hebrew." Roshwald (1999: 113).
19 Kazovsky (1993: 5–22); Kazovsky (2009: 32–50, 35); Goudz (2008a: 28); Roshwald (1999: 123, 113).

In January 1915, all Jewish publications and theatre stages were forbidden by the Russian government, fearful of the "secret communication of the Jews". Under German occupation, by early 1916, the major Yiddish and Hebrew dailies in Poland were reactivated and partly filled with news translated from German and Austrian sources, becoming a forum of debate on German hegemony in Eastern Europe, whilst adopting an ambiguous stance. Poland's leading Hebrew Zionist daily *Ha-Tsefirah* [The (Horn) Blast; Warsaw], for example, reprinted an article from a Berlin Zionist publication, expressing how simple translations of Yiddish works into German, combined with the prospect of social advancement through the German educational system, could increase cultural assimilation. Thus, by use of content as the argument for the cultivation of Hebrew, the advocates of Yiddish formulated speculative conclusions. To the minds of German, Yiddish-speaking Jews, the best candidates for Germanization could be used to receive support for the Yiddish school network as a first step in a fight for the national autonomy for Jews in Poland.[20]

The internal debates in "Yiddishland" were conducted in paralell to those among the German Jewish elites, largely of an assimilationist orientation, who promoted the idea of a Reformed Judaism that separated religious identity from ethnicity. Perceiving themselves as Germans of Mosaic faith, they distanced themselves from their "uncultured cousins" and from Yiddish as an unseemly jargon, and supported German language education among the *Ostjuden*. Their relief agency *Hilfsverein der Deutschen Juden* also organized material support for the Jews in Poland and the *Ober Ost* [Upper East], similar to a coalition of liberal and Zionist Jews led by Max Bodenheimer — the *Komitee für den Osten* [Committee for the East]. In opposition to the *Hilfsverein*, the *Komitee* insisted on the cultural autonomy of the Polish Jewry, simultaneously claiming that Yiddish speakers could serve as propagators of German influence in the occupied areas. The German authorities protected the formation in 1916 of a Polish branch of the anti-Zionist *Agudat Isroel*, under the patronage of the German rabbinate, and in November of that year formally recognized

20 Roshwald (1999: 115, 116).

the Jewish population of Poland as a religious rather than national minority. This institutional solution to the Jewish question was contested by many members of the younger generation, who questioned the assimilatory attempts of the older one. Their representation was a miniature counter-culture movement of German Jews, acting as censors and translators in the press section of the *Ober Ost* administration in Kovno (Kowno/Kaunas), calling itself the "Intellectuals' Club" (*Klub der Intellektuellen*). Its members were the author of acerbic satirical sketches *Hawdoloh und Zapfenstreich* [Havdalah — Jewish ceremony marking end of Sabbath — and (Military) Tatoo], published in 1925, Sammy Gronemann, the Zionist novelist Arnold Zweig and the artist Hermann Struck, as well as German philo-Semites, among them the modernist poet Richard Dehmel. Inspired by Martin Buber's translations and interpretations of Hasidic tales and legends, published from 1906 on, they contributed to a specific "cult of *Ostjuden*", perceiving Eastern European spiritual wisdom and spontaneity as a remedy to the Western world's moral collapse.[21] The aforementioned political and cultural discourses on the status of Yiddish, widely perceived as a debased dialect of German and reinforcing the German sense of cultural superiority over Eastern European Jewry, such as attempts to Germanize the *Ostjuden* were not comprehensive. The Austro-German policy of issuing proclamations to the Jewish population in 1915–1916 in Hebrew-scripted German instead of Yiddish seem to highlight this.[22] The German and Austro-Hungarian administration also supported Jewish national education in occupied areas, while under Russian domination only a small minority of the Jewish population had access to a modern education at the Russian-language high schools. This was because the Orthodox and Hasidic Jews often opposed the state educational system as a means of secularization and Russification, partly because of the extremely low *numerus clausus* for the Jews, and mostly only absolved traditional elementary religious schools, whilst the German authorities enabled the establishment of the Jewish-run secular educational system for both sexes. In Poland, as a consequence of teachers' strikes

21 Roshwald (1999: 103, 105, 106, 107–111); Isenberg (1999: 172).
22 Roshwald (1999: 112, 118–119); Laučkaite (2015).

in 1917, the obligatory usage of German was abandoned and the Yiddish school network was permitted. *Ober Ost* children of various ethnic groups were able to study in their native languages — Yiddish and Hebrew. In Cracow, under Austro-Hungarian domination, even the Orthodox *Agudat Isroel* party modernized religious education, establishing schools for both boys and girls. During WWI efforts to recognize Yiddish as a national language were also realized through the standardization of language, being on one side the result of publication of several German-Yiddish dictionaries, but also of the initiatives of the editorial boards of the Yiddish-language daily, *Letze Nayes* [Latest News]. They were continued by the YIVO Institute for Jewish research established at the end of the war.[23]

The aesthetic avant-garde admired both Jewish languages in part: the young one — Yiddish — and the ancient one — Hebrew — the language of the prophets, and both, the Orthodox and the Hasidic traditions. In this sense, the members of the Łódź based *Yung-Yidish* [Young Yiddish/Jung Jidysz; 1919–1923] circle, unlike other groups, used the Hebrew inscription of the publication's date on their almanac, connoting a continuation of old Hebrew and new Yiddish culture, cast in the idiom of new European art. Later this union was symbolized by Hebrew inscriptions in Jankel Adler's paintings.[24]

In the discussed context, a paradoxical fact concerning the Yiddishist movement as an intellectual project of modernity should be also maintained: not only as a literary but also as a communicative medium, Yiddish often has to be constituted, even among members of the Yiddish avant-garde. Some of them couldn't speak it — like Ida Brauner, Dina Matus or Zofia Gutentag from the circle of the literary-artistic magazine *Yung-Yidish*,[25] some didn't use it in their everyday lives and received their acculturation and education only in the literary

23 The most Jewish males only attended *cheder* (where they were taught mainly *Torah*) and a small number were able to be sent for serious studies of *Talmud* in *yeshivah*, while girls generally learnt in separate *chadarim* (plural of *cheder*) or at home, receiving elementary knowledge of religion and the ability to read and write in Yiddish. See: Roshwald (1999: 117, 118).
24 Rozier (2010: 35–36); Krempel (1985: 182); Guralnik (1985: 223).
25 Gadowska/Klimczak/Śmiechowska (2019); Głuchowska (2022a).

languages — Russian, Polish, French, German — like Henryk (Henoch) Berlewi, who understood Yiddish, but not enough to write it himself. And — not a well-known fact — they mostly communicated in the languages of the household states, like the *Yung-Yidish* members, who for example would speak Polish during artistic debates. On the other hand, the Yiddish poets, like Peretz Markish, creatively used the polysemiotic senses of the Slavic languages, even in their programmatic manifestoes.[26]

The multiliguality of the Jewish artists destined them to be paradigmatic intermediators, who participated in the avant-garde network on two levels. On an international level its members cooperated locally with Russian, Polish, Romanian or German groups in the singular national household countries and their representatives abroad. Simultaneously, on the national level they had several other local and cross-border contacts and were involved in the artistic life of their Yiddish-speaking communities. Whereas Yiddish-speaking artistic circles were rather hermetic and inaccessible to the non-Jewish outside world due to linguistic barriers, a great number of Yiddish-speaking artists were multilingual and participated in other cultural networks in a local (e.g. Jewish-Russian, Jewish-Polish, Jewish-Romanian) setting as well. It was the reason for the fact that, paradoxically, it was the Yiddish network which often played a seminal role in the circulation of artistic novelties throughout the vast territory of Central-Eastern Europe.[27]

Whilst analyzing the role of language as a token of national identification and the Jewish modernization project of establishing Yiddish as a literary medium and promoting archaic Hebrew as the everyday language of communication during WWI, one should remember that within the described culture a further experiment, being the expression of opposite — anational tendecies — had come to life. In 1888 the ophthalmologist Ludwik Lejzer Zamenhof, born in Białystok, at the time part of the Russian Empire, but would later become a part of Poland, created an artificial language — Esperanto.[28] This began

26 Wolitz (2010: 68–71); Głuchowska (2012b: 157).
27 Głuchowska (2012b: 147).
28 Boulton (1960).

to serve as a universal *lingua franca* of the avant-garde, parallel to particular ones, such as, for example, German, French and later English, which were broadly spoken in the transnational artistic circles, but could be associated with cultural and political domination of certain nations. Zamenhof was assimilated and Russian-speaking, but with his mother he communicated in Yiddish and even wrote grammar for this language as it was still perceived as debased jargon. As Zamenhof believed, Esperanto might enable humanity to overcome the nationalist ideology, with its tendency to lead humanity into open conflicts. This linguistic utopia was intended to enable a dialogue between different nations on an equal basis, and as such became a medium, in which numerous avant-garde publications since the late first decade of the 20th century were published. Esperanto, surely not by coincidence, created by a Jewish intellectual and being a subject of aesthetic experimentalism probably most extensively in the Ukraine region as a part of the "Yiddishland", was a substitute for the lost paradise,[29] the lost unity of the world after the attempt to construct the Tower of Babel.

The Record of the Great War: Foreign Propaganda and the Own Expression of the Decay of the Sthetl

The Jewish record of WWI differs from those of other nations. There is no documentation of the fights or the martyrdom related to specific political liberation. The Jews (like the Poles) served in the armies of all powers dominating "Yiddishland" — Russia, Gemany and Austria-Hungary. However in opposition to other occupied nations they didn't intend to solve the question of their own independence or autonomy in the course of military action.

The residents of the transborder "Yiddishland" were imposed upon by German and Austrian Yiddish-language propaganda, promising them civic equality and liberation from the systematic persecution they had suffered under Tsarist dominance which, with the aid of graphic images, appealed to their nationalist sentiments. An example of this is the sarcastic front-page cartoon of the October 1914 issue of *Kol Mevaser* [The Heraldic Voice], a Hebrew and Yiddish-language publication, produced by the

29 Hjartarson (2014: 267–268, 276, 286, 288).

aforementioned German Jewish *Komitee für den Osten*, featuring Tsar Nicholas II standing in the Jewish cemetery in Bessarabian Kishinev (site of the 1903 pogrom), draped in a prayer shawl, and calling on his dear Jewish subjects to rise up from their graves and help him in his hour of need.[30] The German and Austro-Hungarian war painters such as Max Wislicenus, reared in traditional Jewish culture and facing its familiar fate, acted mostly in the western part of "Yiddishland", meaning the territories of Poland,[31] while the semi-assimilated Jewish artists served for example in the German Army, like Heinrich Tischler from Silesia, who created graphic series related to the war. German propaganda in neutral countries such as the United States also used (partly staged) photographs documenting the destruction of Jewish towns by the retreating Russian Army in 1915, and German soldiers providing Polish Jewish children in cholera-ravaged neighbourhoods with clear drinking water, intended as the proofs of the advance of civilization in the face of "barbarism". On the other side these served record of the ambiguous interest in the traditional Jewish culture as an exotic phenomenon and the negative perception of *Ostjuden*. In the interwar period the Jews themselves used photography as a means of creating of the national myth of "Yiddishland".[32]

The typical specific Jewish descriptions of the *meshiach-tseitn* [Messiah times] of WWI found expression in the pogrom poetry — the genre, which arose in the wake of the 1903 Kishinev (Chișinău/Kischinau/Kischinjow) massacre, full of lamentations and the mockery of Covenantal promises, e.g. in the work by Moyshe-Leyb Halpern, a Galician émigré living in New York, or Peretz Markish, a Russian soldier and witness of the devastations of *shtetlach* (plural of *sthetl*) in the Ukraine.[33] Apart from the Jewish martyrdom documented in such poems, the result of WWI was also a moral decline of *sthetl*, with

30 Roshwald (1999: 103).
31 Brade/Weger (2015: 151).
32 See: articles *International Expressionism…*, and *The Great War and the New Art…* by Lidia Głuchowska in this volume. Roshwald (1999: 103–104); Manikowska (2021); see: text by Teresa Śmiechowska in Gadowska/Świętosławska (2022).
33 Roshwald (1999: 92–95); Głuchowska (2012b: 157).

Fig. 1

Jankel Adler, *Błogosławieństwo Baal Szem Towa* [Rabbi Ba'al Shem-Tov's Blessing], 1918–1919. Private collection, Poland

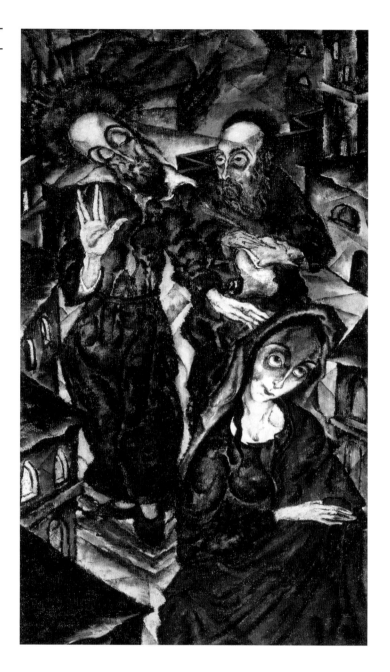

sexual anarchy, the breakdown of social hierarchies and the black market, depicted in Ozer Varshavsky's novel *Shmuglars* [Smugglers; 1922].[34]

In opposition to such negative records the memoirs of the wartime innuendo left Samuel An-sky, a later co-founder of *Kultur-lige* who travelled in

34 Roshwald (1999: 103, 126).

Russian-occupied Galicia as an officer of a governmental accredited relief organization — *Der yidisher khurbn fun Poilen, Galitsye un Bukovina fun tag-buch 1914–1917* [The Jewish Catastrophe in Poland, Galicia, and Bukovina. A Diary of the Years 1914–1917], was able to raise spirits in the postwar period. They included anecdotes, fables and tragic tales reflecting the Hasidic culture of the *shtetlach* and refer for example to cases of the false accusation of Jews being in secret contact with Germans, or the violation of the Sabbath under German occupation. Some of the stories also transfer mystic expression and belief, like those concerning letters disappearing from the writings of the 18th-century founder of Hasidism, Ba'al Shem-Tov (Fig. 1), which had to be saved from the Russian Army or the broken tablets of the law in a destroyed synagogue of Dembitz (Dębica), including fragments of two commandments, "Thou shalt not covet" and "Thou shalt not murder", with word "not" missing from each one.[35]

While Jewish expression in national languages was generally forbidden due to the Tsarist decrees during WWI, the literary production of women, in the context of male dominated traditional culture, was doubly suppressed. One of the underrepresented female writers, whose debut took place at this time, was Breyndl Boym (Bronia Baum). Born in Tomaszów Mazowiecki and originating from a Hasidic family, Boym left several manuscripts (1912–1921) in Yiddish, Polish and Russian and publications (written also in Hebrew and German). Her *sthetl* belonged to the territory, which in the second half of 1915 was dominated by Russians, then Germans, again by Russians and was finally, after the battle of Łódź, one of the bloodiest of the war, taken by the Germans.[36] In her Russian written memoirs Boym mentioned that the local cementery was the burial place of Jewish soldiers belonging to all three armies acting there — the Russian, the German and the Austro-Hungarian. With no true allies, the Jews could become victims of each side: "If there were no Jews, the same famous soldiers would not know any victories (it is mainly we who are the subject of their

35 Roshwald (1999: 94–99). See: text *International Expressionism...* by Lidia Głuchowska in this volume.
36 Lisek (2018: 263–267, 274).

victories, as they win just over us, not their enemies)."[37] While Boym, like An-sky and many historians describing the Jewish fate in Central-Eastern Europe during WWI, states that the Tsarist domination was more suppressive and barbaric than the German occupation, calling the former "the terrible reality" and the latter — "the beautiful dream",[38] she also explains that the Jews not only suffered permanent famine as they were forced to give their last food to the Germans, but also for doing this were often betrayed by their Polish neighbours and punished with hanging by the Russians.[39] "The land of tears and blood" described by Breyndl Boym and other Jewish writers was also captured in numerous paintings by Jankel Adler or Issachar Ber Ryback,[40] depicting the pogroms. Other artists who referred to this martyrdom were not eyewitnesses, such as the Russian Jewish Zionist artist Abel Pann, who spent most of the war in Paris and depicted his war innuendo in the "Yiddishland" in a series of harrowing drawings, drawing the public in the West's attention to the plight of Russia's Jews.[41]

Theatre, Film and Popular Culture

One of the most contradictory and long-lasting experiments within "Yiddishland" culture was theatre. On one side radical, as being the first step in the breaking of the aniconic ban, on the other conservative, possessing as it did its roots in the Hasidic religious tradition of folk songs and the *purim shpil*, the celebration of the Purim Holy Day, it remained at once an emanation of authentic Jewish identity and national emancipation for nearly half a century, yet also being the catalyst for the process of assimilation, transgression and disintegration. Due to its carnival-like art character — in the sense of Mikhail Bakhtin — it appeared as especially attractive to a wide audience in Central-Eastern Europe, especially among the lower-class audience, and the most performative and thus

37 Baum (1912), cit. in Lisek (2018: 280), transl. L.G.
38 Baum (1915), cit. in Lisek (2018: 282), transl. L.G.
39 Lisek (2018: 268, 288–290).
40 See reproductions in: Meidler-Waks (2012: 37–41) and Malinowski (2000: 183–184).
41 Roshwald (1999: 100).

effective, manifesto of the Yiddish avant-garde.[42] In the European context, due to the hostility of Orthodox religious communities, it was formed relatively late, in 1876 in Jassy (Iași, Romania) by Avrom Goldfadn, whose name inspired the description of the whole genre. Coarse humour and simple rhymes characterized its style, while the contrast between modern city life and the *sthetl*, the tension between assimilation and tradition, provided much of its thematic content. The second pioneer of these productions, Jacob Gordin, an émigré who wrote for the New York Yiddish stage, partly integrated components of the moralistic tradition and social radicalism. Between 1878 and 1905 up to the Tsar's edict, it was forbidden to stage plays in Yiddish in the Russian dominated territories. Disregarded on one side by some Jewish intellectuals, pushing for the revival of Hebrew, or the assimilation, concerning it as *shund* [garbage] on the other. Since about 1910, due to its plagiaristic, patchwork, improvised character — also by the aforementioned initiators of the modern Yiddish literature — Peretz, Aleykhem, and Sforim, all three of whom passed away during WWI — it became, in the process of the various stages of evolution, an established and transborder-recognized artistic medium. Even before 1914 followers of the three playwrights drew inspiration from Konstantin Stanislavsky's Moscow Art Theater, while Ester Rokhl Kamińska's renowned Warsaw-based theatrical company also staged a number of their serious dramas.[43]

Soon after the outbreak of WWI, Yiddish theatres were closed down by the Russian authorities, but they reopened in Warsaw, Vilnius and other Polish and Lithuanian cities in the wake of the German advance. The overthrow of the Tsar in the spring of 1917 was followed by the elimination of all restrictions on Jewish culture and the explosion of Jewish cultural productivity in every sphere. An-sky and his followers promoted the professionalization of Yiddish theatre, while the *Fareyn fun Yidishe Dramatishe Artistn* [Federation of Yiddish Dramatic Actors] led by Mordehay Mazo, soon becoming known as *Vilner Troupe* [Vilna Troupe] also replaced the

42 Głuchowska (2012b: 162).
43 Berkovitsh (1976); Roshwald (1999: 120); Głuchowska (2012b: 163).

diversity of accents and dialects typical for the traditional ensembles by a uniform Lithuanian (Litvak) pronunciation of Yiddish, and expected the audience to behave in a refined manner and not interfere with the staging of the plays, so as a consequence the performances also lost some of their authentic earthiness. With the support of the *Ober Ost*'s "Intellectuals' Club" promoting the "cult of *Ostjuden*", the *Vilner Troupe* was not only granted use of the old circus building downtown, but also the permission to tour Poland and Lithuania, a rare privilege. While German officers who could comprehend snatches of Yiddish attended its performances, under the influence of its sympathizers the group included classical plays by Molière, Arthur Schnitzler and Eugene O'Neill in its repertoire.[44]

The year 1918 and the end of the world conflict heralded a new era in the history of Jewish theatre. Its fragmentation meant the exchange between New York, London and Central-Eastern Europe was over. Shortly earlier, in 1917–1918 the Moscow Hebrew theatre — *Ha-Bima* [The Stage] was established by Yevgeny Vakhtangov, following existing Yiddish ensembles.[45] Theatre stages with an Expressionist touch, designed among others by Dina Matus and Jankel Adler for the plays in Łódź[46] introduced the international visual experimentation to a wider audience and adapted the records of the ethnographic expeditions initiated by the *Kultur-lige* in 1911 and 1916–1917. The masterpiece of the Yiddish artistic theatre was the staging of An-sky's *Der Dibuk* [The Dybbuk], the mystical story of possession and exorcism in 1920, a month after his death. The *Vilner Troupe* was able to include it in the international Yiddish theatrical repertoire and to gain high recognition for the piece itself, for its artistic merit and for the use of Yiddish as a legitimate medium for national and aesthetic expression.[47] Henryk Berlewi's poster for An-sky's play still remains the blueprint for folkloristic inspirations of avant-garde Yiddish, with

44 Roshwald (1999: 120, 121, 123); Isenberg (1999: 172); Caplan (2018).
45 Roshwald (1999: 123).
46 Radziszewska/Dekiert/Wiatr (2017: XXII).
47 Roshwald (1999: 122).

a typically Expressionist coexistence of explosive word and image.[48] He also designed stage settings and costumes for this play.

In the two decades after WWI the professional Yiddish theatre scene emerged in cities such as Warsaw. It was partly shaped by assimilationist approaches. The *Folks und Jungt Teater* [The Folk and Youth Theatre] founded in 1937 by Klara Segałowicz and directed by Mazo cooperated with Polish directors such as Leon Schiller and Władysław Daszewski, while Marek Arnshtejn collaborated with prominent Polish avant-garde painter and stage designer Andrzej Pronaszko, producing stagings of the best-known works from Jewish repertoire for a non-Jewish audience. The latter also arranged scenes for the *Vilner Trupe* by Jakob Rotbaum. This contradictory attempt at the transmission of the foreign/own cultural experience was partly criticized from both sides — Polish and Jewish — the latter as a betrayal of its own culture.[49]

Apart from these artistic ensembles, there were also small artistic theatres and cabarets like the *Jewish Review*, *Sambation* or *Di Yidishe Bande*, which disappeared as quickly as they were set up, or the Chamber Theatre *Ararat* (established 1927), and the puppet theatre *Chad Gadje* (since 1922),[50] the latter two were founded by a member of the *Yung-Yidish* circle, Moyshe Broderzon and his wife Miriam — the most prominent artistic couple within the Yiddishist movement. Theatre coexisted with mass media and later cinema. In the three most important centers of Jewish community — Soviet Union, USA, and Poland — the Polish one was characterized by the greatest activity and inspiration, influencing the other two. Its film industry was dominated by the Jews — producers, directors, cameramen and actors were all of Jewish origin. It is astonishing that the records of Jewish films from Poland during WWI only include seven items, although until 1917 parts of Polish territory were occupied by the Russians, and some films produced in Warsaw and Vilnius have been registered in the Russian

48 See reproduction in: Frankowska/Frankowski (2010: 27).
49 Leyko (2010: 36); Kuligowska-Korzeniewska (2010); Steinlauf (1990: 164); Głuchowska (2012b: 163); Chudzikowska (2017: 153–211).
50 Rozier (1999).

filmography.[51] It could also be a consequence of the fact that only the German occupation put an end to the Tsarist censors' wartime exclusion of all Jewish themes and language from the cinema. The most important movie created after this turning point was the German *remake* of a pre-war Yiddish play — *Der Gelbe Schein* [The Yellow Ticket, 1918] — with Pola Negri in the main role — set in the Jewish quarter of Warsaw, concerning Tsarist anti-Semitism — the story of a young Jewish woman whose only chance to escape the Pale of Settlement and obtain an education in St. Petersburg is to work as a prostitute.[52]

One of the early postwar period's examples of Jewish interest in experimental film was Henryk Berlewi's Yiddish review of the abstract films by Viking Eggeling. The same author was also fascinated in jazz,[53] while others contributed to the popularization of tango[54] and other novelties of popular culture, such as animation,[55] introducing them to the "Yiddishland" regions, and acting as mediators between them and Western European and non-European countries.

51 These movies were: *Dem chazns tochter* [The Kantor's Daughter], *Di Shtifmuter* [The Stepmother], *Di Shhichte* [Uboe], *Ziemia święta/ Egipt/Palestyna* [The Holy Earth/Egypt/Palestine], produced in 1914, *Di farsthoisene Tohter* [The Anathematized Daughter] from 1915, and *Rodzina Cwi* [The Zwi Family, 1916] as well as *Zajn waybs man* [The Marriage at a Crossroads, 1916]. See: Gross (2002: 12, 16, 148).

52 Roshwald (1999: 119, 120). See: Hagener (2012); Hagener (2014); text *The Great War and the New Art...* by Lidia Głuchowska in this volume.

53 Głuchowska (2020: 100). In the first issue of the Warsaw magazine *Jazz* in 1924 Berlewi intended to publish the article on Eggeling's abstract film.

54 Agata Chałupnik, "Tango judío i asymilacja przez muzykę" ["Tango Judío and Assimilation through Music"], lecture at the conference *Grupa Jung Idysz i żydowska awangarda artystyczna w dwudziestoleciu międzywojennym. Idee — postawy — relacje* [Group Yung Yiddish and the Jewish Artistic Avant-Garde], Museum of the City Łódź, June 12–13, 2019. See: Gadowska/ Świętosławska (2022).

55 Maltin/Beck (1987); Barrier (1999); Pointer (2017).

The "Oxymoron of Jewish Art" and the "Express-Sionists"

Although the opinion that Jewish art remains something of an oxymoron[56] is quite common, it is in fact limited to the secular mimetic *tableaux*, as the sacral art. The architecture of synagogues with their ornamentation and paramenta of course existed for thousands of years, having even been described in the *Old Testament*. Two reforms of Jewish culture, the *Haskala* renaissance, the revival of Hebrew and Zionism, aiming at founding an independent Jewish state and based on the restitution of Hebrew as an official literary language but also aligned to the universal European tradition, and Yiddishism, connected with the idea of presenting Jewish culture to "others".[57] The first reform in the 19th century already resulted in the rich visual production of Jewish art, initially in western parts of the former Polish-Lithuanian Commonwealth under German and Austro-Hungarian domination.[58] The assertion often appearing in studies of Jewish art,[59] that it mimicked Western patterns, should be partly refuted, as only the adaptation of the tradition of *tableau* paintings could really be seen as such, while their content with references to everyday Jewish life or *Old Testament* legends, was unique. One such example is the *œuvre* of Maurycy Gottlieb, who received his artistic instruction in the class of the famous Polish realist painter, Jan Matejko, in Cracow.[60]

As mentioned, before and during WWI, Jewish paintings became more popular in eastern parts of "Yiddishland". In 1911 and 1915–1916, *Kultur-lige*[61] organized two ethnographic expeditions in the former Pale of Settlement, along the Dnieper. Their participants El Lissitzky and Issachar Ber Ryback published photos, sketches and their own works of art, rediscovering traditional Jewish ornaments and folklore and circulating them all over Europe.[62] In 1916 the painter Nathan Altman and the sculptor Ilya Ginzburg joined others in founding the *Yidisher*

56 Olin (2001: 5).
57 Geller (2010: 26–28); Goudz (2011: 495–496); von Hülsen-Esch/Aptroot (2004: 6–18).
58 Malinowski (2000).
59 See e.g.: Sandqvist (2012: 129).
60 Malinowski (2000: 25–30).
61 Kazovsky (1993: 5–22); Kazovsky (2009: 35).
62 Gottesmann (2003); von Hülsen-Esch/Aptroot (2004: 15).

Gezelshaft cu Farshpraynt Kunst [Jewish Society for the Encouragement of the Arts; JSEA]. Based in St. Petersburg with branches in other cities, the society organized exhibitions by Jewish artists, with its Moscow affiliate following with its own show in April 1917. The efforts of JSEA, reinforced by An-sky, succeeded in founding a Jewish Museum in St. Petersburg, where the collection of ethnographic materials from the aforementioned expeditions were presented. They were intended to serve as guidance for painters and sculptors eager to create a synthesis of European high culture and Jewish folk motives.[63] With the toppling of the Tsarist regime in 1917, visual production blossomed among semi-Russified Jewish artists.[64] In 1918 and 1918/1919 great exhibitions of Jewish art were also organized e.g. in Łódź.[65]

While between 1881 and 1914 over two million Jews left Russia, mostly for the New World,[66] artistic migration to Paris resulted in the creation of the large Jewish artistic colony called *École de Paris*,[67] with such artist as for example "the three magi" of Vilnius — Michel Kikoïne, Pinkus Krémégne and Chaim Soutine — being *peintres maudites* who transgressed the culture of origin.[68] At the time of WWI several Jewish artists also joined artistic groups founded by the representatives of other "small nations" such as *Osma* [The Eight, 1900-1910][69] in Prague or *Ekspresjoniści Polscy/Formiści* [Polish Expressionists/Formists, 1917-1922] in Cracow,[70] and even inspired certain movements, such as Zurich Dada, with redoubtable founding personalities like Tristan Tzara, Marcel Iancu and his brothers originating from

63 Krupnik (1989: 35–48); Lukin (2006: 281–306).

64 Kampf (1978: 48–75); Golomstock (1984: 23–64); Apter-Gabriel (1988); Cohen (1998: 220–255); Kazovsky (1991: 7–77); Goodman (1995); Roshwald (1999: 122, 124); Kantsedikas/Sergeeva (2001); Glants (2003: 224–251); Kazovsky (2003); Cohen (2012a: 1–24).

65 Malinowski (2000: 153–154).

66 Sonn (2018: 332).

67 Wierzbicka (2004).

68 Sonn (2018: 340, 33).

69 Sawicki (2007); Rakušanová (2021: 16).

70 Geron (2012: 155–164). See also: texts *International Expressionism…*, and *The Great War and the New Art…* by Lidia Głuchowska in this volume.

NATIONALISM AND COSMOPOLITANISM IN THE AVANT-GARDE AND MODERNISM
The Impact of the First World War

Fig. 2

Marc Chagall, *Autoportrait aux sept doigts* [Self-Portrait with Seven Fingers] (originally painted 1913), photograph from magazine *Yung–Yidish* 4–6 (1919)

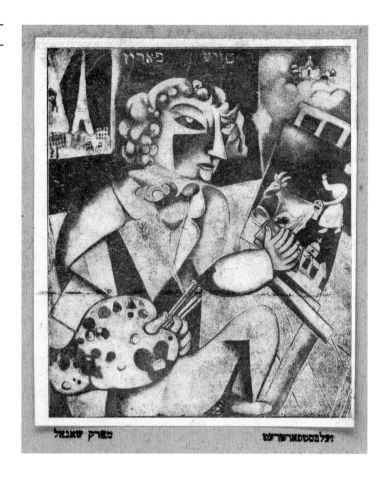

the territory of Romania/Moldova or Marceli Słodki from Łódź.[71]

Attempts at characteristic Jewish art during WWI and in the interwar period often include terms such as synthetic, hybrid, or eclectic to describe its specific features, with the argument they are the consequence of the mimetic assimilation of Western patterns on one side and syncreticism of Hasidism with its constant interaction between the sacred and profane in non-hierarchical order[72] on the other. But are such qualities really unique for Jewish art? Are not the same adjectives used for the definitions of the Central-Eastern local idioms of the great

71 Sandqvist (2012: 122); Głuchowska (2009d: 65–71); Głuchowska (2009/2010: 39, 40, 52); Głuchowska (2012d: 219, 224); Głuchowska (2020: 88–90).

72 Sandqvist (2012: 124, 125, 129); Ksiazenicer-Matheron (2012: 137).

artistic currents of the first half of the 20th century?[73] Another tendency of the research of this artistic period is conviction, that the Jews were particularly drawn by Expressionism with its spiritual content and "massacre of forms" also due to the belief its adaptation could bring an end to their marginalization.[74] Even the prominent Polish-Jewish critic Adolf Basler labeled some of the Jewish artists of the *École de Paris* with an attractive portmanteau term "Express-Sionistes" [Express-Zionists].[75] This act corresponded with the opinions of his French colleagues, that their art represented a spirit opposed to the Latin tradition of rigor and logic (which enabled them to accept Cubism, even the Polish-Jewish Cubist — Louis Marcoussis).[76] *Nota bene* for the same reasons "German" Expressionism with its center around Herwarth Walden's gallery and magazine *Der Sturm* was criticized by Constructivists, among them the Polish-Jewish artist and art critic, Henryk Berlewi, who perceived Dadaism as agony of Expressionism.[77] The generalization of the entire *École de Paris* with Jewish Expressionism, which was also associated with the "Slavic soul"[78] and its character marked by a spirit of pessimism and intellectualism, despair and disquietude,[79] seems problematic if one compares at least works by two paradigmatic Jewish Expressionists — "an action painter *avant la lettre*", Chaim Soutine[80] and the poetic-melancholic Marc Chagall (Fig. 2). So, what in fact was Jewish Expressionism? And was Expressionism in fact not an international style?[81]

If Expressionism in general cannot be described as a typically Jewish artistic invention then the typical Jewish one was surely the experiment of the Yiddish avant-garde, which remained closed to the culture of the book and contributed to a "worldwide network

73 Mansbach (1999); Mansbach (2002: 289–303); Benson (2002).

74 Sandqvist (2012: 127).

75 Basler (1926: 16).

76 Sonn (2018: 333); Głuchowska (2012d: 219, 224); Głuchowska (2020a: 96).

77 Berlewi (1922: 398); Głuchowska (2018a: 143–146).

78 Sonn (2018: 336).

79 Stolarska-Fronia (2010: 313–318); Sonn (2018: 339).

80 Sonn (2018: 334).

81 Benson (2014). See: text *International Expressionism…* by Lidia Głuchowska in this volume.

Fig. 3

Artur Nacht-Samborski,
*Portret Żyda czytającego
gazetę* [Portrait of a Jew
Reading Newspaper], c. 1921.
Private collection, Warsaw

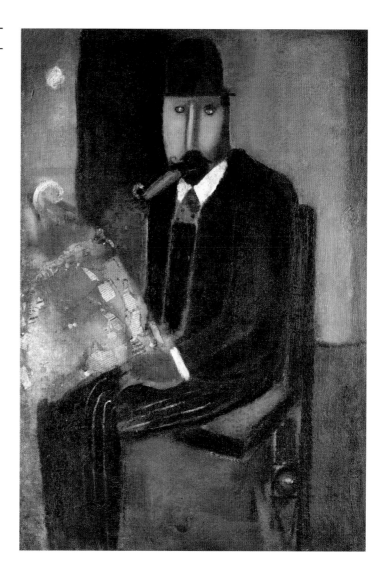

of periodicals", as Henryk Berlewi called it, himself affili-
ated with several periodicals of different national prove-
nance, such as *Yung-Yidish* in Łódź, *Der Sturm* (1910–1932)
in Berlin and *Blok* [Bloc, 1924–1926] in Warsaw.[82] The
Jewish avant-garde developed its own network within the
international one, with its typical structure consisting
of cultural institutions, artistic and literary groups, insti-
tutions, magazines and cafés.[83] The recollection of one

82 Berlewi (1922: 399).
83 Pinsker (2010: 56–77); Goudz (2008b: 7–8); Saß (2012: 180–189);
 Głuchowska (2012b: 145).

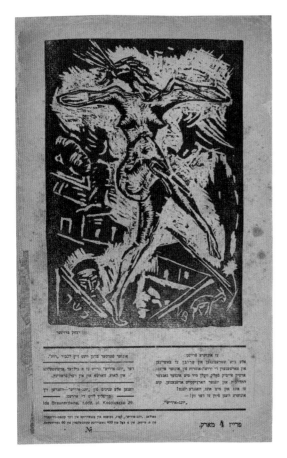
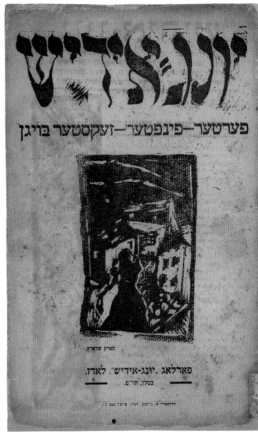

Fig. 4

Back and front cover
of magazines *Yung-Yidish*:

↑ **Wiktor** (**Victor**/**Icchak**)
Brauner, linocut *Tańczący
diabeł* [Dancing Devil], back
cover of *Yung-Yidish* 2-3 (1919)

↗ **Marek Szwarc** (**Schwarz**),
untitled linocut, front cover
of *Yung-Yidish* 4-6 (1919)

of them seems to be a painting *Portrait of a Jew Reading
Newspaper* (Fig. 3) by Artur Nacht-Samborski, a Pol-
ish-Jewish artist close to the circles of *Yung-Yiddish* and
the Polish group *Bunt* [Rebellion, 1918–1922].[84]

The network of the Yiddish avant-garde was dynamic
and encompassed centers such as Minsk, Kiev, Kharkov,
Riga, Odessa, St. Petersburg, Moscow, Vilnius, Łódź and
Warsaw, as well as Berlin, Paris and New York. With the
growing restrictions against artistic experimentation and
Jewish culture in the Soviet Union it became smaller
and shifted to the West.[85] Due to postwar inflation in Ger-
many, the most important center — where until the mid

84 Stajuda (1977: 68–79); Głuchowska (2009a: 171, 183); Głuchowska
(2020: 106); Głuchowska (2022b).

85 Hazan-Brunet/Ackerman (2009: 85, 181); Głuchowska
(2012b: 148–149).

twenties Yiddish artistic books and magazines could have been produced at relatively low cost — became Berlin.[86] Apart from Central-Eastern Europe it had representatives in New York, where the magazine *Inzikh* [Within Oneself, 1920–1939] appeared.[87] While most Yiddish magazines had a literary character, the typical avant-garde integration of word and image was best reflected in the *Albatros*. *Zshurnal fer dem nayen dikhter un kinstler-oysdru* [Albatros. Revue of New Poetic and Artistic Expression; first edited in Warsaw, then Berlin, three issues, 1922–1923], in the Łódź magazine *Yung-Yidish* (three issues in 1919; Figs. 4 and 5) the domination of image over word was a kind of redefinition of a cultural code of aniconic Jewish culture and

86 Krüger (2012, 72–81); Bienert (2012, 82–84).
87 Szymaniak (2005: 8, 11–13); Katz (2004: 283).

Jewish Artistic Networks Around the Great War
The Voice of "Others" and the Utopia of "Yiddishland"

its extension into the realms of taboo.[88] The main three artists who created this magazine: Moyshe Broderzon, Jankel Adler, and Marek Szwarc, having spent some or all of their childhood in Łódź, returned with knowledge of Dadaism and Cubism and brought to *Yung-Yidish* the inspiration of Russian Futurism and the Moscow renaissance of Jewish art and literature, German Expressionism, contemporary French art, and the *École de Paris*.[89] Interesingly Szwarc, living in Paris, co-edited an Expressionist magazine *Makhmadim* [Precious Ones; inaugurated in 1912], promoting the imitation of the synagogue and oriental ornamentation, which consisted of only images. The *Yung-Yiddisthists* promoted plurality of styles and cultural syncretism both in the form and content of their manifesto's artistic production. This was apparent among others in a non-confessional religiousness which combined Christianity or Jewish religious conceptions, via theosophy, with Buddhism and other Eastern religions, which documents are the subject of the Jankel Adler's painting *Ba'al Shem and Buddha* (c. 1919) and Marek Szwarc's woodcut *The Crucifixion* (see Fig. 5). In the wider circle of *Yung-Yidish* this tendency is depicted for example in the so-called christological poems by Uri Tsvi Grinberg (Fig. 6) and Ber Horowitz.[90]

While numerous Paris-based Polish-Jewish art critics introduced new artistic currents abroad, for example in Cracow and Berlin even before WWI,[91] in the postwar period artists, journalists and writers widely discussed what Jewish art should be specifically, perceiving it as the "liberation of mankind"[92] and "staying on the barricades",[93] but with no consensus about its shape.[94] At the beginning of the twenties some prominent advocates of Yiddish avant-garde had already abandoned the idea of national art for universal Constructivism. Berlewi with his non-personal, rational Mechano-Facture and

88 Rozier (2008: 44); Głuchowska (2013f: 1216–1233).
89 Malinowski (2000); Rozier (2008: 52); Krempel/Thomas/Guralnik (1985: 59–65); Gadowska (2015: 347–369).
90 Rozier (2008: 74–75); Szymaniak (2005: 22–24).
91 Wierzbicka (2009a); Wierzbicka (2009b); Głuchowska (2015g: 297–299).
92 Markish (1922: 35–41).
93 Weinig (1921: 19).
94 See e.g.: Głuchowska (2012b: 161).

Fig. 6

Uri Tsvi Grinberg, christological poem "Uri Cwi farn cejlem" ["Uri Tsvi in Front of the Cross"], from magazine *Albatros* 2 (November 1922)

pan geometrical approaches by El Lissitzky, who facing the necessity of transgression not only in a sense of ethnic and religious tradition, but also in a general sense, developed the conception of the four Covenants (Old — New — Communist — Suprematist).[95]

Jankel Adler's painting *My Parents* with its reflections on Eastern European mysticism, cabbalistic teachings, Cubism, Dada and Marc Chagall's work, was created after his emigration to Berlin, and could be understood as his taking leave with the culture of the *sthetl*. The inclusion

95 Lissitzky (1925: 103–113); Dukhan (2010: 291–298, 294, 296). See: text by Eleonora Jedlińska in Gadowska/Świętosławska (2022).

Fig. 7

Henryk (Henoch) Berlewi, front cover from magazine *Albatros* 3 (1923)

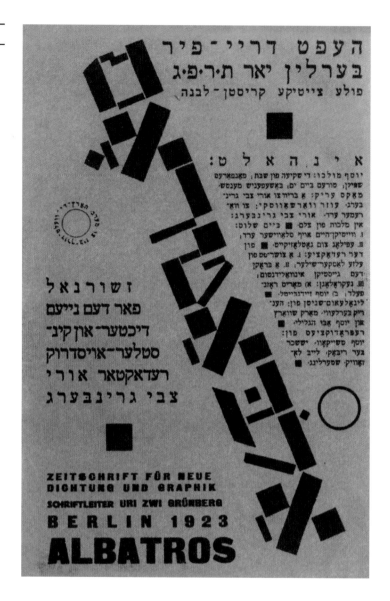

of the Hebrew letters and texts in Adler's paintings from the early 1920s was of Cubist provenience,[96] but more generally it was an essential message of the Yiddish avant-garde. It was transferred in the most suggestive way into the congenial cover of the third issue of the Yiddish magazine *Albatros*[97] (Fig. 7) designed by Henryk

96 Guralnik (1985: 204–205); Głuchowska (2022b).

97 Von Hülsen-Esch/Aptroot (2004: 42); Kazovsky (2009: 37); Estraikh (2010: 77–94); Lipsker/Bar-Ilan (1995: 89–108).

Berlewi.[98] On one side this nearly abstract, dynamic Constructivist composition, consisting predominantly of letters, is not comprehensible for international readers and could be perceived as an attempt at modern non-verbal communication, at creating a universal visual language of modernity. On the other it is in fact a text. This typography replacing image, at the same moment being a semi-image, seems to be the most suggestive emanation of the contradictory conception of Jewish art as a return to the tradition of the *Torah* and the kind of visual but aniconic manifesto of the Yiddish avant-garde, *quelque chose entre l'algèbre et la musique*,[99] maybe a culminative point of its self-definition.[100] Berlewi's cover has been admired by many researchers, but who remembers that the inventor of the Constructivist square Hebrew letters and their dynamic composition was not him, but the German-Israeli calligrapher, Franziska Baruch, who designed it for the first issue of the Hebrew/Yiddish magazine *Rimon/Milgroim* [Garnet, 1922–1924]?[101] The idea of national romanticism and the emancipation of women, including acknowlegment of their contributions towards national culture, only emerged at the same time, but both still remain an "unfinished project of modernism".

The Voice of "Others" and the *Froyen Frage*

While within international artistic circles the Jews were perceived as "universal others", and — in a deeper sense than other avant-garde members — as "outsiders acting as insiders",[102] such a perception was doubly true of female artists, as they could achieve both national and social emancipation only through assimilation. Their public

98 Głuchowska (2012b: 159–160); Głuchowska (2013b: 313); Głuchowska (2013d: 202, Fig. 5).

99 Głuchowska (2013b: 62–66).

100 Other covers of Yiddish publications with Hebrew letters replacing image or stylized to a semi-image, but created in a Futuro-Expressionist style, were also designed by Berlewi, Melekh Ravitsh, and Władysław Weintraub in Warsaw. See reproductions in: Frankowska/Frankowski (2010: 33–36); Szymaniak (2005: Fig. 9–14); Hazan-Brunet/Ackerman (2010: 193, 195, 198, 205).

101 Wardi (2015); Słupska (2015: 103–114).

102 Gay (1968); Szábo (1994: 175–186); Forgács (2013: 150); Głuchowska (2012b: 164–165).

activities were not possible in the conservative structure of the *sthetl*. During WWI the *Froyen Frage* [Woman Question] received further resonance and emancipatory process on both levels and was accelerated through German domination over the majority of the "Yiddishland" and the confrontation of Eastern and Western culture. At this time the women section of *Agudas Isroel* was created, within which some writers like the aforementioned Breyndl Boym devoted themselves to charity and Zionist activities, also teaching Orthodox girls and fellow women. The socialist *Bund* in Poland created *Yidishe Arbeter-Froy* [Jewish Working Woman] — an organization promoting activities of working women as well as workers' wives, later, in 1925.[103]

In 1918, directly after the war, the first Yiddish feminist manifesto appeared in Poland — *Di yidishe froy* [Yewish Woman] by Pua Rakowska,[104] pioneer of the Zionist women's movement. She initiated the founding of the *Yidishe Froyen Organizacye* [Society of Jewish Women], which promoted emancipation and modernization of Jewish culture and marriage customs, facing vehement opposition from the traditional section of male Jewish society.[105] Symptomatic of the changes of the social and cultural position of women is the fact that in the same year one of the issues of *Jugend. Zamelheft far Shener Literatur un Frayen Gedank* [Youth. Almanac of Belle Lettres and Free Thought], edited by Cwi Kohen included a special chapter: "Froyen-Motivn" ["Female Motives"], and poems by five female authors: Roza Jakubowicz, Miriam Ulinower, Shoshana Częstochowska, Mirl Erdber and Chana Gerson, with an editor's introduction.[106]

Around the end of WWI the consolidation of the most important literary-artistic circles of "Yiddishland" took place. It focused on the previously mentioned almanac *Yung-Yidish*. One of the appealing aspects of the profile of this circle, in comparison with other Western and Yiddish arts associations, typically exclusively "men's

103 Lisek (2018: 263–267, 326–327).
104 Rakowska (1918).
105 Lisek (2018: 326–327).
106 Kohen (1918: 27); Lisek (2018: 344–345).

NATIONALISM AND COSMOPOLITANISM IN THE AVANT-GARDE AND MODERNISM
The Impact of the First World War

clubs",[107] was a relatively wide participation of female artists in its activities. Concerning *Yung-Yidish*, it should be stressed that not only the editor of the group's almanac Felicja Prywes, along with other female members (Ida Brauner, Pola Lindenfeld, Dina Matus, and Zofia Gutentag), enriched several publications of the group and related Yiddish circles with their art prints,[108] but they (Dina Matus, Ida Brauner, together with Esther Carp) also cocreated artistic books, illustrated, for example, with woodcuts painted in watercolour,[109] while other women artists, like Moyshe Broderzon's wife, Miriam Orleska, participated in the performative activities of the group, similar to those by *Bunt*,[110] such as the Yiddish cabaret *Ararat*, whilst Mark Szwarc's wife Gina Markowa could be described as the chronist the of *Yung-Yidish*'s circle.[111] In the framework of other Yiddishist artistic-literary groups there were either no women or they were at least underrepresented (to mention the *Kultur-lige* members Sarah Shor and Rokhl Sutzkever or Sheine Efron from the circle of *Yung Vilne* [Young Vilna, 1929–1941]),[112] while others acted in the circle of *École de Paris* (e.g. Mela Mutter, Chana Orloff) or contributed to the development of non-specific Jewish movements in Russia or France (like Sonia Delaunay-Terk or Tamara Lempicka). In the 1920s there were numerous Jewish female (and male) *Bauhaus* students, designers or photographers, who partly transferred its tradition to Israel after their emigration,[113] but their recognition in international research is still

107 Thormann (1987: 405–420); Głuchowska (2007: 66).

108 Malinowski (2000: 192–193).

109 David Mazower, "Fun'm opgrunt/Out of the Abyss: The Women Artists of Farlag Achrid — A Forgotten Chapter of Yung Yidish", lecture at the conference *Grupa Jung Idysz i żydowska awangarda artystyczna w dwudziestoleciu międzywojennym. Idee — postawy — relacje* [The Group Young Yiddish and the Jewish Artistic Avant-Garde in the Interwar Period. Ideas — Attitudes — Relationships], Museum of the City of Łódź, June 12–13, 2019. See: text by Magdalena Maciudzińska-Kamczycka in Gadowska/Świętosławska (2022).

110 Głuchowska (2015b); Głuchowska (2015e).

111 Markowa (1961); Rozier (1999); Malinowski (2000: 167–168); Głuchowska (2022b).

112 Kac (2003); Lisek (2005).

113 See e.g.: Störtkuhl/Makała (2020).

relatively limited. Among the acknowledged representatives of *neues Bauen* in Germany one has to mention Grete Schütte-Lihotzky, the designer of the so-called Frankfurt Kitchen.[114]

While the assimilated female artists found limited access to the canon of art history, the literary production of Yiddish writing women, among them prominent art critics such as Debora Vogel, only recently gained recognition in grounded studies.[115] In this context one should again note the case of Breyndl Boym, who used several male pseudonyms. In 1925 she left the "Yiddishland" for *Erec Israel*, until the end of her life remaining Orthodox Hasidic and as such never fully accepted the emancipative function of her own literary expression, perceiving the written word to be the domain of male control, conventions and institutions.[116]

Bebelplatz, Holocaust and Paradise Lost

The Jewish national revival in the 19th and first half of the 20th century could in many ways be perceived through the lens of similar, parallel processes concerning "small nations". In comparison to the latter, the Jewish revival was accelerated by the residents of the "Yiddishland" underground structure of existent political organisms within Central-Eastern Europe, using the different languages of host countries to blithely adapt and exchange impulses observed within the various cultures and disperse them further. Of course it was assimilated or semi-assimilated Jews, mostly migrating ones, who had the most significant impact on international political and intellectual life, in the same way their colleagues from the nations dominated by big empires, who had to use foreign languages or travel abroad to introduce their ideas beyond their *Fatherlands*. Jewish artists had to leave *sthetl* to develop their aesthetic creativity, but wasn't departing rural "Arcadia" for "Metropolis" not also the experience of many artists of other nations, particularly Central-Eastern European ones? Establishing modern literary Yiddish seems

114 Prokop (2016).
115 Lisek (2018); Bojarov/Polit/Szymaniak (2017).
116 Lisek (2018: 263–268, 288–290).

NATIONALISM AND COSMOPOLITANISM IN THE AVANT-GARDE AND MODERNISM
The Impact of the First World War

to have been a cultural revolution within Judaism, incomparable with anything that has previously occurred on the Old Continent. But was standarization of the mother tongue a uniquely Jewish experience? Hadn't Czechs or Norwegians undertaken steps towards it in the first half of the 19th century? There are many more similarities concerning different aspects of the modernization process of Judaism and other "small cultures", to mention just emancipation of women or the fact that the art of the Jewish Expressionists in Paris was often perceived as "Slavic", while the spirituality of this style was also rooted in German romantic philosophy.

The main difference concerning arrival points of the national revival of Jewish and non-Jewish inhabitants of the Old Continent is that, while before and during WWI various other "small nations" achieved their autonomy through the creation of independent new states using diplomatic and military means, the Jews never intended to establish their own country in Europe and didn't form national military units. As a consequence "Yiddishland" didn't appear on the new political map of the interwar period, but Jewish thought, transferred by the *assimilées* inspired international intellectuals even more then in the 19th century.

The most evident sign of the modernization of Judaism was breaking the taboo of aniconism, as a consequence of *Haskala*'s opening to universal European heritage. If the first step in establishing secular visual Jewish culture and its most performative manifesto was theatre, then its institutionalization (encompassing the standarization of Yiddish) during WWI was intended as a means of presenting it in a contemporary way to "others". Foreign language productions can be perceived however as a compromise, in which the stage performances lost their spontaneous, carnival-like character and authenticity. From the modern perspective this reform can be understood as a regress, considering the 20th century development of intermedial visual arts opening to interaction with the audience and participative forms.

Within European culture, aniconism has been mostly regarded as something specific for conservative Jewish culture, and mimicry, especially concerning adaptation of the figurative *tableau* paintings, has been often seen

as a Jewish strategy of assimilation. But was early Christian art not also a kind of mimicry as an adaptation of Hellenic stylistic and partly iconographic patterns? Was the evolution of sacral Christian art not limited mostly to a Roman Catholic model, partly as a consequence of the secularization of culture since the time of the Renaissance, especially since the French Revolution? Is the Orthodox tradition of icon not a conservative one? Was the ban of idolatry not also a postulate of Protestants? And finally, can the assimilation not be seen as an initial stage of postcolonial globalization, even if the Jews were not colonized in a sense in which other "small nations" were, but hosted in Europe?

If globalization is the consequence of transgressing particular national and ethnic tradition, the assimilated Jews merely transgressed theirs in an accelerated way and more purposely than the others. Significantly it was within their culture where, next to competing concepts of national revival and modernization, two anational ideas emerged — Communism and Esperanto. Both were realized — on a macro and micro scale, but in a general sense failed during the course of the 20th century due to the weakness of human nature tending to serve itself, and the constraints of time.

In 1933 thousands of books were burnt by the Nazis at the Berlin Bebelplatz, and other German cities. In 1938 the synagogues burnt. Holocaust followed. The Central-Eastern European culture of the *sthetl* perished, similarly to Yiddish, which is now spoken only in small enclaves of America and Israel. Modern Yiddish literature remained an experiment. Today it only has a status comparable with ancient Greek, Latin or somehow with Old-Church-Slavic texts, but of course in a more specific sense. In 1948 the Zionist dream of *Erec Israel* became reality, and the modern Israeli Hebrew — Ivrit, was established, but as a consequence of relocation and secularization, Jewish culture lost its continuity. In the context of aesthetic experimentation an important fact must be stressed. While the first generation of Jewish artists adapted the foreign medium of secular figurative painting, the second one, in the 1920s, had already contributed to universal visual culture on an equal level to their colleagues of other nationalities, creating abstract paintings,

new architecture, design and installations, remaining conformed with the antiidolatry of traditional Judaism. Within this pan geometrical approach a specifically Jewish idiom of modernity was the invention of a semi-iconic typography consisting only of Hebrew letters in dynamic constellation, being *quelque chose entre l'algèbre et la musique* and returning to the "culture of the Book".

Closing Remarks and General Reflections

Steven Mansbach

University of Maryland. College Park, United States of America

The essays presented in the volume *Nationalism and Cosmopolitanism in the Avant-Garde and Modernism. The Impact of the First World War*, since reworked and updated by the Prague workshop which initiated it, attest to the intellectual vitality of the field of visual art studies, especially as it focuses on Central-Eastern and "peripheral" Europe. Not only was the workshop's organizing theme inventively approached from a host of perspectives; it was handled imaginatively from the viewpoint of geographical specificity and cultural distinctiveness. Indeed, the essays afford a welcome "offsides" look at Nationalism, Cosmopolitanism, modernism, and the First World War. By displacing — or at least supplementing — the commanding Francocentric perspective in modern art studies, the present volume introduces the decisive roles played by less frequently considered sites of progressive art. As a result, the creative activities that took place in the culturally fertile areas of Northern, Southern, Southeastern, Central-Eastern and Eastern Europe are afforded careful attention. Through the essays published here, one begins to appreciate how modern styles were selectively embraced, adapted, and reoriented to serve local needs, traditions, and audience — while at the same time participating in a cosmopolitan discourse with the western capitals of culture. Thus the findings and interpretations advanced in the present book compel a reconsideration of the very terms (and their usages) that have been all too uncritically employed by art and literary historians for decades, and that are employed in the very title of this volume. The benefit of broadening the geographical and methodological compass will do far more than contribute to the roster of progressive images and inventive artists: it will invite a salutary reappraisal of how we comprehend the classical modernism that was articulated in the great metropoles and reimagined in dozens of locales geographically arcing around them, extending from the Nordic countries through Eastern and Southeastern Europe and reaching Iberia.

A call for a healthy skepticism of canonical grand narratives should be complemented by thinking critically about "smaller" issues and places. The following reflections, prompted by the stimulating findings advanced

by the essays gathered in this book, might best be understood as exhortatory remarks.

The bands of intellectuals active in the principal cities of Northern, Southern, Southeastern, and Central-Eastern Europe were, in general, few in number. They were surely of more modest size and of a different composition than those active in Paris, Berlin, or Munich, for instance. Moreover, their adherents were frequently educated abroad. And finally, the groups were considerably more reliant on an intimate and mutually reinforcing network of the arts — literature, architecture, and especially music — to effect and consolidate a progressive front by which to introduce change within generally conservative societies. Hence, today's historians need to attend to the issue of size of membership within the various progressive formations; for the very practices of the local avant-garde (and their audiences) were dramatically affected by the scale, scope, and character of the (respective) indigenous intelligentsias. Indeed, with comparatively few advanced artists (and supporters) constituting the diverse avant-garde from Finland to Slovenia, scholars might justly inquire into the divergent, as opposed to uniform, roles played by the bands of modernists from the Baltic north to the Adriatic south, from Great Poland to Moldova and beyond.

As political figures, university intellectuals, and even industrialists and merchants were often members or champions of these artist formations, the intimate relationship between art and politics, and between art and social dynamics, was as commonplace in these "small cultures" as it was comparatively rare in the major capitals of art and commerce in France and Germany. This interconnectiveness led to a profound and original intercourse between artists and politicians, and artists and economic leaders, who were the principal audiences-members for the new styles. In this regard, one should note that much of the opposition to the avant-garde stemmed initially less from domestic sources than from the supervening imperial powers, often located at a distance from Tartu, Cracow, Ljubljana, Bucharest, Vilnius, and so forth. This sociopolitical factor should nevertheless not mislead us into thinking that there was a universal sympathy "at home" for what was often seen as radical

NATIONALISM AND COSMOPOLITANISM IN THE AVANT-GARDE AND MODERNISM
The Impact of the First World War

styles. However, what is significant — and notably different from the prevailing attitude in the "West" — was the powerful presence of a shared nationalism that informed both the creation and the appreciation of the artists' efforts, despite the medley of progressive styles evident throughout the region. Whereas modernism as configured theoretically in Holland, France, and Germany, for example, asserted a universality — based variously on a belief in the inherent rationality or human emotionality of modern art — advanced art to the east, north, and southeast inventively united transnational visual idioms with messages or references that had singular local resonances. The advanced styles that were widely embraced, adapted, and consumed in Central-Eastern Europe thus spoke simultaneously a dual language: it was at once a progressive parlance with universal currency, just as it operated as an inventive local dialect or discourse that corresponded to domestic traditions and expectations. Hence, the modernism of the East was at the same instant uncannily forward-looking and retrospective; it was the idiom by which a better cosmopolitan future might be envisioned or projected while conserving the singular characteristics of a specific place and cultural history.

The small size of the various bands of East European artists often allowed for a tolerance of diverse styles, and frequently encouraged variation and experimentation. Hence, one often finds the same few artists negotiating a series of styles — abstract and figurative, Cubist or Expressionist or Constructivist — quickly and sometimes simultaneously. Whereas in Paris or Berlin this inconstancy would likely have been censored; in Bucharest, for instance, it was common practice and frequently seen as a normative means of accommodating modernism to local expectations or needs. As the cohort of Romania's Dadaists, the Activists of the *Contimporanul* circle, and the affiliates of both *Integral* and *Punct* were mostly the same half-dozen or so modernists, the shift among styles was comparatively frictionless, even if there was some variation in ideological orientation or objective. Such fluidity was seldom evinced among the avant-garde in France, Holland, or Germany where steadfastness of view and commitment to a restricted number of styles were practiced as morally warranted and aesthetically

advantageous in order to maintain and promote a dis-
tinctive posture. In essence, the environments in which
western and eastern avant-gardes functioned were so dif-
ferent that both artistic practices and progressive styles
functioned differently, even if they appeared similar.

As a result, Constructivist abstraction, as was also true
for Cubism and every other "-ism", operated dissimilar-
ly in "Western" and "Eastern" Europe despite superficial
commonalities.[1]

Many of the papers gathered here have insightfully
acknowledged that most of the modernist styles were de-
veloped prior to the outbreak of WWI. Hence, there was
already a rich roster of visual idioms on which to draw
(and then adapt) by 1914. Even if the principal vocabulary
was articulated first in France and Germany, although
not infrequently by artists who migrated there from east
and southeast of Europe,[2] the forms and meanings of
Cubism, Expressionism, Futurism, and Constructivism,
for instance, were profoundly enriched by artists to the
east, southeast and northeast during and following the
war, who responded to local needs with notable original-
ity. Paris, Munich, Dresden, and Düsseldorf, among other
cities were surely major incubators of Eastern Europe-
an modernism; but the history of the avant-garde was
by no means concentrated there.[3] Rather, progressive

1 This was especially apparent in Prague, where *Osma* (*Die Acht*
 [The Eight]) and slightly later *Skupina výtvarných umělců*
 [Association of Fine Artists] selectively adapted and repurposed
 stylistic innovations of Cézanneism and Cubism.

2 This is not to ignore those major figures from Catalonia and Italy,
 who played the decisive role in creating Cubism, Futurism, and other
 advanced styles. However, none of these artists was active formally
 as a teacher. As a result, Munich and Paris with their official and
 private academies (the *Akademie der bildenden Künste München*,
 the Bavarian private studio of Anton Ažbe, the *Académie Julian* and
 the *Académie Colarossi* in Paris being the most important) attracted
 large numbers of younger artists from Central-Eastern, Northern,
 and Southeastern Europe. For aspiring artists from the Baltic and
 Russian lands, the School of Technical Drawing of Baron Alexander
 von Stieglitz in St. Petersburg and the various more informal schools
 in Russian Kazan and Penza were of consequence as well. In the
 early 1920s and as a result of the stipulations of governmental
 funding, Baltic (and some Hungarian) artists also traveled to Italy
 for an aesthetic education.

3 For every František Kupka or Constantin Brâncuşi who led

figures from Finland to Slovenia, from Penza to Poznań, developed a modern language — abstract and figurative — by which to communicate an ideal new vision to their compatriots without ignoring an international audience. Through exhibitions, generally modest in scale and local in focus, but mostly by means of reproductions and articles in dozens of small-circulation journals and magazines, the dynamic new art from the east was broadly advertised. This communication went in both directions, as western-based artists sent their periodicals to confederates in the Balkans, the Baltics, and throughout Central-Eastern Europe. As the back covers of so many of these publications reveal, the list of corresponding journals was striking for its geographical breadth (which reached as far as Madagascar!). But the extent of the territorial distribution was almost inversely proportion to the number of subscribers.[4] Nonetheless, these little magazines were instrumental in advancing the art and ideology of the avant-garde; and through these limited publication runs, physical, historical, and cultural distances were partially bridged.

These journals were, of course, also an effective means by which to consolidate and concentrate the efforts of the small bands of modernists everywhere, and not just in the cities of Eastern Europe. Exchanging publications with sympathetic groups beyond a nation's borders augmented the local value of each, as interchange fostered the impression of cosmopolitanism. Nonetheless, we should not mislead ourselves in thinking that the internationalism of the journals meant that the new art was received abroad in the same ways it was comprehended domestically. Akin to the international exhibitions in which artists from Eastern, Central, Southern, and Northern

their careers mostly in the West, there were countless Mikalojus K. Čiurlionises, Kazimir Maleviches, Władysław Strzemińskis, or Vytautas Kairiūkštises who had little need to journey to Paris, for instance, in order to create the most thorough-going modernism.

4 Surviving records suggest that none of these little magazines of avant-garde groups from the 1910s through the 1920s, exceeded a couple hundred of paid subscribers. Of course, the number of readers was surely considerably greater as magazines were frequently freely exchanged among artist formations, and then the gifted copy was most likely read or consulted by at least several of the members.

Fig. 1

German ceramics in the war era:
↑ Königliche Porzellan-
 Manufaktur Berlin [Royal
 Porcelain Manufactury
 in Berlin], two cups
 decorated with black iron
 cross, 1914–1918. Formerly
 Lempertz, Germany
→ Waechtersbacher Keramik
 [Waechtersbacher Ceramics]
 factory, plate decorated
 with black iron cross, 1916.
 Private collection, USA

Europe participated, the art displayed — and especially
that which was reproduced in print periodicals — had
different significance for different audiences, especially
when artists sought to employ progressive forms/styles
for nationalist purposes,[5] as was common practice in
Helsinki, Tallinn, Riga, Kaunas, Vilnius, Budapest, Prague,
and for all the emergent nation-states represented in the
present volume.

Several of these reflections on the modern art from
this diverse region might be illustrated by considering
several porcelain plates from the war and post-war era,
as it is frequently through the decorative arts that big

5 This was especially true for those "national" groups who participated
 under the flag or auspices of the imperial powers to which they were
 subject in the pre-WWI era.

ideas and great ambitions can be most directly expressed. By no means can architecture, painting, sculpture, and the graphic arts be ignored; however, each of these major genres involves a nexus of considerations too lengthy and complex to engage here.

To garner support for the war effort, financially as well as politically, Wilhelmine Germany annually issued porcelain (Fig. 1) in various sizes and forms. These were not principally intended for use; rather they were conceived as showpieces through which the purchaser might demonstrate his or her allegiance to the empire during the world conflict.[6] Many of these plates, cups, and salvers were produced by the Hohenzollerns' favorite (royal) factory, the *Königliche Porzellan-Manufaktur* (KPM, Berlin) for the upper middle-class market. Most bore upon a white surface the King-Emperor Wilhelm's monogram along with the year, as well as the Iron Cross (with or without oak leaves).[7] The strategy informing these porcelain pieces (or those made from stoneware for less well-off patriots; see Fig. 1) was to use the decorative arts to recruit support for the regime and its war effort. Significantly, the designs were almost all spartan (relative to the ornamentation found on pre- and post-war KPM dinnerware and showpieces, such as large decorated vases), excepting, of course, the precious materiality of porcelain.

Less than a year following the last of the KPM war porcelain, the embattled Bolshevist regime in Russia enlisted porcelain for its own defensive and propagandistic purposes. Capitalizing on the numerous blanks produced under the last tsar's reign by the Imperial Porcelain (*Imperatorskii Farforovyi Zavod*) factory in St. Petersburg,[8] the

6 A quite striking flower-holder was produced in 1914 that could easily have been used, as two of the three holes on the top could also accommodate candles. The white flames from the tapers would have complemented the black surface of the vase thereby reproducing the Hohenzollern colors. Flowers in the central hole might have served as a fitting memorial to those who perished in battle.

7 Other manufacturers sometimes included written phrases that ranged from the laconic, "Kriegserinnerung", to the eccentric, "Butterdose aus den Kriegsjahren 1916/18".

8 Petrograd State Porcelain Manufactory was founded in 1744 as Imperial Porcelain Manufactory (*Imperatorskii Farforovyi Zavod*), renamed in 1917 in *Gossudarstvennyi Farforovyi Zavod*, and in 1925 in *Leningradski Farforovyi Zavod imeni M.V. Lomonosova*.

Soviet authorities adapted this precious upper-class stock to revolutionary purposes, known best as "agitational porcelain". Designers included the most progressive artists among the avant-garde: including Kazimir Malevich, Nikolay Suetin, Ilya Chasnik, Nathan Altman, and Sergey Chekhonin among dozens of others. Many had studied at the Stieglitz school in St. Petersburg before enrolling in the new educational programs, formally authorized and informally tolerated: *Vkhtumas* and *Unovis*, for instance, for which Malevich's role was instrumental. Significantly, the former Imperial, now State, Porcelain Factory was a major site of the revolutionary designs of Suprematism, just as the manufactory had formally been the favorite producer for the tsars since the 18th century. What is remarkable in the years of hardship immediately following the Bolshevist Revolution and during the privations of the civil war is that the factory never ceased

In 2005, the stockholders of Lomonosov Porcelain Factory passed a resolution to return to their pre-Soviet name, the Imperial Porcelain Manufactory.

production. As Tamara Kudryavtseva put it in her seminal study, "Nothing, it might seem, could be more incongruous in such terrible times of bitter class conflict and a collapsed economy, when everyday life was dominated by a lack of bread, light or heat, than these fragile plates and figurines [...]."[9]

By autumn 1918, Chekhonin had been appointed the principal artistic director. As an inventive designer, he created numerous examples of agitational porcelain, many of which were given as gifts to delegates to Soviet congresses, or were provided to Russian embassies, or were put on the market in Moscow with notable success. Chekhonin's *Cubist with a Hammer* (*Futurist*) (1919; Fig. 2) is an early popular example of the innovative stylistic melding of Cubo-Futurist abstraction (on the cavetto) and radical emblems (hammer, sickle, and partial cogwheel) in the well. To supporters of the regime, both forms of imagery, the abstract and the figurative, would have signified the social and political dynamism promoted by the workers' state.

In late 1922 the Suprematism-Constructivist painter Nikolay Punin succeeded Chekhonin as factory director. Immediately, he engaged Suetin and Chashnik as designers. Malevich, who had already moved to Petrograd, was also creatively employed at the Petrograd works; and within a year, manifold Suprematism designs had been realized in porcelain table service (Fig. 3) pieces in one-off examples. Despite the market success of this radical abstract imagery, and irrespective of the productivity of the Malevich circle at the Factory, by the end of 1924 Suprematist porcelain production mostly came to an end. Whether the discontinuation was a result of a political decision made in Moscow or the consequence of the artists' desire to focus on other activities, the specific causes are not fully known. Nevertheless, a particular porcelain plate attests to the emerging shift in style (yet consistency in propagandistic message): (Fig. 4). Here, Alexander Samokhvalov relegated Suprematist forms to the rim and allowed the central zone to be occupied by a well-dressed seamstress at her work-table. Both the abstraction and the figuration speak to the dual path modern art pursued

9 Kudryavtseva (2004: 13).

Fig. 3

Nikolay Suetin (painter) in the
Gossudarstvennyi Farforovyi
Zavod [State Porcelain Factory],
*Cup and Saucer with Black
Cross and Circle*, 1923. The
State Hermitage Museum,
St. Petersburg

in early Soviet times. The "either/or" of Dutch, French,
or German advocates of advanced art of the era was
rarely so strictly followed to the east, where oscillation
among styles and an interplay between abstraction and
representation was seldom condemned as being irreso-
lutely modern.

Nowhere is this dual aspect of progressive aesthetics
better observed than in a plate designed by the Latvian
painter Romans Suta.

Although the young state had secured its independ-
ence by 1920 following a savage civil war and foreign in-
tervention, for the progressive cultural forces there were
battles still to be won. With the founding of the *Riga
Artists' Group* (*Rīgas mākslinieku grupa*, 1920–1938) in the
independence year, Suta assumed the role of spokesper-
son for the progressive faction. Along with his colleagues,
he drew upon Cubism (more the principles advanced by
Jean Metzinger and Albert Gleizes than the imagery of
Picasso and Braque) while embracing the innovations
of Malevich. These modern impulses notwithstanding,

Fig. 4

Alexander Samokhvalov
(designer and painter) in the
Gossudarstvennyi Farforovyi
Zavod [State Porcelain Factory],
plate *Seamstress*, 1923. Private
collection, USA

Suta treasured the native Latvian folk traditions, which
the young republic and its artist-supporters endeavored
to safeguard.[10] Introducing a blend of contemporary and
retrospective imagery to his canvases and, especially,
to the theater sets he designed, Suta and his confederates
came to the belief that the decorative arts represented
the most efficacious genre through which to promote
advanced art and native references. Thus in 1924, he
served as a cofounder of the Baltars (Baltic Art) Porcelain
Painting Workshop (*Dibtuvės Baltars/Baltu Menas*, 1924–
1930)[11] Suta hoped that Baltars would function as the ide-
al medium of disseminating modernist-designed articles
of everyday use. Inspired both by the nativist arts-and-
crafts movement and by the inventive Suprematist por-
celain being produced by Russian modernists, Suta made
effective use of ceramic ware to propagate the evolving
Latvian culture. Baltars owed its success in large part to

10 See: Suta (1923).
11 Ļaviņa (2019: 37).

Romans Suta (design) in the
Baltars Porcelain Painting
Workshop, plate *Kāzas* [Wedding],
c. 1928. Latvian National Museum
of Art, Museum of Decorative
Arts and Design, Riga

fortunate timing, as the porcelain manufactory attracted
the participation of Latvia's artists at the pinnacle of the
avant-garde movement, not unlike the case in Petrograd.
Within a year of its founding, Baltars garnered interna-
tional recognition: three medals, included the gold, at the
1925 *Exposition internationale des arts décoratifs et indus-
triels modernes* in Paris. Nevertheless, by about 1926 the
creative fusion of folkloric and modernist elements began
to break down. Perhaps the last signal accomplishment
of this inventive mixture is Suta's *Kāzas* [Wedding] plate
(c. 1928; Fig. 5). Here, the traditional celebration takes
center stage. The triangular forms of the women's trailing
fringed shawls and the segmented composition intro-
duce a rigorous geometry to the scene. But it is on the
rim where the melding of styles and the deeper *content*

are most dramatically served. A bride and groom stand to either side, each holding a Suprematist triangular, flat, solidly-colored textile. Around them and coursing the plate's border are geometric elements: circles, rectangles, and hard-edged forms — all calling to mind the Suprematism employed in the Petrograd State Porcelain Manufactory (*Gossudarstvennyi Farforovyi Zavod*). But here these forms have another dimension of reference, one that departs from the (apparent) universality of Malevich's geometry. This reference is suggested by the reductively rendered deer near the top. The primitive form of the animal is perfectly fitting, as all the abstract planes, arcs, and circles of earthen colors derive as much from the ethnographic studies and archaeological excavations sponsored by the Latvian state as they owe allegiance to Russian modernism. Indeed, government-supported ethnographic projects were part of the popular endeavor to reveal and assert the nation's unique cultural and spiritual (and visual) character, indebted to neither of its erstwhile social and economic masters; namely, the Russians and the Germans (primarily the *Balten-Deutsch* settlers with their Teutonic Knights and Hansa legacy). Hence, these abstract forms around the rim invoke an atavism uncovered through excavation (or ideological projection) that was presumed to pre-date the Slavic and German arrival. Suta's potent stylistic blend of the abstract and the figurative, the native and the cosmopolitan, was an imaginative solution; and it points to the striking ability of progressive forms to resonate locally while also being read universally. It is this duality that is important to recognize; for it was as customary throughout Central-Eastern and Southeastern Europe as it was rare in the centralized cultural capitals to the west, especially Paris and Berlin.

The preceding reflections are intended to enrich the discussion initiated by the papers gathered in this book. The present remarks might be read as considerations to weigh as one investigates and interprets the art and artefacts that our collective scholarly archaeology unearths. They do not constitute a methodology or advance an approach to modern art as a whole.[12] Yet they do, at the very least, urge a review of the attractive title for the

12 See: Mansbach (2002: 288–306).

Prague conference and the resultant publication: *Nationalism and Cosmopolitanism in Avant-Garde and Modernism. The Impact of the First World War*. By keeping in mind the creative exploitation of modern forms and styles to promote local needs and engage domestic audiences while also addressing an internationally cosmopolitan public, the progressive artists from Central-Eastern, Eastern, and Southeastern Europe articulated a multifaceted visual modernism that does not conform to the prevailing viewpoint of modernism, where only relatively recently have its claims to universality, rationality, and utility been challenged. The remarks registered here urge a continuation of approaching classical modern art as a multilayered and often contradictory set of visual styles and ideological discourses. Such a perspective would frame complex issues, such as the nouns in our book's title, less as given nomenclature rather than as questions. As queries for further investigation, they might then lead to a salutary complication of the titular terms themselves.

Contributors

DORTHE AAGESEN

is Chief Curator and Senior Researcher at the Statens Museum for Kunst, (National Gallery of Denmark) in Copenhagen where she oversees the collection of modern painting and sculpture. She has addressed Danish and international art from the 20th century in several articles and exhibitions, including *Avant-Garde in Danish and European Art 1909–1919* (2002), *Wilhelm Freddie — Stick the Fork in Your Eye!* (2009), *Henri Matisse — In Search of True Painting* (co-curated with the Metropolitan Museum of Art and the Centre Pompidou, 2012) and *Asger Jorn — Restless Rebel* (2014). She is a co-editor and contributor to *A Cultural History of the Avant-Garde in the Nordic Countries*, vol. 1 (Rodopi, 2012).
DA@smk.dk

OKSANA DUDKO

is a PhD Candidate in History at the University of Toronto and a Research Fellow at the Center for Urban History in Lviv (Ukraine), where she conducts research on *Urban Culture, Entertainment, and Artistic Networks During Wars, Revolutions, and Social Unrest, 1910s — 1920s*. She received her PhD from Ivan Franko National University of Lviv, where she defended a dissertation on pre-WWI Eastern Galicia in 2011. She is currently working on a second study of Ukrainian soldiers' experiences of wartime and postwar violence on the Austro-Russian borderlands, which is tentatively titled *Recycled Soldiers: Wars, Violences, and Identities (1914–1923)*.
oksana.dudko@mail.utoronto.ca

ÉVA FORGÁCS

is adjunct Professor of Art History at Art Center College of Design in Pasadena. She was Professor of Art History at the László Moholy-Nagy University in her native Budapest, and Visiting Professor at University of California, Los Angeles. Her books include *Hungarian Art. Confrontation and Revival in the Modern Movement* (DoppelHouse Press, Los Angeles, 2016), *The Bauhaus Idea and Bauhaus Politics* (CEU Press, Budapest, 1995), the co-edited volume (with T. O. Benson) *Between Worlds: A Sourcebook of Central European Avant-Gardes* (The MIT Press, Cambridge, MA, 2002), and two volumes of essays published in Hungary. She has widely published essays and reviews in journals, edited volumes, and catalogues.
eva.forgacs.ac@gmail.com

IRINA GENOVA

is Professor in Art Studies at the New Bulgarian University, Sofia, and at the Institute of Art Studies of the Bulgarian Academy of Sciences. Her publications discuss manifestations of modernisms in Bulgaria and neighboring countries, as well as contemporary artistic practices. Her books include: *Modernisms and Modernity — (Im)Possibility for Historicising* (2004) and *Modern Art in Bulgaria: First Histories and Present Narratives beyond the Paradigm of Modernity* (2013). She has received scholar grants from the Paul Getty Foundation (1994, 1998); New Europe College, Bucharest (2004); National Institute of Art History in Paris (2005); Centre for Advanced Study, Sofia (2016–2017); and others.
igenova@nbu.bg

GINTA GERHARDE-UPENIECE

is head of the Latvian Visual Arts Department, Latvian National Museum of Art (LNMA). She was formerly president of ICOM LATVIA and lecturer at the Art Academy of Latvia. Her major exhibition projects include: Mark Rothko's centennial exhibition (from Washington National Gallery, 2003), coordination of exhibitions in LNMA — Festival *France-Latvia: Surprising Latvia*, 2005; *French Spring*, 2007; Regular participation in international conferences. Her major publications include: *The Art and Latvian State. 1918–1940* (Neputns, Riga, 2016), and *50 Masterpieces of Latvian Painting* (Jumava, Riga, 2013). She was curator of the project *1914 — Riga Cultural Capital of Europe 2014*, head of the project *Symbolism in Art of Baltic States* (Musée d'Orsay, Paris, 2018).
ginta.gerharde@lnmm.lv

LIDIA GŁUCHOWSKA

is an art and literary historian and head of the Department of Theory of Art at the Institute of Visual Arts, University of Zielona Góra, Poland. She studied in Warsaw and received her PhD from Humboldt University, Berlin, in 2007. She has widely curated exhibitions on Polish and German modernism and the avant-garde, as well as the Yiddish avant-garde, contemporary photography, painting and graphics in Poland, Germany, Ukraine and Serbia. She has co-organized international conferences in Great Britain, Sweden, Finland and the Czech Republic. From 2011–2013 she held grants from the Government of Norway and City of Oslo, conducting research on Edvard

Munch and Gustav Vigeland. Her books *Stanislaw Kubicki — Kunst und Theorie* (2001, 2nd ed. 2003) and *Avantgarde und Liebe* (2007) received awards from the Polish Association of Art Historians. Her latest book publications include: *Stanisław Kubicki — in transitu. Ein Poet übersetzt sich selbst* (2015) and edited volumes *Transnationality, Internationalism and Nationhood. European Avant-Garde in the First Half of the Twentieth Century* (as co-editor, 2013), *"Bunt" — Expressionismus — Grenzübergreifende Avantgarde* (2015), *Ogrody/Gärten* (2016), *Maler, Mentor, Magier. Otto Mueller und sein Netzwerk in Breslau* (as co-editor, 2018, Polish version: 2019).

l.gluchowska@isw.uz.zgora.pl

ANNIKA GUNNARSSON
has a PhD in Art History and has been curator of Prints and Drawings at Moderna Museet since 2001. She has worked at the Nationalmuseum, Prins Eugens Waldemarsudde and in the Art History Department at Stockholm University as a freelance teacher. Gunnarsson is interested in visual studies, museum and exhibitions studies, and art theory.
A.Gunnarsson@modernamuseet.se

NINA GURIANOVA
is Professor of Slavic Languages and Literatures at Northwestern University (USA). Her scholarship in the fields of literature and art history encompasses both Russian and European modernist and avant-garde movements, with a specific emphasis on the interrelation of aesthetics and politics. She has authored and edited six books on the Russian avant-garde

and served as an exhibition consultant for the Guggenheim Museum of Art and the Museum of Modern Art. Gurianova's most recent book, *The Aesthetics of Anarchy* (University of California Press, Berkeley, 2012) won the AATSEEL Best Book in Literary/Cultural Studies annual award.
n-gourianova@northwestern.edu

BENEDIKT HJARTARSON
is Professor of Comparative Literature and Cultural Studies at the University of Iceland. He is the author of a number of articles on the European avant-garde, published in Icelandic, German, Danish, English, and Swedish. Among his recent publications are the monograph *Visionen des Neuen. Eine diskurshistorische Analyse des frühen avantgardistischen Manifests* (2013); the collective volumes *A Cultural History of the Avant-Garde in the Nordic Countries 1925–1950* (2019); *Utopia: The Avant-Garde, Modernism and (Im)possible Life* (2015); *Decentring the Avant-Garde* (2014); *The Aesthetics of Matter* (2013); *A Cultural History of the Avant-Garde in the Nordic Countries 1900–1925* (2012); *Regarding the Popular* (2011); and *Europa! Europa?* (2009).
benedihj@hi.is

VENDULA HNÍDKOVÁ
is an art historian based in Prague. She has been a researcher at the Institute of Art History at the Czech Academy of Sciences since 2005. Her research focuses on modern and contemporary architecture, with a special emphasis on the analysis of broad political, historical, and economic contexts. She has published multiple books, including *Pavel Janák*.

Obrys doby (2009), and *National Style. Art and Politics* (2013), and recently completed *Moscow 1937. Architecture and Propaganda*. In 2013, she curated the exhibition *National Style. Art and Politics*, and in 2015 cooperated in the exhibition project *Building a State*. Both took place at the National Gallery in Prague.
hnidkova@udu.cas.cz

NAOMI HUME
is Associate Professor of Art History in the Department of Art and Art History at Seattle University. She specializes in late 19th- and early 20th-century Central European art and visual culture. She is particularly interested in questions of national and artistic identity at stake when Central European artists borrowed and adapted French visual vocabularies to serve different, often explicitly political, purposes in new contexts. Her work has been published in international journals including *Slavic Review*, *Umění/Art,* and *Centropa*.
HumeN@seattleu.edu

TORBEN JELSBAK
is Associate Professor of Nordic Literature at the Department of Nordic Studies and Linguistics at University of Copenhagen, Denmark. He has published a series of articles and books on Nordic and European avant-garde art and culture, including the monograph *Ekspressionisme. Modernismens formelle gennembrud i dansk malerkunst og poesi* [Expressionism. The formal breakthrough of Modernism in Danish Art and Literary History, 2005] and the Ph.D.-thesis *Avantgardefilologi og teksttransmission* [Avant-Garde

Philology and Textual Transmission, 2008]. He is co-editor of *A Cultural History of the Avant-Garde in the Nordic Countries*, vol. 1 (Rodopi, 2012) and *Die skandinavische Moderne und Europa. Transmission, Exil, Soziologie* (Praesens Verlag, 2016). tjelsbak@hum.ku.dk

ERWIN KESSLER

is Researcher at the Institute of Philosophy, Romanian Academy and Director of the MARe/Museum of Recent Art Bucharest. His books include: *Tzara. Dada. Etc.* (2016); *Atavistic antropogeographies* (2015); *x20* (2013); and *I Colori delle Avanguardie* (2011). Recent collective books include: *Brancusi — the Man*, 2016; "Erratic dogma: Romanian art after 1965" in *The search for cultural identity in Central and Eastern Europe 1919–2009* (2015); "Neo-Orthodox Art in Romania from 1970 through the 1990s" in *Centropa* (2015), "On Propagarde" in *Art beyond borders. Artistic exchanges in communist Europe (1945–1989)* (2015) and "Picture it Painted: Reality, Real and Realisms in Romanian Art and Theory, 1960-1976" in *East of Eden*, (2012). kesslererwin@yahoo.com

VOJTĚCH LAHODA († 2019)

was Professor of Art History at The Charles University in Prague. He served as Director of the Institute of Art History, Czech Academy of Sciences in Prague from 1993–2001 and 2012–2017. He specialized in Czech and Central European modernism and avant-gardes. He was the author, co-author, and main editor of numerous books and exhibition catalogues on Czech modern art.

He presented lectures and papers in Austria, Belgium, Denmark, Estonia, Finland, France, Germany, Latvia, Lithuania, Netherlands, Poland, Serbia, Slovakia, Sweden, Switzerland, United Kingdom, Israel and the USA. He has received many awards, including the Fondation Maison des Sciences de l'Homme, Paris (2006); The Royal Society of Edinburgh (2001); Czech Academy of Sciences Prize (1999); NIAS Fellowship, Wassenaar, Netherlands (1995); The Getty Grant Program, USA (1994–1995); the Soros Senior Fellowship; CASVA, National Gallery of Art, Washington, D.C. (1991). He contributed to the exhibition catalogues in Von der Heydt Museum, Wuppertal; KUMU, Tallinn; Complesso del Vittoriano in Rome; Galerie Belvedere, Vienna; Albertina, Vienna; Tate Liverpool; Lithuanian Gallery of Art, Vilnius; and Pécs, Hungary.

STEVEN MANSBACH

is Professor of the History of Twentieth-century Art at the University of Maryland. He focuses his research and teaching interests on the genesis and reception of 'classical' modern art, roughly from the last quarter of the 19th century through the middle of the 20th. With interests that encompass all of Europe, his specific area of scholarly publication is the art of Central and Eastern Europe from the Baltic north to the Adriatic south. On this topic he has published numerous books, articles, exhibition catalogues, and essays including *Riga's Capital Modernism* (2013), *Graphic Modernism* (2007), *Modern Art in Eastern Europe: From the Baltic to the Balkans c. 1890 to 1939* (1999), and *Standing in the*

Tempest: Painters of the Hungarian Avant-Garde (1991), among many others. He has also taught this subject as a professor in Germany, Poland, Hungary, and South Africa, as well as at several American universities. In addition to holding fellowships and university professorships in the United States, Europe, and Africa, he served almost a decade as associate dean of the Center for Advanced Study in the Visual Arts at Washington's National Gallery of Art, and as the founding dean and director of the American Academy in Berlin. mansbach@umd.edu

EMILIO QUINTANA PAREJA

was born in Granada and graduated in Romance Philology with a doctorate in Hispanic Philology from the University of Granada, Spain, with a thesis about the beginning of the avant-garde movement in Spain: *Entre el modernismo y la vanguardia* (1996). He has been Permanent Lecturer at the University of Granada (1989–2003), and at the Spanish Cultural Institution (Cervantes Institute; in Italy, The Netherlands, and Sweden). He was Visiting Scholar at the University of Lund, Sweden (2001). He has published widely upon modernism, including translations into Spanish of several avant-garde poets such as Pierre Albert-Birot (2014), Tadeusz Peiper (2014), and Henry Parland (2013). He is currently Academic Coordinator at Spanska Kulturinstitutet i Stockholm. equintan@gmail.com

PETAR PRELOG

Institute of Art History, Zagreb, Croatia. He received his PhD in Art History from the Faculty of Humanities and Social Sciences, University of Zagreb. He is a senior research associate at the Institute of Art History in Zagreb, where he has participated in several research projects related to Croatian modern art. He taught courses at the Academy of Fine Arts and at the Department of Art History, Faculty of Humanities and Social Sciences, University of Zagreb. He is the author of a series of studies on Croatian modern and contemporary art in books and journals, as well as several exhibitions, notably: *Proljetni salon 1916–1928* [Spring Salon 1916–1928; Zagreb, 2007] and *Zagreb–München. Hrvatsko slikarstvo i Akademija likovnih umjetnosti u Münchenu* [Zagreb–Munich. Croatian Painting and the Academy of Fine Arts in Munich, co-author, Zagreb, 2009]. His research interests include avant-gardes in Croatian art, relations between art, ideology and national identity, Croatian modernism in the Central European context, Croatian art historiography, and digital art history.
pprelog@ipu.hr

BELA TSIPURIA

earned her Ph.D. in literature in 1993 from the Tbilisi State University, where she worked as an Associate Professor until 2005. She has also worked as a visiting scholar for a semester at Lund University, Sweden; for two semesters at Pennsylvania State University, USA; and was a Thesaurus Poloniae fellow at the ICC, Cracow. She is a specialist in 20th century Georgian literature and comparative literature — intercultural contacts, Symbolist, modernist and Postmodernist movements, as well as Soviet ideological influences and postcolonialism. She is the author of the book *Georgian Text in Soviet/Post-Soviet/Postmodern Context*, and up to 50 research publications, some available in English. She served as the Deputy Minister of Education and Science of Georgia 2004–2008. She is currently Professor and Director of the Institute of Comparative Literature at the Ilia State University, Tbilisi, Georgia.
bela_tsipuria@iliauni.edu.ge

HARRI VEIVO

is Professor at the Department of Nordic Studies at the University of Caen (France) and member of the ERLIS research group. His research interests concern the history and theory of the avant-garde, the avant-garde and modernism in the Nordic countries, and cultural and literary geography. His recent publications include "Jazzing Up Modernism. Jazz, Popular Culture and Dada in Henry Parland and Gunnar Björling" in *Modernism/Modernity* 4/2015 and "Cosmopolite en crise. Décentrements de modernité et fractures de subjectivité dans les récits de voyage d'Olavi Paavolainen" in *Revue de littérature comparée* 2/2015. He is also co-editor of *Utopia. Avant-Garde, Modernism and (Im)possible Life* (De Gruyter, 2015).
harri.veivo@unicaen.fr

MICHAŁ WENDERSKI

is an architect, translator, and scholar of modern Dutch literature. He is a Senior Lecturer at Adam Mickiewicz University in Poznań, Poland, and the head of a research project in the field of cultural mobility between Poland and the Low Countries in the 1920s (National Science Centre, Poland; 2014/13/N/HS2/02757). He is also the author of several publications on the interwar network of literary and artistic avant-gardes.
mwenderski@wa.amu.edu.pl

TOMÁŠ WINTER

studied art history at the Faculty of Arts, Charles University (Ph.D. 2006). During his studies, he began to work at the Institute of Art History of the Czech Academy of Sciences where he still works today (he is a director of the Institute). He focuses on the history of Czech and international art of the 19th and 20th centuries and on the relationship between European and non-European art and the questions of caricature, folk art and "low" genres. He taught art history at the University of West Bohemia in Pilsen, Masaryk University in Brno, University of South Bohemia in České Budějovice and the Academy of Arts, Architecture and Design in Prague where he became Associate Professor in 2015. Since 2018 he has been teaching at Palacký University in Olomouc. He has authored dozens of journal articles, monographs in both Czech and other languages, and prepared a number of exhibitions and catalogues. He is a member of academic advisory boards and he is on the editorial boards of art history journals.
winter@udu.cas.cz

List of Images

"THE WAR TO END ALL WARS"… (A)NATIONALISM AND COSMOPOLITANISM IN THE AVANT-GARDE AND MODERNIST STUDIES ON VISUAL CULTURE AND LITERATURE. INTRODUCTION

Lidia Głuchowska

1.

Overview of the *Riflemen* section at the *1914* exhibition (11.01.–20.04.2014), held in Exhibition Hall Arsenāls, Latvian National Museum of Art, Riga, photographer: Kristaps Kalns (photograph: provided by Latvijas Nacionālais mākslas muzejs)

2.

Overview of the *Eyewitnesses* section at the *1914* exhibition (11.01–20.04.2014), held in Exhibition Hall Arsenāls, Latvian National Museum of Art, Riga, photographer: Kristaps Kalns (photograph: provided by Latvijas Nacionālais mākslas muzejs)

3.

Overview of the *Eyewitnesses* section at the *1914* exhibition (11.01.–20.04.2014), held in Exhibition Hall Arsenāls, Latvian National Museum of Art, Riga, photographer: Kristaps Kalns (photograph: provided by Latvijas Nacionālais mākslas muzejs)

4.

Overview of *The Offensive* section at the *Wielka Wojna* [The Great War] exhibition (23.11.2018–17.03.2019), held in Museum of Art in Łódź, photographer: Piotr Tomczyk (photograph: Muzeum Sztuki w Łodzi). With works by Ernst

Barlach (*Soldatengruppe*; 1932), Anna Airy (*Women Working in a Gas Retort House*; 1918) and Roberto Marcello Baldessari (*Soldati alla stazione*; c. 1917).

5.

Overview of *The Offensive* section at the *Wielka Wojna* [The Great War] exhibition (23.11.2018–17.03.2019), held in Museum of Art in Łódź, photographer: Piotr Tomczyk (photograph: Muzeum Sztuki w Łodzi). With works by a.o. Vladimir Mayakovsky (*Patriotic Poster against the Turks*; 1914) and photo by Stanisław Janowski (*Horses of the 2ⁿᵈ Uhlan Regiment, XV. Front of the Polish Legions in Wołyń*; April–May 1916).

6.

Overview of foyer with map and chronology at the *Rozlomená doba 1908–1928. Avantgardy ve střední Evropě* [Years of Disarray 1908–1928. Avant-Gardes in Central Europe] exhibition (21.09.2018–27.01.2019), held in Olomouc Museum of Art, photographer: Zdeněk Sodoma (photograph: Olomouc Museum of Art).

7.

Overview of *Shared World* and *Visual Speech* sections concerning the international magazine network at the *Rozlomená doba 1908–1928. Avantgardy ve střední Evropě* [Years of Disarray 1908–1928. Avant-Gardes in Central Europe] exhibition (21.09.2018–27.01.2019), held in Olomouc Museum of Art, photographer: Zdeněk Sodoma (photograph: Olomouc Museum of Art)

8.

Pola Lindenfeld, *Frauentorso* [Female Torso], c. 1922, bronze

after original plaster. Private collection, Berlin (photograph: provided by author). Presented at the *Ekspresje Wolności. Bunt i Jung Idysz – wystawa, której nie było…* [Expressions of Freedom. Bunt and Yung-Yidish — The Exhibition That Never Was…] exhibition (12.06.–30.10.2019), held in Museum of the City of Łódź.

INTERNATIONAL EXPRESSIONISM AS THE STYLE OF THE GREAT WAR? REMARKS ON ITS ADAPTATION AND EVALUATION

Lidia Głuchowska

1.

Henry Ericsson, *Karagusteknu nometne* [Prison Camp], 1919, oil on canvas, 68 × 48 cm. Finnish National Gallery, Ateneum Art Museum, Helsinki, A IV 3316 (photograph: Kansallisgalleria, Ateneumin taidemuseo, Hannu Pakarinen)

2.

Max Wislicenus, tapestry *St. Georg* (realized by Wanda Bibrowicz; 250 × 200 cm), 1917, archival photograph. Schlesisches Museum zu Görlitz, F/2005/0910 (artwork: permission provided by the family of Max Wislicenus; photograph: provided by Schlesisches Museum zu Görlitz)

3.

Max Wislicenus, *Ruinen von Konstantinów bei Kalisch* [Ruins in Konstantynow near Kalisz], c. 1915, wool, cardboard, 57 × 61 cm. Schlesisches Museum zu Görlitz, 2014/0403 (artwork: permission provided by the family of Max Wislicenus; photograph: provided by Schlesisches Museum zu Görlitz / René E. Pech)

4.

Tone Kralj, *Na razvalinah* [Among the Ruins], 1922, oil on canvas, 115.5 × 115.5 cm. Božidar Jakac Art Museum, Kostanjevica na Krki, TK 181 (photograph: provided by © Božidar Jakac Art Museum, Kostanjevica na Krki)

5.

Pranas Domšaitis (Franz Domscheit), *Flucht nach Egypten* [Flight to Egypt], 1918, oil on canvas, 95 × 71 cm. Lithuanian National Museum of Art, Vilnius, T-12318 (photograph: provided by Lietuvos nacionalinis dailės muziejus)

6.

Jerzy Hulewicz, *Święty Jerzy pogromca smoków* [Saint George the Dragon Slayer], 1917, oil on canvas, 80 × 100 cm. Museum of Art in Łódź, private deposit (photograph: Muzeum Sztuki w Łodzi)

7.

Bohumil Kubišta, *Pobřežní děla v boji s loďstvem* [Coastal Cannons in the Battle with a Fleet], 1913–1915, oil on canvas, 37.0 × 49.3 cm. National Gallery in Prague, O 3327 (photograph: © National Gallery in Prague 2020)

8.

Heinrich Tischler, *Zug* [Train], 1915, linocut on paper, 22.3 × 11.3 cm. Schlesisches Museum zu Görlitz, 2003/1282 (photograph: provided by Schlesisches Museum zu Görlitz / René E. Pech)

9.

Heinrich Tischler, *Gebete* [Prayers], 1916, linocut on paper, 37.5 × 25.3 cm. Schlesisches Museum zu Görlitz, 2003/1242 (photograph: provided by Schlesisches Museum zu Görlitz / René E. Pech)

10.

Stanisław Kubicki, *Wohin?* [Where to Go?], 1919, ink on paper, 48 × 31 cm. Private collection, Berlin (photograph: provided by author). Inscription: WOHIN? / MENSCHEN / PLANET ERDE, SONNE. Wer den Gipfel einmal erklettert hat, der wird nicht so bald hinunter wollen zu EUCH. [WHERE TO GO? / HUMANS / PLANET EARTH, SUN. Whoever has once climbed to the summit will not want to come back down so quickly to YOU].

11.

Stanisław Kubicki, *Der Eintretende II* [The Entering One II], 1919, oil on board, 95 × 75 cm. Museum of Art in Łódź (photograph: provided by author)

THE RUSSIAN AVANT-GARDE AND THE GREAT WAR. VISIONS AND UTOPIAS

Nina Gurianova

1.

Natalia Goncharova, *Angely i aeroplany* [Angels and Airplanes], 1914, from *Voina: Misticheskie obrazy voiny* [War: Mystical Images of War], Moscow: V. N. Kashin, 1914, lithograph, composition: 30.6 × 22.7 cm. Minneapolis Institute of Art, The Ethel Morrison Van Derlip Fund, P.90.26.10 (artwork: © Natalia Goncharova/OOA-S, 2021; photograph: provided by Minneapolis Institute of Art)

2.

Natalia Goncharova, *Grad obrechennyi* [The Doomed City], 1914, from *Voina: Misticheskie obrazy voiny* [War: Mystical Images of War], Moscow: V. N. Kashin, 1914, lithograph, composition: 30.80 × 23.18 cm. Minneapolis Institute of Art, The Ethel Morrison Van Derlip

Fund, P.90.26.11 (artwork: © Natalia Goncharova/OOA-S, 2021; photograph: provided by Minneapolis Institute of Art)

3.

Olga Rozanova, *Fragmenty iz gazetnogo soobshcheniia* [Fragments from Newspaper Reports], 1915–1916, from Aleksei Kruchenykh, *Voina* [War], Petrograd: Andrei Shemshurin, 1916, linocut, composition: 37.5 × 27.3 cm. Philadelphia Museum of Art, Philadelphia, 125th anniversary acquisition, gift of The Judith Rothschild Foundation, 2002, 2002-233-2 (photograph: Philadelphia Museum of Art/ Bridgeman Images)

4.

Olga Rozanova, *Aeroplany nad gorodom* [Airplanes over the City], 1915–1916, from Aleksei Kruchenykh, *Voina* [War], Petrograd: Andrei Shemshurin, 1916, collaged papers, including woodcuts, printed in color, composition: 38 × 30 cm. The Museum of Modern Art, New York, gift of The Judith Rothschild Foundation, 368.2001.4 (photograph: DIGITAL IMAGE © 2021, The Museum of Modern Art, New York/Scala, Florence)

5.

Aleksei Kruchenykh, *Voennoe gosudarstvo* [Military State], 1916, from Aleksei Kruchenykh, *Vselenskaia Voina* [Universal War], Petrograd: Andrei Shemshurin, 1916, paper and fabric collage on colored paper, composition: 21 × 30 cm. Des Moines Art Center, gift of Louise R. Noun, 1991.45.12 (photograph: provided by Des Moines Art Center Permanent Collections / Rich Sanders)

RIFLEMEN ART. VISUALIZING THE UKRAINIAN WAR

Oksana Dudko

1.

Yulian Krajkivski (designer), postcard *Artystychna horstka* [The Artistic Handful], 1916, as published in Roman Yatsiv and Andriy Yatsiv, *Ivan Ivanets' (1893–1946). Strilets'ki memuary, tvorcha spadschyna*, Lviv: Apriori, 2019, p. 196. Private collection (photograph: provided by Roman Yatsiv)

2.

Osyp Kurylas (designer), postcard "Oi vydno selo, shyroke selo…" ["Oh, Look Over There, You Can See the Great Village…"], 1917–1918. Andrey Sheptytsky National Museum in Lviv, Ft – 17060 (photograph: provided by Andrey Sheptytsky National Museum in Lviv)

3.

Photograph of Osyp Kurylas in Tudynka, 1916, photographer: Ivan Ivanets' (?), as published in Roman Yatsiv and Andriy Yatsiv, *Ivan Ivanets' (1893–1946). Strilets'ki memuary, tvorcha spadschyna*, Lviv: Apriori, 2019, p. 193. Location unknown (photograph: provided by Roman Yatsiv)

4.

Osyp Kurylas, *Portrait of Sen' Horuk*, 1916, oil on canvas, 105.5 × 66.5 cm. Andrey Sheptytsky National Museum in Lviv, NML – 27250 F – 268 (photograph: provided by Andrey Sheptytsky National Museum in Lviv)

5.

Osyp Kurylas, *Portrait of Olena Stepaniv*, c. 1914–1918. Destroyed (photograph: provided by author)

6.

Photograph of Ivan Ivanets', c. 1918, photographer: unknown, as published in Roman Yatsiv and Andriy Yatsiv, *Ivan Ivanets' (1893–1946). Strilets'ki memuary, tvorcha spadschyna*, Lviv: Apriori, 2019, p. 14. Location unknown (photograph: provided by Roman Yatsiv)

7.

Ivan Ivanets', *Skirmish*, c. 1915–1918, watercolor on paper, as published in Roman Yatsiv and Andriy Yatsiv, *Ivan Ivanets' (1893–1946). Strilets'ki memuary, tvorcha spadschyna*, Lviv: Apriori, 2019, p. 377. Private collection (photograph: provided by Roman Yatsiv)

8.

Ivan Ivanets', *Fight*, 1920s, watercolor on paper, as published in Roman Yatsiv and Andriy Yatsiv, *Ivan Ivanets' (1893–1946). Strilets'ki memuary, tvorcha spadschyna*, Lviv: Apriori, 2019, p. 334. Location unknown (photograph: provided by Roman Yatsiv)

9.

"Zavtra v pidofitsers'kii kukhni pyrohy" ["There'll be Pierogies in the Sergeants' Mess Tomorrow"] by unknown designer, 1915, cartoon from self-published frontline newspaper *Samokhotnyk* 5 (1915), p. 4 (photograph: provided by Central State Historical Archives of Ukraine in Lviv)

10.

"Zhertva kholery v Kamintsi" ["Cholera Victim in Kaminka"] by unknown designer, 1915, cartoon from self-published frontline newspaper *Samokhotnyk* 4 (1915), p. 5 (photograph: provided by Central State Historical Archives of Ukraine in Lviv)

11.

Olena Kul'chyts'ka, *The Unknown Rifleman* (also known as *The Fallen Rifleman*), 1915, woodcut on paper, 20.3 × 29.4 cm, from as published in Roman Yatsiv and Andriy Yatsiv, *Ivan Ivanets'*

Olena Kul'chyts'ka, woodcut series *Ukrains'ki sichovi stril'tsi* [Ukrainian Sich Riflemen], 1915, n.p. (photograph: provided by author)

12.

Osyp Kurylas, *The Dead Rifleman Near the Cross* (also known as *Unknown Rifleman*), c. 1915–1916, oil on canvas, 37 × 54 cm. Andrey Sheptytsky National Museum in Lviv, NML – 27273 F – 269 (photograph: provided by Andrey Sheptytsky National Museum in Lviv)

13.

Olena Kul'chyts'ka, *Life Wins* (also known as *After the War* and *Birch Cross*), 1915, etching and aquatint on half cardboard, 17.0 × 12.3 cm. Andrey Sheptytsky National Museum in Lviv, NML – 45687 / a, Gk – 2822 (photograph: provided by Andrey Sheptytsky National Museum in Lviv)

WAR AS PSYCHOLOGICAL, SOCIAL AND INTELLECTUAL EXPERIENCE. THE CONCEPT OF "NATIONAL ART" AND THE FIRST WORLD WAR IN HUNGARY. LAJOS FÜLEP AND THE DYNAMICS OF "NATIONAL" AND "INTERNATIONAL"

Éva Forgács

1.

Postcard with some members of the *Vasárnapi Kör* [Sunday Circle] in Budapest, 1917, photographer: unknown. Petöfi Literary Museum, Budapest, F.1745.1 (photograph: Petöfi Irodalmi Múzeum, Budapest). From left to right: Károly Mannheim, Béla Fogarasi, Ernő Lorsy, József Nemes Lampérth, Elza Stephani, Anna Schlamadinger, Edit Hajós, Béla Balázs.

2.

József Nemes Lampérth, *Kolzsvár (Cluj)*, 1920, Indian ink, 72 × 100 cm.

List of Images

Nancy G. Brinker's collection, USA (photograph: provided by Nancy G. Brinker)

3. _____

Béla Uitz, *Siratás* [Mourning], 1916, etching on paper, 19.0 × 28.7 cm. Museum of Fine Arts, Budapest, G58.22 (artwork: © Béla Uitz/ OOA-S, 2021; photograph: © Szépművészeti Múzeum/ Museum of Fine Arts, 2021)

4. _____

Lajos Tihanyi, *Lajos Fülep*, 1915, oil on canvas, 78 × 95 cm. Museum of Fine Arts, Budapest, 70.152T (photograph: © Szepművészeti Muzeum/ Museum of Fine Arts, 2021)

RESPECT AND TRIUMPH. INTENTIONS AND MEANINGS OF CZECH ARCHITECTURE BEFORE AND AFTER THE FIRST WORLD WAR

Vendula Hnídková

1. _____

Dům U Černé Matky Boží [House at the Black Madonna] (built 1912) in Prague by Josef Gočár, photographer: unknown. Institute of Art History, CAS, Prague, O 50065 (photograph: provided by Institute of Art History, CAS)

2. _____

The main square in Pelhřimov with *Fárův dům* [Fára House] (built 1913–1914) by Pavel Janák, 1930, photographer: Zikmund Kohn. Museum of the Vysočina Region in Pelhřimov, F445-Rx3100 (photograph: provided by Museum of the Vysočina Region in Pelhřimov)

3. _____

Legionářská banka or *Legiobanka* [Czechoslovak Legions Bank] (built 1922–1923) in Prague by

Josef Gočár, c. 1930, photographer: Jaroslav Bruner-Dvořák (?). Scheufler Collection, Czech Republic, KD 901 (photograph: Scheufler Collection)

4. _____

Model of the *Riunine Adriatica di Sicurtà* palace in Prague by Pavel Janák, 1922–1925. National Technical Museum, Museum of Architecture and Civil Engineering, Prague, Janák, ID 085/ kt. 013 (photograph: provided by National Technical Museum)

TRANSNATIONAL OR NATIONAL CUBISM? VINCENC KRAMÁŘ ON CUBISM

Vojtěch Lahoda[†]

1. _____

Vincenc Kramář as a soldier, 1916, photographer: Atelier Deyl Pardubice. Institute of Art History, CAS, Prague, Sc 57/17 (photograph: provided by Institute of Art History, CAS)

2. _____

Emil Filla, *Hlava starce* [Head of an Old Man], 1914, oil on canvas, 66.5 × 50.0 cm. Gallery of West Bohemia in Pilsen, O 632 (artwork: Emil Filla © OOA-S 2020; photograph: © Gallery of West Bohemia in Pilsen)

3. _____

Pablo Picasso, *Le Poète* [The Poet], 1912, oil on canvas, 59.9 × 47.9 cm. Kunstmuseum Basel, G 1967.14 (artwork: Pablo Picasso © OOA-S 2021; photograph: provided by Kunstmuseum Basel)

4. _____

Vincenc Kramář's apartment in Prague with part of his art collection (works by Picasso and Braque), photographer: unknown. Institute of Art History, CAS, Prague, Sc 57/25 (photograph:

provided by Institute of Art History, CAS). From left to right: Picasso's *Absinthe and Cards* (1912; National Gallery in Prague), *Chop* (1912; private collection, Prague), *Violin, Glass, Pipe and Anchor* (1912; National Gallery in Prague), *Sitting Nude* (1912; private collection, Prague), *Ice* (1912; private collection, Prague), *Head of a Man with a Pipe/Boxer* (1912; National Gallery in Prague) and Braque's *Clarinet and Violin* (1912; National Gallery in Prague).

5. _____

Vincenc Kramář's bureau in Prague with works by Picasso, Braque, Gutfreund, and Kubišta's *Pierrot* (1911; National Gallery in Prague), photographer: unknown. Institute of Art History, CAS, Prague, Sc 57/47 (photograph: provided by Institute of Art History, CAS)

6. _____

Cooperative Housing *Domovina* (built 1919–1921) in Znojmo by Otakar Novotný, c. 2000, photographer: Jan Malý (photograph: Jan Malý, CC BY-SA 3.0)

CUT & PASTE IN EXILE AND WAR: OTTO GUTFREUND'S PARISIAN COLLAGES

Naomi Hume

1. _____

Otto Gutfreund, *Kubistické poprsí* [Cubist Bust], view from the front, 1913–1914, bronze, h. 60 cm. National Gallery in Prague, P 5263 (photograph: © National Gallery in Prague 2015)

2. _____

Otto Gutfreund, *Hlava* [Head], 1913–1914, colored chalk and collage on newspaper, 67.8 × 43.0 cm. Gallery of Fine Arts in Ostrava, Gr 1402 (photograph: provided by Gallery of Fine Arts in Ostrava / BcA. Vladimír Šulc)

3.

Otto Gutfreund, *Zátiší s láhví* [Still Life with Bottle], 1913–1914, colored chalk, Indian ink and collage on paper, 40.5 × 23.0 cm. Gallery of Fine Arts in Ostrava, Gr 1399 (photograph: provided by Gallery of Fine Arts in Ostrava / BoA. Vladimír Šulc)

4.

Otto Gutfreund, *Úzkost* [Anxiety], 1911–1912, bronze, 148 × 50 × 43 cm. National Gallery in Prague, P 4259 (photograph: © National Gallery in Prague 2015)

5.

Otto Gutfreund, *Kubistické poprsí* [Cubist Bust], view from the right, 1913–1914, bronze, h. 60 cm. National Gallery in Prague, P 5263 (photograph: © National Gallery in Prague 2015)

6.

Otto Gutfreund, *Kubistické poprsí* [Cubist Bust], view from the left, 1913–1914, bronze, h. 60 cm. National Gallery in Prague, P 5263 (photograph: © National Gallery in Prague 2015)

7.

Otto Gutfreund, *Kubistická kompozice — Hlava* [Cubist Composition — Head], 1912–1913, pencil on paper, 28.3 × 22.6 cm. National Gallery in Prague, K 39192 (photograph: © National Gallery in Prague 2015)

8.

Otto Gutfreund, *Hlava (Kubistická kompozice)* [Head (Cubistic Composition)], 1911–1913, drawing on paper, 27.7 × 22.4 cm. Olomouc Museum of Art, K 3492 (photograph: provided by The Olomouc Museum of Art Archive)

9.

Pablo Picasso, *Bouteille sur une table* [Bottle on a Table], 1912,

pasted papers and charcoal on paper, 62 × 44 cm. Musée national Picasso-Paris, Paris, MP369 (artwork: Picasso, Pablo (1881–1973) © ARS, NY; photograph: © RMN-Grand Palais (Musée national Picasso-Paris), Hervé Lewandowski)

THE GREAT WAR AND THE NEW ART IN POLAND. BETWEEN PATRIOTIC ETHOS, NATIONALIZATION OF MODERNISM, AND INTERNATIONAL ATTEMPTS IN AESTHETICS

Lidia Głuchowska

1.

Witold Hulewicz at the Western Front, c. 1916, photographer: unknown, as published in Agnieszka Karaś, *Der Pole, der auch Deutscher war. Das geteilte Leben des Witold Hulewicz*, Warsaw: Pod Wiatr & fibre, 2004, p. 30. Private collection (photograph: provided by Agnieszka Karaś)

2.

Bogdan Nowakowski, poster for Stanisław Dzikowski's, *"Powrót taty", czyli wojska rosyjskie zajmują Warszawę* ["Daddy's Return", i.e. the Russian Troops Invade Warsaw], 1917, color lithograph, 72.0 × 53.5 cm. Poster Museum at Wilanów, Division of the National Museum in Warsaw (photograph: provided by Muzeum Plakatu w Wilanowie, Oddział Muzeum Narodowego w Warszawie)

3.

Jerzy Hulewicz, *Na tle Króla Ducha* [On the Background of the King the Spirit], 1919, front cover of magazine *Zdrój* IX/3 (November 1919), linocut (photograph: provided by Kórnik Library, Polish Academy of Science). Illustration with the motive of the Polish Winged Hussars — a metaphor of the Polish-Soviet war — is

inspired by the poem "Król-Duch" ["King, the Spirit", 1847] by Juliusz Słowacki.

4.

Poster *Tak działa każda marka zapisana na polską pożyczkę odrodzenia* [This is How Each [Polish] Mark Given to the Polish Resurrection Fund Works], 1920, color lithograph, 94.8 × 62.8 cm. Poster Museum at Wilanów, Division of the National Museum in Warsaw (photograph: provided by Muzeum Plakatu w Wilanowie, Oddział Muzeum Narodowego). Headlined: "Purchase Polish Resurrection Bonds!"

5.

Josef Fenneker, film poster *Der gelbe Schein* [The Devil's Pawn], 1918, color lithograph, 71.4 × 94.7 cm. Stiftung Deutsche Kinemathek — Museum für Film und Fernsehen, Berlin, G1_00_033 (artwork: permission provided by Stadt Bocholt — Stadtmuseum Bocholt / City Museum Bocholt; photograph: Stiftung Deutsche Kinemathek — Museum für Film und Fernsehen)

6.

Wojciech Jastrzębowski, *Józef Piłsudski — Wódz Polski* [Józef Piłsudski — Commander-in-Chief of Poland], 1914, color lithograph, composition: 45.5 × 41.3 cm. Museum of Independence in Warsaw, Gr. 1970 (photograph: provided by Museum of Independence in Warsaw)

7.

Jacek Malczewski, *Nike Legionów* [Nike of the Polish Legions], 1916, oil on wood, 193 × 94 cm. Cracow Society of Friends of Fine Arts (photograph: provided by Towarzystwo Przyjaciół Sztuk Pięknych w Krakowie / Przemysław J. Witek)

8.

Stanisław Kubicki, *Wieża Babel II/ Der Turmbau zu Babel II* [The Tower of Babel II], 1917, linocut, 24.0 × 24.8 cm. Private collection, Berlin (photograph: provided by author)

9.

Stanisław Kubicki, *Bunt* [Rebellion], 1918, front cover of magazine *Die Aktion* VIII/21/22 (June 1918), linocut, c. 12 × 17 cm (photograph: provided by author). Programmatic illustration *Bunt* — of a double Polish/German meaning: "rebellion/coloured" — for special issue of the Berlin magazine titled *Polnische Kunst* [Polish Art].

10.

Stanisław Kubicki, *Wioślarz/ Der Ruderer* [The Rower], 1918, linocut from magazine *Zdrój* III/1 (April 1918) (photograph: provided by Kórnik Library, Polish Academy of Science)

11.

Adam Bunsch, *Kula karabinowa* [Machine Gun Bullet], 1946, oil on canvas, 108 × 145 cm. Private collection, Poland (artwork: permission provided by the family of Adam Bunsch; photograph: provided by the family of Adam Bunsch). Replica of the original painting from 1929 (today in National Museum in Warsaw).

UNCANONICAL IMPULSES TO THE CANON: POLISH AND BELGIAN CONTRIBUTIONS TO INTERNATIONAL CONSTRUCTIVISM

Michał Wenderski

1.

Fictional dialogue ridiculing the Belgian avant-garde, from magazine *Mécano* 3–4 (1924), n.p. (photograph: provided by author)

2.

Front covers of Constructivist magazines from Poland and the Low Countries, 1917–1926 (photograph: provided by author). Magazines: *Zwrotnica* 6 (October 1923), *Praesens* 1 (June 1926), *De Stijl* 1 (October 1917), *De Driehoek* 1 (April 1925), *Blok* 8–9 (November/December 1924), *Mécano* 3 (October 1922), *The Next Call* 9 (November 1926) and *Het Overzicht* 20 (January 1924).

3.

Lists of "congenial avant-garde magazines":
a. from magazine *Het Overzicht* 20 (1924), p. 136. (photograph: provided by IADDB, www.iaddb.org)
b. from magazine *The Next Call* 6 (1924), n.p., ink on paper, 54.0 × 42.7 cm. (photograph: provided by Groninger Museum / Marten de Leeuw)

4.

Catalogue of the first *Cercle et Carré* exposition, from magazine *Cercle et Carré* 2 (1930), n.p. (photograph: provided by IADDB, www.iaddb.org). The exposition was held in Paris between April 18 and May 1, 1930.

5.

Examples of Polish influence within the avant-garde network:
a. Mieczysław Szczuka, *Collage*, 1924, from magazines *Blok* 3–4 (1924), n.p., and *Dźwignia* 5 (1927), p. 12 (photograph: provided by Library of The Institute of Literary Research of the Polish Academy of Sciences)
b. Hendrik Nicolaas Werkman, *Compositie met letters en haken* [Composition with Letters and Hooks], 1932, offset on paper, 17.8 × 11.2 cm. Municipal Museum Amsterdam, A 8098 (1-5) (photograph: Collection Stedelijk Museum Amsterdam)

COSMOPOLITANISM, NATIONALISM, AND THE RECONFIGURATIONS OF THE MAP OF EUROPE IN THE DISCOURSE OF MODERNITY IN FINLAND IN THE 1920S

Harri Veivo

1.

Olavi Paavolainen (text and layout), poem "Rikkinäiselle pulloverille" ["To the Old Pullover"], from album *Tulenkantajat* 4 (January 1927), pp. 126–127 (text: Olavi Paavolainen © SANASTO; photograph: National Library of Finland, Digital Collections, www.digi.kansalliskirjasto.fi)

2.

Olavi Paavolainen (text and layout), essay "Nykyaikaa etsimässä" ["In Search of Modern Times"], from magazine *Aitta* 7 (July 1927), pp. 20–21 (text: Olavi Paavolainen © SANASTO; photograph: National Library of Finland, Digital Collections, www.digi. kansalliskirjasto.fi)

3.

Olavi Paavolainen (text), Eeli Jaatinen (layout), text "Helsinki by Night", from magazine *Aitta* 12 (December 1929), pp. 34–35 (text: Olavi Paavolainen © SANASTO, layout: © Eeli Jaatinen/OOA-S, 2021; photograph: National Library of Finland, Digital Collections, www.digi. kansalliskirjasto.fi)

4.

Olavi Paavolainen (text), Eeli Jaatinen (layout), text "Helsinki by Night", from magazine *Aitta* 12 (December 1929), pp. 36–37 (text: Olavi Paavolainen © SANASTO, layout: © Eeli Jaatinen/OOA-S, 2021; photograph: National Library of Finland, Digital Collections, www.digi.kansalliskirjasto.fi)

5.

Ludvig Wennervirta (text), article "Virolainen taidenäyttely" ["The Estonian Art Exhibition"], from magazine *Tulenkantajat* 5 (February 1929), pp. 74–75 (photograph: provided by author)

6.

Ludvig Wennervirta (text), article "Virolainen taidenäyttely" ["The Estonian Art Exhibition"], from magazine *Tulenkantajat* 5 (February 1929), p. 76 (photograph: provided by author)

7.

Lauri Viljanen (text), article "Eestin kautta Eurooppaan" ["To Europe via Estonia"], from magazine *Tulenkantajat* 11–12 (June 1930), pp. 150–151 (text: Lauri Viljanen © SANASTO; photograph: National Library of Finland, Digital Collections, www.digi. kansalliskirjasto.fi)

ABSTRACT CONSTRUCTIVISM AND THE CASE OF FINNUR JONSSON. UNIVERSAL LANGUAGE — NATIONAL IDIOM?

Benedikt Hjartarson

1.

Finnur Jónsson, *Borgarstemmning* [City Atmosphere] (also known as *Berlin*), 1921, ink on paper, 31.4 × 41.0 cm. National Gallery of Iceland, Reykjavík, LÍ-5377 (artwork: © Finnur Jónsson/Myndstef; photograph: ©Listasafn Íslands/Sigurður Gunnarsson)

2.

Finnur Jónsson, *Model*, 1923, tusche drawing on paper, 41 × 26 cm. National Gallery of Iceland, Reykjavík, LÍ 4560 (artwork: © Finnur Jónsson/Myndstef; photograph: ©Listasafn Íslands/Sigurður Gunnarsson)

3.

Finnur Jónsson, *Composition*, 1924, tusche drawing on paper, 28.0 × 15.5 cm. National Gallery of Iceland, Reykjavík, LÍ 4565 (artwork: © Finnur Jónsson/Myndstef; photograph: ©Listasafn Íslands/Sigurður Gunnarsson)

4.

Lothar Schreyer, *Figur des lüsternen Mannes*, 1920, color lithograph on light cardboard, sheet: 39.7 × 29.5 cm. Formerly Ketterer Kunst GmbH und Co. KG (artwork: permission provided by family of Lothar Schreyer; photograph: provided by Ketterer Kunst GmbH und Co. KG)

5.

Hans Haffenrichter, linocut *Op. 23/37b* with seated female figure, 1923, linocut on chamois paper, composition: 19 × 15 cm. Formerly Lehr Berlin (artwork: permission provided by family of Hans Haffenrichter; photograph: provided by Lehr Berlin / Stefan Schiske)

6.

Finnur Jónsson, *Kona við spilaborð* [Woman at the Card Table], 1925, oil and gold paint on burlap, 64.1 × 51.6 cm. Yale University Art Gallery, gift of Collection Société Anonyme, 1941.510 (artwork: © Finnur Jónsson/Myndstef; photograph: provided by Yale University Art Gallery, gift of Collection Société Anonyme)

7.

Finnur Jónsson, *Marglitur heimur* [Colored World], 1925. Lost, formerly Yale University Art Gallery, gift of Collection Société Anonyme (artwork: © Finnur Jónsson/Myndstef; photograph: provided by Yale University Art Gallery, gift of Collection Société Anonyme)

8.

Finnur Jónsson, *Composition*, 1923, tusche drawing on paper, 30.0 × 22.5 cm. National Gallery of Iceland, Reykjavík, LÍ-4561 (artwork: © Finnur Jónsson/Myndstef; photograph: ©Listasafn Íslands/Sigurður Gunnarsson)

9.

Finnur Jónsson, *Óður til mánans* [Ode to the Moon], 1925, oil on canvas, 78 × 68 cm. National Gallery of Iceland, Reykjavík, LÍ-4785 (artwork: © Finnur Jónsson/Myndstef; photograph: ©Listasafn Íslands/Sigurður Gunnarsson)

10.

Finnur Jónsson, *Örlagateningurinn* [Dice of Destiny], 1925, oil on canvas, 45 × 45 cm. National Gallery of Iceland, Reykjavík, LÍ-4784 (artwork: © Finnur Jónsson/Myndstef; photograph: ©Listasafn Íslands/Sigurður Gunnarsson)

ART AND THE NEW LATVIAN STATE (1918-1920). MODERNISM — BETWEEN COSMOPOLITAN INSPIRATIONS AND A SUBSTANTIVE NATIONAL FACTOR

Ginta Gerharde-Upeniece

1.

Jāzeps Grosvalds, *Karavīri bēdājās* [Soldiers Were Grieving], c. 1917, tempera on cardboard, 54.5 × 67.0 cm. Latvian National Museum of Art, Riga, VMM GL-2785 (photograph: provided by Latvijas Nacionālais mākslas muzejs)

2.

Romans Suta, *Uzbrukumā* [Attack], 1919, linocut on paper, sheet: 31.6 × 25.5 cm. Private collection (photograph: provided by author)

3.

Konrāds Ubāns, *Bēgļi* [Refugees], 1917, oil on canvas, 97.0 × 76.0 cm. Latvian National Museum of Art, Riga, VMM GL-4796 (artwork: © Konrāds Ubāns/OOA-S, 2021; photograph: provided by Latvijas Nacionālais mākslas muzejs)

4.

Oto Skulme, *Composition*, 1920, oil on canvas, 81.5 × 75.0 cm. Latvian National Museum of Art, Riga, VMM GL-959 (artwork: © Oto Skulme/OOA-S, 2021; photograph: provided by Latvijas Nacionālais mākslas muzejs)

5.

Valdemārs Tone, *Portreta mets* [Sketch of a Portrait], 1920, oil on canvas, 101 × 60 cm. Latvian National Museum of Art, Riga, VMM GL-826 (photograph: provided by Latvijas Nacionālais mākslas muzejs).

6.

Jāzeps Grosvalds, *Trīs krusti* [Three Crosses], 1917, oil on canvas, 57 × 69 cm. Latvian National Museum of Art, Riga, VMM GL-783 (photograph: provided by Latvijas Nacionālais mākslas muzejs)

7.

Jēkabs Kazaks, *Bēgļi* [Refugees], 1917, oil on canvas, 210.5 × 107.0 cm. Latvian National Museum of Art, Riga, VMM GL-826 (photograph: provided by Latvijas Nacionālais mākslas muzejs)

8.

Ģederts Eliass, *Vagonā* [In a Railway Carrriage], 1917, oil on canvas, 85.5 × 67.0 cm. Latvian National Museum of Art, Riga, VMM GL-4729 (photograph: provided by Latvijas Nacionālais mākslas muzejs)

9.

Aleksandrs Drēviņš, *Bēgles* [Refugee Women], 1916, oil on canvas, 100 × 100 cm. Latvian National Museum of Art, Riga, VMM GL-479 (photograph: provided by Latvijas Nacionālais mākslas muzejs)

10.

Photograph of the *Riga Group of Artists* in the *Sukubs* canteen, 1920, photographer: unknown. Latvian National Museum of Art, Riga, LNMM ZDC, MP-89 (2036) (photograph: provided by Latvijas Nacionālais mākslas muzejs). From left to right: Romans Suta, Niklāvs Strunke, Valdemārs Tone, Jēkabs Kazaks, Konrāds Ubāns and Oto Skulme.

THE AESTEHTICS OF NEUTRALITY. THE IMPACT OF THE FIRST WORLD WAR ON DANISH ART AND CULTURE

Torben Jelsbak, Dorthe Aagesen

1.

Axel Thiess, *Gullasch Capitalism*, 1915, illustration from satirical magazine *Blæksprutten* (1915), p. 29 (photograph: Det Kgl. Bibliotek, Copenhagen). The caption reads: "Huckster Jensen's birthday party 1914. Goulash supplier Jensen's birthday party 1915."

2.

Karl Larsen, *En trappegang* [A Staircase], 1917, oil on paper on canvas, 95 × 63 cm. Private collection (artwork: © Karl Larsen/OOA-S, 2021; photograph: provided by Ole Hein Pedersen, Denmark)

3.

Vilhelm Lundstrøm, *Composition 2*, 1918, oil on wood, 113.5 × 81.5 cm. National Gallery of Denmark, Copenhagen (artwork: © Vilhelm Lundstrøm/OOA-S, 2021; photograph: provided by Statens Museum for Kunst / Jacob Skou-Hansen)

4.

Per Lasson Krohg, *Granaten* [The Grenade], 1916, oil on canvas, 172.5 × 135.0 cm. Trondheim Art Museum (artwork: © Per Lasson Krohg/OOA-S, 2021; photograph: NTNU/Trondheim kunstmuseum, Freia Beer)

5.

Mogens Lorentzen, front cover of war issue of magazine *Klingen* I/8 (May 1918) (artwork: © Mogens Lorentzen/OOA-S, 2021; photograph: provided by Marquand Library of Art and Archaeology, Princeton University)

6.

Lithograph by Kurt Jungstedt and Jacques de Chouden's poem "Min Sabel" ["My Sword"], from war issue of magazine *Klingen* I/8 (May 1918), pp. 8–9. (artwork: © Kurt Jungstedt/OOA-S, 2021; photograph: provided by Marquand Library of Art and Archaeology, Princeton University)

COSMONATIONAL. NEITHER NATIONAL NOR COSMOPOLITAN — BUT A TINGE OF AVANT-GARDE MODERNISM

Annika Gunnarsson

1.

View on the area of the *Baltic Exhibition* in Malmö, 1914, photographer: unknown. Malmö City Archive (photograph: provided by Malmö Stad Bildbank)

2.

Åhlen & Holm's Pavilion for the *Baltic Exhibition* (built 1914), 2011, photographer: Jan Ainali (photograph: Jan Ainali,

3.
Ernst Norlind, Poster of the *Baltic Exhibition*, 1914. Malmö City Archive (artwork: © Ernst Norlind/OOA-S, 2021; photograph: provided by Malmö Stad Bildbank)

MODERNISM AND THE NATIONAL IDEA — REFLECTIONS OF THE FIRST WORLD WAR: THE CASE OF BULGARIA

Irina Genova

1.
Vasil Zahariev, *Golgotha*, 1915–1918, illustration from magazine *Vezni* I/9 (1919–1920), pp. 274–275 (photograph: provided by Sts. Cyril and Methodius National Library, Sofia)

2.
Vladimir Dimitrov-Maystora, *Razpyatie* [Crucifixion], 1920–1921, Indian ink, 65 × 50 cm. National Gallery, Sofia, III-1787 (photograph: provided by National Gallery, Sofia)

3.
Sirak Skitnik, *Placheshti mayki* [Mourning Mothers], 1920–1921:
a. from magazine *Vezni* I/5 (1919–1920), pp. 138–139 (photograph: provided by Sts. Cyril and Methodius National Library, Sofia)
b. from Teodor Trayanov, *Bulgarski baladi* [Bulgarian Ballads], Sofia: Hemus, 1920, n.p. (photograph: provided by Sts. Cyril and Methodius National Library, Sofia)

4.
Ivan Lazarov, *Placheshti zheni* [Mourning Women], 1922, relief frieze, artificial stone, 42 × 105 × 6 cm. National Gallery, Sofia, III-29 (photograph: provided by National Gallery, Sofia)

5.
Ivan Milev, *Nashite mayki vse v cherno hodyat* [Our Mothers are Forever in Mourning], 1926, watercolor, 58 × 86 cm. National Gallery, Sofia, 111-1523 (photograph: provided by National Gallery, Sofia)

6.
Ivan Milev, *Razpyatie* [Crucifixion], 1923, gouache, 68 × 55 cm. Sofia City Art Gallery, 36 (photograph: provided by Sofia City Art Gallery)

7.
Pencho Georgiev, *Pieta*, 1920s, woodcut, each composition: 19 × 22 cm. National Gallery, Sofia, III-794 (photograph: provided by National Gallery, Sofia)

8.
Ivan Milev, *Bauernhochzeit* [Peasants' Wedding], 1929, illustration from magazine *Der Sturm* XX (April 1929), p. 104 (photograph: Universitätsbibliothek Heidelberg)

WAR AS INVERTER IN ROMANIAN ART BETWEEN 1912 AND 1924

Erwin Kessler

1.
Milton and Ianaki Manakia, *Cobza Fiddler*, c. 1905, photograph, as published in Marian Țuțui, *Fratii Manakia si imaginea Balcanilor*, Bucharest: Noi Media Print, 2009, p. 220. Romanian Academy of Sciences (photograph: provided by Marian Țuțui)

2.
Milton and Ianaki Manakia, *Circle Dance in Avdella*, 1903, photograph, as published in Marian Țuțui, *Fratii Manakia si imaginea Balcanilor*, Bucharest: Noi Media Print, 2009, p. 25. Romanian Academy of Sciences (photograph: provided by Marian Țuțui)

3.
Still from Aristide Demetriade's movie *Independența României: Războiul Româno-Ruso-Turc din 1877* [Romania's Independence: Romanian-Russo-Turkish War of 1877] depicting round dance, 1912. National Film Archive — Romanian Cinematheque, Jilava (photograph: National Film Archive — Romanian Cinematheque)

4.
Theodor Aman, *Hora de la Aninoasa* [Round Dance at Aninoasa], 1890, oil on canvas, 45.5 × 67.5 cm. The National Museum of Art of Romania, Bucharest, 1959 (photograph: © The National Museum of Art of Romania)

5.
Iosif Iser, *Tartar Odalisque*, 1933, needle engraving on thick ochre paper, composition: 18.8 × 14.8 cm. Tulcea Fine Arts Museum, 285 (photograph: provided by Tulcea Fine Arts Museum)

6.
Nicolae Tonitza, *Turtucaia Prisoners*, 1920, engraving from G. Millian-Maximin, *În Mâinile Dușmanului. Însemnările unui Prizonier* [In the Hands of the Enemy. The Notes of a War Prisoner], Bucharest: Alcalay & Co., 1920, p. 55 (photograph: provided by author)

7.
Nicolae Tonitza, *Oh, Those Frayed Odalisques…*, 1920, engraving from G. Millian-Maximin, *În Mâinile Dușmanului. Însemnările unui Prizonier* [In the Hands of the Enemy. The Notes of a War Prisoner], Bucharest: Alcalay & Co., 1920, p. 79 (photograph: provided by author)

IN PURSUIT OF NATIONAL IDENTITY: CROATIAN MODERN ART BEFORE AND AFTER THE GREAT WAR

Petar Prelog

1.

Photograph of *Caryatids of Vidovdan Temple* by Ivan Meštrović on the 35th *Exhibition of the Vienna Secession*, 1910, photographer: unknown. Ivan Meštrović Museums — Meštrović Gallery, Split, FGM-1033 (photograph: provided by Muzeji Ivana Meštrovića — Galerija Meštrović)

2.

Ivan Meštrović, wooden model of *Vidovdanski hram* [Vidovdan Temple], 1908–1912, photographer: unknown. Ivan Meštrović Museums — Meštrović Gallery, Split, FGM-1063 (photograph: provided by Muzeji Ivana Meštrovića — Galerija Meštrović)

3.

Miroslav Kraljević, *Bonvivant — Portrait of Ante Masovčić*, 1912, oil on canvas, 91.5 × 65.5 cm. National Museum of Modern Art, Zagreb, MG-771 (photograph: provided by © Moderna galerija, Zagreb / Goran Vranić)

4.

Ljubo Babić, *Udovice* [Widows], 1912, tempera on canvas, 149.0 × 179.5 cm. National Museum of Modern Art, Zagreb, MG-3425 (photograph: provided by © Moderna galerija, Zagreb / Goran Vranić)

5.

Ljubo Babić, *Kastiljanski pejzaž* [Castilian Landscape], 1920–1921, oil on canvas, 49.0 × 64.5 cm. National Museum of Modern Art, Zagreb, MG-964 (photograph: provided by © Moderna galerija, Zagreb / Goran Vranić)

6.

Ljubo Babić, *Moj rodni kraj* [Land of My Birth], 1936, oil on canvas, 180 × 150 cm. National Museum of Modern Art, Zagreb, MG-2235 (photograph: provided by © Moderna galerija, Zagreb / Goran Vranić)

DON QUIXOTE IN THE TRENCHES: THE BIRTH OF AVANT-GARDE POETRY IN SPANISH LANGUAGE BETWEEN CIVILIZATION AND BARBARISM

Emilio Quintana Pareja

1.

Luis Bagaría, *Los moralistas en la otra vida* [The Moralists in the Afterlife], 1915, illustration from newspaper *La Tribuna* (June 30, 1915) (photograph: Biblioteca Nacional de España, Madrid). Satirical drawing was accompanied by the text: "First dead man: — What a shame, boy, I died 'barbarously' suffocated by poison gas. Second dead man: — Bad for you, I felt the pleasure of dying 'in a civilized way', shattered by a grenade."

2.

Francisco Sancha, "Madness is the sickness/ for which there is no cure", 1917, illustration from Francisco Sancha, *Libro de horas amargas* [Book of Bitter Hours], London: Jones, 1917 (photograph: Biblioteca Nacional de España, Madrid). Illustration represents the German modern weapon production.

3.

Diego Rivera, front cover of Salomón de la Selva, *El soldado desconocido* [The Unknown Soldier], México: Cvltvra, 1922 (artwork: © 2021 Banco de México Diego Rivera Frida Kahlo Museums Trust, Mexico, D.F. / Artists Rights Society (ARS), New York; photograph: provided by La Murciélaga, Mexico City)

GEORGIAN MODERNISM, NATIONAL EXPECTATIONS, AND THE FIRST WORLD WAR

Bela Tsipuria

1.

Above the fold of the Georgian newspaper *Sakartvelo* (საქართველო [Georgia]) 8 (May 31, 1915) (photograph: provided by National Parliamentary Library of Georgia, Iverieli Digital Library, www.dspace.nplg.gov.ge)

2.

Photograph of Mikheil Javakhishvili (left) as the administrator of the 5th Red Cross hospital in Salmas County, 1916–1917, photographer: unknown. Private collection (photograph: provided by family of Mikheil Javakhishvili)

3.

Photograph of Paolo Iashvili after his return from Paris, after January 1915, photographer: unknown. Private collection (photograph: provided by family of Paolo Iashvili)

JEWISH ARTISTIC NETWORKS AROUND THE GREAT WAR. THE VOICE OF "OTHERS" AND THE UTOPIA OF "YIDDISHLAND"

Lidia Głuchowska

1.

Jankel Adler, *Błogosławieństwo Baal Szem Towa* [Rabbi Ba'al Shem-Tov's Blessing], 1918–1919, oil on canvas, 107.2 × 42.0 cm. Private collection, Poland (photograph: © Christie's Images / Bridgeman Images)

2.

Marc Chagall, *Autoportrait aux sept doigts* [Self-Portrait with Seven Fingers] (originally painted 1913), photograph from magazine *Yung-Yidish* 4–6 (1919), n.p. (artwork: © ADAGP, Paris, 2021; photograph: provided by the Department of Special Collections, Stanford University Libraries)

3.

Artur Nacht-Samborski, *Portret Żyda czytającego gazetę* [Portrait of a Jew Reading Newspaper], c. 1921, oil on canvas and collage, 100 × 70 cm. Private collection, Warsaw (artwork: permission provided by family of Artur Nacht-Samborski; photograph: provided by Tomasz Lec)

4.

Back and front cover of magazines *Yung-Yidish*:
a. Wiktor (Victor/Icchak) Brauner, linocut *Tańczący diabeł* [Dancing Devil], from *Yung-Yidish* 2–3 (1919), back cover (artwork: © ADAGP, Paris, 2021; photograph: provided by the Department of Special Collections, Stanford University Libraries)
b. Marek Szwarc (Schwarz), untitled linocut, from *Yung-Yidish* 4–6 (1919), front cover (artwork: © ADAGP, Paris, 2021; photograph: provided by the Department of Special Collections, Stanford University Libraries)

5.

Linocuts from magazine *Yung-Yidish* 2–3 (1919):
a. Marek Szwarc (Schwarz), linocut *Crucifiction*, from *Yung-Yidish* 2–3 (1919), n.p. (artwork: © ADAGP, Paris, 2021; photograph: provided by the Department of Special Collections, Stanford University Libraries)

b. Jankel Adler, untitled linocut and poem "Ikh zign mayn tfile" ["I Sing My Prayer"], from *Yung-Yidish* 2–3 (1919), n.p. (photograph: provided by the Department of Special Collections, Stanford University Libraries)

6.

Uri Tsvi Grinberg, christological poem "Uri Cwi farn cejlem" ["Uri Tsvi in Front of the Cross"], from magazine *Albatros* 2 (November 1922), p. 3–4 (photograph: provided by author)

7.

Henryk (Henoch) Berlewi, front cover of magazine *Albatros* 3 (1923) (photograph: provided by author)

CLOSING REMARKS AND GENERAL REFLECTIONS

Steven Mansbach

1.

German ceramics in the war era:
a. Königliche Porzellan-Manufaktur Berlin [Royal Porcelain Manufactury in Berlin], two cups decorated with black iron cross, 1914–1918. Formerly Lempertz, Germany (photograph: provided by Lempertz)
b. Waechtersbacher Keramik [Waechtersbacher Ceramics] factory, plate decorated with black iron cross, 1916, glazed porcelain. Private collection, USA (photograph: provided by author)

2.

Sergey Chekhonin (designer) and Mikhail Peshcherov (painter) in the Gossudarstvennyi Farforovyi Zavod [State Porcelain Factory], *Cubist Plate with a Hammer (Futurist)*, 1919, porcelain, polychrome overglaze painting, gilding, selective polishing. The State Hermitage Museum,

St. Petersburg, MZ-S-3151 (photograph: provided by © The State Hermitage Museum, photo by Vladimir Terebenin)

3.

Nikolay Suetin (painter) in the Gossudarstvennyi Farforovyi Zavod [State Porcelain Factory], *Cup and Saucer with Black Cross and Circle*, 1923, porcelain. The State Hermitage Museum, St. Petersburg, MZ-S-2983 (artwork: © Nikolay Suetin/OOA-S, 2021; photograph: provided by © The State Hermitage Museum, photo by Vladimir Terebenin)

4.

Alexander Samokhvalov (designer and painter) in the Gossudarstvennyi Farforovyi Zavod [State Porcelain Factory], plate *Seamstress*, 1923, porcelain. Private collection, USA (artwork: provided by Alexander Samokhvalov's heirs; photograph: provided by author)

5.

Romans Suta (design) in the Baltars Porcelain Painting Workshop, plate *Kāzas* [Wedding], c. 1928, porcelain, dia 35.5 cm. Latvian National Museum of Art, Museum of Decorative Arts and Design, Riga, LNMM DLM/K 230 (photograph: provided by Latvijas Nacionālais mākslas muzejs, Dekoratīvās mākslas un dizaina muzejs)

Bibliography

A

Aagesen 2002a = Aagesen, Dorthe: "The Avant-Garde Takes Copenhagen," in: Aagesen (2002b: 152–171).

Aagesen 2002b = Aagesen, Dorthe (ed.): *The Avant-Garde in Danish and European Art 1909–19*, Statens Museum for Kunst, Copenhagen 2002.

Aagesen 2012 = Aagesen, Dorthe: "Art Metropolis for a Day. Copenhagen during World War I," in: van den Berg/Hautamäki/Hjartarson (2012: 299–324).

Abel 2012 = Abel, Tiina: "Some Remarks About Early Modernism in Estonian Art," in: Głuchowska (2012e: 304–314).

Abel 2014 = Abel, Tiina: "The First World War and Estonian Art," in: Gerharde-Upeniece/Jevsejeva (2014: 127–134).

Abel 2018 = Abel, Tiina: "The Ambivalent Affair of Estonian Expressionism," in: Wünsche (2018c: 173–190).

Abellán 1996 = Abellán, José Luis: "Una manifestación del modernismo: la acepción española de la palabra 'raza'," *Cuadernos Hispanoamericanos* 553-554 (1996): 203–214.

Abildgaard 1984/1985 = Abilgaard, Hanne: "Dysmorfismedebatten — en diskussion om sundhed og sygdom i den modernistiske bevægelse omkring første verdenskrig" [The Dysmorphism Debate — a Discussion on Health and Illness in the Modernist Movement around the First World War], *Fund og Forskning* 137 (1984/1985), No. 27: 131–158.

Abildgaard 1993 = Abildgaard, Hanne: "Fra collager til kæmpekvinder. Lundstrøm og den tidlige danske modernisme" [From Collages to Giant Women. Lundstrøm and Early Danish Modernism], in: Thelle (1993: 31–55).

Abildgaard 1994 = Abildgaard, Hanne: *Tidlig modernisme* [Early Modernism], Fogtdal, Copenhagen 1994.

Abildgaard 2002 = Abildgaard, Hanne: "The Nordic Paris," in: Aagesen (2002b: 172–187).

Agnew 1993 = Agnew, Hugh LeCaine: *Origins of the Czech National Renascence*, University of Pittsburgh Press, Pittsburgh 1993.

Ahlstrand 2013 = Ahlstrand, Jan Thorsten: "Sweden, Denmark, and the International Avant-Garde 1918–1931," in: Fabre/Hansen/Mørland (2013: 135–150).

Ahlstrand/Reinhardt 2000 = Ahlstrand, Jan Torsten/Reinhardt, Sophie: *Svenskt avantgarde och der Sturm i Berlin/Schwedische Avantgarde und der Sturm in Berlin*, Felix-Nussbaum-Haus, Lund/Osnabrück 2000.

Ahtola-Moorhouse 1996 = Ahtola-Moorhouse, Leena: "Ekspressionismi ja kubismi Aaro Hellaakosken tulkitsemina 1925" [Expressionism and Cubism Interpreted by Aaro Hellaakoski 1925], in: Ruotsalainen (1996: 121–124).

Aijmer Rydsjö/Jonsson 2013 = Aijmer Rydsjö, Celia/Jonsson, AnnKatrin: "Transition and Internationalism as Praxis," in: van den Berg/Głuchowska (2013: 61–74).

Akhmatova 1992 = Akhmatova, Anna: *My Half Century: Selected Prose*, transl. Ronald Meyer, Northwestern University Press, Evanston 1992.

Albertini 1942/1943 = Albertini, Luigi: *Origini della guerra del 1914*, Fratella Bocca, Milano 1942/1943.

Alexander Bozhinov 1957 = *Alexander Bozhinov. Caricatures and Sketches*, introductory essay by Iliya Beshkov, Bulgarian Academy of Sciences, Sofia 1957.

Allgemeines Künstlerlexikon = *Allgemeines Künstlerlexikon. Die Bildenden Künstler aller Zeiten und Völker* (AKL), Saur, Munich.

Anderson 1991 = Anderson, Benedikt: *Imagined Communities. Reflections on the Origin and Spread of Nationalism*, 2nd rev. and ext. ed., Verso, London/New York 1991.

Andrew/Baxmann/Elswit 2017 = Andrew, Nell/Baxmann, Inge/Elswit, Kate et al. (eds.): *Moved Bodies. Choreographies of Modernity*, transl. William Glicher/Burke Barett/Anna Kanigowska Giedroyć et al., Muzeum Sztuki w Łodzi, Łódź 2017.

Andriušytė-Žukienė 2012 = Andriušytė-Žukienė, Rasutė: "Between Königsberg and Berlin: Pranas Domšaitis and the German Art Scene," in: Głuchowska (2012e: 269–286).

Angell 1910 = Angell, Norman: *The Great Illusion: A Study of the Relation of Military Power in Nations to Their Economic and Social Advantage*, G. P. Putnam's Sons, New York/London 1910.

Anonym 1921 = Anonym [= Doesburg, Theo van]:

"Ontvangen boeken en tijdschriften" [Received Books and Magazines], *De Stijl* IV (1921), No. 12: 187.

Anonym 1922a = Anonym [= Doesburg, Theo van]: "Ingekomen boeken en tijdschriften" [Received Books and Magazines], *De Stijl* V (1922), No. 1: 12.

Anonym 1922b = Anonym [= Doesburg, Theo van]: "Ontvangen boeken en tijdschriften" [Received Books and Magazines], *De Stijl* V (1922) No. 9: 142.

Anonym 1922c = Anonym: "Ett slags prenumerationsanmälan" [A Kind of an Ordering Announcement], *Ultra* 1 (1922): 15–16.

Anonym 1923 = Anonym [= Berckelaers, Fernand/Peeters, Jozef]: "Wij ontvingen als periodieken" [We Received as Magazines], *Het Overzicht* 16 (1923): 76.

Anonym 1924a = Anonym [= Szczuka, Mieczysław/ Żarnower, Teresa]: "Co to jest konstruktywizm" [What is Constructivism], *Blok* 6–7 (1924): n.p.

Anonym 1924b = Anonym: "Od krytyka wymaga się…" [A Critic is Required to…], *Blok* 2 (1924): n.p.

Anonym 1925b = Anonym [= Szczuka, Mieczysław/Żarnower, Teresa]: "Qu'est-ce que le Constructivisme," *Anthologie du Groupe Moderne d'Art de Liège* 3–4 (1925): 6–7.

Ansart/Pelat/Boelle 2009 = Ansart, Séverine/Pelat, Camille/ Boelle, Pierre-Yves et al.: "Mortality Burden of the 1918–1919 Influenza Pandemic in Europe," *Influenza and Other Respiratory Viruses* 3 (2009), No. 3: 99–106.

Appiah 1997 = Appiah, Kwame Anthony: "Cosmopolitan Patriots," *Critical Inquiry* 23 (1997), No. 3: 617–639.

Ara Torralba 1996 = Ara Torralba, Juan Carlos: *Del modernismo castizo. Fama y alcance de Ricardo León*, Prensas Universitarias, Universidad de Zaragoza, Zaragoza 1996.

Arnaldo 2008 = Arnaldo, Javier (ed.): *¡1914! La vanguardia y la Gran Guerra*, Museo Thyssen-Bornemisza, Madrid 2008.

Asholt/Fähnders 1995 = Asholt, Wolfgang/Fähnders, Walter (eds.): *Manifeste und Proklamationen der europäischen Avantgarde (1909–1938)*, Metzler, Stuttgart/Weimar 1995.

Asholt/Fähnders 2000 = Asholt, Wolfgang/Fähnders, Walter (eds.): *Der Blick vom Wolkenkratzer. Avantgarde — Avantgardekritik — Avantgardeforschung*, Rodopi, Amsterdam/Atlanta 2000.

Asmussen 1993 = Asmussen, Marianne Wirenfeldt: *Wilhelm Hansens oprindelige franske samling på Ordrupgaard/ Wilhelm Hansen's Original French Collection at Ordrupgaard*, Munksgaard, Copenhagen 1993.

Aubert 2007 = Aubert, Nathalie et al. (eds.): *From Art Nouveau to Surrealism. Belgian Modernity in the Making*, Legenda, London 2007.

Ausstellung deutscher, österreichisch-ungarischer und bulgarischer Kriegsbilder 1917 = *Ausstellung deutscher, österreichisch-ungarischer und bulgarischer Kriegsbilder*, Königliche Akademie der Künste, Berlin Mai–Juni 1917, Berlin 1917.

Avramov 1989 = Avramov, Dimitar: *Maystora i negovoto vreme* [Vladimir Dimitrov — the Master and his Time], Bulgarski hudojnik, Sofia 1989.

"Azorín" 1912 = "Azorín," Martínez Ruiz, José: *Lecturas españolas*, Imprenta de la "Revista de Archivos", Madrid 1912.

"Azorín" 1913a = "Azorín," Martínez Ruiz, José: *Clásicos y modernos*, Renacimiento, Madrid 1913.

"Azorín" 1913b = "Azorín," Martínez Ruiz, José: *Los valores literarios*, Renacimiento, Madrid 1913.

"Azorín" 1915 = "Azorín," Martínez Ruiz, José: *Al margen de los clásicos*, Publicaciones de la Residencia de Estudiantes, Madrid 1915.

"Azorín" 1916 = "Azorín," Martínez Ruiz, José: *Entre España y Francia (Páginas de un francófilo)*, Bloud y Gay, Barcelona 1916.

B

Babić 1929a = Babić, Ljubo: *Hrvatski slikari od impresionizma do danas* [Croatian Painters from Impressionism to the Present], Zaklada tiskare Narodnih novina, Zagreb 1929.

Babić 1929b = Babić, Ljubo: "O našem izrazu. Uz slike Jerolima Miše" [On Our Expression. About the Paintings of Jerolim Miše], *Hrvatska revija* 3 (1929): 196–202.

Babić 1943 = Babić, Ljubo: *Boja i sklad: prilozi za upoznavanje hrvatskog seljačkog umieća* [Colour and Harmony: Contributions for Learning about Croatian Folk Art], Hrvatski izdavački bibliografski zavod, Zagreb 1943.

Bäckström/Hjartarson 2014 = Bäckström, Per/Hjartarson, Benedikt (eds.): *Decentring the*

Avant-Garde, Rodopi, Amsterdam/
New York 2014.

Bade 1998 = Bade, Klaus J.:
Migration in European History,
transl. Allison Brown, Blackwell,
Oxford 1998.

Bajcurová 2014 = Bajcurová,
Katarína: "The War and
the 'Slovak Modern',"
in: Gerharde-Upeniece/Jevsejeva
(2014: 160–166).

Balkelis 2014 = Balkelis,
Tomas: "Demobilisierung,
Remobilisierung.
Paramilitarische Verbände in
Litauen 1918–1920," in: Sapper/
Weichsel (2014: 197–220).

Bann 1974 = Bann, Stephen (ed.):
The Tradition of Constructivism,
Viking Press, New York 1974.

Barashevich 1915 = Barashevich
[Baranstshevich], K.: [No title],
reproduced in: Kruchenykh/
Malevich/Kliun (1915: n.p.).

Barbarus 1930 = Barbarus,
Johannes: "Multipliseert
poeet" [The Multiplied Poet],
Tulenkantajat 11–12 (1930): 151.

Barnev/Yurukov 2006 = Barnev,
Ivan-Bubi/Yurukov, Lyubomir:
*Nepoznatata Bulgaria. Hora
i sabitiya 1878–1944* [Unknown
Bulgaria. People and Events
1878–1944], Iztok — Zapad,
Sofia 2006.

Barrier 1999 = Barrier, Michael:
*Hollywood Cartoons: American
Animation in Its Golden Age*,
Oxford University Press,
Oxford 1999.

Barron 1988 = Barron,
Stephanie (ed.): *German
Expressionism, 1915–1925:
The Second Generation*, LACMA,
Los Angeles 1988.

**Barta/Breu/Hammer-Tugendhat
1987** = Barta, Ilsebill/Breu, Zitta/
Hammer-Tugendhat, Daniela
(eds.): *Frauen-Bilder, Männer-*

*Mythen. Kunsthistorische
Beiträge*, Reimer, Berlin 1987.

Bartelik 2005 = Bartelik, Marek:
*Early Polish Modern Art. Unity
in Multiplicity*, Manchester
University Press, Manchester/
New York 2005.

**Bartetzky/Dmitrieva/Troebst
2005** = Bartetzky, Arnold/
Dmitrieva, Marina/Troebst, Stefan
(eds.): *Neue Staaten — neue
Bilder? Visuelle Kultur im Dienst
staatlicher Selbstdarstellung in
Zentral- und Osteuropa seit 1918*,
Böhlau, Cologne 2005.

Basler 1908 = Basler, Adolf:
"Salony paryskie" [Paris Salons]
(continuation), No. 316,
supplement to *Nowa Gazeta* 20
(1908), No. 20: 2.

Basler 1913a = Basler, Adolf:
"Stare i nowe konwencje
w malarstwie (od Cezanne'a
do kubizmu)" [Old and New
Conventions in Painting (from
Cézanne to Cubism)], *Krytyka*
38 (1913), No. 4: 210–220;
No. 5: 260–271.

Basler 1913b = Basler, Adolf:
"Nowa sztuka" [New Art], *Museion*
3 (1913), No. 12: 23.

Basler 1926 = Basler, Adolphe:
La peinture… Religion nouvelle,
Bibliothèque les Marges,
Paris 1926.

Bataille 1994 = Bataille,
Georges: "The Absence of Myth,"
in: Bataille (1994a: 48).

Bataille 1994a = Bataille, Georges:
*The Absence of Myth: Writings
on Surrealism*, transl. Michael
Richardson, Verso, London 1994.

Baudelaire 1863 = Baudelaire,
Charles: "La peintre de la vie
moderne," *Le Figaro* (Nov. 26
and 29, Dec. 3, 1863), collected
in: *L'Art romantique*, Michel Lévy
frères, Paris 1868: 51–114.

Baudelaire 1964 = Baudelaire,
Charles: *The Painter of Modern*

Life and other Essays, transl. and
ed. Jonathan Mayne, Phaidon
Press, London 1964.

Baudin/Jedryka 1977 = Baudin,
Antoine/Jedryka, Pierre-Maxime:
*L'Espace uniste: écrits du
constructivisme polonais*, L'Âge
d'homme, Lausanne 1977.

Baudrillard 1996 =
Baudrillard, Jean: "Modernité,"
in: *Encyclopædia Universalis*
(1996: 552–554).

Baum 1912 = Baum, Bronia:
Dziennik [Diary, manuscript],
May 4, 1912, cit. in: Lisek
(2018: 280).

Baum 1915 = Baum, Bronia:
Dziennik [Diary, manuscript],
Apr. 15, 1915, cit. in: Lisek
(2018: 282).

Baxandall 1985 = Baxandall,
Michael: *Patterns of Intention:
On the Historical Explanation
of Pictures*, Yale University Press,
New Haven 1985.

Baxandall 1992 = Baxandall,
Michael: *Patterns of Intention:
On the Historical Explanation of
Pictures*, 5th pr., Yale University
Press, New Haven 1992.

Beardsley 1967 = Beardsley,
Theodore S. Jr.: "Rubén Darío
and the Hispanic Society: The
Holograph Manuscript of ¡Pax!,"
Hispanic Review 35 (1967),
No. 1: 1–42.

Beck 2006 = Beck, Ulrich: *The
Cosmopolitan Vision*, Polity Press,
Cambridge 2006.

Bečková 2000 = Bečková,
Kateřina (ed.): *Sto let Klubu
Za starou Prahu 1900–2000*
[One Hundred Years of the Club
for Old Prague 1900–2000],
Prague 2000.

Bederski 1917 = Bederski,
Adam: "Działa biją na Wogezach"
[Cannons Offend in the Vosques],
Zdrój 1 (1917), No. 3: 68.

Beil/Dillmann 2010 = Beil, Ralf/Dillmann, Camilla (eds.): *Gesamtkunstwerk Expressionismus*, Institut Mathildenhöhe/Hatje Cantz, Ostfildern/Darmstadt 2010.

Bela/Zepa 2012 = Bela, Baiba/ Zepa, Brigita (eds.): *Modernisma un postmodernisma nacionālie diskursi nacionālās identitātes skaidrojumā. Identitātes. Kopienas. Diskursi* [Explanations of National Identity through Modernist and Post-Modernist Discourses. Identities. Communities. Discourses], LU Akadēmiskais Apgāds, Riga 2012.

Belleguie 1984 = Belleguie, André: *Le Mouvement de l'espace typographique: années 1920-1930*, Jaques Damase, Paris 1984.

Bendianishvili 2008 = Bendianishvili, Alexander et al.: *Rusuli colonializmi sakartveloshi* [Rusian Colonialism in Georgia], Universali, Tbilisi 2008.

Bendtsen 2012 = Bendtsen, Bjarne S.: "Copenhagen Swordplay — Avant-Garde Manoeuvres and the Aesthetics of War in the Art Magazine Klingen (1917-1920)," in: van den Berg/Hautamäki/Hjartarson (2012: 391-400).

Beneš 1912 = Beneš, Vincenc: "Čin Paula Cézanna" [The Work of Paul Cézanne], *Umělecký měsíčník* 1 (1912): 254-262.

Beneš 1914 = Beneš, Vincenc: "Kubistická výstava v Mánesu" [Cubist Exhibition at Mánes], *Umělecký měsíčník* 2 (1914): 326-328.

Bennhold 1992 = Bennhold, Martin: "Mitteleuropa — eine deutsche Politiktradition. Zu Friedrich Naumanns Konzeption und ihren Folgen," *Blätter für deutsche und internationale Politik* 37 (1992): 977-989.

Benson 2002 = Benson, Timothy O. (ed.): *Central European Avant-Gardes: Exchange and Transformation, 1910-1930*, Los Angeles County Museum of Art/The MIT Press, Los Angeles/ Cambridge, Mass. 2002.

Benson 2006 = Benson, Timothy O.: "Nomadic Modernism: The Search for an International Art," in: Purchla/ Tegethoff (2006: 127-142).

Benson 2013 = Benson, Timothy O.: "Two Phases of European 'Internationalism'," in: van den Berg/Głuchowska (2013: 1-22).

Benson 2014 = Benson, Timothy O. (ed.): *Expressionism in Germany and France: From Van Gogh to Kandinsky*, Prestel, Munich/ London/New York 2014.

Benson/Forgács 2002 = Benson, Timothy O./Forgács, Éva (eds.): *Between Worlds: A Sourcebook of Central European Avant-Gardes, 1910-1930*, The MIT Press/LACMA, Cambridge, Mass./ Los Angeles 2002.

Berckelaers 1924 = Berckelaers, Fernand [= Seuphor, Michel]: "Over Kunst in 12 Punt" [On Art in 12 Points], *Het Overzicht* 20 (1924): 121-124.

van den Berg 1999 = van den Berg, Hubert F.: *Avantgarde und Anarchismus. Dada in Zürich und Berlin*, Winter, Heidelberg 1999.

van den Berg 2000 = van den Berg, Hubert F.: "'Übernationalität' der Avantgarde — (Inter) Nationalität der Forschung. Hinweis auf den internationalen Konstruktivismus in der europäischen Literatur und die Problematik ihrer literaturwissenschaftlichen Erfassung," in: Asholt/Fähnders (2000: 255-288).

van den Berg 2006a = van den Berg, Hubert F.: "Mapping Old Traces of the New. Towards a Historical Topography of Early Twentieth-Century Avant-Garde(s) in the European Cultural Field(s)," *Arcadia* 41 (2006): 331-351.

van den Berg 2006b = van den Berg, Hubert F.: "'A Worldwide Network of Periodicals Has Appeared…' Some Notes on the Inter-and Supranationality of European Constructivism between the Two Wars," in: Purchla/Tegethoff (2006: 143-156).

van den Berg 2006c = van den Berg, Hubert F.: "Jón Stefánsson og Finnur Jónsson. Frá Íslandi til evrópsku framúrstefnunnar og aftur til baka. Framlag til kortlagningar á evrópsku framúrstefnunni á fyrri helmingi tuttugustu aldar" [Jón Stefánsson and Finnur Jónsson. From Iceland to the European Avant-Garde and Back. A Contribution to the Mapping of the European Avant-Garde in the First Half of the Twentieth Century], transl. Guðrún Jóhannsdóttir, *Ritið* 6 (2006): 51-77.

van den Berg 2008 = van den Berg, Hubert F.: "The Autonomous Arts as Black Propaganda. On a Secretive Chapter of German 'Foreign Cultural Politics' in the Netherlands and Other Neighbouring Neutral Countries during the First World War," in: Dorleijn (2008: 71-120).

van den Berg 2009 = van den Berg, Hubert F.: "*Der Sturm* als Kunsthandlung und Nachrichtenbüro in der deutschen Propagandapolitik in den neutralen Nachbarländern während des Ersten Weltkriegs," in: Briens/Mohnike (2009: 135-152).

van den Berg 2012 = van den Berg, Hubert F.: "The Early

Twentieth Century Avant-Garde and the Nordic Countries. An Introductory *tour d'horizon*," in: van den Berg/Hautamäki/Hjartarson (2012: 19–63).

van den Berg 2013 = van den Berg, Hubert F.: "Expressionism, Constructivism and the Transnationality of the Historical Avant-Garde," in: van den Berg/Głuchowska (2013: 23–41).

van den Berg/Dorleijn 2002 = van den Berg, Hubert F./Dorleijn, Gillis J. (eds.): *Avantgarde! Voorhoede? Vernieuwingsbewegingen in Noord en Zuid opnieuw beschouwd* [Avant-Garde! Vanguard? Renewal Movements in North and South Reconsidered], Vantilt, Nijmegen 2002.

van den Berg/Głuchowska 2013 = van den Berg, Hubert F./Głuchowska, Lidia (eds.): *Transnationality, Internationalism and Nationhood. European Avant-Garde in the First Half of the Twentieth Century*, Peeters Publishers, Leuven/Paris 2013.

van den Berg/Głuchowska 2013a = van den Berg, Hubert F./Głuchowska, Lidia: "Introduction. The Inter-, Trans- and Postnationality of the Historical Avant-Garde," in: van den Berg/Głuchowska (2013: IX–XX).

van den Berg/Hautamäki/Hjartarson 2012 = van den Berg, Hubert F./Hautamäki, Irmeli/Hjartarson, Benedikt et al. (eds.): *A Cultural History of the Avant-Garde in the Nordic Countries 1900–1925*, Rodopi, Atlanta/Amsterdam/New York 2012.

van den Berg/Hjartarson 2012 = van den Berg, Hubert F./Hjartarson, Benedikt: "Icelandic Artists in the Network of the European Avant-Garde. The Cases of Jón Stefánsson and Finnur Jónsson," in: van den Berg/

Hautamäki/Hjartarson (2012: 229–247).

Berger 2000 = Berger, Renate (ed.): *Liebe, Macht, Kunst. Künstlerpaare im 20. Jahrhundert*, Böhlau, Cologne 2000.

Berghaus 2011 = Berghaus, Günter (ed.): *Futurism in Eastern and Central Europe* (*International Yearbook of Futurism Studies* 1), De Gruyter, Berlin/Boston/New York 2011.

Berghaus 2016 = Berghaus, Günter (ed.): *International Yearbook of Futurism Studies* 6, De Gruyter, Berlin/Boston/New York 2016.

Berkovitsh 1976 = Berkovitsh, Yisrael: *Hundeṭ yor Yidish ṭeaṭer in Rumenye, 1876–1976* [A Hundred Years of Yiddish Theatre in Romania, 1876–1976], Kriteryon, Bucharest 1976.

Berlewi 1922 = Berlewi, Henryk: "Międzynarodowa wystawa w Düsseldorfie," *Nasz Kurier* 209 (1922), No. 2: 2; transl. Wanda Kemp-Welch as "International Exhibition in Düsseldorf," in: Benson/Forgács (2002: 397–399).

Berlewi 1924 = Henryk Berlewi, "Mechano-Faktur," *Der Sturm* XV (1924), No. 5: 155–159; Pol. version: *Mechnofaktura*, Warsaw 1924; transl. David Britt as "Mechano-Facture," in: Benson/Forgács (2002: 489–490).

Bertz/Dohrn/Goldmann 2012 = Bertz, Inka/Dohrn, Verena/Goldmann, Miriam et al. (eds.): *Berlin Transit*, Stiftung Jüdisches Museum Berlin/Wallstein, Göttingen 2012.

Beyerdörfer 2010 = Beyerdörfer, Hans-Peter: "Żydowska tożsamość — problem awangardy teatralnej w Niemczech i Austrii w okresie międzywojennym" [Jewish Identity — Problem of the Avant-Garde Theatre in Germany and Austria in the Interwar

Period], in: Suchan/Szymaniak (2010: 129–141).

Białostocki 1986 = Białostocki, Jan: "Crises et fulgurations de l'art," *Diogène* 133 (1986): 3–22.

Bienert 2012 = Bienert, Michael: "Nomadenstadt und Menschenwerkstatt. Das literarische Berlin der Weimarer Republik," in: Bertz/Dohrn/Goldmann (2012: 82–84).

Bjurström 1992 = Bjurström, Per: *Nationalmuseum 1792–1992*, Wiken, Höganäs 1992.

Blanchot 1993 = Blanchot, Maurice: *The Infinite Conversation*, transl. Susan Hanson, University of Minnesota Press, Minneapolis 1993.

Blanchot 1993a = Blanchot, Maurice: "Reflection on Nihilism," in: Blanchot (1993: 136–170).

Blau/Troy 1997 = Blau, Eve/Troy, Nancy J. (eds.): *Architecture and Cubism*, Centre Canadien d'Architecture, Montreal/The MIT Press, Cambridge, Mass./London 1997.

Bless/Jedliński 1996 = Bless, Frits/Jedliński, Jaromir: *Vision and Unity: Strzemiński, 1893–1952, en 9 hedendaagse Poolse kunstenaars* [Vision and Unity: Strzemiński, 1893–1952, and 9 Contemporary Polish Artists], Muzeum Sztuki w Łodzi, Apeldoorn 1989.

Bloch 1899 = Bloch, Jan: *Przyszła wojna pod względem technicznym, politycznym i ekonomicznym* [Future of War in Its Technical, Economic and Political Relations], Gebethner i Wolff, Warsaw 1899.

Blok 1913 = Blok, Alexander: "Plamen" [The Flame], first published in: *Den'* (Oct. 28, 1913).

Blok 1962 = Blok, Alexander: *Sobranie sochinenii* [Collected Writings], vol. 7, Gosudarstvennoe izdatelstvo

khudozhestvennoi literatury, Moscow 1962.

Blotkamp 1990 = Blotkamp, Carel et al: *De Stijl: The Formative Years 1917–1922*, The MIT Press, Cambridge, Mass. 1990.

Blotkamp 1996 = Blotkamp, Carel (ed.): *De vervolgjaren van De Stijl 1922–1932* [The Following Years of De Stijl 1922–1932], Uitgeverij L. J. Veen, Amsterdam/ Antwerp 1996.

Blum de Almeida 2018 = Blum de Almeida, Nina: "Portuguese Expressionism, or German Expressionism in Portugal?," in: Wünsche (2018c: 377–392).

Bobrov 1915 = Bobrov, Sergei: "O Novoi Illiustratsii" [About the New Illustration], in: Bobrov (1915a: 156).

Bobrov 1915a = Bobrov, Sergei: *Vertogradari nad lozami* [Gardeners over the Vines], Lirika, Moscow 1915.

Bobrowska-Jakubowska 1997 = Bobrowska-Jakubowska, Ewa: *Bolesław Biegas 1877–1954. Rzeźba, malarstwo* [Bolesław Biegas 1877–1954. Sculpture, Painting], Muzeum Mazowieckie, Płock 1997.

den Boef/van Faassen 2013 = Boef, August H. den/Faassen, Sjoerd van: *Van De Stijl en Het Overzicht tot De Driehoek* [From De Stijl and Het Overzicht to De Driehoek], Garant, Antwerp/ Apeldoorn 2013.

Boev 1983 = Boev, Petar: *Fotografsko izkustvo v Bulgaria* [Photographic Art in Bulgaria], Septemvri, Sofia 1983.

Bogdanović 2018 = Bogdanović, Ana: "On New Art and its Manifestations: Rethinking Expressionism in the Visual Arts in Belgrade," in: Wünsche (2018c: 426–441).

Boia 2014a = Boia, Lucian: *"Germanofilii". Elita intelectuală românească în anii primului război mondial* [The "Germanophiles". The Romanian Intellectual Elite during the First World War], Humanitas, Bucharest 2014.

Boia 2014b = Boia, Lucian: *Primul razboi mondial. Controverse, paradoxuri, reinterpretari* [First World War. Controversies, Paradoxes, Reinterpretations], Humanitas, Bucharest 2014.

Bojarov/Polit/Szymaniak 2017 = Bojarov, Andrij/Polit, Paweł/ Szymaniak, Karolina (eds.): *Montages. Debora Vogel and the New Legend of the City*, transl. Benjamin Paloff/Paulina Duda/ Jodi Greg et al., Muzeum Sztuki w Łodzi, Łódź 2017.

Bolanos 2009 = Bolanos, Luis: "Salomón de la Selva as a Soldier of the Great War," *Hallali. Revista de Estudios Culturales sobre la Gran Guerra* 4 (2009): http://www. revistahallali.com/2009/06/29/ luis-bolanos-salomon-de-la-selva- as-a-soldier-of-the-great-war/ (accessed: Nov. 11, 2021).

Bonet 2014 = Bonet, Juan Manuel: "Hiszpański ultraizm — panorama" [The Spanish Ultraism — a Panorama], in: Rypson (2015: 42–74).

Born/Janatková/Labuda 2004 = Born, Robert/Janatková, Alena/Labuda, Adam (eds.): *Die Kunsthistoriographien in Ostmitteleuropa und der nationale Diskurs*, Gebr. Mann, Berlin 2004.

Boshev 2007 = Boshev, Nikolay: *Ivan Lazarov, sculptorat* [Ivan Lazarov, the Sculptor], Bulgarian Academy of Sciences Press "Prof. Marin Drinov", Sofia 2007.

Botar/Hartel 2018 = Botar, Oliver A. I./Hartel, Herbert R. Jr.: "Expressionism in Canada and the United States," in: Wünsche (2018c: 487–506).

Boulton 1960 = Boulton, Marjorie: *Zamenhof, Creator of Esperanto*, Routledge and Paul, London 1960.

Bourdieau 1992 = Bourdieau, Pierre: *Les règles de L'art. Gènese et structure du champ littéraire*, Seuil, Paris 1992.

Bourdieau 1999 = Bourdieau, Pierre: *Die Regeln der Kunst. Genese des literarischen Feldes*, transl. Bernd Schwibs/Achim Russer, Suhrkamp, Frankfurt a.M. 1999.

Bourke 1996 = Bourke, Joanna: *Dismembering the Male: Men's Bodies, Britain, and the Great War*, The University of Chicago Press, Chicago 1996.

Bowlt 1988 = Bowlt, John (ed.): *Russian Art of the Avant- Garde: Theory and Criticism, 1902–1934*, Thames & Hudson, New York 1988.

Bowlt/Drutt 1999 = Bowlt, John E./Drutt, Matthew (eds.): *Amazonen der Avantgarde. Alexandra Exter, Natalja Gontscharowa, Ljubow Popowa, Olga Rosanowa, Warwawa Stepanowa, Nadeschda Udalzowa*, Solomon R. Guggenheim Museum für Deutsche Guggenheim Berlin, Berlin 1999.

Bozhkov 1978 = Bozhkov, Atanas: *Bulgarskata istoricheska zhivopis* [Bulgarian Historical Painting], vol. II, Bulgarski hudojnik [Bulgarian artist], Sofia 1978.

Brade 2015 = Brade, Johanna: "Künstler zwischen patriotischem Pathos und Kriegswirklichkeit"/"Między patriotycznym patosem i wojenną rzeczywistością," in: Brade/Weger (2015: 13–239).

Brade/Weger 2015 = Brade, Johanna/Weger, Tobias (eds.): *Kunst zur Kriegszeit. Künstler aus Schlesien zwischen Hurrapatriotismus und*

Friedenssucht/Sztuka czasu wojny 1914-1918/Artyści ze Śląska między hurrapatriotyzmem i pragnieniem pokoju, Schlesisches Museum zu Görlitz/Verlag Günter Oettel, Görlitz/Zittau 2015.

Brandes 1915a = Brandes, Georg: "Lettre de Georges Brandes," *L'Homme Enchaîné* (Mar. 11, 1915), reprinted in: Brandes (1966: 108-110).

Brandes 1915b = Brandes, Georg: "Réponse á Georges Clemenceau," *L'Homme Enchaîné* (Mar. 29, 1915), reprinted in: Brandes (1966: 114-120).

Brandes 1915c = Brandes, Georg: "A Scandinavian View of the War," *The Atlantic Monthly* (Dec. 1915): 848-852.

Brandes 1916 = Brandes, Georg: *Verdenskrigen* [The World War], Gyldendal, Copenhagen/ Kristiania 1916.

Brandes 1952 = Brandes, Georg: *Correspondance. Lettres choisies et annotées*, ed. Paul Krüger, vol. 4, Rosenkilde og Bagger, Copenhagen 1952.

Brandes 1966 = Brandes, Georg Morris Cohen: *Correspondance. Lettres choisies et annotées*, vol. 3, ed. Paul Krüger, Rosenkilde og Bagger, Copenhagen 1966.

Brănişteanu 1910 = Brănişteanu, Barbu: "Expoziţia Arthur Segal" [The Arthur Segal Show], *Adevărul* (Mar. 13, 1910): 9.

Braşlina 2012 = Braşlina, Aija: "Latvian Modernists in Berlin in the Early 1920s: Impulses and Resonance," in: Głuchowska (2012e: 286-303).

Braşlina 2014 = Braşlina, Aija (ed.): *Lettonie — Belgique: Les relations artistiques au 20e et au debut du 21e siècles/Latvia — Belgium: Art Relations in the 20th Century and the Beginning of the 21st Century*, Latvijas Nacionālais

Mākslas Muzejs/Neptuns, Riga 2014.

Bregadze 2013 = Bregadze, Konstantine: *Qartuli Modernizmi: Gr. Robaqidze, K. Gamsakhurdia, G. Tabidze* [Georgian Modernism: Gr. Robaqidze, K. Gamsakhurdia, G. Tabidze], Meridiani, Tbilisi 2013.

Bregovac Pisk 2014 = Bregovac Pisk, Marina: *Slike Velikog rata/ Images of the Great War*, Hrvatski povijesni muzej, Zagreb 2014.

Breuer 1995 = Breuer, Stefan: *Anatomie der konservativen Revolution*, Wissenschaftliche Buchgesellschaft, Darmstadt 1995.

Briens/Mohnike 2009 = Briens, Sylvain/Mohnike, Thomas (eds.): *Capitales culturelles et Europe du Nord/Kulturhauptstädte Nordeuropas*, Université de Strasbourg, Départements d'études néerlandaises et scandinaves, Strasbourg 2009.

Bring 1960 = Bring, Maj: *Motsols. Memoarer och konst* [Memory on Art], Gothenburg 1960 (2nd ed. 2007).

Brix 1999 = Brix, Emil: "The Structure of the Artistic Dialogue between Vienna and Other Urban Centres in the Habsburg Monarchy Around 1900," in: Krakowski/Purchla (1999: 11-16).

Brooker 2013a = Brooker, Peter et al. (eds.): *The Oxford Critical and Cultural History of Modernist Magazines. Volume III: Europe 1880-1940*, Part 1, Oxford University Press, Oxford 2013.

Brooker 2013b = Brooker, Peter et al. (eds.): *The Oxford Critical and Cultural History of Modernist Magazines: Volume III: Europe 1880-1940*, Part 2, Oxford University Press, Oxford 2013.

Brossat/Klingberg 2016 = Brossat, Alain/Klingberg, Sylvie: *Revolutionary Yiddishland:*

A History of Jewish Radicalism, Verso, London 2016.

Bru 2009 = Bru, Sascha: "Borderless Europe, Decentring Avant-Garde, Mosaic Modernism," in: Bru/Baetens/Hjartarson (2009: 3-17).

Bru/Baetens/Hjartarson 2009 = Bru, Sascha/Baetens, Jan/ Hjartarson, Benedikt et al. (eds.): *Europa! Europa?: The Avant-Garde, Modernism and the Fate of a Continent*, De Gruyter, Berlin 2009.

Bru/Martens 2006 = Bru, Sascha/Martens, Gunther (eds.): *The Invention of Politics in the European Avant-Garde (1906-1940)*, Rodopi, Amsterdam/New York 2006.

Brummer 2002 = Brummer et al.: *Moderna Museet c/o Waldemarsudde, Moderna Klassiker* [Moderna Museet c/o Waldemarsudde, Modern Classics], Moderna Museet och Prins Eugens Waldemarsudde, Stockholm 2002.

Brzękowski 1924 = Brzękowski, Jan: "Nieuwe Kunst in Polen" [New Art in Poland], *Het Overzicht* 21 (1924): 155.

Brzękowski/Chwistek/Smolik 1934 = Brzękowski, Jan/Chwistek, Leon/Smolik, Przecław (eds.): *O sztuce nowoczesnej* [On Modern Art], Towarzystwo Bibljofilów, Łódź 1934.

Buelens 2013 = Buelens, Geert: "Facing Your Friend as Enemy. Nationalism and Internationalism in Avant-Garde Circles around the Great War," in: van den Berg/ Głuchowska (2013: 43-60).

Bujkiewicz 1998 = Bujkiewicz, Zbigniew: *Aspiracje kolonialne w polityce zagranicznej Polski* [Colonial Aspirations in Polish Foreign Politics], Lubuskie Towarzystwo Naukowe, Zielona Góra 1998.

Bulgarska etnologiya 2014 = *Bulgarska etnologiya* [Bulgarian Ethnology] 3 (2014), ed. Aneliya Kasabova, (*Obrazite na voynata. Voynata v obrazi* [The Images of War. The War in Images]).

Burliuk 1988 = Burliuk, David: "Cubism," transl. John Bowlt, in: Bowlt (1988: 69–77).

Burmeister/Oberhofer/ Francini 2016 = Burmeister, Ralf/Oberhofer, Michaela/ Francini, Esther Tisa (eds.): *dada Afrika. Dialog mit dem Fremden*, Scheidegger & Spiess, Zurich 2016.

Buruma/Margalit 2004 = Buruma, Ian/Margalit, Avishai: "Heroes and Merchants," in: Buruma/Margalit (2004a: 49–73).

Buruma/Margalit 2004a = Buruma, Ian/Margalit, Avishai: *Occidentalism. The West in the Eyes of Its Enemies*, The Penguin Press, New York 2004.

Bury 2007 = Bury, Stephen (ed.): *Breaking the Rules: The Printed Face of the European Avant Garde 1900–1937*, The British Library, London 2007.

C

Cabanes/Duménil 2013 = Bruno, Cabanes/Duménil, Anne (eds.): *Der Erste Weltkrieg. Eine Europäische Katastrophe*, transl. Birgit Lamerz-Beckschäfer, Bundeszentrale für Politische Bildung, Bonn 2013.

Căliman 2000 = Căliman, Călin: *Istoria filmului românesc 1897–2000* [The History of Romanian Cinema 1897–2000], Romanian Cultural Foundation, Bucharest 2000.

Căliman 2011 = Căliman, Călin: *Istoria filmului românesc* [The History of Romanian Cinematography], Contemporanul Editions, Bucharest 2011.

Călinescu 1941 = Călinescu, George: *Istoria literaturii române de la origini până în prezent* [The History of Romanian Literature from its Origins to Presend Day], The Royal Foundation for Literature and Art, Bucharest 1941.

Calinescu 1987 = Calinescu, Matei: *Five Faces of Modernity: Modernism, Avant-Garde, Decadence, Kitsch, Postmodernism*, Duke University Press, Durham 1987.

Cantacuzino 1971 = Cantacuzino, Ion (ed.): *Contributii la istoria cinematografiei in Romania, 1896–1948* [Contributions to the History of Romanian Cinema, 1896–1948], Romanian Academy Editions, Bucharest 1971.

Čapek 1912 = Čapek, Josef: "Kandinsky: Über das Geistige in der Kunst," *Umělecký měsíčník* 1 (1912): 236–237, 269–270.

Caplan 2018 = Caplan, Debra: *Yiddish Empire: The Vilna Troupe, Jewish Theatre, and the Art of Itinerancy*, University of Michigan Press, Ann Arbor 2018.

Cărăbaş 2012 = Cărăbaş, Irina: "To Germany and Back Again: the Romanian Avant-garde and its Forerunners," in: Głuchowska (2012e: 253–268).

Carlberg/Gunnarsson 2004 = Carlberg, Camilla/Gunnarsson, Annika (eds.): *Karl Isaksson. Målaren 1878–1922* [Karl Isaksson. Painting 1878–1922], Moderna Museet, Stockholm 2004.

Carol of Romania 1899 = Carol of Romania: *Reminiscences of the King of Romania*, Harper & Brothers, New York/London 1899.

Carpenter 1983 = Carpenter, Bogdana: *The Poetic Avant-Garde in Poland 1918–1939*, University of Washington Press, Seattle/ London 1983.

Carrere 1917 = Carrere, Emilio: "Los cantos de la guerra," *Cervantes. Revista Mensual Ibero-americana* II (1917), No. X: 21–27.

Casanova 1999 = Casanova, Pascale: *La république mondial des lettres*, Seuil, Paris 1999.

Casanova 2004 = Casanova, Pascale: *The World Republic of Letters*, Harvard University Press, Cambridge, Mass./London 2004 (2007).

Casanova 2012 = Casanova, Pascale: *Světová republika literatury* [The World Republic of Letters], transl. Čestmír Pelikán, Karolinum, Prague 2012.

Catalogue Sculpture 2007 = *Catalogue Sculpture/Catalog Skulptura*, Sofia City Art Gallery, Sofia 2007.

Cēbere 2015 = Cēbere, Gundega (ed.): *1914. War and Modernism* (= *Muzeja raksti* 6/*Museum Writings* 6: Starptautisko zinātnisko konferenču referāti: "1914 uz Brīvības ielas," veltīta 1. Pasaules karam — 10.10.2012; "Pompeju pēdējā diena" — Rundāles pils muzejs, 06.06.2013, "1914. Karš un modernisms" — 17.–21.01.2014. [Proceedings of International Scientific Conferences: "1914 and Freedom Street," "Last Day of Pompeii" — Rundāle Palace Museum, 06.06.2013; "1914. War and Modernism" — 17.–21.01.2014.]), National Museum of Riga/Latvijas Nacionālais mākslas muzejs, Riga 2015.

Cerdá 1915 = Cerdá, Elías: *Don Quijote en la guerra. Fantasía que pudo ser historia*, Yagües, Madrid 1915.

Ceuleers 1996 = Ceuleers, Jan: *Georges Vantongerloo 1886–1965*, Snoeck-Ducaju & Zoon, Gent 1996.

Chambers 2018 = Chambers, Emma (ed.): *Aftermath: Art in the Wake of World War One*, Tate Publishing, London 2018.

Chapman 2013 = Chapman, Kathleen: "Dresden: 'Collectivity Is Dead, Long Live Mankind'. *Der Komet* (1918–19), *Menschen* (1918–21), and *Neue Blätter* für Kunst und *Dichtung* (1918–21)," in: Brooker (2013a: 888–904).

Chesterton 2012 = Chesterton, Gilbert Keith: *Sobre el concepto de barbarie: seguido de Cartas a un viejo garibaldino*, Renacimiento, Edición de Emilio Quintana Pareja, Sevilla 2012.

Chilvers 1999 = Chilvers, Ian: *A Dictionary of 20th-Century Art*, Oxford University Press, Oxford/New York 1999.

Chipp 1975 = Chipp, Herschel B.: *Theories of Modern Art: A Source Book by Artists and Critics*, University of California Press, Berkeley 1975.

Christenson/Ericsson/Pehrsson 1989 = Christenson, Göran/Ericsson, Anne-Marie/Pehrsson, Per Jan: *Baltiska utstallningen 1914*, Signum, Lund 1989.

Christova-Radoeva 2013= Christova-Radoeva, Vessela (ed.): *Boris Denev (1883–1969)*, Support for the Art in Bulgaria Foundation, Sofia 2013.

Chudzikowska 2017 = Chudzikowska, Monika: "'Cubist of Iron Rigor and a Staunch Romantic'. Stage Design by Andrzej Pronaszko in 1924–1937," transl. Katarzyna Gucio, in: Strożek (2017: 153–165).

Chwalba 2017 = Chwalba, Andrzej: *Samobójstwo Europy. Wielka Wojna 1914–1918* [Europe's Suicide. The Great War 1914–1918], Wydawnictwo Literackie, Cracow 2017.

Chwistek 1960 = Chwistek, Leon: *Wielość rzeczywistości w sztuce i inne szkice literackie* [Multiplicity of the Reality in Art and Other Literary Sketches], Czytelnik, Warsaw 1960.

Chytraeus-Auerbach 2018 = Chytraeus-Auerbach, Irene: "German Expressionism in Italy: Herwarth Walden's Der Sturm, the Berlin Novembergruppe, and the Modernist Circles of Florence, Turin, and Rome," in: Wünsche (2018c: 348–364).

Cioran 1998 = Cioran, Emil: *History and Utopia*, transl. Richard Howard, University of Chicago Press, Chicago 1998.

Císařovský 1962 = Císařovský, Josef: *Otto Gutfreund*, Státní nakladatelství krásné literatury a umění, Prague 1962.

Claustrat 2012 = Claustrat, Frank: "Nordic Writers and Artists in Paris before, during and after World War I," in: van den Berg/Hautamäki/Hjartarson (2012: 129–148).

Claverie/Klein/Lahoda 2002 = Claverie, Jana/Klein, Hélène/Lahoda, Vojtěch et al. (eds.): *Vincenc Kramar: Un théoricien et collectionneur du cubisme à Prague*, La Réunion des musées nationaux, Paris 2002.

Clemenceau 1915a = Clemenceau, George: "L'Ennemi du Genre humain," *L'Homme Enchaîné* (Feb. 9, 1915), reprinted in: Brandes (1952: 103–104).

Clemenceau 1915b = Clemenceau, George: "Réflexions de Neutres," *L'Homme Enchaîné* (Feb. 16, 1915), reprinted in: Brandes (1952: 104–108).

Clemenceau 1915c = Clemenceau, George: "Réponse à Georges Brandes," *L'Homme Enchaîné* (Mar. 11, 1915), reprinted in: Brandes (1952: 110–114).

Clemenceau 1915d = Clemenceau, George: "Adieu Brandes," *L'Homme Enchaîné* (Mar. 29, 1915), reprinted in: Clemenceau (1916: 207–212), also reprinted in: Brandes (1966: 120–124).

Clemenceau 1916 = Clemenceau, George: *La France devant L'Allemagne*, Payot, Paris 1916.

Cockroft 1974 = Cockroft, Eva: "Abstract Expressionism, Weapon of the Cold War," *Artforum* 12 (1974), No. 10: 39–41.

Cohen 1996 = Cohen, Milton A.: "Fatal Symbiosis: Modernism and World War I," *War, Literature and the Arts* 7 (1996), No. 3: 1–46.

Cohen 1998 = Cohen, Richard I.: *Jewish Icons: Art and Society in Modern Europe*, University of California, Berkeley 1998.

Cohen 2012 = Cohen, Richard I. (ed.): *Visualizing and Exhibiting Jewish Space and History* (= *Studies in Contemporary Jewry*, vol. 26), Oxford University Press, New York 2012.

Cohen 2012a = Cohen, Richard I.: "The Visual Revolution in Jewish Life — An Overview," in: Cohen (2012: 1–24).

Collection of the Société Anonyme 1950 = *Collection of the Société Anonyme. Museum of Modern Art 1920*, Yale University Art Gallery, New Haven, Conn. 1950.

Compagnon 1994 = Compagnon, Antoine: *The Five Paradoxes of Modernity*, transl. Philip Franklin, Columbia University Press, New York 1994.

Congdon 1991 = Congdon, Lee: *Exile and Social Thought. Hungarian Intellectuals in Germany and Austria 1919–1933*, Princeton University Press, Princeton/New Jersey 1991.

Conservatorul 1913 = "Țară civilizată" [Civilized Country],

Conservatorul XIII (1913),
No. 161: 21.

Constantiniu 2002 =
Constantiniu, Florin:
*O istorie sincera a poporului
roman* [A Sincere History
of the Romanian People],
Univers Enciclopedic,
Bucharest 2002.

Cottington 1998 = Cottington,
David: *Cubism in the Shadow
of War: The Avant-Garde and
Politics in Paris 1905–1914*,
Yale University Press, New
Haven 1998.

Cottington 2004 = Cottington,
David: *Cubism and Its Histories*,
Manchester University Press,
Manchester 2004.

Cox 2000 = Cox, Neil: *Cubism*,
Phaidon, London 2000.

Cruceanu 1911 = Cruceanu,
Mihail: "Anchetă asupra
curentelor noastre literare"
[An Inquiry into Our
Literary Trends], *Rampa*
(Oct. 22, 1911): 4.

Čubrilo 2012 = Čubrilo, Jasmina:
"Yugoslav Avant-Garde Rewiev
Zenith (1921–1926) and its Links
with Berlin," in: Głuchowska
(2012e: 234–252).

Cuddy-Keane 2003 = Cuddy-
Keane, Melba: "Modernism,
Geopolitics, Globalisation,"
Modernism/Modernity 10 (2003),
No. 3: 539–540.

Cullinan 2012 = Cullinan,
Nicholas (ed.): *Edvard Munch:
The Modern Eye*, Tate Publishing
London/New York 2012.

Cuvardic García 2013 =
Cuvardic García, Dorde:
"El topos simbolista de la
ciudad muerta en la tradición
literaria europea y española,"
*Revista de filología y
lingüística de la Universidad
de Costa Rica* 39 (2013),
No. 2: 27–50.

**Czyż/Chrudzimska-Uhera
2017** = Czyż, Anna Sylwia/
Chrudzimska-Uhera, Katarzyna:
Migracje [Migrations], Zarząd
Główny SHS Oddział Warszawski,
Warsaw 2017.

D

DaCosta Kaufmann 2004 =
DaCosta Kaufmann, Thomas:
Towards a Geography of Art,
University of Chicago Press,
Chicago 2004.

DaCosta Kaufmann 2004a =
DaCosta Kaufmann, Thomas:
"Die Geschichte der Kunst
Ostmitteleuropas als
Herausforderung für die
Historiographie der Kunst
Europas," in: Born/Janatková/
Labuda (2004: 51–64).

Daix 1979 = Daix, Pierre: *Picasso:
The Cubist Years, 1907–1916.
A Catalogue Raisonné of the
Paintings and Related Works*,
New York Graphic Society,
Boston 1979.

Danto 2013 = Danto,
Arthur C.: *What Art Is*, Yale
University Press, New Haven/
London 2013.

**"Das alte Spruchgedicht
aus der *Edda*" 1913** = "Das
alte Spruchgedicht aus der
Edda," transl. Felix Genzmer,
*Die Aktion. Wochenschrift
für Politik, Literatur, Kunst* 3
(1913): 1162–1163.

**Das Junge Rheinland et al.
1922** = Das Junge Rheinland
et al.: "Gründungsaufruf
der Union internationaler
fortschrittlicher Künstler,"
De Stijl V (1922), No. 4: 49–52.

Debelyanov 1920 =
Debelyanov, Dimcho: *Poemi*
[Poems], Alexander Paskalev,
Sofia 1920.

Degen 1919 = Degen, Yuri: "Kirill
Zdanevich", *Feniks* (Tbilisi) 2/3
(1919): 1–6.

Degler 2013 = Degler,
Janusz (ed.): *Witkacy: bliski czy
daleki?* [Witkacy: Near or Far?],
Muzeum Pomorza Środkowego,
Słupsk 2013.

Dekkers 2008 = Dekkers,
Dieuwertje et al.: *H. N.
Werkman: het complete oeuvre*
[H. N. Werkman: the Complete
Works], NAi Uitgevers,
Rotterdam 2008.

Denegri 2011 = Denegri, Ješa:
*Ideologija postavke Muzeja
savremene umetnosti —
Jugoslavenski umetnički prostor*
[Ideology of the Display at
the Museum of Contemporary
Art — Yugoslav Art Space], self-
published edition, Belgrade 2011.

Denis 1915 = Denis, Ernest:
*La guerre. Causes immédiates
et lointaines — L'intoxication
d'un peuple*, Le Traité Classic,
Paris 1915.

Derrida 2014 = Derrida, Jacques:
*Politik und Freundschaft.
Gespräch über Marx und
Althusser*, ed. by Peter
Engelmann, transl. Noe Tessmann.
Passagen, Vienna 2014.

Derrida 2021 = Derrida, Jacques:
*Geschlecht III. Geschlecht,
Rasse, Nation, Menschheit*,
transl. Johannes Kleinbeck/
Oliver Precht, Turia + Kant,
Vienna 2021.

Der Weg 1972 = *Der Weg. Neue
Schule für Kunst*, Galleria del
Levante, Milano/Munich 1972.

De Smet 2013 = De Smet, Johan
(ed.): *Modernisme. L'art abstrait
belge et l'Europe*, Fonds Mercator/
Museum voor Schone Kunsten,
Gent 2013.

Detloff 2011 = Detloff, Madelyn:
*The Persistence of Modernism:
Loss and Mourning in the*

Twentieth Century, Cambridge University Press, Cambridge 2011.

Deudney 2007 = Deudney, Daniel H.: *Bounding Power: Republican Security Theory from the Polis to the Global Village*, Princeton University Press, Princeton 2007.

Díaz-Plaja 1973 = Díaz-Plaja, Fernando: *Francófilos y germanófilos; los españoles en la guerra europea*, Dopesa, Madrid 1973.

Dickerman 2012 = Dickerman, Leah (ed.): *Inventing Abstraction, 1910–1925*, Museum of Modern Art, New York 2012.

Dietrich 1918 = Dietrich, Rudolf Adrian: "Isländischer Friedhof," *Die Dachstube* 4 (1918): 256.

Dietrich 1919 = Dietrich, Rudolf Adrian: "Island," *Die Sichel* 1 (1919): 86.

Diktonius 1922 = Diktonius, Elmer: "Muualla ja meillä" [Elsewhere and Here], *Ultra* 2 (1922): 24–25.

Dimitrova/Popov 1992 = Dimitrova, Tatyana/Popov, Chavdar (eds.): *Iz istoriyata na bulgarskoto izobrazitelno izkustvo* [From the History of Bulgarian Art], vol. 3, Bulgarian Academy of Sciences, Sofia 1992.

Dobrev 2007 = Dobrev, Marin: *Hudojnitzite na Stara Zagora* [The Artists of Stara Zagora], Daga +, Stara Zagora 2007.

van Doesburg 1922 = Doesburg, Theo van: "K. I. Konstruktivistische Internationale schöpferische Arbeitsgemeinschaft," *De Stijl* V (1922), No. 8: 113–115.

van Doesburg 1926a = Doesburg, Theo van: letter to the editors of *Praesens* from early 1926, Archive of Theo and Nelly van Doesburg, Netherlands Institute for Art History (Rijksbureau voor Kunsthistorische Documentatie) in The Hague, inv. nr. 308.

van Doesburg 1926b = Doesburg, Theo van: letter to the editors of *Praesens* from late 1926, Archive of Theo and Nelly van Doesburg, Netherlands Institute for Art History (Rijksbureau voor Kunsthistorische Documentatie) in The Hague, inv. nr. 308.

van Doesburg 1930a = Doesburg, Theo van: "Kunsten architectuurvernieuwing in Polen" [Evolution of Art and Architecture in Poland], *Het Bouwbedrijf* 18 (1930) No 7: 358–361.

van Doesburg 1930b = Doesburg, Theo van: "Belangrijke nieuwe uitgaven over nieuwe architectuur" [Major New Publications on New Architecture], *Het Bouwbedrijf* 20 (1930), No. 7: 401–403.

van Doesburg 1931 = Doesburg, Theo van: "Kunsten architectuurvernieuwing in Polen" [Evolution of Art and Architecture in Poland], *Het Bouwbedrijf* 5 (1931), No. 8: 87–90.

Dohrn/Pickhan 2010 = Dohrn, Verena/Pickhan, Gertrud (eds.): *Transit und Transformation. Osteuropaisch-judische Migranten in Berlin 1918–1939*, Wallstein, Göttingen 2010.

Dolgoff 1980 = Dolgoff, Sam (ed.): *Bakunin on Anarchism*, Black Rose Books, Montréal 1980.

Dorleijn 2008 = Dorleijn, Gillis J. et al. (eds.): *The Autonomy and Engagement in Literature at the two Fins de Siècles, 1900 and 2000*, Peeters, Leuven/Paris/Dudley, MA 2008.

Dorontchenkov 2009 = Dorontchenkov, Ilia (ed.): *Russian and Soviet Views of Modern Western Art: 1890s to Mid-1930s*, University of California Press, Berkeley 2009.

Dreier 1950 = Dreier, Katherine S.: "Finnur Jonsson," in: *Collection of the Société Anonyme* (1950: 120).

Dreier/Aladjalov 1926 = Dreier, Katherine S./Aladjalov, Constantin (eds.): *Modern Art. International Exhibition of the Société Anonyme for the Brooklyn Museum*, Museum of Modern Art, New York 1926.

Ducmene 2008 = Ducmene, Kristīne: "Simboli" [Symbols], *Māksla Plus* 5 (2008): 8–9.

Dudko 2013 = Dudko, Oksana: "Between the Past and the Future: Mass Rallies as the Staging of the Ukrainian National Project (1911–1914)," *Roczniki dziejów społecznych i gospodarczych* LXXIII (2013): 177–199.

Dukhan 2010 = Dukhan, Igor: "El Lissitzky and the Search for New Jewish Art (Vitebsk — Moscow — Berlin)," in: Malinowski/Piątkowska/Sztyma-Knasiecka (2010: 291–298).

Duménil 2013 = Duménil, Anne: "17. Mai 1915. Der Völkermord an den Armeniern," in: Cabanes/Duménil (2013: 121–125).

Dumin 1936 = Dumin, Osyp: *Istoriia lehionu Ukrains'kykh Sichovykh Stril'tsiv. 1914–1918* [History of the Legion of the Ukrainian Sich Riflemen. 1914–1918], Chervona kalyna, Lviv 1936.

Dusse 2007 = Dusse, Debora: "'Seit Altersher eine entschieden beliebte Gestalt'. Zur Rezeption der altnordischen Überlieferung von Wieland dem Schmied in den europäischen Kulturen," in: von See/Zernack (2007: 48–64).

Dzikovs'kyi 1967 = Dzikovs'kyi, Vasyl': "Syluety starshyn USS" [Portraits of Ukrainian Officers], in: Ripets'kyi (1967: 235–239).

E

Eberle 1989 = Eberle, Matthias: *Der Weltkrieg und die Künstler der Weimarer Republik. Dix. Grosz. Beckmann. Schlemmer*, Belser, Stuttgart/Zurich 1989.

Ecker/Henon-Reynaud/Possémé 2022 = Ecker, Heather/Henon-Reynaud, Judith/Possémé, Évelyne et al.: *Cartier and Islamic Arts: In Search of Modernity*, Thames & Hudson, London/New York 2022 (forthcoming).

Egbert 1970 = Egbert, Donald Drew: *Social Radicalism and the Arts: Western Europe*, Knopf, New York 1970.

Eigl 2018 = Eigl, Steffen: "Between Self-Stylisation and International Breakthrough. Some Aspects of the Major Exhibitions of the 1910s in the European Context," in: Srp (2018: 194–201).

Einstein/Freud 1933 = Einstein, Albert/Freud, Sigmund: *Correspondance Albert Einstein-Sigmund Freud: Pourquoi la guerre?*, Société des Nations, Paris, 1933.

Einstein/Westheim 1925 = Einstein, Carl/Westheim, Paul (eds.): *Europa Almanach*, Kiepenhauer, Potsdam 1925 (reprint: Kiepenheuer, Leipzig 1984).

Ekspresje Wolności 2019 = *Ekspresje Wolności. Bunt i Jung Idysz — Wystawa, której nie było/ Expressions of Freedom. Bunt and Jung Idysz — the Exhibition that Never Was...* (magazine accompanying the exhibition, 2), Muzeum Miasta Łodzi, Łódź 2019.

Eksteins 1989 = Eksteins, Modris: *Rites of Spring. The Great War and the Birth of the Modern Age*, Houghton Mifflin Company, Boston 1989.

Elbakidze/Ratiani 2016 = Elbakidze, Maka/Ratiani, Irma (eds.): *Bolshevizmi da Qartuli Literatura, 1921–1941* [Bolshevism and Georgian Literature, 1921–1941], Shota Rustaveli Institute of Georgian Literature, Tbilisi 2016.

Elenkov 1998 = Elenkov, Ivan: *Rodno i dyasno* [Native and Right], LIK, Sofia 1998.

Enäjärvi 1928 = Enäjärvi, Elsa: "Suomalainen — eurooppalainen?" [Finnish — European?], *Tulenkantajat* 1 (1928): 10–12.

Encyclopaedia 1980 = *Encyclopaedia na izobrazitelnite izkustva v Bulgaria* I [Encyclopaedia of Fine Arts in Bulgaria, vol. I], Bulgarska academiya na naukite, Sofia 1980.

Encyclopaedia 1987 = *Encyclopaedia na izobrazitelnite izkustva v Bulgaria* II [Encyclopaedia of Fine Arts in Bulgaria, vol. II], Bulgarska academiya na naukite, Sofia 1987.

Encyclopædia Universalis 1996 = *Encyclopædia Universalis*, vol. 12, Société d'édition Encyclopædia Universalis SA, Paris 1996.

Engwall 1944 = Engwall, Gustaf: *Karl Isaksson*, Sveriges allmänna konstförenings årsbok, Stockholm 1944.

E. R. 1918 = E. R.: "Bréf frá Berlín" [Letter from Berlin], *Fréttir. Dagblað* (July 31, 1918): 1–3.

Eram 2008 = Eram, Cosama: "Dada East: The Romanians of Cabaret Voltaire, by Tom Sandqvist," *Centropa* 8 (2008), No. 3: 292–294.

Ersoy/Górny/Kechriotis 2010 = Ersoy, Ahmet/Górny, Maciej/ Kechriotis, Vangelis (eds): *Discourses of Collective Identity in Central and Southeast Europe 1770–1945: Texts and Commentaries, vol. III/1:*

Modernism: The Creation of Nation-States, Central European University Press, Budapest/New York 2010.

Estraikh 2010 = Estraikh, Gennady: "Weimar Berlin — An International Yiddish Press Center," in: Dohrn/Pickhan (2010: 77–94).

Even-Zohar 1997 = Even-Zohar, Itamar: "Factors and Dependencies in Culture: A Revised Draft for Polysystem Culture Research," *Canadian Review of Comparative Literature/Revue Canadienne de Littérature Comparée* XXIV (1997), No. 1: 15–34.

Ex 1996 = Ex, Sjarel: "De blik naar het oosten: De Stijl in Duitsland en Oost-Europa" [A Glance Eastwards: De Stijl in Germany and Eastern-Europe], in: Blotkamp (1996: 67–112).

Ex 2000 = Ex, Sjarel: *Theo van Doesburg en het Bauhaus: de invloed van De Stijl in Duitsland en Midden-Europa* [Theo van Doesburg and Bauhaus: the Impact of De Stijl in Germany and Central Europe], Museum, Utrecht 2000.

F

Fabre/Hansen/Mørland 2013 = Fabre, Gladys C./Hansen, Tone/ Mørland, Gerd Elise (eds.): *Electromagnetic. Modern Art in Northern Europe, 1918–1931*, Hatje Cantz, Ostfilden 2013.

Fabre/Wintgens Hötte 2009 = Fabre, Gladys/Wintgens Hötte, Doris (eds.): *Van Doesburg & the International Avant-Garde. Constructing a New World*, Tate Publishing, London 2009.

Facos/Hirsh 2003a = Facos, Michelle/Hirsh, Sharon L. (eds.): *Art, Culture and National Identity in Fin-de-Siècle Europe*, Cambridge University Press, Cambridge 2003.

Facos/Hirsh 2003b = Facos, Michelle/Hirsh, Sharon L.: "Introduction," in: Facos/Hirsh (2003a: 1–15).

Fagure 1912 = Fagure, Emil: [Editorial], *Adevărul* (Scpt. 3, 1912): 6.

Fauchereau 2012 = Fauchereau, Serge: *Le Cubisme une révolution esthétique sa naissance et son rayonnement*, Flammation, Paris, 2012.

Filla 1947 = Filla, Emil: *O svobodě* [On Freedom], Jan Pohořelý, Prague 1947.

Finkeldey 1992 = Finkeldey, Bernd (ed.): *Konstruktivistische Internationale. Utopien für eine Europaische Kultur 1922–1927*, Cantz'sche Verlag, Ostfildern-Ruit 1992.

Forgács 1986 = Forgács, Éva: "József Nemes-Lampérth," in: Gassner (1986: 135–136).

Forgács 2002 = Forgács, Éva: "National Traditions," in: Benson/Forgács (2002: 47–48).

Forgács 2013 = Forgács, Éva: "Internationality Stretched Thin. The Hungarian Aspect (1920–1922)," in: van den Berg/Głuchowska (2013: 145–164).

"Formiści. Wystawa III" 1919 = "Formiści. Wystawa III. Katalog" [Formists. 3rd Exhibition. Catalogue] (1919), in: Chwistek (1960: 98).

Forrest/Koos 2001 = Forrest, Jennifer/Koos, Leonard (eds.): *Dead Ringers: The Remake in Theory and Practice*, State University of New York Press, Albany/New York 2001.

Foster 2004 = Foster, Hal et al.: *Art since 1900. Modernism, Antimodernism, Postmodernism*, Thames & Hudson, London 2004.

Franga 2013 = Franga, Liviu: "Vasile Pârvan și cultura slavă, II"

[Vasile Pârvan and the Slavic Culture, II], *Viata romaneasca* 11/12 (2013): 88–108.

Frank 2009 = Frank, Tibor: *Double Exile: Migrations of Jewish-Hungarian Professionals through Germany to the United States, 1919–1945*, Peter Lang, Oxford 2009.

Frankowska/Frankowski 2010 = Frankowska, Magdalena/Frankowski, Artur: *Berlewi, czysty warsztat*, Gdańsk 2010.

Frick 2018 = Frick, Maria: "Expressionism in Latin America and Its Contribution to the Modernist Discourse," in: Wünsche (2018c: 507–524).

Fry 1966 = Fry, Edward: *Le cubisme*, DuMont Schauberg, Cologne 1966.

Fuentes Codera 2014 = Fuentes Codera, Maximiliano: *España en la Primera Guerra Mundial: Una movilización cultural*, Akal, Madrid 2014.

Fülep 1971 = Fülep, Lajos: *Magyar művészet. Művészet és világnézet* [Hungarian Art. Art and Weltanschauung], selected essays, Corvina Kiadó, Budapest 1971.

Funda (1978) = Funda, Otakar A.: *Thomas Garrigue Masaryk: Sein philosophisches, religiöses und politisches Denken*, Peter Lang, Bern/Frankfurt a.M./Las Vegas 1978.

G

Gadowska 2015 = Gadowska, Irmina: "In Search of Spirituality. Religious Reorientation or Radical Assimilation? The Case of Marek Szwarc," *Art Inquiry. Recherches sur les arts* XVII (2015): 347–369.

Gadowska/Klimczak/Śmiechowska 2019 = Gadowska, Irmina/Klimczak, Adam/

Śmiechowska, Teresa (eds.): *Jung-Idisz/Yung-Yidish 1919* (reprint), Muzeum Miasta Łodzi/Polski Instytut Badań nad Sztuką Świata, Łódź/Warsaw 2019.

Gadowska/Świętosławska 2022 – Gadowska, Irmina/Świętosławska, Agnieszka (eds.): *Każdą iskrą rozpaleni... Żydowscy artyści w kręgu nowej sztuki. Idee — postawy — relacje* [Burnt with each Spark... Jewish Artists in the Sphere of the New Art. Ideas — Attitudes — Relationships], Wyd. Uniwersytetu Łódzkiego, Łódź 2022 (forthcoming).

Gagro 1966 = Gagro, Božidar: "Slikarstvo Proljetnog salona 1916–1928" [Painting of Spring Salon 1916–1928], *Život umjetnosti* 2 (1966): 46–54.

Gagro 1972 = Gagro, Božidar: "Putevi modernosti u hrvatskom slikarstvu" [Pathways of Modernity in Croatian Painting], in: Protić (1972: 34–45).

Galjer 2000 = Galjer, Jasna: *Likovna kritika u Hrvatskoj 1868–1951* [Art Criticism in Croatia 1868–1951], Meandar, Zagreb 2000.

Galjer/Maroević/Maruševski 1998 = Galjer, Jasna/Maroević, Tonko/Maruševski, Olga et al.: *Hrvatski Salon 1898* [Croatian Salon 1898], Umjetnički paviljon, Zagreb 1998.

García Calderón 1916 = García Calderón, Ventura: *Une enquête littéraire. Don Quichotte à Paris et dans les tranchées*, Centre d'études franco-hispaniques de l'Université de Paris, Paris 1916.

Gassner 1986 = Gassner, Hubertus (ed.): *Wechselwirkungen. Ungarische Avantgarde in der Weimarer Republik*, Jonas Verlag, Marburg 1986.

Gay 1968 = Gay, Peter: *Weimar Culture: The Outsider as Insider*, Harper & Row, New York 1968.

Gazeta Ilustrată 1912 = *Gazeta Ilustrată* (Mar. 24, 1912): 4.

Gazeta Ilustrată 1912a = ("Notice on Cinema"), *Gazeta Ilustrată* (Sept. 15, 1912): 4.

Geertz 1973 = Geertz, Criffold: *The Interpretation of Cultures*, Basic Books, Inc., New York 1973.

Geller 2010 = Geller, Ewa: "Yiddishland — Jewish Identity in East Central Europe," in: Malinowski/Piątkowska/Sztyma-Knasiecka (2010: 25–32).

Gellner 1983 = Gellner, Ernest: *Nations and Nationalism*, Blackwell, Oxford 1983.

Genova 1992 = Genova, Irina: "Dekorativno i kartinno v grafikata na Pencho Georgiev" [The Decorative and Pictorial in the Graphic Art of Pencho Georgiev], in: Dimitrova/Popov (1992: 73–89).

Genova 2013 = Genova, Irina: "Modernisms and the National Idea," in: Genova (2013a: 194–201).

Genova 2013a = Genova, Irina: *Modern Art in Bulgaria: First Histories and Present Narratives beyond the Paradigm of Modernity*, transl. Maria Petrova Dimitrova/Albena Evlogieva Vitanova, New Bulgarian University, Sofia 2013.

Genova 2018a = Genova, Irina: "Expressionism in Bulgaria: Critical Reflections in Art Magazines and the Graphic Arts," in: Wünsche (2018c: 465–483).

Genova 2018b = Genova, Irina: "Reflections of World War I: Modernism and the National Idea in Bulgaria", transl. by Albena Vitanova, *Sledva* 38 (2018): 95–112.

Gerharde-Upeniece 2016 = Gerharde-Upeniece, Ginta: *Māksla un Latvijas valsts. 1918–1920/Art et État en Lettonie. 1918–1940* [Art and the Latvian State. 1918–1940], Neputns, Riga 2016.

Gerharde-Upeniece 2018 = Gerharde-Upeniece, Ginta: "Expressionist Originality in Latvian Art: Between Confirmation and Destruction," in: Wünsche (2018c: 158–172).

Gerharde-Upeniece/Jevsejeva 2014 = Gerharde-Upeniece, Ginta/Jevsejeva, Naṭaļa (eds.): *1914*, Latvian National Museum of Art/Latvijas Nacionālais mākslas muzejs, Riga 2014.

Gerhart/Grasskamp/Matzner 2008 = Gerhart, Nikolaus/Grasskamp, Walter/Matzner, Florian (eds.): *200 Jahre Akademie der Bildenden Künste München. "… kein bestimmter Lehrplan, kein gleichförmiger Mechanismus"*, Hirmer Verlag, Munich 2008.

Gerle 2003 = Gerle, János (ed.): *Lechner Ödön. Az építészet mesterei* [Lechner Ödön. Masters of Architecture], Holnap Kiadó, Budapest 2003.

Geron 2012 = Geron, Małgorzata: "The Formist Group (1917–1923). Trends in Research and the Assessment of Polish Avantgarde Art in the 20th Century," in: Malinowski (2012: 155–164).

Geron 2015 = Geron, Małgorzata: *Formiści. Tworczość i programy artystyczne* [Formists. Creativity and Artistic Programs], Zakład Historii Sztuki Nowoczesnej Wydziału Sztuk Pięknych Uniwersytetu Mikołaja Kopernika, Toruń 2015.

Geron/Malinowski 2009 = Geron, Małgorzata/Malinowski, Jerzy (eds.): *Dzieje krytyki artystycznej i mysli o sztuce* [A History of Art Criticism and Thought on Art], Zakład Historii Sztuki Nowoczesnej Wydziału Sztuk Pięknych Uniwersytetu Mikołaja Kopernika/Stowarzyszenie Sztuki Nowoczesnej w Toruniu/DiG., Toruń/Warsaw 2009.

Gheorghiu-Cernat 1971 = Gheorghiu-Cernat, Manuela: "Independența României" [Romania's Independence], in: Cantacuzino (1971: 39–47).

Giersing 1917 = Giersing, Harald: "Der Sturm," *Klingen* 1 (1917), No. 2: n.p.

Gitelman/Glants/Goldman 2003 = Gitelman, Zvi/Glants, Musya/Goldman, Marshall I. (eds.): *Jewish Life after the USSR*, Indiana University Press, Bloomington 2003.

Giżycki 2008 = Giżycki, Marcin: "'Polski film — dobry!' Kino w kręgach artystycznych dwudziestolecia" ["Polish Film — Great!" Cinema in the Artistic Circles of the Interwar Period], in: Nowakowska-Sito (2008: 290–299).

Glants 2003 = Glants, Musya: "Jewish Artists in Russian Art: Painting and Sculpture in the Soviet and Post-Soviet Eras," in: Gitelman/Glants/Goldman (2003: 224–251).

Głuchowska 2007 = Głuchowska, Lidia: *Avantgarde und Liebe. Margarete und Stanislaw Kubicki 1910–1945*, Gebr. Mann, Berlin 2007.

Głuchowska 2009a = Głuchowska, Lidia: "Avantgarde: Berlin — Poznań," in: Traba (2009: 160–196).

Głuchowska 2009b = Głuchowska, Lidia: "'Totenmesse', 'Lebensfries' und 'Die Holle'. Przybyszewski, Munch, Vigeland und die protoexpressionistische Kunsttheorie," *Deshima* 1 (2009, hors-serie): 93–130.

Głuchowska 2009c = Głuchowska, Lidia: "Okkultismus, Esoterik, Mystik und die Ikonographie des Unsichtbaren in der frühen

mitteleuropäischen Avantgarde. Das Beispiel der Posener Gruppe Bunt and des Bauhausprofessors Lothar Schreyer," in: Bru (2009: 306-327).

Głuchowska 2009d = Lidia Głuchowska: "Tristan Tzara — monsieur dada, Manifest dada 1918 i polskie konteksty dadaizmu" [Tristan Tzara — Monsieur Dada, the 1918 Dada Manifesto and Polish Dada Contexts], *Rita Baum* 13 (2009), No. 1: 65-71.

Głuchowska 2009/2010 = Głuchowska, Lidia: "'Dadaland — Polen'?, 'Dada Polen'?, 'un dadaïsme polonais'? Anmerkungen zu zwei genealogischen Linien der semidadaistischen Bewegung in Polen," *Hugo-Ball-Almanach. Neue Folge* 1 (2009/2010): 39-62.

Głuchowska 2012a = Głuchowska, Lidia: "Berlin as a Center of International Modernism and a Turnstile of the Avant-Garde," in: Głuchowska (2012e: 214).

Głuchowska 2012b = Głuchowska, Lidia: "From Transfer to Transgression. Yiddish Avant-Garde — a Network within the Universal Network of the International Movement or a Complementary One?," in: Veivo (2012: 143-168).

Głuchowska 2012c = Głuchowska, Lidia: "Polnische Künstler und 'Der Sturm': Enthusiasten und Polemiker. Nationale und transnationale Narrative des postkolonialen Avantgarde- und Modernediskurses," in: von Hülsen-Esch/Finckh (2012: 455-482).

Głuchowska 2012d = Głuchowska, Lidia: "Polish and Polish-Jewish Modern and Avant-Garde Artists in the 'Capital of the United States of Europe', c. 1910-1930," in: Głuchowska (2012e: 216-233).

Głuchowska 2012e = Głuchowska, Lidia (ed.): "Berlin as a Center of International Modernism and a Turnstile of the Avant-Garde", *Centropa. A Journal of Central European Architecture and Related Arts* 12 (2012), No. 3: 215-355.

Głuchowska 2013a = Głuchowska, Lidia: "Artyści polscy w orbicie 'Der Sturm'. Historia i historyzacje" [Polish Artists in the Orbit of *Der Sturm*. History and Historizations], *Quart* 3 (2013): 3-15.

Głuchowska 2013b = Głuchowska, Lidia: "From Abstract Film to Op Art and Kinetic Art? Henryk Berlewi's Mechano-Facture as a Transmedial Adaptation of the Experimental Films by Viking Eggeling," in: Posman (2013: 306-327).

Głuchowska 2013c = Głuchowska, Lidia: "Munch, Przybyszewski and *The Scream*," *Kunst og Kultur* 96 (2013), No. 4: 182-193.

Głuchowska 2013d = Głuchowska, Lidia: "The 'New World' of the Avant-Garde and the 'New States' in Central Europe. Perspectives of a Postnational and Postcolonial New Art History. Postface," in: van den Berg/Głuchowska (2013: 165-212).

Głuchowska 2013e = Głuchowska, Lidia: "Station Warsaw. Malevich, Lissitzky and the Two Traces of Cultural Transfer between 'East' and 'West'," *Centropa* 13 (2013), No. 3: 241-257.

Głuchowska 2013f = Głuchowska, Lidia: "Poznań and Łodź: National Modernism and International Avant-garde. *Zdrój* (1917-22); *Yung-Yidish* (1919); and *Tel-Awiw* (1919-21)," in: Brooker (2013b: 1208-1233).

Głuchowska 2014a = Głuchowska, Lidia: "Der 'fremde Krieg' und der 'neue Staat'. Polnische Kunst 1914-1918," in: Sapper/Weichsel (2014: 291-316).

Głuchowska 2014b = Głuchowska, Lidia: "In the Shadow of the Official Discourse: Towards a Revision of the History and Theory of Polish Idiom of Cubism," in: Lahoda (2014a: 156-171).

Głuchowska 2015a = Głuchowska, Lidia: "Between 'Isms', Internationalism and Patriotism. The Case of Stanisław Kubicki," in: Kossowska (2015: 233-256).

Głuchowska 2015b = Głuchowska, Lidia (ed.): *Bunt — Ekspresjonizm — Transgraniczna awangarda. Prace z berlińskiej kolekcji prof. St. Karola Kubickiego/ Bunt — Expressionismus — Grenzübergreifende Avantgarde. Werke aus der Berliner Sammlung von Prof. St. Karol Kubicki*, Muzeum Narodowe, Poznań 2015.

Głuchowska 2015c = Głuchowska, Lidia: "'In Poland that Means Nowhere'. The 'Foreign War' and the 'New Country' 1914-1918. Polish art Between Tradition and the Avant-garde," in: Cēbere (2015: 201-213).

Głuchowska 2015e = Głuchowska, Lidia: "'Nicht unsere Werke sind wichtig, sondern das Leben'. Performative Manifestationen der Gruppen Bunt und Die Kommune," *Expressionismus* 2 (2015): 15-36.

Głuchowska 2015f = Głuchowska, Lidia: *Stanisław Kubicki — in transitu. Poeta tłumaczy sam siebie/Ein Poet übersetzt sich selbst*, OKiS, Wrocław 2015.

Głuchowska 2015g = Głuchowska, Lidia: "Anna Wierzbicka: We Francji i w Polsce 1900-1939. Sztuka, jej historyczne uwarunkowania i odbiór w świetle krytyków polsko-francuskich,

Instytut Sztuki Polskiej Akademii Nauk, 2009" [Anna Wierzbicka: In France and in Poland, Art Institute of the Polish Academy of Sciences, 2009], *Zeitschrift für Ostmitteleuropa-Forschung* 64 (2015), No. 2: 297–299.

Głuchowska 2016 = Głuchowska, Lidia: "Bunt — Refleks — Ulotka — Ich 7 — performatywna, ekstrerytorialna i międzygeneracyjna 'międzynarodówka ducha'?"/ "Bunt — Refleks [Reflex] — Ulotka [The Flyer] — Ich 7 [The 7 of Them] — the Performative, Exterritorial and Intergenerational 'International of the Spirit'?", in: Kurak (2016: 16–37/107–116).

Głuchowska 2016a = Głuchowska, Lidia: "Zdrój — Die Aktion — Der Sturm. Czasopisma artystyczne i transfer kulturowy a echa kubizmu w twórczości graficznej artystów grupy Bunt" [Zdrój — Die Aktion — Der Sturm. Artistic Magazines and Cultural Transfer. Echoes of Cubism in the Graphical Art of Members of the Group Bunt], in: Głuchowska/ Gołuńska/Woźniak (2016: 37–60).

Głuchowska 2018a = Głuchowska, Lidia: "Cosmopatriots? Internationalism and Patriotism in the Thinking of the Classic Avant-Garde. The Case of Stanislaw Kubicki (1889–1942)," in: Monkiewicz (2018: 141–162).

Głuchowska 2018b = Głuchowska, Lidia: "Der Expressionismus in der polnischen Kunst — ein Überblick," in: Schmengler/Kern/ Głuchowska (2018: 378–392).

Głuchowska 2018c = Głuchowska, Lidia: "Kunst, Politik und Eskapismus. Expressionistische Künstler-Seher und avantgardistische Konstrukteure der Welt in der polnischen Kunst- und Kulturgeschichte,"

in: Schmengler/Kern/Głuchowska (2018: 303–411).

Głuchowska 2018d = Głuchowska, Lidia: "The Great War and Expressionism apart of Center — 'The Rite of Spring', Masochism, Suppression," in: Kurc-Maj/Saciuk-Gąsowska/ Polit (2018: 39–64).

Głuchowska 2018e = Głuchowska, Lidia: "'Poznań Expressionism' and its Connections with the German and International Avant-garde," in: Wünsche (2018c: 92–113).

Głuchowska 2020a = Głuchowska, Lidia: "Artists from Poland in the International Milieu of Classical Berlin Avant-Garde *Die Aktion*, *Der Sturm*, and Die Novembergruppe," in: Stolarska-Fronia (2020: 81–119).

Głuchowska 2020b = Głuchowska, Lidia: "Sto lat awangardy i transgraniczny hołd dla Buntu i Jung Idysz"/"One Hundred Years of Avant-garde and Cross-border Homage to Bunt and Yung Yidish," in: Kurak (2020: 116–181).

Głuchowska 2022a = Głuchowska, Lidia: "Bunt and Yung-Yidish. Between Poznań, Łódź and Berlin. Contacts, Conceptions, Artistic Events," in: Gadowska/ Świetosławska (2022) (forthcoming).

Głuchowska 2022b = Głuchowska, Lidia: "Der Erste Weltkrieg — Unabhangigkeit Polens — Polonisierung des Expressionismus," in: Marek/ Lipińska/Bernhardt (2022) (forthcoming).

Głuchowska/Gołuńska/Woźniak 2015 = Głuchowska, Lidia/ Gołuńska, Honorata/Woźniak, Michał F. (eds.): *Bunt a tradycje grafiki w Polsce i w Niemczech* [Bunt and Traditions of Graphics in Poland and

Germany], Muzeum Okręgowe im. Leona Wyczółkowskiego, Bydgoszcz 2015.

Głuchowska/Lahoda 2022 = Głuchowska, Lidia/Lahoda, Vojtěch (eds.): *Cubism, its Idioms and Re-visions "out of the Centre". Aesthetics, Functions and Political Connotations*, Artefactum, Prague 2022 (forthcoming).

Gluck 1985 = Gluck, Mary: *Georg Lukács and his Generation 1900–1918*, Harvard University Press, Cambridge, Mass./London 1985.

Goda 1993 = Goda, Gertrud: *Izsó Miklós, 1831–1875*, Herman Ottó Múzeum, Miskolc 1993: http://mek.oszk.hu/06600/06622/ (accessed: Oct. 8, 2020).

Golan 1995 = Golan, Romy: *Modernity and Nostalgia. Art and Politics in France between the Wars*, Yale University Press, New Haven/London 1995.

Golomstock 1984 = Golomstock, Igor: "Jews in Soviet Art," in: Miller (1984: 23–64).

Golubović/Subotić 2008 = Golubović, Vidosava/Subotić, Irina: *Zenit 1921–1926*, Narodna biblioteka Srbije/Institut za umetnost i književnost/Srpsko kulturno društvo Prosvjeta, Belgrade/Zagreb 2008.

Goodman 1995 = Goodman, Susan Tumarkin (ed.): *Russian Jewish Artists in a Century of Change*, Prestel, Munich/New York 1995.

Gotsiridze 2014 = Gotsiridze, Giorgi: "Qartvelebi pirveli msoflio omis frontebze" [Georgians at the Fronts in World War One], *Akhali da Uakhlesi Istoriis Sakitkhebi* 1 (2014), No. 14: 150–158.

Gottesmann 2003 = Gottesmann, Itzik Nakhmen: *Defining the Yiddish Nation. The Jewish Folklorists of Poland*, Wayne State University Press, Detroit 2003.

Gottlieb 1984 = Gottlieb, Lennart: "Tetzen-Lunds samling — om dens historie, indhold og betydning" [The Tetzen-Lund Collection — on its History, Content and Significance], *Kunst og Museum* 19 (1984): 18–49.

Gottlieb 2012 = Gottlieb, Lennart: *Modernisme. Maleriets fornyelse 1908–41* [Modernism: The Innovation of Painting 1908–41], Aros, Aarhus 2012.

Gottskálksdóttir 1993 = Gottskálksdóttir, Júlíana: "Tilraunin ótímabæra. Um abstraktmyndir Finns Jónssonar og viðbrögð við þeim" [The Untimely Experiment. Finnur Jónsson's Abstract Paintings and their Reception], in: Nordal (1993: 74–101).

Goudz 2008a = Goudz, Inna: "Auf dem Weg zu einer neuen Kultur — Die Kultur-lige," in: von Hülsen-Esch/Aptroot (2008: 19–29).

Goudz 2008b = Goudz, Inna: "Die Künstlertreffpunkte in Berlin und Paris zu Beginn des 20. Jahrhunderts," in: von Hülsen-Esch/Aptroot (2008: 6–10).

Goudz 2011 = Goudz, Inna: "Herwarth Walden und die jüdischen Künstler der Avantgarde," in: von Hülsen-Esch/Finckh (2011: 493–518).

Greenblatt 1988 = Greenblatt, Stephen: *Shakespearean Negotiations. The Circulation of Social Energy in Renaissance England*, University of California Press, Berkeley/Los Angeles, 1988.

Grindstaff 2001 = Grindstaff, Laura: "Pretty Woman with a Gun: La Femme Nikita and the Textual Politics of 'the Remake'," in: Forrest/Koos (2001: 273–308).

Grislain 2007 = Grislain, Jean-Etienne (ed.): *Georges Vantongerloo 1886–1965: un pionnier de la sculpture moderne*, Gallimard, Paris 2007.

Gronemeyer 2018 = Gronemeyer, Wiebke: "Expressionism and the Spanish Avant-Garde between Restoration and Renovation," in: Wünsche (2018c: 365–376).

Gross 2002 = Gross, Natan: *Film żydowski w Polsce* [Jewish Film in Poland], transl. Anna Ćwiakowska, Fundacja Dziedzictwo/Rabid, Cracow 2002.

Grosvalds 1919 = Grosvalds, Jāzeps: Letter to Arturs Tupiņš, July 8, 1919, Latvian National Museum of Art, VMM JGM-1519.

Grosvalds 1919a = J. G. [= Grosvalds, Jāzeps]: "L'Art Letton. Les Jeunes," *La Revue Baltique* 13 (1919), No. 1: 25–28.

Grosvalds 1919b = J. G. [= Grosvalds, Jāzeps]: "L'Art Letton (II)," *La Revue Baltique* 16 (1919), No. 4: 59–61.

Groys 1997 = Groys, Boris: *Logik der Sammlung: Am Ende des musealen Zeitalters*, Carl Hanser Verlag, Munich 1997.

Groys 2012 = Groys, Boris: *Avantgardet och samlingens logik* [Avant-Garde and the Logic of Collection], Site Editions/Propexus, Lund 2012.

Gryglewicz 2015 = Gryglewicz, Tomasz: "Nieistnienie — cecha konstytutywna Europy Środkowej — w polskiej sztuce (1919–2012)" [Non-Existence — a Constitutive Quality of Central Europe — in Polish Art (1919–2012)], in: Kossowska (2015: 47–60).

Guerra Junqueiro 1918 = Guerra Junqueiro, Abílio Manuel: *O monstro alemão: Atila e Joana d'Arc*, Junta Patriotica do Norte, Oficinas do Comercio do Porto, Porto 1918.

Guilbaut 1983 = Guilbaut, Serge: *How New York Stole the Idea of Modern Art. Abstract Expressionism, Freedom, and the Cold War*, The University of Chicago Press, Chicago/London 1983.

Guillemont 1919 = Guillemont, Michel: "Le monument des Alliés," Apr. 15, 1919, quot. in: Bobrowska-Jakubowska (1997: 42).

Gunnarsson 2004 = Gunnarsson, Annika: "Konsten att finna sig själv" [The Art of Finding Oneself], in: Carlberg/Gunnarsson (2004: 56–67).

Guralnik 1985 = Guralnik, Nehama: "Jankel Adler, European Artist in Quest of a Jewish Style," in: Krempel/Thomas/Guralnik (1985: 202–232).

Gurianova 2000 = Gurianova, Nina: *Exploring Color: Olga Rozanova and the Early Russian Avant-Garde, 1910–1918*, G&B Arts International, Amsterdam 2000.

Gurianova 2012 = Gurianova, Nina: *The Aesthetics of Anarchy: Art and Ideology in the Early Russian Avant-Garde*, University of California Press, Berkeley 2012.

Gutfreund 1913 = Gutfreund, Otto: "O Donatellovi" [On Donatello], *Umělecký měsíčník* 2 (1913): 137.

Gutman/Mendelsohn/Reinharz 1989 = Gutman, Yisrael/Mendelsohn, Ezra/Reinharz, Jehuda et al. (eds.): *The Jews of Poland between Two World Wars*, United Press of New England, Hanover/London 1989.

Gwódź-Szewczenko 2011 = Gwódź-Szewczenko, Ilona: "Futurism. The Hidden Face of the Czech Avant-Garde," in: Berghaus (2011: 154–174).

H

Haapalainen 2002 =
Haapalainen, Riikka: "Väinö
Kunnas," in: Sederholm/Salin
(2002: 286–291).

Habermas 1994 = Habermas,
Jürgen: *Die Moderne — Ein
unvollendetes Projekt*, Reclam,
Leipzig 1994.

Habermas 1998 = Habermas,
Jürgen: *Die postnationale
Konstellation. Politische Essays*,
Suhrkamp, Frankfurt/M. 1998.

Habermas 2001 = Habermas,
Jürgen: *The Postnational
Constellation. Political Essays*,
The MIT Press, Cambridge,
Mass. 2001.

Hagener 2012 = Hagener, Malte:
"Turnstile Berlin: The Film Avant-
Garde, the City, and the Birth of
Film Culture," in: Głuchowska
(2012e: 316–326).

Hagener 2014 = Hagener, Malte:
"Mushrooms, Ant Paths and
Tactics. The Topography of the
European Film Avantgarde,"
in: Bäckström/Hjartarson
(2014: 145–168).

Hain 1999 = Hain, Radan:
*Staatstheorie und Staatsrecht
in T. G. Masaryks Ideenwelt*,
Schulthess, Zurich 1999.

Hakh 2012 = Hakh, Iryna:
"Mystets'ka spadschyna
Ukrains'kykh sichovykh
stril'tsiv u fondovii zbirtsi
Natsional'noho muzeiu u Lvovi
im. Andreia Sheptyts'koho" [Art
Heritage of the Ukrainian Sich
Riflemen at the Sheptytsky
National Art Museum in Lviv],
Viis'kovo-istorychnyi al'manakh 1
(2012): 150–158.

Hałasa 2003 = Hałasa, Grażyna
(ed.): *Bunt. Ekspresjonizm
Poznański 1917–1925/
Bunt. Poznań Expressionism
1917–1925*, Muzeum Narodowe,
Poznań 2003.

Hausmann 2014 = Hausmann,
Guido: "Die Kultur der Niederlage.
Der Erste Weltkrieg und die
Ukraine," in: Sapper/Weichsel
(2014: 127–140).

Hautala-Hirvioja 2018 = Hautala-
Hirvioja, Tuija: "Expressionism in
Sámi Art: John Savio's Woodcuts
of the 1920s and 1930s,"
in: Wünsche (2018c: 243–256).

Havlová 2018 = Havlová, Eliška:
*František Kupka — legionář
a vlastenec/Legionnaire and
Patriot*, transl. Helena Musilová,
Museum Kampa — Nadace
Jana a Medy Mládkových,
Prague 2018.

Havránek 1967 = Havránek,
Jan: "The Development of
Czech Nationalism," *Austrian
History Yearbook* 3 (1967), No. 2:
223–260.

Hazan-Brunet/Ackerman 2009 =
Hazan-Brunet, Natalie/Ackerman,
Ada (eds.): *Futur antérieur:
L'avant-garde et le livre yiddish
(1914–1939)*, Flammarion,
Paris 2009.

Heidegger 1993 = Heidegger,
Martin: "Letter on Humanism,"
in: Heidegger (1993a: 213–266).

Heidegger 1993a = Heidegger,
Martin: *Basic Writings*, transl.
David Farrel Krell, HarperCollins,
San Francisco 1993.

Held/McGrew/Goldblatt 1999 =
Held, David/McGrew, Anthony
G./Goldblatt, David et al.:
*Global Transformations: Politics,
Economics and Culture*, Stanford
University Press, Stanford,
Cal. 1999.

Heller 2003 = Heller, Steven: *Merz
to Emigre and Beyond: Avant-
Garde Magazine Design of the
Twentieth Century*, Phaidon Press,
London/New York 2003.

Henningsen 1918 = Henningsen,
Poul: "Der Sturm," *Klingen* 2
(1918), No. 3: n.p.

Henschel 2008 = Henschel,
Frank: *Mitteleuropa gegen das
neue Europa. Ein Vergleich der
Schriften Friedrich Naumanns und
Tomas Garrigue Masaryks*, Grin,
Munich 2008.

**Herzogenrath/Schmidt
1991** = Herzogenrath, Wulf/
Schmidt, Johann-Karl (eds.): *Dix*,
Gerd Hatje, Stuttgart 1991.

Heschel/Baker 2010 = Heschel,
Susannah/Baker, Timothy:
"Introduction: Transnational
Migrations of Identity: Jews,
Muslims, and the Modernity
Debate," *Comparative Studies
of South Asia, Africa and the
Middle East* 30 (2010), No. 1: 1–5.

Hidalgo 1916 = Hidalgo, Alberto:
*Arenga lírica al emperador de
Alemania*, Tipografía Quiroz
Hermanos, Arequipa 1916.

Hidalgo 1917 = Hidalgo, Alberto:
Panoplia lírica, Imprenta Víctor
Fajardo III, Lima 1917.

Hjartarson 2006 = Hjartarson,
Benedikt: "Dragging Nordic
Horses past the Sludge of
Extremes. The Beginnings of the
Icelandic Avant-Garde," in: Bru/
Martens (2006: 235–263).

Hjartarson 2014 = Hjartarson,
Benedikt: "Anationalism and
the Search for a Universal
Language. Esperantism and
the European Avant-Garde,"
in: Bäckström/Hjartarson
(2014: 267–303).

Hjartarson 2016 = Hjartarson,
Benedikt: "'A New Movement
in Poetry and Art in the
Artistic Countries Abroad'. The
Reception of Futurism in Iceland,"
in: Berghaus (2016: 220–249).

Hnatkevych 2011 = Hnatkevych,
Bohdan: *Ukrains'ki sichovi stril'tsi,
1914–1920* [Ukrainian Sich

Riflemen, 1914–1920], Krai, Lviv 2011.

Hnídková 2009 = Hnídková, Vendula: "Rondokubismus versus národní styl" [Rondocubism versus National Style], *Umění/ Art* 57 (2009), No. 1: 74–84.

Hnídková 2010 = Hnídková, Vendula: "Rondocubism versus National Style," *RIHA Journal* 0011 (Nov. 8, 2010): n.p.; originally published as: Hnídková (2009).

Hnídková 2013 = Hnídková, Vendula: *Národní styl. Kultura a politika* [National Style. The Arts and Politics], Národní galerie v Praze/VŠUP, Prague 2013.

Hoberg 2015 = Hoberg, Annegret: *August Macke, Franz Marc — der Krieg, ihre Schicksale, ihre Frauen*, Wienand, Cologne 2015.

Hobsbawm 1990 = Hobsbawm, Eric: *Nations and Nationalism since 1780*, Cambridge University Press, Cambridge 1990.

Hoensch 1997 = Hoensch, Jörg K.: *Geschichte Böhmens. Von der slavischen Landnahme bis zur Gegenwart*, 3rd ed., C. H. Beck, Munich 1997.

Hofstaetter/Tack 2006 = Hofstaetter, Constanze/Tack, Peter: "Auf der Suche nach dem Neuen Menschen. Karl Peter Röhl und das frühe Bauhaus," in: Wagner (2006: 125–134).

Holbraad 1991 = Holbraad, Carsten: *Danish Neutrality. A Study in the Foreign Policy of a Small State*, Clarendon Press, Oxford 1991.

Holeczko-Kiel 2004 = Holeczko-Kiel, Andrzej: "Kunst und Politik — Zur Identitätsfindung zwischen Realismus, Symbolismus und Avantgarde," in: Schuler/ Gawlik (2003: 140–146).

Holm 2012 = Holm, Michael et al. (eds.): *Women of the Avant-Garde*

1920–1940, Louisiana Museum of Modern Art, Humlebæk 2012.

Hörstmann 2018 = Hörstmann, Lisa: "The Expressionist Roots of South African Modernism," in: Wünsche (2018c: 525–541).

Hrankowska 1993 = Hrankowska, Teresa (ed.): *Przed wielkim jutrem. Sztuka 1905–1918* [Before the Great Tomorrow. Art 1905–1918], IS PAN, Warsaw 1993.

Hrytsak 2014 = Hrytsak, Yaroslav: "Ukraine 1914– 2014: An Unfinished War 1914–2014," in: Markó/Schmidt (2014: 265–282).

Hubert 1994 = Hubert, Renee Riese: *Magnifying Mirrors. Women, Surrealism and Partnership*, University of Nebraska Press, Lincoln/ London 1994.

Hulewicz 1919 = Hulewicz, Jerzy: *Na tle Króla Ducha* [On the Background of the King the Spirit], *Zdrój* 9 (1919), No. 3: cover.

von Hülsen-Esch/Aptroot 2004 = von Hülsen-Esch, Andrea/ Aptroot, Marion et al. (eds.): *Jüdische Illustratoren des 20. Jahrhunderts aus der Sammlung jiddischer Bücher der Universitäts- und Landesbibliothek Düsseldorf*, Heinrich-Heine-Universität, Düsseldorf 2004.

von Hülsen-Esch/Finckh 2012 = von Hülsen-Esch, Andrea/Finckh, Gerhard (eds.): *Der Sturm — Zentrum der Avantgarde. Bd. 2: Aufsätze*, Von der Heydt Museum, Wuppertal 2012.

Hume 2012 = Hume, Naomi: "Avant-Garde Anachronisms: Prague's Group of Fine Artists and the Vienna School of Art History," *Slavic Review* 71 (2012): 516–545.

Hunczak 1967 = Hunczak, Taras: "Polish Colonial Ambitions in

the Inter-War Period," *Slavic Review* 26 (1967), No. 4: 648–656.

Hunkeler 2006 = Hunkeler, Thomas: "Cultural Hegemony and Avant-Gardist Rivalry. The Ambivalent Reception of Futurism in France, England and Russia," in: Bru/Martens (2006: 203–216).

Hupchick/Cox 2001 = Hupchick, Dennis P./Cox, Harold: *The Concise Historical Atlas of the Balkans*, Palgrave Macmillan, London 2001.

Husslein-Arco/Köhler/Burmeister 2013 = Husslein-Arco, Agnes/ Köhler, Thomas/Burmeister, Ralf et al. (eds.): *Wien — Berlin. Kunst zweier Metropolen*, Berlinische Galerie Museum für Moderne Kunst/Belvedere/Prestel, Munich/ London/New York 2013.

Huusko 2012 = Huusko, Timo: "Finnish Nationalism and the Avant-Garde," in: van den Berg/Hautamäki/Hjartarson (2012: 557–572).

Huusko/Palin 2018 = Huusko, Timo/Palin, Tutta: "Nationalism, Transnationalism, and the Discourses on Expressionism in Finland: From the November Group to Ina Behrsen-Colliander," in: Wünsche (2018c: 222–242).

I

Iashvili 1916 = Iashvili, Paolo: "Pirvelitqma" [The First Word], in: *Tsisperi Qantsebi* (Kutaisi) 1 (1916): 3–5.

Iashvili 1965 = Iashvili, Paolo: *Leksebi, poemebi, targmanebi* [Poetry, Epic Poems, Translations], coll. Shalva Demetradze, ed. Irakli Abashidze, Sakhelgami, Tbilisi 1965.

Iliev/Petrov 2014 = Iliev, Krassimir/Petrov, Plamen V.

(eds.): *Sirak Skitnik*, Sofia City Art Gallery, Sofia 2014.

Imanse/Langfeld 2018 = Imanse, Geurt/Langfeld, Gregor: "Expressionism in the Netherlands," in: Wünsche (2018c: 295–315).

"Independența României" 1911 = "Independența României" [Romania's Independence], *Rampa* (Dec. 1, 1911).

Ingólfsson/Nordal 1992 = Ingólfsson, Aðalsteinn/Nordal, Bera: "Umfjöllun um átta myndir Finns Jónssonar" [Approach to Finns Jónssonar's Eight Photographs], in: Kristjánsdóttir (1992: 15–46).

Irzykowski 1924 = Irzykowski, Karol: *Dziesiąta Muza* [The Tenth Muse], Krakowska Spółka Wydawnicza, Cracow 1924.

Isac 1912 = Isac, Emil: "Protopopii familiei mele" [The Archpriests of my Family], *Simbolul* 1 (1912): 2.

Isenberg 1999 = Isenberg, Noah William: *Between Redemption and Doom: The Strains of German-Jewish Modernism*, University of Nebraska Press, Lincoln 1999.

Ivanets' 1914 = Ivanets', Ivan: "Moderne maliarstvo" [Modern Painting], *Iliustrovana Ukraina* 1 (1914): 10–12.

Ivanets' 1935a = Ivanets', Ivan: "Zaviia" [Snowstorm] (image), *Nazustrich* 1 (1935): 5.

Ivanets' 1935b = Ivanets', Ivan: "Mytets'-anakhoret" [Artist-Anchoret], *Nazustrich* 9 (1935), No. 1: 1.

Ivanets' 1935c = Ivanets', Ivan: "Rozgubleni strilecki pamiatky" [Lost Riflemen Relics], *Nazustrich* 1 (1935), No. 2: 1.

Ivanets' 1936a = Ivanets', Ivan: "Batal'ne maliarstvo" [Battle Painting], *Nazustrich* 21 (1936), No. 1: 1–2.

Ivanets' 1936b = Ivanets', Ivan: "Velykodnia Bomba" [The Easter Bomb], *Litopys Chervonoi Kalyny* 4 (1936), No. 2: 7–9.

J

Jach/Kurc-Maj 2017 = Jach, Aleksandra/Kurc-Maj, Paulina (eds.): *Superorganism. The Avant-Garde and the Experience of Nature*, transl. Marcin Wawrzyńczak, Muzeum Sztuki w Łodzi, Łódź 2017.

Jacoby 2007 = Jacoby, Petra: *Kollektivierung der Phantasie? Künstlergruppen in der DDR zwischen Vereinnahmung und Erfindungsgabe*, Transcript, Bielefeld 2007.

Jaffé 1956 = Jaffé, Hans L. C.: *De Stijl. The Dutch Contribution to Modern Art*, J. M. Meulenhoff, Amsterdam 1956.

Janák 1909–1910 = Janák, Pavel: "Od moderní architektury k architektuře" [From Modern Architecture towards Architecture], *Styl* 2 (1909–1910): 105–109.

Janák 1912 = Janák, Pavel: "Hranol a pyramida" [The Prism and the Pyramid], *Umělecký měsíčník* 1 (1912): 163.

Janák 1918a = Janák, Pavel: "Národní věc a čeští architekti" [National Issue and Czech Architects], *Národ* 2 (1918), No. 295: 305–306.

Janák 1918b = Janák, Pavel: "Nedočkavá procházka" [Impatient Walk], *Umění* 1 (1918): 81–86.

Janecek/Toshiharu 1998 = Janecek, Gerald/Toshiharu, Omuka (eds.): *The Eastern Dada Orbit. Russia, Georgia, Ukraine, Central Europe, and Japan*, G. K. Hall, New York 1998.

Janeke 2015 = Janeke, Kristiane: "Russia's Commemoration on the First World War. Remarks on the Policy of History and Culture of Memory," in: Cēbere (2015: 120–125).

Janion 1998 = Janion, Maria: *Płacz generała. Eseje o wojnie* [The General's Scream. Essays on the War], Sic!, Warsaw 1998.

Jankevičiūtė/Laučkaitė 2018 = Jankevičiūtė, Giedrė/Laučkaitė, Laima: "Expressionism in Lithuania: From German Artistic Import to National Art," in: Wünsche (2018c: 134–157).

Jaroszewski 1993 = Jaroszewski, Tadeusz: "Dwór polski tuż przed I wojną światową" [Polish Manor House shortly before World War One], in: Hrankowska (1993: 21–59).

Javakhishvili 2001 = Javakhishvili, Mikeil: *Tserilebi* [Essays], coll. and ed. Rusudan Kusrashvili, Tbilisi 2001.

Javakhishvili 2004 = Javakhishvili, Mikheil: *Lambalo da Kasha* [Lambalo and Kasha], vol. 1, in: Javakhishvili (2004a: 309–386).

Javakhishvili 2004a = Javakhishvili, Mikheil: *Tkhzulebani 7 Tomad* [Selected Works in 7 Volumes], Sakartvelos Macne, Tbilisi 2004.

Javakhishvili K. 2000 = Javakhishvili, Ketevan: *Mogonebebi mamaze* [Memoirs of my Father], Merani, Tbilisi 2000.

Jędrzejczyk/Słoboda 2019 = Jędrzejczyk, Małgorzata/Słoboda, Katarzyna (eds.): *Composing the Space. Sculptures in the Avant-Garde*, transl. Barbara Askanas et al., Muzeum Sztuki w Łodzi, Łódź 2019.

Jēkabsons 2014 = Jēkabsons, Ēriks: "The Latvian Rifle Units

of 1915–1918," in: Gerharde-Upeniece (2014: 33–40).

Jeleński 1965 = Jeleński, Konstanty A.: *Anthologie de la poésie polonaise*, Seuil, Paris 1965.

Jelsbak 2005 = Jelsbak, Torben: *Ekspressionisme. Modernismens formelle gennembrud i dansk malerkunst og poesi* [Expressionism. The Formal Breakthrough of Modernism in Danish Art and Poetry], Forlaget Spring, Copenhagen 2005.

Jelsbak 2013 = Jelsbak, Torben: "'Order and Regularity and Solidarity in all Things'. Internationalist Aesthetics and Politics of the Danish Avant-Garde(s) around 1920," in: van den Berg/Głuchowska (2013: 99–116).

Jelsbak 2016 = Jelsbak, Torben: "'Lifeless glaciers': The History of Futurism in Denmark," in: Berghaus (2016: 147–168).

Jelsbak 2018 = Jelsbak, Torben: "Expressionism in Denmark: Art and Discourse," in: Wünsche (2018c: 191–205).

Jenko 2018 = Jenko, Marko: "Expressionism in Slovenia: The Aspects of a Term," in: Wünsche (2018c: 395–407).

Johansen 1957 = Johansen, Svend: *Et af Rafaels guddommelige forbilleder* [About Divine Role Models], Munksgaard — Udgivet, Copenhagen 1957.

de Jongh 1972 = Jongh, Ankie de: "De Stijl," *Museumjournaal* XVII (1972), No. 6: 262–282.

Jordahl 2007 = Jordahl, Anneli: "Kvinnor i kravatt" [Women in Tie], in: Widenheim (2007: 136–143).

Joris 1957 = Joris, Ward: "'De Stijl'. Nederlandse bijdrage tot de moderne kunst" ["De Stijl". Dutch Contribution to Modern Art], *De Tafelronde* III (1957), No. 5–6: 215–220.

Joyeux-Prunel 2017 = Joyeux-Prunel, Béatrice: "Circulation and the Art Market," *Journal for Art Market Studies* 2 (2017): 1–19.

Joyeux-Prunel/DaCosta Kaufmann/Dossin 2015 = Joyeux-Prunel, Béatrice/DaCosta Kaufmann, Thomas/Dossin, Catherine (eds.): *Circulation in the Global History of Art*, Ashgate, Burlington, Vt. 2015.

Jurecki 2003 = Jurecki, Krzysztof: "Die fotografischen Masken Witkacys," in: Schuler/Gawlik (2003: 280–281).

K

Kac 2003 = Kac, Daniel: *Wilno Jerozolimą było. Rzecz o Abrahamie Sutkeverze* [Vilnius was Jerusalem. A Study of Abraham Sutkever], Pogranicza, Sejny 2003.

Kafka 1997 = Kafka, Franz: *Deníky 1909–1912. Dílo Franze Kafky — Svazek 7* [Journals 1909–1912. The Complete Work of Franz Kafka, vol. 7], Nakladatelství Franze Kafky, Prague 1997.

Kampf 1978 = Kampf, Avram: "In Quest of Jewish Style in the Era of the Russian Revolution," *Journal of Jewish Art* 5 (1978): 48–75.

Kandinsky 1911 = Kandinsky, Wassily: *Über das Geistige in der Kunst: insbesondere in der Malerei*, Piper, Munich 1911 (rev. new ed.: Benteli Verlag, Bern 2004).

Kandinsky 1989 = Kandinsky, Wassily: "On the Question of Form," in: Lankheit (1989: 147–187).

Kandinsky 2009 = Kandinsky, Wassily: "The Great Utopia (1920)," transl. Charles Rougle, in: Dorontchenkov (2009: 199–200).

Kant 1795 = Kant, Immanuel: *Zum ewigen Frieden: ein philosophischer Entwurf*, Friedrich Nicolovius, Königsberg 1795.

Kant 2016 = Kant, Immanuel: *Perpetual Peace: A Philosophical Essay*, transl. Mary C. Smith, Project Gutenberg 2016.

Kantsedikas/Sergeeva 2001 = Kantsedikas, Alexander/Sergeeva, Irina (eds.): *Al'bom evreiskoi khudozhestvennoi stariny Semena An-skogo/Jewish Artistic Heritage Album by Semyon An-sky*, Mosty kul'tury, Moscow 2001.

Karádi/Vezér 1985 = Karádi, Éva/Vezér, Erzsébet (eds.): *Georg Lukács, Karl Mannheim und der Sonntagskreis*, Sendler, Frankfurt/M. 1985.

Karaś 2004 = Karaś, Agnieszka: *Der Pole, der auch Deutscher war. Das geteilte Leben des Witold Hulewicz*, Fibre Verlag, Warsaw/Osnabrück 2004.

Kardjilov 2006 = Kardjilov, Petar: *Zagadkite na filma "Balkanskata voyna"* [The Puzzles of the Documentary "The Balkan War"], Titra, Sofia 2006.

Kargiotis 2013 = Kargiotis, Dimitrios: "Internationality and Greek Modernism. On the Particularities of the Greek Avant-Garde," in: van den Berg/Głuchowska (2013: 165–182).

Karlholm 2013 = Karlholm, Dan: *Vad är ett museum?* [What is a Museum?], Axl Books, Stockholm 2013.

Kaser 2014 = Kaser, Karl: "Vizualizatsiata na Balkanite: Balkanskite voyni, Parvata svetovna voyna i vizualnata modernizatsia" [The Visualization of the Balkans: Balkan Wars, World War One and Visual

Modernization], *Balgarska etnologia* 3 (2014): 332–348.

Kasten 1990 = Kasten, Jürgen: *Der expressionistische Film*, Maks Publikationen, Münster 1990.

Katz 2004 = Katz, David: *Words on Fire. The Unfinished Story of Yiddish*, Basic Books, New York 2004.

Kazovsky 1991 = Kazovsky, Hillel: *Khudozhniki Vitebska: Ieguda Pėn i ego ucheniki* [Artists from Vitebsk: Yehuda Pen and His Pupils], Image, Moscow 1991.

Kazovsky 1993 = Kazovsky, Hillel: "The Art Section of the Kultur-Lige," *Jews in Eastern Europe* 22 (1993), No. 3: 5–22.

Kazovsky 2003 = Kazovsky, Hillel: *The Artists of the Kultur-Lige*, Gesharim-Bridges of Culture, Jerusalem/Moscow 2003.

Kazovsky 2009 = Kazovsky, Hillel: "C'etait l'epoque où l'on commncé à illustrer les livres juifs," in: Hazan-Brunet/Ackerman (2009: 32–50).

Keegan 1998 = Keegan, John: *The First World War*, Hutchinson, London 1998.

Kessler 2014 = Kessler, Erwin: "M. H. Maxy: Cubo-Constructivist Integralism," in: Lahoda (2014a: 134–145).

Kessler 2018 = Kessler, Erwin: "Tokens of Identity: Expressionisms in Romania around the First World War," in: Wünsche (2018c: 442–463).

Khmuryi 1931 = Khmuryi, Vasyl: *Ukrainske maliarstvo. Novakivsky* [Ukrainian Art. Novakivs'kyi], Ruch, Kharkov 1931.

Kisseler/Nikolaeva 2009 = Kisseler, Denitsa/Nikolaeva, Anelija (eds.): *Die bulgarischen Künstler und München. Die neue Kunstpraxis von Mitte des 19.*

bis Mitte des 20. Jahrhunderts/ Bulgarskite hudozhnitsi i Munchen. Moderni praktiki ot sredata na 19 do sredata na 20 vek, Sofia City Art Gallery/ National Art Gallery, Sofia 2009.

Kiss-Szemán 2018 = Kiss-Szemán, Zsófia: "Košice Modernism and Anton Jaszusch's Expressionism," in: Wünsche (2018c: 56–72).

Kjærboe 2016 = Kjærboe, Rasmus: *Collecting the Modern. Ordrupgaard and the Collection Museums of Modernist Art*, PhD dissertation, Aarhus University, Aarhus 2016.

Kjaran 1960 = Kjaran, Magnús: "Tryggvi Magnússon listmálari" [The Painter Tryggvi Magnússon], *Morgunblaðið* (Sept. 14, 1960): 8.

Kļaviņš 2006 = Kļaviņš, Eduards: *Džo. Jāzepa Grosvalda dzīve un māksla* [Joe. Life and Art of Jāzeps Grosvalds], Neputns, Riga 2006.

Kļaviņš 2016 = Kļaviņš, Eduards: "The Dramatic Process of Dispersal and Re-unification of Artistic Life. 1914–1925," in: Kļaviņš/Pelše/Vanaga (2016: 33–73).

Kļaviņš/Pelše/Vanaga 2016 = Kļaviņš, Eduards/Pelše, Stella/ Vanaga, Anita et al.: *Art History of Latvia. Vol. V. Period of Classical Modernism and Traditionalism 1915–1940*, Institute of Art History of the Latvian Academy of Art Riga, Riga 2016.

Klee/Rollig 2018 = Klee, Alexander/Rollig, Stella (eds.): *Beyond Klimt: New Horizons in Central Europe*, Hirmer, Munich 2018.

Kleiverda-Kajetanowicz 1985 = Kleiverda-Kajetanowicz, Joanna: *Elementen van de Nieuwe Beelding in het werk en de theorie van Henryk Stażewski 1923–1936* [Elements of Neo-Plasticism in the Works and Theories of

Henryk Stażewski 1923–1936], PhD dissertation, University of Utrecht, Utrecht 1985.

Kleßmann 2011 = Kleßmann, Christoph: "Prekäre Nachbarschaft. Deutschland und Polen zwischen den Weltkriegen," in: Omilanowska/Torbus (2011: 538–543).

Klimczak/Głuchowska/ Śmiechowska 2019 = Klimczak, Adam/Głuchowska, Lidia/ Śmiechowska, Teresa: *Ekspresje Wolności. Bunt i Jung Idysz — Wystawa, której nie było/ Expressions of Freedom. Bunt and Jung Idysz — the Exhibition That Never Was...* (magazine accompanying the exhibition, 1), Muzeum Miasta Łodzi, Łódź 2019.

Klingberg 2013 = Klingberg, Torkel: *Den översvämmade hjärnan. En bok om arbetsminne, IQ och den stigande informationsfloden* [The Overflowing Brain: Information Overload and the Limits of Working Memory], Natur och Kultur, Stockholm 2007, 2nd ed. 2013.

Kliun 1988 = Kliun, Ivan: "Primitives of the Twentieth Century," transl. John Bowlt, in: Bowlt (1988: 136–138).

Kocka 2000 = Kocka, Jürgen: "Das östliche Mitteleuropa als Herausforderung für eine vergleichende Geschichte Europas," *Zeitschrift für Ostmitteleuropa-Forschung* 49 (2000), No. 2: 159–174.

Kohen 1918 = Kohen, Cwi (?): "Froyn Motivn" [Female Motives], in: *Yugend. Zamelheft far Shener Literatur un Frayen Gedank* [Youth. Almanach of the Belles-Lettres and Free Thought], Łódź 1918: 27.

Kokovs'kyi 1934 = Kokovs'kyi, Franz: "Strilets'ka antolohia"

[The Riflemen Anthology], *Nazustrich* 21 (1934): 2.

"Kongeligt Budskab" 1914 = "Kongeligt Budskab" [Message from the King], *Statstidende* [The Danish Official Gazette] (Aug. 3, 1914): n.p., English quot. in: Sørensen (2014: 289).

Konsulova-Vazova 2002 = Konsulova-Vazova, Elisaveta: "Trevozhni dni" [Troubled Days], in: Nikolaeva (2002: 50–56).

Kossowska 2015 = Kossowska, Irena (ed.): *Poszukiwanie tożsamości kulturowej w Europie Środkowo-Wschodniej 1919–2014/The Search for Cultural Identity in Central and Eastern Europe 1919–2014*, Wydawnictwo Naukowe Uniwersytetu Mikołaja Kopernika, Toruń 2015.

Kossowski 1995 = Kossowski, Łukasz (ed.): *Totenmesse: Munch-Weiss-Przybyszewski*, Muzeum Literatury, Warsaw 1995.

Kost' 2007 = Kost', Liuba: "Zhyttia u tvorchosti" [Life in Art], *Galycka Brama* 9/10 (2007): 2–8.

Kostelanetz 1993 = Kostelanetz, Richard: *Dictionary of the Avant-gardes*, A Cappella Books, Pennington 1993.

Kotkowska-Bareja 1993 = Kotkowska-Bareja, Hanna: "Wacława Szymanowskiego Pochód na Wawel" [Wacław Szymanowski's Procession to Wawel], in: Hrankowska (1993: 261–274).

Kovtun/Monolatii 2007a = Kovtun, Valerii/Monolatii, Ivan: *Ukrain'ski sichovi stril'tsi — lytsari ridnoho kraiu* [The Ukrainian Sich Riflemen — Knights of the Native Land], vol. 1, Vik, Kolomyia 2007.

Kovtun/Monolatii 2007b = Kovtun, Valerii/Monolatii, Ivan: *Ukrain'ski sichovi stril'tsi — lytsari ridnoho kraiu* [Ukrainian Sich

Riflemen — Knights of the Native Land], vol. 2, Vik, Kolomyia 2007.

Kozloff 1973 = Kozloff, Max: "American Painting During the Cold War," *Artforum* 11 (1973), No. 9: 43–54.

Krakowski/Purchla 1999 = Krakowski, Piotr/Purchla, Jacek (eds.): *Art Around 1900 in Central Europe: Art Centres and Provinces*, International Cultural Centre, Cracow 1999.

Kramář 1913 = Kramář, Vincenc: "Kapitola o -ismech. K výstavě Le Fauconnierove v Mnichove" [A Chapter on -Isms. On Le Fauconnier's Exhibition in Munich], *Umělecký měsíčník* 2 (1913): 115–130.

Kramář 1921 = Kramář, Vincenc: *Kubismus* [Cubism], Moravsko-slezská revue, Brno 1921, reprint in: Kramář (1983: 61–119).

Kramář 1983 = Kramář, Vincenc: *O obrazech a galeriích* [On Pictures and Galleries], Odeon, Prague 1983.

Kramář 2002 = Kramář, Vincenc: *Le Cubisme*, transl. Erika Abrams, L'École nationale supérieure des Beaux-Arts, Paris 2002.

Kraševac/Prelog 2008 = Kraševac, Irena/Prelog, Petar (eds.): *Akademija likovnih umjetnosti u Münchenu i hrvatsko slikarstvo/ Die Akademie der Bildenden Künste in München und die kroatische Malerei*, Institut za povijest umjetnosti, Zagreb 2008.

Krauss 1986 = Krauss, Rosalind: *The Originality of the Avant-Garde and other Modernist Myths*, MIT Press, Cambridge, Mass. 1986.

Krempel 1985 = Krempel, Ulrich: "From Expressivity Towards Constructivity, From Objectivism Towards an Abstract Symbolism," in: Krempel/Thomas/Guralnik (1985: 182–202).

Krempel 1985a = Krempel, Ulrich (ed.): *Am Anfang: Das Junge Rheinland. Zur Kunstund Zeitgeschichte einer Region 1918–1945*, Claassen, Düsseldorf 1985.

Krempel/Thomas/Guralnik 1985 = Krempel, Uwe/Thomas, Karin/Guralnik, Nehama et al. (eds.): *Jankel Adler*, DuMont, Cologne 1985.

Kristjánsdóttir 1992 = Kristjánsdóttir, Karla (ed.): *Finnur Jónsson í Listasafni Íslands* [Finnur Jónsson at the National Gallery of Iceland], Listasafn Íslands, Reykjavík 1992.

Krleža 1919 = Krleža, Miroslav: "VI. izložba Hrvatskog Proletnog salona" [The VI. Exhibition of the Croatian Spring Salon], *Plamen* 12 (1919): 244–247.

Krohg 1917 = Krohg, Per: "Nervositet eller En stille Nat ved Fronten" [Nervousness or A Quiet Night at the Front], *Klingen* 1 (1918), No. 8: n.p.

Kroupa/Šeferisová Loudová/ Konečný 2009 = Kroupa, Jiří/ Šeferisová Loudová, Michaela/ Konečný, Lubomíř (eds.): *Orbis artium: k jubileu Lubomíra Slavíčka* [Orbis Artium: on the Anniversary of Lubomír Slavíček], Masarykova Univerzita, Brno 2009.

Kruchenykh 1916 = Kruchenykh, Aleksei: *Vselenskaia voina* [Universal War], A. A. Shemshurin, Petrograd 1916.

Kruchenykh 2001 = Kruchenykh, Aleksei: "Pobeda nad Solntsem" [Victory over the Sun], in: Kruchenykh (2001a: 381–406).

Kruchenykh 2001a = Kruchenykh, Aleksei: *Stikhotvoreniia, poemy, romany, opera* [Narratives, Poems, Romans, Operas], Akademicheskii proekt, St. Petersburg 2001.

Kruchenykh/Malevich/ Kliun 1915 = Kruchenykh, Aleksei/Malevich, Kazimir/ Kliun, Ivan: *Tainye poroki akademikov* [Secret Vices of the Academicians], Moscow 1915 (dated 1916 on the cover).

Krüger 2012 = Krüger, Maren: "Babylon," in: Bertz/Dohrn/ Goldmann (2012: 72–81).

Krumeich 2013 = Krumeich, Gerd: "Vorwort," in: Cabanes/Duménil (2013: 7–9).

Krustev 1974 = Krustev, Kiril: *Sirak Skitnik*, Bulgarski hudojnik, Sofia 1974.

Krustev 1988 = Krustev, Kiril: *Spomeni za kulturniya zhivot mezhdu dvete svetovni voyni* [Memories of Cultural Life between the Two World Wars], Bulgarski pisatel, Sofia 1988.

Krustyo Sarafov 1921 = *Krustyo Sarafov. Collection to Celebrate Thirty Years of His Theatre Stage Activity*, State edition, Sofia 1921.

Ksiazenicer-Matheron 2012 = Ksiazenicer-Matheron, Carole: "Une revue yiddish d'avant-garde: Khaliastra — La Bande (Varsovie 1922–Paris 1924)," in: Veivo (2012: 131–141).

Kubicki 1932 = Kubicki, Stanisław: "Das Verhältnis des Menschen zur Schöpfung," *a bis z* XXI (1932) 81.

Kubicki et al. 1922a = Kubicki, Stanisław et al.: "Erstes Manifest der *Kommune*" (Flyer, Berlin, Mar. 1922), transl. David Britt as "Manifesto of the Commune," in: Benson/Forgács (2002: 395).

Kubicki et al. 1922b = Kubicki, Stanisław et al.: "Zweites Manifest der *Kommune*" (Flyer, Berlin, May 1922), transl. David Britt as "Second Manifesto of the Commune," in: Benson/Forgács (2002: 395–397).

Kubicki St. K. 2003 = Kubicki, St. Karol: "'Zdrój' and 'Die Aktion'. Cooperation of Two Cultural Periodicals during the First World War," in: Hałasa (2003: 80–95).

Kubišta 1912 = Kubišta, Bohumil: "Druhá výstava Skupiny výtvarných umělců v Obecním domě" [The Second Exhibition of the Group of Fine Artists at the Municipal House], *Česká kultura* 1 (1912): 58–60.

Kudryavtseva 2004 = Kudryavtseva, Tamara (ed.): *Circling the Square: Avant-Garde Porcelain from Revolutionary Russia*, State Hermitage Museum/ Courtauld Institute of Art, Fontanka, London 2004.

Kuligowska-Korzeniewska 2010 = Kuligowska-Korzeniewska, Anna: "Polsko-żydowski symultanizm teatralny (w latach międzywojnia)" [Polish-Jewish Theatre Symultanism (in the Interwar Period)], in: Suchan/ Szymaniak (2010: 109–128).

Kurak 2016 = Kurak, Maciej (ed.): *Der Flyer*, Wydział Grafiki i Komunikacji Wizualnej, Uniwersytet Artystyczny w Poznaniu, Fundacja Rarytas, Poznań 2016.

Kurak 2020 = Kurak, Maciej (ed.): *Bunt. Nowe ekspresje/ Bunt. New Expressions*, Wydział Grafiki i Komunikacji Wizualnej, Uniwersytet Artystyczny w Poznaniu, Poznań 2020.

Kurc-Maj 2015 = Kurc-Maj, Paulina: "Władysław Strzemiński i Tadeusz Peiper — sojusz dla nowej sztuki, [Władysław Strzemiński and Tadeusz Peiper — An Alliance for the New Art], in: Rypson (2015: 325–351).

Kurc-Maj/Polit 2017 = Kurc-Maj, Paulina/Polit, Paweł (eds.): *Impuls dadaistyczny w polskiej sztuce i literaturze dwudziestowiecznej* [Dada Impulse in Polish Art and Literature of the 20th Century], Muzeum Sztuki w Łodzi, Łódź 2017.

Kurc-Maj/Polit/Saciuk-Gąsowska 2018 = Kurc-Maj, Paulina/Polit, Paweł/Saciuk-Gąsowska, Anna (eds.): *The Great War*, transl. Ada Arendt/William Glicher/ Katarzyna Gucio et al., Muzeum Sztuki w Łodzi, Łódź 2018.

Kurc-Maj/Saciuk-Gąsowska 2017 = Kurc-Maj, Paulina/Saciuk-Gąsowska, Anna (eds.): *Organizers of Life. De Stijl, The Polish Avant-Garde and Design*, transl. Magdalena Świątczak, Muzeum Sztuki w Łodzi, Łódź 2017.

Kurylas 1917 = Kurylas, Osyp: (cartoon), *Chervona Kalyna* 1 (1917): 13.

Kusber 2014 = Kusber, Jan: "Wegscheide Krieg. Defekte Imperien, defekte Nationalstaaten," in: Sapper/ Weichsel (2014: 233–246).

Kvaran 1976 = Kvaran, Ólafur: "Finnur Jónsson. Yfirlitssýning í Listasafni Íslands" [Finnur Jónsson. Retrospective at the National Gallery of Iceland], *Þjóðviljinn* (Nov. 7, 1976): 16–17.

L

Lagerkvist 2007 = Lagerkvist, Bengt: "Exil — Tora Vega Holmström och Ivan Aguéli" [Exil — Tora Vega Holmström and Ivan Aguéli], in: Widenheim (2007: 94–111).

Lahoda 1995 = Lahoda, Vojtěch: "Metafyzika závrati: Ke kresbám Otty Gutfreunda 1913–1916" [The Metaphysics of Giddiness: On the Drawings of Otto Gutfreund], in: *Otto Gutfreund* (1995: 123–131).

Lahoda 1996 = Lahoda, Vojtěch: *Český kubismus* [Czech Cubism], Brána, Prague 1996.

Lahoda 1998 = Lahoda, Vojtěch: "Proměny realismu a kubismu v malířství dvacátých a třicátých let" [Transformations of Realism and Cubism in Painting of 1920s and 1930s], in: Lahoda (1998a: 101–145).

Lahoda 1998a = Lahoda, Vojtěch et al. (eds.): *Dějiny českého výtvarného umění 1890–1938* [History of Czech Fine Arts 1890–1938], Academia, Prague 1998.

Lahoda 2006 = Lahoda, Vojtěch (ed.): *Local Strategies. International Ambitions. Modern Art in Central Europe*, Artefactum/Ústav dějin umění AV ČR, Prague 2006.

Lahoda 2006a = Lahoda, Vojtěch: "Global Form and Local Spirit: Czech and Central European Modern Art," in: Lahoda (2006: 9–20).

Lahoda 2009 = Lahoda, Vojtěch: "Český kubismus a ‚vertikální' kánon dějin umění" [Czech Cubism and the "Vertical" Canon of Art History], in: Kroupa/Šeferisová Loudová/Konečný (2009: 417–426).

Lahoda 2010 = Lahoda, Vojtěch: "Cubism Translated? The Western Canon of Modernism and Central-Eastern European Art History," *Art in Translation* 2 (2010), No. 2: 223–238.

Lahoda 2013 = Lahoda, Vojtěch: "The Canon of Cubism and the Case of Vincenc Kramář. On the Place of Czech Cubism in the History of Modern Art," in: van den Berg/Głuchowska (2013: 131–143).

Lahoda 2014a = Lahoda, Vojtěch (ed.): *Teritoria kubismu/Cubist Territories* (Ars: časopis Ústavu dejín umenia Slovenskej akadémie vied (2014), No. 2).

Lahoda 2014b = Lahoda, Vojtěch: "Migration of Images. Private Collections of Modernism and Avant-Garde and the Search for Cubism in Eastern Europe," in: Bäckström/Hjartarson (2014: 187–196).

Lahoda 2014c = Lahoda, Vojtěch: "Teritoria kubismu/Cubist Territories," in: Lahoda (2014a: 109–112).

Lahoda 2018 = Lahoda, Vojtěch: "'New Art' in the 'Last Days of Mankind'," in: Srp (2018: 226–235).

Lahoda/Uhrová 2000 = Lahoda, Vojtěch/Uhrová, Olga: *Vincenc Kramář. From Old Masters to Picasso*, Národní galerie, Prague 2000.

Lamač 1988 = Lamač, Miroslav: *Osma a Skupina výtvarných umělců 1907–1917* [The Eight and the Group of Fine Artists 1907–1917], Odeon, Prague 1988.

Lamač/Padrta 1992 = Lamač, Miroslav/Padrta, Jiří (eds.): *Osma a Skupina výtvarných umělců: Teorie, kritika, polemika* [The Eight and The Group of Fine Artists: Theory, Criticism, Polemic], Odeon, Prague 1992.

Lamberga 2001 = Lamberga, Dace: *Rīgas mākslinieku grupa* [Riga Group of Artists], Neputns, Riga 2001.

Lamberga 2002 = Lamberga, Dace/Bremša, Laila/Konstants, Zigurds: *Kubisms Latvijas mākslā* [Cubism in Latvian Art], Neputns, Riga 2002.

Lamberga 2004 = Lamberga, Dace: *Klasiskais modernisms. Latvijas glezniecība 20. gadsimta sākumā* [Classical Modernism. Early 20th Century Latvian Painting], Neputns, Riga 2004.

Lamberga 2005 = Lamberga, Dace: *Le Groupe de Riga 1915–1940: un modernisme classique*, Musée des Beaux-Arts de Bordeaux, Neputns, Riga 2005.

Lamberga 2014 = Lamberga, Dace: "The War and Art," in: Gerharde-Upeniece/Jevsejeva (2014: 58–61).

Lambrechts 2002 = Lambrechts, Marc (ed.): *Affinités et particularités. L'art en Belgique et Pays-Bas 1890–1945*, Museum voor Schone Kunsten, Gent 2002.

Langfeld 2013 = Langfeld, Gregor: "Bedeutungsveränderung und Kanonisierung des deutschen Expressionismus in den USA," in: Posman (2013: 194–206).

Lankheit 1989 = Lankheit, Klaus (ed.): *The Blaue Reiter Almanac*, ed. Wassily Kandinsky/Franz Marc (new docum. ed.), Da Capo Press, New York 1989.

Larvová 1996 = Larvová, Hana (ed.): *Sursum 1910–1912*, Galerie hlavního města Prahy, Prague 1996.

Lasovs'ky 1935 = Lasovs'ky, Volodymyr: "Batalist ponevoli" [Battle Painter by Fate], *Nazustrih* 12 (1935): 3–5.

Latour 2005 = Latour, Bruno: *Reassembling the Social: An Introduction to Actor-Network-Theory*, Oxford University Press, Oxford 2005.

Laučkaite 2015 = Laučkaite, Laima: "At the Opposite Side of the Front. German Artists in Ober Ost in the First World War," in: Cēbere (2015: 213–224).

Lawaty 2003 = Lawaty, Andreas (ed.): *Deutsche und Polen: Geschichte, Kultur, Politik*, Beck, Munich 2003.

Lazarovych 2005 = Lazarovych, Mykola: *Legion Ukrain'skych sichovykh stril'tsiv: formuvannia, ideia, borot'ba* [The Legion of the Ukrainian Sich Riflemen: Establishment, Idea, Struggle], Dzura, Ternopil 2005.

Lazarovych 2007 = Lazarovych, Mykola: "Kul'turnytska ta

prosvitnia pratsia Lehionu ukrains'kykh sichovykh stril'tsiv pid chas Pershoi svitovoi viiny" [Cultural and Educational Work of the Ukrainian Sich Riflemen during World War One], in: Monolatii (2007a: 75–83).

Leen 1992 = Leen, Frederik et al. (eds.): *Avant-garde en Belgique, 1917–1929*, Musée d'Art moderne, Brussels/Koninklijk Museum voor Schone Kunsten, Antwerp 1992.

Leighten 1989 = Leighten, Patricia: *Re-Ordering the Universe: Picasso and Anarchism, 1897–1914*, Princeton University Press, Princeton 1989.

Leilach/Rypson 2011 = Leilach, Michael/Rypson, Piotr et al.: *Kilométrage. Jan Brzękowski und seine Künstwelten*, Polnisches Institut Berlin/Sammlung Marzona, transl. Marcin Zastrożny/Sophie Lindenau, Walther König, Berlin/Cologne 2011.

Lemberg 2003 = Lemberg, Hans: "'Drang nach Osten' — Mythos und Realität," in: Lawaty (2003: 33–38).

Lenas 2014 = Lenas, Sverker: "Moderna visar upp en ny sida av Dardel" [Moderna Presents a New Side of Dardel], *Dagens Nyheter* (May 25, 2014): http://www.dn.se/kultur-noje/konst-form/moderna-visar-upp-en-ny-sida-av-nils-dardel/ (accessed: Dec. 29, 2014).

Leśnikowski 1996 = Leśnikowski, Wojciech: *East European Modernism. Architecture in Czechoslovakia, Hungary & Poland between the Wars 1919–1939*, Rizzoli, New York 1996.

Levinas 1999 = Levinas, Emanuel: *Die Spur des Anderen. Untersuchungen zur Phänomenologie und Sozialphilosophie*, 4th ed., transl. and ed. Wolfgang Nikolaus Krewani/Karl Alber, Freiburg i.Br./Munich 1999.

Levine 1981 = Levine, Madeline G.: *Contemporary Polish Poetry 1925–1975*, Twayne Publishers, Boston 1981.

Leyko 2010 = Leyko, Małgorzata: "Żydowska awangarda teatralna jako poszukiwanie nowej tożsamości kulturowej" [Jewish Avant-Garde Theatre as a Search for New Identity], in: Suchan/Szymaniak (2010: 95–108).

Lipińska 2017 = Lipińska, Aleksandra: "'Mobility turn' w historii sztuki? Kierunki i metody badań nad migracją artystów" ["Mobility Turn" in Art History? Directions and Methods in the Research on the Artists' Migration], in: Czyż/Chrudzimska-Uhera (2017: 9–22)

Lipsker/Bar-Ilan 1995 = Lipsker, Avidov/Bar-Ilan, Ruth: "The Albatrosses of Young Yiddish Poetry: An Idea and Its Visual Realization in Uri Zvi Greenberg's Albatros," *Prooftexts* 15 (1995), No. 11: 89–108.

Lisek 2005 = Lisek, Joanna: *Jung Wilne. Żydowska grupa artystyczna* [Young Vilne. Jewish Artistic Group], Wyd. Uniwersytetu Wrocławskiego, Wrocław 2005.

Lisek 2018 = Lisek, Joanna: *Kol isze/głos kobiet w poezji jidysz (od XVI w. do 1939 r.)* [Kol ishe/The Women's Voice in Yiddish Poetry (from the 16th Century to 1939)], Pogranicze, Sejny 2018.

Liška/Švestka 1991 = Liška, Pavel/Švestka, Jiří et al. (eds.): *Český kubismus 1909–1925. Malířství, sochařství, umělecké řemeslo, architektura* [Czech Cubism 1909–1925. Painting, Sculpture, Crafts, Architecture], Hatje Cantz, Stuttgart 1991.

Lissitzky 1925 = Lissitzky, El: "Kunst und Pangeometrie," in: Einstein/Westheim (1925:

103–113) (reprint: Kiepenheuer, Leipzig 1984).

Lissitzky 1967 = Lissitzky, El: "Unser Buch," in: Lissitzky-Kuppers (1967: 357–360).

Lissitzky-Kuppers 1967 = Lissitzky-Kuppers, Sophie (ed.): *El Lissitzky. Maler, Architekt, Typograf, Fotograf. Erinnerungen, Briefe, Schriften*, Verlag der Kunst, Dresden 1967.

Litvak 1980 = Litvak, Lily: *Latinos y anglosajones. Orígenes de una polémica*, Puvill, Barcelona 1980.

Litvak 1992 = Litvak, Lily: "Panlatinismo y fraternidad hispánica en España y Latinoamérica a finales del siglo XIX," *Insula* 549/550 (1992): 15–17.

Liulevicius 2013 = Liulevicius, Vejas Gabriel: "5. August 1915. Die Einnahme von Warschau," in: Cabanes/Duménil (2013: 126–130).

Lomidze/Ratiani 2016 = Lomidze, Gaga/Ratiani, Irma (eds): *Qartuli Modernizmis Typologia* [The Typology of Georgian Modernism], Shota Rustaveli Institute of Georgian Literature, Tbilisi 2016.

Lovinescu 1916 = Lovinescu, Eugen: "Soluții" [Solutions], *Revista Idealistă* (Sept. 1916): 5.

Luba 2004 = Luba, Iwona: *Dialog nowoczesności z tradycją: malarstwo polskie dwudziestolecia międzywojennego* [Dialog of Modernity and Tradition: Polish Painting of the Interwar Period], Neriton, Warsaw 2004.

Luba 2012 = Luba, Iwona: *Duch romantyzmu i modernizacja. Sztuka oficjalna Drugiej Rzeczypospolitej* [Spirit of Romanticism. The Official Art of the Second Polish Republic], Neriton, Warsaw 2012.

Ludwisiak 2011 = Ludwisiak, Małgorzata: "Die Künstlergruppe a.r. (1929–1936). Eine Sammlung macht Revolution," in: Omilanowska/Torbus (2011: 548–553).

Lukin 2006 = Lukin, Benyamin: "'An Academy Where Folklore Will Be Studied': Ansky and the Jewish Museum," in: Safran/Zipperstein (2006: 281–306).

Lustig Cohen/Lupton 1996 = Lustig Cohen, Elaine/Lupton, Ellen: *Letters from the Avant-Garde: Modern Graphic Design*, Princeton Architectural Press, Princeton 1996.

Lyon 2012 = Lyon, Janet: "Cosmopolitanism and Modernism," in: Wollaeger/Eatough (2012: 387–412).

M

Machen 1915 = Machen, Arthur: *The Angels of Mons: The Bowmen, and Other Legends of the War*, G. P. Putnam's Sons, New York/London 1915.

Machnicka 2008 = Machnicka, Zofia (ed.): *Dada East? Rumuńskie konteksty dadaizmu* [Dada East? Romanian Context of Dadaism], Zachęta, Warsaw 2008.

Madeline 2006 = Madeline, Laurence (ed.): *Picasso and Africa*, Bells-Roberts Publ., Cape Town 2006.

Mádl 1912 = Mádl, Karel Boromejský: "Dvě výstavy v Obecním domě" [Two Exhibitions at the Municipal Hall], *Zlatá Praha* 30 (1912): 83.

Magarotto 1982 = Magarotto, Luigi: "Storia e teoria dell'avanguardia georgiana (1915–1924)," in: Magarotto/Marzaduri/Cesa (1982: 45–99).

Magarotto 2006 = Magarotto, Luigi: "Literary and Cultural Life in

Tiflis (1914–1921)," in: Tsitsishvili/Tchogoshvili (2006: 73–91).

Magarotto/Marzaduri/Cesa 1982 = Magarotto, Luigi/Marzaduri, Marzio/Cesa, Giovanna Pagani (eds.): *L'avanguardia a Tiflis: Studi, ricerche, cronache, testimonianze, documenti*, Dell'Università degli studi di Venezia, Venezia 1982.

Magerski 2011 = Magerski, Christine: *Theorien der Avantgarde. Gehlen — Bürger — Bourdieu — Luhman*, Springer, Wiesbaden 2011.

Mainer 1988 = Mainer, José-Carlos: *La doma de la quimera: ensayos sobre nacionalismo y cultura de España*, Servei de Publicacions de la Universitat Autònoma de Barcelona, Madrid 1988 (reed. Iberoamericana, Madrid 2004).

Mainer 1993 = Mainer, José-Carlos: "La invención estética de las periferias," in: Sopena (1993: 26–33).

Mainer 2000 = Mainer, José-Carlos: *Historia, literatura, sociedad (y una coda española)*, Biblioteca Nueva, Madrid 2000.

Maković 2013 = Maković, Zvonko: *Praška četvorica/The Prague Four*, Umjetnički paviljon, Zagreb 2013.

Maković 2018 = Maković, Zvonko: "Ratni reporter Vladimir Becić/Vladimir Becić, War Correspondent," *Život umjetnosti* 103 (2018): 64–87.

Malinowski 1991 = Malinowski, Jerzy: *Sztuka i nowa wspólnota. Zrzeszenie artystów Bunt 1917–1922* [Art and New Community. Artists' Association Bunt/Revolt 1917–1922], Wiedza o Kulturze, Wrocław 1991.

Malinowski 2000 = Malinowski, Jerzy: *Malarstwo i rzeźba Żydow Polskich w XIX i XX wieku* [Painting and Sculpture of

the Polish Jews in 19th and 20th Century], PWN, Warsaw 2000.

Malinowski 2012 = Malinowski, Jerzy (ed.): *History of Art History in Central, Eastern and South-Eastern Europe*, vol. 2, Polski Instytut Studiów nad Sztuką Świata, Toruń 2012.

Malinowski/Piątkowska/Sztyma-Knasiecka 2010 = Malinowski, Jerzy/Piątkowska, Renata/Sztyma-Knasiecka, Tamara (eds.): *Jewish Artists and Central-Eastern Europe. Art Centres — Identity — Heritage from the 19th Century to the Second World War*, DiG, Warsaw 2010.

Maltin/Beck 1987 = Maltin, Leonard/Beck, Jerry: *Of Mice and Magic. A History of American Animated Cartoons*, rev. ed., Plume Books, New York 1987.

Manchev 2000 = Manchev, Krustyo: *Istoriya na balkanskite narodi (1918–1945)* [History of the Balkan Nations (1918–1945)], Paradigma, Sofia 2000.

Mandache 2014 = Mandache, Diana: *Balcicul Reginei Maria* [Queen Mary's Balchik], Curtea Veche Editions, Bucharest 2014.

Manikowska 2021 = Manikowska, Ewa: *Photography and Cultural Heritage in the Age of Nationalisms Europe's Eastern Borderlands (1867–1945)*, Bloomsbury Visual Arts, London 2019.

Mansbach 1999 = Mansbach, Steven A.: *Modern Art in Eastern Europe. From the Baltic to the Balkans 1890–1939*, Cambridge University Press, Cambridge 1999.

Mansbach 2002 = Mansbach, Steven A.: "Methodology and Meaning in the Modern Art of Eastern Europe," in: Benson (2002: 289–306).

Mansbach 2018 = Mansbach, Steven A.: "Toward an Art of Redemption for Modern Mankind," in: Srp (2018: 33-45).

Mantis 1975 = Mantis, Peter (ed.): *Versuch einer Rekonstruktion. Internationale Ausstellung Revolutionärer Kunstler 1922 in Berlin*, Neuer Berliner Kunstverein, Berlin 1975.

Marc 1978 = Marc, Franz: *Schriften*, DuMont, Cologne 1978.

Marek/Lipińska/Bernhardt 2022 = Marek, Michaela/Lipińska, Aleksandra/Bernhardt, Katja (eds.): *Die Künste in Zeiten politischer Zäsuren und gesellschaftlicher Transformation. Agens, Arena, Projektionsraum*, Humboldt Universität/Technische Universität/IS PAN, Berlin/Warsaw 2022 (forthcoming).

Marinska 1997 = Marinska, Ruja: *Ivan Milev (1897-1927)*, National Art Gallery, Sofia 1997.

Marinska 2000 = Marinska, Ruja: *Nikola Tanev/Nicolas Taneff*, Panteley Kisseloff, Sofia 2000.

Markish 1922 = Markish, Peretz: "Estetyka walki w nowoczesnej poezji" [Aesthetics of Fight in Modern Poetry], in: Szymaniak (2005: 46-69); orig. published in: *Ringen* (1922), No. 10: 35-41.

Markó/Schmidt 2014 = Markó, György/Schmidt, Mária (eds.): *Europe's Fraternal War*, Public Foundation for the Research of Central and East European History and Society, Budapest 2014.

Markowa 1961 = Markowa, Gina: *Le Choix*, Desclée/De Brouwer, Paris 1961.

Martinet 1977 = Martinet, Jan: *Hendrik Nicolaas Werkman 1882-1945. 'druksels' en gebruiksdrukwerk/'druksel' prints and general printed matter*, Stedelijk Museum, Amsterdam 1977.

Martinet 1995 = Martinet, Jan: *The Next Call. Avant-garde geschriften van Hendrik Werkman, uitgegeven van september 1923 tot november 1926 in Groningen* [The Next Call. Avant-Garde Writings of Hendrik Werkman, Published between September 1923 and November 1926 in Groningen], André Swertz, Utrecht 1995.

Masaryk 1895 = Masaryk, Tomáš G.: *Česká otázka: snahy a tužby národního obrození* [The Czech Question: Endeavours and Yearnings of the National Revival], Čas, Prague 1895.

Masaryk 1918a = Masaryk, Tomáš G.: *The New Europe. The Slav Standpoint*, Eyre and Spottiswoode, London 1918.

Masaryk 1918b = Masaryk, Tomáš G.: *L'Europe nouvelle* (manuscript), not distributed in bookshops.

Masaryk 1920 = Masaryk, Tomáš G.: *Nová Evropa. Stanovisko slovanské* [New Europe. A Slavonic Standpoint], Gustav Dubský, Prague 1920.

Masaryk 1922 = Masaryk, Tomáš G.: *Das neue Europa. Der slawische Standpunkt*, transl. Emil Saudek, C.A. Schwetschke & Sohn, Berlin 1922 (new edition: 1991).

Masaryk 1991 = Masaryk, Tomáš G.: *Das neue Europa. Der slawische Standpunkt*, transl. Emil Saudek, Volk und Welt, Berlin 1991.

Matoš 1913 = Matoš, Antun Gustav: "Slike Miroslava Kraljevića" [Paintings of Miroslav Kraljević], *Savremenik* 1 (1913): 68-69.

Matthews 2004 = Matthews, Steven: *Modernism (Contexts)*, Bloomsbury, New York 2004.

Matuszek 2013 = Matuszek, Gabriela: *Krisen und Neurosen — Das Werk Stanislaw Przybyszewskis in der literarischen Moderne*, Igel, Hamburg 2013.

Mayakovsky 1955 = Mayakovsky, Vladimir: "Shtatskaia shrapnel" [Civilian Shrapnel], in: Mayakovsky (1955-1961, vol. 1: 304).

Mayakovsky 1959 = Mayakovsky, Vladimir: "Za chto boretsia LEF?" [What LEF Fights For?], in: Mayakovsky (1955-1961, vol. 12: 41).

Mayakovsky 1955-1961 = Mayakovsky, Vladimir: *Polnoe sobranie sochinenii* [Collected Writings], 13 vols., ed. Vasilii Katanian, Gosudarstvennoe izdatelstvo khudozhestvennoi literatury, Moscow 1955-1961.

McLuhan 1962 = McLuhan, Marshall: *The Gutenberg Galaxy. The Making of Typographic Man*, Routledge and Kegan, London 1962.

Meidler-Waks 2012 = Meidler-Waks, Sigalit: "Die Pogromserie von Issachar Ber Ryback," in: Bertz/Dohrn/Goldmann (2012: 37-41).

Melsted 2016 = Melsted, Óðinn: *Með nótur í farteskinu. Erlendir tónlistarmenn á Íslandi 1930-1960* [Music Sheets in the Baggage. Foreign Musicians in Iceland 1930-1960], Sögufélag, Reykjavík 2016.

Mesens 1924 = Mesens, Cornelis Nelly [= Doesburg, Theo van?]: "...waar de maes K en Scheldwoorden vloeien...," *Mécano* 4/5 (1924): n.p.

Meyer/Hossli/Bolliger 1994 = Meyer, Raimund/Hossli, Judith/Bolliger, Hans (eds.): *Dada global*, Kunsthaus Zürich, Zurich 1994.

Mezei 1984 = Ottó, Mezei: *Nemes Lampérth József*, Corvina Kiadó, Budapest 1984.

Micić 1921 = Micić, Ljubomir: "Savremeno novo i slućeno slikarstvo" [Contemporary New and Foreboded Painting], *Zenit* 10 (1921): 11–13.

Mihalcheva 1964 = Mihalcheva, Irina: *Boris Denev*, Bulgarski hudojnik, Sofia 1964.

Milev 1920 = Milev, Geo: "Rodno izkustvo" [Native Art], *Vezni* 1 (1920): 40–50.

Milev 1920a = Milev, Geo: *Zhestokiyat prusten* [The Cruel Ring], Vezni, Sofia 1920.

Milev 1921 = Milev, Geo: "Vazvanie kum bulgarskiya pisatel" [Appeal to the Bulgarian Writer], Vezni 4 (1921): 56–59.

Milev 1923 = Milev, Geo: *Almanah Vezni*, Vezni, Stara Zagora/Sofia 1923.

Milev 1964 = Milev, Geo: *Literaturen arhiv*, II. [Literary Archive, vol. II], introductory article and comments Georgi Markov, Bulgarian Academy of Sciences, Sofia 1964.

Milewska 2008 = Milewska, Wacława: "Sztuka Legionów" [Legion's Art], in: Nowakowska-Sito (2008: 24).

Milewska/Zientara 1993 = Milewska, Wacława/Zientara, Maria: "O ikonografii sztuki legionowej" [On the Iconography of the Legion's Art], in: Hrankowska (1993: 167–185).

Miller 1984 = Miller, Jack (ed.): *Jews in Soviet Culture*, Transaction Books, New Brunswick/London 1984.

Millian-Maximin 1920 = Millian-Maximin, G.: *Ĩn mâinile dușmanului* [In the Hands of the Enemy], Alcalay & Co., Bucharest 1920.

Milner 1968 = Milner, John: "Ideas and Influences of De Stijl," *Studio International* 175 (1968): 115–119.

Mitter 2008 = Mitter, Partha: "Decentring Modernism: Art History and Avant-Garde Art from the Periphery," *The Art Bulletin* 90 (2008), No. 4: 531–548.

Mitter 2014 = Mitter, Partha: "Modern Global Art and Ist Discontents," in: Bäckström/Hjartarson (2014: 35–54).

Mol'nar 1967 = Mol'nar, Frants: "Divchata-boiovyky u rozsril'nii" [Female Fighters in a Line Formation], in: Ripets'kyi (1967: 185–187).

Monkiewicz 2018 = Monkiewicz, Dorota (ed.): *The Avant-garde & the State*, transl. Aušra Simanavičiũté/Daniel Sipos/Sarbara Szot/Marcin Wawrzyńczak, Muzeum Sztuki w Łodzi, Łódź 2018.

Monolatii 2007a = Monolatii, Ivan (ed.): *Lytsari ridnoho kraiu. Sichovo-strilets'ka tradytsiia v istorii, kul'turi ta mystetstvi Ukrainy XX st.* [Knights of the Homeland. The Sich Riflemen Tradition in Ukrainian History, Culture, and 20th Century Art], Vik, Kolomuia 2007.

Monolatii 2007b = Monolatii, Ivan: "Strilets'ka lystivka iak dzerelo z istorii ukrains'koho mystetstva XX stolittia" [Riflemen Postcard as a Source for the History of 20th-Century Ukrainian Art], in: Kovtun/Monolatii (2007b: 161–202).

Monolatii 2007c = Monolatii, Ivan: "Informacijno-propagandystski lystivky" [Information–Propaganda Postcards], in: Kovtun/Monolatii (2007a: 153–156).

Monrad 1999 = Monrad, Kasper: "Christian Tetzen-Lund. The Merchant with the Sharp Eye and Unlimited Ambition," in: Monrad (1999a: 137–155).

Monrad 1999a = Monrad, Kasper (ed.): *Henri Matisse. Four Great Collectors*, Statens Museum for Kunst, Copenhagen 1999.

Morales 1914 = Morales, Tomás: "Oda a las glorias de don Juan de Austria," *Mundial Magazine* 39 (July 1914): 227–230.

Morales 1919 = Morales, Tomás: *Las rosas de Hércules*, Imprenta Clásica, Madrid 1919.

Mueggenberg 2014 = Mueggenberg, Brent: *The Czecho-Slovak Struggle for Independence, 1914–1920*, McFarland & Company, Jefferson, N. C. 2014.

Müller 1992 = Müller, Maria: "Der Kongress der 'Union fortschrittlicher internationaler Künstler' in Düsseldorf," in: Finkeldey (1992: 17–22).

Munteanu 1913 = Munteanu, Cassian: "Filmul Independența României" [Romanian Independence (The Movie)], *Drapelul*, Lugoj (Aug. 1, 1913): 3.

Myzak 2015 = Myzak, Nestor: *Pidpilna grafika OUN, UPA u borotbi za ukrainsku samostijnu derzhavu* [Underground Graphic Art of the OUN (= Organization of Ukrainian Nationalists) and the UPA (= The Ukrainian Insurgent Army) in the Struggle for an Independent Ukrainian State], Chernivetskyi nacionalny universytet, Chernivci 2015.

N

Nádas 2002 = Nádas, Péter: "A Careful Definition of the Locale: Walking Around and Around a Solitary Wild Tree," in: Benson (2002: 23–33).

Naumann 1915 = Naumann, Friedrich: *Mitteleuropa*, Reimer, Berlin 1915.

Navarra Ordoño 2014 = Navarra Ordoño, Andreu: *1914. Aliadófilos y germanófilos en la cultura española*, Cátedra, Madrid 2014.

Nazaruk 1916 = Nazaruk, Osyp: *Slidamy ukrain'skykh sichovykh stril'tsiv* [In the Footsteps of the Ukrainian Sich Riflemen], Drukarnia Naukovogo tovarystva imeni Shevchenka, Lviv 1916.

Niedziałkowska 2013 = Niedziałkowska, Dorota: "Autoportrety Stanisława Ignacego Witkiewicza — twarze dandysa" [Stanisław Ignacy Witkiewicz's Self-Portraits — Faces of a Dandy], in: Degler (2013: 369–386).

Niedziałkowska 2014 = Niedziałkowska, Dorota: "Orang Blanda i inne autoportety z czasow rosyjskich. Kilka uwag" [Orang Blanda and Other Self-Portraits from the Russian Period. Some Remarks]: http://www.witkacologia.eu/uzupelnienia/Niedzialkowska_Orang%20Blanda.pdf (accessed: Dec. 2, 2021).

Nikolaeva 1999 = Nikolaeva, Aneliya (ed.): *Alexander Bozhinov. 120th Anniversary of His Birthday/Alexandar Bozhinov. 120 godini ot rozhdenieto mu*, introductory essay by Rouzha Marinska, National Art Gallery, Sofia 1999.

Nikolaeva 2002 = Nikolaeva, Aneliya (ed.): *Nepoznatata Elisaveta Konsulova-Vazova. Spomeni, kritika i publicistika* [The Unknown Elisaveta Konsulova-Vazova. Memoires, Criticism, Journalism], Nacionalna hudojestvena galeriya, Sofia 2002.

Nikolskaia 2000 = Nikolskaia, Tatiana: *"Fantasticheskii gorod": Russkaia kul'turnaia zhizn' v Tbilisi (1917–1921)* ["Fantastic City": Russian Cultural Life in Tbilisi, 1917–1921], Piataia strana, Moscow 2000.

Nilsson 2010 = Nilsson, John Peter (ed.): *Andra Önskemuseet/ The Second Museum of Our Wishes*, Steidel, Göttingen 2010.

Nolte 1999 = Nolte, Claire: "Ambivalent Patriots: Czech Culture in the Great War," in: Roshwald/Stites (1999: 162–175).

Nordal 1992 = Nordal, Bera: "Aðfararorð" [Preface], in: Kristjánsdóttir (1992: 7–13).

Nordal 1993 = Nordal, Bera (ed.): *Árbók Listasafns Íslands 1990–1992* [Yearbook of the National Gallery of Iceland], Listasafn Reykjavíkur, Reykjavík 1993.

Nothomb 1915a = Nothomb, Pierre: *La Belgique martyre*, Perrin et Cie, Paris 1915.

Nothomb 1915b = Nothomb, Pierre: *The Barbarians in Belgium*, transl. Jean E. H. Findlay, prefatorial letter Carton de Wiart, Jarrold & Sons, London 1915.

Novikova 2014 = Novikova, Ljudmila: "Kontinuum der Gewalt. Der Norden Russlands 1914–1920," in: Sapper/Weichsel (2014: 157–170).

Novotný 2013 = Novotný, Michal (ed.): *Kubismus v české kultuře — Sto let poté* [Cubism in Czech Culture — One Hundred Years Later], Národní technické muzeum, Prague 2013.

Nowakowska-Sito 2003 = Nowakowska-Sito, Katarzyna: "Fliegerdenkmal," in: Schuler/Gawlik (2003: 148).

Nowakowska-Sito 2008 = Nowakowska-Sito, Katarzyna (ed.): *Wyprawa w dwudziestolecie* [An Expedition into the 1920s], Muzeum Narodowe, Warsaw 2008.

Nowakowska-Sito 2011 = Nowakowska-Sito, Katarzyna: "Nike der Polnischen Legionen," in: Omilanowska/Torbus (2011: 561).

Nummelin 1987 = Nummelin, Rolf: "Måleri och grafik 1918 — ca 1960" [Painting and Graphic Art 1918 — c. 1960], in: Ringbom (1987: 277–297).

Nussbaum 1997 = Nussbaum, Martha C.: "Kant and Stoic Cosmopolitanism," *The Journal of Political Philosophy* 5 (1997), No. 1: 1–25.

Nygård 2012 = Nygård, Stefan: "The National and the International in *Ultra* (1922) and *Quosego* (1928)," in: van den Berg/Hautamäki/Hjartarson (2012: 337–350).

O

Ojanperä 2002 = Ojanperä, Riitta: "Pariisin lupauksia ja viettelyksiä" [Paris's Promises and Temptations], in: Sederholm/Salin (2002: 228–231).

Okkonen 1924 = Okkonen, Onni: "Maalaustaiteen uusimmista suunnista" [On the Most Recent Tendencies in Painting], *Valvoja-Aika* (1924): 466–476.

Ólafsdóttir 2013 = Ólafsdóttir, Margrét Elísabet: "Viðtökur expressjónískra málverka Finns Jónssonar í ljósi skrifa Alexanders Jóhannessonar um 'Nýjar listastefnur'" [The Reception of Finnur Jónsson's Expressionist Paintings in the Light of Alexander Jóhannesson's Writing on the "New Art Movement"], *Ritið* 13 (2013): 83–105.

Ólafsdóttir 2018 = Ólafsdóttir, Margrét Elísabet: "Early Expressionism in Icelandic Art: Jón Stefánsson, Jóhannes Kjarval, and Finnur Jónsson," in: Wünsche (2018c: 257–272).

Olin 2001 = Olin, Margaret: *The Nation without Art. Examining Modern Discourses on Jewish Art*, University Nebraska Press, Lincoln/London 2001.

Olsson 1953 = Olsson, Hagar: *Tidiga fanfare och annan dagskritik* [Early Fanfares and Other Reviews], Holger Schildt, Helsingfors 1953.

Omăt 2008 = Omăt, Gabriela: *Modernismul literar românesc în date (1880–2000) și texte (1880–1949)* [Romanian Literary Modernism in Dates (1880–2000) and Texts (1880–1949)], vol. I, The Romanian Cultural Institute, Bucharest 2008.

Omilanowska/Torbus 2011 = Omilanowska, Małgorzata/ Torbus, Tomasz (eds.): *Tür an Tür. Polen — Deutschland. 1000 Jahre Kunst und Geschichte*, DuMont, Cologne 2011.

Onciu 2012 = Onciu, Camelia: "Un centenar de la premieră" [One Hundred Years after the Launch], *Monitorul Expres*, Brașov (Aug. 31, 2012): 8.

Ortega y Gasset 1925 = Ortega y Gasset, Jose: *La deshumanización del arte*, Revista de Occidente, Madrid 1925.

Orzoff 2009 = Orzoff, Andrea: *Battle for the Castle: The Myth of Czechoslovakia in Europe 1914–1948*, Oxford University Press, Oxford 2009.

Ostroverha 1962 = Ostroverha, Mykhailo: *Hrozna kalyny. V Ukrains'kykh Sichovykh Stril'tsiv* [Guelder-Rose Cluster. In the Ukrainian Sich Riflemen], New York 1962.

Otto Gutfreund 1995 = *Otto Gutfreund*, Národní galerie, Prague 1995.

Oud 1923 = Oud, Jacobus J. P.: "Geschakelde aforismen over kunst en bouwkunst" [Selected Aphorisms on Art and Architecture], *Het Overzicht* 15 (1923): 41.

Oud 1925 = Oud, Jacobus J. P.: "Onwterp (sic) van huizenreeks met plan door J. J. P. Oud" [J. J. P. Oud's Design for Terraced Houses with a Plan], *De Driehoek* 11/12 (1925): n.p.

Oud 1926 = Oud, Jacobus J. P.: letter to Szymon Syrkus from Apr. 12, 1926, The New Institute (Het Nieuwe Instituut), Rotterdam, inv. nr. 29:26:46.

Overy 1969 = Overy, Paul: *De Stijl*, Studio Vista, London 1969.

Overy 1979 = Overy, Paul: *De Stijl*, transl. Teresa Lachowska, Wydawnictwa Artystyczne i Filmowe, Warsaw 1979.

P

Paavolainen 1926 = Lauri, Olavi [= Olavi Paavolainen]: "Rikkinäiselle pulloverille" [To the Old Pullover], *Tulenkantajat* 4 (1926) 126–127.

Paavolainen 1927 = Paavolainen, Olavi: "Nykyaikaa etsimässä" [In Search of Modern Times], *Aitta* 7 (1927): 20–26.

Paavolainen 1929 = Paavolainen, Olavi: "Helsinki by Night," *Aitta* 12 (1929): 34–43.

Paavolainen 2002 = Paavolainen, Olavi: *Nykyaikaa etsimässä. Esseitä ja pakinoita* [In Search of the Modern Times. Essays and Causeries], Otava, Helsinki 2002 (1929).

Paddock 2014 = Paddock, Troy (ed.): *World War I and Propaganda*, Brill, Leiden 2014.

Paenhuysen 2010 = Paenhuysen, An: *De nieuwe wereld. De wonderjaren van de Belgische avant-garde (1918–1939)* [A New World. The Wonder Years of the Belgian Avant-Garde (1918–1939)], Meulenhoff Mantenau, Antwerp 2010.

Pählapuu 2012 = Pählapuu, Liis: "Eesti Kunstnikkude Rühm. Experimen 1920.–1930. aastate Eesti kultuuris/The Group of Estonian Artists. An Experiment in the Culture of 1920s and 1930s Estonia," in: Pählapuu/Hennoste/ Lahoda (2012: 11–69).

Pählapuu/Hennoste/Lahoda 2012 = Pählapuu, Liis/Hennoste, Tit/Lahoda, Vojtěch: *Geometriline Inimene. Eesti Kunstikkude Rühm Ja 1920.–1930. Aastate Kunstiuuendus/Geometrical Man. The Group of Estonian Artists and Innovation in the 1920s and 1930s*, trans. A&A Lingua/Martin Rünk, Eesti kunstimuuseum KUMU, Tallin 2012.

Pálmadóttir 1970 = Pálmadóttir, Elín: "Vor hinnar ungu listar. Spjallað við Finn Jónsson um listir í Evrópu á öðrum og þriðja áratugnum" [The Spring of Young Art. An Interview with Finnur Jónsson on European Arts in the 1910s and 1920s], *Morgunblaðið* (Dec. 19, 1970): 44–45.

Panikkar 1953 = Panikkar, Kavalam Madhava: *Asia and Western Dominance: A Survey of the Vasco Da Gama Epoch of Asian History 1498–1945*, Allen & Unwin, London 1953.

Partsch 2009 = Partsch, Susanna: *Marc*, 9th ed., Taschen, Cologne 2009.

Pârvan 1913 = Pârvan, Vasile: "Romania și criza balcanică"

[Romania and the Balkan Crisis], *Viața românească* 3 (1913): 97–99.

Passuth 1988 = Passuth, Krisztina: *Les Avant-Gardes de l'Europe centrale: 1907–1927*, Flammarion, Paris 1988.

Passuth 2002 = Passuth, Krisztina: "The Exhibitions as Work of Art: Avant-Garde Exhibitions in East Central Europe," in: Benson (2002: 226–246).

Passuth 2003 = Passuth, Krisztina: *Trefpunkte der Avantgarde Ostmitteleuropa 1907–1930*, transl. Anikó Harmath, Balassi Kiadó/Verlag der Kunst, Budapest/Dresden 2003.

Pavlík 2000 = Pavlík, Milan: "Tvůrčí architekti mezi členy a funkcionáři Klubu Za starou Prahu" [Architects among Members and Officials of the Club for Old Prague], in: Bečková (2000: 88–92).

Peiper 1922 = Peiper, Tadeusz: "Punkt wyjścia" [The Point of Departure], *Zwrotnica* (1922), No. 1: 6.

Peiper 1923 = Peiper, Tadeusz: letter to Michel Seuphor from Dec. 15, 1923, Michel Seuphor's Archive, Letterenhuis in Antwerp, inv. nr. 186877/1.

Peiper 1924 = Peiper, Tadeusz: letter to Michel Seuphor from Feb. 12, 1924, Michel Seuphor's Archive, Letterenhuis in Antwerp, inv. nr. 186877/2.

Peiper 1926 = Peiper, Tadeusz: "7 Arts et la presse étrangère. Pologne," *7 Arts* IV (1926) 24: n.p.

Pencakowski 1993 = Pencakowski, Paweł: "Cmentarze wojenne z lat 1914–1918 w Galicji. Przegląd problematyki" [The War Cemeteries from 1914–1918 in Galicia. Overview of the Problematics], in: Hrankowska (1993: 99–114).

Petrova 2003 = Petrova, Yevgenia (ed.): *Origins of the Russian Avant-Garde*, Walters Art Museum Baltimore, in partnership with the State Russian Museum, St. Petersburg, Baltimore/St. Petersburg 2003.

Phillips/Pérez Alonso 2017 = Phillips, Brian M./Pérez Alonso, Leticia: "The Impact of Vicente Huidobro and Ramón Gómez de la Serna in the Spanish Avant-Garde: Visualization and Rhetorical Artifice," *Cincinnati Romance Review* 43 (2017): 66–89.

Pick 1993 = Pick, Daniel: *War Machine. The Rationalisation of Slaughter in the Modern Age*, Yale University Press, Yale 1993.

Pingoud 1922 = Pingoud, Ernest: "Kansallinen musiikki" [National Music], *Ultra* 3 (1922): 37–38.

Pinsker 2010 = Pinsker, Shahar: "Spaces of Hebrew and Yiddish Modernism. The Urban Cafés of Berlin," in: Dohrn/Pickhan (2010: 56–77).

Piotrowski 1989 = Piotrowski, Piotr: *Stanisław Ignacy Witkiewicz*, KAW, Warsaw 1989.

Piotrowski 2002 = Piotrowski, Piotr: "Avant-Garde Art and Polish Independence. 1912–1922," in: Benson (2002: 313–326).

Piotrowski 2003 = Piotrowski, Piotr: "The Avant-Garde Institutionalised? The 1932 City of Lódź Art Prize Awarded to Władysław Strzemiński," *Umění/Art* 3 (2003): 211–218.

Piotrowski 2009 = Piotrowski, Piotr: "Toward a Horizontal History of the European Avant-Garde," in: Bru/Baetens/Hjartarson (2009: 49–58).

Pirsig-Marshall 2018 = Pirsig-Marshall, Tanja: "Otto Muellers Berliner Jahre 1907 bis 1919," in: Schmengler/Kern/Głuchowska (2018: 65–69).

Plokhy 2012 = Plokhy, Serhii: *The Cossack Myth: History and Nationhood in the Age of Empires*, Cambridge University Press, Cambridge, Mass. 2012.

Pointer 2017 = Pointer, Ray: *The Art and Inventions of Max Fleischer: American Animation Pioneer*, McFarland & Company, Jefferson, N. C. 2017.

Ponzi 1983a = Ponzi, Frank: "Artist Before His Time," in: Ponzi (1983b: 53–60).

Pollack 2006 = Pollack, Emmanuelle: *The Tradesmen and Farmers of Yiddishland*, Somogy Art Publishers, Paris 2006.

Ponzi 1983b = Ponzi, Frank (ed.): *Finnur Jónsson. Íslenskur brautryðjandi* [Finnur Jónsson. An Icelandic Pioneer], Almenna bókafélagið, Reykjavík 1983.

Popov 1983 = Popov, Anatoly: *Elena Kulchitskaya*, Sovetskiy chudozhnik, Moscow 1983.

Poprzęcka 2018 = Poprzęcka, Maria: [review/fragment], in: Monkiewicz (2018: cover).

Porter 2015 = Porter, Patrick: *The Global Village Myth: Distance, War, and the Limits of Power*, Georgetown University Press, Washington, D. C. 2015.

Posman 2013 = Posman, Sarah et al. (eds.): *The Aesthetics of Matter. Modernism, the Avant-Garde and Material Exchange*, De Gruyter, Berlin/Boston 2013.

Po zakupy **1915** = "Po zakupy ide Mrochko" [Mrochko Goes Shopping] (cartoon), *Samokhotnyk* 3 (1915): 10.

Pravdová/Hubatová-Vacková 2018 = Pravdová, Anna/Hubatová-Vacková, Lada (eds.): *First Republic 1918–1939*, National Gallery Prague, Prague 2018.

Prelog 2007a = Prelog, Petar: *Proljetni salon 1916–1928/*

The Spring Salon 1916–1928, Umjetnički paviljon, Zagreb 2007.

Prelog 2007b = Prelog, Petar: "Strategija oblikovanja 'našeg izraza': umjetnost i nacionalni identitet u djelu Ljube Babića" [The Strategy of Formulating "Our Expression": Art and National Identity in the Work of Ljubo Babić], *Radovi Instituta za povijest umjetnosti* 31 (2007): 267–282.

Prelog 2008 = Prelog, Petar: "Od Münchena prema Parizu: slikarstvo Münchenskog kruga/ Von München nach Paris: Die Malerei des Münchner Kreises," in: Kraševac/Prelog (2008: 62–85).

Prelog 2018 = Prelog, Petar: "From Anxiety to Rebellion: Expressionism in Croatian Art," in: Wünsche (2018c: 408–425).

Prinz 1926 = Prinz, Reinhard: "Hin þýska æskuhreyfing" [The German Youth Movement], *Lesbók Morgunblaðsins* (May 23, 1926): 1–5.

Prokop 2016 = Prokop, Ursula: *Zum jüdischen Erbe in der Wiener Architektur. Der Beitrag jüdischer ArchitektInnen am Wiener Baugeschehen 1868–1938*, Böhl, Vienna/Cologne/Weimar 2016.

Pronaszko 1914 = Pronaszko, Zbigniew: "Przed wielkim jutrem" [Before the Great Tomorrow], *Rydwan* 1 (1914): 125–129.

Protić 1972 = Protić, Miodrag B. (ed.): *Počeci jugoslovneskog modernog slikarstva 1900–1929* [The Origins of Yugoslav Modern Painting 1900–1929], Muzej savremene umetnosti, Belgrade 1972.

Przybyszewski 1916 = Przybyszewski, Stanisław: *Polen und der Heilige Krieg*, G. Müller, Munich/Berlin 1916.

Purchla/Tegethoff 2006 = Purchla, Jacek/Tegethoff, Wolfgang (eds.): *Nation, Style, and Modernism*, International Cultural Centre/Zentralinstitut für Kunstgeschichte, Cracow/ Munich 2006.

Q

Quintana Pareja 2007 = Quintana Pareja, Emilio: "El sol de Flandes. Eduardo Marquina y el modernismo castizo," Lecture at the University of Sevilla, Oct. 15, 2007.

Quintana Pareja 2011 = Quintana Pareja, Emilio: "Francisco Sancha y Sileno. Dos ilustradores espanoles de la Gran Guerra," *Hallali. Revista de Estudios Culturales sobre la Gran Guerra* 6 (2011): http://www.revistahallali. com/2011/03/03/sileno-y-francisco-sancha-dos-ilustradores-aliadofilos/ (accessed: Sept. 15, 2021).

Quintana Pareja 2012 = Quintana Pareja, Emilio: "Introducción," in: Chesterton (2012: 7–38).

R

Raaschou-Nielsen 1992 = Raaschou-Nielsen, Inge Vibeke: "Storm over København. Berlinergalleriet ,Der Sturm' besøger København 1912–1918" [Storm over Copenhagen. The Berlin Gallery "Der Sturm" Visits Copenhagen 1912–1918], *Kunstmuseets Årsskrift* [Writings on Art of the Statens Museum for Kunst Copenhagen] 1992: 95–99.

Radziszewska/Dekiert/Wiatr 2017 = Radziszewska, Krystyna/ Dekiert, Dariusz/Wiatr, Ewa (eds.): *Sztetl, szund, bund i Palestyna. Antologia twórczości literackiej Żydów w Łodzi (1905–1939)* [Shtetl, Shund, Bund and Palestina. Anthology of the Literary Creation of Jews in Łódź (1905–1939)], Uniwersytet Łódzki, Łódź 2017.

Raev 2014 = Raev, Ada: "Fragmentierte Wahrnehmung. Kunst in Russland aus dem Geist des Kriegs," in: Sapper/Weichsel (2014: 317–338).

Ragona 2003 = Ragona, Melissa: "J. Forrest — R. Koos (eds.), Dead Ringers: The Remake in Theory and Practice," *Film Quarterly* 57 (2003), No. 1: 50.

Rakowska 1918 = Rakowska, Pua: *Di yidishe froy* [The Jewish Woman], Warshe [Warsaw] 1918.

Rakušanová 2018 = Rakušanová, Marie: "Prague — Brno: Expressionism in Context," in: Wünsche (2018c: 33–55).

Rakušanová 2021 = Rakušanová, Marie et al.: *Degrees of Separation. Bohumil Kubišta and the European Avant-Garde*, transl. Phil Jones/Dan Morgan/Brian Neville et al., Charles University/ Karolinum Press, Prague 2021.

Ram 2004 = Ram, Harsha: "Modernism on the Periphery: Literary Life in Postrevolutionary Tbilisi," *Kritika: Explorations in Russian and Eurasian History* 5 (2004), No. 2: 367–382.

Rampley 2020 = Rampley, Matthew: "Years of Disarray 1908–1928: Avant-Gardes in Central Europe: Catalogue Review" (Mar. 17, 2020), *Craace. Continuity/Rupture: Art and Architecture in Central Europe 1918–1939*: https://craace. com/2020/03/17/years-of-disarray-1908-1928-avant-gardes-in-central-europe-catalogue-review/ (accessed: Sept. 29, 2021).

Rangelova/Dimitrova 2010 = Rangelova, Bistra/Dimitrova, Plamena: *Nikola/Nicola Tanev 1890–1962*, National Art Galery, Sofia 2010.

Bibliography

Rausing 1981 = Rausing, Birgit: *Tora Vega Holmström*, Rabén & Sjögren, Stockholm 1981.

Rausing 1989 = Rausing, Birgit: *Rainer Maria Rilke och Tora Vega Holmström* [Rainer Maria Rilke and Tora Vega Holmström], Signum, Lund 1989.

Rayfield 2010 = Rayfield, Donald: *The Literature Georgia — A History*, 3rd rev. ed., Garnet Press, London 2010.

Rayfield 2012 = Rayfield, Donald: *Edge of Empires: A History of Georgia*, Reaktion Books, London 2012.

Reberski 1998 = Reberski, Ivanka: "Rađanje hrvatske moderne 1898. godine" [The Birth of Croatian Modern Art in 1898], in: Galjer/Maroević/Maruševski (1998: 11–29).

Reitala 1990 = Reitala, Aimo: "Maalaustaide 1918-1940" [Painting 1918–1940], in: Sarajas-Korte/Oukari (1990: 222–243).

Renouvin 1925 = Renouvin, Pierre: *Les origines immédiares de la guerre. 28 juin — 4 août 1914*, A. Costes, Paris 1925.

Revărsat de zori 1913 = [Editorial], *Revărsat de zori* (Aug. 3, 1913): 6.

Rickey 1967 = Rickey, George: *Constructivism: Origins and Evolution*, G. Brazillier, New York 1967.

Ringbom 1928 = Ringbom, Lars-Ivar: "Begreppsoredan i kunstkritiken" [Conceptual Mess in Art Criticism], *Quosego* 1 (1928): 43-46.

Ringbom 1987 = Ringbom, Sixten et al. (eds.): *Konsten i Finland* [Art in Finland], Holger Schildt, Helsingfors 1987.

Ripets'kyi 1967 = Ripets'kyi, Stepan (ed.): *Za voliu Ukrainy. Istorychnyi zbirnyk. U 50-littia zbroinogo vystupu Ukrains'kykh Sichovykh Stril'tsiv proty Moskvy 1914-1964* [For Ukrainian Freedom. The 50th Anniversary of the Military Battle between the Ukrainian Sich Riflemen and Moscow, 1914–1964], Holovna uprava USS, New York 1967.

Ripets'kyi 1995 = Ripets'kyi, Stepan: *Ukrains'ke sichove striletstvo. Vyzvol'na ideia i zbroinyi chyn* [The Ukrainian Sich Riflemen. The Idea of Liberation and Armed Action], Naukove tovarystvo imeni T. Shevchenka, Lviv 1995.

Robakidze 1917 = Robakidze, Grigol: "Kartuli Renesansi" [Georgian Renaissance], *Sakartvelo* [Georgia] 257 (1917): 2.

Robakidze 1988 = Robakidze, Grigol: *Gvelis Perangi* [The Snake's Skin], Merani, Tbilisi 1988.

Robertson 1992 = Robertson, Roland: *Globalisation: Social Theory and Global Culture*, Sage, London 1992.

Rodenbach 1892 = Rodenbach, Georges: *Bruges-la-Morte*, Flammarion, Paris 1892.

Roshwald 1999 = Roshwald, Aviel: "Jewish Cultural Identity in Eastern and Central Europe during the Great War," in: Roshwald/Stites (1999: 89–126).

Roshwald/Stites 1999 = Roshwald, Aviel/Stites, Richard (eds): *European Culture in the Great War. The Arts, Entertainment, and Propaganda 1914-1918*, Cambridge University Press, Cambridge 1999.

Röske/Guratzsch 2003 = Röske, Thomas/Guratzsch, Herwig (eds.): *Expressionismus und Wahnsinn*, Prestel, Munich/Berlin/London/ New York 2003.

Rozanova 2000 = Rozanova, Olga: "Suprematism and the Critics," transl. Charles Rougle, in: Gurianova (2000: 201–202).

Rozhak-Lytvynenko 2015 = Rozhak-Lytvynenko, Ksenia: "Temy i obrazy ukrains'koho sichovoho striletstva u tvorchosti Ivana Ivantsia (do problem batal'noho zhanru v ukrains'komu mystetstvi pershoi tretyny XX stolittia) [The Themes and Images of the Ukrainian Sich Riflemen in the Artwork of Ivan Ivanets' (Discussing the Problem of Development of the Battle Genre in Ukrainian Art during the First Third of the 20th Century)]," *Visnyk Kharkivs'koi derzhavnoi akademii dyzainu i mystetstv* 6 (2015): 90–96.

Rozhak-Lytvynenko 2017 = Rozhak-Lytvynenko, Ksenia: *Mystetske uhrupovannia Ukrains'kykh sichovykh stril'tsiv: khudozhnyky, tradytsii, zhanrovi ta styliovi osoblyvosti tvoriv* [The Artistic Group of the Ukrainian Sich Riflemen: Artists, Traditions, Genres, and Stylistic Characteristics of Works], Dysertatsia na zdobuttia stupenia kandydata mystetstvoznavchykh nauk [Dissertation for the Degree of Candidate of Sciences in Art Studies], University of Lviv, Lviv 2017.

Rozier 1999 = Rozier, Gilles: *Moyshe Broderzon. Un ecrivain yiddish d'avant-garde*, Presses Universitaires des Vincennnes, Paris 1999.

Rozier 2008 = Rozier, Gilles: *Mojżesz Broderson. Od Jung Idysz do Araratu*, Hamal, Łódź 2008; orig. *Moyshe Broderzon. Un ecrivain yiddish d'avant-garde*, Presses Universitaires des Vincennnes, Paris 1999.

Rozier 2010 = Rozier, Gilles: "Jung Idysz: banda kpiarzy z polskiego Manchesteru" [Young Yiddish: A Mockery Band from the Polish Manchester], in: Suchan/ Szymaniak (2010: 30–39).

Rozier 2011 = Rozier, Gilles: *D'un pays sans amour*, Édition Grasset, Paris 2011.

Rubin 2002 = Rubin, William S. (ed.): *Primitivism in Twentieth Century Art: Affinity of the Tribal*, The Museum of Modern Art, New York 2002.

Rüdiger 1991 = Rüdiger, Ulrike: "Grüße aus dem Krieg. Feldpostkarten für eine Gleichgesinnte. Otto Dix an Helene Jakob 1915-1918," in: Herzogenrath/Schmidt (1991: 51-56).

Ruotsalainen 1996 = Ruotsalainen, Anna (ed.): *Näköalapaikalla. Aimo Reitalan juhlakirja* [At the Observation Post. Festschrift for Aimo Reitala], Taidehistorian Seura, Helsinki 1996.

Russett/Oneal/Davis 1998 = Russett, Bruce/Oneal, John R./Davis, David R.: "The Third Leg of the Kantian Tripod for Peace: International Organizations and Militarized Disputes, 1950-85," *International Organization* 52 (1998), No. 3: 441-467.

Rydel 2011 = Rydel, Jan: "Polen und Deutsche während des Ersten Weltkriegs," in: Omilanowska/Torbus (2011: 526-531).

Rypson 2015 = Rypson, Piotr (ed.): *Papież awangardy. Tadeusz Peiper w Hiszpanii, Polsce, Europie* [The Pope of the Avant-Garde. Tadeusz Peiper in Spain, Poland, and Europe], transl. from Spanish Inés Ruiz Artola/Katarzyna Górna, Muzeum Narodowe, Warsaw 2015.

S

Sabarsky 1991 = Sabarsky, Serge: *Graphik des deutschen Expressionismus*, Neuer Sächsischer Kunstverein, Dresden 1991.

Sadovyi 2013 = Sadovyi, Volodymyr: *Ukrain'ski Sichovi Stril'tsi u pisniakh i poeziiakh* [The Ukrainian Sich Riflemen in Songs and Poetry], Kolo, Drohobyh 2013.

Safran/Zipperstein 2006 = Safran, Gabriella/Zipperstein, Steven J. (eds.): *Words of S. An-sky: A Russian Jewish Intellectual at the Turn of the Century*, Stanford University Press, Stanford 2006.

Salamon 2003 = Salamon, Agnieszka: "Graphic Art as a Tool in the Struggle for Independence," in: Hałasa (2003: 96-118).

Šalda 1911 = Šalda, František Xaver: "Starý a nový Mánes" [The Old and New Mánes], *Novina* 4 (1911): 161-165, 202-207; reprinted in: Lamač/Padrta (1992: 15-18).

Salto 1917 = S. [= Salto, Axel]: "Kunstnernes Efteraarsudstilling" [Artists' Autumn Exhibition], *Klingen* 1 (1917), No. 2: n.p.

Samyro 1912 = Samyro, S. [= Tzara, Tristan]: Editorial Note, *Simbolul* 3 (1912): 48.

Sandqvist 2006 = Sandqvist, Tom: *Dada East. The Romanians of Cabaret Voltaire*, Cambridge University Press, Cambridge, Mass. 2006.

Sandqvist 2012 = Sandqvist, Tom: "Stylistic Purity versus 'Eclecticism'. Reflections Regarding the Impact of Jewish Culture on Central and Eastern European Modernism," in: Veivo (2012: 119-129).

Sapper/Weichsel 2014 = Sapper, Manfred/Weichsel, Volker (eds.): *Totentanz. Der Erste Weltkrieg im Osten Europas*, BWV Berlin (= *Osteuropa* 2014/2-4).

Sarajas-Korte/Oukari 1990 = Sarajas-Korte, Salme/Oukari, Tytti et al. (eds.): *Ars Suomen*

taide 5 [The Art of Finland 5], Weilin+Göös, Helsinki 1990.

Saß 2012 = Saß, Anne-Christin: *Berliner Luftmenschen. Osteuropäisch-jüdische Migranten in der Weimarer Republik*, Wallstein, Göttingen 2012.

Saunders 1999 = Saunders, Frances Stonor: *Who Paid the Piper? The CIA and the Cultural Cold War*, Granta Books, London 1999.

Savchuk 2007 = Savchuk, Mykola: "Striletska tema u Ukrains'kii smikhovii kul'turi" [The Riflemen Theme in Ukrainian Humour], in: Monolatii (2007a: 160-164).

Savolainen 1967 = Savolainen, Leena: "Ilmari Aallon taiteen alkuvaiheita" [Early Steps in Ilmari Aalto's Art], *Ateneumin taidemuseon museojulkaisu* [Museum Publication of the Atheneum Art Museum] XII (1967), No. 1/2: 16-27.

Sawicki 2007 = Sawicki, Nicholas: *Becoming Modern: The Prague Eight and Modern Art, 1900-1910*, PhD dissertation, University of Pennsylvania 2007.

Sayer 1998 = Sayer, Derek: *The Coasts of Bohemia: A Czech History*, Princeton University Press, Princeton 1998.

Schmengler/Kern/Głuchowska 2018 = Schmengler, Dagmar/Kern, Agnes/Głuchowska, Lidia (eds.): *Maler. Mentor. Magier. Otto Muller und sein Netzwerk in Breslau*, Kehrer, Heidelberg 2018.

Schmitt 1930 = Schmitt, Bernadotte E.: *Coming of the War, 1914*, Charles Scribner's Sons, New York/London 1930.

Schneede 2013 = Schneede, Uwe M. et al. (eds.): *1914 Die Avantgarden im Kampf*, Bundeskunsthalle Bonn, Bonn 2013.

Schreyer 1920 = Schreyer, Lothar: "Skirnismól. Nach den

Worten der Edda," *Der Sturm. Monatsschrift* 11 (1920): 4-6.

Schreyer 1925 = Schreyer, Lothar: *Deutsche Mystik*, Deutsche Buchgemeinschaft, Berlin 1925.

Schuler/Gawlik 2003 = Schuler, Romana/Gawlik, Goschka (eds.): *Der neue Staat. Polnische Kunst 1918-1939*, Leopold Museum/Hatje Cantz, Ostfildern-Ruit 2003.

Schürmann 1986 = Schürmann, Reiner: *Heidegger on Being and Acting: From Principles to Anarchy*, Indiana University Press, Blomington 1986.

Schwitters 1998 = Schwitters, Kurt: *Das literarische Werk*, vol. 5, DuMont, Cologne 1998.

Sederholm/Salin 2002 = Sederholm, Helena/Salin, Saara et al. (eds): *Pinx. Maalaustaide Suomessa. Maalta kaupunkiin* [Pinx. Visual Arts in Finland. From the Countryside to the City], Welin+Göös, Helsinki 2002.

von See 1994 = von See, Klaus: *Barbar, Germane, Arier. Die Suche nach der Identität der Deutschen*, Winter, Heidelberg 1994.

von See/Zernack 2007 = von See, Klaus/Zernack, Julia: *Þú ert vísust kvenna. Beatrice la Farge zum 60. Geburtstag*, Winter, Heidelberg 2007.

Segel 1999 = Segel, Harold B.: "Culture in Poland During World War I," in: Roshwald/Stites (1999: 58-88).

de la Selva 1922 = de la Selva, Salomón: *El soldado desconocido*, Cvltura, México 1922.

Šetlík 1989 = Šetlík, Jiří: *Otto Gutfreund: Zázemí tvorby* [Otto Gutfreund: Background to Creation], Odeon, Prague 1989.

Šetlík 1995 = Šetlík, Jiří: "Život a dílo Otty Gutfreunda" [The Life and Work of Otto Gutfreund], in: *Otto Gutfreund* (1995: 11-32).

Šetlík 2012 = Šetlík, Jiří: *Otto Gutfreund: Cesta ke kubismu* [Otto Gutfreund: The Path to Cubism], National Gallery, Prague 2012.

Seton-Watson H./Seton-Watson Ch. 1981 = Seton-Watson, Hugh/Ch. 1981 Seton-Watson, Christopher: *The Making of a New Europe: R. W. Seton-Watson and the Last Years of Austria-Hungary*, Taylor & Francis, London 1981.

Seuphor 1930a = Seuphor, Michel: letter to Theo van Doesburg from Jan. 8, 1930, Archive of Theo and Nelly van Doesburg, Netherlands Institute for Art History (Rijksbureau voor Kunsthistorische Documentatie) in The Hague, inv. nr. 189.

Seuphor 1930b = Seuphor, Michel: letter to Hendrik Werkman from Jan. 13, 1930, Werkman's Archive, Stedelijk Museum in Amsterdam, inv. nr. 1.

Seuphor 1956 = Seuphor, Michel: *Piet Mondrian. Life and Work*, Harry Abrams, New York 1956.

Seuphor 1962 = Seuphor, Michel: "De Stijl," *XXe Siècle* 19 (1962): 9-12.

Seuphor 1990 = Seuphor, Michel: *Cercle et Carré: Thoughts for the 1930's. Painting, Sculpture, Architecture, Theatre*, Rachel Adler Gallery, New York 1990.

Shebets' 1912 = Shebets', Sofron: "Nynishni kozaky" [Contemporary Cossacks], *Visty z Zaporozha*, (Dec. 31, 1912).

Shen 2009 = Shen, Shuang: *Cosmopolitan Publics: Anglophone Print Culture in Semi-Colonial Shanghai*, Rutgers University Press, Brunswick 2009.

Shmeruk 1989 = Shmeruk, Chone: "Hebrew — Yiddish — Polish: A Trilingual Jewish Culture," in: Gutman/Mendelsohn/Reinharz (1989: 285-311).

Silver 1989 = Silver, Kenneth E.: *Esprit de Corps: The Art of the Parisian Avant-Garde and the First World War, 1914-1925*, Thames & Hudson, London 1989.

Šimičic 2006 = Šimičic, Darko: "The Case of Dada: Searching through the Archipelago of the Avant-Gardes in Central Europe," in: Lahoda (2006: 141-147).

Simon 1978 = Simon, Hans-Ulrich (ed.): *Eberhard von Boddenhausen, Harry Graf Kessler. Ein Briefwechsel 1894-1918*, Deutsches Literaturmuseum, Marbach 1978.

Sinisalo 2002 = Sinisalo, Soili: "Länsimaisia vaikutteita Pietariin" [Western Influences into St. Petersburg], in: Sederholm/Salin (2002: 224-227).

Skalbe 1924 = Skalbe, Kārlis: *Sarkanās lapas. Kara laika tēlojumi* [The Red Pages. Portrayals of Wartime], Jāņa Rozes apgāds, Riga 1924.

Sloterdijk 2018 = Sloterdijk, Peter: "Zurich, 5 February 1916," in: Kurc-Maj/Polit/Saciuk-Gąsowska (2018: 65-75).

Słupska 2015 = Słupska, Alicja: "*Milgroim* Magazine as a Carrier of the Idea of a New Jewish Art and Modern Reproductive Graphic Art," in: Głuchowska/Gołuńska/Woźniak (2015: 103-114).

Šmite 2014 = Šmite, Edvarda: "On the Front Line with a Pencil," in: Cēbere (2014: 175-188).

Smith 1998 = Smith, Anthony D.: *Nationalism and Modernism: A Critical Survey of Recent Theories of Nations and Nationalism*, Routledge, London/New York 1998.

Smith 2002 = Smith, Anthony D.: "Nationalism and Modernity," in: Benson (2002: 68-80).

Smith 2013 = Smith, Leonard V.: "14. Juli 1916. 'Dada ist der Clou'," in: Cabanes/Duménil (2013: 217–123).

Smrekar 2014 = Smrekar, Andrej: "Slovene at and the First World War," in: Gerharde-Upeniece/Jevsejeva (2014: 167–174).

Snodgrass 2007 = Snodgrass, Susan: "Ukrainian Modernism: Identity, Nationhood, Then and Now," *Artmargins* (Apr. 13, 2007): http://www.artmargins.com/index.php/archive/123-ukrainian-modernism-identity-nationhood-then-and-now (accessed: Dec. 15, 2018).

Sokolova 2004 = Sokolova, Doroteya: "Album s risunki na elenskite zografi v NHG" [Album of Drawings by Painters/Zografs from Elena in National Art Gallery], *Pametnitzi, restavratziya, muzei* [Monuments, Restoration, Museums] 5/6 (2004): 65–74.

Sokołowska 2014 = Sokołowska, Alina: "'Kiedyż bedzie koniec tej okropnej wojny…?' Wojenne listy matki do synów z archiwum rodzinnego Kubickich. Pierwsza wojna światowa i przewrót 1914–1918" ["When Will This Awful War End?" The War Letters of Mother to Sons from the Kubicki Family Archive], *Kronika Miasta Poznania* 2 (2014: 145–166).

Sollors 2008 = Sollors, Werner: *Ethnic Modernism*, Harvard University Press, Cambridge 2008.

Sombart 1915 = Sombart, Werner: *Händler und Helden. Patriotische Besinnungen*, Duncker & Humblot, Munich/Leipzig 1915.

Sondhaus 2011 = Sondhaus, Lawrence: *World War One. The Global Revolution*, Cambridge University Press, Cambridge 2011

Sonn 2018 = Sonn, Richard D.: "Jewish Expressionists in France, 1900–1940," in: Wünsche (2018c: 332–347).

Sopena 1993 = Sopena, María Carmen: *Centro y periferia en la modernización de la pintura española (1880–1918)*, Ambit Editorial-Ministerio de Cultura, Barcelona 1993.

Şorban 1965 = Şorban, Raul: *Nicolae Tonitza*, Editura Meridiane, Bucharest 1965.

Sørensen 2014 = Sørensen, Nils Arne: *Den store krig. Europæernes Første Verdenskrig* [The Great War. The Europeans' First World War], Gads Forlag, Copenhagen 2014.

Spencer 1987 = Spencer, Herbert: *The Liberated Page*, Bedford Press, San Francisco 1987.

Spencer 2004 = Spencer, Herbert: *Pioneers of Modern Typography*, MIT Press, Cambridge 2004.

Spreeuwenberg 2019 = Spreeuwenberg, Peter et al.: "Reassessing the Global Mortality Burden of the 1918 Influenza Pandemic," *American Journal of Epidemiology* 187 (2019), No. 12: 2561–2567.

Srp 2002 = Srp, Karel: "Poetry in the Mist of the World: The Avant-Garde as Projectile," in: Benson (2002: 110–131).

Srp 2018 = Srp, Karel (ed.): *Years of Disarray 1908–1928. Avant-Gardes in Central Europe*, Arbor vitae societas/Muzeum umění Olomouc, Prague/Olomouc 2018.

Srp/Bydžovská 2018 = Srp, Karel/Bydžovská, Lenka (eds.): *Rozlomená doba 1908–1928/Years of Disarray 1908–1928*, Arbor vitae societas/Muzeum umění, Olomouc 2018.

Stajuda 1977 = Stajuda, Jerzy: "Artur Nacht-Samborski (I)," *Miesięcznik Literacki* 12 (1977), No. 9: 68–79.

Stanisławski 1973 = Stanisławski, Ryszard et al.: *Constructivism in Poland 1923–1936. Blok, Praesens, a.r.*, Dr. Cantz'sche Druckerei, Stuttgart 1973.

Stanisławski/Brockhaus 1992 = Stanisławski, Ryszard/Brockhaus, Christoph (eds.): *Europa, Europa. Das Jahrhundert der Avantgarde in Mittel- und Osteuropa*, Stiftung Kunst und Kultur des Landes Nordrhein-Westfalen, Bonn 1992.

Stażewski 1924 = Stażewski, Henryk: "O sztuce abstrakcyjnej" [On Abstract Art], *Blok* 8/9 (1924): n.p.

Stażewski 1926 = Stażewski, Henryk: "Styl współczesności" [Contemporary Style], *Praesens* 1 (1926): 2–3.

Steiner 1971 = Steiner, George: *In Bluebeard's Castle. Some Notes Towards the Redefinition of Culture*, Yale University Press, Yale 1971.

Steinlauf 1990 = Steinlauf, Michael C.: *Polish-Jewish Theatre: The Case of Mark Arnshteyn. A Study of the Interplay Among Yiddish, Polish and Polish-Language Jewish Culture in the Modern Period*, authorized facs., Univ. Microfilms Internat, Ann Arbor, Mich. 1990.

Steorn 2012 = Steorn, Patrick: "Tora Vega Holmström", *Konstvetenskaplig tidskrift* 3 (2012): 150–165.

Stere 1912a = Stere, Constantin: "Războiul balcanic și România" [The Balkan War and Romania], *Viața românească* 7/8 (1912): 378–387.

Stere 1912b = Stere, Constantin: "România și perspectivele războiului austro-rus" [Romania and the Perspectives of the Austrian-Russian War], *Viața românească* 11/12 (1912): 265–280.

Stirton 2013 = Stirton, Paul: "Hungarian Visual Culture in the First World War," *Austrian Studies* 21 (2013): 182–200.

Stolarska-Fronia 2010 = Stolarska-Fronia, Małgorzata: "Jewish Expressionism — a Guest for Cultural Space," in: Malinowski/Piątkowska/Sztyma-Knasiecka (2010: 313–318).

Stolarska-Fronia 2018 = Stolarska-Fronia, Małgorzata: "Jüdische Künstler und Künstlerinnen aus Breslau um Otto Mueller," in: Schmengler/Kern/Głuchowska (2018: 366–377).

Stolarska-Fronia 2020 = Stolarska-Fronia, Małgorzata (ed.): *Polish Avant-Garde in Berlin*, Peter Lang, Berlin 2020.

Störtkuhl 2013 = Störtkuhl, Beate: "'International Architecture'. Contacts and Collaborative Efforts of the Architectural Avant-Garde Between the World Wars," in: van den Berg/Głuchowska (2013: 117–130).

Störtkuhl/Makała 2020 = Störtkuhl, Beate/Makała, Rafał (eds.): *Nicht nur Bauhaus — Netzwerke der Moderne in Mitteleuropa/Not Just Bauhaus — Networks of Modernity in Central Europe*, De Gruyter Oldenbourg, Berlin 2020.

Stounbjerg/Jelsbak 2012 = Stounbjerg, Per/Jelsbak, Torben: "Danish Expressionism," in: van den Berg/Hautamäki/Hjartarson (2012: 463–480).

Strożek 2011 = Strożek, Przemysław: "'Marinetti is Foreign to Us'. Polish Responses to Italian Futurism, 1917–1923," in: Berghaus (2011: 85–109).

Strożek 2013 = Strożek, Przemysław: "Pismo 'Formiści' i początki międzynarodowych kontaktów polskiej awangardy (1919–1922)" [The Magazine "Formiści" and the Beginnings of the International Contacts of the Polish Avant-Garde (1919–1922)], *Rocznik Historii Sztuki* 38 (2013): 71–87.

Strożek 2017 = Strożek, Przemysław (ed.): *Enrico Prampolini. Futurism, Stage Design and the Polish Avant-garde Theatre*, transl. Anna Fabjańczyk-Woźniak/Joanna Figiel/Katarzyna Gucio et al., Muzeum Sztuki w Łodzi, Łódź 2017.

Strzemiński 1932 = Strzemiński, Władysław: *Międzynarodowa Kolekcja Sztuki Nowoczesnej/Collection Internationale d'art Nouveau. Katalog nr 2* [International Collection of Modern Art. Catalogue nr. 2], Miejskie Muzeum Historji i Sztuki im. J. i K. Bartoszewiczów w Łodzi, Łódź 1932.

Strzemiński 1934 = Strzemiński, Władysław: "Sztuka nowoczesna w Polsce" [Modern Art in Poland], in: Brzękowski/Chwistek/Smolik (1934: 59–93).

Strzemiński 1975 = Strzemiński, Władysław: *Pisma* [Writings], Zakład Narodowy im. Ossolińskich, Wrocław 1975.

Strzemiński/Kobro 1931 = Strzemiński, Władysław/Kobro, Katarzyna: *Kompozycja przestrzeni. Obliczenia rytmu czasoprzestrzennego* [Spatial Composition. Calculating the Space-Time Rhythm], a.r., Łódź 1931.

Suarès 1916 = Suarès, André: *Don Quijote en Francia*, Minerva/Atenea, Madrid 1916.

Suchan/Pindera 2020 = Suchan, Jarosław/Pindera, Agnieszka (eds.): *The Avant-Garde Museum*, Muzeum Sztuki w Łodzi/Walther und Franz König Verlag, Łódź/Cologne 2020.

Suchan/Szymaniak 2010 = Suchan, Jarosław/Szymaniak, Karolina (eds.): *Polak, Żyd, Artysta. Tożsamość i awangarda* [Pole, Jew, Artist. Identity and Avant-Garde], Muzeum Sztuki w Łodzi, Łódź 2010.

Suchodolski 1986 = Suchodolski, Bogdan: *Geschichte der polnischen Kultur*, transl. Kordula Zubrzycka, Interpress, Warsaw 1986.

Suta 1921 = Suta, Romans: "L'Art en Lettonie. La jeune école de peinture," *L'Esprit Nouveau* 10 (1921): 1168–1171.

Suta 1923 = Suta, Romans: *60 Jahre lettischer Kunst*, Pandora Verlag, Leipzig 1923.

Šuvaković 1999 = Šuvaković, Miško: *Pojmovnik moderne i postmoderne likovne umetnosti i teorije posle 1950* [A Glossary of Modern and Postmodern Art and Theory After 1950], SANU/Prometej, Belgrade/Novi Sad 1999.

Švácha 2000 = Švácha, Rostislav: *The Pyramid, the Prism & the Arc. Czech Cubist Architecture 1911–1923*, transl. David Vaughan, Prague Gallery, Prague 2000.

Švestka/Vlček/Liška 1991 = Švestka, Jiří/Vlček, Tomáš/Liška, Pavel (eds.): *1909–1925 Kubismus in Prag*, Gerd Hatje, Stuttgart 1991.

Syrkus 1926 = Syrkus, Szymon: letter to Theo van Doesburg from Nov. 13, 1926, Archive of Theo and Nelly van Doesburg, Netherlands Institute for Art History (Rijksbureau voor Kunsthistorische Documentatie) in The Hague, inv. nr. 201.

Syrkus/Stażewski 1926a = Syrkus, Szymon/Stażewski, Henryk: letter to Theo van Doesburg from Mar. 20, 1926, Archive of Theo and Nelly van Doesburg, Netherlands Institute for Art History (Rijksbureau voor

Kunsthistorische Documentatie) in The Hague, inv. nr. 308.

Syrkus/Stażewski 1926b = Syrkus, Szymon/Stażewski, Henryk: letter to Theo van Doesburg from Aug. 3, 1926, Archive of Theo and Nelly van Doesburg, Netherlands Institute for Art History (Rijksbureau voor Kunsthistorische Documentatie) in The Hague, inv. nr. 308.

Szábo 1994 = Szábo, Júlia: "Avant-garde Visitors in Central Europe 1913-1931," *Ars* 2 (1994): 175-186.

Szarota 2009 = Szarota, Tomasz: "Begegnungen zwischen Polen und Deutschen in Berlin (1815–1945)," in: Traba (2009: 55-79).

Szczerski 2010 = Szczerski, Andrzej: *Modernizacje. Sztuka i architektura w nowych państwach Europy Środkowo-Wschodniej 1918-1939* [Modernizations. Art and Architecture in New States of Central-Eastern Europe 1918-1939], Muzeum Sztuki w Łodzi, Łódź 2010.

Szczerski 2015 = Szczerski, Andrzej: "Inna perspektywa. Europa Środkowo-Wschodnia jako artystyczne centrum" [The Other Perspective: Central Eastern Europe as an Artistic Center], in: Kossowska (2015: 61-80).

Szczuka 1924 = Szczuka, Mieczysław: manuscript of "Le mouvement artistique en Pologne," Archive of Theo and Nelly van Doesburg, Netherlands Institute for Art History (Rijksbureau voor Kunsthistorische Documentatie) in The Hague, inv. nr. 202.

Szczuka 1925 = Szczuka, Mieczysław: "Le mouvement artistique en Pologne," *Anthologie du Groupe Moderne d'Art de Liège* 3-4 (1925): 4-5.

Szramm 2014 = Szramm, Tomasz: "Czym była I wojna światowa?"

[What Was World War I?], *Kronika Miasta Poznania (Wielka Wojna)* (2014), No. 3: 7-25.

Szücs 2014 = Szücs, György: "Hungarian Artists' Activity in the First World War," in: Gerharde-Upeniece/Jevsejeva (2014: 183-187).

Szymaniak 2005 = Szymaniak, Karolina (ed.): *Warszawska awangarda jidysz* [The Warsaw Avant-Garde Yiddish], słowo — obraz — terytoria, Gdańsk 2005.

Szymański 2019 = Szymański, Wojciech: "Wyjść poza ułański werstern. Wokół wystawy *Wielka Wojna* w Muzeum Sztuki w Łodzi" [Transgressing the Ulan's Western. About the Exhibition The Great War in the Museum of Art in Łódź], *Szum* 24 (2019): 106-119.

T

Tabidze G. 1977 = Tabidze, Galaktion: *Rcheuli* [Collected Poems], coll. by Revaz Tvaradze, Sabchota Sakartvelo, Tbilisi 1977.

Tabidze N. 2016 = Tabidze, Nino: *Tsisartkela Gantiadisas. Titsiani da Misi Megorbebi* [The Rainbow at Dawn: Titsian and His Friends], Artanuji, Tbilisi 2016.

Tabidze T. 1916 = Tabidze, Titsian: "Tsisperi Qantsebit" [With Blue Horns], *Tsisperi Qantsebi* (Kutaisi) 1 (1916): 21-26; *Tsisperi Qantsebi* 2 (1916): 20-26.

Tanikowski 2014 = Tanikowski, Artur (ed.): *Pole, Jew, Legionary 1914-1920*, transl. Dominika Gajewska, Muzeum Historii Żydów Polskich POLIN, Warsaw 2014.

Tate 1998 = Tate, Trudi: *Modernism, History and the First World War*, Manchester University Press, Manchester 1998.

Taylor 2010 = Taylor, Robert S.: "Kant's Political Religion: The Transparency of Perpetual Peace and the Highest Good," *The Review of Politics* 72 (2010): 1-24.

Teige 1930 = Teige, Karel: *Moderní architektura v Československu* [Modern Architecture in Czechoslovakia], Odeon, Prague 1930.

Teja Zabre 1917 = Teja Zabre, Alfonso: "París en el Marne" [Paris in Marne], *Cervantes. Revista Mensual Ibero Americana*, Madrid (Sept. 1917): 77-81.

Tellgren/Sundberg 2008 = Tellgren, Anna/Sundberg, Martin (ed.): *The History Book*, Steidel, Göttingen 2008.

Thelle 1993 = Thelle, Mette (ed.): *Vilhelm Lundstrøm 100 år* [The Centenary of Vilhelm Lundstrøm], Charlottenborg, Copenhagen 1993.

Thormann 1987 = Thormann, Ellen: "Am Rande des Blickfeldes. Männerbilder von Künstlerinnen in Paris Anfang des 20. Jahrhunderts," in: Barta/Breu/Hammer-Tugendhat (1987: 405-420).

Thoroddsen 1983 = Thoroddsen, Emil: "Sýning Finns Jónssonar" [Finnur Jónsson's Exhibition], in: Ponzi (1983b: 50).

Traba 2009 = Traba, Robert (ed.): *My, Berlińczycy! Wir Berliner!: Geschichte einer deutsch-polnischen Nachbarschaft*, CBH PAN/Koehler & Amelang, Berlin/Leipzig 2009.

Trávníček 2018 = Trávníček, Jiří: "'And So They've Gone and Killed Our Central Europe...'. On the History of the Concept," in: Srp (2018: 46-55).

Trayanov 1921 = Trayanov, Teodor: *Bulgarian Ballads*, Hemus, Sofia 1921.

Tschichold 1987 = Tschichold, Jan: *Die neue Typography*.

Bibliography

Ein Handbuch für Zeitgemäss Schaffende, Brinkmann und Bose, Berlin 1987.

TsDIAL fund 353, inv. 1, file 7 = Central State Historical Archive in Lviv (Tsentral'nyi derzhavnyi istorychnyi arkhiv u Lvovi, TsDIAL), fund 353, inventory 1, file 7, *Materialy do istorii Lehionu Ukrains'kykh Sichovykh Stril'tsiv: referaty, lysty ta in* [Materials about the History of the Legion of the Ukrainian Sich Riflemen: Summaries, Letters, etc.], 1915–1918.

TsDIAL fund 359, inv. 1, file 74 = Central State Historical Archive in Lviv (Tsentral'nyi derzhavnyi istorychnyi arkhiv u Lvovi, TsDIAL), fund 359, inventory 1, file 74, *Charakterystyka na starshynu Olenu Stepaniv* [Reference for Officer Olena Stepaniv], 1915.

Tsikarishvili 2002 = Tsikarishvili, Lela: "Mikheil Javakhishvilis *Kalis Tvirtis* sakhismetkvelebisatvis" [For Tropology of Michael Javakhishvili's *A Woman's Burden*], *Literaturuli Dziebani* 23 (2002): 339–356.

Tsipuria 2011 = Tsipuria, Bela: "H2SO4: The Futurist Experience in Georgia," in: Berghaus (2011: 299–322).

Tsipuria 2016 = Tsipuria, Bela: *Qartuli Texti Sabchota/Postsabchota/Postmodernul Kontekstshi* [Georgian Text in Soviet/Post-Soviet/Postmodern Context], Ilia State University Press, Tbilisi 2016.

Tsitaishvili 2014 = Tsitaishvili, Nia: "Pirveli msoflio omi da Sakartvelo" [First World War and Georgia], *Istoriuli Memkvidreoba* 8 (2014), No. 49: 9–21.

Tsitsishvili/Tchogoshvili 2006 = Tsitsishvili, Maia/Tchogoshvili, Nino (eds.): *Kartuli*

Modernizmi, 1910–1930/Georgian Modernism, 1910–1930, Sezani, Tbilisi 2006.

Tuijn 2003 = Tuijn, Marguerite I.: *Mon cher ami … Lieber Does …*, PhD dissertation, University of Amsterdam, Amsterdam 2003.

Turowski 1973 = Turowski, Andrzej: "Listy Władysława Strzemińskiego do Juliana Przybosia z lat 1929–1933" [Władysław Strzemiński's Letters to Julian Przyboś from 1929–1933], *Rocznik Historii Sztuki* 9 (1973): 223–268.

Turowski 1979 = Turowski, Andrzej: "De Stijl i polska awangarda" [De Stijl and the Polish Avant-Garde], in: Overy (1979: 140–163).

Turowski 1981 = Turowski, Andrzej: *Konstruktywizm polski. Próba rekonstrukcji nurtu (1921–1934)* [Polish Constructivism. An Attempt to Reconstruct the Trend (1921–1934)], Zakład Narodowy im. Ossolińskich, Wrocław 1981.

Turowski 1986 = Turowski, Andrzej: *Existe-t-il un art de l'Europe de l'Est? Utopie & Idéologie*, Editions de la Vilette, Paris 1986.

Turowski 1990 = Turowski, Andrzej: *Wielka utopia awangardy* [The Great Utopia of the Avant-Garde], Państwowe Wydawnictwo Naukowe, Warsaw 1990.

Turowski 1998 = Turowski, Andrzej: *Awangardowe marginesy* [Margins of the Avant-Garde], Instytut Kultury, Warsaw 1998.

Turowski 2000 = Turowski, Andrzej: *Budowniczowie świata. Z dziejów radykalnego modernizmu w sztuce polskiej* [Builders of the World. The History of Radical Modernism in Polish Art], Universitas, Cracow 2000.

Turowski 2002 = Turowski, Andrzej: *Malewicz w Warszawie* [Malevich in Warsaw], Universitas, Cracow 2002.

Turowski 2004 = Turowski, Andrzej (ed.): *"Fin des Temps! L'histoire n'est plus". L'art polonais du 20e siècle*, Hôtel des Arts, Toulon 2004.

Țuțui 2007 = Țuțui, Marian: *Frații Manakia sau Balcanii mișcători* [Manakia Bros or the Moving Balkans], National Film Archive Editions, Bucharest 2007.

Țuțui 2008 = Țuțui, Marian: *Orient Expres: filmul românesc și filmul balcanic* [Orient Express: Romanian and Balkan Film], NOI MediaPrint Editions, Bucharest 2008.

Tzara 1915 = Tzara, Tristan: "Furtuna și cântecul dezertorului" [The Storm and the Song of the Defector], *Chemarea* II (1915): 26–27.

U

Uhryn-Bezhrishnyi 1935 = Uhryn-Bezhrishnyi, Mykola: "Kish Ukrains'kykh Sichovykh Stril'tsiv. Istorychnyi narys" [The Ukrainian Sich Riflemen *Kish* (Reserve Unit)], *Litopys Chervonoi Kalyny* 1 (1935): 5–7.

Unamuno 1915 = Unamuno, Miguel de: "La guerra y la vida de mañana" [War and Life Tomorrow], *La Nación*, Buenos Aires (Mar. 28, 1915).

Unamuno 1917 = Unamuno, Miguel de: "Una plaga" [A Plague], *La Nación*, Buenos Aires (Feb. 18, 1917).

Urushadze 2005 = Urushadze, Levan: *Bolshevizmi-Menshvizmi da Sakartvelos Demokratiuli Respublika (1918–1921)* [Bolshevism-Menshevism and the

Democratic Republic of Georgia (1918–1921)], Ena da Kultura, Tbilisi 2005.

Urushadze 2009 = Urushadze, Levan: *Kartuli Idea — The Georgian Idea (About History of Georgia and History of the National-Liberation Movement of Georgia)*, Museum of the Soviet Occupation of the Georgian National Museum, Tbilisi 2009.

V

Vala 1929 = Vala, Erkki: "Kuka on vanhollinen? Mikä on uutta?" [Who is Conservative? What is New?], *Tulenkantajat* 6–7 (1929): 110–113.

Valjakka 2009 = Valjakka, Timo: *Modernin kahdet kasvot* [The Two Faces of the Modern], SKS, Helsinki 2009.

Valkonen 1990 = Valkonen, Olli: "Maalaustaide vuosisadan vaihteesta itsenäisyyden aikaan" [Painting from the Turn of the Century to Independence], in: Sarajas-Korte/Oukari (1990: 174–217).

Varela 1998 = Varela, Javier: "Los intelectuales españoles ante la Gran Guerra," *Claves de razón práctica* 88 (1998): 27–37.

Vasconcelos 2015 = Vasconcelos, Ana et al. (eds.): *O Círculo Delaunay/The Delaunay Circle*, Fundação Calouste Gulbenkian, Lisbon 2015.

V borot'bi **1915** = "V borot'bi za chlib nash nasuschnyi" [Straggling for Daily Bread] (cartoon), *Samokhotnyk* 4 (1915): 6.

von Vegesack 1992 = von Vegesack, Alexander (ed.): *Czech Cubism. Architecture, Furniture, and Decorative Arts, 1910–1925*, Princeton Architectural Press, Princeton 1992.

Veivo 2012 = Veivo, Harri (ed.): *Transferts, appropriations et fonctions de l'avant-garde dans l'Europe intermediataire et du Nord*, L'Harmattan, Paris 2012.

Verleysen 2018 = Verleysen, Cathérine: "Flemish Expressionism in Belgium," in: Wünsche (2018c: 316–331).

Veselý 2005 = Veselý, Dalibor: "Czech New Architecture and Cubism," *Umění/Art* 53 (2005), No. 6: 586–604.

Vidal Maza 2001 = Vidal Maza, Margarita: "Valle-Inclán y la I Guerra Mundial: Declaraciones a *El radical* (1916)," *Anales de Literatura Española Contemporánea* 22 (2001): 245–281.

Viefhaus 2008 = Viefhaus, Erwin: *Die Minderheitenfrage und die Entstehung der Minderheitenschutzverträge auf der Pariser Friedenskonferenz 1919. Eine Studie zur Geschichte des Nationalitätenproblems im 19. und 20. Jahrhundert*, Textor, Frankfurt/M. 2008 (1st ed.: 1960).

Viljanen 1930 = Viljanen, Lauri: "Eestin kautta Eurooppaan" [To Europe via Estonia], *Tulenkantajat* 11–12 (1930): 150–152.

Vojvodík 2018 = Vojvodík, Josef: "The Dynamics of Explosion and Art at the Centre of Europe (1908–1928)," in: Srp (2018: 23–31).

Voloshyn 2007 = Voloshyn, Liubov: "Iz pleiady tvortsiv ukrains'koho modernu: Olena Kul'chyts'ka" [From the Constellation of Creators of Ukrainian Modern Art: Olena Kul'chyts'ka], *Halyts'ka Brama* 9/10 (Sept.–Oct. 2007): 9–14.

Voronca 1927 = Voronca, Ilarie: [Editorial], *Integral* 9 (1927): 2.

W

Waenerberg 2006 = Waenerberg, Annika: "National Features in Modern Art: Edwin Lydén (1879–1956) and Wassily Kandinsky (1866–1944)," in: Lahoda (2006: 53–58).

Wagner 1896 = Wagner, Otto: *Moderne Architektur*, Vienna 1896.

Wagner 2006 = Wagner, Christoph (ed.): *Das Bauhaus und die Esoterik*, Kerber, Bielefeld/Leipzig 2006.

Wallin Wictorin 2018 = Wallin Wictorin, Margareta: "Expressionisms in Sweden: Anti-Realism, Primitivism, and Politics in Painting and Print," in: Wünsche (2018c: 206–221).

Wardi 2015 = Wardi, Ada: *The Graphic Design of Moshe Spitzer, Franzisca Baruch, and Henri Friedlaender*, The Israel Museum, Jerusalem 2015.

Waters 1995 = Waters, Malcolm: *Globalisation*, Routledge, London/New York 1995.

Weber 1948 = Weber, Max: *Essays in Sociology*, ed. Hans Gerth and C. Wright Mills, Routledge and Kegan, London 1948.

Weger 2015 = Weger, Tobias: "Der ausgeblendete Krieg im Osten"/"Przemilczana wojna na Wschodzie," in: Brade/Weger (2015: 241–269).

Weikop 2018 = Weikop, Christian: "Early Engagements: Peripheral British Responses to German Expressionism," in: Wünsche (2018c: 275–294).

Weinig 1921 = Weinig, Naftali: "In di trit fun a najem judishn stil" [Towards a New Jewish Style], *Kritik* 9 (1921): 19.

Weisgerber 1991 = Weisgerber, Jean (ed.): *Les avant-gardes*

littéraires en Belgique, Centre d'Etude des Avant-Gardes Littéraires de l'Université de Bruxelles, Brussels 1991.

Weisstein 1973 = Weisstein, Ulrich (ed.): *Expressionism as an International Literary Phenomenon*, Akad. Kiado/Didier, Budapest/Paris 1973.

Wells 1914 = Wells, Herbert George: *The War That Will End War*, Frank & Cecil Palmer, Red Lion Court, London 1914.

Wenderski 2015a = Wenderski, Michał: "The Influence of Interpersonal Relationships on the Functioning of the Constructivist Network — a Case Study of Poland and the Low Countries," *Journal of Dutch Studies* VI (2015), No. 2: 1–20.

Wenderski 2015b = Wenderski, Michał: "Mutual Exchange between Polish and Belgian Modernist Magazines as a Case Study in Cultural Mobility within the Interwar Network of the Avant-Garde," *Tijdschrift voor Tijdschriftstudies* 37 (2015): 37–52.

Wenderski 2016 = Wenderski, Michał: "Literary, Artistic and Architectural Exchange between Dutch and Polish Avant-Gardes: a Case Study in European Cultural Mobility in the 1920s and 30s," *Dutch Crossing: Journal of Low Countries Studies* XX (2016), No. 10: 1–16.

Wenderski 2019a = Wenderski, Michał: *Cultural Mobility in the Interwar Avant-Garde Art Network: Poland, Belgium and the Netherlands*, Routledge, New York 2019.

Wenderski 2019b = Wenderski, Michał: "From 'Peripheries' to 'Centres', Westwards: On the Influence of Katarzyna Kobro on Georges Vantongerloo," *Dutch Crossing: Journal of*

Low Countries Studies (2019) (online: May 9, 2019).

Wenderski 2020 = Wenderski, Michał: "From 'Peripheral' Warsaw to No Less Marginal Groningen: Mieczysław Szczuka's Artistic Influence on Hendrik Nicolaas Werkman," *Dutch Crossing: Journal of Low Countries Studies* 44 (2020), No. 3: 283–293.

Wennervirta 1929 = Wennervirta, Ludvig: "Virolainen taidenäyttely" [The Estonian Art Exhibition], *Tulenkantajat* 5 (1929): 74–76.

Werenskiold 1975 = Werenskiold, Marit: "Die 'Brücke' in Skandinavien — zwei Ausstellungen in Kopenhagen und Christiania 1908," *Brücke-Archiv Heft* 7 (1975): 3–21.

Werenskiold 1984 = Werenskiold, Marit: *The Concept of Expressionism. Origin and Metamorphoses*, Universitetsforlaget, Oslo/Bergen/ Stavanger/Tromsø 1984.

Werfel 1933 = Werfel, Franz: *Die vierzig Tage des Musa Dagh* (vol. 1: *Das Nahende*, vol. 2: *Die Kämpfe der Schwachen*), Zsolnay, Berlin 1933.

Werner 2014 = Werner, Jeff: "Blond och blåögd. Vithet, svenskhet och visuell kultur/ Blond and Blue-eyed: Whiteness, Swedishness, and Visual Culture," *Skiascope* 6, Göteborgs Konstmuseum, Gothenburg 2014.

Westheim 1925 = Westheim, Paul: "Im bunten Rock," *Die Kunst für Alle* 30 (1925), No. 5/6: 81.

White 2003 = White, Michael: *De Stijl and Dutch Modernism*, Manchester University Press, Manchester 2003.

Widenheim 2007 = Widenheim, Cecilia (ed.): *10 historier. Svensk konst 1910–1945. Ur Moderna Museets samling* [10 Stories. Swedish Art 1910–1945.

On the Collection of the Moderna Museet], Moderna Museet, Stockholm 2007.

Widenheim 2014 = Widenheim, Cecilia: "Tora Vega Holmström": http://www.modernamuseet.se/ sv/Moderna-Museet/Om-museet/ Forskning/Det-andra-onskemuseet/ Tora-Vega-Holmstrom/ (accessed: Dec. 29, 2014).

Wierzbicka 2004 = Wierzbicka, Anna: *Ècole de Paris. Pojęcie, środowisko, twórczość* [Ècole de Paris. Term, Milieu, Artistic Production], Neriton/IS PAN, Warsaw 2004.

Wierzbicka 2009a = Wierzbicka, Anna: "'Nowa Sztuka' w tekstach krytyka sztuki i marszanda Adolfa Baslera. Lata 1907–1913" ["New Art" in the Texts by Adolf Basler, Art Critic and Marchand. The Years 1907–1913], in: Geron/ Malinowski (2009: 215–229).

Wierzbicka 2009b = Wierzbicka, Anna: *We Francji i w Polsce 1900– 1939. Sztuka, jej historyczne uwarunkowania i odbiór w świetle krytyków polsko-fracuskich* [In France and in Poland 1900–1939. Art, its Historical Determinants and Reception in the Light of the Polish-French Critics], IS PAN, Warsaw 2009.

von Wiese 1985 = Wiese, Stefan von: "Ein Meilenstein auf dem Weg in den Internationalismus. Die '1. Internationale Kunstausstellung' und der Kongress der 'Union fortschrittlicher internationaler Künstler' 1922 in Düsseldorf," in: Krempel (1985a: 50–62).

Williams 2014 = Williams, Rachel: *Dual Threat: The Spanish Influenza and World War I*, University of Tennessee Thesis (2014: 4–10).

Willmott 2003 = Willmott, H. P.: *World War I*, Dorling Kindersley, New York 2003.

Winskell 1995 = Winskell, Kate: "The Art of Propaganda: Herwarth Walden and 'Der Sturm' 1914–1919," *Art History* 18 (1995), No. 3: 315–344.

Winter 2017 = Winter, Jay: *War Beyond Words*, Cambridge University Press, Cambridge 2017.

Wirth/Matějček 1922 = Wirth, Zdeněk/Matějček, Antonín: *Česká architektura 1800–1922* [Czech Architecture 1800–1922], Jan Štenc, Prague 1922.

Wischnitzer-Bernstein 1924 = Wischnitzer-Bernstein, Rahel: "Mechanofaktur. Henryk Berlewis Ausstellung im 'Sturm'," *Jüdische Rundschau* (Aug. 8, 1924): 452.

Wisłocka 1968 = Wisłocka, Izabella: *Awangardowa Architektura Polska 1918–1939* [Polish Avant-Garde Architecture 1918–1939], Arkady, Warsaw 1968.

Witkovsky 2007 = Witkovsky, Matthew S.: *Foto. Modernity in Central Europe, 1918–1945*, Thames & Hudson, New York 2007.

Włodarczyk 2000 = Włodarczyk, Wojciech: *Kunst in Polen in den Jahren 1918–2000*, Arkady, Warsaw 2000.

Wolbert/Buchholz/Latocha 2003 = Wolbert, Klaus/Buchholz, Kai/Latocha, Rita (eds): *Die Lebensreform. Entwürfe zur Neugestaltung von Leben und Kunst um 1900*, Mathildenhöhe, Darmstadt 2003.

Wolitz 2010 = Wolitz, Seth: "Henryk Berlewi i nieostra tożsamość. Estetyczne poszukiwania autentyczności" [Henryk Berlewi and the Fluent Identity. Aesthetic Search for Authenticity], in: Suchan/Szymaniak (2010: 66–79).

Wollaeger/Eatough 2012 = Wollaeger, Mark/Eatough, Matt (eds): *The Oxford Handbook of Global Modernisms*, Oxford University Press, Oxford 2012.

"Woman…" 1915 = "Woman in Austrian Army Bearing Sword," *Svoboda* 43 (1915): 2.

Worringer 1959 = Worringer, Wilhelm: *Abstraktion und Einfühlung. Ein Beitrag zur Stilpsychologie*, Piper, Munich 1959 (1908).

Wroniecki 1917 = Wroniecki, Jan Jerzy: "Św. Sebastian" [St. Sebastian], *Zdrój* 1 (1917), No. 3: 68.

Wünsche 2018a = Wünsche, Isabel: "Expressionist Networks, Cultural Debates, and Artistic Practices: A Conceptual Introduction," in: Wünsche (2018c: 1–30).

Wünsche 2018b = Wünsche, Isabel: "Expressionist Networks in the Russian Empire, Soviet Russia, and the Soviet Union," in: Wünsche (2018c: 113–133).

Wünsche 2018c = Wünsche, Isabel (ed.): *The Routledge Companion to Expressionism in a Transnational Context*, Routledge, London/New York 2018.

Wyganowska 1993 = Wyganowska, Wanda: "Pierwsza Brygada" [The First Brigade], in: Hrankowska (1993: 187–192).

Y

Yatsiv R./Yatsiv A. 2019 = Yatsiv, Roman/Yatsiv, Andriy: *Ivan Ivanets' (1893–1946). Strilets'ki memuary, tvorcha spadschyna*, Apriori, Lviv 2019.

Z

Zalizniak = Zalizniak, Bogdan: "Olena Kulchycka. Zamaliovky z zhyttipysu i tvorchoi dorogy" [Olena Kulchycka. Sketches from the Artist's Biography and Artistic Life], *Mystecka storinka* (without date): https://storinka-m.kiev.ua/article.php?id=696 (accessed: Sept. 19, 2019).

Zavtra 1915 = "Zavtra v pidofitsers'kii kukhni pyrohy" [There'll be Pierogies in the Sergeants' Mess Tomorrow] (cartoon), *Samokhotnyk* 5 (1915): 4.

Zbuchea 1999 = Zbuchea, Gheorghe: *România și războaiele balcanice 1912–1913. Pagini de istorie sud-est europeană* [Romania and Balkan Wars 1912–1913. Pages of Southeastern European History], Albatros Editions, Bucharest 1999.

Zepa/Kļava 2012 = Zepa, Brigita/Kļava, Evija: *Modernisma un postmodernisma nacionālisma diskursi nacionālās identitātes skatījumā* [Interpretation of National Identity through Modern and Postmodern Discourses], in: Bela/Zepa (2012: 9–25).

Zhertva 2015 = "Zhertva kholery v Kamintsi" [Cholera Victim in Kaminka] (cartoon), *Samokhotnyk* 4 (1915): 5.

Znaniecki 1921 = Znaniecki, Florian: *Upadek cywilizacji zachodniej* [The Fall of Western Civilization], Komitet Obrony Narodowej, Poznań 1921.

Zweig 1942 = Zweig, Stefan: *Die Welt von Gestern*, Williams Verlag, Zurich 1942.

Zweig 2011 = Zweig, Stefan: *Världen av igår* [Die Welt von Gestern: Erinnerungen eines Europäers], Ersatz, Stockholm 2011.

Zwickl 2018 = Zwickl, András: "Expressionism in Hungary: From the Neukunstgruppe to Der Sturm," in: Wünsche (2018c: 73–91).

Indexes

Page references in italics refer to images.
Boldfaced page references refer to the List of Images.

Indexes

NATIONALISM AND COSMOPOLITANISM IN THE AVANT-GARDE AND MODERNISM
The Impact of the First World War

NATIONALISM AND COSMOPOLITANISM IN THE AVANT-GARDE AND MODERNISM
The Impact of the First World War

NATIONALISM AND COSMOPOLITANISM IN THE AVANT-GARDE AND MODERNISM
The Impact of the First World War

Nationalism and Cosmopolitanism in the Avant-Garde and Modernism

The Impact of the First World War

Lidia Głuchowska — Vojtěch Lahoda (eds.)

Texts: Dorthe Aagesen, Oksana Dudko, Éva Forgács, Irina Genova, Ginta Gerharde-Upeniece, Lidia Głuchowska, Annika Gunnarsson, Nina Gurianova, Benedikt Hjartarson, Vendula Hnídková, Naomi Hume, Torben Jelsbak, Erwin Kessler, Vojtěch Lahoda, Steven Mansbach, Petar Prelog, Emilio Quintana Pareja, Bela Tsipuria, Harri Veivo, Michał Wenderski, Tomáš Winter

Copy and technical editor: Jiří Odvárka
Language editor: Eleanor Stoltzfus
Proofreading: Rupert Brow
Graphic design and photo editing: Jana Vahalíková
Printed by: Havlíčkův Brod Printing House, Ltd.

Published by Artefactum Publishing House, Institute of Art History of the Czech Academy of Sciences, with the cooperation of Karolinum Publishing House, Charles University, and Institute of Visual Arts, University of Zielona Góra

1st edition

Prague 2022

ISBN 978-80-88283-69-0 (Artefactum)
ISBN 978-80-246-5121-7 (Karolinum)